COLONIAL AMERICAN PORTRAITURE

COLONIAL AMERICAN PORTRAITURE

*The Economic, Religious, Social, Cultural,
Philosophical, Scientific, and Aesthetic Foundations*

WAYNE CRAVEN

*H. F. du Pont Winterthur Professor of Art History
University of Delaware*

The right of the
University of Cambridge
to print and sell
all manner of books
was granted by
Henry VIII in 1534.
The University has printed
and published continuously
since 1584.

CAMBRIDGE UNIVERSITY PRESS

Cambridge

*London New York New Rochelle
Melbourne Sydney*

Published by the Press Syndicate of the University of Cambridge
The Pitt Building, Trumpington Street, Cambridge CB2 1RP
32 East 57th Street, New York, NY 10022, USA
10 Stamford Road, Oakleigh, Melbourne 3155, Australia

First published 1986
Reprinted 1987

Printed in the United States of America

Library of Congress Cataloging-in-Publication Data

Craven, Wayne.
Colonial American portraiture.
Bibliography: p.
1. Portraits, American. 2. Portraits, Colonial –
United States. 3. United States – Civilization – To 1783.
I. Title.
N7593.1.C73 1986 760′.0442′0974 86-12985

British Library Cataloguing in Publication Data
Craven, Wayne
Colonial American portraiture : the economic,
religious, social, cultural, philosophical,
scientific and aesthetic foundations.
1. Portrait painting, American 2. Portrait
painting – United States – History
I. Title
757′.0973 ND1311

ISBN 0 521 32044 5

To Lorna

Contents

CONTENTS

Illustrations

Preface

To Know the Portraits We Must Know the People

In this book I have removed art from the confinements of a single discipline in order to perceive colonial American portraiture as a complex expression of society and the individual, as well as of artistic genius. For some time, scholars have labored at analyzing the styles of early American portraits, and the formal and technical matters are now fairly well understood. But there seems to have been an assumption that colonial portraits – unlike later history paintings, landscapes, genre scenes, and so on – possess no iconography rich enough to warrant study, and so concentration has been largely restricted to formal analysis of style. This flaw in the art-historical methodology has caused a complete comprehension of the portrait to elude us. Furthermore, restricting the study of art to formal analysis deprives us of valuable contributions from specialists in a wide range of fields – literature, history, religion, philosophy, science, and American studies – who are often greatly interested in art but are reluctant to enter into its interpretation because they lack the skills of formal analysis. But, if we are to understand the colonial American portrait totally, the art historian must become familiar with a wide variety of kindred disciplines and must welcome those from other disciplines into the challenging business of analyzing art, for the work of art consists of more than color, light, form, and space. Thus, the direction and purpose of this book are established.

Over the years, while lecturing on colonial American portraits in seminars and writing about them in articles, I became increasingly aware that although I could define their styles, sources, and evolutionary process, the one thing that remained unexplained was the reason why those styles developed as they did. Merely declaring them to be transplantations of contemporary European styles was unsatisfactory; for one thing, that explanation begs the question of what caused the European styles to form as they did. It became evident that what I was searching for was, in fact, outside the field of aesthetics and formal analysis; what was missing was an understanding of the philosophical and cultural basis of colonial American portraiture. Central to such a foundation are religion and economics, but also sociology, philosophy, science, and culture in general.

For many years I realized, in no small amount of frustration, that some door to comprehending the colonial American portrait remained closed to me. The initial key was finally found in the writing of the great religious reformer

John Calvin, in which one gains insight into the complex Protestant personality. Most colonial Americans were Protestants and, therefore, to explain their portraits we must understand the Protestant perspective. In studying a Western world suddenly divided between Catholics and Protestants, it is essential to know how the Protestants – the newcomers to Western civilization – looked upon life, and where their highest values were placed. The task then became one of identifying Protestant religious beliefs and secular priorities, and defining them with greater precision than art historians have done in the past, so that such things could be properly interpreted as they appear in the portraits.

The study of Calvin's religious treatises, specifically his *Institutes*, led directly into the investigation of Protestant secular priorities.[1] Protestantism arose mainly within middle-class societies and nations, and its emergence as a world force was intimately entwined with the rise to wealth and power of the middle class. In 1920, Max Weber published *Die protestantische Ethik und der "Geist" des Kapitalismus*, translated into English as *The Protestant Ethic and the Spirit of Capitalism*, in 1930. The primary focus and the enduring concept of this controversial little book were the interlocking relationships, historically viewed, of the rise of Protestantism and the rise of a middle class made possible by capitalism.[2] The origins of colonial American society, whether for New England, the middle colonies, or the South, were in the middle class; and a primary reason for the success of Protestant spiritualism was its compatibility with the intense secular motivations of an impellent middle class. Although religious convictions were very important to colonial Americans, so was the drive toward worldly prosperity. Protestantism as guided by Calvinist theory and middle-class values, ambitions, accomplishments, and restrictions must be considered in conjunction with aesthetic, technical, and stylistic matters if colonial American portraits are to be understood fully.

The matter is more complex, of course, than the simplistic scheme just outlined. For example, the presence of the Anglican church and the role model of a royal governor with his diminutive court would affect the spiritual and secular development of a given region, as would social organization into rural (the South) or urban (New England) patterns. Identification by certain colonial groups (New England merchants) with the merchants of London, in contrast to affiliations by other groups (southern planters) with English country gentry, would result in regional diversity of character and life-style, and this, too, was bound to influence the portrait image. Moreover, the seventeenth and eighteenth centuries were exciting and fascinating eras insofar as scientific discovery and philosophical inquiry were concerned; surely the enlightenment emanating from such men as Newton, Locke, Berkeley, and Hume should deserve some consideration in the analysis of colonial portraits. Investigation of the phenomena of vision and optics, of the reality and composition of the natural world, and of matter must have had some impact on the perception of both patron and painter. Colonists were not illiterate, nor were they ignorant of the scientific knowledge and philosophical debates of their day.

Too great emphasis has been placed on the role of the ministers in the Protestant world and on the way of life they would have men and women lead; except during periods of extreme zealotry, it was the merchants and

planters who actually dominated their societies through their wealth and social eminence. It was they who really forged the colonial American character, which, of course, included piety but was certainly not totally dominated by it. As the merchants and planters were the primary patrons of the portrait painters, we must seek an explanation of the portrait image more in their secular values and virtues than in the writings of ministers who have left a record of how they would have life be rather than how life actually was. The portraits simply do not mesh with the denial of worldly pleasures and goods that was supposedly one of the dominating canons of Protestantism; we can learn more about a merchant's portrait from his account book or a ship's manifest than from reading Wigglesworth's *Day of Doom*. We must therefore study the secular code of those who were portrayed – primarily the merchants of the North and the planters of the South – for in their economic pursuits and social ambitions will be discovered the ultimate foundations of the portrait styles. In truth, the ministers encouraged devotion to one's secular calling as a part of the fulfillment of God's plan, and that led to a sanctioning of the material prosperity so evident in most colonial American portraits.

The present study will consider the transformation of the colonial character through three periods of time and several geographic regions. Throughout, one may observe the transformations of ideas, institutions, social orders, and communal values that are expressed sequentially in the portraits of colonial men, women, and children. Separate regions will seek and define their own levels of middle-class aristocracy, from yeoman-tradesmen-merchant beginnings to patrimonies of wealth, social position, and elegance of life-style. But in spite of regional differences, a common code revolved around moral and economic responsibility, religious piety, industry, individualism, pragmatism, and prosperity.

Regionally, each society sought a middle course between the lower level of the dull-witted poor and the extravagances and vanities as they existed in the corrupt and immoral segments of European aristocracy. Lines were drawn to separate the life-styles of the New England merchant and the southern planter from these evils beneath and above them in the social order of the day. But we will find that the line between the lower class and the middle class was indeed penetrable from beneath in this land of opportunity, and a person could transcend meager origins by means of industry, piety, and respectable behavior. If that lower line were penetrable, the upper line was flexible. That line defined the limits between an acceptable enjoyment of prosperity and outright ostentatiousness. As these middle-class folk prospered they continually exerted a pressure that effectively forced a gradual elevation of the upper limit, to the point where they lived as moderate aristocrats. Perusing the colonial period from start to finish, we may observe this process in the ever-increasing stylishness of their domestic architecture, in the increasing comfort of their interiors, in the increasing elegance of their dress, in the increasing refinement of their life-styles, and ultimately, of course, in their portraits. But for an understanding of how they arrived at those final pseudoaristocratic images of themselves, we must follow their religious, economic, and cultural histories from their origins in England and on the Continent. In brief, to know the portraits we must know the people.

Finally, because understanding colonial portraiture is the primary purpose of this book, artistic matters will be studied in tandem with the broad cultural characteristics just outlined. We must look into the artistic styles of the middle class in the seventeenth century, particularly those of the English and the Dutch. We must inquire into the means by which style was transmitted and discover the attitudes toward and notions of art among Puritans in Massachusetts or Anglicans in Virginia. What socio-cultural forces finally brought art to the attention of colonists, and, if foreign painters satisfied the demand for portraits at first, how was it that a native school finally arose? Within that native school, what societal forces forged the aesthetic character of the art of a Robert Feke, a John Singleton Copley, or a Charles Willson Peale?

My search for answers to these problems has often carried me into intellectual disciplines that are at once both far removed from and yet overlapping with the work of art itself. Although trained in the history of art, I must venture out, beyond the snug confines of my own discipline, for I know the answers that will give an understanding of colonial American portraiture are not self-contained in the work of art, as an object isolated from society. We therefore commence this study, not with a work of art – which is often the end product of a given society – but with the sixteenth-century theologian and reformer John Calvin and with the social, cultural, and economic structure of the newly emergent middle class.

Acknowledgments

I wish to express my gratitude to President E. A. Trabant, Provost L. Leon Campbell, and Dean Helen Gouldner of the University of Delaware for the support and encouragement they have always given to my work. Dean Gouldner arranged a grant to help defray the expenses of research and manuscript preparation, while the Center for Advanced Studies, established at the University of Delaware by Provost Campbell, provided me with a year's leave, in 1983–84, so I could complete the writing of the book; I am grateful to the Center's Selection Committee for recommending my appointment. I would like to thank an anonymous benefactor who arranged for me to have a full year of sabbatical leave in 1981–82 for research connected with this study.

My good friends and colleagues in various fields at the University of Delaware have generously shared their expertise with me, and I wish to acknowledge these members of our little seminar that has met over lunch every day for many years; their patience is appreciated as much as their guidance: Damie Stillman, Chairman of the Department of Art History, has ever been supportive of my research; J. A. Leo Lemay of the English Department, who first suggested I write this book, responded benevolently with his usual brilliance to my every question and was a constant source of advice as well as encouragement; Professors Donald Mell, Elaine Safer, and Thomas Calhoun of the English Department and Professors Raymond Wolters and George Frick of the History Department were always ready to assist through their critical analysis of ideas and their knowledge of bibliography.

The professional staff of Morris Library at the University of Delaware have assisted me in every possible way. I am especially indebted to Susan Brynteson, Director; Nathaniel Puffer, Associate Director; and Susan Davi, Reference Librarian for the Fine Arts.

At art museums, historical societies, and libraries, in this country and abroad, there are many who have been generous with their time and efforts on my behalf. Foremost among them are Virginius C. Hall, Virginia Historical Society; Graham Hood, Colonial Williamsburg; Jack Jackson and Jonathan Harding, Boston Athenaeum; Jonathan Fairbanks, Museum of Fine Arts, Boston; Monroe H. Fabian, National Portrait Gallery; Karol Schmiegel and McSherry Fowble, H. F. du Pont Winterthur Museum; and Rosalind K. Marshall, Scottish National Portrait Gallery, Edinburgh. Several individuals have

been kind enough to allow me to see and/or obtain photographs of portraits in their possession: the Duke of Grafton, the Earl of Seafield, Lady Daphne Stewart, John Hill Carter, Jr., Mrs. Dorothy Lee, and Mrs. Walter B. Mahoney, Jr.

In fond remembrance I acknowledge the late Henry Francis du Pont, founder of Winterthur Museum, who in 1960 established the professorship that brought me to the University of Delaware.

Finally, I would like to include here my parents, Ernest and Vera Craven, and the parents of my wife, John and Ama Breseke, all of whom deserve greater acknowledgment for their support and encouragement than I can express.

Part I

ORIGINS AND BEGINNINGS, TO 1680

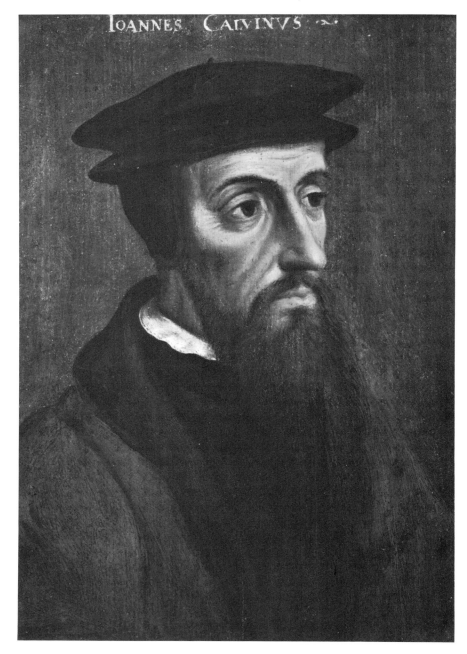

Figure 1. *John Calvin*, French School, c. 1550. Oil on panel, 10¾ × 7¾ inches. Museum Boymans–van Beuningen, Rotterdam.

The Legacy of John Calvin

Christian Virtues and a Doctrine of Prosperity

Colonial American portraiture rises first in New England, about 1665 to 1675, amid a Protestant, mercantile society. In the past scholars have tried to make the portraits mesh with that one great body of published writings of the time, the sermons and theological treatises. But those early portraits were not created as images of Puritan austerity or denial of worldly pleasures. Indeed, John Calvin had declared that austerity was unnecessary and that enjoyment of the world's pleasures was acceptable, as long as moderation was respected. The portraits do, in fact, reflect the doctrine of prosperity and the theory of diligence at one's secular calling, both of which were woven into the theological fabric of Protestantism.

The catalyst for the conciliation of the powerful spiritual yearnings of Protestantism and the worldly, economic propensities of the burgeoning middle class was John Calvin (1509–64; Fig. 1). Although born a Catholic, at Noyon, France, he experienced conversion to Protestantism in 1533, due in part to the influence of the circle of humanists with whom he was intimate in Paris. As religious persecution increased he fled to Switzerland, finding in Basel a center of Protestantism where he took up the study of theology and began writing. His *Christianae Religionis Institutio*, published in Basel in 1536, set forth Calvinist doctrine: rejection of papal authority and the sacraments, acceptance of faith alone, and recognition of the Bible as the only source for knowledge of God's will and God's laws. Calvin soon became the leading theologian of Protestantism, acquiring an international following. In this he became more the official theologian for the new faith than even its founder, Martin Luther, or the early Swiss reformer Huldreich Zwingli. Henceforth, the Bible and Calvin's *Institutes* would be the two primary texts of international Protestantism. Calvin acquired his greatest support from among the mercantile and agrarian middle class, and soon his followers included the Huguenots in France, the Presbyterians in Scotland, and the Puritans in England, all of whom found themselves in conflict with established churches, either Catholic or Anglican.

For our purposes, the most important of these diverging and multiplying strains of deviation was the Puritan sector. During the reign of Catholic Mary, 1553–58, many English Protestants fled to Geneva, where they learned of Calvinist doctrine. When they returned to their homeland after Elizabeth I assumed the throne in 1558, they brought the new theology with them, and

an English edition of the *Institutes* was published in London in 1561.[1] Although Elizabeth espoused the Anglican church, which had been established by her father in 1534, she was generally tolerant of the growing Puritan element among her people.

In England, as the seventeenth century opened, the most popular form of Puritanism was Congregationalism, which continued its growth under the reign of James I from 1603 to 1625, although it did so at royal displeasure. Such a sect would naturally have been out of favor with a monarch with Catholic inclinations, but even the Anglican church saw Congregationalism as a threat and reacted accordingly. The situation worsened after James's son Charles I (reigned 1625–49) became king, when the Episcopal bishop William Laud led the persecution against nonconformity; it was therefore during Charles's reign that the great migration of the 1630s occurred, commencing with the arrival of the *Arabella* at Boston harbor in 1630. As John Winthrop stepped ashore, one may, figuratively speaking, envision him carrying the Bible in one hand and Calvin's *Institutes* in the other. The words of Calvin had an enormous effect upon the lives – and therefore ultimately on the art – of these colonists of the New World and those who followed. To arrive at an understanding of the art of America in the colonial period, it is essential to determine who, precisely, these people were who began streaming into the wilderness, and what it was in Calvin's *Institutes* that gave them spiritual comfort and worldly guidance.

Briefly, the immigrants of the seventeenth century were mainly from the yeoman and middle-class levels of English society, although there was an impressive number of university-educated men, often the minister-leaders of the flocks. To these laborers, farmers, tradesmen, and merchants Calvinism had a very special significance, not only for the spiritual values so dear to them but for their secular concerns as well. In New England, they turned to their copies of Calvin to provide the answers to a wide variety of problems that arose in their daily lives,[2] as when Samuel Sewall noted in his diary that while visiting the Flints in Dorchester, "the time my wife and Mrs. Flint spent in the orchard, I spent in Mr. Flint's study reading Calvin on the Psalms."[3]

The first generations brought Congregationalism with them to New England. Church ceremony was minimal because elaborate ritual had no sanction in the Bible, as Calvin had pointed out. There should be no religious images, for they would lead to the detested idolatry of the Catholics; the minister need not wear the hated surplice nor read from the Book of Common Prayer, which had been demanded by the Anglican hierarchy; the congregation should be free to choose its own minister without his having to be ordained by higher church authority. In other words, Congregationalists insisted on the autonomy of the congregation, and hence the origin of the name "Congregationalist." By 1630, in England, these folk already had a core of their own interpreters of Calvin's theology, led by Robert Browne, Thomas Cartwright, Henry Barrowe, John Greenwood, Paul Baynes, William Perkins, and William Ames, who was one of the most important. Ames sets forth his religious convictions in *Medulla Theologiae* (1628), in which it is evident that Calvin's *Institutes of Christian Religion* was the cornerstone, indeed nearly the whole foundation, for Congregational beliefs. Ames's writings were very popular in New En-

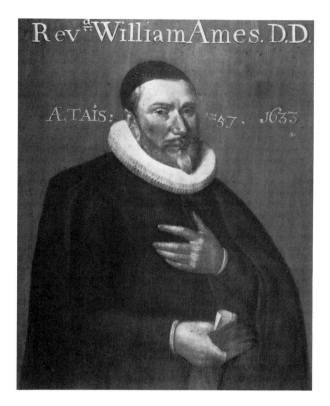

Figure 2. *The Reverend William Ames*, attributed to Willem van der Vliet, 1633. Oil on panel, 31¾ × 26 inches. Harvard University Portrait Collection, Cambridge, Mass.

gland, and although he never visited the area, his portrait is believed to have been brought to Massachusetts by his widow in 1637, making it one of the earliest-known portraits in the colony (Fig. 2).[4]

Although the primary incentive of the first waves of immigrants may have been to escape persecution and find a place where they could worship in their chosen way, free from the contaminating influences of Catholicism and Anglicanism, those were not the only incentives. An economic factor arrived with the first boatloads of colonists; it increased to astounding proportions within the very short time of a generation or two, and it was fully condoned by Calvinist theory. Even John Winthrop, before he departed England with the group headed for Boston, alluded to this economic motive as an inducement apart from religious motivation:

> The whole earth is the Lord's garden and he hath given it to the sons of men with the gen[eral] Commission: Gen: I:28: increase and multi-plie, and replenish the earth and subdue it. . . . Why then should we stand striving here for places of habitation etc. (many men spending as much labour and cost to recover or keep sometimes an acre or two of Land, as would procure them many C[hundred] as good or better in another countrie) and in the mean time suffer a whole Continent as

5

fruitfull and convenient for the use of man to lie waste without any
improvement?[5]

The economic motive in the Protestant world and the blessings on the drive
to prosperity that Calvinism offered are fundamental to understanding colonial
portraiture, our ultimate goal.

In the *Institutes*, Calvin preaches the Christian virtues of thrift, industry,
and sobriety and declares them to be essential to the fulfillment of God's will
on earth. These virtues developed within that class from which Protestantism
drew its greatest constituency, and their constantly increasing acceptance co-
incided with the rise of a commercial economy and a middle-class society.
Capitalism and Protestantism emerged together in the middle class, and the
chief modern spokesman for this theory is Max Weber, who in 1920 published
The Protestant Ethic and the Spirit of Capitalism. According to Weber's theory,

> Calvinism . . . stripped its followers of the shelter of a forgiving
> church, thrust them naked under the eye of God, and demanded that
> they so discipline their faith, time and work that they could withstand
> the scrutiny. Few religions have so energized the worldly activities of
> their believers.[6]

Calvin's personal virtues – frugality, honesty, industry, and simplicity –
constituted a code of virtue that was basically secular and completely com-
patible with the new economic life that pulsated throughout Protestant Europe.
These secular virtues were, in fact, subscribed to by almost every Protestant
sect, no matter how much they differed from one another in religious beliefs.
Calvin established a permanent unity among otherwise contentious Protestant
middle-class groups by promulgating a moral code they could all accept and
live by in their secular endeavors. According to Calvin, Scripture declares that

> earthly blessings . . . have all been given us by the kindness of God,
> and appointed for our use under the condition of being regarded as
> trusts, of which we must one day give account. . . . Let us remember
> by whom the account is to be taken – viz. by him who, while he so
> highly commends abstinence, sobriety, frugality, and moderation,
> abominates luxury, pride, ostentation and vanity.[7]

Such a philosophy would have both immediate and long-lasting effects on
Americans, and one scholar has observed that "The Puritan code has its re-
pellent features, but it is no bad thing to have habits of honesty, sobriety,
responsibility and hard work impressed upon a community."[8] These religio-
secular virtues were essential in what we have come to refer to as the Protestant
work ethic, and they were fundamental to the doctrine of prosperity. Because
all of this will eventually reveal itself as the philosophical foundations of co-
lonial American portraiture, it must be analyzed carefully.

Even earlier than Calvin, Martin Luther (1483–1546) had declared that the
fulfilling of daily tasks and duties of a secular nature was imbued with religious
significance. That is, one leads a religious life in part by the proper performance
of secular tasks. For Luther, labor conducted in the secular world was as valid
in the eyes of God as that performed in monastic withdrawal. Similarly, Calvin

stressed that it is a Christian's obligation to do secular work, for that work is a part of God's plan, and as such it is fully as pleasing to God as ecclesiastical good works. Whereas Catholicism offered little blessing for secular labors, Calvinism appeared in perfect timing for the rising working-class society of merchants, laborers, farmers, tradesmen, and the like to find divine approval and sanction for their temporal endeavors. It was a religion tailor-made for their way of life, for to Christian piety it appended God's blessing on their workaday efforts.

Calvin never denied worldly things, as long as they were not counter to the basic tenets of his religion; the daily affairs of men and women should, he contended, be left to their own consciences. His primary concern was that worldly things be enjoyed in moderation and never to excess. As men and women travel this life they should take a middle course between extremes that are "unnecessarily austere" (monastic or hermitic withdrawal) and "excessively indulgent" (lust, gluttony, pride, avarice, and so on). It is the responsibility of one's own conscience to keep worldly enjoyment in proper restraint, but quite some latitude still is tolerable between the extremes. As Calvin himself says, "Scripture having laid down general rules for the legitimate use [of the things of this world], we should keep within the limits which they prescribe."[9] Moderation is the key element, and Calvin notes that we are well

> instructed by Scripture in the proper use of earthly blessings. . . . For if we are to live, we must use the necessary supports of life; nor can we even shun those things which seem more subservient to delight than to necessity. We must therefore observe a mean, that we may use them with a pure conscience, whether for necessity or for pleasure.[10]

That is, one should be moderate in the enjoyment of such abundance as providence brings one's way. So the limits become general, relative, and even open to personal interpretation as to what is luxury, indulgence, or licentiousness on the one hand, and merely enjoying God's gifts on the other. The limits were sufficiently flexible to accommodate a rising standard of living among prospering middle-class Protestants – an upwardly mobile society that needed a flexible upper limit on the enjoyment of worldly things.

Calvin said that the universe was created and all things set in motion by the will or force of God; therefore, Protestants glorified God by the works they performed, even through labors of a secular nature if they were works that contributed to the perpetuation of God's plan. This was called working at one's calling. Secular work was as important for six days of the week as prayer was for the seventh; work, like prayer, could contribute to one's salvation. "The Lord enjoins every one of us," Calvin writes, "in all the actions of life, to have respect to our own calling [and] in following your proper calling, no work will be so mean and sordid as not to have a splendour and value in the eye of God."[11] That this Calvinistic concept was transmitted to England is evident from the copious instances where it appears in sermons and treatises by English theologians. Englishmen not only listened to sermons on the sabbath but sought them out to read when they were published, and they were published by the score.

One of the most influential of the Elizabethan preachers was William Perkins

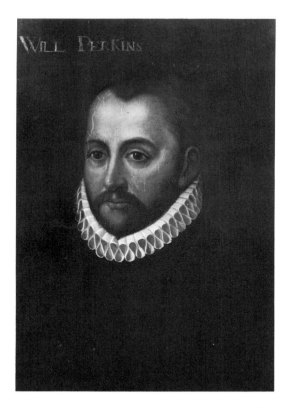

Figure 3. *The Reverend William Perkins*, by an unidentified English artist. c. 1600. Oil on canvas, 16 × 22 inches. Dr. Williams's Library, London. Photo courtesy of the National Portrait Gallery, London.

(1558–1602), who had imbibed the Puritan doctrine while a student of Laurence Chaderton at Christ's College, Cambridge (Fig. 3). He began preaching about 1585, attracting a wide following through the logic and simplicity of his sermons. As delivered orally and as published, they defined the growing controversy between the Anglican and the Reformed churches. Perkins was one of the most respected teachers at Cambridge University, propagating and interpreting Calvinist theory and influencing some of the most eminent theologians of the next generation, among the best known of whom were William Ames and John Robinson. The latter, the founder of Congregationalism, published an edition of Perkins's catechism in Leyden.[12] It was from the teachings of William Perkins that John Cotton was first led away from the established church and into the Puritan sect, and Cotton was but one of many who carried Perkins's ideas to New England in the second quarter of the seventeenth century.

On the subject of the Christian's personal and general callings Perkins was especially influential, and his writings on that theme were found in numerous New England libraries in the century following the first settlements.[13] He puts the matter succinctly in *A Declaration of the True Manner of Knowing Christ Crucified*, stating that men must dedicate themselves "to the service of God,

in the general calling of a Christian, and in the particular callings in which he hath placed us."[14] But his main statement on the matter is made in *A Treatise on the Vocations or Callings of Men, with the Sorts and Kindes of Them, and the Right Use Thereof*, first delivered as a sermon, then published in 1603, and widely available in *The Workes of that Famous and Worthy Minister of Christ in the Universitie of Cambridge, Mr. William Perkins.*[15] Therein, Perkins declares that "Vocations or Callings" come from God and should be respected as divine ordinations; further, men should perform their callings with total diligence, and he cites scriptural authority for doing so. Monks and friars who live apart from the world, he writes, are less pleasing to God than those who diligently pursue their callings in the world.[16] Moreover, as the "meanness of the calling doth not abase the goodness of the work," however lowly the calling, one's labors can find favor with God and should be executed properly.

Perkins declares that one should eschew extravagance and ostentation, but he does not define the actual limits of such things, thereby leaving the limits flexible, just as in Calvin's theory. He sanctions the acquisition of "things necessarie" and says, citing David the psalmist, "that riches should be given to the righteous, unless it be the will of God to exercise and try him by want and poverty."[17] These very words would be echoed by Cotton Mather and later by Benjamin Franklin in the transformation from Puritan to Yankee thought. "So may any men accept abundance," Perkins writes, "when it is the pleasure of God to bestow it upon them, while they walk in their callings, [but] God hath given a commandment, that we must seek only for things, that may be in Christian wisdom esteemed necessarie."[18] Ministerial followers of Perkins would later interpret these words in one way, and colonial merchants in another, but their differences concerned degree only.

The sentiment that prosperity was a reflection of God's favor flourished among the middle class, especially among the successful merchants, and Perkins's discussion of the matter proves its existence at least as early as the end of the sixteenth century.[19] The idea was, in fact, generally accepted by minister and merchant alike, even though the more prosperous the merchants, tradesmen, and so on became under the Calvinist Protestant sanction of material and economic acquisition, the more the ministers felt compelled to rail against such worldly concerns. The merchant class particularly, however, became very headstrong, and when they had their portraits painted they wanted their material success shown therein, for aside from exhibiting social standing it was emblematic of their being in God's favor.[20]

We may observe the influence of Perkins's theo-secular theory being transplanted in New England through men such as John Cotton, who wrote in 1651, in *Christ the Fountaine of Life*, "look to thy worldly business, art thou diligent in thy calling ... and cursed is he that doth the work of the Lord negligently, and the work of his calling is the work of the Lord."[21] Clearly it is secular work here that is "the work of the Lord." Cotton treated the matter more fully in his essay "Christian Calling," in which he wrote that

> if thou wouldst live a lively life and have thy soul and body to prosper in thy calling, labor then to get into a good calling. ... And when thou hast it, serve God in thy calling, and do it with cheerfulness and

faithfulness and an heavenly mind. . . . Thou mayest then have comfort in it, before God and men.[22]

Valentine Hill, a prospering Boston merchant of the 1640s, placed great store in the writings of William Perkins, especially *A Cloud of Faithful Witnesses Leading to the Heavenly Kingdom* (London, 1607), which had quickly become a favorite among the merchant class because it demonstrated by scriptural examples how faith in the Lord revealed the path to worldly riches. Hill would have found similar encouragement in John Preston's *A Remedy Against Covetousness*, published in London in 1632, or about the time that the great migration to New England was under way. "Our aim," Preston decrees, "must be God's glory and the public good, and then God will cast riches upon us as our wages."[23] This is a pivotal point because its implications are transferred to the portraits: If people prospered, it was a manifestation of God's blessing on them for their good work, and it was therefore acceptable to show the fruits of prosperity in a portrait, as long as one did not become ostentatious.

As early as 1616, John Downame wrote that "the Scriptures require that we should be bountiful and plentiful in good works, [and] this should increase our care and diligence in preserving and increasing our estates."[24] In a similar vein, the Reverend Samuel Willard notes in his *Compleat Body of Divinity*:

> It is not enough to get an Estate, but there is a Duty to endeavor that
> it may prosper by good Husbandry of it, in the best way. Prosperity
> is a Blessing to be desired, tho' not insatiably to be grasped after,
> which is a Temptation. . . . Riches are consistent with Godliness.[25]

The conviction emerged among middle-class Protestants that neither the acquisition of wealth nor advancement in social status was inherently evil, except if carried to excess. In fact, William Ames, in his *Conscience with the Power and Cases Thereof*, assures his Puritan followers that "not every desire for riches is covetousness, but only the inordinate love of them."[26] Of course, a man could go too far and be charged in a Massachusetts court with covetousness, as in the case of Robert Keayne.[27] But in principle, work at one's calling and the prosperity that accrued therefrom were, respectively, pleasing to God and a sign of his blessing.[28]

The theory of "callings" transcended religious affiliations and spread throughout the middle class, whether Protestant or Anglican. For example, one of the most influential English authors of the last part of the seventeenth century was Richard Allestree (1619–81), a clergyman of the Anglican Church under the Restoration (Fig. 4). His work *The Gentleman's Calling* was immensely popular, and after being published in London in 1660 it went through ten editions by the turn of the century; it is often listed in colonial libraries in the late seventeenth and early eighteenth centuries. The book was a guide to gentlemen on how to lead respectable lives in the world, and Allestree's instructions were, of course, intertwined with religious dicta. As a guide, it was especially interesting to those who were on their way up in society, for many were of a first generation of prosperity and wanted to shed the coarser habits and manners of their past.

Gentlemen, the rising merchant learned from Allestree, were separated from

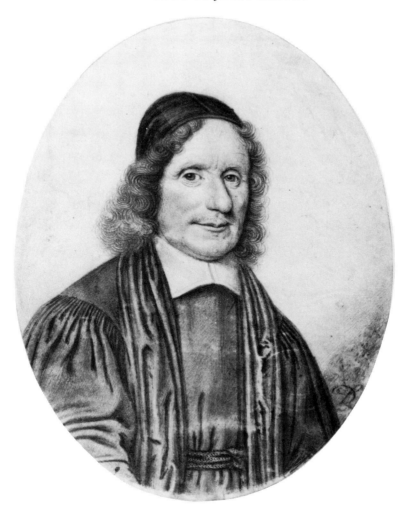

Figure 4. *The Reverend Richard Allestree*, by David Loggan, c. 1675. Black lead and brown wash on vellum, 4⅞ × 3¾ inches. British Museum, London.

the "vulgar" of the social order in several ways—by their education, their wealth, and their leisure time, each allowing the cultivation of a refined life. All these prerogatives of rank God gave as gifts so that his system would be attended to on earth, and such gifts should not be wasted, for that would be a flouting of God's will and purpose. Therefore, even a gentleman had work to do, for it was his responsibility to see that God's system in the secular world be carried out. This theory was, of course, perfectly suited to an upwardly mobile middle class, for it gave validity to their labor and the source of their wealth (as opposed to inherited wealth).

Allestree declared that God gave all men some particular talent and that they should not dissipate this divine legacy by idleness, neglect, or a dissolute way of life.[29] He clearly stated that the man who labors (merchant, tradesman, farmer) would be doing God's bidding better than a gentleman who idled

away his time, talent, and fortune; he thereby instructed the newly arrived gentleman-merchant that with wealth and prosperity came obligations as well. A gentleman would choose not to wallow in luxury, he wrote, even though he might have the means to do it; and the gentleman must be careful not to fall victim to excessive pride, one of the vilest of sins.[30] Finally, Allestree condemned idleness, pointing out that even the beasts and inanimate things of this world perform appointed roles diligently; and he asked, Is man to be the only discordant being in the Divine plan by being lazy and idle?

Nothing clarified the blessedness of industry so much as the attitude toward the sin of idleness. More than a sin, it was a crime, as a Massachusetts statute of 1633 mandated: "No person, householder or other, shall spend his time idly or unprofitably, under pain of such punishment as the Court shall think meet to inflict." Thomas More's *Utopia*, a book often found in seventeenth-century New England homes, declares that idle persons should be banished. During the Commonwealth, in England, "there were many schemes for ameliorating unemployment, but nearly all of them bore traces of a growing disposition to regard poverty as a crime and disgrace."[31] Idleness was a waste of God's precious time, and an idler became a drone within, if not a burden upon, an otherwise vigorous and industrious society.

New England Protestants knew that they had God to thank for their prosperity. For example, John Hull, the successful Boston merchant and silversmith, noted in his diary in 1666: "I sent to England a considerable adventure in sundry ships...; and it pleased the Lord all that I sent arrived safe and came to a good market. The Lord make me thankfull."[32] One senses a kind of business partnership between Hull and the Lord – the merchant working hard at his calling, the Lord rewarding it with success and prosperity. Similarly, Philip English of Salem, one of New England's richest merchants, accepted God as his silent partner in his work: "Shipped by the Grace of God... in the good sloop called *Mayflower*... and by God's grace bound for Virginia or Maryland,... twenty hogsheads of salt.... And so God sent the good sloop to her desired port in safety. Amen."[33]

Industry, among the Protestant merchants and yeomanry, was a passion consummated in prosperity. Cotton Mather, grandson of John Cotton and Richard Mather, urges his flock to industriousness, when he writes:

> I tell you, with Diligence a man may do marvellous things. Young man, Work hard while you are Young: You'll Reap the Effects of it, when you are Old.... Let your Business Engross the most of your Time. Tis not now and then an Hour at your Business that will do. Be stirring about your Business as Early as tis Convenient. Keep close to your Business, until it be convenient you should leave it off.[34]

Mather, in *A Christian at His Calling*, anticipates the pragmatic philosophy of Benjamin Franklin:

> Take this Advice, O Christian; 'Tis a Sin, I say... for a man to Spend more than he Gets, or make his Layings out more than his Comings in. A frequent Inspection into the State of your Business, is therefore not among the least Rules of Discretion. It was among the Maxims of

Wisdom given of Old, Be Thou Dilligent for to know the State of thy
Flocks; That is to say, often Examine the condition of thy Business, to
see whether thou go forward or backward.[35]

The words that have been quoted from Calvin, Perkins, Ames, Mather,
and others constitute the perfect credo for a working, middle-class society that
was intent on rising in the world. Calvin and his interpreters advocated good
Christian virtues of simplicity, honesty, industry, and frugality, and the prin-
ciple of prosperity as a sign of God's blessing upon his chosen people; all of
this evolved with a religion that found these things compatible with a piety
that would, they hoped, lead to salvation and eternity spent in heaven, if it
should be God's pleasure to bestow Grace as well. It offered, literally, the best
in both worlds, and the mutually agentic factors were piety and industry. A
Protestant could not have overt symbols of piety painted into his or her portrait
because of the interdiction against icons and idolatry, but the virtues we have
been discussing could nevertheless be infused into a likeness. In fact, it was
essential to do so.

But the gospel of work and the doctrine of prosperity carried with them
the seeds of erosion of spiritual concerns. In New England, the original Puritan
austerity (such as it was) and religious control soon broke down under the
successes of mercantilism in the second and third generations of colonists.[36]
Although prosperity was the main cause, there were other contributing
factors as well. Up to about 1640 in England, and even well into the years
of the Commonwealth, the Puritans were sustained in their zeal by a crusading
spirit and the belief that events were falling into place which would bring
God's rule to earth, with the elect saints (the Puritans) as his vicars. This gave
vitality to the movement in the 1630s and 1640s. Also, for the colonists,
there was the zeal fired by the confrontations with powerful religious and
governmental opponents at home, and then with the conditions besetting them
when they tried to establish a settlement in the wilderness. Such things kept
spiritual vitality at a high pitch. But a disillusionment set in as the Common-
wealth became a debacle in its late years and the promise of a Puritan gov-
ernment collapsed. With the Restoration of Charles II in 1660, it was clear
that the great experiment had failed, and younger generations of Puritans
turned their considerable energies elsewhere – primarily to mercantile and
agrarian interests.[37]

Religious zeal was only part of the motivation that sent great numbers of
immigrants across the Atlantic. A severe economic depression in England in
the 1620s made food and jobs scarce; this situation was exacerbated by the
decline in the cloth trade, especially in East Anglia, where unemployment ran
exceptionally high. Vaughan has summarized the worldly incentives of many
of the people who were suffering under these conditions:

> Depressions came with sickening frequency: from 1619 to 1624, 1629
> to 1631, and again from 1637 to 1640. . . . Although modern scholars
> are reluctant to explain the settlement of New England on primarily
> economic grounds, there is no doubt that declining wages, increasing
> costs, and unstable incomes encouraged many devout Puritans, and
> many non-Puritans, to believe that God meant for them to join the

experiment in the New World. The autobiographical writings of New Englanders invariably mention economic distress as an impetus to migration. . . . Many also jumped at the chance to earn high wages or set up shops of their own in the rapidly expanding colonies.[38]

The rising middle class in England was, of course, forming a culture of its own, based in part on honored old traditions but in part also on a desire to increase its prosperity, its social position, and its political clout. These very same motivations were transferred to colonial American society and found expression in the portraits of the men and women who were its staunchest advocates. The phenomenon of their prosperity soon sounded an alarm, however, not only to the monarchy, the aristocracy, and the established church, but also even to the Puritan clergy.

The most vocal segment of society in seventeenth-century New England was the clergy, and in the second half of the century their cries of despair betray the loss of the control they had earlier enjoyed. Their near theocracy gave way before an increasing demand for separation of church and state, which brought a concomitant loss of pulpital political power, for power began to shift from the meetinghouse to the countinghouse as the Protestant's love affair with prosperity became more impassioned.

William Bradford of Plymouth was bewailing the change that had set in as early as 1647, only seventeen years after the Great Migration had begun at Boston.[39] In 1674, or about the time the portraits of John Freake and Elizabeth Freake with her daughter (Figs. 10 and 11) were painted, the Reverend Samuel Torrey wrote, in *An Exhortation unto Reformation*, "Truly, the very heart of New England is changed, and exceedingly corrupted with the sins of the times. There is a spirit of profaneness, a spirit of pride, a spirit of worldliness, a spirit of sensuality . . . , a spirit of libertinism, a spirit of carnality."[40] Conditions had so deteriorated that it was necessary to hold a synod in 1679 that drew up a list of sins the younger generations had fallen into; this list was submitted to the General Court, which accepted it, had it printed under the title "The Necessity of Reformation," and circulated it.

The very fervor and frequency with which the ministers, law courts, and old-timers bewailed an increased worldliness are conclusive evidence of its existence. But the ministers were in a difficult position because the theological foundation of their faith – Calvinism – condoned, even encouraged, the gospel of secular work and the doctrine of prosperity. Therein, of course, lay one of the chief reasons for the continuing viability and longevity of Calvinism because, the moanings of the clergy and old guard notwithstanding, it was flexible at the upper limits of prosperity. That is, the line that separated condonable prosperity from the sins of ostentation and vanity was never rigid or even precisely drawn. In their impellent drive to wealth, the merchants, or whoever, could salve their consciences with the authority of Calvin's own writings. So they listened patiently to the scathing sermons of a Sunday or at prayer meetings on Thursdays, but they otherwise went about their business of gathering wealth and enjoying the worldly objects and power it brought – and still, they could convince themselves, they were in a mutually respected partnership with God.[41] After all, their very prosperity was an irrefutable sign of God's approval,

for everyone knew that one could not be successful if God had not willed it. All of this, of course, appears in most of the portraits that were painted of these prospering, upwardly mobile middle-class folk and culminates in the portraits by John Singleton Copley.

Although the original colonists may have sought in their "howling wilderness" an isolation to protect them from the contamination of corrupt religions and licentious courts, that isolation was short-lived. Subsequent waves of immigrants brought those who sought wealth and prosperity at least as much as a wilderness isolation for their soul's sake. The composition of the colony changed as outsiders – that is, people who were not dedicated Congregationalists – arrived. Furthermore, business enterprise contributed to the fast-occurring change. The colonists' ships that soon ran to many different parts of the world returned bearing the world's goods and worldly ways. As constant contact with the rest of the world (even with Spaniards, Frenchmen, and other Catholics!) eroded the feeling that they were the chosen people, New Englanders began taking their place in the world rather than insulating themselves from it. Among other things, this meant assuming some of the cultural values of the wealthy of the world, which in turn meant a new enthusiasm for the arts. Such enthusiasm would affect the fashion of a gown, the design of a chair, and, in time, the style of a painting. Even that lewd pastime visited upon the people by the devil himself – mixed dancing – was so popular, the Puritan clergy could not repress it. Dancing, of course, implies the presence of music as well, but the Puritans had few objections to music, unless it was ribald or bawdy or was a part of elaborate ceremonies in the church. After all, John Foster, creator of the well-known woodcut of Richard Mather, was himself a fiddle player. Thus, change was surely hard upon New Englanders; it worried some, but it excited others.

Boston by 1664, at the eve of the commencement of painting in colonial America, had a population that reportedly numbered 14,300 souls. Its fine harbor was home to about three hundred merchant ships. Even a quarter-century earlier there had been a goldsmith there, for around 1640, John Hull was apprenticed to him. Hull became a respected silversmith, along with his partner, Robert Sanderson; they crafted bright pins, buckles, and buttons for the fashionable attire that preening Bostonians now appeared in. Hull made silver bowls and pitchers for their tables and silver pine-tree shillings for their pockets. This craftsman amassed a considerable fortune, relatively speaking, and owned several ships that engaged in trade. Withal, he was a pious man who had prospered, catering to the vanities or at least the modest desires for the things that made life on earth pleasant.

Hull owned a fine house, another testimony before the eyes of his neighbors of his industry and prosperity – and, ergo, of his favor in the eyes of God. The ministers could hardly fault him on that ground, for even they enjoyed that secular pleasure, and indeed the minister's house was often as fine as any in a town. The house of the merchant increasingly became a symbol of secular and spiritual well-being; in time the desire arose for images of family likenesses, which took their place as part of the interior scene, amid furnishings that became continually more comfortable and more refined, and eventually even elegant. The portraits of the master of the house and/or his wife were, after

all, icons of the persons who had created that little corner of security and comfort. The shrine to Protestant prosperity would thus be completed when its icon was set within it.

The several components that were to effect the style of seventeenth-century New England portraiture include the doctrine of prosperity, acceptance of such virtues as industry and moderation, and commitment to one's calling. All of these found sanction in Calvinism and were, it would seem, inherent in a rising middle class determined to succeed in this world. Moreover, although piety was maintained and ministers were respected, the merchants increasingly dominated the course that colonial society was taking and that had a profound impact on colonial American art. But before we can analyze colonial portraiture, we must consider the role and character of art in England in the seventeenth century, especially in relation to Protestantism and Anglicanism.

Calvin, Milton, Cromwell, and the Role of Art

Nationalism, Naturalism, and the Survival of the Elizabethan–Jacobean Style

From the beginning of the Renaissance in northern Europe, wealthy burghers joined the Roman Catholic church and the aristocracy as patrons of art. As increasingly greater proportions of wealth came into the hands of the middle class, the bourgeois patron gained sufficient confidence in himself and his way of life to demand of the artist a reflection of his own prosperous world, which he tended to prefer to pictures of saints, angels, or princes. In Protestant middle-class Holland this gave rise to a splendid school of portraiture as well as genre, landscape, and still-life painting. In England, the middle-class patron was content with portraiture. Before the seventeenth century the English middle class had little art that was truly its own, little experience in playing the role of patron, and little exposure to matters of aesthetics. But here were people, now rich and powerful, with sufficient excess wealth to lavish on art; whatever form their art would take, it would have to evolve in accordance with the spiritual and secular forces that had guided the middle class to its present position. As in so many other aspects of life, this class looked to its great theologian, John Calvin, for guidance. Although he did not say much about art, his succinct statements established a Protestant perspective on the subject.

Calvin devoted many pages of his *Institutes* to what art should not be, his purpose being to attack the idolatry of Catholicism. It was a sin, he pronounced, to create images of God or other religious personages, and it was forbidden to place such idols in the church. A few passages from Chapter 9 of Book One of *Institutes* will suffice to convey his position. "God's glory," he writes, "is corrupted by an impious falsehood whenever any form is attached to him, [and therefore] God repudiates all likenesses, pictures, and other signs by which the superstitious have thought he will be near them." Calvin further admonished that "we must hold it as a first principle, that as often as any form is assigned to God, his glory is corrupted by an impious lie." His main authority was, of course, the Second Commandment with its proscription against graven images; but there are other scriptural sources as well: "Isaiah is . . . copious on the subject . . . in order to show how the majesty of God is defiled by an absurd and indecorous fiction, when he who is incorporeal is assimilated to corporeal

matter." Calvin's attack on Catholic idolatry was paralleled by a purging of the painted and carved image from the Protestant church, interior and exterior.

In England, as on the Continent, this Protestant position led to a gross destruction of religious art. Among the most notorious agents of demolition in England was William Dowsing (c. 1596–1679), who saw himself as one of God's avenging angels during the Civil War. On August 28, 1643, when Parliament decreed the destruction of altars and the defacement of paintings and statues in and on churches, Dowsing was dispatched to Suffolk to see to it. In a passage from his journal that relates his activities near Ipswich in January of 1644, we gain an idea of the wholesale destruction that occurred:

> We broke down about an hundred superstitious Pictures; and seven
> Fryars hugging a Nunn; and the picture of God and Christ... and 200
> had been broken down before I came. We beat down a great stone
> Cross on the top of the Church. [And at Clare] we broke down 1,000
> Pictures superstitious; I broke down 200; 3 of God the Father, and 3
> of Christ and the Holy Lamb, and 3 of the Holy Ghost like a Dove
> with Wings; and the 12 Apostles were carved in Wood, on the top of
> the Roof, which we gave order to take down.[1]

Fanatical destruction of this sort has laid upon the leaders of the Commonwealth a reputation for being anti-art, but this was not true. Their wrath was reserved solely for religious imagery; with other types of art they had no quarrel.

After severely attacking the practice of making and displaying religious images, Calvin explained (Book One, chap. 11, section 12 of *Institutes*) his stand on art otherwise, and this is a fundamental passage in understanding the Protestant attitude toward art:

> And yet I am not gripped by the superstition of thinking absolutely
> no images permissible. But because sculpture and painting are gifts of
> God, I see a pure and legitimate use of each.... Only those things are
> to be sculptured or painted which the eyes are capable of seeing.
> Within this class some are histories and events, some are images and
> forms of bodies without any depicting of past events. The former
> have some use in teaching or admonition; as for the latter, I do not see
> what they can afford other than pleasure.

Calvin therefore declared that there was no sin in the enjoyment of art in secular life, and that paintings and statues may adorn "our homes, the palaces of our cities or their museums."[2] He held that it was permissible to paint or carve anything the eye could see, and that left a wide range of subjects including portraiture, landscape, still-life, genre, secular history, and secular literary themes.

In seventeenth-century England the attitude toward art (outside the court circles of Charles I) followed Calvinist doctrine closely. Even as the century opened, William Perkins discussed the acceptable uses for images in *A Warning Against the Idolatry of the Last Times* (Cambridge, 1601), in which party-line Calvinist views were confirmed. After directing harsh invectives against religious icons, Perkins willingly conceded that there are lawful uses for images,

dividing them into three types: The first is symbolic or political, as in coins, where images may be used to distinguish them one from another; the second type is historical. "The third use is, when Images are made for the beautifying of houses, either publick, or private, that serve only for civil meeting. Wherefore it is the scope and intent of the commandment of God, only to forbid the making of images, in respect they are to be applied to Divine or religious use."[3] This attitude was held generally by Protestants in England in the seventeenth century, even by archetypal Puritans such as John Milton and Oliver Cromwell.

Milton (1608–74) accepted as one and the same thing his calling as a poet and as a Christian, and he placed painters on the same high level with poets. As a Puritan he did not oppose literature, music, or the visual arts per se but did so only when these arts were debased or misused, as they too often were, he felt, at the royal court or in the services of the church. In his *Eikonoklastes* (London, 1649) he inveighed against vanity, theatricality, and courtly taste in a general indictment of the misuses of the arts; however, he did not attack the arts as such. As a young man, Milton had spent a year in Italy, in Florence, Venice, Rome, Naples and elsewhere, where he went to see the great art collections, the splendid architecture, and the grand antiquities.[4] He wrote a treatise on the excavation and repair of ancient statues, a treatise that was as advanced as anything then being written on the subject. Once, when he took part in an excavation, he noted, regarding the statues unearthed, that "the naked ones are of the greatest value."[5]

Milton's apartments back in England were anything but austere. The walls were covered with splendid wallpapers and tapestries and were adorned with numerous paintings.[6] Although little is known about his collection specifically, he was a great admirer of Dutch art and once declared that no Englishman was more ardent than he in his delight in it. Milton's own likeness was painted many times, and most portraits show a definite flair for voguish styles of hair and clothing, while there is anything but an austere artistic style in their execution.[7] Sufficient evidence therefore exists to dispel any lingering myth that John Milton held broad prejudices against art.

If the Puritans of England of midcentury had a hero, it was surely Oliver Cromwell (1599–1658). A Puritan, he was a member of Parliament, then during the Civil War a victorious military commander, and finally Lord Protector of England. Cromwell has been blamed for widespread destruction of art, even though recent scholarship shows that the destruction of certain church treasures occurred some sixty-five years before he was born.[8] Religious art was destroyed in prodigious amounts, it is true, but even art of that type was occasionally spared, as when Cromwell interceded to retain Raphael's famed "Cartoons" when they were scheduled to be sold. The sale of Charles I's magnificent art collection is frequently cited as an example of Puritan prejudice against art generally, religious or otherwise; the collection was sold, however, not by order of Cromwell or because the Puritans found collecting and enjoying art detestable, but because the king's debts were enormous and the new government felt honor-bound to pay them.[9] Accordingly, in July 1649, Parliament passed an act confiscating all royal possessions and authorizing their sale. But by 1653, Cromwell interceded to stop the "wholesale dispersal of

Stuart splendor"[10] and to recover as much of the royal furniture and objets d'art as he could.

Cromwell now emerges not as a zealous, destroying iconoclast but rather as a true patron of the arts.[11] The Protector delighted in music and kept an orchestra at court; and it was during Puritan rule that opera, "after the Italian way," was introduced into England in 1656. From the sale of King Charles's collection, Cromwell himself bought a number of pieces, which he installed in his own apartments. One need only look at Robert Walker's portrait of Cromwell (National Portrait Gallery, London) to see that the subject had no objection to having himself portrayed in a sophisticated artistic style.[12]

Cromwell's image is perhaps best known from the portrait of him painted by Sir Peter Lely.[13] Dutch-born and trained, Lely had come to England about 1643 and within a few years was painting splendid portraits of the royal family at Hampton Court. He no doubt would have become Van Dyck's successor at the court of Charles I had the civil upheaval not intervened; soon after Charles II restored the Stuart line to the throne of England, he appointed Lely his Principal Painter, and it is as the portrayer of English Cavalier and court society that Lely is best remembered. But even during the Commonwealth, Lely found many patrons among Parliamentarians, and he was kept busy painting their portraits as well as copies of his likeness of Oliver Cromwell. This suggests anything but an aversion in the Puritan camp toward the making of art, at least insofar as secular art, and particularly portraiture, was concerned.

If Puritan antipathy toward secular pictorial arts did not exist in England, it could not be transplanted to America. John Cotton, while he was still living in England, revealed that he followed Puritan ideology when he noted in one of his early writings that "all Portraitures, Shapes, Resemblances, and Forms of things, Natural, or Artificial, Real or Imaginary, devised by man for religious use, worship or instruction, are forbidden by the scope and letter of the [Second] Commandment."[14] But he, like Calvin, placed no interdiction on other types of painting. We know, in fact, that Cotton kept a portrait of the Reverend Richard Sibbes, a follower of William Perkins, hanging "in that part of the house where he might oftenest look upon it."[15] So, when John Cotton immigrated to Massachusetts, he, like others of his kind, brought with him no prejudices against most secular art.

The Calvinist attitudes toward religious and secular art that were transplanted to New England by the first generation of settlers were perpetuated by later generations. Cotton Mather, for example, published his views on the matter in his *Icono-clastes, An Essay upon the Idolatry Too Often Committed Under the Profession of the Most Reformed Christianity*. Mather called idols "Abominations" and the worship of them "spiritual adultery," and he admonished his readers to "Flee from the Idolatry of Popery."[16] For an expression of the acceptable view on secular art in early New England, the Reverend Samuel Mather's *A Testimony from the Scripture Against Idolatry & Superstition, in Two Sermons . . . Preached the One on September 27, the Other on September 30, 1660* may be cited. The first sermon is a tirade directed against religious imagery, but in it Mather does mention secular art briefly, saying that the condemnation and prohibition of images in the Second Commandment

is not meant of Images of Civil use, but for Worship. . . . For the Civil use of Images is lawful for the representation and remembrance of a person absent, for honour and civil worship to any worthy person, and also for ornament, but the Scope of the Command is against Images in State and use religious.[17]

Samuel Mather, son of Richard Mather and brother of Increase, must have been advocating the authorized Puritan position on secular art. Although Samuel Mather had gone to England in 1650, never to return to Massachusetts, his writings and sermons were known and respected in the Bay Colony. His words demonstrate that there was absolute acceptance of the painted portrait within Puritan society in 1660, the very eve of the first appearance of portrait painting in America.

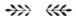

From about 1625 to around 1680, England possessed two distinct artistic traditions – one imported from the Continent into the court of Charles I and its satellites, the other arising from a native English art that was championed by the middle class and many of the gentry. From the moment Charles I assumed the throne of England in 1625, his court became increasingly Continental in its overall character, and the king became increasingly alienated from a large segment of his subjects – the country gentry and the middle class. As their sovereign led his court into decidedly new avenues of taste, manners, fashions, and the arts, the gentry and the middle class tended to hold staunchly to the traditions of their ancestors. They looked disapprovingly upon the lavishness of court life, upon the use of tax monies to support a zeal for collecting art that they deemed excessive, the squandering of revenues to pay for a large, immoral retinue that indulged itself in ostentatious attire and in such sinful pastimes as masques and ribald dramas. Much of what they saw as evil and wasteful came from foreign sources – especially from Italy, France, and Spain – and was therefore interpreted as a monarchial betrayal of national pride and national traditions.

Charles had a French Catholic wife who loved outrageously decorative dresses of Continental vogue and acted in the endless masques and fancy balls that were held at court. His father, King James I, had futilely attempted a reconciliation of Anglicanism and Catholicism by marrying his children into the royal families of Europe, and hence was Charles wed to Henrietta Maria, daughter of Henri IV of France. The queen, a Catholic, had close contacts with the pope and with representatives of Catholic nations, which brought distrust down not only upon her but upon her husband as well. The countervoice to court extravagance and the drift away from national customs and religion was William Prynne's *Histrio-Mastix, The Players Scourge, or, Actors Tragedie* (London, 1632), an indictment of Charles and his court and a compendium of the Puritan code of secular and religious conduct; the book was found in many colonial American libraries well into the eighteenth century.[18]

And so the two forces were aligned in opposition to each other. Anticourtly

feelings actually drove many Englishmen either to Puritanism or to sympathetic alliances with it. The Anglican church, with its close connections to the royal court, did not offer the resistance to the erosion of national traditions that the several Protestant sects of England did, so it was groups such as the Puritans that represented a conservative nationalism. Among those nationalistic traditions to which the middle class and the gentry tended to cling tenaciously were what they considered to be the truly English styles of artistic and literary expression, developed during the reigns of Elizabeth I and James I. In literature we find such sentiments stated by Stephen Gosson, a late-sixteenth-century Elizabethan playwright who was critical of imported customs and goods, especially "Italian devices" that had "poisoned the old manners of our Country with foreign delights [and] to the hazard of their souls [men had deserted] the old discipline of England."[19] The Elizabethan–Jacobean survival style in painting was transplanted to New England in the seventeenth century, so the first portraits painted there were an integral part of an established cultural pattern and were consistent with many other aspects of the society from which the subjects came.[20]

The indigenous English style in portraiture – the Elizabethan–Jacobean tradition – evolved in the art of painters such as George Gower (active c. 1570–96) and Marcus Gheeraerts (c. 1520–c. 1590), and it culminated in the work of Nicholas Hilliard (1547–1619), William Larkin (active 1609–19), and Isaac Oliver (c. 1560–1617).[21] Those of the latter group were active toward the close of Elizabeth's reign and throughout most of that of James I. After them came the great change, in court circles at least, as Charles's taste inclined increasingly toward the antique and Continental Renaissance and baroque art. Charles brought Peter Paul Rubens (1577–1640) to London to create the ceiling decorations for Inigo Jones's beautiful new Palladian-style Whitehall Banqueting Hall, and later he persuaded young Anthony Van Dyck (1599–1641) to settle in London as court portrait painter.[22] Indeed, we know the likeness of Charles from his several portraits by Van Dyck – those sensuous, richly painterly, superbly aristocratic images of monarchial bearing, grace, hauteur, and extravagance.[23] With the reign of Charles I, art in England – at the court, anyway – came apace at last with the contemporary styles and tastes of the other major aristocracies of Europe, that is, with the courts of France, Spain, Flanders, and Italy.

But the indigenous style of England, with its compression of form and space, its timid use of light and shade, its decorative coloring, linear patterning, and rich detailing – a style that retained many medieval characteristics – remained alive as the national style of the middle class and country gentry. Examples of that quintessential Elizabethan–Jacobean style are seen in the "Ditchley Portrait" of Queen Elizabeth I (c. 1592, National Portrait Gallery, London), by an unknown artist; in John de Critz's portrait of James I (1610, National Maritime Museum, Greenwich); in Isaac Oliver's diminutive full-length portrait of the third Earl of Dorset (1616, Victoria and Albert Museum); and in the *Pocahontas* of about 1616.[24]

Pocahontas (Fig. 5), daughter of the Indian chief Powhatan, was married in 1614 to the Virginia colonist John Rolfe, who took her in 1616 to England, where she was presented to society and to the king and queen. It was at that

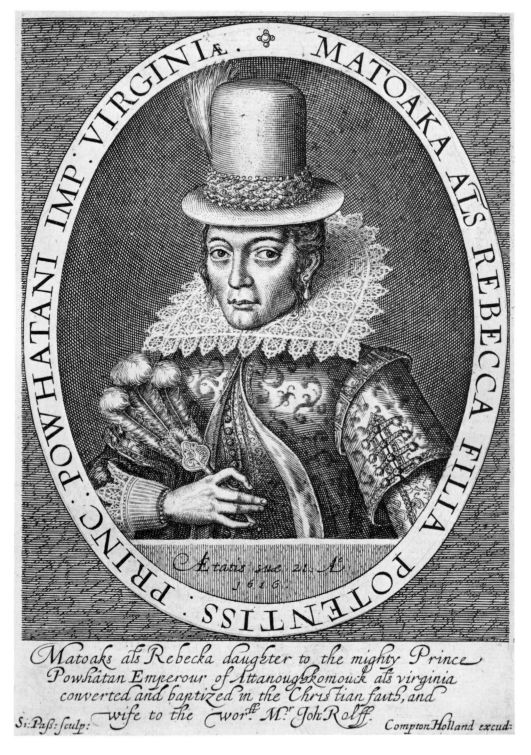

VIRGINIÆ · MATOAKA ALS REBECCA FILIA POTENTISS · PRINC · POWHATANI IMP · VIRGINIÆ

Ætatis suæ 21. A.
1616.

Matoaks als Rebecka daughter to the mighty Prince
Powhatan Emperour of Attanougskomouck als virginia
converted and baptized in the Christian faith, and
wife to the wor.ll M.r Joh: Rolff.

S: Paß: sculp: Compton Holland excud:

Figure 5. *Pocahontas*, by Simon van de Passe, c. 1616. Engraving, 5¾ × 4⅝ inches.
National Portrait Gallery, Smithsonian Institution, Washington, D.C.

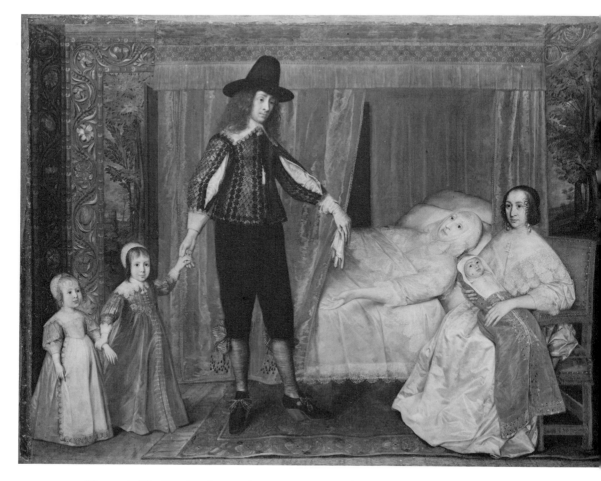

Figure 6. *The Family of Sir Richard Saltonstall*, by David des Granges, c. 1637. Oil on canvas, 84 × 108 inches. Tate Gallery, London.

time, during the reign of James I, that her portrait was engraved by Simon van de Passe. The image possesses the stylistic characteristics of the neomedieval, Elizabethan–Jacobean manner: linear definition of form with emphasis on linear decoration, timid shading, and compressed form and space. In looking at it, one may tend to forget it is roughly contemporary with the work of such Continental artists as Caravaggio, El Greco, and Peter Paul Rubens. Its style represents the native tradition that would be retained out of nationalistic pride outside the court and in preference to imported foreign styles. The Elizabethan–Jacobean survival style has been largely ignored, even by historians of English painting, who are prone to concentrate on the Van Dyck, Lely, and Kneller tradition. But it continued to be practiced in England throughout most of the century, and it had its own champions in artists such as Cornelius Johnson, David des Granges (Fig. 6), and David Loggan (Fig. 15).

Johnson (1593–1664), the best known of this school, was probably raised

in a Dutch community in London, and there is circumstantial evidence that he had his early artistic training under a Dutch master. Although Johnson retained certain features of the Elizabethan–Jacobean style (pronounced linear definition of form, emphasis on decorative detail, and subtle shading), an important modification of that style occurred in his work, for he imposed Dutch features in the neutral background and the low-keyed tonality of his palette generally. A good example of this amalgamated style is seen in his portrait of Susanna Temple of about 1620.[25] The strong Dutch influence is understandable, for if there was any contemporary Continental artistic tradition with which the English middle class could associate itself, it was that of Holland. The lavish styles of the courts of France, Spain, Italy, and Flanders were alien to English middle-class merchants and conservative country gentry, but Dutch art found a great popularity among them. We have already noted the attraction that Dutch painting held for John Milton. Therefore, the indigenous English style of portraiture of the seventeenth century – the one carried with them by those folk who left home to settle in the New World – is one of Elizabethan–Jacobean foundations but with important contemporary Dutch modifications, as formulated by Cornelius Johnson, among others.

In Holland, the English middle class found a bourgeois, mercantile society with which it formed economic and sociological affiliations, in spite of the three Dutch–English wars of the seventeenth century. In both countries, Protestantism stood staunchly against attempted incursions of Catholicism; both the Dutch and the English were a seafaring people; both had a middle class that was emerging as the real power of the nation, and middle-class restraint and decorum prevailed in the moral codes of both countries. Across the North Sea, one merchant could communicate with another through the international economic language of mutual profit-making. When religious persecution had earlier beset the Netherlands, Dutchmen often fled to England; when nonconformist Englishmen sought a haven from persecution, they frequently found it in Holland. If the Elizabethan–Jacobean tradition in art, kept alive by powerful socio-cultural, economic, religious, and nationalistic forces, were to be "modernized," then it would be through affiliation with the nonaristocratic, non-Catholic art of the Dutch. It was that tradition which survived among the great body of folk from whom the emigrants to New England would come in the seventeenth century.

One of the most interesting paintings of that Elizabethan–Jacobean, Dutch-influenced style, in relation to the later development of colonial American painting, is David des Granges's *The Saltonstall Family* of 1637–39 (Fig. 6). Although several men of the Saltonstall family named Richard were living at about that time, it is believed that the man standing in the center of the picture represents Sir Richard Saltonstall (1595–1650) of Chipping Warden, near Banbury in Oxfordshire.[26] His first wife, Elizabeth Basse, is shown in her deathbed, gesturing toward their two children, Richard and Ann, while Sir Richard's second wife, Mary Parker, to whom he was wed in 1633, sits at the right holding an infant, either John (b. 1634, died young) or Philip (b. 1636). In *The Saltonstall Family*, the style is a blend of that love of intricate pattern, bright color, compressed space, linear definition of form, and timid shading found in Tudor and early Stuart portraits, with the new Dutch-influenced

manner of Cornelius Johnson. The picture demonstrates a preference for the old, truly English style rather than the new but foreign style then being imported to the court of Charles I (in 1637–39, it should be noted, Anthony Van Dyke was working in London as Charles's official portraitist). The Saltonstall picture reveals the strength of the indigenous English style in the provinces, during the very period of the Great Migration to New England. Other branches of the Saltonstall family had by that time settled in London, where they became prominent and prosperous merchants; among them was the Sir Richard Saltonstall who brought his family to Boston with John Winthrop in 1630.[27] The *Saltonstall Family* is therefore important for our purposes, not only as an example of the style we have been discussing, but because it shows how that style could be transported through the aesthetic traditions of a family, a part of which is known to have emigrated to New England.

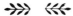

Before we leave the Protestant, middle-class artistic tradition of seventeenth-century England, one vital component remains to be considered. Naturalism, the basic ingredient in the style of colonial New England portraiture, had its societal foundations in Calvinist theory and in the bourgeoisie's preference for a realistic reflection of their own world. When we look ahead, much of what we find in the vivid portraits of Copley or Peale finds first sanction in the words of Calvin.

Calvin advocated, both implicitly and explicitly, a naturalistic style. In Book I, Chapter 10, of the *Institutes*, he writes, "We must therefore admit in God's individual works . . . that God's powers are actually represented as in a painting." Nature is to God what the painting is to the artist – the thing created; God created nature and thereby provided the models for man the artist. The latter was to take inspiration from the works that God had created, and nature is therefore the rightful subject of art. As an artist is imitating God's act of creation, and the result (his painting) is an imitation of the physical results of God's creative act, the artist is most like God the creator when his art is most like the nature that God created. To paraphrase, it was a "naturalism is next to godliness" point of view. Things should be painted basically as God created them, and to represent them in a manner that deforms them, even through idealization, would imply that God had erred in the form he had given them, which would be presumptuous to say the least. Sir Godfrey Kneller, in the portrait style he devised to suit his courtly patrons, erred in the voguish mannerisms that appealed to vanity but departed from nature; such a style would never find permanent acceptance in colonial America, in part because it was not in agreement with a basically Calvinistic attitude as to the purpose of art. According to Calvin, there is no justification to deform (i.e., to idealize) nature in portraiture, for every line, wrinkle, and so on, in the human face was a part of natural truth and expressive of that divine particle within, the soul.[28] In an aesthetic such as this, truthful representation is equated with beauty; hence, beauty may be found in the portrayal of a subject who is very plain of countenance or even somewhat ugly. For example, Oliver Cromwell

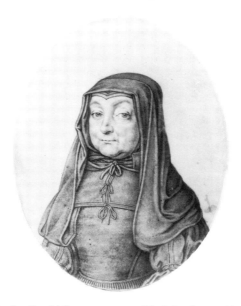

Figure 7. *Mrs. Baily*, by David Loggan, 1668. Black lead on vellum, 5½ × 4½ inches. British Museum, London.

reportedly instructed a painter who was taking his likeness "to paint my picture truly like me and not flatter me at all, but remark all these ruffness, pimples, warts and every thing as you see me."[29] David Loggan's little portrait (1668) of Mrs. Baily (Fig. 7) demonstrates just such an aesthetic as it existed among the English middle class. The English aristocracy, under the influence of the art of foreign courts, might prefer an artistic style that idealized; but the pragmatic, middle-class English merchant, close both to the real world and to Calvin, would turn to a naturalistic, truthful style. This attitude that finds beauty in truth, even if the subject is so plain as nearly to exclude the possibility of beauty, culminates in the portraiture of Copley, where a perfect example would be his *Mrs. Thomas Boylston* (1766) in which the subject's face is excruciatingly plain, yet beautiful (Fig. 152). In this regard, Copley's *Mrs. Boylston* and Loggan's *Mrs. Baily* have much in common.

In this chapter we have seen that those Protestants of the gentry and middle class who were guided by Calvinist theology had no antipathy toward art and could accept the representation of anything that could be seen with the eye, as long as it was not lewd or immoral. They detested images of God, saints, angels and the like, and forbade them in their churches. They disapproved of imported styles that emanated from aristocratic, Catholic courts on the Continent – styles that they saw their king and queen embracing in a betrayal of an honored English tradition. Out of nationalistic pride they retained the Elizabethan–Jacobean tradition, which was their own national version of Renaissance art, but allowed it to be modified by the art of a kindred middle-class, Protestant, mercantile society, that of the Dutch. And finally, truthful

naturalism rather than an artificial idealization formed the foundation of the style with which they wished to see themselves portrayed. This was precisely the aesthetic that was transferred to New England through immigration in the course of the seventeenth century, at least up to about 1680.

The Comeliness of Attire and the Loathsomeness of Long Hair

Studies in Iconography

In a portrait, primary emphasis is normally given to the face of the sitter. But attire and hair are usually the next most important components in the image, and the role they play should not be underestimated. Actually, the face usually occupies a relatively small area of the total canvas, while the costume and hair are used to expand considerably upon the visual biography of the subject, revealing to the viewer many things about the person portrayed that could not be conveyed through the face alone. Although clothing and hairstyles in real life were subject to the fashions and restrictions set by peer groups, they were also expressions of religious convictions, cultural as well as nationalistic associations, social position, and socio-economic aspirations. Therefore, in the portraits, representation of attire and hair was manipulated to suggest those very things, and in order to interpret the portraits accurately and thoroughly, it is essential to understand the prevailing attitudes about them in seventeenth-century England. Once again we commence with John Calvin and his comments on clothing.

First, a brief comment should be made about Calvin's attitude toward the unclad figure, for before the figure is attired, it is nude. Calvin never opposed nudity in art per se, as long as the image did not become lascivious. That Protestants could have paintings of the nude figure adorning even the public areas of their homes is demonstrated in van der Neer's *A Dutch Interior*, which shows a picture of a voluptuous Venus hanging above the fireplace (Fig. 8). But Calvin and his English followers perceived the human form very differently from the classicist, who saw it as the supreme accomplishment of nature and, when properly idealized by the artist, as the ultimate vehicle for aesthetic perfection. Still, as far as Calvin was concerned, the nude human figure was a part of God's created nature, and as such it was acceptable for the artist to paint it or carve it, as long as the representation avoided lewdness.

Ever since the Fall of Adam and Eve the perpetual sins of innumerable generations have deformed the physical body far beyond its original godlike state. It is therefore wrong to attempt to conceal our shame by covering our bodies with beautiful raiments; the primary justifications for attire, according to Calvin, are to protect us from wrong and from inclemency and to avoid

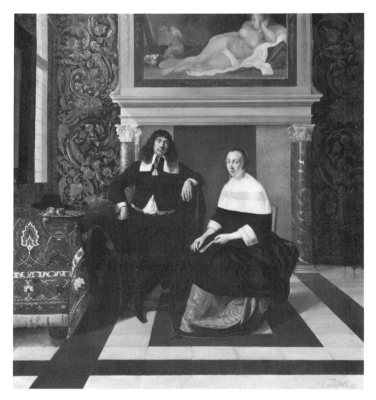

Figure 8. *A Dutch Interior*, by Elgon Hendrick van der Neer, c. 1670. Oil on panel, 28⅝ × 26½ inches. Museum of Fine Arts, Boston, Seth K. Sweetser Fund.

indecent exposure.[1] Protestant moderation in attire thereby had its justification, and Calvin further queries: "Where [is the] thankfulness to God for clothing, if on account of sumptuous raiment we both admire ourselves and disdain others? if, from a love of show and splendour, we pave the way for immodesty?"[2]

Nevertheless, in keeping with his policy that austerity was not required for the good of the soul, Calvin never advocated that people had to wear hairshirts; instead he stressed moderation. Excessive luxury in one's attire – in fabrics or color or design, in jewels, ribbons, or lace – led to vanity, which was a sin. But rich fabrics, laces, ribbons, shiny buttons, brooches or buckles, even jewels were tolerable as long as used in moderation, and Calvin saw them as inoffensive indulgences which caused no harm and which added some pleasure to daily life. He expressed his position on the matter by stating: "If we consider for what end he [God] created food, we shall find that he consulted not only for our necessity but also for our enjoyment and delight. Thus, in clothing, the end was, in addition to necessity, comeliness and honour."[3] Calvin understood full well the acquisitive nature of his middle-class following and refused to advocate the austerity of the hermit to a class of people who were just discovering the pleasures of prosperity. The key was moderation, and as time passed the flexible upper limit of moderation was simply adjusted upward as prosperity increased. Colonial portraits show that the subjects were as proud

of their handsome raiments as they were of the other pleasures their affluence brought them, and their comely attire was looked upon as an emblem of moderate prosperity that indicated God's favor. This was as true in the seventeenth-century portrait of John Freake (Fig. 10) as it was of Copley's image of the merchant John Hancock (Fig. 151).

The issue of hairstyles led to a socio-cultural debate in the seventeenth century that was even more heated than the one it caused in the 1960s. The length and style of the hair and whether it was one's own (or a wig) became an indication of a person's religion, moral code, nationalistic or cosmopolitan preference, and position within the social structure of the several classes. The way in which persons wore their hair revealed much about them, and its symbolic overtones were, of course, wrought into the portraits.

A book by Thomas Hall, *The Loathsomnesse of Long Haire* (1653), focuses on the issues just mentioned. From it we may deduce the several points of view in the argument, for although Hall uncompromisingly declares his own position, the nature of his harangue discloses the other existing positions. Hall (1610–65) was born into the middle class; his father was a clothier, which is interesting in relation to the author's pronouncements on attire. After studying theology at Oxford University he became a teacher and a preacher, converted from Anglicanism to Presbyterianism, and was persecuted for his nonconformity. As a religious extremist, he took as his mission to denounce Anglicans, Catholics, foreigners, and even members of his own sect for their wicked ways insofar as their hair and apparel were concerned.

Hall begins by quoting a "Reverend Master Gipps" (probably Thomas Gipps, d. 1709), who addressed the House of Commons on the very disturbing matter of "Cavalierian garb of clothes . . . and Ruffianly hair. . . . Certainly (saith he) it was not so within these few years, when the poor fugitive posted to New-England, in another cut of hair and clothing."[4] Hall, citing Scripture, asserts that "any man, Be he high or low, rich or poor . . . may not transgress the Commands of God in wearing Long Haire."[5] He also appeals to Englishmen on nationalistic grounds, saying that long hair "is contrary to the civil and laudable custom of those civilized Nations which we live in. . . . Now the known commendable custom of our Land (all the reign of Queen Elizabeth, King James, and the beginning of the late King's [Charles I's] reign) was short haire."[6] Hall then quotes the Reverend William Perkins on the matter with "it is not our ancient English fashion, but instead it is a foreign trick, and therefore as unlawful as foreign attire, which God condemns. . . . Our ancient English fashion was to wear short haire."[7] Later, Hall claims that long hair is "against the modest, civil, and commendable custom of our Nation, till lately that we began to follow the French and Spaniards, who yet are known Papists and Idolaters."[8] All of this was aimed against an increasingly fashion-conscious society that had taken to aping Continental styles, which led the soul toward wordly pleasures and away from Puritanical spiritualism in its extremity. The court of Charles I had, of course, been instrumental in importing foreign fashions, some of which had begun to filter down to the lower levels of English society.

Hall appeals to his readers' respect for practicality when he writes that "The Haire of a Man's Head is too long when tis an impediment to him, and hinders

him in the works of his calling."[9] Moreover, the length of hair is excessive when it "covers the eyes, the cheeks, the countenance, etc. God hath ordeined those parts to be visible, for the face is a special glass wherein the glory & Image of God . . . doth shine forth."[10] Taking the example of a portrait of John Calvin, he writes, "As for Calvin, however some would wrest his words, yet his Practice [short hair] is well known, and his Effigie in Oxford Library (which I believe is drawn from life) will tell you that he never intended to be the Ruffian's Patron."[11] Hall further notes:

The gravest and godliest Divines and Christians in our Nation . . . so still wear, and formerly did wear the shortest Haire. . . . In their works they plead for it . . . and the Effigies [portraits] of many of them which are to be seen at this day in Oxford library (which we may conceive were the liveliest [most lifelike] and exactest that could be had) do plainly show it.[12]

He argues that long hair is not only the emblem of an evil and corrupt element within England – Cavalier society – but also of the dregs of society:

Consider there are many base and beggarly brats that wear long locks, as well as some great ones. Are not the dross and dregs of men companions with thee in this sin? Look abroad into the world, and see whether the vilest men do not usually wear the longest locks. Tell me whether ragged Rascals, nasty Varlets, Raggamuffian Souldiers, Tinkers, Crate-carriers, Jail-birds, etc., are not partakers with thee in this Ruffianly guise?[13]

What Hall preferred was "a rounding of the head," although he says it was by actors on the stage – "that shop of the Devil" – that the derogatory term "Round-heads" was first used in reference to Puritans.[14] He also would forbid shaving the head, citing again scriptural authority, but one of the worst offenses was the wearing of a wig.

No man should wear the hair of another, Hall exclaims, be it the hair of "a man, a woman, or . . . of some harlot, who is now in Hell."[15] He continues that wigs are unlawful and condemned by Christ. The author then touches on a matter that had definite ramifications for portraiture, declaring that one ought to accept one's features as they are, for they are nothing less than God's own "handywork," and should not beautify one's self falsely; when this attitude is transferred to portraiture, it advocates a nonidealizing, naturalistic paint-me-as-I-am style. Hall declares:

What is this but to correct God's handywork, and in the pride of their hearts to think they can make themselves better than God hath made them. . . . Better wear an hundred caps than one Periwig: for as reverend Perkins well observes, it is an odious thing for any man or women to be ashamed of God's workmanship in their own haire, and therefore to beautify their heads with bought haire.[16]

Still, Hall conceded that even among clergymen and scholars at the universities long hair and wigs were increasingly finding favor.

For a woman, according to Hall, long hair is natural, for it "is an ornament

to her, and given to her [by God] for a covering."[17] However, he again found fault with the current styles of hair worn by some women, seeing such things as a curse brought upon the English as fopish importations from the Continent:

> Nor is that presently to be accounted an Ornament, which the profane of the World esteem so; for then painting of the Face, curling and powdering of the Haire, black Spots, naked Breasts, etc., would all be lawfull. . . . It is an abuse of the haire, when the locks are hung out to be seen by others; a modest matron hides them. . . . Thy hair should be bound up like modest matrons, & not lasciviously hung out.[18]

Van der Neer's *A Dutch Interior* (Fig. 8) shows a Protestant woman whose hair is properly "bound up like modest matrons" and not "hung out" in a great profusion of curls. And in New England portraiture when we observe a woman's hair discreetly bound up and covered, as in the *Elizabeth Freake* (Fig. 11), and then see it "hung out," as in the *Maria Catherine Smith* (Fig. 45) of only a few years later, we may be sure changes were occurring in colonial society.

In a new edition of *The Loathsomness of Long Haire* (London, 1654), a section addressed to "the Female Sex" was added, titled *An Appendix Containing Diverse Reasons and Arguments Against [Cosmetic] Painting, Spots, Naked Backs, Breasts, Arms, etc.* . . . It commences with several pages of instructions and admonitions regarding proper and improper feminine attire and fashions from Hall's point of view. Restating a philosophy that would underlie the paint-me-as-I-am theory in portraiture, he explains

> The beauty of God's people is an inward beauty (Psalms 45:13) consisting in holiness, humility, meekness, modesty, mercy, etc., no matter what the skin or outside to be. . . . Lying is unlawfull; but this [cosmetic] painting and disguising of faces is no better than dissimulation and lying; they teach their faces to lye, and to show what is not; and so by deceiving others, at last they deceive themselves, getting deformity instead of beauty, losing that true beauty which they have by Nature [as a gift from God]. . . . Let everyone be content with those favours and features which the most wise God hath given them.[19]

Although the middle class generally advocated moderation, it lived in a world that continually exposed it to the allurements of that higher faction in society which indulged itself in fanciful, gay attire and pastimes. A tug-of-war resulted, with men like Hall, the Puritan archconservative, pulling on one arm of the prospering middle-class merchant or his wife, while the aristocracy and nobility, with their merry ways and sartorial extravagances, tugged at the other. When the New England portraits of middle-class laymen, their wives, and their children are reviewed in sequence from the mid-seventeenth century to the mid-eighteenth century, it is obvious that with each passing year the subjects succumbed increasingly to the sirenlike attraction of the more elegant life-style.

The excesses in hair length and clothing as well as the adoption of foreign styles – in brief, the very things to which Hall and others like him objected – are epitomized in Sir Peter Lely's portrait of Charles II (Fig. 9). With the

Figure 9. *Charles II*, by Sir Peter Lely, c. 1675. Oil on canvas, 91½ × 56¾ inches. Collection of the Duke of Grafton. Photo courtesy of the National Portrait Gallery, London.

advent of the Civil War, Charles (reigned 1660–85) had gone into exile, at age sixteen, in Paris, where his Catholic mother, Henrietta Maria, sister of King Louis XIII, was living. Upon the execution of his father in 1649 he was proclaimed king, but all attempts to regain the throne were futile. In 1655 he took up residence in the Spanish Netherlands, and his years of exile at French and Spanish courts influenced his vision of what the manners, fashions, and life-style of a great monarchial court ought to be. After his restoration he established the Continental fashions, extravagances, and lascivious ways at his own court in England. In Lely's portrait of him we may observe the length of hair – which was the style at the French and Spanish courts but was considered excessive by such persons as Thomas Hall – and also the elaborate style of dress, which was thoroughly French and was deemed outrageous by many Englishmen. In all, Lely's portrait captured the very excess and betrayal of English customs to which Hall and others objected so strenuously. But the power of the court of the realm as a style setter cannot be denied, and the ways of the court began filtering down through the nobility to the gentry and middle class, and, even, insofar as they could be afforded, to the lower level of English society.

Whereas Hall had been a spokesman for Puritan conservatism during the Commonwealth, after the Restoration of 1660 the issue was taken up by many of the Anglican clergy as well. One of the most influential voices denouncing extravagance during the Restoration era was that of Richard Allestree, who for several years preached at Charles's court. His *The Whole Duty of Man, Laid Down in a Plain and Familiar Way for the Use of All* (London, 1660) was one of the most widely read publications of the late seventeenth and early eighteenth centuries, and, like his books *The Gentleman's Calling* and *The Ladies Calling*, was frequently found in colonial libraries. As a minister at the royal court, Allestree could hardly advocate austerity of fashions, yet pride and its emblems were of major concern to him.

Regarding pride, Allestree writes that "You may load an Ass with money, or deck him with rich trappings, yet still you will not make him a whit the nobler kind of beast by either of them."[20] In a section devoted to apparel he makes several observations that have a bearing on the attire we see in colonial American portraits.[21] Clothes are worn for three reasons: First, they cover nakedness; as the first sin required clothes thereafter, they should remind everyone of inherited sin and not merely fill us with pride by their splendor. Second, clothes should be worn for health's sake; thus, clothes that expose parts of the body for fashion's sake when it is cold are foolish. Third, clothes distinguish men from women and also distinguish the several levels of society as well as ranks and professions. In conclusion, Allestree warns that one person should not envy another for the finery of his or her clothes but rather should seek to clothe himself or herself in Christian virtue rather than expensive raiments. Those who heard or read Allestree's words had the wealth to wrap themselves in fashion and luxury, and some obviously did so, especially in court circles. But among the gentry and the upper middle class, his words were an effective bulwark against peacockishness. Although in their portraits the prospering New England merchants increasingly imitated the fashions of the aristocracy in an effort to display their success and social position, they

did so only to a certain degree, for they themselves would have agreed with Allestree and their own ministers that pride and vanity were sins of the worst kind. They wanted material success written into the story told by their portraits, but they did not want symbols of pride, excessive luxury, ostentation, and the like woven among the threads of the attire they wore in the portraits. Also, implying social position beyond one's actual status was to be avoided. What one was entitled to wear in actual life therefore became significant for portraiture, in which a person's attire and hairstyle carried the message of his or her status in society.

It was one thing if those of considerable fortune indulged in lavish apparel, but it was a breach of social restrictions if persons of mean position arrayed themselves in fancy clothes, and those who did so were chastised under law by fines, punishment, or imprisonment. Sumptuary laws were passed in England even in Queen Elizabeth's time, and the concept was transported to the New World. Alice Morse Earle, in her study of early American costume, quoted from a sumptuary law enacted by the Massachusetts General Court when she discussed the matter: "In 1639, 'immoderate great breeches, knots of ribbon, broad shoulder bands and rayles, silk roses, double ruffles and capes' were forbidden to folk of low estate. . . . Tailors who made garments for servants or children, richer than the garments of the parents or masters . . . were to be fined."[22] Similarly, Carl Degler has summarized the situation as follows:

> Most restrictions on [Puritan] dress were imposed for purposes of class differentiation rather than for ascetic reasons. Thus long hair was acceptable on an upper-class Puritan like Cromwell or Winthrop, but on the head of a person of lower social stature it was a sign of vanity. In 1651 the legislature of Massachusetts called attention to that "excess in Apparell" which has "crept in upon us, and especially amongst people of mean condition, to the dishonor of God . . . and the consumption of Estates. . . ." The law declared "our utter detestation and dislike, that men or women of mean condition, should take upon them the garb of Gentlemen . . ."[23]

All of this had important implications for portraiture. When prosperous merchants or their wives had a portrait made, they would certainly want their hairstyles and clothing to convey their social position. A seventeenth-century New England gentleman-merchant, for example, such as John Freake (Fig. 10), would want his hair shown shoulder-length, for that was an acceptable emblem of his place in his society and separated him from the coarser lower class of laborers and menial servants as well as from the "Cavalier society" in which men wore their hair in long cascades of curls, as in Lely's portrait of Charles II.

Men like Thomas Hall and Richard Allestree saw themselves as guardians of spiritual and secular virtues in the perpetual tug-of-war. Their very warnings and admonitions confirm the existence of a compellent urge among the middle class to rise in prosperity and, within limits, in social status; and this urge found satisfaction in fine and fashionable clothing, voguish hairstyles, comforts and niceties for their homes, and the customs and manners of refined society. When persons of the middle class had their portraits painted, they were as

circumspect in not exceeding the boundary of vanity and ostentation at the upper limit as they were careful not to permit inclusion of any coarse element that would associate them with the grosser lower levels of society, which to them seemed stained with sin of a different kind. Prosperity was an emblem of their calling – their doing of God's bidding and their industry – and in it they could take justifiable pride. All of this is written into the hairstyles, clothing, and occasional objects seen in colonial American portraits. As decade followed decade, prosperity induced ever greater fascination with worldly things, and the ministers had to harangue all the more sternly to maintain a balance between spiritual and temporal interests; but moderation remained the guiding principle for prospering upper-middle-class merchants, who would neither be denied the pleasures of refined life nor allow themselves to become overindulgent in them.

The purposes of this chapter have been, first, to demonstrate how two of the most salient features in almost every portrait – hairstyle and clothing – are important as iconographic symbols and must receive careful consideration when a given portrait is interpreted, and second, to suggest that the middle class had a powerful will and was determined to forge a life-style on its own terms, even if that meant defying the dictates of the ministers and the extremists of its several sects. The portraits themselves illustrate that the middle class was capable of imposing its own limits upon material worldliness and could restrain itself sufficiently to avoid the sins of vanity, excessive pride, and ostentation. Again, we must conclude that what we read in the religious literature – the sermons and books like *The Loathsomnesse of Long Haire* – is not an accurate description of the daily conduct of life among most middle-class English Protestants; such literature presents a vision of how life ought to be conducted, from the ministerial perspective, rather than how it was actually lived. We now turn to the early New England portraits, to analyze them in light of what has been discussed up to this point.

The Seventeenth-Century New England Mercantile Image

Social Content and Style in the Freake Portraits

Painting in colonial New England began in the 1660s, some thirty to forty years after the earliest settlements were established there. In the English tradition, portraiture was virtually the exclusive theme. The subjects were merchants, ministers, and civil officials, along with their wives and children. Boston was the center of activity for the region, and evidence now suggests that the town possessed, at one time or another, several men capable of taking likenesses after about 1664. They have been called "limners," but the term does not mean untrained "primitives," as we shall see in Chapter 6. Rather, they were trained artists, working in an established tradition. Patronage of their talents evolved slowly at first; for portrait painting to exist as a profession there had to be sufficient wealth and patronage to employ the practitioner regularly at his craft. In New England – indeed, in any North American colony – that situation did not exist until the second quarter of the eighteenth century. Although the middle class had patronized artists in England, the early colonists had no money for such a luxury. Economic contingencies, and not a distaste for art, prevented the rise of painting in the New World during the first decades of settlement.

The early likenesses were executed by someone who had probably come to the Bay Colony fully prepared to make his living in some way other than painting portraits, even if he had been trained in that art in England. In Massachusetts he would have turned to painting of a utilitarian nature – signs, furniture, houses, and so forth. When the need arose, he would put his former training to use, but by and large the opportunity to do so was infrequent. The early portraitists were familiar with the style of the art of their homeland, England, and they were, in fact, gifted artists, aesthetically sensitive to such formal aspects of art as line, color, design, and pattern. By no means were the early New England portraits the work of amateurish hacks.

We now have a list of about forty portraits believed to have been executed in or around Boston before 1700.[1] Of these, many would agree, the two masterpieces are the *John Freake* and the *Elizabeth Freake and Baby Mary* of about 1674 (Figs. 10 and 11). These portraits offer an excellent case study for

the type of image that emerged amid a community that was fast becoming dominated by the mercantile spirit.[2]

John Freake (1635–75) was born in England but by 1658 had immigrated to Boston, where he became a merchant, lawyer, and a man of property and means. He owned two houses as well as a brewhouse, a mill, some land at Fort Hill, and partial interest in at least six ships. An inventory of his estate valued his property at well over two thousand pounds, a large sum by the standards of the day.[3] In 1661 he married Elizabeth Clarke (1642–1713), daughter of Thomas Clarke, also a merchant of Boston, and the Freakes were very much a part of the mercantile establishment when they had their portraits painted.

The Freake portraits may have been painted as early as 1671, at which time no child was present in the picture of Mrs. Freake.[4] The infant was added and several changes made in the figure of the mother in 1674; little Mary was born on May 6 of that year, and an inscription in the lower left reads "Aetatis Suae 6 moth," in reference to the child's age.

These are family portraits; that is, they are familial icons, and this provided ample utilitarian and societal value for their existence, which was to celebrate marital domesticity and family lineage as well as social position. Family life was sacred, and colonial American portraits, particularly in pendant portraits of man and wife, of parents with children, or of children alone, were hymns to that divinely blessed institution.[5] The sensual yet spiritual relationship of man and wife is evident in Anne Bradstreet's poem "To My Dear and Loving Husband," written in 1678, or only a few years after the Freake portraits were painted:

> If ever two were one, then surely we.
> If ever man were loved by wife, then thee;
> If ever wife was happy in a man,
> Compare with me the women if you can.
> I prize thy love more than whole mines of gold,
> Of all the riches that the East doth hold.
> My love is such that rivers cannot quench,
> Nor aught but love from thee give recompence.
> Thy love is such I can no way repay,
> The heavens reward thee manifold I pray. . . .

Familial contentment was one of the sweetest aspects of middle-class life, and the Freake portraits, among others, were odes to powerful values that found approval in Scripture, in Calvin's writings, and in Protestant sermons of England and New England.

The Freake and related portraits also express another idea that had Calvinist support – the doctrine of prosperity, or God's blessing, for diligence at one's calling, which was manifested in the form of material rewards. Such portraits raise a number of issues about affluence, pride, and the continual upward pressure on the limits between moderation and ostentation.

Freake had prospered as a merchant, attorney, and shipowner, and he may be seen as an archetypal counterfoil to the old-guard establishment of the

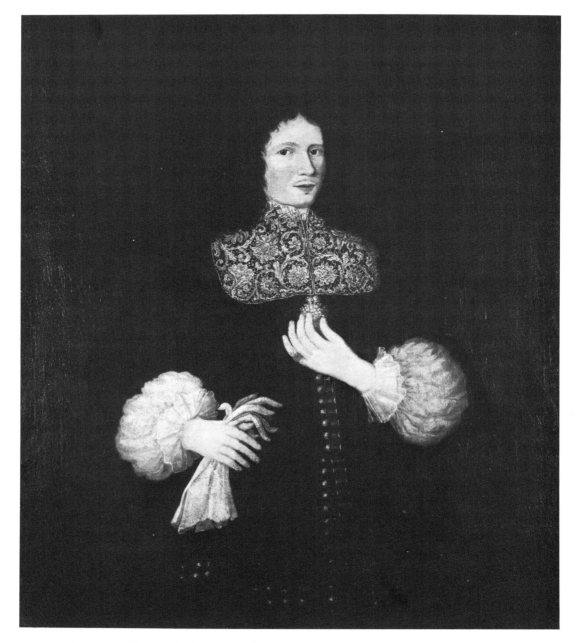

Figure 10. *John Freake*, by the Freake Limner, c. 1674. Oil on canvas, 42½ × 36¾ inches. Worcester Art Museum, Worcester, Mass. Gift of Mr. and Mrs. Albert W. Rice.

ministers and the General Court, which still schemed, in the 1670s, to petrify life according to the will of the founding fathers. For example, when King Charles's commissioners were in Boston in 1666, Freake petitioned that their authority be accepted, thereby indicating his preference for crown rule in place

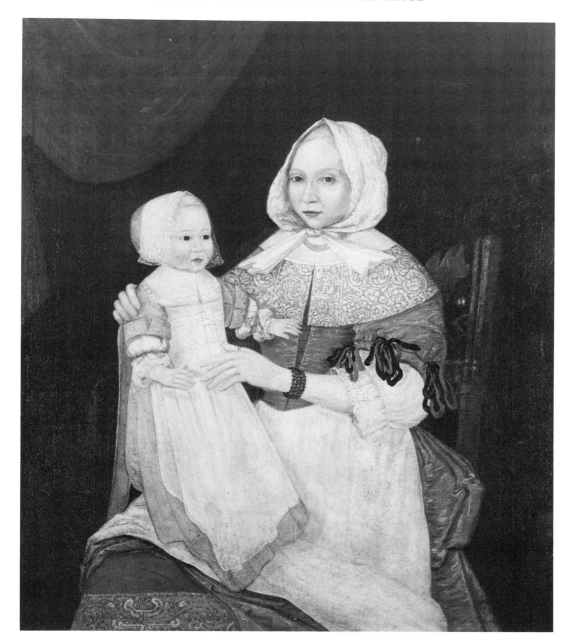

Figure 11. *Elizabeth Freake and Baby Mary*, by the Freake Limner, c. 1674. Oil on canvas, 42½ × 36¾ inches. Worcester Art Museum, Worcester, Mass. Gift of Mr. and Mrs. Albert W. Rice.

of the oligarchy that the ministers and religious zealots were anxious to maintain. Furthermore, this up-and-coming young merchant was at times in partnership with the wealthy, vain, and hedonistic Samuel Shrimpton (Fig. 44). A rebel against the authority of the old-guard theocrats, as we shall see,

Shrimpton asserted his right to strive for personal fortune in opposition to those who maintained that a collective spiritual well-being should be the colony's highest priority. Men such as Freake and Shrimpton, although pious in their own way, represented the headstrong will of the mercantile sector to break the hold of the theocratic power base in order to redirect the course of their lives into avenues of personal affluence. John Freake enjoyed his ever-increasing prosperity and sided with other ascending merchants to form a social elite within the colony. That early mercantile elite, by 1670, was contributing to the collapse of the old Puritan regime. Therefore, Freake's portrait should not be seen as an image that expresses the spiritualistic Puritanism of the founding fathers; it is, in actuality, a thoroughly secular portrait and not a representation of Puritanical religious sentiments.

John Freake's portrait is a three-quarter-length, largely frontal view, with the head turned slightly to our right. The subject, who looks at us directly, is a handsome young man with pleasant features; he wears a neatly trimmed little mustache, but his chin is clean-shaven. There is a suggestion of a smile, and the countenance expresses self-confidence and self-consciousness in about equal measure.

No feature should be overlooked or considered inconsequential in studying the iconography of a portrait, and Mr. Freake's hair is a case in point. It tells us certain things about the man. First of all, it is his own – not a wig – and second, it is shoulder-length; it contains a social statement that was compatible with this merchant's brand of religion. Freake chose not to wear his hair in the style of the great lovelocks, which William Perkins had condemned as a symbol of frivolous extravagance and a "foreign trick," and which William Prynne had called "a vile abuse . . . , an incitation to lust . . . and Sodomy."[6] Freake did not want to be associated with such things as the lovelocks of Cavalier society connoted among his peers. His fellow townsman John Hull, the silversmith, condemned the wearing of long hair as a sin on a level with gambling, drinking, and idleness, while William Woods was fined by the General Court of Massachusetts in 1676 – only a few years after Freake's portrait was painted – for "wearing his haire long as womens haire."[7] But if Freake wished to avoid association with lovelock society, neither did he want to be shown as a "Roundhead," which would have carried the connotation of a commitment to Puritanism that was stronger than he wanted to imply. Short hair had been the emblem of the Puritan in anti-Puritan plays at the court of Charles I, and courtiers had joked mockingly that one should never trust a man if one could see his ears. Moreover, short-cropped hair was a symbol imposed on men of the lower class as a badge of their low social standing. For example, in 1675 the Massachusetts General Court told John Gatchell, convicted of building on public land, that his fine would be reduced by half if he would "cut off the long hair off his head into a civil frame"[8] – that is, if he would cut it to the length proper for a man of his low station. What all of this means in connection with the portrait of John Freake is that, by the length and style of his hair, the subject did not want to imply he was of that rakish Cavalier set with its low morals, nor did he want to make a declaration, through a Roundhead cut, of a strong commitment to Puritanism; and he certainly did not want to be associated with the lower class, which was

identified in part by its short-cropped hair and associated with idleness and poverty, both of which were sins. Instead, he is shown with medium-long, shoulder-length hair, which designated him to be a gentleman – which within his community meant he held an honored position at the peak of the social and economic pyramid.

John Freake's hair was not the only symbol of his place in society, for his attire bears further testimony to his prosperity and therefore, in a mercantile community, to his rank among men. His costume is one of comeliness, which Calvin condoned, and not austerity, which Calvin dismissed as unnecessary; Freake and his kind, after all, lived by the code of Calvinist virtues. His coat is a rich brown, not the black so often associated with the attire of zealous, dedicated Puritans; it has full, ample sleeves, it flairs gracefully from the waist, and it was cut from a fine velvet fabric. The stylishness and neatness of its tailoring suggest sartorial refinement expressed in a moderate fashion design; it is neither extravagant nor mean, and so places its wearer, appropriately, somewhere between Cavalier society and the indolent, indigent poor. The coat has a decorative row of silver buttons, of which at least twenty can be seen down the front while more adorn the pocket flaps. The buttonholes are nicely embroidered with silver thread. This is very similar to the coat and buttons in the English portrait of *Sir John Clerk, Baronet* (1675), by John Scougall, suggesting that Freake was imitating the fashions of the English peerage, when those fashions were of a moderate design.[9]

John Freake, the prosperous gentleman-merchant, wears other items that bear witness to a moderate love of finery. His white shirt, made of fine muslin, has fashionable puffed sleeves with crenelated cuffs. In his right hand he holds a pair of long-cuffed gloves, another designation of gentleman status. On the little finger of his left hand he wears a large ring, which appears to be made of gold. The same hand fondles an ornate silver brooch of superb design – the work of a very gifted silversmith – which reveals Freake's enjoyment of decorative baubles made of precious metals; it was probably an imported piece. The final ornamentation for the sake of "comeliness" is the beautiful lace collar; fine lace of that quality had to be imported from the Continent, and it appears to be of the "Spanish" design but of Venetian workmanship.[10] A contemporary example of just such a lace collar, very similar in design, survives and is said to be the work of an Italian or Spanish lace maker.[11] The collar John Freake wears is the antithesis of the simple white, squared collar associated with Puritan garb, and it again testifies to his separation from any stringent dress code set up by that sect. This exquisite detail would make it difficult to deny the subject's pride in personal appearance and his joy in the materialistic pleasures brought him by his God-blessed, Calvin-condoned prosperity.

In the companion portrait of Mrs. Freake and her infant daughter, Mary, those same characteristics bring several socio- and religio-economic problems into even clearer focus. Close inspection places in question a number of previously held assumptions about life in seventeenth-century New England.

Mrs. Freake is a pleasant-looking young woman but plain of feature. A few strands of her blond hair are visible at her forehead, but the rest of her hair is "bound up" beneath a white lace hood. A slight smile suggests a good nature, contentment, even self-satisfaction. About her neck hangs a triple strand of

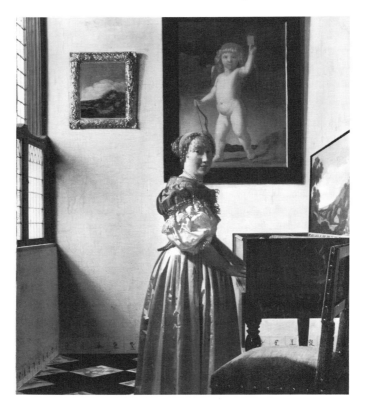

Figure 12. *Young Woman Standing at a Virginal*, by Jan Vermeer, 1670. Oil on canvas, 20¼ × 17¾ inches. National Gallery of Art, London.

pearls, and her other jewelry includes a four-strand garnet bracelet on her left wrist and a gold ring on the thumb of the left hand. She wears a dress of heavy moire or taffeta, which is a warm silver gray with much yellow in the hue; it reveals a bright red–orange velvet underskirt richly adorned with gold guipure. Red–orange laces are seen at the bodice and large red and black bows decorate the sleeve, from which emerges the white puffed sleeve of a blouse with a crenelated lace ruffle. About her shoulders is a narrow white collar to which is appended a broad band of very handsome lace.

Considering the several beautiful and fine fabrics, the numerous instances of colorful or intricate decorative details, and the three pieces of jewelry, Mrs. Freake's costume could hardly be called austere, or even reserved. Indeed, if we put aside the differences in the styles of painting, Mrs. Freake's dress is not unlike that of the young woman at a virginal in a painting by Vermeer (Fig. 12), and few would call the fabric, fashion, and color of the gown worn by the Dutch woman austere. Both the woman at the virginal and Elizabeth Freake were middle-class Protestants, and both were probably wives of successful merchants, at least Mrs. Freake was; both would, in fact, even seem elaborately dressed until their costumes were compared with the extravagant fashions of the courts of France, Spain, England, and elsewhere. It is evident from these portraits that fine fabric, fashion, and color were enjoyed among

prosperous Protestant folk, whether in Amsterdam or Boston, and Elizabeth Freake's attire refutes any notion that all seventeenth-century New England women wore reserved and unadorned black, white, and gray dresses out of dedication to austere Puritanical principles.

The question arises as to where the fabrics worn by Mrs. Freake came from. Their fineness suggests they were imported, for taffeta, brocade, and lace were high quality, specialty goods that were seldom attempted by colonial weavers by 1675.[12] Not only English fabrics but fancy stuffs from the Continent and the far reaches of the Anglo-American trading system were imported, and in such quantities as to indicate considerable demand for them. Mrs. Freake's taffeta may well have come from France; the lace, from Spain, Venice, or the Netherlands; the brocade, from England; the pearls, from the Orient; and the garnets of the bracelet, from India. New England merchants of the 1670s had ready access to worldwide markets, either directly or through trade with intermediaries, and both they and their wives were unwilling to forgo the fancy stuffs that could brighten and refine their life-styles. The merchants' new wealth and trade connections made it possible to have them, and in spite of ministerial admonitions about too much worldliness, they felt they were not becoming ungodly, as long as they did not become ostentatious by their own − not the ministers' − standards.

The pleasures of prosperity were too powerful for either the pulpit or the bench to withstand. As the merchants and their wives created a pressure on the upward limits of what was tolerated as being within moderation, the ministers and the magistrates felt compelled to restrain that pressure. The very sermons and laws aimed at stultifying the hedonistic urges that came with mercantile affluence reveal that the pressure was very real. But it should be remembered that such sermons and laws were directed only at placing limits upon, and seldom at outlawing totally, the enjoyment of material things. The disputation was always over where the line between moderation and osten-tation was to be drawn, and much of Protestantism's success among an up-wardly mobile, prospering middle class was due to its flexibility in setting that line. In essence, the clergyman−magistrate group and the affluent merchants were not in basic disagreement, for most merchants were themselves offended by ostentation − which they saw as economically imprudent as well as morally sinful − and the ministers and magistrates certainly condoned the prosperity that came from the pursuit of one's Christian calling.

The Puritan old guard had difficulty convincing many of the people that their indulgences were destroying God's little plantation in New England and that they would ultimately be carried off to hell because of them. The mer-chants and their wives knew their Calvinist theology. In his writings they read passages in which the Reformer said prosperity was God's reward for diligence at one's secular calling, while other sections declared that "comeliness" in attire was perfectly acceptable. The ineffectiveness of the laws designed to restrict indulgences is amusingly demonstrated in a few lines from Governor Win-throp's *History of New England*, in which he noted that in spite of the General Court's mandate to the church elders to urge upon the consciences of their flocks a reduction of ostentatiousness in attire, little could be done "for divers of the elders' wives, etc., were in some measure partners in this disorder."[13]

In 1679, only a few years after the Freake portraits were painted, the General Court again tried to legislate, on moral grounds, against excessive pride in apparel, declaring it to be a great evil for which God would visit transgressors with "loathsome diseases." That law, too, had little effect among the merchant families.

Then, as now, it was difficult to legislate moral issues and enforce the laws effectively. But even civil, economic laws were flouted when they stood between the affluent upper middle class and its acquisition of the material goods it craved. Laws were enacted in England (and supposedly enforced in the English colonies as well) to protect the home industries in cloth and lace making. As early as 1622, Parliament passed a law to prohibit the importation of Continental laces,[14] but, of course, the king of the realm, Charles I, was the worst offender of all in breaking that law, so Englishmen generally did likewise. Laces were smuggled into England in loaves of bread, in Turkish turbans, and in coffins that were later dug up to retrieve the contraband.[15] The prohibited laces and fabrics were similarly smuggled into New England in prodigious amounts.

When John, Elizabeth, and even little Mary Freake are shown wearing a goodly amount of imported lace, it means that they, like other members of the middle-class mercantile establishment, were determined to create a lifestyle according to their own terms; the Parliament in England could not prevent them from obtaining the material stuffs they desired, any more than their own clergy could dictate to them the fashion of their attire. This further indicates it was the merchant class with its indomitable spirit, rather than the clergy, that would ultimately be the sector to establish the character of colonial life in New England. The secularism of the merchant class formed the foundation for most colonial portraiture in the region, not the spiritualism of the ministers. The previously held stereotype of the seventeenth-century Puritan will match up only with portraits of old men and ministers, as we will see in Chapter 5. But already present in the Freake portraits are the socio-economic foundations for the materialism and affluence underlying Copley's and Peale's portraits of the mercantile class of a hundred years later.

From the perspective of the merchant class, piety and prosperity were completely compatible, and the two were united through the doctrine of prosperity, which proclaimed the validity of one's secular calling, diligence at which God rewarded in a material way. The merchants saw themselves as living according to the Christian virtues that Calvin had defined and that were particularly suited to the middle class. If New England had not been founded as a haven for Puritan zealots, a confrontation between merchant and clergyman probably would not have arisen; the two worked in harmony, for example, in contemporary Holland. In North American colonies where Anglicanism prevailed, the confrontation was not as intense. But as the seventeenth century progressed in New England, an adversary relationship developed that was in reality an internal struggle for control of the course of life. The rancor of the ministers and magistrates sounds increasingly, the more we read their writings, like a petrification of mores as the old guard tried to retain the faith and morals of the founders of their colony. Many a lament was heard from the pulpit, well

into the eighteenth century, that the present generations had lost the religious zeal and piety that enflamed the souls of the founding generation. Such wailing and gnashing of teeth was dutifully listened to on Sunday morning; but in the counting room and in the ever better-stocked shops there arose pressures that colonial mercantile society was unwilling to resist entirely. The result was, as we see in the images of John and Elizabeth Freake, that when members of this society had their portraits painted, they wanted included in them symbols of what their honest hard work at their calling had brought in both material goods and social position. Indeed, the prosperity shown in their portraits was a visible expression of their piety.

Finally, the furniture in Mrs. Freake's portrait also bears on the matters under discussion, and it sets a precedent for much of the colonial portraiture that follows. The table, chair, and curtain, in their own subtle way, make a complementary reference to prosperity and materialism. Hereafter, we will frequently find the unobtrusive inclusion of a portion of a table or chair or of some other well-crafted object as a quiet indication of the subject's affluence, social position, and good taste. Such a motif, in the Elizabeth Freake portrait, is the forerunner of that beautiful table in Copley's colonial masterpiece, the *Mr. and Mrs. Isaac Winslow* of 1774 (Fig. 165). These symbols of prosperity and materialism are a very important part of the iconography of the colonial American portrait, whether they be a silver inkstand, a porcelain bowl with fruit, a pewter teapot, or the exquisitely wrought card table in Peale's portrait of the family of John Cadwalader (Fig. 189). They are all emblems of success and social position. The chair in which Mrs. Freake sits is of the finest, most costly type then found in colonial New England homes and is sometimes referred to as a Cromwellian chair. A handsome example is preserved in the Metropolitan Museum of Art in New York, and two more are in the Museum of Fine Arts in Boston. The type is sometimes included in Vermeer's Dutch interiors, such as *The Concert* (c. 1660; Fig. 13). The bright and colorful material of its upholstery is of woven wool, in imitation of exotic fabrics from the Middle East; Turkey work, as it was called, was produced in England and imported to the colonies, where the chair itself was probably made. The inventory taken after John Freake's death indicates that fourteen such chairs were actually in the Freake household.[16] Such furniture surely dispels the myth that seventeenth-century New England interiors were purposefully drab.

Objects such as the chair in Mrs. Freake's portrait are indeed emblems of success, relative affluence, and social position of the upper-middle-class New England mercantile aristocracy. Together with the laces, taffetas, and velvets, the silver buttons and the brooch, the pearls and garnets, and the styles of the hair, they report to the viewer the things the Freakes wanted to be known about themselves. The faces, rendered in an uncomplicated, straightforward naturalism, preserve the likenesses of the sitters, and the hair, attire, and household objects expand upon the stories of their lives. In the style of the portraits we find similarly interesting expressions of their taste, nationalistic feelings, and affiliation with middle-class cultural traditions.

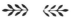

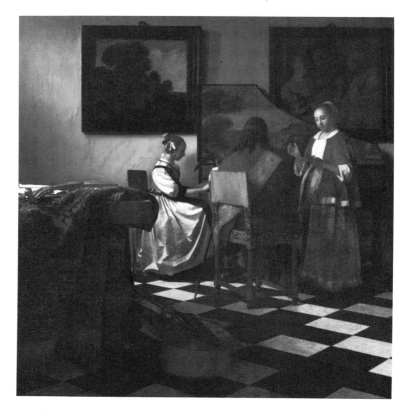

Figure 13. *The Concert*, by Jan Vermeer, c. 1660. Oil on canvas, 28 × 24¾ inches. Isabella Stewart Gardner Museum, Boston.

The Freake portraits were painted in Boston about the same time that Godfrey Kneller settled in England, in 1674, where for the next half century he perpetuated the courtly, aristocratic style in portraiture that had been practiced by Van Dyck and Lely before him. Van Dyck, Lely, and Kneller all went to England from the Continent, taking with them the rich Continental baroque style, and between 1620 and 1723 they established an artistic tradition that was the perfect aesthetic vehicle for portraying the English aristocracy. But because of its sensuousness, foreign origins, and associations with Cavalier society and, at times, with Catholicism, such a style was ill-suited to the tastes and convictions of the English middle class, as we have seen in Chapter 2. The middle class had its own artistic tradition, and in New England as in England itself the merchant sector played a major role in keeping the tradition alive until about 1680. Most New England portraits painted before that date belong to the subcourtly style.

The research of Louisa Dresser and Samuel Green first demonstrated that the early New England portraits were not merely inept attempts at the baroque high style of Van Dyck or Lely, but that they belong to a separate tradition of their own – the Elizabethan–Jacobean survival style.[17] However, the problem still remains concerning the time lag between the latest examples of the style that Dresser and Green have discovered – pictures dating from about

48

Figure 14. *Unknown Woman*, by an unidentified English artist, c. 1640–45. Oil on canvas, 29½ × 24½ inches. Private collection, Newark, Delaware.

1635 – and the rise of New England painting several decades later. But the subcourtly or middle-class style did in fact continue in use through the decades until the 1660s and 1670s, when it appeared in the Boston area.

The portrait of Pocahontas of about 1616 (Fig. 5) offers a good example of the Jacobean style: Substances are noncorporeal and nontactile; shadow is used timidly (as opposed to the rich chiaroscuro of the Continental art of, say, Caravaggio); emphasis is on decorative detail; space is generally compressed; and form is defined by crisp, linear contours. Dresser has shown its use in the 1620s in the *Sir Thomas Leventhorpe Family*, which is at Melbourne Hall.[18] Comparison may be made between the image of the child, Lucy Leventhorpe, and little Mary Freake, and a comparable similarity exists between Sir Thomas's head and face and those of John Freake. There is a softening of linear contours and more suggestion of solid form as well as tactile substance in John Souch's *Sir Thomas Aston at the Deathbed of his First Wife* of 1635, but compressed space, emphasis on linear detail, and timid use of shadow reveal even this to be a work of the subcourtly style.[19]

An even more interesting comparison is found in David des Granges's portrait of *The Family of Sir Richard Saltonstall* of about 1637, particularly when the image of Mrs. Saltonstall holding her baby in her lap is compared with

Figure 15. *Portrait of a Woman*, by David Loggan, c. 1665. Black lead on vellum, 5¾ × 4¾ inches. Henry E. Huntington Library and Art Gallery, San Marino, Calif.

that of Mrs. Freake with her infant (Figs. 6 and 11). Although there is a somewhat greater indication of form, space, and tactility in the earlier English example, the New England portrait clearly belongs to the same tradition. Both paintings have the crisp outline around the figures of the two women and the children they hold, the linear detail, and the conservative use of shading. The style is traced into the 1640s through a portrait of an unidentified woman (Fig. 14); the rendering of her face in particular reveals the perpetuation of the Elizabethan–Jacobean style down to midcentury, while the dark color scheme indicates a modification of that style through Dutch influence, as already noted in connection with the work of Cornelius Johnson.

In specific stylistic similarities, however, a little drawing by David Loggan is perhaps closest of all to the Freake portraits (Fig. 15).[20] It is signed and dated, "D.L. 166–" (the last digit of the date is unreadable), and so with this drawing we are able to trace the modified Elizabethan–Jacobean style to the very threshold of painting in New England. The linear contour of the Loggan drawing is virtually identical, although reversed, to that found in the *Mrs. Freake*, as is the gentle use of shading; the treatment of the lace collars provides another strong similarity, and still another is found in the representation of the bodice and waist. Significantly, Loggan worked for a while in Cambridge,

Figure 16. *Self-Portrait*, by Edward Argall, 1682. Black lead on vellum, 4¼ × 3¼ inches. British Museum, London.

in East Anglia, an area from which many of the immigrants to New England had come.

Stylistically similar to Loggan's work is a faint little drawing believed to be a self-portrait by an otherwise unknown amateur, Edward Argall, which invites comparison with the image of John Freake (Figs. 10 and 16). The hairstyle, neatly trimmed mustache, lace collar, and coat with a row of small buttons down the front resemble those parts in the Freake portrait; the style of the two works is virtually the same, and the inscribed date indicates this modified Elizabethan–Jacobean style was still in use in 1682, about a decade after the Boston picture was painted.

Two interesting groups of portraits, representing members of the Winslow and Roberts families, demonstrate the manner in which the subcourtly style transmigrated from England to Massachusetts. The first group portrays Edward Winslow, his son Josiah, and the latter's wife, Penelope (Figs. 17, 18, and 19).[21] Edward – one of the founders of Plymouth Plantation and governor of the colony in 1633, 1636, and 1644 – was a printer, a scholar, and an author as well as a statesman and soldier; he served as the colony's agent in England and was in Cromwell's service during the Commonwealth. His son, Josiah, was also a governor of Plymouth Colony, from 1673 to 1680. Father and son were both in London in 1651 when Josiah married Penelope, daughter of Henry Pelham, the first treasurer of Harvard College. At that time the three had their

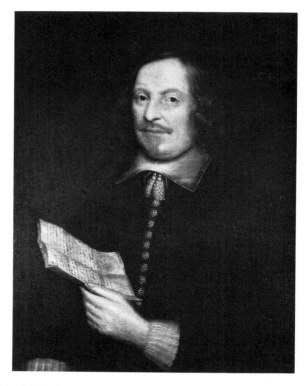

Figure 17. *Edward Winslow*, artist unknown, 1651. Oil on canvas, 38 × 32½ inches. Pilgrim Society, Plymouth, Mass.

portraits painted in the conservative, subcourtly, nationalistic style espoused by upper-middle-class mercantile and gentry society. It is believed this group of portraits was brought to New England soon thereafter, to assume a place in the Winslow house in Plymouth, where it would be seen by all who came there, thereby creating a stimulus for other families of the area to have their portraits painted in the indigenous, subcourtly English style. Although the style is not as linear as that used in the Freake portraits, the images of Edward and Josiah Winslow bear sufficient similarity to the portrait of John Freake to be assigned to the same general tradition. The picture of Penelope Winslow reveals a fashion consciousness in the colorful attire, the way her hair is "hung out" and styled in the current vogue, and the strands of pearls about her neck and in her hair. The Winslow pictures are among the earliest portraits known to be in New England, and the one of Edward Winslow is the only known portrait of any of the *Mayflower* passengers who founded Plymouth Colony.

The portraits of the Roberts family demonstrate the transmission of the middle-class, subcourtly style from London to Massachusetts in the 1670s. Soon after a young widow, Elizabeth (Roberts) Breeden of London, married the prosperous Boston merchant and landowner Samuel Shrimpton in 1669, the couple sailed for New England. This was a sad parting of daughter and parents, and to ease the pain, Nicholas Roberts, Elizabeth's father, promised to have likenesses of her mother and himself taken and sent to her, a situation

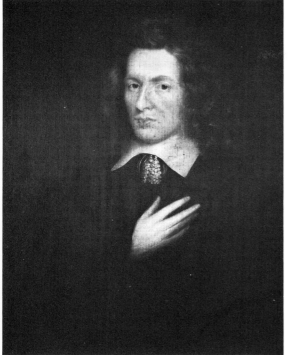

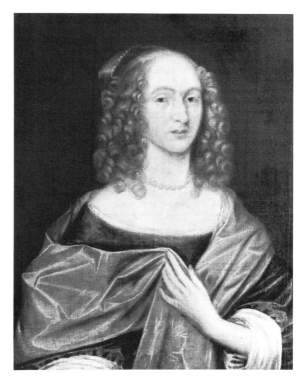

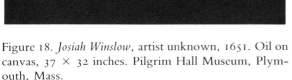

Figure 18. *Josiah Winslow*, artist unknown, 1651. Oil on canvas, 37 × 32 inches. Pilgrim Hall Museum, Plymouth, Mass.

Figure 19. *Penelope Winslow*, artist unknown, 1651. Oil on canvas, 37 × 32 inches. Pilgrim Hall Museum, Plymouth, Mass.

that must have arisen often as families were separated by migration to the New World. By 1675 the Shrimptons had received in Boston not only the portraits of Nicholas Roberts and his wife, Elizabeth, but also of Mrs. Shrimpton's grandmother, Mrs. Baker, and of her three sisters. The portraits of the sisters have disappeared, but those of Mr. and Mrs. Roberts (Figs. 20 and 21) and of Grandmother Baker survive at the Massachusetts Historical Society.[22] The image of Mrs. Roberts bears strong stylistic similarities to that of Elizabeth Freake, particularly in the rendering of the face and in the rich patterns of the dress. The Roberts portraits demonstrate both the strength and the high quality of the middle-class tradition in London at the very time portrait painting began to flower in New England.

The Shrimptons, prominent citizens of Boston mercantile society in the 1670s, had one of the finest houses, located on Noddle's Island, which they owned. It must have been an encouragement to the rise of painting in the Bay Colony when guests in the Shrimpton home saw hanging there a collection of portraits including the six sent over by Nicholas Roberts plus a handsome portrait of Samuel Shrimpton, which he had had painted in London before 1669. Shrimpton's portrait is stylistically quite different and will be discussed later (Fig. 44). There may well have been a companion portrait of Mrs. Shrimp-

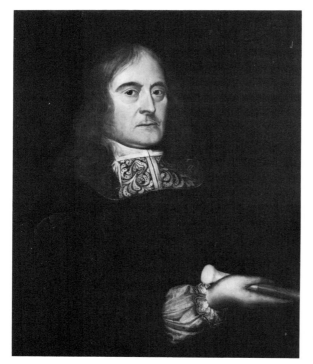 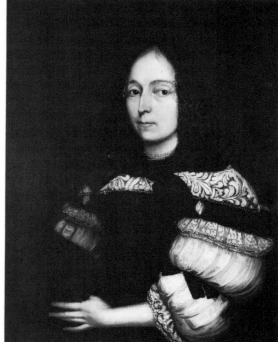

Figure 20. *Nicholas Roberts*, by an unknown English art-
ist, c. 1674. Oil on canvas, 30 × 25 inches. Massachu-
setts Historical Society, Boston. Bequest of William H.
Sumner.

Figure 21. *Mrs. Nicholas Roberts*, by an unknown English
artist, c. 1674. Oil on canvas, 30 × 25 inches. Massa-
chusetts Historical Society, Boston. Bequest of William
H. Sumner.

ton in the same style as her husband's likeness, which would have made a
group of eight portraits hanging in the Shrimpton home by about 1675.

By that year, there were already a number of portraits, painted in or around
Boston, hanging in the homes of New England merchants, ministers, and
public officials. More than a dozen are currently known, and there were un-
doubtedly more that have been lost. Most of these were in the same generic
style of the Freake portraits, and all were intended to express – through their
means of execution and in their faces, hairstyles, and attire – the same socio-
cultural values of the upper-middle-class Protestant community.

5

Portraits of Prosperity versus Images of Gloom

The Myth of Old Men and Ministers – A Hawthorne Legacy

Two types of portraits, not one, were created in New England in the years between the early 1660s and about 1690. One was an expression of moderate enjoyment of temporal life among the mercantile sector; the other depicted the mood and spiritual concerns of old men and ministers – the lingering remnants of a zealous old guard. The portraits themselves illustrate the bifurcation of seventeenth-century Massachusetts society, and they demonstrate the fundamentally different attitudes of the two groups as to the purpose of life in the colony. The old monolithic socio-religious structure of the early decades of settlement was by then under assault from the rising power and ambitions of the merchant class, and the portraits bear evidence that it is no longer possible to think in terms of Puritan fanaticism as the one and only framework around which all life was organized.

There were, of course, factions other than those of the merchants and ministers that were guiding the course of life in seventeenth-century society. There were laborers and craftsmen, and by 1670 the New England population contained at least as many farmers as merchants. However, the merchants, ministers, and civil officials were the ones who were most effective in forming the character of the colony, and, significantly, they were the ones who had their portraits painted. Among those three groups, the clergymen and the civil authorities tended to unite in a conservative coalition to preserve the original purpose of the colony. But after about 1685–86, when Massachusetts became a crown colony with a royal governor and when toleration of the Anglican church was enforced, the power base of the old guard began to erode rapidly. Even before that date, the influence of the merchants was being exerted, as the portraits reveal.

Of the portraits painted in New England before 1680 about one-third represent children, and our study in this chapter will commence with the images of Elizabeth Eggington, Robert Gibbs, and the Mason children. Children, symbols of happy and contented family life, were rarely the center of a psychological drama such as Hawthorne created in *The Scarlet Letter* in the character of little Pearl. Also, the prematurity mortality rate being as high as it was, parents had good cause to commission portraits of their children. Just as some portraits of adults were painted as visual mementos for spouses who

were separated for business reasons (i.e., a sea captain or a public official sent abroad), so the painted effigies of children were insurance against the day when death might take them. As children were, at that time, considered apprentice adults, their likenesses express much about their society generally;[1] if the father and mother wanted their own portraits to bear witness to their social position, religious associations, and cultural heritage, they wanted no less for such things to be wrought into the pictures of their children.

The earliest portrait known to have been painted in New England is the *Elizabeth Eggington*, which is inscribed with the date 1664 (Fig. 22). Born in 1656, the subject was the daughter of Jeremiah and Elizabeth (Cotton) Eggington; her mother, the daughter of the Reverend John Cotton, died two weeks after childbirth and the infant was taken in by her widowed grandmother, Sarah Cotton, who in 1656 married the Reverend Richard Mather. The child lived in the Mather home until her death at the age of eight in 1664. From what meager evidence can be discovered, her father appears to have been a merchant of Boston and the captain of a merchant ship; the portrait may have been painted on the occasion of her death as a memento for her absentee parent.

As Elizabeth Eggington lived at the center of both the merchant and ministerial societies of Boston, it is especially interesting to observe how she was portrayed. Stylistically her image is of the subcourtly style, which tended toward flattened form defined linearly, with emphasis on decorative details, while the flesh is treated as a noncorporeal symbol that differs from the tactile, sensuous painting of the Van Dyck–Lely tradition. The style of the *Eggington* represents a conservative strain in seventeenth-century painting, which is understandable among New Englanders of staunch middle-class, Protestant persuasion. This conservativism was rooted in the life-style of families such as the Cottons and the Mathers, amid whom young Elizabeth had lived. The Puritan church and the civil government had joined forces to maintain and control that way of life which the founding fathers had envisioned, and thus for a while the oligarchy was successful in repulsing any force from outside itself – that is, it erected a hedge against outside influences. Being suspicious of change or innovation, the ruling old guard tended to reject any attempted alteration of its cultural traditions, including the manner in which they allowed their likenesses to be painted. New England Puritans such as John Cotton, the Mathers, Urian Oakes, and so on advocated a status quo in their society and its traditions; this attitude, reinforced by remote isolation, tended to freeze cultural patterns, and this is exactly what happened in early colonial portraiture, of which the *Elizabeth Eggington* is an excellent example. The prevailing conservativism was nicely summarized by the Reverend Urian Oakes in 1673: "Those that break down the hedge of our civil government . . . would break in and devour all that is precious and dear to us. The change of our government will inevitably introduce a sad change in our Churches."[2] Ultimately, change would be forced upon the old guard by a rising new element in New England society, as we shall see; but for the painting of the portrait of a granddaughter of John Cotton and a step-granddaughter of Richard Mather, the conservative, nationalistic style of the Elizabethan–Jacobean tradition was a natural preference.

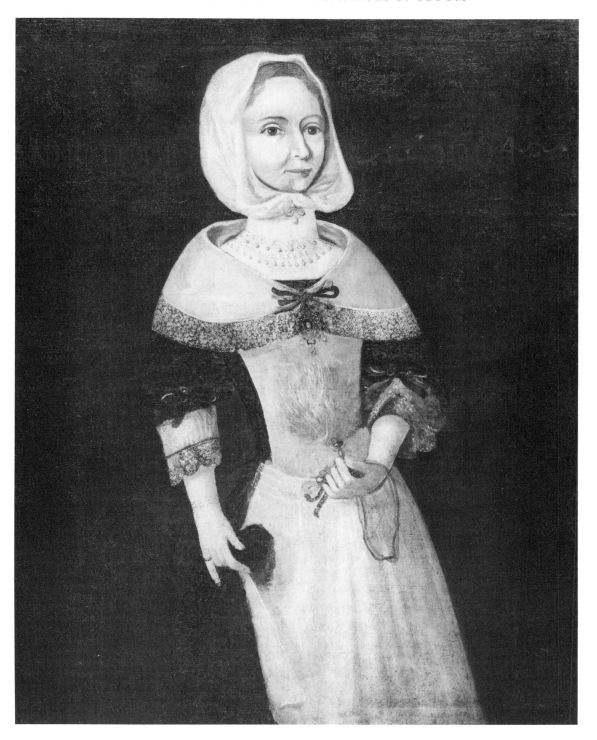

Figure 22. *Elizabeth Eggington*, artist unknown, 1664. Oil on canvas, 36¼ × 29¾ inches. Wadsworth Atheneum, Hartford, Conn. Gift of Mrs. Walter H. Clark.

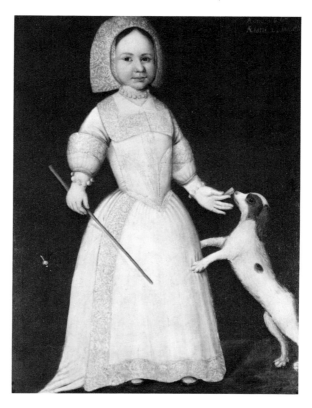

Figure 23. *Lady Anne Ogilvy*, by an unknown Scottish artist, 1663. Oil on canvas, 33½ × 25½ inches. Collection of the Earl of Seafield.

Whoever the anonymous painter was, he executed his image with such skill and sensitivity in the line, color, patterning, and design of shapes that we may presume he was something more than a tradesman-painter (i.e., a house painter), that he was familiar with the artistic tradition of the British middle class and country gentry, and that he had had at least some training in it. He may well have made his living in Boston as a house painter, but his style is too close to that practiced in the homeland and reflects too high a degree of understanding of the subtle sophistications of that style for us to call him an untrained primitive. The style survived even among the peerage, in areas remote from the influences of the court of Charles II, as a Scottish example demonstrates; the *Lady Anne Ogilvy* (Fig. 23) was painted in 1663, only one year before the *Elizabeth Eggington*, and it possesses the same stylistic characteristics. The posture (especially the swayback), the rendering of the flesh and anatomical structure, and the decorative treatment of the attire are similar in each portrait. It is pointless to compare the style of the *Eggington* with a portrait of a child by, say, Lely, for the New England picture had its own, still viable artistic tradition that was quite distinct from the courtly style.

The *Elizabeth Eggington* contradicts old notions about seventeenth-century New England rejection of the pleasures of this world, for the image is anything but joyless and suggests more moderation than austerity. It is true that the

little girl wears a dark brown dress and is set against a dark neutral background, but this, as we have seen, is due to the influence of Dutch baroque painting on the Elizabeth–Jacobean survival style. There is a spritely liveliness in the face of Elizabeth Eggington – a pleasant demeanor, animated by sparkling eyes and a hint of a smile. Her brown dress has a very ornate floral design woven into it, and the fabric is of a rich and costly imported type. Her hood is fastened at the neck with a petite bow with a pearl drop, while about her neck she wears a beautiful multistranded necklace that appears to be of gold filigree with at least twenty-seven pearls visible. The broad white starched collar is ornamented with a wide band of lace and fastened with an attractive bow, from which is suspended a lovely miniature portrait set within an ornate gold frame. Ribbons decorate her brocaded sleeves, which are adorned with still more lace. A bracelet is on her right wrist and in her left hand she holds a feather fan with what is probably a brass handle, from which dangle more colorful ribbons.[3] She wears a ring on the little finger of her right hand. Her attire is completed with a white stomacher and apron, the latter having a bow for decoration, seen just behind her left hand. In all, there is sufficient jewelry, ribbon, lace, and fine fabric to suggest that this subject and her parent or guardians not only possessed a modest amount of wealth but enjoyed it and took decorous pride in it. There is nothing in the portrait, in fact, that indicates a morose society that repressed materialistic pleasure and encouraged deprivation for the sake of religious values.

The portraits of the children of Robert Gibbs bear these same characteristics.[4] The father of little Margaret, Robert, and Henry Gibbs was for many years a merchant in Boston before becoming, in 1697, a minister in Watertown, Massachusetts. If the father's religious zeal dated to as early as 1670, when the three portraits were painted, then the children's lives would certainly have been touched by the two most powerful forces of their society – mercantilism and the church – and we may therefore suppose that their images were reflective of the beliefs inherent within those sectors.

All three children stand on a black and white tile floor or, more likely, a floor painted to simulate tiling. This is yet another influence from Holland, for one is reminded of seventeenth-century Dutch interior scenes such as Vermeer's *Young Woman Standing at a Virginal* (Fig. 12). Also of Dutch influence is the dark neutral background, upon which is inscribed the year 1670 and the age of each child. The children are finely dressed, and their attire is generally in keeping with the stylishness, quality of workmanship, and quality of fabrics that would be worn by the children of successful merchants in England or on the Continent.

Robert Gibbs is shown at age four and a half, as indicated in the inscription to our right of his head (Fig. 24). The manner in which his face is painted is quite similar to that of John Freake's portrait, with a comparable promise of a smile, and bold, dark eyes. He assumes the pose of a gentleman by placing his right hand on his hip. Master Robert also wears an elaborate outfit, the slash sleeves being decorated with several bands of ornate brocade before giving way to the puffed sleeves and crenelated cuffs of his shirt. A cape trimmed with brocade trails down his back. His shoulders and neck are covered by a broad, stiffly starched white collar, and a white stomacher merges with a

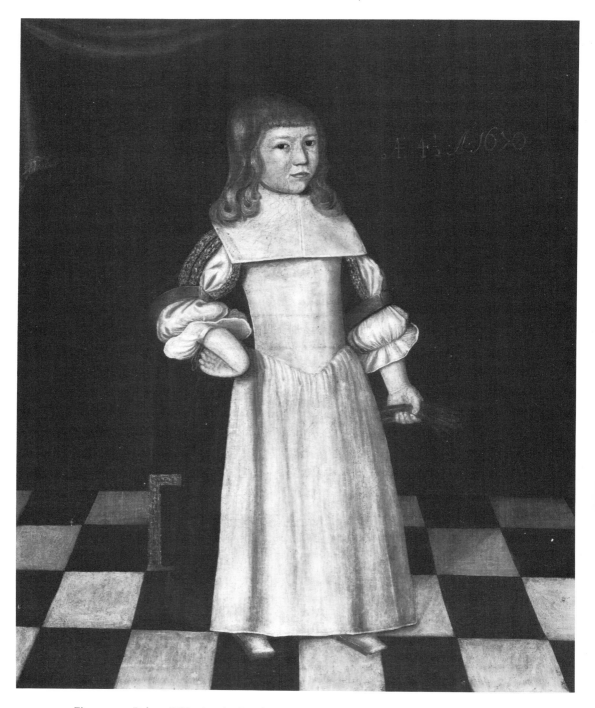

Figure 24. *Robert Gibbs*, by the Freake Limner, 1670. Oil on canvas, 40 × 33 inches. Museum of Fine Arts, Boston, M. and M. Karolik Fund.

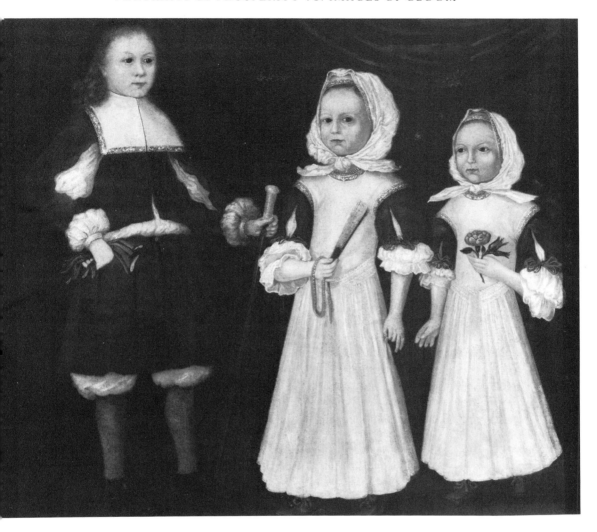

Figure 25. *The Mason Children*, by the Freake Limner (?), 1670. Oil on canvas, 39½ × 42¾ inches. The Fine Arts Museums of San Francisco, M. H. de Young Memorial Museum. Gift of Mr. and Mrs. John D. Rockefeller III.

gathered white apron. His costume is essentially the same as the one worn by Elizabeth Eggington except for the square collar and the absence of ribbon bows, which indicate he is a boy and not a girl. Up to the age of about eight, boys and girls were dressed in basically the same kind of clothing, but after that age a boy's attire changed from a dress with long skirt to a doublet and knee breeches (as seen in the picture of the Mason children; Fig. 25), whereas a girl's clothing changed very little throughout her life.[5] Robert Gibbs wears square-toed red and beige shoes, and in his left hand he, like John Freake, holds a pair of gloves. His soft brown hair curls gently down upon his shoulders. The Elizabethan–Jacobean survival style emphasizes the decorative detail and patterning in his clothing, and in this portrait of a merchant's child there

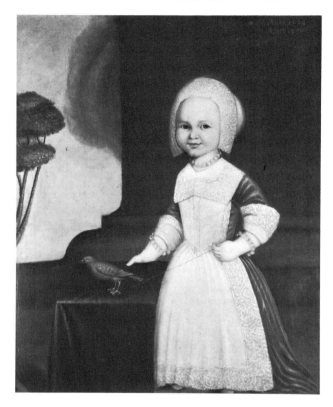

Figure 26. *Lady Mary Ogilvy*, by an unknown Scottish artist, 1664. Oil on canvas, 34 × 28 inches. Collection of the Earl of Seafield.

is an obvious delight in the handsomeness of the costume. Such finery is visible evidence of a joyous materialism, prosperity, and the social standing of the Gibbs family.

Of the same generic style as the Gibbs portraits, but somewhat looser in brushwork and with slightly softer edges of forms, is the portrait representing the three Mason children (Fig. 25).[6] The artistic tradition to which the *Mason Children* belongs is demonstrated by comparing the youngest child, at the right, with the Scottish portrait of Lady Mary Ogilvy (Fig. 26), whose sister, Lady Anne Ogilvy, has already been mentioned. Inscribed on the canvas "Anno Dom 1670," the *Mason Children* was painted in the same year as the Gibbs children, and the ages of the two girls are inscribed beside their heads – Joanna (age six), and Abigail (age four). David, who was born in 1661, was then nine years old. They are the children of the Boston merchant Arthur Mason and his wife, Joanna. Here, too, the affluence of the parents is reflected in the attire of the children – pearls, gay ribbons, laces, and slash sleeves, spotless white pinafores, and starched white collar; puffed sleeves of shirt and blouses – the very things the theocratic General Court considered excessive and was still, in the 1670s, trying to legislate against. David, who has long, soft brown curly hair, assumes the stance of a gentleman and holds a silver- or pewter-headed walking stick and a pair of gloves. Joanna holds a fold-up

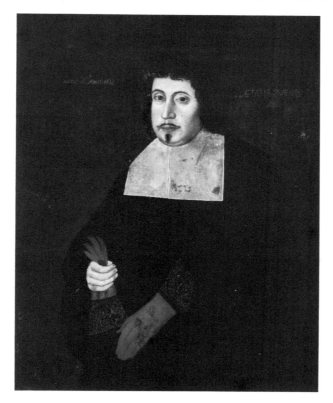

Figure 27. *Edward Rawson*, artist unknown, 1670. Oil on canvas, 42 × 34 inches. New England Historic Genealogical Society, Boston. Gift of Reuben Rawson Dodge.

fan, while little Abigail has a pink flower in her left hand. Square-toed shoes are decorated with ribbons. That David Mason has passed from infancy to young manhood can be seen in his doublet and knee breeches.

The stylistic and social characteristics observed in the portraits of the Eggington, Gibbs, and Mason children are also present in portraits of adults, such as that of Edward Rawson (Fig. 27). The *Rawson* (1670) and its companion, representing Edward's daughter, Rebecca, are believed to be the work of the Freake limner. The *Rebecca Rawson* is not illustrated here because it has experienced considerable damage and extensive recent repainting. However, a photograph of it before "restoration" shows that it was sensitively executed, with a linear definition of compressed form, timid shading, and emphasis on decorative patterns – in brief, stylistically identical to the portrait of Edward Rawson.[7] Rebecca Rawson is of interest because her life led her circuitously into the outer perimeter of the art world of her day. In 1679 she married a rogue named Thomas Rumsey, lately from England, who pretended to be Sir Thomas Hale, nephew of Lord Chief Justice Matthew Hale. The young couple sailed to England, and upon their arrival Rumsey deserted her, making off with all of her belongings, and returned to a wife in Canterbury. By then she was with child, and to support herself and her infant she "learned many curious works, such as painting on glass, and by her ingenuity and industry procured

63

a genteel subsistence for herself and child.'"[8] Although this artistic activity was carried on, as far as we know, only in England after Rebecca Rawson had left Massachusetts, it indicates an awareness of the art of painting, and she was probably the first American woman to become an artist.

Edward Rawson, too, was tangentially connected with painting in Boston in the mid-1660s, but in another way. Rawson, as Cotton Mather tells us, tried to persuade his uncle, the Reverend John Wilson, "to let his Picture be drawn. . . . And when [Rawson] introduced the Limner, with all things ready, Vehemently importuning [Wilson] to gratify so far the Desires of his Friends, as to sit a while for the taking of his Effigies, no Importunity could ever obtain it from him."[9] Who the unidentified limner was we do not know, but the reference documents his presence.[10]

Edward Rawson (1615–93) was born in Dorset, England, the son of a London merchant-tailor. He married Rachael Perne, with whom he had seven sons and five daughters. The Rawsons came to New England in 1636 or 1637, settling in Newbury, where Edward began his career as a public official, beginning as the "publick notary and register of the towne."[11] He was soon elected a selectman and then a representative to the General Court from Newbury. In 1650, Rawson was appointed secretary to the General Court, and he and his family moved to Boston. He held the position of secretary until 1686; during those thirty-six years at the center of the civil–religious power base, he tended to side with the court and the ministers in attempting to maintain the original religious foundations for the life of the colony, in the face of increasing secularism among the merchants and the intrusions of non-Puritans.

It was Edward Rawson who announced to the assembled people of Boston on June 8, 1661, that Charles II had been crowned king, returning a Stuart to the throne of England. For the next twenty-five years he was part of the organized frustration of the king's will as concerned the Massachusetts Bay Colony. But in 1686, with the arrival of the king's agent Edward Randolph, and later with the arrival of the first royal governor, Sir Edmund Andros (Fig. 92), Rawson's career in public service was terminated.

Rawson therefore emerges as a vital character in the affairs of Massachusetts but clearly of the old guard in religious and civil matters. He was definitely not inclined toward either the aristocratic ways of Charles II's regime or the Church of England, which the king wished to see accepted, or at least tolerated, in New England. His portrait, accordingly, is of the middle-class, nonaristocratic, English nationalistic style. Although Rawson was firmly committed to the ideology of the old guard, certain details in his portrait reveal that some degree of vanity marked his life-style – for example, the neatly trimmed mustache and beard, the gold ring on the little finger of his right hand, and the elaborate embroidery on the cuffs of his gloves. A similar pair of gloves, which survive in the Essex Institute in Salem, were once owned by Governor John Leverett, who served for a number of years in the General Court for which Rawson was secretary; a descendant reported that Leverett wore them "on public days and on his attendance on the Great and General Court."[12] Rawson's gloves were clearly emblems of his high social and civic position and marked him as a gentleman, and so they were unobtrusively worked into his portrait. Moreover, his hair – which is neither too long nor too short

– identified his social standing; in style it is not unlike that seen in the portrait of John Freake. But there the flair ends, for Rawson preferred not to be represented in finery to the degree that the prosperous merchant John Freake did, no doubt in part because he was not as prosperous and in part because a restraint was imposed by his connections with the old-guard, ministerial set.

A superficial examination of the portrait of Edward Rawson, with its dark, low-keyed coloration and its seriousness of demeanor, could produce a conclusion that it expresses a lack of interest in the pleasant, joyous things of temporal existence. Similarly, other early New England portraits have often been used as visual documents to prove a supposed austere, dour, morose, gloomy, and basically unhappy way of life among the first settlers and the generations that followed, all in the name of piety and Calvinism. The commonly held view was expressed by H. L. Mencken when he described Puritanism as "a haunting fear that someone, somewhere, may be happy," while another wit declared that we would all be better off if, instead of the Pilgrims landing on Plymouth Rock, Plymouth Rock had landed on the Pilgrims. To such people, seventeenth-century portraits with skulls in them were especially useful in demonstrating Puritan preoccupation with death, as was that enormous body of surviving artifacts of the Puritan era, the gravestones with their skeletons or skulls, that are so visible in New England burial grounds. The gravestones warned *Memento Mori* (be mindful, death is coming) or *Fugit Hora* (earthly time is fleeting by), urging the reader to reflect more on death and the eternity of the next world than on life on earth or any of its joys. Closely related to this is the *Self-Portrait* of 1680–90 by Thomas Smith, which has two components of a seventeenth-century gravestone: a gloomy elegaic poem and the ghastly symbol of death, the skull (Fig. 28).[13] The poem, presumably written by Smith himself as his own epitaph, reads:

> Why, why should I the World be minding
> therein a World of Evils Finding
> Then Farwell World: Farwell thy Jarres
> thy Joise, thy Toies, thy Wiles, thy Warrs
> Truth Sounds Retreat: I am not sorye.
> The Eternal Draws to him my heart
> By Faith (which can thy Force Subvert)
> To Crowne me (after Grace) with Glory.
> <div align="right">T.S.</div>

The message is clear enough: Smith, in his old age, has wearied of the thorny path through life and yearns for that moment when death will end his miseries and bring him to that glorious union with God in heaven. The skull refers to death or the approach thereof, and there is a grimness in the character of the portrait – all of which has been employed by some scholars to support the theory of seventeenth-century distaste for life and even a desire for death.

Other paintings presented similar evidence. In England about 1635, Sir Thomas Aston, standing at the deathbed of his wife, had been portrayed with his left hand on a skull.[14] From Holland came a representative example in the portrait of the Reverend Lazare Bayard (1636) which reportedly was brought

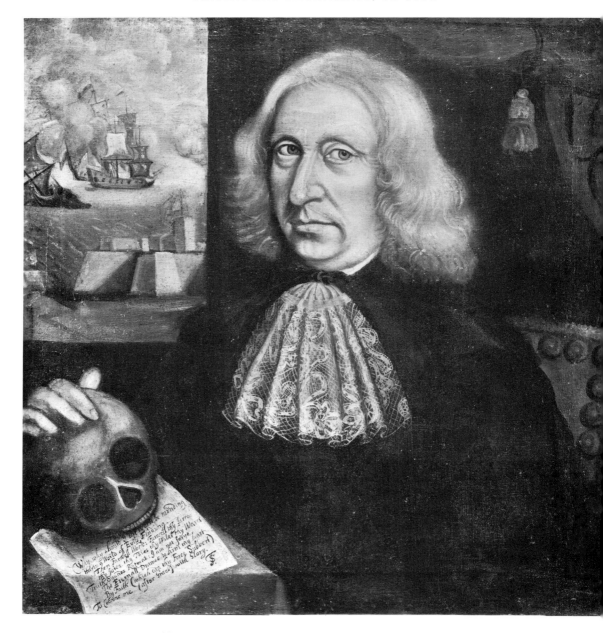

Figure 28. *Self-Portrait*, by Thomas Smith, c. 1680–90. Oil on canvas, 24¾ × 23¾ inches. Worcester Art Museum, Worcester, Mass.

to New Netherland in 1654 (Fig. 39). And then there is the portrait of Dr. John Clark (1664), in which the skull is a prominent feature (Fig. 29). Also, it is true, there are no "Laughing Cavalier" types of portraits of Protestant New Englanders and many of the portraits do have sober expressions on the faces.

A dour expression in the countenance seemed to dominate a whole group of seventeenth-century portraits, and the general darkness of the canvases

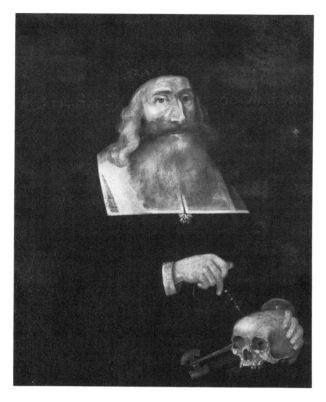

Figure 29. *Dr. John Clark*, artist unknown, 1664. Oil on canvas, 34 × 27 inches. Boston Medical Library, Francis A. Countway Library of Medicine, Harvard University.

confirmed the gloomy mood. In addition to the images of Thomas Smith and Dr. Clark are the portraits of the Reverend Richard Mather (Fig. 30), the Reverend John Davenport (Fig. 31), the Reverend Increase Mather (Fig. 32), and Governor John Winthrop (Fig. 33). The woodcut of Richard Mather and the painting of Davenport show the subjects in their black clerical robes, and in the eyes is the stark, haunted look of the religious visionary; the visage of Increase Mather presents a doleful, sorrowful expression that might seem to bespeak a fanatic's anguish over the sin and guilt of mankind, while the face of Winthrop possesses the gauntness associated with patriarchs, prophets, and unrelenting men who would lead fellow zealots into a wilderness to found a Bible commonwealth upon a rocky, hostile shore.

All this meshed perfectly with the concept of the seventeenth-century New Englander vividly formed for us by Nathaniel Hawthorne in his novels *The Scarlet Letter* (1850) and *The House of Seven Gables* (1851). Hawthorne was fascinated with the brooding and, to him, gloomy mind of his guilt-ridden ancestors, and he imposed those characteristics on virtually every person in the Massachusetts Bay Colony. Hawthorne was a nineteenth-century romantic novelist, however, and his romantic fiction should not be accepted as historical fact. It is a testimony to the power with which he created his Puritan personalities that for more than a century to follow we have forced our interpretation

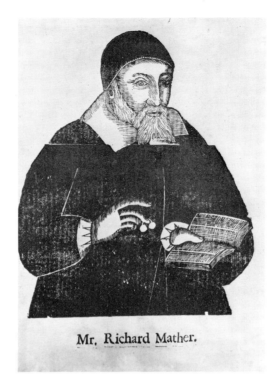

Mr. Richard Mather.

Figure 30. *The Reverend Richard Mather*, by John Foster, 1670. Woodcut on paper, 6⅛ × 4⅞ inches. Massachusetts Historical Society, Boston.

of seventeenth-century New England portraits to fit the mold of Hawthornian characters. The portraits just mentioned do seem to affirm the gloominess of life in Puritan New England, and the writings of several of the subjects tend to reinforce their dour solemnity as well. Moreover, gravity was a mark of the minister's profession, and Thomas Hall, in *The Loathsomnesse of Long Haire* of 1653, declared a look of gravity was to be preferred, especially in ministers, over some outward appearance suggesting pride and luxury. But Hall belonged to the conservative fringe of the Protestant world, which must be taken into account when we read his admonishments to look to "the most grave, gravitious, sober and civill men of your ranke and quality" for a model.[15] The ministers and old-men-turned-obsessively-religious – the subjects of the dour portraits now under consideration – may have looked far more to the rewards of the next life than to the pleasures of this one, but many of the lay community were increasingly determined to enjoy a life that combined prosperity and pleasure with their piety. Indeed, the macabre images of death on tombstones indicate no more than an appropriate concern with the finale of life and are unrelated to the zest or acquisitive dynamics of the earlier years of life. Portraits like Thomas Smith's mirror only the feelings of an old man who has wearied of life's tribulations, but not the vital energy of, say, a prospering young merchant such as John Freake. Hawthorne seized on only one aspect of Protestant life in early Massachusetts and, of course, did so to emphasize that strain

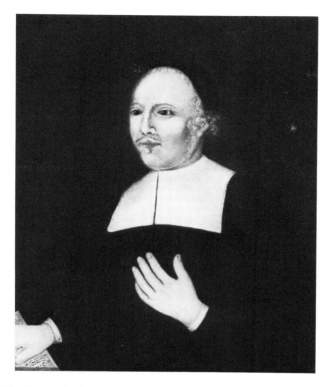

Figure 31. *The Reverend John Davenport*, artist unknown, 1670. Oil on canvas, 33½ × 27⅛ inches. Yale University Art Gallery, New Haven, Conn.

within Puritanism that he found so fascinating. However, the gloomy, moody, guilt-ridden strain represents only one facet of early New England life, and the prosperity motive was equally powerful, particularly among the mercantile sector.

Although some portraits do seem to support the theory of Puritan gloom, great care must be taken in their interpretation. In the portrait of Dr. John Clark, for example, the skull is not there as a symbol of death but as an indication of the man's profession of physician and surgeon; hence, his surgeon's instruments are also included (Fig. 29).[16] The skull, as a symbol of scientific accomplishment, is therefore a reference to a positive human accomplishment, and not at all to a preoccupation with death, any more than is Rembrandt's *Anatomy Lesson of Dr. Tulp* (Maritshuis, The Hague). An English portrait of Sir William Petty, professor of anatomy at Oxford and ardent supporter of the Commonwealth, shows the subject holding a skull in one hand and with the other pointing to a copy of Spigelius's *De Humani Corporis Fabrica* (1627). The picture's intent, like that of the *Dr. John Clark*, was to inform the viewer that the subject was a physician,[17] and it would be totally incorrect to interpret either portrait as an expression of a morbid fascination with death, merely because a skull is present.

Nor can the portrait of Increase Mather be interpreted as an image based solely on Puritanic religious values, for other factors are involved (Fig. 32).

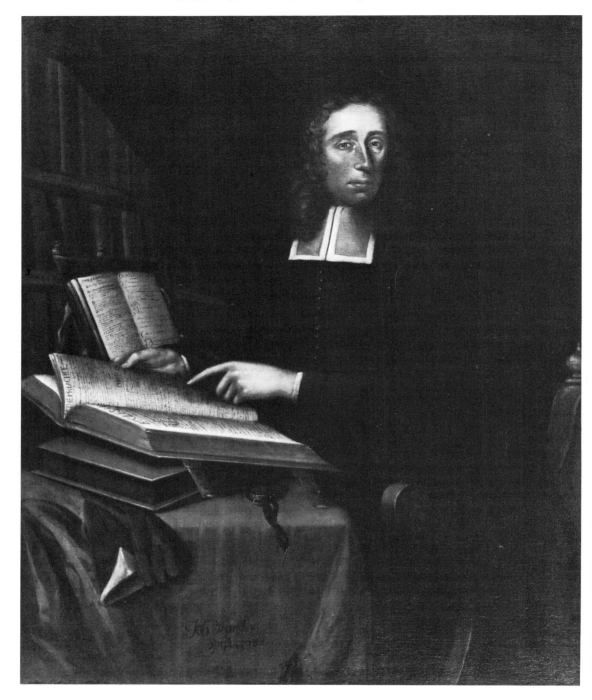

Figure 32. *The Reverend Increase Mather*, by Jan van der Spriett, 1688. Oil on canvas, 49¼ × 40¾ inches. Massachusetts Historical Society, Boston.

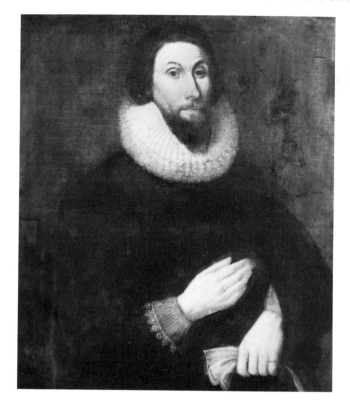

Figure 33. *John Winthrop*, artist unknown, c. 1629. Oil on canvas, 35 × 29 inches. American Antiquarian Society, Worcester, Mass.

The doleful countenance may in part be explained by a minister's coveted gravity, but the circumstances under which the portrait was painted should also be considered. Mather, who was in London in 1688 when his likeness was taken by the Dutch artist Jan van der Spriett, was having little success on his diplomatic mission to try to regain the Massachusetts charter, which had been revoked by the king, and he faced the reality of seeing the Bible commonwealth become a royal colony – which meant an enforced toleration of Anglicanism in New England. He was ill during this period, and his infirmity may well have had something to do with the expression on his face. In addition, the importance of the books in his portrait should not be overlooked. Although Mather was a dedicated man of God, he was also learned in secular affairs, as is evident from the titles of the nearly one thousand volumes in his personal library.[18] Books on religion, which naturally made up the majority of his collection, included Calvin's *Institutes* as well as works by William Perkins and most of the other leading ecclesiastical authors; there was also Prynne's *Histriomastix* and his diatribe against lovelocks, and Thomas Hall's *The Loathsomnesse of Long Haire*. But there were many works by the great classical authors, such as Ovid, Cicero, and Horace, and a wide variety of literature by contemporary writers on natural history, chemistry, medicine, math, history, and logic. Mather was obviously proud of his learning, for he had van der Spriett

portray him in his library setting. Even such staunch Puritans as Mather detested ignorance and loved learning, including that of a secular nature. Additionally, in his portrait he had the artist include his long-cuffed, gentleman's gloves and his watch in its ornate gold case, both lying on the table, as references to his high standing in society. Any question about his recognition of a stratified society, the affluence of a ruling class and the right of that class to possess worldly goods, is dispelled by Mather's own words, from his election day sermon of 1693: "It is very meet that persons Nominated for Counsellers should be men of Estate, and of some Port in the World. Isa. 3.7. Thou hast Cloathing, be then our Ruler. Thou hast an Estate to Support the place and Dignity of a Ruler, then therefore we choose thee."[19] Thus, in the interpretation of Mather's portrait, his discouragement over the failure of his diplomatic mission, his ill health, his interest in secular knowledge, his modest pride in his social standing, and his attitude about worldly estates should be considered along with Puritanical values.

In the portrait of John Winthrop (1587–1649), the governor is dressed as a gentleman (Fig. 33).[20] His elaborate ruff collar is trimmed in lace, with more lace adorning his white cuffs, and he holds a pair of long-cuffed gloves; he wears the stylish "Van Dyck beard," and his hair is of a length appropriate to a gentleman. Although Winthrop was the grandson of a clothier, his father was lord of Groton Manor in Suffolk; accordingly, the future governor was raised with all the privileges attending the gentry class. After studying briefly at Cambridge he became a lawyer and established a successful practice in London. By 1619 he had inherited his father's title and estate in Suffolk. Fond of books and learning, he was reportedly of a cheerful and amiable disposition and generous in his hospitality. Winthrop turned to Puritanism in the 1620s, but when his portrait was painted in 1629 – the year before he led the Great Migration to New England – he was a learned gentleman of property and profession, and his portrait indicates these things at least as much as Puritan asceticism.

Great care must be taken, therefore, in applying the theory of Puritan gloom to seventeenth-century New England portraits, even to those of old men, ministers, and civic leaders. Gravity may have been appropriate to some subjects, whereas others, like the elderly Thomas Smith, may have felt that death offered a respite from life's afflictions. Even in the group of portraits under discussion (Figs. 28–33), Puritan factors were often only a part of what is expressed and combine with a concern for learning, social position, and other temporal affairs. Moreover, if we return to the portraits of the merchants and their families, Hawthorne's characterization of a pervasive Puritan gloom simply is not substantiated, and the portraits are more reliable documents of the true New England character than the fictional creations of a nineteenth-century romantic novelist.

We conclude this chapter with a discussion of two portraits from the mercantile sector that illustrate the colonists' drive toward prosperity and their enjoyment of worldly stuffs, and the establishment of a mercantile aristocracy – the *Elizabeth Paddy Wensley* and the so-called *Elisha Hutchinson*, both of about 1680.

Elizabeth Paddy was the daughter of William Paddy, an Englishman who had immigrated in 1635 to Plymouth, where he became a merchant (Fig. 34).[21]

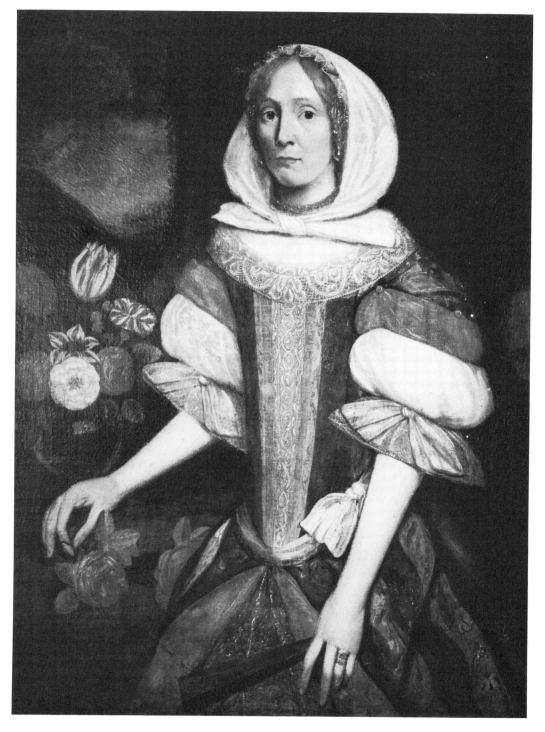

Figure 34. *Elizabeth Paddy Wensley*, artist unknown, 1670–80. Oil on canvas, 41½ × 33¼ inches. The Pilgrim Society, Plymouth, Mass.

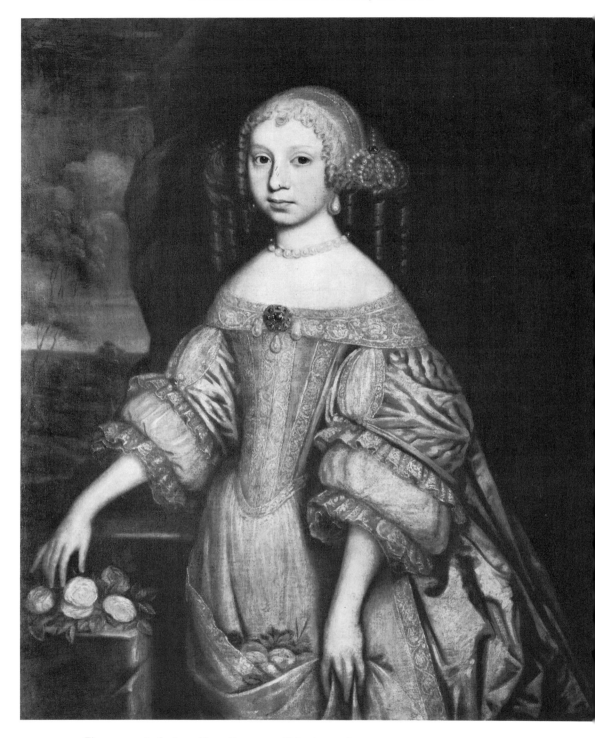

Figure 35. *Lady Jean Hay, Countess of March*, attributed to Michael Wright, c. 1666. Oil on canvas, 36 × 30 inches. Collection of Lady Daphne Stewart.

She married John Wensley,[22] a mariner, and judging by her attire, her husband must have prospered in his mercantile endeavors. She is shown wearing pearl earrings and a double-strand pearl necklace, two rings on one finger of her left hand, much lace, and many ribbons and bows on her multicolored gown. She carries a fan in one hand and in the other holds a flower that has been taken from the bouquet beside her, a motif derived from seventeenth-century Dutch floral paintings. Her outfit is the most elaborate of any known in seventeenth-century portraits of colonial American women, and the portrait seems to represent the very words of John Calvin: "In clothing, [God's purpose] was, in addition to necessity, comeliness and honor."[23] Her costume is, in fact, remarkably similar to that worn by Lady Jean Hay, Countess of March and daughter of the first Marquis of Tweeddale, who was a member of the Privy Council under Charles II and William III (Fig. 35). Lady Jean's dress, in this portrait of c. 1666, is very close in design to that seen in the New England portrait, and is similarly embellished with embroidery and lace; the countess, too, wears large pearl earrings and a pearl necklace. Moreover, Lady Jean is shown about to pick up a flower from a cluster of blossoms in the lower left, while more flowers are held in her skirt. In the upper left of each picture a landscape opens beyond a craggy rock formation. Such similarities of detail suggest that Elizabeth Paddy Wensley, daughter and wife of New England merchants, attired herself and had herself portrayed in the manner of aristocracy.

Little in the portrait of Mrs. Wensley suggests Puritan asceticism. The face of the subject is anything but gaunt or stark, and if it seems devoid of emotion, that was characteristic of almost every portrait painted in the Elizabethan–Jacobean survival style. The face is plain, to be sure, but it is beautifully painted and has a sensitive, thoughtful expression. Plainness of face becomes an integral part of the aesthetics in portraits of colonial American women, from the seventeenth century to the consummation of the style in the work of Copley and Peale. Thus, if the *Wensley* expresses anything about the so-called Puritan century, it is a drive toward a prosperity compatible with Calvinist virtues and piety, a desire to ascend socially in the temporal class structure of the day, and not the self-imposed deprivations of religious zealots concerned only with salvation of the soul.

The *Elizabeth Paddy Wensley* represents the final expression of the old Elizabethan–Jacobean survival style, modified by Dutch influences. The linear definition of form, decorative detail, compression of form, timid shading, and lack of sensuous tactility characterize the image of the figure, while the floral motif and the opening up of space in the landscape background are traceable to midcentury Dutch art. The portrait now believed to represent Elisha Hutchinson also shows influences from Holland in its dark tonality and its greater emphasis on form and tactile substances, but the delight in decorative detail persists in certain parts – as in the lace neckpiece and the pattern on the great sword belt (Fig. 36).[24] The Hutchinson invites comparison with David Loggan's little drawing of the Earl of Rochester of 1671, in which a late version of the Elizabethan–Jacobean survival style still prevails (Fig. 37). Moreover, many of the details of the costumes in the two portraits are similar – such as the lace gorget at the neck, the shoulder epaulets, and the elaborate design of

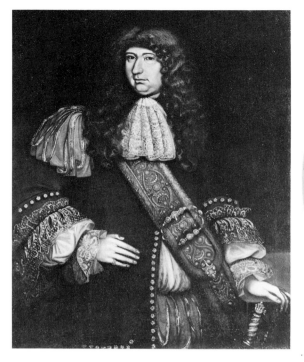

Figure 36. *Portrait of a Gentleman (possibly Elisha Hutch-inson or George Downing)*, attributed to Thomas Smith, c. 1680–90. Oil on canvas, 43½ × 35⅞ inches. Harvard University Portrait Collection, Cambridge, Mass.

Figure 37. *The Earl of Rochester*, by David Loggan, 167▮ Plumbago on vellum, 5¾ × 4½ inches. British Mu▮ seum, London.

the sleeves; Hutchinson has arrayed himself in the finery of the English aris-tocracy, and his attire can hardly be called an example of Puritan deprivation for the good of the soul. The very fact that Hutchinson patterned his costume after a person such as John Wilmot, second Earl of Rochester, is revealing, for the earl was a well-known libertine, poet of amorous and obscene lyrics, and an intimate friend of Charles II, with whom he joined in the infamous debaucheries at the royal court.

Hutchinson was a Boston merchant who prospered, in part, through the wealth he gained when he married Elizabeth, the widow of John Freake. In his portrait he, again, like Rochester, wears what seems to be a wig – that symbol of courtliness that scandalized the old guard of New England; its length is also significant, for it trails down well below the shoulders in what can only be described as a Massachusetts version of Cavalier lovelocks. The ornateness of the rest of his costume suggests a hedonistic delight in such sumptuousness as the prosperity of a Boston merchant could obtain, while the great decorative belt across his chest and the elaborate sword hilt – symbols of his high rank in the Ancient and Honorable Artillery Company – make overt reference to his exalted status among his peers.

The merchants and their wives were increasingly conscious of the class structure developing in their colony. Becoming ever more aware of family

status, members of the rising mercantile aristocracy wanted to pass on their secular creed and their form of piety to their children. Their drive frequently brought censure upon them from the old guard of ministers and civic officials, who wanted to perpetuate the goals of the colony along lines established by the founders. Old men at times wearied of the search for wealth and power, and tended to side with the clergy and the court in denouncing worldly pleasures. These things all show up in the portraits. But a seventeenth-century New England portrait must be interpreted according to the diverse concerns that arose within the colony's population, for no single force dominated all of life, as much as the Puritan ministers would have had it be so. The merchants continually assumed greater leadership in directing the course of the colony, while the ministers and the General Court cried out against the destruction of the hedge that had encapsulated the faltering Bible commonwealth. The merchants had sanction to pursue their prosperity, for Calvin and his interpreters had laid the blessing of God upon diligence at earthly callings. The prosperity theme and the imagery of the good life become increasingly apparent in colonial portraits as the decades pass, and culminate in the works by John Singleton Copley and Charles Willson Peale. But they are already present in many portraits painted before 1680. It was not the brooding gloom, asceticism, and distaste for life Nathaniel Hawthorne wrote about that would give direction to colonial New England life – it was the merchants' zeal for prosperity. That impellent drive, blessed by God, is the major theme of colonial New England portraiture.

Seventeenth-Century Manuals on Art, and the Search for the Early Portrait Painters

In addition to the portraits themselves, those books on art which seventeenth-century New Englanders had at their disposal should be considered in this study, as should the known facts about three men who have been proposed as portrait painters in early Massachusetts. The first topic offers hints about the level of knowledge about art and about how pictures were made; the second presents a collective biography of the type of person serving the colony as a painter of portraits. There were, in seventeenth-century England, numerous books available on the art of painting, both theoretical treatises and "how to" manuals. The former – such as Du Fresnoy's *The Art of Painting* – do not become significant for colonial American painting until the eighteenth century because they involve a more sophisticated knowledge of aesthetic matters than the early colonists had. However, many other books were sufficiently less esoteric and less complex to permit a newly arrived "gentleman" to grasp their meaning. Moreover, in New England – where there were no art schools or masters' ateliers – when colonial painting began, such books could theoretically offer valuable guidance to anyone who wanted to take a brush in hand for the purpose of making a portrait.

The total body of literature on art published in seventeenth-century England is vast, and catalogues of most of the titles have been published.[1] But a few works had special significance for the newly arrived gentleman and for the untrained novice of portrait painting, and these have heretofore received very little attention from art historians. The earliest are by Henry Peacham (1576? –1643?), beginning with *The Art of Drawing with the Pen, and Limning in Water Colours* (London, 1606), followed by *The Gentleman's Exercise, or, An Exquisite Practise, as well for Drawing all manner of Beasts in their true Portraitures, as also the making of all kinds of colours to be used in Lymning, Painting, . . .* (London, 1612), and, finally, a portion of *The Compleat Gentleman* (London, 1622), Chapter 12 of which treats "Drawing, Limning, and Painting."[2] *The Gentleman's Exercise* appears to have been the most widely read of Peacham's books, with subsequent editions issued in 1634 and 1661, and its title was included in William London's *Catalogue of the Most Vendible Books in England* (London, 1657). Later in the century came John White's *Art's Treasury, Containing Ex-*

traordinary Rarities and Curious Inventions, published in London in 1671, with six additional editions by 1700; and then there was William Salmon's *Polygraphice* (London, 1672), which by 1701 had gone through nine editions. There were others, such as John Bate's *The Mysteries of Nature and Art* (London, 1634)[3] and Alexander Browne's *Ars Pictoria; or, an Academy Treating of Drawing, Painting, Limning, and Etching* (London, 1669). For gentlemen seeking edification, that is, education and culturalization, these books were important; moreover, the "how to" portions of the manuals explain the technical means used to execute colonial portraits of the seventeenth century.

Peacham's work, although often indebted to Giovanni Paolo Lomazzo's *Trattato dell'arte della Pittura, Scoltura, et Architettura* (Milan, 1584), differs from it in the important point that the Italian author had declared that the main purpose of art was to serve religion. Peacham believed art had other purposes, and his own primary concern was with the edification of the gentleman. To him, for a gentleman to make art in an amateurish way was harmless entertainment while a knowledge about art was somehow socially and morally uplifting, and therein lay its justification. There were times when a command of drawing or of watercoloring might even be useful, and the utilitarian potential gave art further validity.

Peacham's *The Gentleman's Exercise* of 1612 opens with a history of painting from ancient times to about 1600, thus providing an instructional service to anyone who would be informed on such matters as a step toward refinement and culture. He condemns, however, the "lewde art" (probably referring to nudes) then being imported into England from Italy and Flanders, and he also attacks religious art as "blasphemous and utterly unlawful."[4] Peacham praises Dürer for his drapery, Holbein for a sense of life, and the Italian painters Titian, Michelangelo, and Correggio, while among his countrymen he extols the work of Nicholas Hilliard and Isaac Oliver for their portraits "in small," and Robert Peake and "Mr. Marques" (Marcus Gheeraerts?) for larger portraits in "oyle colours."[5]

Turning then to his instructions in drawing, Peacham lists the materials that will be needed. A black lead should be sharpened and inserted into a quill for drawing, and one should also have some "sallow coales," or charcoal sticks made from willow spikes; a compass and straight rule should be at hand for copying prints. There should also be fine crumbs of white bread for erasing errors in lead or charcoal. Twenty or thirty raven- or goose-quill pens and some ink were required; raven quills were designated best for fine work, goose quills for heavier work.[6]

The beginner commences by drawing squares, circles, and triangles, which Peacham observes, are the basic forms of nature as found in the shapes of the sun, moon, buildings, towers, pyramids, and so on. One advances to drawing simple objects such as cups or bowls, then on to more complicated things such as flowers, and Peacham supplies engraved illustrations to assist the novice. Chapter 7 is devoted to "drawing the face or countenance of a man," with instructions on how to draw eyes, nose, mouth, facial expressions, and national traits. Subsequent chapters deal with drawing the body and "getting good proportions thereof," shadowing, perspective, and landscapes, while a separate section discusses the painting of drapery. Next are chapters on the drawing

of beasts, common errors made by artists, sight as a sense, colors and the making thereof, and the preparation of the support and the laying on of colors. Book Two is concerned with iconography – that is, how to portray concepts such as Eternity, Hope, Victory, Virtue, and so on, and personifications such as river gods, nymphs, muses, satyrs, gods and goddesses of the ancient pantheon, and the months of the year. In Book Three, Peacham discourses on coats of arms and their proper representation.

The Gentleman's Exercise of 1612, an expansion of an earlier book by Peacham titled *The Art of Drawing* (London, 1606), provides instructions that are "in respect of their brevitie & plainnesse, fit for the capacitie of the young learner, for whom they were first and principally intended."[7] The simplicity of his directions would in truth make it possible for a person – say, a prospering merchant or a would-be portrait painter in the colonies – to comprehend the basic steps of making art, or to acquire an elementary appreciation of art, something that Peacham, following Castiglione's *Il Libro del Cortegiano* (Venice, 1528), considered necessary in a gentleman.

In Chapter 12 of *The Compleat Gentleman* of 1622, Peacham lists the practical uses of art, as in drawing fortifications or the arrangement of troops on a battlefield, views of towns, rivers, bridges, geographical formations, and the like, all useful in making war; art is also useful in making maps, in describing fruits, flowers, and medicinal herbs, or the attire, religious rites, and weapons observed while traveling in foreign lands. Moreover, art "preserveth the memory of a dearest friend, or fairest Mistress. And by it . . . we read a continual Lecture of the wisdom of the Almightie Creator."[8] Furthermore, Peacham placed a knowledge of art among the higher refinements, informing the reader that "in ancient times painting was admitted into the first place among the liberal arts, & throughout all Greece taught only to the children of Noble men in the schools."[9] Similarly, the best families of Rome had recognized "the dignity of the practise," and

> in our times we see it practised by the greatest princes of Europe
> without prejudice to their Honors. Francis the first, king of France,
> was very excellent with his pencil; and the virtuous Margaret, Queen
> of Navarre, beside her excellent vein in Poesie, could draw and limn
> excellently; the like is reported of Emanuel, Duke of Savoie. Nor can
> I overpass the ingenuitie and excellence of many Noble and Gentle-
> men of our own nation herein, of whom I know many.[10]

Peacham constantly stressed a knowledge of the art of painting among those things with which a gentleman should be familiar. Although published in the first quarter of the seventeenth century, his books were widely read and respected throughout the century, and they, more than any others, laid the foundation for a knowledge of painting among the English middle class and gentry before 1670, after which time White's and Salmon's books appeared. It is very possible that such knowledge of art as immigrants to the colonies had in midcentury came from the reading of Peacham's publications.

Art's Treasury (1671) by John White (d. 1671) was a polyglot of useful information on a variety of subjects, ranging from how to dye cloth to the coloring of leather, from the repair of silver and gold lace to the reweaving

of linen and woolens, from the making of perfume to the painting of a portrait, and much more. The section on art begins with Chapter 5, in which he says that since drawing and limning are much admired and "sought after in all Ages, and especially in the present," he will explain the techniques in a manner designed for beginners.[11] His list of necessary materials is almost identical to that given by Peacham, and the student is again told to commence by drawing geometric forms, then advance to the forms of nature.

White's Chapter 6 treats the drawing of the face, with instructions about obtaining proper proportions and expressions. After making a simple oval for the shape of the head, the proportions are devised as follows:

> There is usually a threefold Proportion observed in a face, as first
> from the top of the Fore-head to the Eye-brows. Secondly, from the
> Brows to the bottom of the Nose, and Thirdly, from thence to the
> bottom of the Chin, but in some the Fore-head is lower, and in others
> the Nose longer.[12]

The beginner should then proceed to drawing the other parts of the body, and as an aid he should purchase prints of them to copy, "which may be had at most Picture Shops for a small matter [price]."[13] White then gives advice on the proportions of the figure: "A man standing . . . is in due proportion eight times the length of the Head. The hand must be the length of the face. The Arms of a Man extended are his full length [height]."[14] Then he provides directions for drawing drapery, especially as it is represented on the human figure.

Chapter 8 of *Art's Treasury* informs the reader about "The Curious and Esteemed Science of Painting or Limning in Water Colours, and exactly how to proceed therein, either on Parchment, Glass or Copper."[15] ("Limning," it should be noted, originally referred to painting in watercolors on a small scale, as opposed to "painting" which was done in oils, usually on a larger scale; a "limner" was therefore understood to mean one who painted small pictures, such as miniatures, in watercolors. Over time, however, the distinction blurred, and a portrait painter working in oils might also be called a limner.) White lists the tools and materials needed, tells how to make the various colors, what media to use, how to prepare parchment, and how to lay in the colors. The reader is told how to select proper lighting, that it should come over the limner's left shoulder and fall upon the sitter. White says it takes three sittings to complete a portrait in watercolors: At the first the general colors of the face are laid in; at the second, the face, the rest of the figure, and the background are developed; and at the third, all parts are carried to the finished state.

White's Chapter 10 is titled "Directions for the most Curious Painter, or Limning in Oil, with the various Colours, and Materials, with their manner of preparing, and ordering; also Instructions to Paint to the Life, &c. wonderfully pleasing, and much profitable to be known, as well by the Gentry, and others, as those that intend it for their Profession."[16] Herein is given such practical information as the list of colors to be used, "the greatest part of them to be ground upon your flat stone with a Muller," which are then mixed "with Line-seed Oil [except for] White Lead which you must mix with Oil of Walnuts, by reason the other will in a short time turn yellowish." Brushes – or

pencils, as they were called – should have a stick or handle about nine inches long, and there should be two "Duck-quill Fitch-Pencils, two Goose Quill fitch'd, two pointed, and two bristled." The painter must also have a "Pallet to lay your Colours on ... an Eysil [easel] to lay your cloth upon ... and a straining Frame to which it must be nailed," and a "Stay or Molstick" made of wood about a yard long. The strained cloth should be scraped "to take off the knots," and set upon the easel at a convenient height to work on as the painter sits upon a stool. After drawing the face on the cloth with chalk, "take a Swan's Quill pointed Pencil, and begin with some of the lightest colours in the lightest part of the Face."[17]

White then reveals his method to be generally that of the old Elizabethan –Jacobean technique when he says the painter should develop the eyes, then the nose, mouth, and ears *in outline*, "before you lay on any Colour." This produced a linear definition of form such as we find in Elizabethan–Jacobean portraits, or in New England portraits such as those of the Freakes, the Gibbs children, or the Rawsons. The result was the opposite of the fluid, richly painterly effect found in the art of Van Dyck, Lely, or the Dutch masters. We have seen that the modified Elizabethan–Jacobean style survived as late as the 1670s (as in the Roberts portraits, Figs. 20 and 21), and White's treatise shows that instruction in that style was still being given. It is known that White's *Art's Treasury* existed in colonial American libraries, even as late as 1717 when it was listed in the catalogue (as number 156) of the sale of the books of the Reverend Joshua Moodey and Daniel Goodkin that was held in Boston.

Potentially even more important for colonial American painting than the works of Peacham or White is William Salmon's *Polygraphice, the Art of Drawing, Engraving, Etching, Limning, Painting, Washing, Varnishing, Colouring, and Dyeing,* of 1672. Salmon (1644–1713) was a noted physician and an author of scientific, mathematical, medical, and architectural treatises. It is known that he visited New England, although the date is uncertain. The 1675 edition of his *Polygraphice* contains an engraved portrait of him as the frontispiece, showing him wearing a white collar and dark coat, with shoulder-length hair. His book contains the fullest exposition of the techniques and materials of the arts of drawing and painting of all those we have considered.

Book One of the *Polygraphice* deals with drawing, describing the various utensils already encountered. The drawing is begun with charcoal made from willow branches "split into the form of Pencils," so that "if any thing be drawn amiss it may be wiped out" with duck feathers. Next, black and red lead pencils are used "to go over your Draught the second time more exactly, because this will not wipe out with your hand, when you come to draw it over with the pen."[18] The novice advances from the drawing of geometric forms to natural objects and finally to the human figure, "of which a variety of Prints may be bought at reasonable prices" for purposes of copying; the student should also practice drawing drapery, which, with the "imitation of the choicest Prints will become facile and easie."[19] In Chapter 9 he writes that "In drawing the Muscles of a human body you must have either the life or very good patterns made either of Plaister, or drawn in Pictures, enough of

which are to be found in Anatomical books, but chiefly the Book of Jacob Vander Gracht."[20]

In drawing technique, Salmon explains that "you must be perfect . . . in the general outward lines before you fall to shadowing . . . your work within." But he quickly leads the learner beyond the linear definition of form by seeking a well-modeled, corporeal form, and to assist in this he supplies a number of engravings done in a robust baroque manner. In the matter of proportion, the head is to be used as the module that determines all other measurements of the body, the figure to be in all eight heads tall.

Book Two of the *Polygraphice* treats limning, which "is an Art whereby in water Colours, we strive to resemble Nature in every thing to the life."[21] Salmon lists the materials needed for limning, such as pointed brushes, parchment pasted over pasteboard to paint on, and gum arabic as a medium; he also informs the reader how to obtain and prepare watercolors. Limning requires three sittings for a portrait: the first, for dead coloring, will take about two hours; the second sitting, however, will require about five hours, for it is then that the details of the face and the shadows are developed; the final sitting of approximately three hours is devoted to perfecting the face and finishing the drapery and background.

In Book Three of his *Polygraphice*, Salmon explains that "Painting in Oyl is nothing but the work or Art of Limning performed with colours made up or mixed with Oyl."[22] First the cloth must be primed: "Take good Canvas and smooth it over with a slick stone, size it over with size and a little honey, then white it over once. . . . Honey keeps it from cracking, peeling or breaking out."[23] He then tells how to make size (glue boiled in water) and whiting (size mixed with white pigment), how to prepare the colors, and how to stretch the canvas on its frame. Then follow passages that give us insight into the manner of executing a portrait. First,

with a piece of [tinted] chalk draw the proportion of the face upon the cloth. . . . Then take a pencil [brush] Swans quill pointed, and begin to paint some of the lightest parts of the face with the lightest colours (as the heightening of the fore-head, nose, cheek-bone of the lightest side); the mean [middle tone] parts next (as the cheek-bone of the dark-side, chin and over the upper lip); proceeding gradually till you come to the reddest parts of all. Lay faint greenish shadows in convenient places. . . . The faint or light parts thus done, take one of the Goose quill pointed [brushes], or Duck's quill fitched [brushes, made with pig bristles], and begin at the eyes to shadow with Lake [red], going over the nose, mouth, compass of the ear, etc., before you lay on any colour, wiping it lightly over with a linen rag, to prevent the overcoming of the other colours. The colours both light and dark being put in, take a great fitch pencil, and sweeten [blend] the colours therewith. . . . Where note, the bigger the pencils you use, the sweeter and better your work will lie. At the second sitting . . . heighten or deepen the shadows as occasion requires. Lastly, take a Goose quill bristle, and put in the hair (if there be any) and rub in the greater

[mass of the] hair, with the greater bristle, heightening it up with the Goose quill pencil.[24]

Much of Salmon's treatise deals with techniques and material, and only occasionally does he make statements concerned with style; when he does, they are something like this: "The work of the Painter is to express the exact imitation of natural things."[25] Similarly, he advises the learner to observe closely "the beauties or deformities, as they are in Nature," indicating a respect for truth that leads to a fundamentally naturalistic style – that is, the student should not falsify nature for the attainment of some artificial ideal in portraiture. All in all, however, the author has little to say about stylistic matters.

Finally, Salmon treats a couple of other issues that probably had some influence on the development of taste and awareness of art in colonial America. He discusses how important art was in the lives of the ancient Greeks and Romans, cites biblical sources for the making of art, and points out that the true artist holds an esteemed place in society, for artists "must be of an exceeding great spirit, and entertain upon every occasion great thoughts, and lofty imaginations; by this means they shall gain everlasting fame."[26] Again, anyone aspiring to rise from the lower ranks of society to its higher, more refined levels, would learn from such books that a knowledge and appreciation of art was one of the requisites.

Finally, Salmon's *Polygraphice* considers where, throughout the house, pictures were to be hung, and what subjects were appropriate for each room. Although large collections extending throughout the house were rare in seventeenth-century America, Salmon's words might still have helped a gentleman or lady to decide where to place such pictures as they did possess. What emerges is a kind of iconographic program based on appropriateness, as found in Book Three, Chapter 15:

> Of the Disposing of Pictures and Paintings. Let the Porch or entrance into the house, be set out with Rustick figures, and things rural. Let the Hall be adorned with Shepherds, Peasants, Milk-maids, Neat-herds, Flocks of Sheep and the like, as also Fowls, Fish and the like. Let the Stair-case be set off with some admirable monument or building, either new or ruinous, to be seen and observed at a passing up.
>
> Let Landskips, Hunting, Fishing, Fowling, Histories and Antiquities be put in the Great Chamber. In the Dining-room let be placed the Pictures of the King and Queen; or their Coat of Arms; forbearing to put any other Pictures of the life, as not being worthy to be their Companions; unless at the lower end, two or three of the chief Nobility, as attendants of their Royal Persons....
>
> In the inward or with-drawing Chambers, put other draughts of the life, or Persons of Honour, intimate or special friends, and acquaintances, or of Artists only. In Banqueting-rooms, put cheerful and merry Paintings, as of Bacchus, Centaurs, Satyrs, Syrens, and like, but forbearing all obscene Pictures. Histories, grave Stories and the best works become Galleries, where any one may walk, and exercise their senses, in viewing, examining, delighting, judging and censuring.... Upon Chimney-pieces, put only landskips.

And in the Bed-chamber, put your own, your Wifes and Childrens Pictures; as only becoming the most private Room, and your Modesty: lest (if your Wife be a beauty) some wanton and libidinous guest should gaze too long on them.[27]

In summation, Peacham, White, Salmon, and others wrote their manuals on art in a style the seventeenth-century colonist could understand, whereas the theoretical treatises such as Du Fresnoy's *The Art of Painting* or De Piles's book of the same title, neither of which was available in an English translation until the early eighteenth century, would have been too esoteric for general consumption. The works of Du Fresnoy, De Piles, and others were, in time, to take their place in colonial libraries; but for the seventeenth century, the manual type had greater significance. The manuals discussed above are known to have been in early colonial libraries and therefore available to the rising upper-middle-class aristocracy of colonial society, or to a house painter called upon to paint a portrait in a community that at a given moment had no trained specialist in residence.

We know of three men who were connected in some way with art or with the trades of utilitarian painting in New England in the seventeenth century, and attempts have been made to associate them with portrait painting. The evidence is reviewed here concerning Augustine Clement, John Foster, and Tom Child, with the idea of seeking a composite biography of the type of person who might have painted portraits among those who were only beginning to desire images of themselves. Judging by the relatively small number of portraits that exist from the years 1664 to about 1680, even Boston would not have supported a portraitist full-time, and so it is possible that such a person would have made a living by some utilitarian craft or trade for which there was a demand.

Augustine Clement (c. 1600–1674) grew up in Reading (Berkshire) and in Windsor, about twenty miles from London.[28] He was apprenticed to a painter named Jonathan Miller for about seven years and then spent an additional four years assisting another painter, Edward Newman of Eaton. Both Miller and Newman were decorative painters, but Clement's nearness to Windsor during those years – 1613 to 1624 – might have provided him an opportunity to observe, in the studios, the new Continental styles that were in vogue at the court of Charles I. This could be a significant point, for certain of the portraits painted in New England in the 1660s were of a decidedly Continental (not Elizabethan–Jacobean survival) style; however, it should be noted that their style is more related to Dutch portraiture than to any Continental aristocratic style. About 1625, Augustine Clement is mentioned in the records of Reading as being a portrait and decorative painter.

In 1635, Clement, with his wife, son, and servant (possibly an apprentice), sailed for New England. Settling first in Dorchester, they later established themselves in Boston in 1650, and two years later when Augustine Clement

bought some land in the town, he was referred to in the deed as a "Painter"; unfortunately, the document does not reveal what kind of painter – house, decorative, portrait, or whatever. A few references from late in his life inform us of his activities as a painter. By 1668 he had moved back to Dorchester, and the next year, when the Reverend Richard Mather died, the Congregational Church of Dorchester appropriated funds for "erecting of a piller on his grave" and instructed "bror Clement & bror Jn° Smith to git the worke done about ye grave."[29] John Smith was probably the maker of the wooden grave marker, which Augustine Clement was to paint, letter an inscription upon, and apply some appropriate device to, such as a death's-head, hourglass, or other image such as we find on seventeenth-century gravestones. In 1671 the Church of Dorchester employed the same Smith and Clement to finish the work on the new house for its new minister, and two years later a man named Clement was paid by the Town of Dorchester for some painting done at the meetinghouse.[30]

Augustine Clement died on October 1, 1674, and his will gives no indication of his activity as a painter – no mention of brushes, pigments, or other artist's equipment, such as those specified by Peacham, White, or Salmon. He seems to have been moderately prosperous, in part as a farmer, but there is no documentation that he was ever a portrait painter once he set foot ashore in New England. The most that can be said is that he was trained as a portrait and decorative painter in England, and that he was present in Massachusetts when some portraits were painted that show evidence of their creator having been trained professionally. But the connecting documentary link remains missing.

Nevertheless, his biographer, Sidney Gold, tried to attribute a group of paintings to Augustine Clement, admittedly on circumstantial evidence: the *Dr. John Clark* (Fig. 29), the *Governor John Endecott*, and the badly deteriorated *Reverend Richard Mather*.[31] There is a problem, however, in that stylistic differences exist within the group, which one would not expect to find in paintings done within a span of a few years in the mid–1660s, if they were executed by the same hand. Still, Gold's study and the records he has brought to light are revealing, for they demonstrate how a trained, professional painter who was among the early immigrants had to be prepared to forgo his vocation or modify it so that it was in some way useful to the founding community – that is, he had to become a house painter, for example. And then, beginning in the 1660s or 1670s, he may have been called upon to revive his long-dormant talents when the community at last had need of a portrait painter.

Another whose biography helps create a composite picture of the life of an image maker in seventeenth-century New England is John Foster (1648–81).[32] Although his connection with the visual arts now seems to be limited to his activity as a wood engraver, his name has in the past been linked (usually for no very good reason) with several painted portraits. Born in Dorchester, he was baptized by the Reverend Richard Mather; his father was a man of some standing and means, being a brewer, a captain in the militia, and a member of the General Court. After graduating from Harvard College in the class of 1667, Foster returned to Dorchester, and the town paid him to teach English grammar, Latin, and writing.

But Foster soon became a printer and in connection with that trade took up engraving. The earliest example of his work is the well-known woodcut of the Reverend Richard Mather of 1670 (Fig. 30). The subject, father of Increase and grandfather of Cotton Mather, was the respected minister of the First Congregational Church of Dorchester, which Foster's family had long attended. After thirty-three years of service to that community, Mather died, and in the next year a book titled *The Life and Death of That Reverend Man of God, Mr. Richard Mather* (Cambridge, Mass., 1670) was published. For this little book John Foster made the small woodcut, to be tipped in as the frontispiece.[33] The image shows the aged subject in oblique pose, three-quarter length, wearing his ministerial robe and skullcap, holding a Bible in one hand and a pair of eyeglasses in the other. There are several states with minor variations. The impression at Harvard is inscribed "Richardus Mather" and "Johannes Foster sculpsit"; the handwriting is that of a friend of Foster, a Reverend William Adams who once owned the print. So far as is known, this is the earliest example of a portrait in the graphic arts executed in America.

Woodcuts, like engravings, are normally copied from paintings or drawings, and the model for Foster's print of Mather still survives, although in very poor condition, at the American Antiquarian Society in Worcester, Massachusetts.[34] Although Gold tried to make a case that the portrait was painted by Augustine Clement, it was at one time believed that Foster himself had painted a portrait of Mather from which to take his woodcut; on the basis of that belief, other seventeenth-century portraits were soon attributed to him. However, the Mather woodcut is the only portrait Foster is known to have done in any medium. He did, of course, do a few woodcuts of emblems and some decorative cuts for use after he became a printer. The Seal of the Colony was published in *The General Laws and Liberties of the Massachusetts Colony* (Cambridge, 1672), and a map of New England that Foster cut from a woodblock was published in the Reverend William Hubbard's *Narrative of the Troubles with the Indians* (Boston, 1677). By 1675, Foster had established himself as a printer in Boston, and that seems to have been his profession for the remaining six years of his life.

There is no proof that John Foster ever painted a portrait, but a couple of references to him made shortly after his death provided some historians with circumstantial evidence that he had been a painter. An item in the inventory of his estate reads "To his Cutts and Colours, £ . . . :15:00"; but this probably refers to the woodblocks and inks of a printer rather than to the pigments of a painter. In another posthumous reference, an elegiac poem by Thomas Tileston, there is a reference to Foster as a "rare Apelles," comparing him to the celebrated Greek painter of the fourth century B.C.; this led some to believe it was an indication of his abilities as a painter.[35] But as a teacher he may well have given rudimentary lessons in drawing, or the comparison to Apelles may have derived from Foster's woodcut images such as the Mather portrait or the Indian in the Seal of the Colony. Again, here was a man who seems to have been at least on the fringe of the artist's profession at the time portrait painting first rose in New England, but the all-important link is still missing that would connect him with any known painted likeness.

Finally, Tom Child (d. 1706) comes into focus in London in 1679 when he

was admitted to the London Painters and Stainers Guild. Nine years later he was in New England, where he was listed "Thomas Child the Painter" as one of the debtors to the estate of one Samuel Smith of Boston. Child's name was recorded among those "sure, honest, and well-disposed persons who Contributed their assistance for and towards erecting a Church for God's worship in Boston, according to the Constitution of the Church of England."[36] Among other work performed gratuitously in 1689 at the building that preceded the present King's Chapel, Child is noted as having painted the window frames. Nine years later, when wealthy landowner and merchant Samuel Shrimpton died, an elaborate funeral was held, and Samuel Sewall made a notation in his diary of the decoration on the horses that pulled the mourning coach: "Scutcheon on their sides and Deaths heads on the foreheads."[37] These were reportedly by Child, who also painted the hatchment emblazoned with the Shrimpton family coat of arms, which was, if normal procedure was followed, displayed outside the house of the deceased for a year as a part of the bereavement ritual.

There were other miscellaneous references to Tom Child in the years that followed, most of which suggest his main business was the making and selling of house paint. He imported a great stone trough, about twelve feet long with a large stone ball, that was used to grind pigments into powder so they could be mixed with oil to produce interior and exterior house paints. A portion of this stone, inscribed "The Boston Stone," still survives along with the great ball. But the question remains, did Thomas Child ever paint portraits?

Again, the evidence is circumstantial. Born in England around the middle of the century, he served an apprenticeship to a member of the London Painters and Stainers Guild, from 1671 to 1679. In the latter year he was admitted to the guild. Nothing more is known of him or the type of work he did in England, and the next record places him in New England in 1688, where he began painting houses, churches, fences, hatchments, and scutcheons – in brief, any kind of painting that was required. That this included taking likenesses is impossible to say, but the poem that Judge Sewall wrote in his diary on November 10, 1706, is indeed intriguing and invites speculation: "This morning, Tom Child, the Painter, died," he noted, before adding his doggerel:

> Tom Child had often painted Death,
> But never to the Life, before:
> Doing it now, he's out of Breath:
> He paints it once, and paints no more.[38]

The quatrain may mean Child had taken posthumous likenesses, but it specifically says he never took them from life; the line about his often painting death may refer to the painting of hatchments and other funerary ornaments.

So, the link that connects Child with portraiture is missing, just as it was with Augustine Clement and John Foster. It is clear that all three men had to make their living in some way other than one directly connected with portraiture. Even if trained as an artist in England, an immigrant portraitist would have found insufficient demand for that skill once he arrived in the colonies; there he had to take up some other, usually related but always more "useful" calling. A professional portrait painter would not earn his living at taking likenesses in New England until John Smibert arrived in 1729.

Portraits of the Dutch in New Netherland

In 1609, Henry Hudson, an English sea captain and navigator employed by the Dutch, explored the mouth and part of the length of the river that now bears his name, and that area of the New World became a Dutch possession. An enormous but ill-defined tract of land was chartered to the Dutch West India Company – a trading and colonizing company – in 1621 for establishing settlements, but ultimately for the purpose of making a profit for its share-holders. Three years later a group of Walloon religious refugees – Protestants from Belgium – settled well up the Hudson River at a site called Fort Orange (later renamed Albany), and in 1625, New Amsterdam at the mouth of the great river was established as the capital of New Netherland. The immigrants from Holland brought with them the Dutch Reformed Church, a branch of Calvinist Protestantism.

In contrast to the English Puritans and Quakers and the Protestants of Continental Catholic countries, the Dutch were generally happy and content at home. They prospered in their mercantile pursuits there, and as the nation was essentially of one faith, there was no religious persecution from which they were forced to flee. This latter is an important point, for unlike the situation in New England, New Netherland was established and settled by Dutchmen who unabashedly had economic gain in mind rather than religious freedom. Through its worldwide colonial commercial empire, its efficient navy and merchant fleets, and its devotion to Calvinist-Protestant values such as industry, frugality, and moderation, middle-class mercantile society in Holland rose to a broad prosperity such as that class had never before known in the history of the world. Because things were so good at home, the Dutch West India Company even had some difficulty enticing Dutchmen to immigrate. This led to the publication of a considerable amount of "promotional litera-ture," which praised not only the economic opportunities but also the beauties of New Netherland. For example, Adriaen Van der Donck's comment of 1654 about the Hudson Highlands states that: "here our attention is arrested in the beautiful landscape around us; here the painter can find rare and beautiful subject for his brush."[1] Similarly for promotional purposes, Jacob Steendam, New Netherland's first poet, composed a poem in 1661 about the Hudson Valley, one stanza of which reads:

It is the land where milk and honey flow;
Where plants distilling perfume grow;
Where Aaron's rod with budding blossoms blow;
 a very Eden.[2]

In Holland, in spite of such literature, New Netherland was often viewed as the far end of the world, a crude, barbaric place surrounded by dark forests filled with savages, panthers, and rattlesnakes. So the population grew slowly, and much of the colony remained rather mean in character throughout the period of Dutch rule.

Although the church played an important role in the life of New Netherland, there was not the same church–state relationship that existed in the early decades of the Massachusetts settlement. When Peter Minuit arrived as governor in 1626, he recognized the need for a regular church in what had formerly been not much more than a trading post on the fringe of an economic empire. Peter Stuyvesant, too, perceived the necessity of the clerical influence and worked with the church to promote piety and morality in a colony that evidently needed them. For example, the Reverend Johannes Megapolensis, who became minister in New Amsterdam in 1648, complained of his charges's "weakness for Indian women and drunkeness."[3] Stuyvesant and the ministers of the Reformed Church tended to be intolerant of other religions in New Netherland, but the Dutch West India Company, anxious to attract settlers for economic reasons, forced toleration of them.

A few of the yeomen, tradesmen, and merchants who immigrated to New Netherland were ambitious enough to aspire to the modest comforts we see depicted in interior scenes by Vermeer and de Hooch, which show that at home in Holland, art had become a major component of domestic decor. This was true not only for the prospering upper-middle-class merchants but also among the yeomanry. When the Englishman John Evelyn visited Rotterdam in 1641, he recorded that the city

> was so furnished with pictures (especially landscape and drolleries, as they call those clownish representations), that I was amazed. . . . It is an ordinary thing to find a common farmer lay out two or three thousand pounds in this commodity. Their houses are full of them, and they vend them at their fairs to very great gains.[4]

Patronage of art at nearly all levels of society was a heritage that would be carried by Dutch immigrants to New Netherland. Record survives of the collection of Dr. Jacob De Lange of New Amsterdam, which in 1685 contained sixty-one pictures including the full range of subjects known to Dutch art in the seventeenth century – landscape, still-life, genre, portraiture, and religious.[5] In the same town, Mrs. Margarita Van Varick had hanging on the walls of her house sixteen paintings of a variety of subjects, two maps, twelve framed prints and fourteen "East India Pictures."[6] Granted, these were exceptionally large collections and well above the average number, but, as Singleton has shown, there are many references to paintings, prints, and maps hanging in the Dutch homes in New Amsterdam, even after it became New York.[7]

Cornelius Steenwyck, for example, had at least thirty-nine pictures arranged about his house, including his own portrait (Fig. 38).

The portrait of Cornelius Steenwyck was painted by Jan van Goosen during the subject's return visit to his homeland in 1667–68, and it was then brought back to New Amsterdam – or New York, as it had been renamed. Steenwyck was a prosperous merchant whose trading ventures sent his ships to Virginia, the West Indies, and the west coast of Africa; he had risen to prominence during the Dutch reign and after the English rule was established he continued as a central figure, serving as mayor of New York in 1668–70 and 1682–83. By 1674 he was the second wealthiest man in the colony, outdistanced in that respect only by Frederick Philipse, who had come to New Netherland as a penniless carpenter and had prospered greatly. Steenwyck's portrait, which confirms his reputation for being well dressed, hung in his home at the corner of Whitehall and Bridge streets in Manhattan.

Steenwyck had one of the finest houses in New Amsterdam, the rooms of which must have resembled those depicted in Vermeer's interiors where paintings are conspicuous. The inventory of his estate reveals that the house was as commodiously furnished as those of all but the very richest of his burgher counterparts back home in Holland. In the anteroom alone were eight paintings, while the great chamber – which contained, among other furnishings, twelve Russian leather chairs, "two velvet chairs with fine silver lace," a large looking glass, a carpet, curtains at the windows, and "five alabaster images" – had no less than fourteen pictures hanging on its walls.[8] Even the kitchen chamber had six pictures. The pictures, along with 723 ounces of silver plate and numerous pieces of china and porcelain listed in the inventory and the other items noted above, established in Steenwyck's home a standard of elegance for New Netherland. Moreover, his residence was one of the foremost social gathering places, as when, about 1668, a club was organized consisting of sixteen French, Dutch, and English families to integrate the several national factions of the town and to improve the level of refined society. In the winter the club met twice a week in the evening over silver tankards of Madeira, rum, and brandy. When it met at Steenwyck's house, its twenty or thirty members, from the town's most prominent citizenry, could hardly escape noticing the presence of large numbers of pictures hanging upon the walls, among which must have been several portraits.

The earliest known surviving examples of portraits associated with New Netherland are those of the Reverend Lazare Bayard, minister of the Walloon Church at Breda in Holland, and his wife (Figs. 39 and 40). The Bayards were the parents of Peter Stuyvesant's brother-in-law, Samuel Bayard, and according to family tradition the portraits were brought over in 1654 when the widowed Anna (Stuyvesant) Bayard joined her brother, the governor, in New Amsterdam. The Bayard portraits were painted in 1636 by an unidentified Dutch baroque artist in the realistic portrait style that the middle class so greatly admired. This conservative Dutch style, appropriate for a minister and his wife, is quite different from the "Laughing Cavalier" type made popular by Frans Hals. The minister points to an open Bible, beside which are Protestant symbols of fleeting earthly time and the sureness of death – the hourglass and the skull. Several other books allude to Reverend Bayard's learnedness.

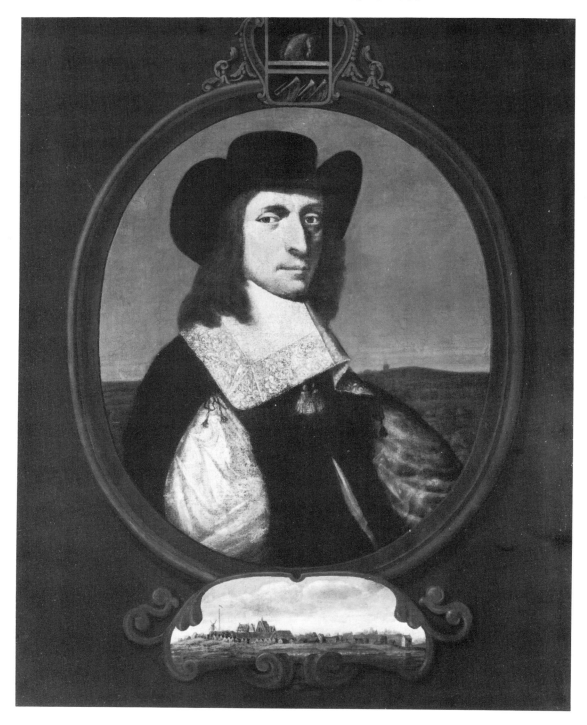

Figure 38. *Cornelius Steenwyck*, by Jan van Goosen, c. 1668. Oil on canvas, 32 × 25 inches. The New-York Historical Society, New York City.

Figure 39. *The Reverend Lazare Bayard*, by an unknown Dutch artist, 1636. Oil on panel, 45 × 33 inches. The New-York Historical Society, New York City.

Figure 40. *Mrs. Lazare Bayard*, by an unknown Dutch artist, 1636. Oil on canvas, 45 × 33 inches. The New-York Historical Society, New York City.

Judith De Vos Bayard is shown wearing a nicely tailored black dress with handsome neckruff and lace-trimmed cuffs. She has a ring on a finger of her right hand, which rests on a sturdy chair decorated with red and black fabric, brass nails, and ball finials; the chair, like her attire, is a subtle reference to her moderate but comfortable life-style, and the little book in her left hand informs us that she could read.

Other Dutch portraits are known to have made their way into the struggling little colony. For example, the portrait of the Reverend Johannes Weeckstein (1638–87) shows that the Dutch tradition continued to receive some infusion from Holland even after the English conquest of New Netherland (Fig. 41). Weeckstein, a Latin teacher at Haarlem in Holland, immigrated in 1681 to become minister of the Dutch Reformed Church at Kingston, New York. His portrait was painted in 1674 by Mathys Naiveu, a student of Gerard Dou, and was brought to the colony by the subject; in it, Weeckstein wears the ministerial robe appropriate to his profession. The likeness was taken at about the same date as that of John Freake (Fig. 10), but unlike the Elizabethan–Jacobean survival style of the latter, the image of Weeckstein possesses corporeality, three-dimensionality, and tactile substance, with a rich play of light and shade

93

Figure 41. *The Reverend Johannes Weeckstein*, by Mathys Naiveu, 1674. Oil on canvas, 27¼ × 23¾ inches. The New-York Historical Society, New York City.

as well as an understanding of the beauty of a fluid brushstroke. By comparison, the Freake portrait seems but a symbol of the subject, rather than the re-creation of a real person found in the *Weeckstein*.

The portrait of the Reverend John Livingston (1603–72) brings together the English and Dutch cultures (Fig. 42). Livingston, a nonconformist who fled England shortly before the Restoration of Charles II, sought religious asylum in Holland. There, in 1660, his portrait was painted – a stern-faced, ministerial image with black skullcap and robe, white collar, and dark background, and executed in the Dutch baroque style. Livingston and his wife attempted to immigrate to New Netherland, but foul weather drove their ship back to Holland. It is not certain when the portrait of the Reverend Livingston came to America, but his son, Robert, who eventually became the first lord of Livingston Manor and one of the wealthiest of the Hudson Valley patroons, crossed the Atlantic in 1673 and settled in Albany; there is a possibility that it came over with him. Thus we have a portrait of an Englishman painted by a Dutch artist in Holland, which was probably brought over by another Englishman, to an English colony that was still basically Dutch. It would be difficult to find an example to demonstrate better the commingling of the cultural, religious, economic, and artistic traditions of middle-class Protestant England and the Netherlands in the seventeenth century.

So far we have been discussing paintings executed in Holland and then brought to New Netherland; by the 1660s, however, we find the first instances of portraits being painted in the Dutch colony. It is believed that the portrait

Figure 42. *The Reverend John Livingston*, by an unidentified Dutch artist, 1660. Oil on wood panel, 33½ × 24½ inches. The New-York Historical Society, New York City.

of Governor Peter Stuyvesant was painted in New Amsterdam in or about 1663, the year before the English conquest, and it is thought to be the work of Henri Couturier, a Dutch artist who immigrated to the colonies about 1660 (Fig. 43). By 1648, Couturier had been admitted to the Leyden Guild of Painters, presumably as a fully trained, professional artist. The next year he moved to Amsterdam – a city where competition ran high, beginning with no less a painter than Rembrandt. About 1660 he immigrated to America, where the first record of his presence lists him as a trader and a public official in the Dutch settlement of New Amstel (New Castle, Delaware). There is no indication that he was then practicing the profession for which he had been trained, and there would have been little demand for it in New Amstel in 1661. Couturier next appears, in 1663, in New Amsterdam, where he obtained burgher rights by painting a portrait of Governor Peter Stuyvesant – thought to be the one at the New-York Historical Society. At a hearing before the burgomasters, Couturier's wife testified that her husband had painted the portraits of the governor and his two sons.[9] Little else is known about Henri Couturier except that he remained in New York, as it was renamed, until 1674, when he removed to London. There he died in 1684.

The portrait of Governor Stuyvesant is a competent if not inspiring characterization and exhibition of painterly virtuosity, capturing the stern, gruff personality of the subject while displaying the Dutch delight in chiaroscuro and textures within a limited, low-keyed palette. Its solid corporeal form,

95

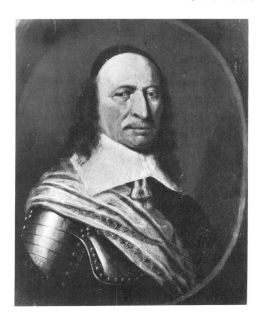

Figure 43. *Governor Peter Stuyvesant*, attributed to Henri Couturier, c. 1663. Oil on canvas, 21½ × 17½ inches. The New-York Historical Society, New York City.

believable space, painterly brushwork, and attempt at a rich manipulation of light and shade distinguish it from the English Elizabethan–Jacobean survival style then first being practiced in New England; the contemporary portrait of Elizabeth Eggington offers an interesting stylistic contrast (Fig. 22). But even with a competent portrait painter in residence, there was – considering the love of painting for which the Dutch were famous in the seventeenth century – surprisingly little demand for Couturier's skills. So, like the early limners of New England, Couturier had to serve his community in some other, more utilitarian way, and only rarely exercise his special gifts as an artist.

Hardly was the paint dry on Peter Stuyvesant's portrait when he was forced to surrender New Netherland to the English, in 1664. Thereafter, for nearly half of a century, there was very little painting done between New York and Albany. Unlike in New England, where painting activity escalated after once getting started around 1665–70, in the Hudson Valley it became dormant until revived about 1710 by the so-called patroon painters, who will be discussed in Chapter 10.

Before the English conquest, the Dutch colony had not advanced along with its neighbor to the northeast, New England. When Stuyvesant arrived in 1647, there were only about one thousand people in New Amsterdam, the only major town of the colony; even by the time of the conquest there were no more than eight thousand inhabitants throughout the Dutch territory, from the upper Hudson to the shores of Delaware Bay. The colony was the stepchild of the Dutch West India Company because its meager products were far less profitable than those from other parts of its worldwide commercial empire, and the company, in charge of virtually all that happened in New Netherland, had very little interest in colonization except as it resulted in higher profits.

The administrations of several Dutch governors had been ineffective or frustrated by inattentiveness from the company directors or the States–General at home. The great patroon system of the upper Hudson had not yet become widely established and, in fact, developed more under the English rule than it did under the Dutch. When Colonel Richard Nicolls sailed his small English fleet of four ships into New York Harbor in August 1664, the Dutch administration, military defenses, and will of the people were such that capitulation occurred almost instantly without a shot having to be fired. New Amsterdam became New York, with Nicolls replacing Stuyvesant as governor, and the titleholder became James, Duke of York, brother and future successor of King Charles II of England.

The transition from Dutch to English rule occurred just at the moment in history when the art of painting was about to be established in New Netherland. Although many Dutch cultural and social patterns survived in the years that followed, ultimately the English tradition in painting would dominate, which meant that portraiture would be virtually the only type of painting to be practiced. Painting, as produced in what had now become New York, would accordingly be deprived of the rich variety of Dutch art – which included landscape, still–life, genre, and other forms – that might have arisen in the late seventeenth century if the area had remained under Dutch control. Although several sizable collections in New Amsterdam would suggest that a Netherlandish tradition was about to be implanted through the seemingly innate propensity of the Dutch to adorn their homes with pictures, a Dutch tradition did not take root. Even in portraiture, little was established in New Netherland that led to a continuous artistic tradition after the colony became New York. To pick up the thread of the English tradition after 1680, we must return to New England. There, the confluence of firmly implanted cultural virtues with irresistible changes in social, religious, and economic patterns gave a special character to colonial American life. A transition phase – a middle period between the establishment of settlements and the full flowering of a mercantile aristocracy – was commencing, and both change and fidelity to basic cultural convictions would appear in the portraits.

97

Part II

THE TRANSITION,
1680–1740

The Signs of Change, 1680–1740

Cotton Mather, Royal Governors, Anglicans, George Lillo and the Merchants

Men, brethren, and fathers, you had once another spirit. A right New England Spirit. . . . Is the old zeal, love, heavenly-mindedness that was in [your] heart twenty, thirty years ago, is it still there? Are you the same men you were? Are you not strangely changed? Have you as much of God as you had? Hath not the world got something?[1]

These words, spoken from the pulpit in 1671 by the Reverend Eleazer Mather, reveal the change – some called it erosion – that was taking place within colonial society now that permanent, prospering settlements had replaced the harsh but holier existence on the edge of the "howling wilderness." In truth, colonial society had been in a state of flux from the moment the first immigrants touched ground, realized they had survived the perils of the Atlantic crossing, thanked God, and then began to think of improving their worldly lot. By 1680 it was all too clear to the New England clergy that the flock had gone astray. Exhortations rang constantly from the pulpits to return to the godly ways of the founders, and the Puritan poets were eloquent on the matter; Michael Wigglesworth, as early as 1662, had God himself address his wayward wards:

> Are these the men that erst at my command
> Forsook their ancient seats and native soil?
> Whence cometh it, that Pride and Luxurie
> Debate, Deceit, Contention and strife,
> False dealing, Covetousness, Hypocrisie
> (With such like crimes) amongst them are so rife?[2]

From Rhode Island, Roger Williams wrote to John Winthrop, Jr., in 1664:

> Sir, when we that have been the eldest and are rotting [in our graves] a generation will act, I fear, far unlike the first Winthrops and their *Models of Christian Charity:* I fear that the common trinity of the world – Profit, Preferment, Pleasure – will be here the *tria omnia*, as in all the world besides: that Prelacy and Popery too will in this wilderness predominate.[3]

By 1669, the great founders were all dead, except for Roger Williams (d. 1683): William Brewster, Thomas Hooker, Thomas Shepherd, John Winthrop, John Cotton, William Bradford, John Endecott, and Richard Mather. It was obvious that the times they were a-changing,[4] for even the Laws of the General Court, as published in 1675, spoke of the "shameful and scandalous sin of excessive drinking, tipling, & company keeping in taverns . . . [that] grows upon us," and noted that children are unruly at prayer meeting, and that there "is a loose & sinful custom of going or riding from town to town, and that oft times men & women together, upon pretence of going to lecture, but it appears to be meerly to drink & revel in ordinarys and taverns."[5]

The worldly drift of colonial society in matters that related to the market-place greatly concerned the Reverend John Norton; in his election-day sermon of 1659, titled "The Heart of New-England Rent," he exhorted, "It concerneth New England always to remember that originally they are a plantation religious, not a plantation of trade."[6] Another minister, John Higginson, admonished in 1663, "Let merchants and such . . . remember this, that worldly gain was not the end and design of the people of New England, but religion."[7] These, however, were the laments of an old guard that could see its grip slipping, and it is obvious that they held mercantile prosperity responsible for many of the woes besetting their Bible commonwealth.[8]

Whenever there is a significant change in a society, a noticeable shift in attitudes toward the arts and a change in artistic styles may be expected. But if some things changed in New England, others remained constant, and before the art may be properly analyzed – in both iconography and style – it is necessary to assess what was retained as basic to the beliefs of these people, and what was admitted that was new – or if not new, at least altered.

In both the societal transition noted above and the perpetuation of Calvinism, a central figure was Cotton Mather (1663–1728), son of Increase Mather and grandson of the founders, the reverends Richard Mather and John Cotton. He touched innumerable lives through the sermons he preached from his pulpit in the Second Congregational Church in Boston and many more through the hundreds of pamphlets, sermons, and books he published.[9] As his sermons and publications expressed the philosophical and theological convictions that underlay much of life in colonial New England, they offer a basis for interpretating many New England portraits. The youngest student that Harvard College had yet graduated, at the age of fifteen Mather already displayed a keen mind and a broad range of interests including history, the classics of ancient Greece and Rome, science, natural history, and philosophy as well as theology. By the time of his death his personal library had grown to more than three thousand volumes, about as many books as were in the Harvard College library. Cotton Mather was a combination of worldly interests and religious passions, and in this he was typical of the transition that was occurring in New England. Although he often tried to thwart the inexorable change unfolding before his eyes, he wanted only to keep his flock godly; it was never his intention to make ascetics of them, for he advocated diligence at one's secular calling and even endorsed the doctrine of prosperity. Mather's point of view was essentially Calvinistic. In *The Right Way to Shake Off a Viper* (Boston, 1720), he referred to "the Great, the Sweet, the dear Calvin."[10] A

scholar of Calvin's *Institutes*, he became an eloquent spokesman for a cultural pattern that evolved around industriousness and piety – two of the Calvinist virtues that led to prosperity and godliness.

In his *A Christian at His Calling, Two Brief Discourses, One Directing a Christian in His General Calling; Another Directing Him in His Personal Calling* (Boston, 1701), Mather expounded on the close relationship between secular prosperity and religion. In his general calling a man should, he wrote, serve the Lord Jesus Christ, whereas in his personal calling he should find "a certain Particular Employment by which his Usefulness in his neighborhood is distinguished."[11] A Christian, Mather declared, is like a man in a boat with two oars, rowing for heaven: if he pulls on only one oar, he gets nowhere; a person must exercise both general and personal callings if he is to make his way to heaven. Furthermore, "A Christian should be able to give this Account, That he hath an Occupation . . . so he may Glorify God, by doing Good for others, and getting of Good for himself. . . . 'Tis not Honest, not Christian, that a Christian should have no Business to do."[12] Mather cites scriptural authority, which instructs men to "seek for themselves a comfortable Subsistence. How? But in the way of some good Occupation."[13] He paraphrases the words of Calvin and William Perkins when he writes that even a hardworking, pious shoemaker may have a higher seat in heaven than a devout hermit: "A poor man, that minds the Business of his Calling and weaves a Thread of Holiness into all his Business, may arrive to some of the highest Glories in Heaven."[14] In the following passage, in which he again unites secular labor with piety, Mather states one of the fundamental principles later expressed by Benjamin Franklin, and he is thus seen as a link in the chain between Calvin and Perkins before him, and the great secularizer of colonial American religious thought after him: ". . . when you follow your Business, have you Dependence upon God for the succeeding of it. . . . Oh, Don't imagine that your Hands will be sufficient for you, without the Help of God. And with the Help of God, never fear, but your Hands will be sufficient for you."[15]

The refrains in praise of industry and against idleness are again heard as Mather declares that a Christian must "follow his Occupation with Industry" and that idleness is a sin at any level of society:

> There are Gentlemen, 'tis true, who Live upon their Means. . . . But yet it well becomes the best Gentlemen, to study some way of being serviceable to the World, and Employ themselves in some good Business. . . . Idle Gentlemen have done as much Hurt in the World as Idle Beggars. And . . . any Honest Mechanicks really are more Honorable than Idle and Useless men of Honour.[16]

Men who have no calling will surely fall into sin, and to those who "neglect their Occupation," Mather issues a stern warning: "Thou Wicked and slothful Person, Reform thy Ways, or thou art not far from Outer Darkness. Is it nothing to thee, that by much Slothfulness, thy Money & Credit, and all is Decaying, and by the Idleness of thy Hands, thy House [estate] is coming to nothing."[17] From all of this a code emerges: Be pious, industrious, frugal, honest, and sober, and avoid being slothful and impious; the person who lives by this code will please God and will prosper. The code defines the very

characteristics that become visible in the portraits of the transitional period, and such visualization intensifies in later years, culminating in the portraits by Copley and Peale.

Cotton Mather was not the only one to advocate the union of industry and piety. For example, the Reverend Samuel Whitman, in his *Practical Godliness, The Way to Prosperity* (1714), developed the idea of "Practical Religion." He commences with the observation that the purpose of many of Solomon's wise sayings "is to represent Religion as a friend to the Temporal interests of Mankind."[18] Religion was not, he declared, the opponent of secular prosperity, but rather its foundation: "While a People Walk with god, and are careful to Uphold Religion in its Power and Purity, they are under Promises of Outward Prosperity."[19] Practical religion, by which he means that religion practiced by men and women in their daily lives and occupations, "contributes very much to the Prosperity of a People," and furthermore, "The way to the Paradise of Temporal Prosperity, lieth thro' the Temple of Vertue. When there is much of Practical Religion among a people, God usually maketh them to Prosper in all that they set their hands to. . . . Practical Religion lifts a People high, into the Affections of the Almighty."[20] Like Mather and other ministers, however, Whitman also cautioned against coveting too much of the things of this world, which would be "Spiritual Adultery and Idolatry."[21] Again, the concept of moderation imposes a limit on just how prosperous a people should hope to become, but the idea of worldly prosperity itself is never challenged.

Cotton Mather accepted and promoted the Calvinist theory of God's blessing upon the industrious, pious person, and this concept became so ingrained in the minds of colonial New Englanders that it was bound to show up in their portraits. In his *Bonifacius* of 1710, Mather addressed in particular those who have prospered:

> Sirs, you cannot but acknowledge, that it is the Sovereign God, who has bestowed upon you, the riches which distinguish you. A devil himself, when he saw a rich man, could not but make the acknowledgment unto God in Heaven, "Thou hast blessed the work of his hands, and his substance is increased in the land.[22]

Whitney Griswold has pointed out that it was a comfort to businessmen "to hear their occupations sanctified," and, further, that we should not be surprised "to find Puritan merchants mentioning God prominently in their invoices – thanking him for profit gained."[23] Mather's words establish a continuity, extended into the transitional period, of the concept of God as a silent partner in one's business affairs, for we have already noted it, in Chapter 1, in connection with some of the earliest merchants of New England.

If Cotton Mather praised industry as one's secular calling and declared that God would bless the diligent with prosperity, he was also distressed by what he felt was an inordinate concern with worldly affluence. As far as the laity were concerned, however, the good minister's position was undermined by the theological doctrine of prosperity, the validity of which rested on no less an authority than John Calvin. The seeds first sown by Calvinist sanctioning of secular prosperity produced richer harvests with each succeeding generation. Colonial merchants, simply by following Mather's (and Calvin's) advice, had

grown wealthy, and they were unwilling to reverse a path that was leading them pell-mell into prosperity. In the end, however, Mather only wanted to keep his flock godly, and it was never his intention to dissuade his followers from an earnest pursuit of their secular callings. Even under Cotton Mather's tenure, Congregationalist Protestantism remained a religion that encouraged material prosperity, and that prosperity, as it appeared in colonial portraits, was emblematic of dedication to both religious and secular callings.

The tug-of-war between the minister and his parishioners was, in reality, over the matter of where to draw the line separating acceptable prosperity from unacceptable vanity and ostentation. The more the colonists gained of the world's goods and comforts, the higher they wished the upper limit drawn; but from their point of view they remained devout in the religion of their fathers. They were perfectly happy in their partnership with God, and in general they continued to credit him for their success in business ventures. In this tug-of-war the colonial merchant emerged the winner, not by any religious rebellion or coup, but by a constant pressure that forced continual elevation of the imaginary line of transgression.

Indeed, even the ministers participated in the joys of colonial prosperity. Not only did the affluent laity of Boston live in fine houses of high-style design, the clergy often did so as well. Cotton Mather's house on Hanover Street in Boston rivaled those of wealthy merchants such as Peter Faneuil, Edward Bromfield, and John Mico. Moreover, the image of Cotton Mather is preserved for posterity in a style then popular in fashionable circles in London (Fig. 70). Peter Pelham's mezzotint (1728) of the jovial, corpulent, bewigged minister reveals that insofar as portraiture was concerned, the culture gap between the high style of England and the *retardataire* style of the seventeenth-century founders had been essentially eliminated. In the portrait Mather is represented in the same style used to portray elegant society in England.

During the transitional decades New England portraiture changes from the Elizabethan–Jacobean survival style to a middle-class adaptation of the fashionable, refined early Georgian mode that, although not as lavish as the style of aristocratic portraits, is nevertheless of that same general manner. Whereas as late as the 1670s, two distinct styles existed for the portrayal of Englishmen (colonial or otherwise), by 1740 there was but a single style, which served both the aristocracy in its highest form and the wealthy upper middle class in a tempered form. For example, John Smibert employed basically the same style whether painting the peerage of London or the merchants of Boston; he had only to modify the London style to meet the tastes of his New England clientele. The situation is similar in architecture, where the medieval-survival-style house of the Boston merchant of the 1670s was replaced by the more elegant early Georgian design with its classical influences.

All of this suggests a much more unified society of Englishmen, in which the middle class adopted more and more of the ways of the aristocracy. The transformation was not superficial, in other words, not just a matter of appropriating an aristocratic style in painting or architecture that was otherwise

outside the context of middle-class life. The colonists themselves changed, and the changes seen in their art are the results of the forces that brought about the transformation.

The signs of change were continual and, especially in the towns along the seaboard, everywhere to be seen. In addition to the increased wealth of the merchant class, other forces were at work to encourage those changes. When a Stuart king was reinstated on the English throne in 1660 in the person of Charles II (Fig. 9), the structure of governance for Englishmen around the world shifted from one of Puritan Commonwealth to grand monarchy. Although Massachusetts had enjoyed virtual autonomy under the charter granted by Charles I, after the Restoration change was often forced on its citizens by royal decree. For example, the charter of 1629 had given the Congregational Church enormous power over the temporal lives of all the colonists, whether or not they were members of it; that church even had the power, through the General Court, to involve itself in secular matters, and that is how the Puritan oligarchy was able to survive as long as it did. The greatest changes did not fall upon New England until the 1680s; before that time Charles generally ignored the colonies, even when their actions displeased him, for it was difficult to enforce his will across a three-thousand-mile span of ocean. In Massachusetts, anyone belonging to the Church of England was excluded from participation in government; New Englanders in general avoided the trade restrictions, taxes, and customs laws of the Navigation Acts as much as possible; they began coining their own silver currency – the pine tree shilling – and they harbored the men who murdered the king's father, Charles I. All of this, reported back to Charles II in 1676 by his agent Edward Randolph or by disenfranchised Anglican colonists, greatly displeased the king.

Charles informed the people of Massachusetts that if they did not accept his authority, his laws, and his decrees, he would revoke their charter. When they chose to fight this maneuver in court, the king merely nullified the charter by fiat in June 1684, and thereafter Massachusetts became a royal colony with a governor appointed by the king instead of elected by the people. To many in the Bay Colony the situation worsened the next year with the death of Charles II and the ascension of James II, who was known to have strong sympathies with the Catholic church, mainly through his queen, Mary of Modena. James appointed Edmund Andros, formerly governor of New York, to become the first royal governor of Massachusetts, and he arrived on December 20, 1686 (Fig. 92). Accompanied by his naval officers and sixty soldiers, the governor disembarked, as Samuel Sewall noted in his diary, wearing "a Scarlet Coat, laced; several others [in his party also] were in Scarlet."[24]

Since the Restoration, King Charles's court had provided a role model in fashions, manners, architecture, cultivation of the arts, and so on, and at this point in history the upward-bound middle class was far more receptive to court leadership than it had been before the Commonwealth. The royal governor with his scarlet-clad officers and other members of his entourage represented an extension of the court itself, and thereby introduced into New England an elegant and fashionable new element. This, of course, would have significant ramifications for economic and religious matters, for the style of life, and for portraiture. Although the old guard bewailed Andros's arrival,

many others of the colony rejoiced as they saw the control of the Puritan oligarchy destroyed. But Andros's administration was as unpopular as it was short-lived; when news arrived in 1689 of the landing of William of Orange in England and of the fall of James II, Andros was overthrown and sent home.

The precedent of a royal governor, however, had been established. When Increase Mather went to London to obtain a new charter, he found King William sympathetic, but unwavering on two points: a royal governor must be appointed and the Church of England must be tolerated. After Mather's return in 1692, bearing the new charter, New England's way of life began to change rapidly. The resident royal governor provided a role model that fascinated merchants who were becoming wealthy, and his little court offered them something to emulate that was very different from the role model offered by the old Puritan oligarchy. A rise in life-style was generally facilitated because that life-style no longer required the approval of the Congregationalist old guard. An atmosphere arose that was more conducive to the growth of the refinements of life and that ultimately effected the way a people were depicted in their portraits.

Another contributing factor in the transition from seventeenth-century restraint to eighteenth-century elegance was the emergence of the Anglican church in New England. With the restoration of the monarchy it was inevitable that the Crown would press for establishment of the Church of England in British colonies, and New England was no exception. When the royal agent Edward Randolph returned from London in 1686, he brought with him the Anglican priest Robert Ratcliffe.[25] Randolph forced the Congregationalists to permit Ratcliffe to hold services (the first on June 15, 1686) in their own meetinghouse (Old South), a situation as unsavory to Congregationalists as it was inadequate for Ratcliffe's services. Soon after Governor Andros arrived, he ordered the building of an Anglican church in Boston. Its name, King's Chapel, left little doubt that its presence there was at the pleasure of the king and his Anglican subjects. Samuel Sewall confided his indignation to his diary when Andros demanded contributions from Congregationalists for building an Anglican church,[26] but built it was, in 1688–89, to accommodate the four hundred or so Episcopalians who lived in Boston.

The resentment felt by the Congregationalist majority ran deep and was long-lasting. An example of anti-Episcopalian literature, published in Boston in 1725, is a pamphlet titled *A Brief Account of the Revenues, Pomp and State of the Bishops, and other Clergy of the Church of England,* which contains an unmasked accusation that an increase in devotion to worldly pleasures is directly connected with the presence of the Episcopal church in New England. In addition, it expresses veiled concern over an increasing defection from Congregationalism:

> How apt are people, upon any little Disgust, to leave our Side and go over to the Contrary! How many do act as Men-pleasers, adapting themselves to the Humor of some Companion or Superior! Are not many carried away by a Spirit of Licentiousness, and Profaneness, because they dislike our grave Worship, our searching and faithful Sermons, our pure Administration and Discipline. And are there not

many others, led by a Worldly Principle, Lovers of their own Selves, Covetous![27]

The author contrasts the simple organization, administration, and service of the Congregationalist church with the complexity, hierarchical system, and pomp of the Anglican, and then he hits them where it is apt to hurt the most, in their pocketbooks; he lists the vast numbers that will be on the Episcopal payroll – archbishops, bishops, deans, priests, chancellors, clerks, registers, proctors, and other officers who will "squeeze out of the poor people" at least £450,000 per year.[28]

The sight of a surpliced priest leading a congregation in the reading of the detested Book of Common Prayer, or conducting the Sacraments, or of a congregation kneeling before an altar, all within the fine new King's Chapel, was bitter gall to many of the Congregationalists. What is more, there would soon be Baptist and Quaker meetinghouses in Boston as well. That which the older and more conservative members of New England society had originally left England to escape was now being forced on them. The signs of change were inescapable, and the change itself was irreversible.

Part of the appeal of the Church of England was that if Congregationalism drew the line of acceptable indulgence in the enjoyment of worldly things at one level, Anglicanism drew it at a level appreciably higher. To be sure, many Englishmen of the middle and lower class belonged to the Episcopal church, but Anglicanism, as the religion of the monarchy and much of the nobility, had never saddled itself with the restraints that the nonconformist sects had imposed upon themselves, or at least not to the same degree. It tended to accept the often extravagant life-style of the aristocracy, chastising it only when it became outrageously excessive, and, in fact, it indulged in a pomp and ceremony that at times rivaled aristocratic display. Condoning such things in its own affairs and in courtly circles, it did the same for the upwardly mobile middle class. Thus, many prospering New England families of the emerging mercantile aristocracy found Episcopalianism more to their liking than the entrenched Congregationalism of their forefathers. As Anglicans increased in number and became more active in the affairs of the colony, they contributed to a greater awareness of high style in many aspects of life, including the arts of architecture and painting. Anglicanism therefore became a force for the rise of a more liberal and refined taste than that which existed previously in New England.

During the transitional period the middle class itself was undergoing transformation in its life-style, and nowhere is this more apparent than in the design and concept of the home. Whereas generations of London shopkeepers had been content with family quarters in a few rooms above the shop, their descendants now built fine houses away from the business, Bloomsbury being a favored area.[29] Eventually some rich merchants even bought freeholds in the country, and if there was not a fine house already standing there, they built one. They rejected the neomedieval, Elizabethan–Jacobean architectural style of their forefathers and erected structures that were modest adaptations of the current baroque, Palladian, and early Georgian designs – inspired by the works of Wren, Gibbs, and others – espoused by the aristocracy. Similarly, the New

England merchant established an architectural environment for himself and his family that reflected a change of taste in the direction of Georgian refinement. The no longer extant Foster–Hutchinson House, built in Boston in 1688, was already of a proto-Georgian style, with a symmetrical design and classical adornments; among existing buildings the McPhedris–Warner House in Portsmouth, New Hampshire, of 1718–23, is an excellent example of the change from the simplicity and, by comparison, austerity of most seventeenth-century New England houses to a modest version of the more elegant Georgian design.[30] The interiors of houses erected in the new style expressed a similar passion for refinement and comfort as well as a taste for the style currently in vogue with the aristocracy.

In England, the confluence of the two levels of society is equally apparent in the marriages arranged between them. One of the shortest roads to an elevated social status was via the marriage of a merchant's daughter to a nobleman, for there was often at hand such a man who stood in need of a handsome dowry. Moreover, the union could assure the progeny of being landed proprietors and could be the first step in bringing the family into a noble, titled line. Although this seldom occurred in New England because resident nobility were rare, it did establish in the homeland a precedent that permitted the middle class to dream of ascending still higher in the social order. By and large, however, the middle class moved up the social ladder cautiously, maintaining their place in the well-defined English structure of the classes. Even as they copied the mannerisms and fashions of the peerage, they retained many of the ancient ways, mores, and values of their class.

The moral code of the new upper middle class, which was still compatible with the virtues prescribed by John Calvin, is set forth in George Lillo's popular play *The London Merchant*, which first appeared on the stage in Drury Lane in 1731, ran through seven printed editions in the decade that followed, and was staged ninety-six times before 1747. It was also performed at Williamsburg, Virginia, in 1752 and two years later in Philadelphia and Charleston, South Carolina. Theophilus Cibber declared in 1753 that the play was "judged a proper entertainment for the apprentices, etc., as being a more instructive, moral, and cautionary drama" than most other plays that had "little but farce and ribaldry to recommend them."[31] Indeed, here was literature that took as its primary theme not the heroic events in the lives of kings and princes, but the values of merchant folk. In literature as in so many facets of life, middle-class influence was asserting itself, calling into existence a mode of expression reflective of its own culture.

The scenario of Lillo's *The London Merchant* begins with Maria, the attractive young daughter of the kindly and wealthy merchant Thorowgood, being courted by a gentleman of aristocratic lineage – a theme just discussed; but Maria, as fate would have it, loves only her father's young apprentice, Barnwell, who is led to his doom by Miss Millwood, a fashionable "lady of pleasure." The message is clear, for Barnwell breaks almost every moral known to the middle class. The play is introduced here because of the several lines that bespeak the values that a merchant held in highest esteem and that gave him a conviction of self-worth. Implicit in the play is the message that apprentices eventually become merchants, and that above all else, merchants

must be honorable men. Trueman, another young apprentice in Thorowgood's service, says to Maria: "Few men recover reputation lost; a merchant never."[32] If Boston merchants, as painted by Feke or Copley, seem to exude honesty and integrity, it is because such things were a part of their code.

Another theme in *The London Merchant* stresses the honorableness of the merchant's place in society. "The name of merchant never degrades the gentleman," Thorowgood pronounced to Trueman.[33] We learn from Lillo's play that a merchant has every right to hold his head high because of the role he might play in national and even international affairs where the very safety of his country could be at stake – and he could be effective in a way that even princes could not be. The play is set in Elizabethan times, and Thorowgood has been instrumental in preventing the king of Spain from securing a loan from Venice for the building of the Armada, which was to sail against a vulnerable England. He instructs Trueman:

> . . . you may learn how honest merchants, as such, may sometimes contribute to the safety of their country as they do at all times to its happiness; that if hereafter you should be tempted to any action that has the appearance of vice or meanness in it, upon reflecting upon the dignity of your profession, you may with honest scorn reject whatever is unworthy of it.[34]

The dignity of an honest merchant and his importance to his community and nation are explicit here, just as they are masterfully woven into the character studies of many early New England portraits in which mercantile honor and self-esteem are evident.

Lillo's play makes several points that are quite significant in understanding the societal changes that occurred between 1680 and 1740, for the metamorphosis greatly affected the art of that period. First, the middle-class merchant rose to such prominence in English society that his code and his problems could become the theme of a very successful play. Second, the merchant became a political force and effective agent in national and international affairs – thus establishing his credentials as something other than a lower-class moneygrubber and giving him cause to take pride in his rank in the social strata. Third, the merchant could become an honorable man if he lived circumspectly according to the well-defined moral code of his own class. All in all, a well-to-do merchant could have a rather good life: He could become a man of wealth and property; he could merge his family line through marriage into an aristocratic line; his wealth and connections provided a power base for influencing events; and, philosophically viewed, his profession offered the means for "promoting arts, industry, peace and plenty."[35] If a Boston, New York, or Philadelphia merchant looks self-confident, prosperous, and moderately proud of the life he made for himself and his family in portraits by Feke, Copley, Peale, and others, one can certainly understand why.

In the years between 1680 and 1740 the merchant class in England and New England reached an elevated and honorable level of society and often attained a life-style emulating that of nobility; as this happened, middle-class preferences in styles of art were greatly affected. Men and women of the merchant class wanted their likenesses to be portrayed in the contemporary high style (or at

least in a modest version of it) because that style better expressed the image they had of themselves and their place in society than did the old, *retardataire* Elizabethan–Jacobean survival style. The artistic revolution that occurred may be seen by comparing the portrait of Mrs. Freake with John Smibert's picture of Mrs. Francis Brinley (Figs. 11 and 80). In the portraits of the transitional period there was but one style, for it was no longer necessary to have separate styles to accommodate the tastes of the aristocracy and the middle class. But although the upper middle class imitated the English aristocracy, it did so only up to a point, for it still respected the line that was drawn between them. For the purposes of analyzing the portraits, it is important to realize that even as the upwardly bound middle class approached the level of aristocracy in its life-style, it usually stopped well short of total emulation. The prosperous merchant and his family had, after all, grown up with their own set of rules, which were usually traceable to the secular virtues of industry, frugality, sobriety, moderation, and so on – the very virtues that Calvinism advocated. Thus, as merchants became rich and richer still, they nevertheless respected the upper limit self-imposed by their class.

At that fairly high level on the social scale but short of aristocratic status, a wealthy mercantile class stopped and formed its own character. It was exactly this proud, self-composed, self-confident, self-made, and occasionally self-conscious personality, this prosperous, materialistic, yet pious personality, that Feke, Copley, and others would attempt to capture in their portraits. More-over, it was during the transitional period that the materialistic propensities, the Calvinist and Anglican religious convictions, the elevated social position, and the aristocratic portrait style were first united to create the consummate image of middle-class mercantile aristocracy in colonial New England.

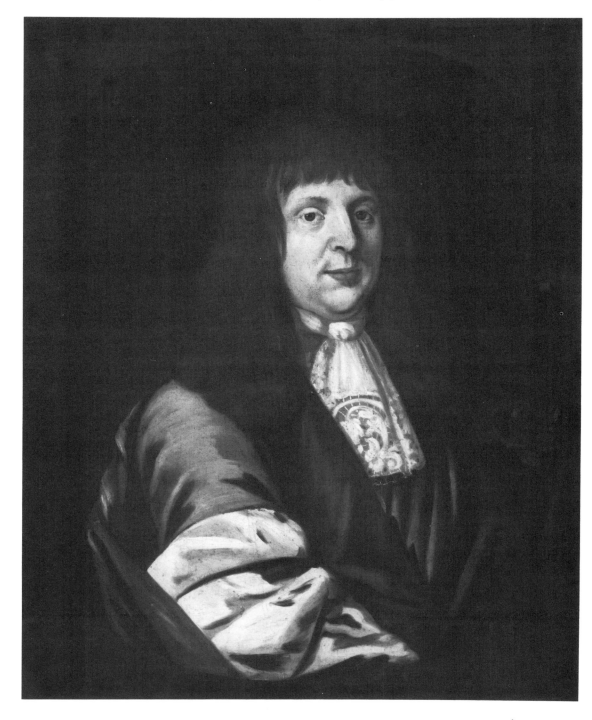

Figure 44. *Samuel Shrimpton*, artist unknown, c. 1675. Oil on canvas, 30 × 25 inches. Massachusetts Historical Society, Boston.

The Transition in
New England, to 1720

'Tis Now the Time for New England to Dance

Samuel Shrimpton (1643–1703) offers an excellent case study for the transition occurring in New England from the rule of the Puritan oligarchy to the dominance of the merchant, and his portrait presents a visual testimony to the changing order of things (Fig. 44). Henry Shrimpton, Samuel's father, was a brazier from London who had immigrated with his wife, Elinor, to Boston in 1639; he had prospered as a tradesman, and when he died in 1666 he left a large fortune of nearly twelve thousand pounds, most of it to his son. Samuel soon became the wealthiest man in New England, thus demonstrating the potential for upward mobility by the second generation. Not long after his father's death Samuel was in England on business, possibly in connection with his uncle's firm, "Edward Shrimpton and Company," a major exporter of goods to New England; there he married Elizabeth Roberts Breeden, widowed daughter of the London merchant Nicholas Roberts, whose family portraits were discussed in Chapter 4. The newly married couple returned about 1670 to Boston, where they became primary figures in the emerging mercantile society that was as much interested in prospering and establishing a refined life-style as it was in the religion of the founders – indeed, it seems, more so.

Shrimpton, who had mercantile and shipping interests, was one of the largest landowners of the Boston area. He acquired property in Chelsea, Dorchester, and Brookline, was the proprietor of Deer Island and Noddles Island, and in 1673 purchased Beacon Hill. His house on Noddles Island (now East Boston) was one of the finest of the day: "Mr. Shrimpton has a very stately house, with a brass kettle atop, to show his father [he] was not ashamed" of his origins.[1] Shrimpton, who paid the highest taxes in Boston in the 1680s,[2] lived a life very different from that of Samuel Sewall, who often made note of the merchant's activities in his famous diary. Sewall once noted in the diary that Shrimpton and several of his crowd had

> come in a Coach from Roxbury about 9. aclock or past, singing as they come, being inflamed with Drink: At Justice Morgan's they stop and drink Healths, curse, swear, talk profanely and baudily to the great disturbance of the Town and grief of good people. Such high-handed wickedness has hardly been heard of before in Boston.[3]

Shrimpton and Sewall were often on opposite sides, for the former was de-
termined to challenge the old guard in order to institute the refinements of
life. Under the dates of November 12 and December 17, 1685, Sewall made
note of the controversy then raging over the introduction into Boston of those
evils, mixed dancing and the theater:

> ... the ministers of this Town Come to the Court and Complain
> against a Dancing Master who seeks to set up here and there and hath
> mixt Dances; and 'tis reported he should say that by one Play he could
> teach more Divinity than Mr. [Samuel] Willard or the Old Testament.
> Mr. Moodey said 'twas not a time for N[ew] E[ngland] to dance. Mr.
> Mather struck at the Root, speaking against mixt Dances. ... Mr.
> [Francis] Stepney, the Dancing Master, desired a Jury, so He and Mr.
> Shrimpton Bound in 50 £ to January Court.[4]

The conservative Sewall and the liberal Shrimpton were clearly of two different
factions in Boston society. In May 1696, when Shrimpton's son, Samuel, Jr.,
was married to his cousin, Sewall recorded in his diary the affront he felt:

> Col. Shrimpton marries his Son to his wive's Sister's daughter, Eliza-
> beth Richardson. All of the Council in Town were invited to the
> Wedding, and many others. Only I was not spoken to ... so it grieves
> me to be taken up in the Lips of Talkers, ... if any should happen to
> say, Why was not such a one here?[5]

The wedding of the only son of the richest man in town was a major social
event, and such an occasion offered the leading mercantile families an oppor-
tunity to engage in as elegant a social display as was possible in late-seven-
teenth-century Boston. In doing so, they often exceeded the limits prescribed
by the old guard that was led by the Congregational ministers and old-timers
like Sewall. But in spite of censure from those quarters, they asserted their own
considerable power and determined their own style of living. In effect, they
were redirecting the course of colonial New England society and culture.

Shrimpton was also exemplary of the opposition rising against the old
oligarchy in his acceptance of the royal authority that was newly imposed on
the colony in 1686 and in his acceptance of the presence of the Anglican church,
also newly imposed by royal decree. The first wedding performed by an
Episcopal priest in New England took place in Shrimpton's house, for before
1686 the Anglicans had not been permitted to build a church of their own.
Shrimpton was the very personification of the wealthy, prospering merchant
who had established himself at the head of the social order, and saw himself
as an English gentleman:

> He scorned the Puritan movement. ... He welcomed the arrival of
> [Edward] Randolph [the king's representative]. ... By the end of the
> Dominion period he had become one of the leaders of what might be
> called Anglican officialdom. This faction, formed around the royal
> governor and the English naval and military officers in Boston, in-
> cluded a number of merchants like Shrimpton [who], if not actually
> Anglicans ... sympathized with the Church of England.[6]

Samuel Shrimpton was close to the center of royal power in New England through his friendship with Edward Randolph and Governor Edmund Andros, the latter appointing him to the Governor's Council in 1687. So, with the governor and his retinue, the military officers attached to his mission, and the Anglican church with its liberal religion and its flair for ceremony, there was now in Boston a society that men such as Shrimpton felt was worthy of their company.

All of this has been preparatory to an analysis of the portrait of Samuel Shrimpton (Fig. 44), of about 1675. If we compare the *Shrimpton* with the *John Freake* or the *Edward Rawson* (Figs. 10 and 27), the difference in the styles is obvious. The *Shrimpton* represents the style of the future for colonial Englishmen, whereas the latter is the style of the past. The fluid, loose brushstroke, the tactile sensuality, the feeling for corporeal form and fleshiness, the three-dimensional quality achieved by a rich play of light and shade – all distinguish the *Shrimpton* from the Elizabethan–Jacobean survival style championed for nationalistic and societal reasons by the middle class and much of the country gentry throughout most of the seventeenth century. But, in England and New England, the old style died out about 1675–80, and we now see the portraits of the Freakes not only as the apogee of that style in colonial America but also as its swan song. The contrast is equally dramatic if we compare the *Nicholas Roberts* (Fig. 20) and the *Samuel Shrimpton*. Roberts, a prosperous London merchant and Shrimpton's father-in-law, had his and his family's portraits painted in the old style; but Samuel Shrimpton went to a painter in London who worked in a very different style, one that was of the current mode at court and among the nobility. He undoubtedly saw himself as a different social creature – that is, different from his father-in-law – and he wished his painted likeness to bespeak the transformation. The style of the *Shrimpton* is generally that which was practiced by Sir Peter Lely, who was court painter to Charles II and was patronized by the highest levels of English nobility. Although the *Shrimpton* is not as lavish as some aristocratic portraits, it nevertheless belongs to the Van Dyck, Lely, and Kneller tradition. Hereafter, a growing number of New England merchants will wish their likenesses to be perpetuated in a modest version of the elegant, refined aristocratic style. When Shrimpton placed his portrait in his fine house, all of Boston society who saw it there must have noticed its significant difference from what they and their forebears had been used to in images of their kind.

Finally, note should be taken of Shrimpton's hair and attire. His hair is his own and it is longer than that seen in the portraits of, say, John Freake or John Winthrop (Figs. 10 and 33). Although it is not quite of the Cavalier lovelock style, it suggests something beyond middle-class conservativism, more a commitment to the fashions of the nobility. Shrimpton's lace-trimmed cravat subtly reminds the viewer of his wealth and his enjoyment of fine stuffs, while the ample folds of his mantle and the elegant satin fabric of his coat reveal that he is a man of means. There is a tactile sensuousness in the garments that is not found in the clothing as rendered in portraits of the old Elizabethan–Jacobean style. The combined features indicate that a new kind of image (that is, new to New England) has been adopted to express the sentiments and ambitions of a new type of man – one who was leaving the socio-cultural patterns of the founders, in search of a higher social status and a more refined and fashionable life-style.

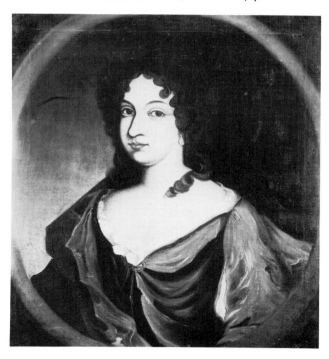

Figure 45. *Maria Catherine Smith*, possibly by Thomas Smith, c. 1690. Oil on canvas, 27½ × 25½ inches. American Antiquarian Society, Worcester, Mass.

The *Maria Catherine Smith* of about 1690 also belongs to the new artistic tradition (Fig. 45). It has been assumed that because the subject was the daughter of an artist, Thomas Smith, it was her father who painted the portrait. But a stylistic comparison of the self-portrait of *Thomas Smith* (Fig. 28) and the *Maria Catherine Smith* suggests otherwise. The former possesses a tightness of execution and a multitude of details (some meticulously delineated), whereas the latter was created with a much more fluid brushstroke and a reduction of details. The artist who painted the Smith woman had a better command of the painterly baroque tradition than did Thomas Smith. Indeed, the illusion of soft, fleshy, corporeal form, the stylishly curled hair, the tactile fabrics, and the high-fashion couture, all set within a comprehendible space, suggest an imitation of the styles of Peter Lely or Godfrey Kneller; its sensuousness distinguishes it from the desensualized, noncorporeal, nontactile images of, say, the portraits of Elizabeth Freake or Elizabeth Eggington (Figs. 11 and 22). Curls are suggested by fluid swirls of the brush, and folds in the fabric are indicated by slashing strokes, whereas in the Elizabethan–Jacobean survival style the brushwork is meticulous and virtually imperceptible. In the soft rotundity of the flesh and in the vigor expressed in the cascading curls and active drapery, we find manifestations of the Continental baroque style that passed through England on its way to the colonies. It is again evident that the style of the aristocracy is now being adopted as the style of the upper middle class. This could occur because the bipartite class-cultures of England were drawing closer together as a result of the prospering mercantile group ad-

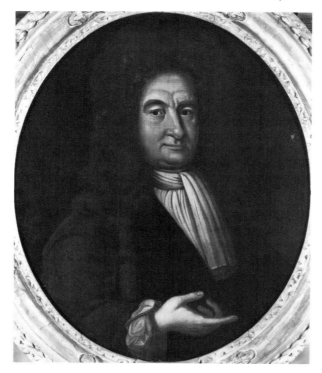

Figure 46. *Wait Still Winthrop*, artist unknown, c. 1695. Oil on canvas, 29⅞ × 25⅙ inches. Harvard University Portrait Collection, Cambridge, Mass.

vancing yet another level up the social pyramid.

Aside from painting style, the manner of dress in the *Maria Catherine Smith* further suggests that the two upper segments of English society were drawing closer together, for the low neckline and the bare shoulders indicate an acceptance of the aristocratic fashion of the day. The Smith portrait may be compared, for example, with a mezzotint taken from a portrait by Kneller, the *Countess of Ranelagh* (Fig. 63). In earlier images of New England women such exposure of the flesh would have been forbidden, and when Maria Smith's portrait was first displayed in her Boston home around 1690, it very probably shocked many who saw it because of its sauciness and obvious alliance with that higher social order which some still considered lewd and extravagant as well as of French or Italian origin and therefore associated with Catholicism. But a portion of colonial society seemed to be ever more willing to buck such censure for the sake of being "in style." As Benjamin Franklin would later write to the Reverend George Whitefield, "there are numbers [of people] that perhaps fear less the being in Hell, than out of the fashion."[7]

The portrait of Wait Still Winthrop of about 1695 also indicates the change occurring in New England life and art (Fig. 46). Wait Still (1642–1717) was the grandson of John Winthrop, Sr., the son of John Winthrop, Jr., and the brother of Fitz-John Winthrop, about all of whom a biographer of the family has noted:

John Winthrop [Sr.] was a man of the Puritan Revolution, a single-minded crusader who established a Bible commonwealth in Massachusetts and bat-

tled every sinner and wayward saint who tried to challenge his plan. . . . Fitz-John and Wait Still Winthrop were men of the Glorious Revolution, narrowly secular and parochial, . . . and always chiefly absorbed with fashion, status, and the accumulation of real estate. . . . [These later] Winthrops lived in an increasingly complex, confused, materialistic, self-seeking society. . . . The brothers displayed an acute awareness of their status as gentlemen and the necessity of living in style.[8]

Wait Still Winthrop was educated at Harvard, spent the years 1661–63 in England, and in 1670 settled in Boston where, at first, he joined no church. He became a merchant and married the daughter of a Salem merchant. After the arrival of Edward Randolph and Sir Edmund Andros, he tended to side with the royalist faction, serving as a member of the Governor's Council. But in the late 1680s he became a Congregationalist in good standing at Samuel Willard's South Church, a devotee of Cotton Mather, and a true man of New England, championing its rights and interests throughout the rest of his life. Even as a staunch Congregationalist, he remained a man of fashion, frequently writing to his brother about the arrival of English shoes or wigs, or of the local tailor fashioning a new suit for one of them, or of the purchase of some boots, buckles, stockings, buttons, or the like. In a letter to Fitz-John in June 1679, he mentions that he had cut off his hair and had received two wigs from England, all of which must have displeased the likes of Samuel Sewall.[9]

Winthrop wanted to perpetuate his image as a fashionable, successful man of the world, a member of New England's mercantile elite. In his portrait he wears a fashionable brown wig of great curls falling well below the shoulders, and he was probably one of the first New Englanders to do so. About his neck he wears a Steinkirk cravat, which was probably imported (the style became popular after the battle of Steinkirk of 1694, in which the new fashion in neckwear was set by French princes and officers).

The portrait – in the manner practiced in the 1690s in the London studios catering to the lesser aristocracy and the rich middle class – is a provincial version of the style of John Riley or Jonathan Richardson. Furthermore, it testifies to the presence of yet another, albeit still unidentified, portrait painter active in New England in the late seventeenth century. That such a painter was then in Boston is indicated in a letter Winthrop wrote to his brother on October 31, 1691; Wait asked Fitz-John to send him the "little picture of my grandfather," John Winthrop, Sr., for there "is one [here who] would copy it for my cousin Adam."[10] There are a few intriguing references to men in Boston who might have painted portraits about this time, such as Joseph Allen from Dublin, who in 1684 listed "limning" as among his several skills, and "Lawrence Brown, a Limner," who in 1701 requested permission to become a resident of the town; but nothing more is known of Allen or Brown.[11] The *Wait Still Winthrop* is stylistically similar to the portrait of George Jaffrey (1638–1707), a wealthy merchant of New Hampshire and member of the Governor's Council.[12]

The portrait of Sir Charles Hobby (c. 1665–1715) is stylistically quite different from the *Winthrop*, but it exhibits a similar desire by a Boston merchant to be portrayed as an English gentleman; indeed, it even suggests aristocratic aspirations (Fig. 47). Raised in Boston, the son of a merchant, Hobby prospered

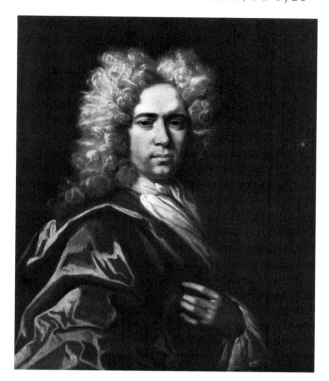

Figure 47. *Sir Charles Hobby*, artist unknown, c. 1705. Oil on canvas, 30⅛ × 25¼ inches. Boston Athenaeum.

in his own mercantile ventures and became a member of the group that was wresting dominance from the old line Congregationalists. He was in Jamaica in June 1692 when the terrible earthquake hit the West Indies, and for his acts of bravery he was knighted in 1705, when he was on a visit to England. Sir Charles and Lady Hobby belonged to the inner circle of New England society, regularly visiting or entertaining Governor Dudley, Cotton Mather, Samuel Sewall, William Dummer, Elisha Cooke, Edward Hutchinson, and the like. The Hobbys owned one large house on King Street and a "mansion" on Marlborough Street, where they were attended by half a dozen slaves, and they went about town in a handsome coach drawn by six richly harnessed horses. Sir Charles, a warden of the Anglican church, was involved in the unsuccessful plan to bring an Episcopal bishop to New England – a plan that may have strained his friendship with many Congregationalists such as Mather, Sewall, and his nephew, the Reverend Benjamin Colman (Fig. 73). Like Samuel Shrimpton, Hobby was a reveler whose life-style brought censure from the more conservative members of his community; he has been described as "a gay man, a free liver," and as being "well known as a man of fashion and a rake."[13]

The portrait of Sir Charles Hobby, which was probably painted while he was in London in 1705, was executed in a style that approximated Sir Peter Lely's in its richness, its painterly brushwork, its sensuousness and tactile qualities, as well as in the aristocratic bearing of the subject.[14] From the facts that can be gleaned about Hobby's biography, it meshes well with the life-

style the man sought to create for himself. Sir Charles wears a great white wig of curled hair that must have scandalized his friend Samuel Sewall, who never relented in denouncing the periwig. The diarist's disgust over the matter is seen when, in June 1701, he heard that Josiah, the son of his own minister, the Reverend Samuel Willard, had cut off his hair and had worn a wig to a church meeting; Judge Sewall visited the young man and lectured him sternly on the evil he had taken upon himself. To demonstrate his displeasure publicly, he snubbed the Reverend Willard by attending the services at the church of the Reverend Benjamin Colman. Among Sewall's papers was a tract written by his friend the Reverend Nicholas Noyes of Salem, titled "Nicholas Noyes on Wigs. Reasons against Wearing of Perriwiggs; especially against Mens wearing of Perriwiggs made of Womens hair, as the custom now is, deduced from Scripture and Reason."[15] Although Sir Charles's clothing in his portrait suggests a dedication to a fine life-style, the wig is the item that identifies the subject with the liberal element in his community, and it is worth noting that he was a member of the governor's circle of friends and of the Anglican church, both of which condoned such stylish adornments. Hobby was making a statement about himself by the way he dressed and the way he had himself portrayed, and his image reveals that he, as a knighted gentleman-merchant, was adopting, as much as he could, the ways of English nobility.

The portraits of Elisha Cooke, Jr. (1678–1737), and his wife, Jane Middlecott Cooke (1682–1743), are similarly of the new type of image (Figs. 48 and 49). Cooke was the son of Elisha Cooke, Sr., an immigrant tailor who had prospered and, upon his death in 1715, had bequeathed to his son a large fortune. Elisha, Jr., also inherited from his father a political position that opposed royal interference in the affairs of the colony as well as a generally mercantile perspective in virtually all matters. He married Jane Middlecott in 1703, and in time the couple resided in the splendid, two-story stone proto-Georgian mansion his father had built on School Street. In this house, according to the inventory of Elisha's estate, six pictures adorned the hall while others were "in the stair"; presumably these included the portraits of Governor Leverett and several members of the Cooke family that are now at the Peabody Museum in Salem.[16] The Cookes were well connected socially: Elisha was the grandson of Governor John Leverett, Jane was the great-granddaughter of Governor Edward Winslow, and their daughter married Judge Nathaniel Saltonstall. The Cooke line was therefore interwoven with what was already emerging as the fabric of family dynasties that provided much of the social and political leadership of New England. Elisha Cooke was first elected a representative to the Assembly from Boston in 1715 and was named to the Governor's Council in 1717, but after calling Governor Shute a blockhead, he was dismissed from that body. Cooke went on to become one of the most powerful and persuasive men in Massachusetts politics and has been seen as the predecessor of James Otis and Samuel Adams in his advocacy of colonial rights.

Such was the man whose portrait was painted about 1715, probably in Boston, which shows the subject wearing a great light brown wig, its long curls trailing well down his back, and a fashionable Steinkirk cravat, the abundant folds of a red coat enveloping him. His countenance possesses a life quality and a self-confidence amid his portly features, and the image is rendered

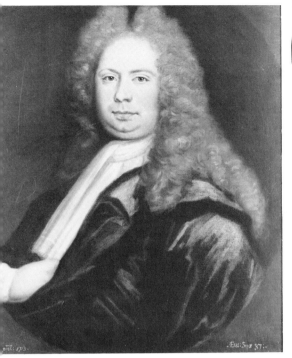

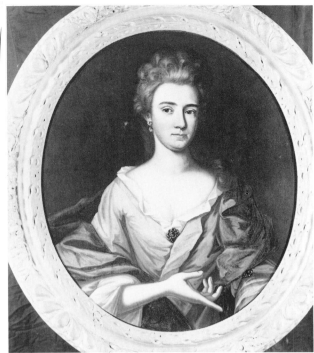

Figure 48. *Elisha Cooke, Jr.*, artist unknown, c. 1715. Oil on canvas, 29 × 24½ inches. Peabody Museum of Salem, Mass.

Figure 49. *Jane Middlecott, Mrs. Elisha Cooke, Jr.*, artist unknown, c. 1715. Oil on canvas, 28⅞ × 24 inches. Peabody Museum of Salem, Mass.

in a middle-class version of the style then being employed by Sir Godfrey Kneller in his famous Kit-Kat series of English noblemen, statesmen, and men of letters (Fig. 76). Cooke no doubt saw this style as being appropriate for the portrayal of a man who was already among the aristocracy of his community and who had entered into high civil service.

Jane Cooke, daughter of Richard Middlecott, a prosperous Boston merchant, is represented in one of the most elegant portraits painted in New England up to that time. Her image is in the manner of those of English ladies of the Queen Anne or George I era, with her hair arranged high on the head and a curl curving about her left shoulder. She wears attractive jewelry, a stylish red dress with a low-cut neckline that partially reveals her breasts, and a green cape. The portrait (c. 1715), of an even higher style than that which John Smibert introduced in the colony in the 1730s, is, like that of her husband, an English portrait, created out of a thoroughly English aesthetic. The result was a cultural dilemma for folk such as the Cookes who were already beginning to see themselves as distinct from homeland Englishmen. Before long, that distinction would cause colonial patrons and native-born painters like Feke and Copley to seek a means of portrayal that would express the colonial American character rather than impose a thoroughly English means on people who were no longer thoroughly English.

In the early eighteenth century, however, the English high style was the

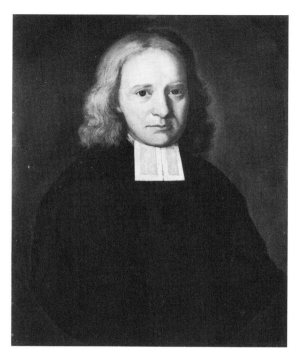

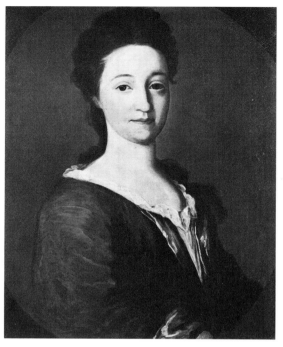

Figure 50. *The Reverend James Pierpont*, by the Pierpont Limner, 1711. Oil on canvas, 31⅛ × 24⅞ inches. Yale University Art Gallery, New Haven, Conn. Bequest of Allen Evarts Foster, B.A. 1906.

Figure 51. *Mrs. James Pierpont*, by the Pierpont Limner 1711. Oil on canvas, 31⅛ × 24⅞ inches. Yale University Art Gallery, New Haven, Conn. Bequest of Allen Evarts Foster, B.A. 1906.

only one available, and in the portraits of the Reverend James Pierpont and his wife we observe that even Congregationalist ministers and their families accepted it (Figs. 50 and 51). These portraits give their name to an artist – the Pierpont Limner – who also executed the images of Caleb Heathcote (Fig. 56), Edward Collins (Albany Institute of History and Art), and Thomas Savage (private collection).[17] The portraits of the Reverend and Mrs. Pierpont are both dated 1711 in the lower right spandrel; according to family tradition, the Pierpont Limner was active in the Boston area around 1710 to 1715 and was "an English painter of repute, then sojourning there."[18]

Although the Reverend James Pierpont (1659–1714) was distantly connected with English aristocracy, he was more closely associated with colonial merchants and tradesmen; by way of his three marriages he was related to some of the foremost churchmen of New England, and he was the great-great-great-grandfather of J. Pierpont Morgan. His grandfather was a cousin to Robert Pierrepont, first Earl of Kingston, and his father, John Pierpont, had immigrated to Massachusetts in 1640. James, who was born in Roxbury, attended Harvard College to prepare for the ministry, graduating in 1681. Three years later he was called to the First Congregational Church in New Haven, where he remained for the next thirty years, until his death. Pierpont was one of the men who founded the Collegiate School of Connecticut, which was chartered in 1701 and seventeen years later became Yale College. In 1691, Pierpont married Abigail, granddaughter of the Rev-

erend John Davenport, but she died within six months; he next wed Sarah, grand-daughter of Governor John Haynes, in 1694; her death came two years later, and in 1698 the widowed minister married Mary, daughter of the Reverend Samuel Hooker and granddaughter of the Reverend Thomas Hooker. It is Mary Hooker Pierpont who is depicted in the portrait. A daughter from this last union, Sarah, became the wife of Jonathan Edwards. In the Pierpont portraits we therefore have subjects who were tied in innumerable ways to the Congregationalist establishment of the early eighteenth century.

Whereas we have seen three merchants and a merchant's wife portrayed in the new style, we now have a clergyman and his wife represented in the sophisticated, painterly style then current in England. Reverend Pierpont's image presents the corporeal reality of the man and captures a sensitive, thoughtful expression in the face, while there is a competent if not exciting brushwork in the creation of form and the handling of light and shade. The portrait of Mary Hooker Pierpont is of a style that began at the court of Queen Anne and was then modified to suit upper-middle-class tastes. A very feminine, even sensuous, image in the general manner of the *Maria Catherine Smith* (Fig. 45), it demonstrates that even the wife of a Congregationalist minister could be portrayed in the elegant new style.

The transition from a reserved, thoroughly middle-class, outmoded style of the 1670s to one that was essentially aristocratic is completed in the portraits of William and Jeremiah Dummer, Jr. (Figs. 52 and 53). Of course, it was unusual for a New Englander to be portrayed in such a manner, which was normally reserved for pictures of dukes or princes, but for some the circumstances of their commitment to English (as opposed to colonial) culture made it appropriate. If those people saw themselves as members of a new society arising in the colonies, others cast their lot with the traditions of the homeland, and wanted to be as English as they could be, and the latter type wanted their portraits to convey their commitment to English traditions. A thoroughly English aesthetic seems fitting in the portraits of William Dummer and Jeremiah Dummer, Jr. They were sons of the well-known Boston silversmith Jeremiah Dummer, Sr., and one became in effect a royal governor and the other lived in England almost all of his adult life, circumstances that account for the way they had themselves portrayed.

William Dummer (1677–1761) married the daughter of Governor Joseph Dudley and entered a political career. He was appointed lieutenant governor in 1716 on the arrival of Governor Samuel Shute and was twice acting governor, in 1723–28 and again in 1729–30. He served his king and England loyally and saw himself more as an extension of the English establishment than as a champion of the colonists' interests. The pure Englishness and aristocratic quality of his portrait are therefore understandable. William's brother, Jeremiah (1679–1739), was equally attached to England. After graduating from Harvard College in 1699, he went to Holland, where he earned a doctorate of philosophy at the University of Utrecht; he returned to Boston briefly, but then settled permanently in London. There he first became involved in politics centered at the court of Queen Anne before turning to business affairs as the agent for the colonies of Massachusetts and Connecticut. Prospering in this service, he became a "man of fashion" about London, circulating in high and influential circles. Although he attended to the interests of the colonists, he was

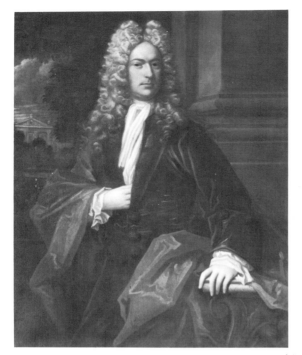

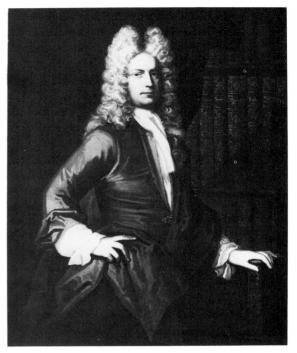

Figure 52. *William Dummer*, by an unknown English artist, c. 1716. Oil on canvas, 50¼ × 41 inches. Essex Institute, Salem, Mass.

Figure 53. *Jeremiah Dummer, Jr.*, by an unknown English artist, 1710–20. Oil on canvas, 50¼ × 41 inches. Yale University Art Gallery, New Haven, Conn.

nevertheless drawn into the political and mercantile power structure of England, which viewed the purposes of a colony differently than did most of the colonists themselves. Jeremiah Dummer is perhaps best remembered as the man who directed the interest of a wealthy Englishman, Eli Yale, toward the new school then being established in Connecticut under the supervision of the Reverend James Pierpont, which soon became known as Yale College. Dummer himself arranged for nearly a thousand books to be collected in England and sent over to form the basis of the school's library. Dummer was himself interested in books and learning, which explains the presence of numerous handsomely bound volumes in his portrait.

The portrait (1710–20) of Jeremiah Dummer was painted in England, and it is not known if it was in New England in the colonial period. It is in the aristocratic tradition of John Kerseboom (d. 1708) or of Sir Godfrey Kneller. Comparison of the *Jeremiah Dummer* with a mezzotint (c. 1710–20) after Kneller's portrait of Charles Mountague (Fig. 54) shows that Dummer wanted his own likeness cast in the image of English aristocracy. But if Jeremiah's portrait was perhaps never in New England in colonial times, that of his brother almost certainly was; the *William Dummer* (c. 1716) may even have been painted in Massachusetts, although it possesses a competence greater than that of any portraitist known to have been in the colony around 1716–20. It, too, is

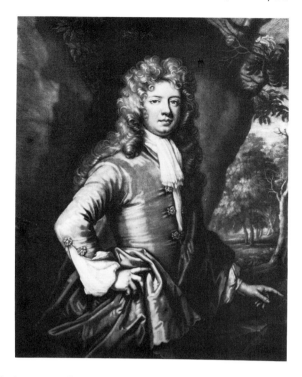

Figure 54. *Charles Mountague*, by John Smith, c. 1710–20. Mezzotint, 13¼ × 9⅞ inches. The Henry Francis du Pont Winterthur Museum, Winterthur, Del. Gift of Mrs. Waldron P. Belknap.

thoroughly English, is completely aristocratic, and betrays no provincial mannerisms. The setting is grand – so grand, in fact, that it suggests England much more than America – and the figure is represented in the same manner as in the English portrait of Jeremiah Dummer. The elaborate wigs, stylish attire, the aristocratic demeanor in the two portraits express the self-image of men who fashioned their life-styles more after the model of English nobility than after that of provincial merchants. Such portraits exerted some influence at this moment in the history of colonial American portraiture, but in the end they were too aristocratic, too purely English, for most New Englanders; their style would have to be modified to suit the taste of colonial mercantile society. Thereafter, what remained was to sort out and reject those elements foreign to the unique culture then being created, and to introduce new aesthetic elements that expressed the real American character as it evolved primarily within the mercantile sector. Feke and Copley would be the painters to accomplish this.

At this point, however, we must leave New England temporarily to study the large group of portraits painted in New York and throughout the Hudson Valley in the early eighteenth century. There, too, we will find that the aesthetic point of departure was the thoroughly English aristocratic portrait, which was made familiar by the vast numbers of imported mezzotints. But here, too, a process of selection, rejection, and modification of aesthetic components was imposed to produce a truly distinctive type of American portrait.

Portraiture in New York,
1710–1735

Mezzotints and the Hudson Valley Patroon Painters

Throughout the length of the Hudson Valley an interesting socio-cultural phenomenon developed when, following the English conquest of 1664, an English tradition was overlaid upon an already existing Dutch tradition. In the wake of that conquest came a succession of royal governors who, as representatives of the English court, served as role models for an emerging society within the valley. Also, such emigrating Englishmen as the wealthy Caleb Heathcote set a new pattern for the patroon families to follow. The patroons, seeing themselves as a special kind of aristocracy, contributed to the rise of the first real "school" of painting in the New World as they commissioned portraits of themselves in the English aristocratic image, which had been transmitted to them by the mezzotint engraving. But under their patronage the aristocratic English icon was tempered by the social and cultural forces controlling their lives, and the penchant for realism rather than idealism became an established part of the American aesthetic.

Analysis of the patroon portraits must begin with the matter of the merger of the two separate nationalistic traditions – the Dutch and the English. After all, the Dutch cultural tradition was firmly implanted and remained strong, yet the portraits are of a basically English type; how is this to be explained? On the morning of September 8, 1664, the Dutch surrendered rickety old Fort Amsterdam to the English without a shot being fired, and that quickly did New Amsterdam become New York. English governors, officers, and soldiers came immediately, followed by emigrants from England, moving in, as it were, on the Dutch in a heretofore Dutch province. One might expect a clash to have arisen out of nationalistic differences, but in fact the amalgamation proceeded smoothly.

First of all, the Dutch had not been blessed with effective governors between Peter Minuet's departure in 1631 and Peter Stuyvesant's arrival in 1647. Moreover, the directors of the Dutch West Indies Company had often imposed impediments to free enterprise and prosperity in the colony in order to assure a maximum profit for stockholders back home. And by 1664 many citizens of the colony had already begun to think of themselves first as New Amsterdamers and second as Dutchmen – so it was not the same situation as if an English occupation force had marched into Amsterdam or Rotterdam. Also, the English policy toward the Dutch was more enlightened than their colonial

policies proved to be at other times and other places throughout the empire. Indeed, it can only be described as decent, benevolent, and even generous. About all the English demanded of the Dutch was that they swear allegiance to the British Crown, and they could otherwise go about their business – which now meant, of course, participating in the British economic network that circumscribed the globe.

The English agreed not to interfere with certain things dear to the Dutch – such as the affairs of the Dutch Reformed church and the continued use of the Dutch language in schools, churches, and even some official offices and the records thereof. Also, as English immigrants arrived to join the established Dutch colonists, it was a meeting of two groups with much in common, nationalism aside, for there was no clash of basic culture or social levels. Both were middle-class and mainly Calvinistic Protestant; both groups sought prosperity, either through agrarian or mercantile channels; and both shared basic moral values. So when the English took over, the change in life-style for the Dutch was far from cataclysmic. Dutch culture was not immediately snuffed out but began to undergo a gradual Anglicization.

For Dutchmen in New York, a continuous infusion of culture from the original homeland – Holland – largely ceased, and the cultural infusion now became English. Accordingly, when the time came that colonists along the valley, from New York City to Albany, began to think about matters of art, it was to the English tradition that they had access. To be sure, in some instances – as in the making of a piece of furniture or even an occasional design of a house – Dutch forms did survive. But although pockets of Dutch culture continued to exist up and down the valley, there were no deep-seated political, religious, or economic issues that prevented the gradual acceptance of many things English. When Schuylers, Van Rensselaers, De Peysters, or whoever of the Dutch-descended patroons traveled abroad on economic, governmental, or military business, it was now to England that they normally journeyed; and there, of course, they saw portraits in the English tradition on the walls of homes and government buildings. When they returned, they might very well have brought with them any number of mezzotints taken from these portraits.

A primary agent for the introduction of English ways into the Hudson Valley was the royal governor and his little court, which established a kind of miniature elite, aristocratic society such as New Netherland had never known. Each governor of the first quarter of the eighteenth century – Edward Hyde (1702–8), Robert Hunter (1710–19), and William Burnet (1720–28) – brought with him something of the refinements of English court life, which were emulated by many of the eager and receptive colonists. Edward Hyde, Viscount Cornbury and a cousin of Queen Anne, was generally detested and was eventually recalled after being arrested for the enormous debts he incurred for his elaborate state levees; nevertheless, through those levees and other lavish displays, Hyde implanted something of the courtly life-style in the colony – a life-style bringing an elegance in manners, dress, decor, and ceremony that colonists had not known previously.

Hyde's successor, Robert Hunter, also introduced a measure of courtly ways after he arrived in 1710. An officer at Marlborough's victory at Blenheim,

Hunter rose to the rank of lieutenant colonel before being appointed lieutenant governor of Virginia; on the voyage over, in 1707, his ship was captured by the French and he was taken prisoner. While incarcerated in France he carried on a correspondence with Joseph Addison and Dean Swift, an indication of his literary interests. Hunter returned to England, in exchange for the bishop of Quebec, and in 1709 he proposed to the government to resettle in New York the large numbers of religious refugees that had arrived from the Rhineland. Appointed governor, he sailed in 1710 with the refugees, who found the Hudson Valley reminiscent of their homeland. Hunter's presence during the second decade of the eighteenth century established an ambience conducive to the rise of the arts. A handsome three-quarter-length portrait (c. 1705) of him is at the New-York Historical Society (Fig. 55). It is not known if the portrait was painted before his departure for New York, or, if it was, whether it was brought with him; but it would not have been out of the ordinary for such a picture to be hung in Government House at the southern tip of Manhattan Island as a symbol of the governor's presence and the authority of the Crown.

William Burnet, who succeeded Hunter as royal governor of New York and New Jersey, was well placed in the social order. Born at The Hague, he was the son of an Anglican bishop, and his godparents were the future King William and Queen Mary. Before his arrival in the colonies he had attended Cambridge University and had become a member of the bar. Burnet, too, served as role model to a rising pseudoaristocracy among the Dutch and English colonists. An oil portrait of him of about 1726, attributed to John Watson, hangs in the State House in Boston.

Caleb Heathcote (1666–1721), one of the most prosperous and influential leaders of the colony of New York, is an excellent case study of the new society that began to flower in the province in the early eighteenth century (Fig. 56).[1] Gilbert Heathcote, his father, was an ironmonger in the Midlands, a Roundhead soldier and a supporter of Cromwell through the Commonwealth, a mayor of Chesterfield in Scarsdale Hundred in Derbyshire, and, by the time of his death, a very wealthy merchant; of Gilbert's seven sons, the eldest, also named Gilbert, was a mercantile prince with interests in the East India Company, a governor of the Bank of England, a knight, a lord mayor of London, and at his death, reportedly the richest commoner in England. The other sons were also successful "merchant-adventurers"; the youngest of these was Caleb, who, when disappointed in love, decided to pursue his fortunes in the New World. Arriving in New York in 1692, with the inheritance he had received after his father's death, he began his mercantile investments; he was assisted by a cousin, George, a merchant whose wealth Caleb would eventually inherit.

Heathcote began his rise to wealth as a factor or agent for London traders, importing from England and elsewhere commodities that netted him enormous profits. Soon he was sending his own ventures to the Antilles, Madagascar, and the Indian Ocean. His mercantile prospects were greatly assisted when he received contracts to supply the troops in the colony with clothes, blankets, bedding, and the like, and to provide government buildings with firewood. Heathcote was diligent in and attentive to his business affairs, habits he had learned from his Puritan middle-class father and from the example of

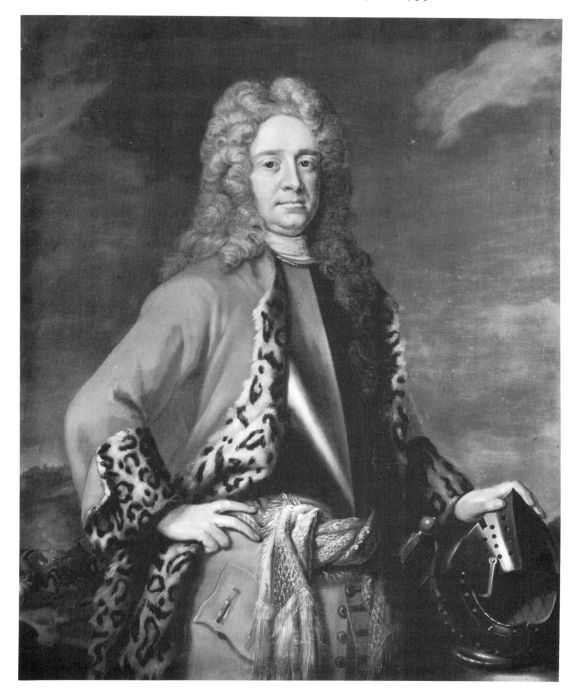

Figure 55. *Robert Hunter*, by an unknown English artist, c. 1705. Oil on canvas, 50 × 40 inches. The New-York Historical Society, New York City.

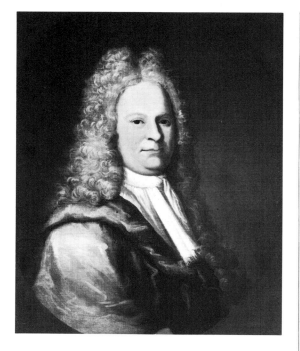

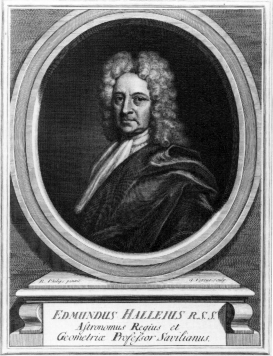

Figure 56. *Caleb Heathcote*, by the Pierpont Limner, 1710–15. Oil on canvas, 31½ × 26¼ inches. The New-York Historical Society, New York City.

Figure 57. *Edmund Halley*, by George Vertue after Richard Philips, c. 1710–20. Engraving, 7¾ × 6¼ inches. British Museum, London.

his brothers and cousins. But to such people there was something even more important than making profits, and that was owning land – the first step in moving up the social ladder from middle-class mercantilism to gentry. Caleb Heathcote acquired vast expanses of land in Ulster, Dutchess, Richmond, and Westchester counties as well as numerous properties in New York City. Being named a judge and a colonel of the militia in Westchester, he established his residence there on a twenty-square-mile tract that, in 1701, was elevated (through letters patent from King William III) to the Manor of Scarsdale. There, the "Lord of Scarsdale" built Heathcote Hill, an exceptionally fine large brick house, at a site near Mamaroneck. In 1699 he married Martha Smith, daughter of Chief Justice William "Tangiers" Smith.

As a member of the Governor's Council, Heathcote became the Honorable Caleb Heathcote, an important matter in a land where aristocratic titles were few indeed and where a title of any sort established the bearer as a rank apart from ordinary men and women. His seat on the council brought him into regular contact with such members as Pieter Schuyler, Frederick Philipse, Stephen van Cortlandt, Nicholas Bayard, and other pseudoaristocratic patroons of the Hudson Valley, as well as with the royal governors and their staffs and families. Heathcote himself at one time hoped to be appointed royal

governor of the colony but had to be content with serving as mayor of New York City, from 1711 to 1713, or at about the time his portrait was painted.

One last feature distinguished the master of Heathcote Hill, even from his own forebears, and that was his affiliation with the Church of England. His devotion to Anglicanism fits a pattern, for in addition to vast landholdings, enormous wealth, and intimacy with the royal governor and his circle, the conversion to the Church of England by this son of a Cromwellian Roundhead fulfilled yet another requisite for membership in the highest social level of the colony. Heathcote worked with Governor Fletcher to establish the Anglican church in a land where either the Dutch Reformed church or, in western Connecticut and Long Island, the Congregational church from New England held majorities; in 1696–97 he was instrumental in the founding of Trinity Parish and the building of its first church in New York City.

In Heathcote's portrait, the subject looks out at the viewer with the self-confidence, dignity, and reserve appropriate to his position. Being committed to a concept of aristocracy, Heathcote expected the artist to produce a portrait of him that was essentially in the same vogue as images of the English nobility. The result was a portrait more English than American, and in this respect it differs from the patroon portraits discussed later in this chapter. Because he is not known to have returned to England, Heathcote's likeness must have been painted in the colonies, probably around 1710. Stylistically, it is similar to the portraits of the Reverend and Mrs. James Pierpont (Figs. 50 and 51) and belongs to the general manner of high-style English portraiture of the early eighteenth century as practiced by several followers of Sir Godfrey Kneller, such as Thomas Hill, Henry Tilson, or Richard Philips. The *Heathcote* invites comparison, for example, with Philips's portrait of the astronomer Edmund Halley – painted and engraved about the same date as the New York picture (Fig. 57) – and also demonstrates the presence in New York of a gifted artist who worked in a style characterized by fluid, painterly brushstrokes, with a fine feeling for fabric, flesh, and curls of hair.

The wearing of wigs frequently inspired controversy, and note must be taken here of the great wig worn by Caleb Heathcote. Charles II introduced the wig into English society, bringing it with him when he returned from exile in France. As the upward-bound middle class came increasingly to imitate the fashions of aristocracy, nobility, and gentry, the wig gained popularity among the prospering merchants, lawyers, gentlemen farmers, and so on, and they especially liked it because, as *Chamber's Journal* pointed out, "wigs came as a broad mark to distinguish rich and poor . . . and were indeed a formidable class barrier."[2] Therefore, when Caleb Heathcote is shown wearing a large, curled white wig, it sends certain signals to the viewer, fully with his approbation: the wig affirms that he is of a social class of a high order and a man of wealth, and it associates him with an elegant life-style that ultimately traces back to the fashion-conscious royal court. In a land where class rank was less well defined than in England and other Old World countries, such symbols assumed extraordinary significance.

The style of the *Caleb Heathcote* places it in the oeuvre of the Pierpont Limner. Another, much larger group of early-eighteenth-century likenesses is that known as the "Hudson Valley patroon portraits." About a hundred por-

traits belonging to the latter "school" are known, although great problems exist in identifying and distinguishing the several artists who created them. Even when specific names of painters are known, it is difficult to assign works to them with any certainty, as in the case of Pieter Vanderlyn. After years of patient searching through account books, letters, and other records from the Hudson Valley, Mary Black made a discovery that allows us to identify Nehemiah Partridge (1683–after 1729) as the painter of a group of portraits associated with the Wendell family.[3] But otherwise, until additional documentation comes to light, we must be content with distinguishing between the works of anonymous painters who are now known only as the "Schuyler Limner," the "Gansevoort Limner," or some other such designation. Therefore, whereas Black's research has centered primarily on problems of attribution, our concern here will be with the patroon portraits as expressions of the society and culture of the Hudson Valley and with their relationships to the English mezzotint portrait.

The patroon portraits of the Hudson Valley possess the same social character that was infused into the *Caleb Heathcote*, as a comparison of the *Johannes De Peyster III* of 1718, for example, with the *Heathcote* reveals (Figs. 56 and 58). De Peyster (1694–1789) was born in New York, the eldest son of Johannes II and grandson of the Johannes De Peyster who immigrated to New Netherland from Haarlem, Holland. The subject of the portrait married Anna, daughter of Myndert Schuyler of Albany. He was thrice mayor of Albany, the paymaster of the New York regiments during the French and Indian Wars, and a judge of the surrogate court in Albany. However, his portrait, painted before he held any of these offices, indicates that even at the age of twenty-four De Peyster saw himself as a member of the elite caste of his society. His father having died in 1711, Johannes III was already, by 1718, a wealthy landowner and scion of one of the established ruling families of the Hudson Valley. It was natural that such a person should seek an aristocratic model on which to base his own image.

The *De Peyster* was taken from a mezzotint engraving (c. 1705) by John Smith that was copied from Kneller's portrait of Sir John Percivale (Fig. 59), thereby demonstrating the transmission of both an artistic style and an aristocratic image from their source in England to a colonial people whose aspirations stopped just short of actual aristocracy. Historically, this print-to-painting relationship is especially interesting because the De Peyster portrait was once owned by Waldron Phoenix Belknap, whose discovery of the picture's relationship to Smith's engraving of Sir John Percivale first launched him into his pioneering research on the influence of English mezzotints on colonial American paintings.[4] In the portrait, Johannes De Peyster III mimics an aristocratic pose and demeanor, and he wears a handsome russet velvet coat and an enormous wig, now an established symbol of high position. The main purpose of the voluminous blue swag of drapery across his right shoulder and waist seems to be nothing more than a symbol of affluence, as is often found in baroque portraits; the swag, too, is taken from the mezzotint of Sir John Percivale.

The "aristocraticization" of the great New York landowners and merchants is further reflected in the portraits of Joseph and Mary (Greenoak) Hallett of

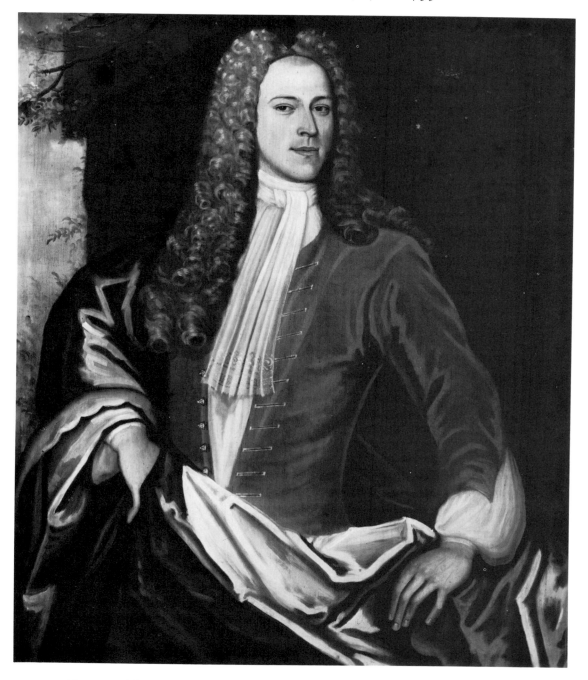

Figure 58. *Johannes De Peyster*, by the Schuyler Limner, 1718. Oil on bed ticking, 44 × 38¼ inches. The New-York Historical Society, New York City.

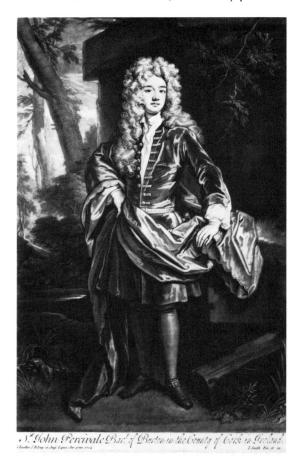

Figure 59. *Sir John Percivale*, by John Smith, c. 1705, after Sir Godfrey Kneller, 1704. Mezzotint, 16⅞ × 10⅝ inches. The Henry Francis du Pont Winterthur Museum, Winterthur, Del. Gift of Mrs. Waldorn P. Belknap.

about 1728 (Figs. 60 and 62). Hallett's English-born father, William, held a large patent of land in Queens County on Long Island, and Joseph's interests additionally included shipping and mercantile activities. The Hallett portraits show that prominent, English-descended families in New York wished to have their portraits based on specific images of homeland nobility, for the likeness of Joseph Hallett is taken from John Smith's mezzotint (c. 1705) after Kneller's *John Cecil, Earl of Exeter* (Fig. 61), while that of his wife is based on Smith's mezzotint (1715–25) of Kneller's *Countess of Ranelagh* (Figs. 62 and 63).[5] The *Joseph Hallett* follows its mezzotint prototype in almost every line, gesture, and fold, the only modification being the view out the window, where Cecil's garden is replaced by a reference to Hallett's shipping interests. Similarly, the *Mrs. Joseph Hallett* closely imitates the artistic language of the *Countess of Ranelagh*, but it is toned down to suit the subaristocratic social pattern and taste of colonial New York society. The ubiquitous mezzotint portraits of English aristocracy were imported by the hundreds into the colonies beginning

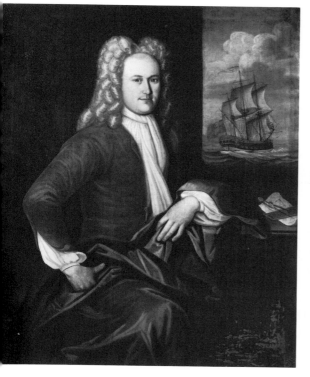

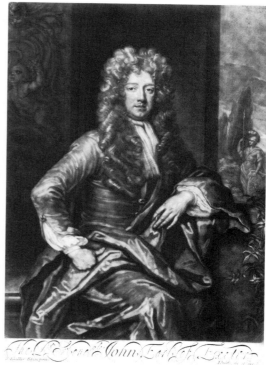

Figure 60. *Joseph Hallett*, artist unknown, c. 1728. Oil on canvas, 49½ × 40¼ inches. The New-York Historical Society, New York City.

Figure 61. *John Cecil, Earl of Exeter*, by John Smith, c. 1705, after Sir Godfrey Kneller, 1704. Mezzotint, 13¾ × 9½ inches. British Museum, London.

early in the eighteenth century, and much of what colonists of that period knew about art came primarily through mezzotints like the ones illustrated here. In a land with neither art schools nor great painting collections, the mezzotints were the "school" for both patron and artist; from them, otherwise untrained would-be portrait painters could learn to draw the figure, drapery, and landscape as well as about perspective, light, and shade, the representation of textures, and the proper image in which to cast their subjects.

Although the rich proprietors, shipowners, and merchants of New York rose to the very heights of middle-class society on the wings of wealth, power, and position, they stopped short of joining or forming an actual aristocracy. Therefore, portraits such as those of Joseph Hallett and his wife, although indebted to specific, highly aristocratic images, stop short of a total commitment to the grandeur and hauteur that existed in the mezzotint portraits of English nobility. Furthermore, they lack the sensuousness and extravagance of their English aristocratic counterparts. In brief, what we see is an aristocratic style that has been modified to suit and reflect the restrictions imposed by upper-middle-class colonial society. That society, for the rest of its existence, will never tolerate either a true aristocracy or an imagery that feigns one. "Colonial American aristocracy" is a term that refers to the upper middle class, but no more.

135

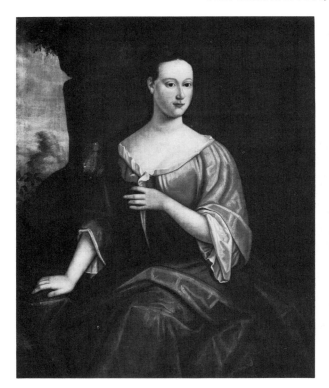

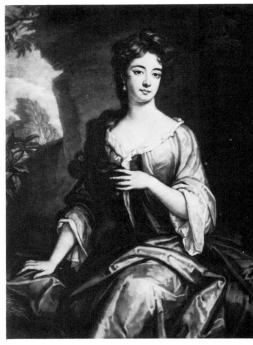

Figure 62. *Mrs. Joseph Hallett*, artist unknown, c. 1728. Oil on canvas, 49½ × 40½ inches. The New-York Historical Society, New York City.

Figure 63. *Countess of Ranelagh*, by John Smith a Sir Godfrey Kneller, 1715–25. Mezzotint, 13⅝ × inches. The Henry Francis du Pont Winterthur seum. Gift of Mrs. Waldron P. Belknap.

Maria (Van Cortlandt) Van Rensselaer (1674–c. 1730) was well placed amid the prominent families of the Hudson Valley (Fig. 64). This daughter of Stephen and Gertrude (Schuyler) Van Cortlandt was baptized into the Dutch Reformed church in 1680, and in 1701 she married Kiliaen Van Rensselaer (d. 1719), third lord of Rensselaerwyck, a vast estate given to her husband's grandfather by the Dutch West India Company and elevated by Queen Anne to a manor in 1704. When her portrait was painted about 1725, she and the artist turned to a mezzotint (c. 1706) representing one of the aristocratic beauties of the English court, the Duchess of Marlborough (Fig. 65).[6] The unidentified painter was unfamiliar with the fluid brushstroke that was an essential component of baroque painting, and his work reveals that he had learned his art from mezzotints rather than from study in the studio of a painting master. His manner of making highlights and of constructing folds, for example, was derived directly from the mezzotint model, as a comparison of the highlights and folds of the fabrics in Figures 64 and 65 demonstrates. Even where hue is concerned – the bright blue dress, say, or the purple curtain – the tonality is that of the mezzotint model, ranging from nearly a black in the shadows to almost a white for the highlights. Although mezzotints could teach an

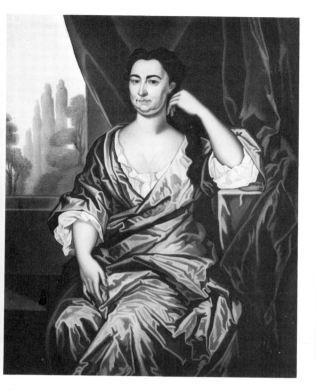

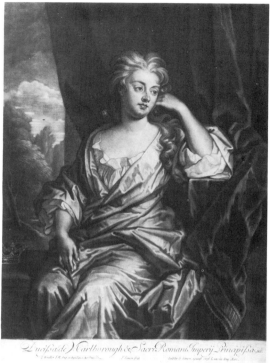

Figure 64. *Mrs. Kiliaen Van Rensselaer*, artist unknown, c. 1725. Oil on canvas, 50 × 41½ inches. The New-York Historical Society, New-York City.

Figure 65. *Duchess of Marlborough*, by John Simon, c. 1706, after Sir Godfrey Kneller. Mezzotint, 13½ × 10¼ inches. British Museum, London.

otherwise untutored artist many things, color theory was not among them, because mezzotints normally existed only in tones of black, white, and gray. Most patroon painters of the Hudson Valley do seem to have been self-taught, and so although the image and form could be learned from the engraving source, coloration could not. The artist who had little access to original English or Continental paintings was generally left to work out his own color schemes.

Although greatly dependent on the mezzotint, the artist who portrayed Mrs. Van Rensselaer did make some modifications. The crown in the lower left beside the Duchess of Marlborough was omitted, and the landscape was simplified and stylized. But nowhere is the modification more significant than in the rendering of the face, which in the *Mrs. Van Rensselaer* is plain and unidealized; the artist may have borrowed unabashedly from the Duchess of Marlborough's refined elegance in pose, gown, and setting, but in the face he felt compelled to create a truthful, straightforward presentation of the physiognomy. The result is a stylistic dichotomy between the plainness of the face and the elegance of the rest of the image. The colonial American character demanded a truthfulness in the face of portraits and permitted little deceit through idealization of features. It would remain for a master of the caliber of John Singleton Copley to make an aesthetic virtue of plainness and endow it with a beauty in its own right so that it could be integrated with fine attire

and setting, as seen in that artist's portrait of Mrs. Thomas Boylston (Fig. 152). Aristocratic English portraiture as practiced by Sir Godfrey Kneller or Sir Joshua Reynolds imposed a class ideal on the face of a subject, for class values were more important than individualism. But a different notion developed in the colonies, where the realism of the face was a manifestation of a powerful individualism – a deep-seated American characteristic that will be considered at length in Chapter 13.

The matter of colonial Americans exerting pressure to modify the English aristocratic image, which was admittedly their model, is especially interesting in connection with the portraits from the Hudson Valley because the patroons, as a group, possessed many of the characteristics that support an aristocracy. They were wealthy, they were powerful politically, and, ensconced within their manor houses, they virtually ruled over the vast tracts of land that made up their domains. They held extraordinary control over the lives of all who lived on their estates, and they saw themselves as different from men and women of lesser social position. But in spite of all of these conditions of aristocracy, they never allowed themselves to become truly aristocratic in the English manner, and their portraits reflect this. Just as life at the Hudson Valley manor house was modeled after life at an English manor, so the portraits were based on images of English nobility, via mezzotint engravings. But the colonial condition wrought modifications on both life-style and portraiture; thus, the patroons and their families never became a true aristocracy, and their portraits stopped short of total imitation of the models on which they were so obviously based. Here is yet another example of the American character asserting itself, for Americans recognized that they were in certain ways different from homeland Englishmen. They proclaimed the fact in the style of portrait they demanded. For all those who, like Caleb Heathcote, wanted their images to be both English and aristocratic, there were scores of other men and women (especially among the native-born) who required that the portraitist "Americanize" the English style. In general, this pattern prevailed throughout the remainder of the colonial period.

Peter Pelham, Art, and Music

" . . . if Madam & Miss are not suffered to shake their Heels Abroad, they will make the House & Family shake at Home."

In 1719, when the population of Boston had reached about 20,000, Daniel Neal, a visiting minister from London, noted that the "conversation in this town is as polite as in most of the cities and towns in England. . . . A gentleman from London would almost think himself at home at Boston, when he observes the numbers of people, their houses, their furniture, their tables [and] their dress."[1] Neal further observed that there were "altogether about three thousand houses, several of which for beauty of the buildings may compare with most in the city of London."[2] Among the fine, large proto-Georgian homes of the prospering merchants were the Thomas Hutchinson House (c. 1688), the Frankland House (c. 1710–20), the Andrew Faneuil House (before 1711), and the Edward Bromfield Mansion (1722); these were impressive three-story brick or stone structures, with symmetrical facades and classical ornamentation, and they represented a decided break with the old medieval-survival wooden houses of seventeenth-century Boston.[3] Architecturally, the town was taking on a new appearance with every building that went up, as affluent Bostonian merchants insisted on designs that were of the current style in London. The interiors reflected a similar demand for elegance, creating a new kind of setting for life and for paintings.

The appearance of Boston and its environs at that period is preserved in William Burgis's map of 1729 and his *South East View of the Great Town of Boston* (1725; revised 1743), which shows the bustling, ship-filled harbor; the numerous wharves, warehouses, and shipyards; the tightly packed houses, shops, and taverns along randomly meandering streets, and a host of church spires that dominated the skyline (Figs. 66 and 67). Burgis also drew a view (1716) of Harvard College in nearby Cambridge, which was already becoming a substantial-looking institution housed in Harvard, Stoughton, and Massachusetts Halls (Fig. 68). Burgis, an Englishman, arrived in Boston in 1722 from New York, where he had drawn a large view of that town.[4] He became associated with William Price, a man who in many ways prefigured Peter Pelham. Price came from England around 1710; an Anglican, he was active in the establishment of Trinity Parish, was the first organist of King's Chapel,

Figure 66. *Boston in New England*, by Thomas Johnston after William Burgis, 1729. Engraving, 10¼ × 14¼ inches. Boston Athenaeum.

and designed the steeple for Christ's church, where he served for many years as organist.[5] Price imported prints from London, and his notice in the *New-England Courant* for May 21, 1722, informed Bostonians that he sold "all sorts of Pictures and Maps." Price was also one of the underwriters of the project that produced the *South East View of... Boston*, and in 1743 he brought out a revised edition of the print. Whereas Burgis's drawing of the view of Boston and probably that of Harvard College had been engraved in England by a John Harris, the map of Boston was engraved locally by Thomas Johnston, indicating the presence of a competent line engraver in the town by the time Peter Pelham arrived in 1727.[6]

All evidence suggests that Peter Pelham (c. 1697–1751) must have been a young man of culture and refinement, well-rounded and polished in the accomplishments of gentry society, as well as a thoroughly trained engraver when he arrived in Boston. This cultural versatility was of consequence because it was more in his social attainments than in his capacity as an artist that he was of use to colonial society. Although he had become a highly skilled

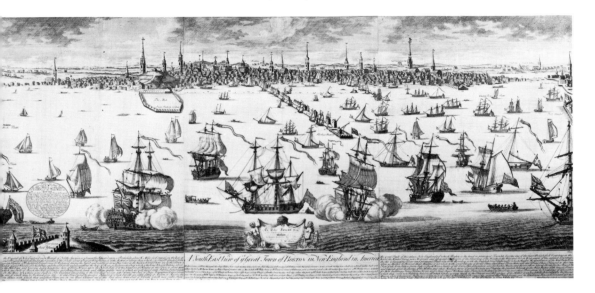

Figure 67. *A South East View of the Great Town of Boston*, drawn by William Burgis, 1725, and revised by William Price, 1743. Engraving by John Harris, 23⅛ × 51⅛ inches. American Antiquarian Society, Worcester, Mass.

mezzotint engraver in London before immigrating, he made only about sixteen mezzotints altogether in his twenty-four years in America, and he sometimes went for years at a time without producing one. That he could not support a family by making and selling mezzotints in New England must have become obvious to him at an early time, and so he became a kind of cultural entrepreneur. It is significant that colonial society did, in fact, support this jack-of-all-trades whose bag of wares included art, dancing, music, and the general business of refinement. A constantly increasing segment of the population was eager to have such things, even if an old guard of pious fundamentalists still resisted their intrusion.

Pelham was born in London, the son of "Peter Pelham, gent." The father's designation probably means the son was raised as a gentleman's son and given a liberal arts education. In 1713 young Pelham was apprenticed to John Simon, at that time the second leading mezzotint engraver in London, after John Smith. Simon frequently had portraits of dignitaries by Sir Godfrey Kneller in his studio to be copied in mezzotint, and an example of the resulting print is seen in the *Duchess of Marlborough* (Fig. 65). Pelham was therefore exposed to the best work of his day, in both painting and mezzotint engraving.

By 1720 he had established his own studio and during the next six years produced about twenty-five mezzotints, six of which were after portraits by Kneller.[7] An early example of Pelham's English work is the portrait (c. 1720) of James Gibbs the architect, shown holding his plan of St. Mary-le-Strand, built in London in 1717 (Fig. 69). Already the young engraver had learned to replicate textures and utilize the rich range of tones from black to white that is the special feature of the medium. Even so, the competition among engravers

141

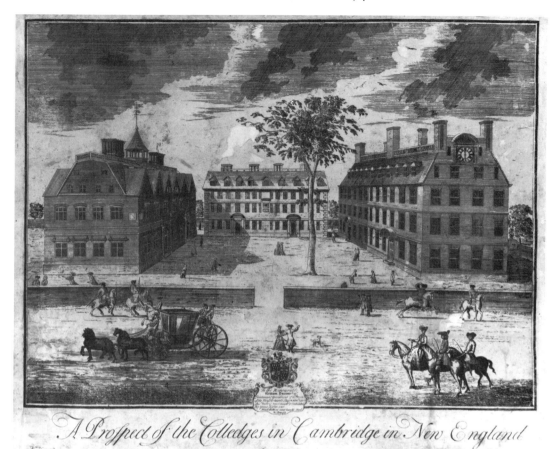

A Prospect of the Colledges in Cambridge in New England

Figure 68. *A Prospect of the Colledges in Cambridge in New England*, drawn by William Burgis, 1716. Engraving by John Harris (?), 19 × 24⅝ inches. Massachusetts Historical Society, Boston.

in London was keen, and as he had a growing family to support, he must have looked abroad for a place to practice his art.

By 1727, Pelham was in Boston, where he set up his studio complete with his own press, which he had probably brought with him.[8] Like nearly every mezzotint engraver, he worked from portraits painted by someone else, but there was no one then painting likenesses in Boston, or at least not of the quality that he thought fit to copy. So when he decided to launch his colonial career by making a print of the venerable Cotton Mather, he was forced into a position theretofore unknown to him – that is, he had to paint his subject's portrait himself. His oil portrait of Cotton Mather, which survives at the American Antiquarian Society, is by no means a masterful example of painting, but the mezzotint that was ultimately worked from it is of very fine quality and was wrought in the most current style of the London studios.

Pelham's image of Cotton Mather (1728), which shows the aged cleric in the last year of his life, was his highest accomplishment as a mezzotint engraver

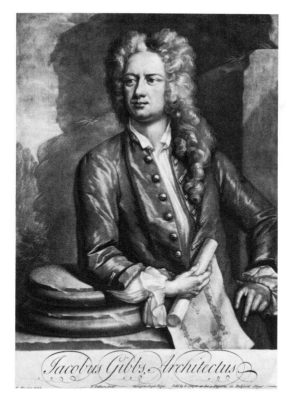

Figure 69. *James Gibbs*, by Peter Pelham after Hans Hysing, c. 1720. Mezzotint, 14 × 10⅛ inches. The Henry Francis du Pont Winterthur Museum. Charles E. Merrill Trust for Purchase of English Objects.

(Fig. 70). Modulations of tone are beautifully executed, and the artist manipulated light superbly to focus attention on the face; the animated spirit of the subject is captured, while textures of flesh, hair, and cloth are convincingly rendered. Pelham was equally successful in portraying the personality of the old minister, for the expression in Mather's countenance betrays a sense of his own worth, position in society, even intellectual attainments – anything but a self-deprecating appearance or a look of religious asceticism.

That Mather wears a great periwig is again worthy of note, for so far has the Puritan colony of yore come that now even the august leader of the flock wears a thing that had been a hated symbol of vanity only a few years before. Instead of careful disassociation with courtly styles (as with an earlier generation's detestation of the Cavalier lovelocks), even the most devout spiritual mentor of the colony has now donned the fashionable wig, with its long curls falling down about the shoulders. Even as early as 1691, Cotton Mather perturbed some of his parishioners by defending, in a sermon, the wearing of wigs, for on March 19 of that year, Samuel Sewall lamented in his diary: "I expected not to hear a vindication of Perriwigs in Boston Pulpit by Mr. Mather." But the times they were achanging, and nowhere is this more apparent than in Pelham's portrait.

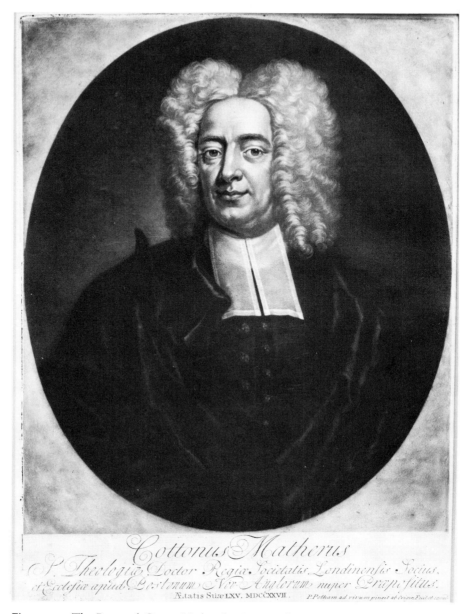

Figure 70. *The Reverend Cotton Mather*, by Peter Pelham, 1728. Mezzotint, 14 × 10 inches. Metropolitan Museum of Art, New York. Bequest of Charles Allen Munn, 1924.

The mezzotint of Cotton Mather invites comparison with contemporary English works. For example, a portrait of about 1730 of Joseph Butler (1692–1752), an Episcopal minister and later dean of St. Paul's in London, is virtually the same type of socio-cultural image as the *Mather* and demonstrates that there was no significant difference between the way an Anglican minister was represented and the manner of portraying a Congregationalist cleric (Fig. 71);

144

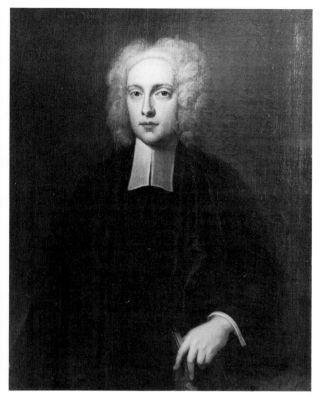

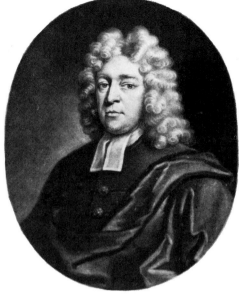

Figure 71. *Dean Joseph Butler*, attributed to William Fayram, c. 1730. 39 × 29⅓ inches. Auckland Castle, Durham.

Figure 72. *The Reverend Samuel Mather*, by John Simon after Richard Philips, c. 1725. Mezzo-tint, 7⅛ × 5⅝ inches. British Museum, London.

in each picture the man wears a shoulder-length, curled white wig, Geneva bands over a black vest, and a black clerical gown. Also, the two images belong to the same general artistic style. Even more directly related to the *Cotton Mather* is a mezzotint of the subject's younger brother, the Reverend Samuel Mather of Witney (1647–1733), which Pelham's former mentor, John Simon, engraved after a painting by Richard Philips (Fig. 72). After graduating from Harvard in 1690, Samuel entered the ministry; by 1698 he had settled in England, never again to return to New England.[9] In England he gained national recognition as a Congregationalist preacher and author of theological treatises. Samuel and Cotton's father, Increase, had earlier had a mezzotint made of his likeness that had widespread popularity in England;[10] this perhaps was the inducement for Samuel to do the same, about 1724 or 1725, and Cotton Mather was no doubt pleased when Peter Pelham presented himself along with a proposal to add the Boston cleric's image to the group of dynastic portraits. Cotton Mather probably owned a print of his brother's portrait and wanted his own image created in the same manner, which Pelham did. In quality, Pelham's work is actually superior to the *Samuel Mather* by Simon.

Pelham did not make his second mezzotint portrait, which represented the

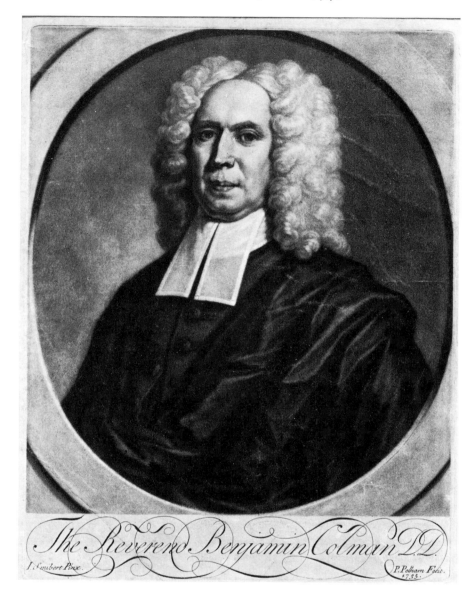

Figure 73. *The Reverend Benjamin Colman,* by Peter Pelham after John Smibert, 1735. Mezzotint, 9¾ × 7⅜ inches. Museum of Fine Arts, Boston. Cutler Bequest.

Reverend Benjamin Colman (1673–1747), until 1735 (Fig. 73). In the years following Cotton Mather's death, Colman became the most famous and respected minister in New England as the pastor of the Brattle Street Congregationalist Church.[11] In 1699 a group of wealthy and influential Bostonians severed themselves from the Mathers' Second Church and erected their own building for worship on land donated by the merchant Thomas Brattle, a liberal adversary of the Mathers. The more liberal attitude generally of the

Brattle Street congregation is seen in the fact that singing by note, long abhorred in New England as popishly ceremonial, was first practiced there, about 1717. Young Benjamin Colman became the new church's first minister, and he, too, often found himself in conflict with the views of the Mathers. Colman was a theological scholar and published many sermons and tracts, such as *Industry and Diligence in the Work of Religion* (Boston, 1717) and *A Dissertation on the Image of God Wherein Man was Created* (Boston, 1736). In the latter he says that the soul or spirit is the greater part of man by far, but he also praises the physical form as God's highest creation, writing that "The Face and Eye and Hand of Men are full of Spirit and Life, from the living Spirit within that animates and acts 'em.'"[12] Such words are in keeping with the type of portrait that developed in the first half of the eighteenth century in New England, matching a physical presence with an inner spirit.

Colman himself had an interest in pictorial images – or at least he had a number of them about his house. Jeremiah Dummer, Jr., once sent him some prints from England,[13] and in 1734, John Smibert painted his portrait and those of his daughter Jane and her husband, the Reverend Ebenezer Turell, all of which hung in Colman's house.[14] Colman's will also mentions Smibert's portrait of the Reverend William Cooper and additional mezzotint portraits. His will is further interesting because he left to Harvard College a nine-volume set of Calvin's writings, suggesting an American minister of the early eighteenth century still held the works of the Great Reformer in high esteem. Colman's total estate amounted to the very large sum of £ 4,000, and the items mentioned in his will indicate that his home was comfortably and handsomely furnished. He conceded that the life of a leader "is usually attended with riches and reputation,"[15] which must have warmed the hearts of the prominent merchants. Although Colman's dedicated concern was to counteract the worldly drift of New England, he seems to have accepted that the mercantile element now directed the thrust of his society, and so his purpose in life became one of antedotal admonition, striving to hold the intense, worldly, materialistic proclivities in check as much as possible by supplying a spiritual balance to them. He even joined his flock, at least to some degree, in its adoption of fashionable ways, as in the wearing of a wig.

There is virtually no difference, in the style or iconography, between the image of a Congregationalist minister such as the *Benjamin Colman*, and the images Pelham made of Episcopal divines such as the *Henry Caner* (Fig. 74). Caner had originally been a Congregationalist but, like many of his fellow New Englanders in the first half of the eighteenth century, had converted to the Episcopal church; he was ordained in England but returned to America to assume his Anglican duties as the minister at King's Chapel. In Pelham's mezzotint, Caner, like Colman, wears a white wig and a black robe with white Geneva bands. The similarity in the subjects' attire is, of course, due to the fact that ministers of the two denominations now wore essentially the same garments and even the same type of wig.[16] The fact that the execution of the mezzotint of 1750 is inferior to that of the artist's earlier prints is due to the diminishing of Pelham's talents through disuse rather than to a desire to render the image of Caner in some way different from that of Colman. Both Peter Pelham and John Smibert, after whose portrait the *Caner* was engraved,

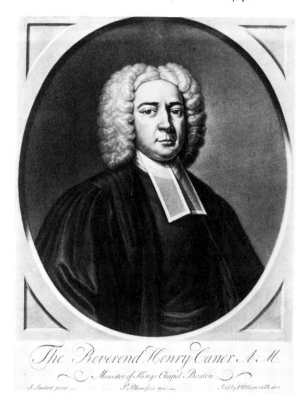

The Reverend Henry Caner A: M.
Minister of Kings Chapel Boston
J. Smibert pinx P. Pelham fecit 1750 Sold by P. Pelham in Boston

Figure 74. *The Reverend Henry Caner,* by Peter Pelham after John Smibert, 1750. Mezzotint, 4⅓ × 3⅓ inches. Museum of Fine Arts, Boston. Gift of Mrs. Frederick Lewis Gray.

employed one and the same style for representing Congregationalists and Anglicans.

As Pelham could not support himself, much less a growing family, from the sale of his mezzotints, he channeled his energies into other activities, mainly into supplying cultural services to a society that yearned to upgrade itself in the refinements of life. Since his arrival he had associated with the liberal element of the colony, and although not wealthy himself he was drawn into the circle of those who were. An Episcopalian, he had his pew first in King's Chapel and later in Trinity Church. In 1738 he joined the recently founded lodge of the Masons, which he served as secretary for several years – a position that brought him into contact with prominent men from whose families came many of the subscribers to his school.

For a while, from 1734 to 1737, he was in Newport, Rhode Island, which was already becoming a resort where wealthy families from as far away as South Carolina and the West Indies went to escape the unpleasantness of summer heat. The philosophical society that Bishop George Berkeley had helped to found was by then well established, and so Newport was a lively spot, socially and intellectually. To the group assembled there, Peter Pelham offered his services as a schoolmaster, but it is significant that his curriculum

was neither gospel-oriented nor vocation-oriented; rather, Pelham ran a "fin-ishing" school for the refinement of colonial society's younger generation. Some idea of what Pelham offered is obtained from his request to the town fathers, soon after his return to Boston in 1737, for permission to open a school to teach children reading, writing, needlework, painting on glass, and dancing. Also, for the elite in Boston and Newport he arranged assemblies – merry gatherings of fashionable people for social entertainment in the forms of con-versation, dancing, and music.

Music was among Pelham's foremost interests, and reportedly the first public "concert of music on Sundry instruments" in America was held in "Mr. Pelham's great room" in Boston.[17] Colonists had suddenly developed a taste for instrumental and choral music. In the seventeenth century, flinty New England Puritans had been opposed to music because organized singing was too popish, reminding them of the cathedral choirs that performed at the celebration of the mass, while time spent learning to play instruments was considered unproductive or nonutilitarian, and therefore led to idleness. When Josiah Flynt, a Harvard student, wrote to his uncle Leonard Hoar in London in 1661 to ask him to send him a fiddle, Hoar replied:

> I suspect you seek it both too soon and too much. This be assured of, that if you be not excellent at it, it's worth nothing at all. And if you be excellent it will take up so much of your mind and time that you will be worth little else; and when all that excellence is obtained your acquest will prove little or nothing of real profit to you. . . . Howbeit, hearing your mother's desires were for it for your sisters, for whom it is more proper and they also have more leisure to look after it: For them I say I had provided the instruments desired.[18]

Music gradually gained community acceptance, however, in part through the presence of organs being placed in the churches. Governor Burnet presented one to the Dutch Reformed Church in New York in 1724 and within about a decade others were to be found in Christ's Church, Philadelphia, in Trinity Church, Newport (a gift from Bishop George Berkeley), in Trinity Church and Christ's Church, Boston, and in Trinity Church, New York. One of the earliest organs in America was imported by Thomas Brattle; when he died in 1713, he left it to Brattle Street Church, with the instructions that the church obtain "a sober person that can play skilfully with a loud noise."[19] But the good elders of Brattle's own church declined the gift, and so it was set up in King's Chapel, again demonstrating how the Episcopal element in New En-gland society could influence the development of the arts. William Price as-sembled Brattle's organ in King's Chapel and probably served as organist until Edward Enstone was brought over from England in 1714 for that purpose, and Enstone's impact on the state of music in the community may be seen from an advertisement he ran in the *Boston News-Letter*:

> This is to give notice that there is lately come over from England a choice collection of Instruments, consisting of Flageolets, Flutes, Haut-boys, Bass-Viols, Bows, Strings, Reeds for Haut-Boys, Books of Instruction for all these Instruments, Books of Ruled Paper. To be

sold at the Dancing School of Mr. Enstone of Sudbury Street . . .
Boston. Note: Any person may have all instruments of Musick
mended, or Virginals and Spinnets Strung and Tuned at a reasonable
Rate and likewise taught to Play on any of the instruments above
mentioned; dancing taught by a true and easier method than has been
heretofore.[20]

This notice reveals that New England was, by the 1720s, making progress in
the social amenities, and the way seems to have been led by Episcopalians.
But others took an interest, too, and sometimes support came from a surprising
quarter; Samuel Sewall, the old-guard conservative Congregationalist, for ex-
ample, enjoyed music very much, and on December 1, 1699, he noted in his
diary that he went that day to a shop to see if his wife's virginal had been
repaired.[21]

Singing was also gaining acceptance. Sewall's diary records that on the
evening of March 16, 1720/21, "Dr. Mather preaches in the School-House to
the young Musicians. . . . House was full, and the singing extraordinarily Ex-
cellent, such as had hardly been heard before in Boston."[22] Cotton Mather
published *The Accomplished Singer* in Boston in 1721, and that same year his
nephew Thomas Walter published the first printed music in bars in America,
*The Grounds and Rules of Musick Explained, or an Introduction to the Art of Singing
by Note* (Boston, 1721). The decade of the 1730s saw the introduction of the
musical concert into American life, all along the seaboard from Boston to
Charleston, South Carolina. We have noted Pelham's "concert of musick"
held in his "great room," and in the early 1740s the selectmen gave approval
to William Sheafe, Samuel Deblois, and Thomas Hancock to use the recently
completed Faneuil Hall for the same purpose. Nor were these entirely ama-
teurish performances. For example, in 1732 or 1733, the German composer
and musician Karl Theodor Pachelbel (1690–1750), son of the famed Johann
Pachelbel and a distant relative of Johann Sebastian Bach, arrived in Boston.
When he left in 1734 he took Peter Pelham's son, thirteen-year-old Peter, Jr.
(1721–1805), with him as his assistant to go to Newport, where they worked
on setting up the organ that Bishop Berkeley had given to Trinity Church.
They then went to New York, where Pachelbel gave his first documented
concert, although there had probably been earlier ones in Boston and Newport.
Pachelbel and young Pelham next went to Charleston, South Carolina, where
they settled for several years, contributing greatly to the musical life of that
city; there, Pachelbel became the organist at St. Philip's Church, from 1740
until his death ten years later. Peter Pelham, Jr., returned to Boston in 1743
and on May 30 advertised in the *Boston Evening Post* that after nine years of
study under "an accomplished Professor in the Art of Musick," he would give
lessons on the harpsichord. He was appointed the first organist of Trinity
Church in Boston, a position he retained until 1749, when he went to Virginia.
There, in 1755, he became the first organist for Bruton Parish Church in
Williamsburg.[23]

In New England, for all of the advancement in the arts that we have been
discussing, there was still resistance, as demonstrated by the following notice
that appeared in the *Boston Gazette* on November 14, 1732; the writer is

startled and concerned at the Birth of so formidable a Monster in this part of the World; and I began to consider what could give encouragement to so Licentious and Expensive a Diversion, in a Town famous for its Decency and Good Order. . . . When we look back upon the Transactions of our Fore-Fathers, and read the Wonderful Story of their godly Zeal, their pious Resolution, and their Publick Virtues, how should we blush and lament our present Corruption of Manners, and Decay of Religious and Civil Discipline. . . . But this their Posterity are too delicate to follow their sober Rules and wise Maxims, and are crying out for Musick, Balls and Assemblies, like Children for their Bells and Rattles. . . . In vain will our Legislature provide wholesome Laws to suppress this Epidemical profaneness. In vain will our Ministers preach Charity, Moderation and Humility to an Audience, whose thoughts are engaged in Scenes of Splendour and Magnificence, and whose Time and Money are consumed in Dress and Dancing.

In concluding his complaint, the anonymous writer unknowingly admits that there may have been pressure from within his own household to engage in such frivolities, for he asks what husband or father, however "prudent or stouthearted," could deny a wife or daughter, conceding that "if Madam & Miss are not suffered to shake their Heels Abroad, they will make the House & Family shake at Home."

These, however, were the anguished cries of a Puritan old guard sensing its helplessness in the face of an impellent urge among fashionable mercantile society to learn and enjoy some of the niceties of life that had earlier been known only to aristocratic circles. If the godly seventeenth-century forefathers had concentrated on the utilitarian things of life – out of necessity of ministerial guidance – colonists of the early eighteenth century had become sufficiently settled in the New World and sufficiently wealthy to seek more than the bare necessities. It was the attainment of this level of society that attracted the likes of Peter Pelham and John Smibert, and although Pelham could not make a go of it as an artist, Smibert did.

John Smibert

*The Knelleresque Ideal and the Empiricism of
George Berkeley*

John Smibert (1688–1751), who arrived in New England less than two years after Pelham, established the profession of portrait painting in the colonies where, according to his account book, he painted 241 portraits – and there were probably more that he neglected to list.[1] This first success story in colonial American painting poses several interesting questions: What socio-aesthetic forces determined the style he brought with him? What was it in his style that colonial society so admired? And how did he, being already trained in a European style, respond to that society – that is, how did the forces inherent in colonial American society modify the painting style the artist brought with him?

The son of an Edinburgh dyer, young Smibert was apprenticed to a house painter before going in 1709 to London where he worked as a coach painter and a copyist for picture dealers.[2] He then began formal study at an academy, where he was taught the English late-baroque style. Finally, to complete an artist's training, a grand tour of the Continent and its great collections was obligatory, and Smibert set off on his in 1719, passing a month in Paris before proceeding to Italy, the Mecca of an artist's pilgrimage. He studiously inspected ancient ruins and the painting galleries of Renaissance and baroque palaces, and he copied numerous pictures by Old Masters in an effort to learn the secrets of the great artists who had preceded them. He also painted portraits from life, with such proficiency that the Grand Duke Cosimo III invited him to remain in Tuscany under his patronage. But Smibert declined this honor and returned to England in 1722.

During the period between his return from the Continent and his departure for America in 1728, Smibert established a reputation for himself as a portrait painter in London, amid a host of others who practiced the same profession. This was a golden era of English music, architecture, and literature. George Frederick Handel had settled in England in 1712, and Palladianism appeared in the London suburb of Chiswick in Lord Burlington's exquisite villa, with its great art collection rivaling that of the Earl of Pembroke at Wilton. The Augustan Age of literature glistened under the brilliant leadership of Pope, Steele, Swift, and Congreve, while Addison had just recently died, in 1719.[3] English painting was then dominated by one towering figure, the portraitist

Figure 75. *Sir Godfrey Kneller*, by John Faber, Jr., 1735, after Sir Godfrey Kneller. Mezzotint, 14⅛ × 10¼ inches. The Henry Francis du Pont Winterthur Museum, Winterthur, Del. Gift of Mrs. Waldron P. Belknap.

Sir Godfrey Kneller (1646–1723; Fig. 75), and by two of his followers, Jonathan Richardson (1665–1745) and Charles Jervas (1695–1739).

No other painter brought to America a style so formed by Kneller as did Smibert; therefore, knowledge of the characteristics of Kneller's style is imperative.[4] Above all else it was aristocratic. Since the reign of Charles II, Kneller had worked to develop a means of portraying English aristocracy and men of letters in a sophisticated manner, imposing class values and ideals on individual appearances. As one looks at his portraits of royalty, aristocracy, and members of the Kit-Kat Club, one senses it was more important to his subjects to have their position in society represented than their individual character. Smibert, like other contemporary English portrait painters, subscribed to this aesthetic theory.

Another characteristic of Kneller's portraits is their formality – an essential element if his art were to obtain the approval of men such as Pope, Addison, and Steele, for their own work and even their very lives revolved on that fundamental characteristic. It was a formality that arose from a sense of correctness and order, and it was based on what were, to the leaders of the Augustan Age, the indisputable laws of nature. These laws, which encompassed something as broad as the order of the universe or as intimate as the

way a man organized and conducted his life, were manifest in the order of
say, a state, an edifice, a poem or a painting; they were seen as following the
pattern of orderliness established by God, as revealed in the universe or in
nature in its cycles and predictability. If one studied physical things scientif-
ically, as Newton had done, one found confirmation of a divinely controlled
order inherent within them. Thereby were spiritual and physical worlds united.
In such a philosophy, logic and rationalism were supreme – the period was,
after all, the dawn of the Age of Reason and the Enlightenment. Such en-
lightenment of the mind was hoped for in a sovereign and his or her ministers,
was expected in scientists and philosophers, and was required in poetry and
painting. When Pope or Addison or Congreve sat to the great Kneller, one
of the most important qualities that had to be infused into the likeness was
enlightenment, and Kneller knew how to put it there.

The formality of a Kneller portrait, then, is based on a respect for order, a
respect for the laws of God and nature, as well as a respect for reason – the
spiritual, philosophical, and scientific banner of the Enlightenment. Therefore,
what is meant by the formality of Kneller's style is this: that there must be a
set of constant and agreed-upon rules for the creation of a portrait image; that
adherence to these rules takes precedence over an individual's personal physical
characteristics; and that the ideal of sophistication and enlightenment be con-
veyed, visually, through observance of these rules. An excellent example of
this theory put into practice is Kneller's portrait of the witty, urbane, sophis-
ticated, and celebrated dramatist William Congreve, painted in 1709, just at
the moment that Smibert arrived in London from Edinburgh (Fig. 76). Of
course, a portrait must bear a resemblance to the features of the sitter, but
those supreme class virtues that the upper echelon of English society had
codified as the laws of good breeding had to be imposed on the likeness as
well. Having arrived at a formal set of rules to accomplish the ultimate of
what is desired in a portrait, Kneller and his patrons recognized within his
style an absolute, in aesthetic terms, and any deviation from the Knelleresque
ideal would have made the portrait inferior.

The essential features of the Knelleresque formula were codified by one of
the master's followers, Jonathan Richardson, in *An Essay on the Theory of
Painting* (London, 1715). Richardson, writing as if he had a portrait by Kneller
before him, declares,

> 'Tis not enough to make a tame, insipid resemblance of the fea-
> tures, . . . nor even to make the picture what is often said to be prodi-
> gious like: (This is often done by the lowest of face-painters, but then
> 'tis ever with the air of a fool, and unbred person.) A portrait painter
> must understand Mankind, and enter into their characters, and express
> their minds as well as their faces: And as his business is chiefly with
> people of condition, he must think as a gentleman, and a man of
> sense, or 'twill be impossible for him to give such their true, and
> proper resemblances.[5]

Because the advice that Richardson gives his readers reflects the theory of
portrait painting that Smibert would have imbibed in the studios of London,
parts of it are quoted here:

Figure 76. *William Congreve*, by Sir Godfrey Kneller, 1709. Oil on canvas, 36 × 28 inches. National Portrait Gallery, London.

Every one of [the portraitist's] people must appear pleased, and in a good humour, but varied suitably to the raised character of the person drawn, whether this tranquility and delight be supposed to arise from the sight of a friend, a reflection upon a scheme well laid, a battle gained, success in love, a consciousness of one's own worth, beauty, wit, agreeable news, truth discovered, or from whatever other cause. . . . Thus to raise the character: to divest an unbred person of his rusticity, and give him something at least of a gentleman. To make one of a moderate share of good sense appear to have a competency, a wise man to be more wise, and a brave man to be more so; a modest, discreet woman to have an air something angelical. . . . is absolutely necessary to a good face-painter: but it is the most difficult part of his art, and the last attained; all that [some] aim at is to make such a likeness of the face as shall be known immediately. . . .

Nor is the beauty of the face, and person, whether as to the age, features, shape, or colour to be unregarded, or (where it can be done) unimproved. . . . The airs of the heads must especially be regarded. This is commonly the first thing taken notice of when one comes into company, or into any public assembly, or at the first sight of any particular person; and this first strikes the eye, and affects the mind when

we see a picture. . . . The same regard must be had to every action, and motion. The figures must not only do what is proper, and in the most commodious manner, but [the] painter's people must be good actors; they must have learned to use a human body well; they must sit, walk, lie, salute, do every thing with grace. . . .

The contours must be large, square, and boldly pronounced to produce greatness; and delicate, and finely waved, and contrasted to be gracious. . . . The draperies must have broad masses of light, and shadow, and noble large folds to give greatness; and these artfully subdivided, add graces. . . . The linen must be clean, and fine; the silks, and stuffs new; and the best of the kind. Lace, embroidery, gold, and jewels, must be sparingly employed. Nor are flowered silks so much used by the best masters as plain. . . . It is of importance to a painter, to consider well the manner of cloathing his people. . . . Portrait painters, seeing the disadvantage they were under in following the dress commonly worn, have invented one peculiar to pictures in their own way. . . . Such is the ordinary habit of the ladies, that how becoming soever they may be fancied to be as being worn by them, . . . it is agreed on all hands that in a picture they have an ill air; and accordingly are rejected for what the painters have introduced in lieu of it, which is indeed handsome.[6]

From what we know of John Smibert's work in London before 1728, it appears that he accepted the Kneller and Richardson formula as if it were aesthetic gospel. A portrait (c. 1726) of Smibert's English period, the *Sir Francis Grant, Lord Cullen* (Fig. 77), for example, is stylistically similar to Kneller's *Self Portrait* (Fig. 75). By following the Knelleresque formula, Smibert achieved considerable success in London, where the competition was great simply from the sheer number of portraitists working there. Smibert's studio was in Covent Garden, the region where most of the fashionable portraitists were located. George Vertue, a kind of eighteenth-century English Giorgio Vasari, spoke highly of Smibert's reputation among British painters, placing him in the second rank along with the young Hogarth and Joseph Highmore, and calling him "a good ingenious man [who] paints and draws handsomely."[7] Smibert's was a portrait studio exclusively, and the notebook he kept, in which he recorded his list of portraits and the amount he was paid for them, informs us that during the seven years of this London period, 1722–28, he executed 175 portraits – an average of 25 per year or about one portrait every two weeks.[8] Moreover, the aristocratic titles that many of his subjects bear in his notebook reveal that Smibert had a clientele of some social standing.

The question arises, then, why did Smibert give up his Covent Garden studio and his wealthy and fashionable London patronage to go to the colonies? Vertue tells us it was partly the prospect of a healthier climate, Smibert "being often inclined to indispositions . . . or Vapours."[9] Vertue also informs us that Smibert was a quiet, modest man, little inclined to toot his own horn amid a clarion host of fellow artists, among whom professional jealousy and backbiting were rampant. In England, Vertue continued, Smibert was "well esteemed by the curious and the judges of art, but he was not contented here,

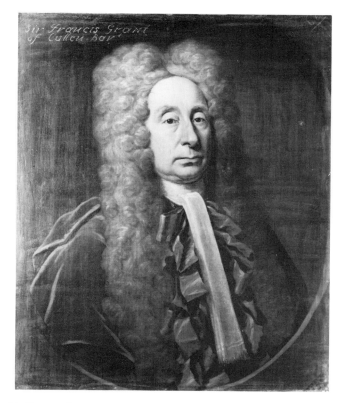

Figure 77. *Sir Francis Grant, Lord Cullen,* by John Smibert, c. 1726. Oil on canvas, 30 × 25 inches. Scottish National Portrait Gallery, Edinburgh.

to be on a level with some of the best painters, but desired to be where he might . . . be looked on as at the top of his profession."[10] So when Dean George Berkeley invited Smibert to go with his group to the New World, there to found a university with Smibert as its first drawing master, the artist accepted.

Originally, Berkeley, who had met Smibert several years earlier in Italy, had formed a plan to establish a school in Bermuda. Well before departing from England, however, he had changed his mind and hoped to establish it in Rhode Island instead, and, in fact, never set foot in Bermuda. From Gravesend, on September 5, 1728, the dean wrote to Thomas Prior: "Tomorrow, with God's blessing, I set sail for Rhode Island, with my wife and a friend of hers, my lady Hancock's daughter, who bears us company. . . . Mr. James, Mr. Dalton, and Mr. Smibert, go with us on this voyage. We are now all together at Gravesend, and are engaged in one view."[11] Berkeley later informed a friend, "We were a long time blundering about the ocean."[12] The little group touched first and briefly at Virginia, and arrived at Newport, Rhode Island, on January 23, 1729, there to await the appropriation from Parliament for the establishment of the university.

During the five-month ocean voyage Smibert must have been exposed to

constant conversation with – or, more likely, to a running monologue by – one of the finest intellects of the period. The inclemency of a North Atlantic winter crossing no doubt frequently brought the group together in the confinement of a cabin belowdecks, where the loquacious Berkeley would have led continuous, stimulating discussions. Furthermore, the philosopher and the artist were very possibly brought intimately together during the long months of the voyage by a painting, for it is believed that Smibert may have been working on the small study for *The Bermuda Group* while he was aboard ship during the crossing. The final sentence from Berkeley's letter to Prior, quoted above, is as intriguing as it is enigmatic: "We are now all together . . . engaged in one view." This might be taken to mean that all members of the party were of one mind in their commitment to the project to found a university; but, as Dalton and James seem not to have been a part of the university project – being instead merely world travelers who were along for the ride – Berkeley's words might very well indicate that the members of his party were engaged in posing to Smibert, who was arranging their portraits on one canvas, for the word "view" carried the meaning of a picture. In any case, what appears to have been a preliminary study for the large painting of the Berkeley entourage survives in the National Gallery of Ireland in Dublin.[13]

If the small Dublin picture was indeed being painted during the ocean crossing, it would have offered a constant stimulus for discussions about art, aesthetics, theories of vision, and related philosophical matters, all of which were of great interest to both Berkeley and Smibert. Smibert, who reportedly said little himself, was surely exposed to hours, days, even months, of philosophical discourse, and so Berkeley's philosophy should be examined to see if there are ideas in it that coincide with eighteenth-century English art in general and the work of Smibert in particular.

George Berkeley (1685–1753) was born in Ireland and educated at Trinity College, Dublin. He became a Fellow at Trinity in 1707 and in 1724 was named dean of Derry. Although committed to the ministry, Berkeley was a philosopher at heart and was possessed of a keen, inquiring mind. In London he became a friend of Jonathan Swift and joined the circle of Addison and Steele. His credentials as an intellectual were established with the publication in 1710, when he was twenty-five, of *A Treatise Concerning the Principles of Human Knowledge*.

In his *Treatise*, Berkeley identifies the five senses and says these are the means of knowing for that "perceiving, active being [which] is what I call mind, spirit, soul, or myself."[14] Objects exist only if they are perceived by a thinking being, and the conceiving or imagining power of the mind "does not extend beyond the possibility of real existence or perception."[15] Therefore, he continues, if it is impossible for a person to see or feel anything without an actual sensation of that thing, so it is impossible for that person to conceive in his thoughts "any sensible thing or object distinct from the sensation or perception of it."[16] He declares that "our ideas are the pictures or representations" in the mind of objects that exist in the physical world.[17] This theory places major emphasis on sensory awareness of the physical properties of the external world and implies that the only things that are real and that exist are

things that can be perceived by our senses. For an artist, what he sees and touches provides what he knows of the physical objects before him, and anything else is unreal and therefore untrue.

This leaves in question, however, the matter of the ideal, of which we have spoken earlier, that Kneller and his followers imposed on the specific individual being portrayed: Can the individual (the specific, sensorially perceived) and the ideal (the universal, as conceived, or imagined) be reconciled within this system? Berkeley was a true man of the Age of Reason when he wrote:

> The ideas of sense are more strong, lively, and distinct than those of the imagination; they have likewise a steadiness, order, and coherence, and are not excited at random, as those which are the effects of human wills often are, but in a regular train or series, the admirable connexion whereof sufficiently testifies the wisdom and benevolence of its Author [God]. Now the set rules or established methods, wherein the mind we depend on excites in us the ideas of sense, are called the *Laws of Nature*; and these we learn by experience.[18]

If, accordingly, a portrait painter such as Kneller observes his aristocratic, sophisticated, and intellectual clientele studiously, he will perceive through his visual sense certain group characteristics that are held in common in their physical being as well as in their personalities; in these he recognizes, through experience, Berkeley's "laws of nature," which are constant and orderly and which, as universal qualities within the group being portrayed, produce an ideal as opposed to a specific. Berkeley would therefore have no quarrel with an ideal derived as a law of nature out of sensory experience, and it would, in fact, be appropriate to impose this law of nature on subjects for whom it is applicable. Implicit in this, of course, is the idea that if an ideal is derived from sensory experience for a society composed of sophisticated aristocracy and intelligentsia, it would not be the same ideal that experience would extract from observing the appearances and characteristics of middle-class merchants and tradesmen, farmers and yeomen. In England, Kneller, Jervas, Richardson, and other portraitists of aristocracy seldom had to concern themselves with these latter groups; but in the American colonies Smibert would be forced to do so – to seek his ideal through sensory perception of their individual and class characteristics.

Berkeley's contention that the world is what we see before us, no more, no less, would naturally have appealed to practical, pragmatic middle-class merchants and others who made up the greater portion of colonial New England society. Even if colonists had not read Berkeley's treatise, they held similar sentiments, and when an artist such as Smibert painted their portraits, he was in fact the middleman who brought together the thought of the philosopher and the outlook of the merchant. Berkeley himself perceived this compatibility engendered by dependence on the senses, for he wrote in his introduction:

> Philosophy being nothing else but the study of wisdom and truth, it may with reason be expected, that those who have spent most time and pains in it should enjoy a greater calm and serenity of mind, a greater clearness and evidence of knowledge, and be less disturbed

with doubts and difficulties than other men. Yet so it is [that] we see
the illiterate bulk of mankind that walk the high-road of plain, com-
mon sense, and are governed by the dictates of Nature, for the most
part easy and undisturbed. To them nothing that's familiar appears
unaccountable or difficult to comprehend. They complain not of any
want of evidence in their senses, and are out of all danger of becoming
sceptics.[19]

New England merchants were not illiterate, and it would be erroneous to
think that there were no persons in the colonies who possessed either an interest
in or the capacity to understand such treatises as Berkeley wrote; indeed,
through enlightened ministers, professors, and intelligent laymen, the thought
of these treatises filtered out to fuse with and influence colonial patterns of
thought. The common denominator of the esoteric thought of the philosopher
and the pragmatic reasoning of the merchant is found in the empirical means
of learning and knowing that which is true, and in a respect for knowledge
that is gained by direct observation. The strength and pervasiveness of this
means became a powerful influence as the colonial American portrait evolved
into its ultimate form.

Berkeley's presence provided a stimulus to the intellectual life of Newport
and Boston for a period of nearly three years, for he did not leave until
September 1731, after there was no longer any hope of receiving funds to
establish the college. By April 1729 he had bought a ninety-six-acre farm near
Newport, where he took up residence, finding the tranquillity of the place
conducive to his philosophical inquiries. In Smibert's *Bermuda Group* he is
represented in the process of dictating his *Minute Philosopher*, or *Alciphron*,
which was later (1732) published in England. Three years after he returned to
England he was appointed, in 1734, the bishop of Cloyne in Ireland, but he
left a legacy in New England. In Newport, he had been among the founders
of a philosophical society, which still exists, and he left his farm and a large
collection of books to the fledgling Yale College.[20]

Smibert's *Bermuda Group*, sometimes called *The Berkeley Entourage*, stands
as a monument of colonial American painting, for its equal had never been
seen here previously, and it was many years before it would be surpassed (Fig.
78). It established a standard of artistic excellence, and it set a precedent in
high-style portraiture. It is thoroughly baroque in its complex yet integrated
compositional patterns, its near saturation of the canvas area with robust figural
forms, and its richness of color and texture. Smibert's ambitiousness in this
painting should be noted, for one seldom finds an English group portrait of
this size and with this number of figures dating from the first three decades
of the eighteenth century; even Kneller himself had not been as adventurous.

Although some problems surround its date, *The Bermuda Group* must have
been finished by November 1730, when Smibert made note of the fact in his
account book; the large version, based on the smaller study that was possibly
painted aboard ship during the crossing, was perhaps commenced in Newport,
between January and May 1729. At the far left we see the artist himself looking
out at us. Seated at the table are, from the left, Richard Dalton, Miss Hancock,
and Mrs. Berkeley, holding her son, Henry; standing behind Mrs. Berkeley

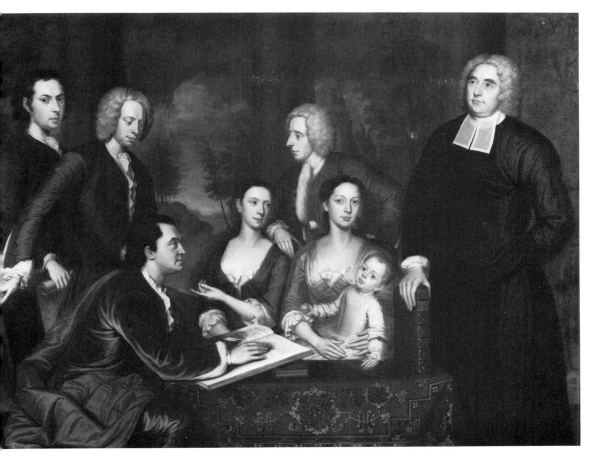

Figure 78. *The Bermuda Group: Dean George Berkeley and His Family,* by John Smibert, 1729. Oil on canvas, 5 feet, 9½ inches × 7 feet, 9 inches. Yale University Art Gallery, New Haven, Conn. Gift of Isaac Lothrop of Plymouth, Mass., 1808.

is John James, and at the far right is George Berkeley himself. The identity of the second figure from the left remains uncertain; he has traditionally been identified as Thomas Moffat, Smibert's nephew and a young physician who joined the group to teach medicine at the university in Bermuda. In his notebook, however, Smibert mystifies us by omitting Moffat's name and substituting "John Wainwright."[21] The latter was the Englishman who commissioned the portrait of the group before its departure and who had originally intended to join the party in its adventure but ultimately remained in England; he was probably the Baron John Wainwright (d. 1741) who was a judge in Ireland and who advocated Berkeley's appointment as bishop of Cloyne. But as there is no record of Wainwright joining the Berkeley entourage in America, the figure in the painting must represent Moffat, leaving unanswered why Smibert recorded the name of Wainwright in his notebook.

Aside from Smibert and Dean Berkeley, little is known about the other members of the group. Berkeley's wife was Anne, daughter of John Forster,

the late chief justice of Ireland; she was an educated woman of genial disposition who was fascinated with the mysticism of Madame Guyon. George Berkeley wrote to his friend Percival from the Newport farm in 1730 that "my wife loves a country life and books so well as to pass her time contentedly and cheerfully without any other conversation than her husband and the dead."[22] The infant on Anne Berkeley's lap is Henry, born September 1, 1729, the first of her six children. At her side sits her companion, a Miss Hancock, daughter of Sir William Hancock, Recorder of Dublin; there evidently was a rumor circulating that she and Smibert were to be married, for George Berkeley denied it in the letter to Percival quoted above. Richard Dalton, Berkeley's amanuensis in the portrait, was a gentleman from Lincolnshire; he and John James were men of fortune who accompanied the Berkeleys for the purpose of seeing parts of America. James and Dalton actually spent little time with the Berkeleys after their ship landed in Virginia; although they eventually made their way to Newport, they quickly deserted the solitude of the farm for Boston – "the place of pleasure and resort in these parts,"[23] as Berkeley described it – where they took a house and lived for several years before returning to England, James to assume the baronetcy of his father at Bury St. Edmunds. Dr. Thomas Moffat – not to be confused with his younger brother John, who became Smibert's associate in the Boston paint shop – was an Edinburgh-trained physician; he was to have sailed with the Berkeley entourage when it left England, but illness prevented his doing so. Moffat joined the group a few months after it arrived in Newport; among his various activities in the years that followed was his position as librarian of the Redwood Library. He owned a collection of paintings, prints, and drawings, and in the 1740s he became a friend of Robert Feke. So, as a composite, the group was well-traveled, well-educated, and interested in books, learning, science, theology, and philosophy as well as the arts.

The Bermuda Group is interesting in relation to what we have discussed in connection with the style of Kneller and the philosophy of Berkeley. Although the painting style was certainly derived from that of Kneller, Smibert must also have looked at group portraits by Kneller's predecessor Sir Peter Lely to achieve such a fine compositional integration of the eight figures; in this regard, one might compare Smibert's picture with Lely's portrait, The Hales Family, of 1656.[24] But the picture differs from the work of Lely and Kneller in an important way, for their portraits are dominated by an aristocratic quality, as was proper for their patrons. Smibert's image, however, is somewhere between the very aristocratic Lely–Kneller type and the bourgeois group portrait that was so masterfully developed in Holland in the seventeenth century. In The Berkeley Entourage, the artist recognized and accepted that the group belonged to a level of society below aristocracy, and therefore he scaled down accordingly to an appropriate means of portrayal. His sensitivity to this situation and his willingness to modify his style out of consideration of his subjects will become increasingly important as he finds his clientele among the wealthy middle class of colonial (primarily New England) society. Here was a style that satisfied colonial merchants' desire for an image of themselves that reflected an increased refinement in their lives and an increased affluence within middle-class perimeters. Essentially what happened after the artist's

arrival in the colonies was this: He scaled down his style a bit to accommodate the taste of his clientele, and his patrons raised the level of their taste a notch or two, to have their likenesses taken in an elegant and refined style.

The Bermuda Group exhibits a richness of stuffs that appealed to the materialism of the colonial middle class, so recently affluent and surrounded by a new abundance of worldly goods. More will be said of this later, but it should be noted as a major characteristic of this portrait. Such things as the Turkish carpet, the velvets and satins, the finely tooled leather-bound books, the wigs, and the rich coloration throughout, provide a profuse variety of visual and tactile sensation; the figures and objects are represented, in fact, with a realism that meshes with Berkeley's theory of vision and sensory experience – a visualization of the philosopher's sensory perception of objects and their physical properties.

Finally, a point should be made about the currency of the baroque style that Smibert brought with him, for it is a curious matter. When the artist left England in 1728, the baroque style of Kneller was still all the rage, and colonial patrons – whose modest concept of art had been formed by mezzotints taken from baroque portraits – saw in Smibert's work the most current and fashionable style of London. But hardly had Smibert sailed when the death knell had already begun to sound for the Knelleresque baroque style. Already the rococo was rising in France, and under its influence, which came quickly to England, the Georgian style would replace the baroque in England; in painting, the change occurred in the 1730s with the emergence of such artists as William Hogarth and Joseph Highmore. So although Smibert and his style were hailed as bringing the latest fashion in portraiture to New England, neither painter nor patron realized – at first, anyway – that what the artist brought was in fact a moribund style. Smibert represented the end of the baroque, but his colonial patrons would not have realized that when first they looked upon his art – especially in his grand and elegant *Bermuda Group* or in the earliest portraits that he executed after arriving in the colonies.

John Smibert

*The Eighteenth-Century Colonial Mercantile
Portrait Style*

Smibert played an important role in the formulation of the style that would find its consummate achievement in work of such native-born painters as Feke and Copley. It was beyond possibility for him to create the ultimate New England mercantile portrait because he was foreign-born and foreign-trained, and therefore not himself a product of colonial America. But immediately upon his arrival, his work became a hybrid of Englishness and colonialisms, of Kneller's ideal and the American penchant for realism. Even in Smibert's earliest portraits he began to accommodate the basically aristocratic style he brought with him to the powerful cultural forces that governed the lives of the prospering middle-class society he was painting.

New Englanders were delighted to have John Smibert join their society, for they appreciated his ability to make images of them that displayed their newfound prosperity and social position in a style that came directly from London studios. When Smibert learned that Parliament would not fund Berkeley's university, he faced the decision of whether to stay or to return. In deciding to remain, he gambled, for no professional painter had previously succeeded in making his living as an artist in the colonies. He judged correctly that the colony of Massachusetts was ready to support an artist in residence, for in the eight months remaining in 1729, after he settled in Boston in May, he recorded in his notebook the painting of twenty-six portraits, while under the year 1730, twenty-five were listed.[1] His income for 1729 was an impressive £760, and the following year brought in £645. Among his patrons were many prominent members of New England society, including, in the first year, Samuel Sewall, Nathaniel Byfield, and Francis and Deborah Brinley.

That Smibert was greeted with an almost euphoric delight is demonstrated in Mather Byles's long poem titled "To Mr. Smibert on the Sight of His Pictures," which was published in the *Daily Courant* on April 30, 1730.[2] Its opening lines reveal that the colonists realized that for all their prosperity, the arts remained undernourished in America:

> Ages our land a barb'rous Desert stood,
> And Savage Nations howl'd in every Wood.

The poem continues with the story of the arrival of the first settlers who brought religion to the land, but their society was "unadorned and rough," a place where "Politeness and the softer Arts [were] unknown":

No heav'nly Pencil the free Stroke could give
Nor the warm Canvas felt its Colors live. . . .
Solid, and grave, and plain the country Stood,
Inelegant, and rigorously good.

But little by little the colony donned a modicum of refinement:

Each Year succeeding the rude Rust devours
And softer Arts lead on the following Hours,
Till the great Year the finish'd Period brought,
A *Smibert* painted and a [Byles] wrote.
 Thy Fame, O *Smibert*, shall the Muse rehearse,
And sing her Sister-Art in softer Verse.
 'Tis yours, Great Master, in just Lines to trace
The rising Prospect, or the lovely Face.

The impact of Simbert's arrival was considerable, for he brought not only a new standard in portraiture but also a collection of paintings, prints, drawings, and sculptures, the likes of which had been unknown in colonial New England. The only collection that might have rivaled Smibert's was the one William Byrd II installed at Westover in the late 1720s and early 1730s, which will be considered in Chapter 15. But those pictures on view at Smibert's studio constituted America's first public art gallery. There one could see the copies Smibert had made in Italy after paintings by Titian, Van Dyke, Poussin, and Raphael, as well as landscapes by Cornelisz van Poelenburgh and several "Roman Views"; there were numerous engravings "after the finest Pictures in Italy, France, Holland, and England."[3] Also on view were casts of ancient sculptures – a head of Homer, and small versions of the *Venus de Medici* and the *Laocoön*. Furthermore, by 1734 he had opened, at his house and studio in Queen Street, a "color shop" where amateurs and the occasional professional painter could acquire brushes, pigments, oils, papers, and various other paraphernalia for the making of pictures. Smibert's residence and studio therefore became a gathering place for all those who wanted their portraits painted, for amateur and professional artists, and for those who wanted to browse among the paintings, prints, drawings and sculptures in order to improve their knowledge of the fine arts. The little art center gave a boost to colonial interests in and awareness of art; for example, many Bostonians went to see the special exhibition Smibert arranged at his place in March 1730.[4] Travelers might visit the gallery and studio, as did the peregrinating Dr. Alexander Hamilton of Maryland, who noted in his diary under date of July 24, 1744, "I went this night to visit Mr. Smibert, the limner, where I saw a collection of fine pictures . . . good busts and statues."[5] The manner in which Hamilton analyzes Smibert's copy of Nicolas Poussin's *Continence of Scipio* suggests there must have been considerable discussion about it among himself, the painter, and others who were present. In their yearning for enlightenment in "the softer Arts," New Englanders and visitors from distant colonies were finding what they sought at the studio, gallery, and color shop of Mr. Smibert.

In Smibert's portraits, colonists found self-images of accruing refinement in life-style and of material prosperity. Among the earliest the artist painted

after settling in Boston are those of Francis Brinley and his wife, Deborah Lyde Brinley, who holds their infant son, Francis, Jr. (Figs. 79 and 80).[6] Francis Brinley (1690–1765), a devout man who took great pleasure in his worldly possessions, offers an interesting case study of the type of clientele from whom Smibert would now obtain much of his patronage. Brinley's great-grandfather Thomas Brinley had served as auditor general under both Charles I and Charles II, knew both monarchs well, and spent much of the period of the Commonwealth in exile with the royal family; his considerable properties were confiscated by the Cromwellians. Thomas's son, Francis, grandfather of the man in Smibert's portrait, moved to Newport, where a son, Thomas, was born; after being educated in England, this Thomas established himself in Boston, where he became a prosperous merchant, married Mary Apthorpe, and was a founder of King's Chapel, for the family had long been ardent Episcopalians. After his first wife died, Thomas returned to England and married Catharine Page, who became the mother of the Francis Brinley of the portrait. Thomas died in the London smallpox epidemic of 1693, and Grandfather Francis Brinley brought Thomas's widow and young Francis to Boston. The Francis of the portrait was sent to England for his schooling at Eton, and then returned to New England, where his grandfather promised to make him the principal beneficiary of his considerable fortune. So Francis Brinley arrived in Newport in 1710, settled in Boston by 1713, and in 1718 married Deborah Lyde, granddaughter of Judge Nathaniel Byfield. The next year his grandfather died, and Francis Brinley became a wealthy man. Over the years that followed, his own business acumen added substantially to his holdings, and he became one of the richest men in the colonies. Brinley represents not a first generation immigrant who clawed a fortune out of a wilderness, but a later generation of colonists who inherited wealth and position. His wealth and standing caused the community to look to him as one of its leaders; he was made a colonel of the militia during the French and Indian War, held the civil offices of deputy surveyor-general and justice of the peace, and was prominent in the affairs of the Anglican church.

Brinley – who owned pew number fifty-two, near those of the wealthy merchants Peter Faneuil, Charles Apthorp, Thomas Hancock, and Isaac Royall, and not far from that reserved for the governor – served as a warden of King's Chapel in 1723 and held several terms as vestryman. When it came time to build a new church in 1749–54, the squire from Roxbury was a generous benefactor for the elegant edifice, which still stands today.

On a tract of land in Roxbury that offered a splendid view of Boston and its harbor, Brinley built, in the mid-1720s, a house that must have been among the finest of that day in all of New England – Datchet House, named after the family seat in England and similarly of an H-shaped plan. An early example of colonial Georgian splendor, it demonstrates the desire of a colonial American to establish a continuity with his family background and to reaffirm the "Englishness" of his heritage. Although it no longer exists, we know it was a three-story clapboard edifice with hipped roof and dormers, pilasters at the corners of the wings, and columns across the front of the recessed section.[7] The large windows were of the new sash type, each with numerous panes of glass set within mullions, à la the fashionable new Georgian mode. On the

first floor was a large reception room that measured forty-four by twenty-two feet, located between the wings, and a "Blue Chamber," the walls of which were covered with blue damask. An inventory taken in 1766 provides some idea of the fine furnishings, including much silver. The design and appointments of Datchet House reveal how far a prosperous colonist could go without incurring condemnation from his church for vanity and ostentation. Of course, Brinley belonged to the Episcopal church, which was the most liberal of all English denominations in the matter of enjoying the good life. Still, middle-class social values imposed their own limitations, and even when persons of great wealth could afford to build and decorate in a very sumptuous manner in New England, they rarely did so because they firmly believed that enjoyment of pleasurable worldly things must stop well short of total hedonism. So we again find a compromise that is beautifully demonstrated in the Brinleys and their fine new house: Their wealth had been gained through industry, with a boost from a rich grandfather and a blessing from God; it was therefore acceptable to use that wealth to create a comfortable and pleasant way of life. But in return for the blessings of prosperity, they would not commit the sin of overindulgence.

Five pairs of paintings are listed in the Brinley inventory of 1766, the Smibert portraits no doubt being among the latter. A man of Brinley's social standing and pride of heritage would naturally have wanted family icons to grace the walls of his fine house. It was in the English tradition to do so, and we have seen that his associations with the homeland were both direct and strong. So when there suddenly appeared in Boston a portrait painter who practiced the current voguish style of the London studios, Francis Brinley was among the first to call upon his talents. The Brinley portraits were, in fact, the third and fifth likenesses painted by John Smibert after his arrival in Boston, and for them the artist was paid ninety pounds. Moreover, they were the first of the large, three-quarter-length portraits that he executed in Boston.

In the Brinley portraits the Knelleresque aristocratic style of England was conditioned by the social, cultural, and religious forces of New England. The corpulent form of Francis Brinley swells out nearly to fill the canvas area, and his sheer bulk gives him an imposing monumentality. The head, encapsulated within the great wig, possesses a countenance that displays a pleasant, content, and somewhat self-satisfied spirit within. The eyes twinkle and the mouth is enlivened by the hint of a smile. Pudgy hands clasp each other casually on the abundant belly, and the whole form of the subject rests comfortably in a great chair of Queen Anne style. The chair itself becomes an iconographic feature, for it is a subtle reference to the fine worldly possessions of the person portrayed. The convention, used as early as the *Elizabeth Freake with Baby Mary* (Fig. 11), first became established in colonial American portraiture in the work of Smibert, and it was picked up by Feke and Copley.

Brinley's attire also attests to his material success, as yard upon yard of velvet fabric envelops his massive form, for the costly material indicates the subject's prosperity. Yet the suit Brinley wears is remarkably plain and without frills or elaborate decoration; large, double-back cuffs on the coat sleeves and rows of simple, cloth-covered buttons on the vest and coat are all that are deemed necessary – or prudent. That is, the meager decoration on a fine velvet

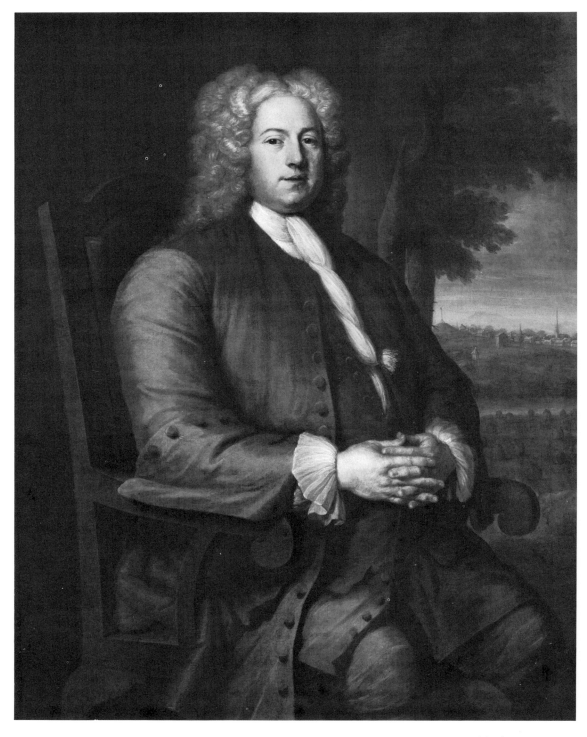

Figure 79. *Francis Brinley*, by John Smibert, 1729. Oil on canvas, 50 × 39¼ inches. Metropolitan Museum of Art, New York. Rogers Fund, 1962.

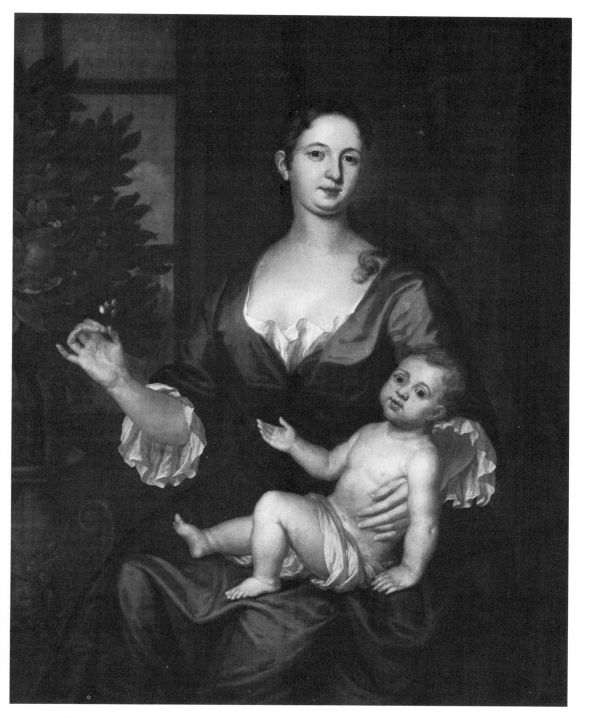

Figure 80. *Mrs. Francis Brinley and Son, Francis*, by John Smibert, 1729. Oil on canvas, 50 × 39¼ inches. Metropolitan Museum of Art, New York. Rogers Fund, 1962.

suit again implies a reluctance to engage in ostentation or to breach the supremely respected frugality factor.

Although the colonists' respect for simplicity is seen in Brinley's attire, this was only emblematic of a broader devotion to that characteristic, which reached even into political theory. Benjamin Franklin noted in his *Poor Richard Improved* of 1756: "By the Word Simplicity, is . . . often [meant] pure and upright Nature, free from Artifice, craft or deceitful Ornament." Although Franklin was thinking more of political matters than of portraits, the basic concept was deeply rooted in each. Critical of the lavish indulgences and vices rampant at monarchial courts, Franklin associated the simplicity of American life with a higher morality and a superior form of government, and wrote that "the Manner of Living in America is in general more simple and less Expensive than in England, [the colonists having] Plain Tables, plain Clothing, [and] plain Furniture in Houses."[8] Thus, the political, moral, philosophical, and social pressures present in the colonies made simplicity – as in Francis Brinley's attire – an admirable quality.

Beyond Brinley, in Smibert's portrait of him, stretches a landscape. Moving visually through the distance, one encounters first a field filled with haycocks, probably in reference to the eighty-acre estate owned by the subject and therefore another symbol of his wealth. Farther on, at the horizon, is a view of the town of Boston as seen from Datchet House on its high ground in Roxbury. The town is identifiable by the flagstaff atop Beacon Hill, which may also be seen in the map and view (Figs. 66 and 67) that William Burgis drew at about the time the townscape was incorporated into the Brinley portrait.

Brinley's face bears the look of individuality. Although the Knelleresque formula had been devised to capture a class ideal that connoted aristocratic status, Smibert's colonial patrons rejected this highborn class ideal in preference for praise of the individual. This was, after all, basically a land of self-made men and women who had established a civilization and become prosperous by individual effort; it was individualism rather than an aristocratic class ideal that they would expect to see in their portraits. Colonists such as the Brinleys were, to be sure, happy to employ Smibert's talents to create an image suggestive of increased refinement, but the artist nevertheless had to retool his style to accommodate this new brand of individualism.

One result of the respect of individualism, translated into artistic matters, is a preference for increased naturalism. Francis Brinley and others like him, believed an artist should paint him as he was, because what he was was good and honorable. This attitude is at the very core of much of colonial portraiture, and one cannot properly interpret portraits by, say, Copley or Peale without taking it into account. It implies many things that are quite revealing of the colonial American character: a distrust of a system that bases a person's worth on something other than personal accomplishment; a distrust of anything false or deceitful, as an idealized likeness usually is; a distrust of anything pretentious; a feeling that what one had accomplished is in itself worthy of respect – an attitude of "what I am is good enough, so paint me as I am." If a person be plain, or fat, or gaunt, or old, or even ugly, his or her appearance is nevertheless one of the chief features of individualism. Unpleasantries of feature could be tempered slightly, but they should not be falsified. Such a thing as Francis

Brinley's obesity was not something to be disguised by an artistic idealization, any more than was the corpulence of Mrs. Charles Willing as Robert Feke painted her (Fig. 134).

The portrait of Francis Brinley establishes a pattern that would influence much of the subsequent portraiture of colonial New England. It is a reconciliation between an artistic style brought over from England and the taste and social code of the colonial American. In its subtle references to material prosperity it reflects the middle-class view of industry, frugality, and honesty as secular virtues, and it implies God's blessing on the subject for diligence in the pursual of his earthly calling. It thereby carries implicit in its imagery a religious element that is present without the employment of overt religious symbols. It demonstrates both the desire for refinement of life-style and the self-imposed limits placed on worldliness that permit the good life but stop short of ostentation and vanity. It praises individualism. It testifies to the self-confidence and self-assurance colonial Americans felt within themselves as a result of what they had done. It is, in summary, a visualization of all that a prosperous, devout, self-made, middle-class society held dear and sacred. Finally, the *Francis Brinley* is truly a descendant, as a cultural icon if not in style, of the *John Freake* (Fig. 10) of half a century earlier, for most of the characteristics we have just detailed were noted in the Freake portrait as well. The continuity of the colonial American character, and its impact upon the portraits, is clearly demonstrated.

In Smibert's portrait of Deborah Lyde Brinley, as in most of his portraits of young women, more of the Knelleresque ideal was retained than in his likenesses of men (Fig. 80). Conformity to that ideal resulted in a general similarity in the women's appearance; for example, comparison of the two women in *The Bermuda Group* and his portraits of Deborah Brinley or Mrs. Samuel Browne (Fig. 82) reveals a sameness that eliminates strong individual characterizations and suggests the artist relied heavily on a preconceived formula for representing feminine grace, poise, and social position. In this he was following the example of Sir Godfrey Kneller, who had resorted to a single ideal of homogenized facial features even more in his images of women than in those of men.

The artistic heritage of the *Mrs. Francis Brinley* traces its lineage through several facets of Smibert's career. The pose in general is reminiscent of many English mezzotints taken from portraits of grand ladies, especially as painted by Sir Peter Lely. But the motif of the right hand plucking a blossom from a potted orange tree is taken specifically from a mezzotint by Alexander Browne, which was copied from Lely's *Lady Price*.[9] Portraits (and mezzotints after them) of women holding infants were rare in late-seventeenth and early-eighteenth-century English art, and so Smibert turned to engravings after Italian paintings of the Madonna and Child. In the portrait of Deborah Brinley the infant reminds us of the Christ Child in, say, Parmigianino's *Madonna with the Long Neck* (Uffizi Collection, Florence).[10]

Mrs. Brinley's countenance is pleasant, animated by a lively twinkle in the eyes and a slight smile on the lips. The smallness of her head contributes to the appearance of monumentality in her full, well-rounded figure, whose ample forms are wrapped in a great abundance of beautiful blue fabric. The gown

is quite fashionable but not ornate; it was a part of Smibert's style, as it had been Kneller's, to paint drapery in broad areas, without a profusion of decorative details, and Richardson's directive on the simplicity of garments and avoidance of voguish excesses has been noted in Chapter 12. Still, the low neckline that exposes broad expanses of shoulders and breasts reflects the subject's adoption of the current fashion of English high society. Low necklines were no less a cause for debate between the religious conservatives and the mercantile progressives than wigs had been a few decades earlier. This will to defy even the admonishments of the Sunday sermon must be recognized as a demonstration of the middle class asserting its determination to enjoy its material prosperity. Although people such as the Brinleys looked to their ministers for spiritual guidance, they refused to let the ministers and their zealous followers prohibit their indulgence in life's material pleasures.

The affluence of Deborah Brinley's life-style is further suggested by the remaining accouterments found in her portrait. The chair she sits in is of the same design as the one in her husband's picture, except that it has no arms, as was usual in a lady's chair in order to accommodate the very full skirt. Behind the subject hangs a large, full drapery, a standard symbol of abundance and affluence in baroque art. Smibert would have been familiar with this convention, of course, and his patron would have known it through mezzotints. At the left is a window with large panes of glass – very different from the small, diamond-shaped panes set within leading that were typical of earlier New England architecture; this, too, in subtle manner, reminds the viewer of the architectural transformation that has occurred, from the medieval survival style of the seventeenth century to the very *courant* early Georgian style. In front of the window stands an orange tree in a large urn decorated with a bas-relief festoon of flowers and fruit. This motif was perhaps included as a reference to the material objects the Brinleys could afford for the decoration of their home, or possibly suggests an interest in scientific horticulture, a subject of interest among many colonists at that time.

By colonial standards the Brinley portraits were elegant, sophisticated, and fashionable. They took their place within the stylish decor of Datchet House, where they would have been seen by New England society and visiting dignitaries – the very group that would be receptive to having images made of themselves. Executed within a few months of Smibert's arrival in Boston, the portraits established a model for both the way colonial persons would be portrayed and the place such pictures would take in the total ambience of the interior of the home of the affluent middle-class aristocracy. In the remaining years of the colonial era, the style would undergo change as the Georgian mode replaced the baroque; but the formula for the cultural icon is already present here.

Smibert's portraits of Samuel Browne, Jr. (1708–42), and Katherine (Winthrop) Browne (1711–81) of 1734 are also emblems of New England mercantile prosperity (Figs. 81 and 82).[11] After graduation from Harvard College (1727) Samuel Browne of Salem entered upon a successful mercantile career, and in 1731 he married Katherine, daughter of John Winthrop of New London, Connecticut. Smibert's portrait of Samuel shows a monumental figure, here abundantly enveloped in a rich, olive-green velvet suit with gold trim. He wears a great white wig, and his air of lordly hauteur suggests his prominence

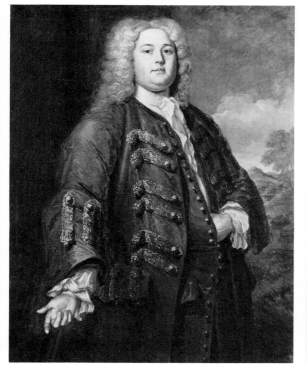

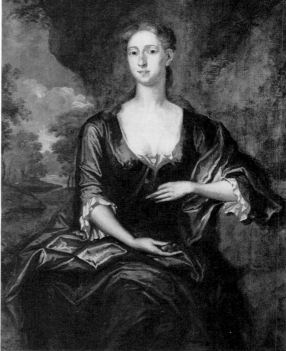

Figure 81. *Samuel Browne, Jr.*, by John Smibert, 1734. Oil on canvas, 50 × 40 inhces. Rhode Island Historical Society, Providence, R.I. Gift of Edward Perry Warren, 1891.

Figure 82. *Mrs. Samuel Browne, Jr.*, by John Smibert, 1734. Oil on canvas, 50 × 40 inches. Rhode Island Historical Society, Providence R.I. Gift of Edward Perry Warren, 1891.

in the colonial social order. The portrait of Mrs. Browne was based on Isaac Beckett's mezzotint after William Wissing's *Princess Anne* (Fig. 146). Both of the Brownes are placed against especially fine, airy landscapes. The painterly richness in the brushwork of the *Samuel Browne* indicates Smibert's training in England and distinguishes the painting from the work of his successor Robert Feke; portraits by native-born painters such as Feke and Copley are characterized by a precise draftsmanship in the painting of all forms, for they did not have exposure to the painterly methods of European baroque masters. Thus we perceive a fundamental difference between the work of an immigrant painter who made images according to European artistic theory and through bold techniques of the brush, and the native-born artist who would create his forms by intensely observing the actual object before him and then delineating its physical properties in meticulous detail. The point is demonstrated by contrasting Smibert's *Browne* with Feke's *General Waldo* or Copley's *Isaac Smith* (Figs. 138 and 153). Basically different processes of perception and execution are involved – one Anglo-European, the other colonial American.

If a general sameness of appearance is found in the features of Smibert's younger women, his portraits of older women are often more individualized, as in his *Mrs. Louis Boucher* and *Mrs. John Pitts* (Figs. 83 and 84). Sarah (Mid-

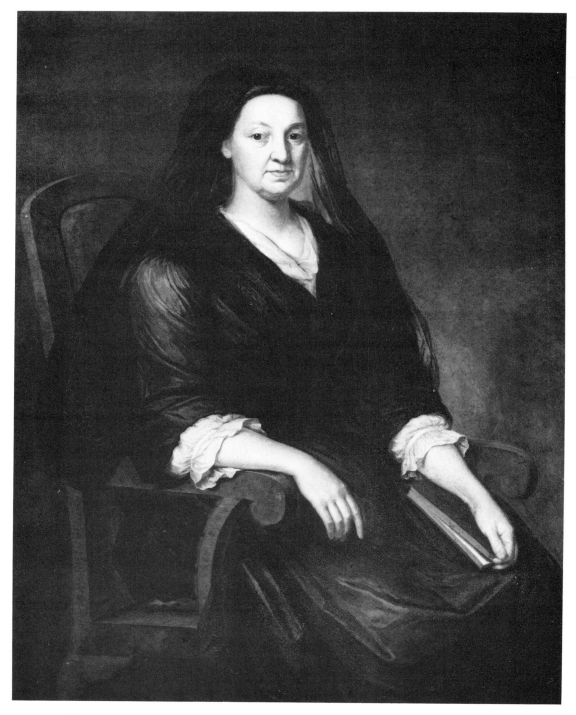

Figure 83. *Mrs. Louis Boucher*, by John Smibert, 1730. Oil on canvas, 51 × 40 inches. The Henry Francis du Pont Winterthur Museum, Winterthur, Del.

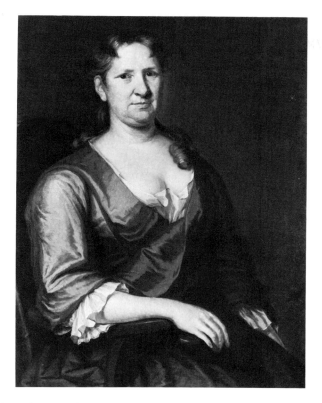

Figure 84. *Mrs. John Pitts* (formerly called *Mrs. James Lindall*), by John Smibert, 1735. Oil on canvas, 36 × 28¾ inches. The Detroit Institute of Arts, Detroit, Mich. Founders Society Purchase, Gibbs–Williams Fund.

dlecott) Boucher (b. 1678) came from a prominent New England family; her father, Richard Middlecott, was an attorney and a merchant, and her mother, Sarah, was a Winslow. She married Louis Boucher, about whom little is known except that he was a merchant of Paris and Boston. When Smibert painted her portrait in 1730 she was fifty-two and a widow, as indicated by the mourning weeds that she wears. As she is an older woman, the neckline of her dress is not as revealing as those worn by younger women such as Deborah Brinley or Katherine Browne, and in the simplicity of her attire Smibert was again following Jonathan Richardson's advice by rendering the fabrics in broad, generalized masses. This resulted in a greater focus on the head, which is desirable in a portrait. The fabric of the dress covers a monumental form underneath, a baroque device used to indicate a monumental stature of the subject – that is, the subject is made more impressive by the sheer monumentality of her physical form, which dominates almost everything else on the canvas.

In Sarah Boucher's portrait a finger marks the place in a book where she has been reading before the viewer entered her presence; this feature, along with eye contact, gives a lively immediacy to the image, and the book further reminds us that she is an educated woman. The book and the chair create a setting that suggests to the viewer that Mrs. Boucher has been portrayed in the quiet

privacy of some snug corner of her own comfortable home, engaged in some customary activity – reading a book from her library. Her pose is relaxed and natural, devoid of any artificial "posing" that might have been employed if the portrait had been dependent on a mezzotint model, which it was not.

In portraits such as the *Mrs. Boucher*, Smibert established the prototype and the archetype of the New England grande dame portrait as created for the area's mercantile set. It is precisely the type that will be followed by Copley in, say, his *Mrs. Thomas Boylston* (Fig. 152). Although the styles of the two are different, the portrait form is the same, and we see once again the indebtedness of subsequent New England portraitists to John Smibert.

The face of Mrs. Boucher possesses a greater individuality than those of the Berkeley, Hancock, Brinley, and Browne women, and this emphasis on individualism, as opposed to the use of a preconceived ideal, is even more pronounced in Smibert's portrait of Mrs. John Pitts (Fig. 84).[12] Elizabeth Lindall (1680–1763) was the daughter of James and Susannah (Hasey) Lindall; her father was one of Salem's most prosperous merchants, and her involvement with the mercantile community continued when she married, in 1697, John Pitts of Boston, who also became wealthy through diligence at his calling. When Smibert painted Mrs. Pitts's portrait in 1735, several years had elapsed since his arrival from London. During that time he continually responded to his new patrons' insistence on their individualism, which encouraged a forthright presentation of their features. But when, as in the *Mrs. Pitts*, he made a truthful representation of the rather coarse features of a fifty-five-year-old woman, Smibert created a problem for himself that he never resolved. His early training had taught him to idealize feminine features, and when his American patrons demanded an unidealized truthfulness, he was ill-prepared to combine truth and beauty. Nor was Smibert unique in this respect, for most European-trained painters who came to the American colonies in the eighteenth century found themselves enmeshed in the same problem – John Wollaston and Joseph Blackburn, to cite two well-known examples. The plainness, coarseness, and truthfulness of Mrs. Pitts's countenance are so blatant, in fact, as to make her appear ugly, which is undesirable in a portrait. A dilemma arose for the painter, for Smibert was simply incapable of finding beauty in plainness, much less in coarseness. As he had neither grown up in New England nor been trained to seek beauty in the real features of a woman's face, he failed to perceive a beauty and dignity in the plain, even homely physiognomy of his middle-class, individualistic, and pragmatic patron. Here we discern a very important difference between Smibert and native-born portraitists such as Feke, Copley, and Peale. Copley, who grew up among mercantile New Englanders and therefore had a sense of their values and strength of character, was far more receptive to the qualities that endowed his merchant-patrons with dignity and honor. In brief, Copley was attuned to the dignity that resided in the leading members of mercantile families, he respected truthfulness in the same way his patrons did, and he could perceive a beauty even in plainness, as the face of Mrs. Boylston clearly demonstrates; this was something Smibert almost never accomplished, his head of Mrs. Boucher coming as close to it as any portrait he painted. Thus, although Smibert should be credited with establishing the form of the rich-merchant and grande dame portraits for

eighteenth-century colonial New England, he left unresolved certain problems – ones that could only be solved by native-born painters.

Smibert's career came to a conclusion in the mid-1740s. By that time Robert Feke had already begun to paint portraits, and before Smibert's death in 1751, a little boy named John Singleton Copley was already observing his stepfather, Peter Pelham, make mezzotint portraits. So the transitional period in the art of New England ends with John Smibert.

The decades from the 1680s to the 1730s have carried us through a transitional phase in New England and New York, to the very threshold of the era in which colonial American life reached its culmination in a refined materialism. The directional thrust of a pious, middle-class mercantile society is reflected in the paintings we have studied between the *Samuel Shrimpton* (Fig. 44) of the 1670s and the Brinley portraits of 1729. In the portraits of that era, the religious, economic, social, cultural, and philosophical determinants imbedded within the colonial personality are there to be read like words on a page. A moderate brand of elegance, sophistication, self-esteem and prosperity, a gentlemanly and ladylike decorum, a strong dose of individualism, pragmatism, and self-confidence, a representation of frugality and of materialistic tastes, and a reference to one's beneficial relationship with God – all are borne out by those portraits. Such qualities intensified with every passing decade, reaching a brilliant culmination in Smibert's portraits of the Brinleys or the Brownes; but they would find even fuller visualization in the portraits by Feke and Copley, and eventually in those by Peale. Before analyzing that final phase, however, we must consider what happened in an area well to the south, and so we turn now to the subject of early portraiture in Virginia.

Virginia

The Cultural Prologue and the Rise of Proto-aristocratic Portraiture in the 1690s

Portrait painting in New England had begun by the 1660s, but it did not begin in Virginia, as far as is now known, until the 1690s; chronologically considered, the story of the rise of painting in the Old Dominion properly belongs in the transitional period. However, portraits – made by English or Continental artists and brought over by emigrants – did exist in Virginia from midcentury on, and we will turn to them after a few observations about the early history of the colony and its formative cultural developments, which had great bearing on the art that eventually arose there.

In 1607 the London Company sent a group of settlers to the wilderness of the New World, to a broad, ill-defined, and little-known expanse of land called Virginia; two years later, the proprietors of that venture were replaced by those of the Virginia Company.[1] For both companies, the sole purpose was profit. The intention was neither to place aristocrats on great landed estates in sumptuous mansions nor, for the emigrants, to escape religious persecution. Among the first to arrive at Jamestown were, it is true, a number of wellborn gentlemen who brought their tailors and a perfumer with them; but in those early torturous years the rigors of frontier survival immediately demonstrated that delicate aristocrats were not hewn from tough enough stock to meet the awesome challenge. Captain John Smith called them a lewd company, more fitted to spoil a land than settle it. Virginia would have its aristocracy, but only in time, and then one emerging from its own people rather than one ready-made and transplanted from England. Such gentility as came to Virginia in those trying early years either went to an early grave or returned to England in defeat.

Those who succeeded in establishing a permanent settlement were, like their counterparts in New England, primarily from that abundant fountain of energy and resourcefulness, the English middle class and yeomanry. As un-idealistic as they were unaristocratic, they brought muscle instead of pomp and a single-minded determination instead of fancy notions. Theirs was a socio-economic venture, and the stout souls who uprooted themselves to immigrate to that hard, demanding country did so mainly to find something all but unavailable to them in England – land, which ultimately meant wealth. Sons and daughters of merchants, tradesmen, and farmers made up the bulk of the early settlers. Although there were some sons from good families whose de-

scendants could legitimately have coats of arms engraved on their silver plate, most were younger sons who were too far down the line to inherit their fathers' wealth, lands, or titles. In England, the first son of an aristocratic family was the primary heir, the second son usually was sent to Cambridge or Oxford to become a lawyer or minister, and the third son and all thereafter normally were sent into an apprenticeship to learn a trade from a craftsman or a merchant.[2] Those wellborn sons who came to Virginia bearing a noble name were usually of the third sort, and they were ready to work and scrape to gain what the law of primogeniture had deprived them of. To the third or fourth son of a lord or a "gentleman," to the laborer, tradesman, merchant, indentured servant, or yeoman, the opportunities of Virginia were understandably inviting; but for Englishmen who stood higher in the social pyramid it was better by far to remain at home.

So it was actually the middle and lower classes that made the settlement successful. But when we look at the early-eighteenth-century portraits that survive from Virginia, they usually have a decidedly aristocratic bearing about them, and one of the primary problems will be to explain this transition from generally modest beginnings to aristocratic status. Moreover, the first settlers found themselves in a land that was raw, and they were too preoccupied with carving a settlement out of a wilderness to have much concern for refinements, even if they could afford them or obtain them. But they were hardworking and they were shrewd when it came to the business of making a profit from the raw materials of their new home.[3] Among these people trade and business were as compatible with social position as they were with religious beliefs. In the forty-four-man Assembly of 1629, seven had been servants only a few years earlier, and by 1662 nearly half of the House of Burgesses "had had their way paid to Virginia as bondsmen."[4] Many of the immigrants were ignorant and crude indentured servants or laborers, brought over to work the fields of the plantations; but when their bondage of four to seven years was up, they, too, could acquire land and begin the process of forming their own estates. Agriculture, primarily tobacco, became the source of wealth, and even men who had been merchants soon became farmers.

The first settlers of Virginia actually had much in common with seventeenth-century New Englanders. Both groups were at the most middle class, and if Anglican Virginians were not exactly Protestants, they were almost as anti-Catholic as their brethren to the north; moreover, aside from the zealots of the first generation of New Englanders, both came in search of prosperity, and that, in truth, was the primary inducement for the majority of immigrants who came to America, be they New Englander or Virginian, Pennsylvanian or Carolinian.

However, from the beginning there were important differences between northerner and southerner. In New England, life, whether it concerned religion, business, or social activity, developed in the town, whereas life in Virginia, which depended on the tobacco crop, centered on the plantation; almost no towns arose in seventeenth-century Virginia, Jamestown being the notable exception, with Williamsburg replacing it as the governmental center in 1699. The plantation system developed almost immediately in Virginia, along the rivers, which were deep enough that oceangoing ships could call at the private

wharves, thus providing direct contact with England without the intermediary of towns and their flocks of merchant middlemen.[5] The lack of towns in part explains why no portraitist established permanent residence in Virginia, for a center of population is normally required if painters are to find sufficient patronage to support their profession.

The merchant middleman so necessary in New England was not essential in Virginia, and this led eventually to the development of two distinct types that dominated the respective societies – one, of mercantile urbanities; the other, of the landed aristocracy. These differences between the societies appear in the portraits from the two regions. Whereas mercantilism became the invigorating force in New England, agrarianism created the main thrust in Virginia, where vast landed estates were owned by men who in time assumed the role of pseudoaristocratic country gentry, in the manner of their peers in England. Concomitantly, the absence of towns made life in Virginia very different from that of England. Without towns, there was "no counterpart to the [English] coffee house, the political club, the literary circle" that offered a forum for sparkling wit, intellect, and camaraderie.[6] This meant that any intellectual and cultural development would take place primarily in the mansion house of the plantation, where it was accessible to a relatively small segment of the total population, a circumstance that further contributed to class distinctions. As the Virginia aristocracy developed it separated itself from the lower classes, not only by its wealth and its political power but also by its intellectual and cultural attainments.

The code of the Virginian, in comparison to that of the New Englander, developed in a different way too. Although both New Englander and Virginian were devoted to such qualities as fortitude, prudence, temperance, and justice, the southerner tended to be more liberal and more generous in his life-style. In the matter of frugality, the New Englander by comparison seemed parsimonious and devoted to work and thrift in a religious sense, whereas the Virginian held "niggardliness . . . in contempt, and penny pinching was a mark of bad breeding."[7]

In New England, men and women tended to make their way to prosperity by means of their own labor, whereas in the South those who owned the plantations soon "came to see the advantages of slave labor, and as a result [the New Englander] never attained that spacious margin of leisure" that flourished in the southern colonies.[8] By the 1680s there was large-scale importation of slaves into Virginia, a phenomenon affecting the life-styles of both wealthy plantation owner and the poorer farmer who had small acreage; the latter, who could not afford to buy slaves, now had to struggle to survive because in raising his tobacco he could hardly compete with the labor force enjoyed by the plantation master. Three definite classes came into existence: those of the lowly slave, the poor white farmer, and, at the peak of the pyramid, the plantation master. By the end of the century such men as Byrd, Carter, Lee, and Fitzhugh owned scores of slaves, and they had adopted the overseer system, with the result that they had more leisure time to devote to pursuits of refinement, cultivation of the mind, and patronage of the arts. Increased wealth also resulted, for with slave labor vast new tracts of land could be cleared and planted in the usually lucrative tobacco crop. There can be no

doubt that the institution of slavery in the last quarter of the seventeenth century contributed enormously to the rise of an aristocratic caste of considerable wealth, which reached its apogee in the first half of the eighteenth century.

A further result of the southern socio-economic system was that there was almost no middle class in Virginia society. Even though most of the great planters had come from middle-class or even yeoman stock, their acquisition of land, their wealth, and their political power pushed them so far above the two lower classes that they soon assumed the role of an aristocracy, while the lower levels of the social order had scant opportunity to become a rich and powerful middle class such as existed in mercantile society in England and New England. Without the mitigating influence of a middle class, there was little economic, political, or social restraint placed on the power of the great planters, further establishing them as an aristocracy. If the prosperous middle-class temperament of New England impressed itself on the portraits of its society, this aristocratic status, in time, equally infused the images of the wealthy Virginian. Remembering life back in England, the early Virginians saw themselves as the new country gentry with all the rights and privileges that went with that position. Indeed, they patterned their lives after the English gentry, unlike the New Englander, who took the prospering London merchant as his role model.

The small ruling clique of the colony was drawn almost exclusively from the great landowners. Although the House of Burgesses, which was composed on a more democratic basis, would eventually exert considerable influence in Virginia, the governor and the Governor's Council held the most power in the colony, especially before 1740. When the Carters, Lees, Byrds, and so on were appointed to the exclusive council, it tended to confirm in their minds that they were different from other men of the colony. And after the Virginia Company folded in 1624 and Virginia became a royal colony, the presence of a royal governor around whom the council clustered (even if they often disagreed with him or found him objectionable in his personality and policies) established a courtly element of some elegance and refinement that had no counterpart in New England until the arrival of its first royal governor in 1686. It is no coincidence that most portraits of Virginians painted before 1730 are of members of the council or of their wives and children.

The settlement may have started out as an assortment of middle-class folk, but by the third quarter of the seventeenth century an aristocratic system was already being established; by the turn of the century it was pronounced, and in the first half of the eighteenth century it reached full bloom, with little of the middle-class or yeoman origins still in evidence among the ruling class. This evolution toward a genteel way of life manifested itself in many ways – in the education the planters obtained for themselves and sought for their children; in the refinements of art, architecture, and music, and in the commodious interiors of the homes they built on the edge of the wilderness; in their social manners and their attire; and even in the religion they embraced. A French Huguenot refugee-traveler named Durand has left an account of his observations, made while touring Virginia in 1686, which summarizes many of the points just discussed:

There are no lords, but each is a sovereign on his own plantation. The gentlemen called Cavaliers are greatly esteemed & respected, & are very courteous & Honorable. They hold most of the offices in the country. . . . They dress as we do in France. Almost all of their clothes are brought ready-made from England. . . . The land is so rich & so fertile that when a man has fifty acres of ground, two men-servants, a maid & some cattle, neither he nor his wife do anything but visit among their neighbors. . . . The farmers' houses are built entirely of wood, the roofs being made of small boards of chestnut, as are also the walls. Those who have some means, cover them inside with a coating of mortar in which they use oyster-shells for lime; it is as white as snow . . . so that they are very pleasant inside, with convenient windows & openings. They have started making bricks in quantities, & I have seen several houses where the walls were entirely made of them.[9]

Amid the trappings of the emerging Virginia aristocracy, portraiture had its role to play. But even before portraits were painted locally, by artists working in the colony, they were imported from England, along with a few pictures of other types. William Moseley, an Englishman in trade with Rotterdam who came to Virginia in 1649, settled in lower Norfolk County on an eight-hundred-acre estate. He reportedly brought over, either at the time of his immigration or on two subsequent trips back from England, twenty-two pictures to adorn his plantation house, Rolleston Hall, which at that time would probably have been a rather plain frame house of the type described by Durand. Among these pictures were said to be four by Anthony Van Dyck, who had worked in England from 1632 until his death in 1641. The portraits of Moseley and his wife, Susanna, are of the Elizabethan–Jacobean survival style that was used in the early New England portraits.[10] William Moseley wears long dark hair (his own), a dark coat, and a broad white lace collar with additional lace at his wrists. His wife wears a dark dress with a broad white collar and wide white cuffs, again trimmed with lace; she is shown wearing a bracelet on each wrist and a ring on each hand, as well as a brooch at her collar. Susanna was well educated, and is represented holding a book in her right hand. There were evidently portraits of the Moseleys' two sons, William and Arthur, as well, but all of these are presently unlocated.

Little more is presently known of the Moseley collection of pictures except that in William's will, dated June 29, 1655, he bequeathed to his wife all of his furniture, which probably included the paintings. In February 1665 their son, William, Jr., filed an inventory of his mother's estate that listed two pictures, probably the portraits of her and her husband. Sometime between her husband's death and her own she had probably given to William, Jr., several of the pictures that had come to her as "furniture," for after her son's death in 1671 his estate contained twelve "picktures."[11] The Moseley family pictures continued as a collection into Revolutionary War times, for Edward Hack Moseley, great-great-grandson of the emigrant, bequeathed in his will of 1782 "all my Family pictures" to his son and namesake; an undated inventory of his estate mentions a total of thirty-nine pictures, of which fourteen were

specified as "Family Pictures."[12] We therefore have a demonstration of how the fascination for paintings that began in the mid-seventeenth century commenced a tradition that escalated in successive generations.

There are records of other pictures, probably imported, from the mid-seventeenth century, as in the estate of Thomas Ludlow (d. 1660), which listed "a picture of Judge Richardson."[13] John Brewer of Isle of Wight County, who died about 1667, left "12 small pictures," and Thomas Madestard of Lancaster County mentioned several pictures in his will of 1675. The inventory of Edward Digges (d. 1691) lists six pictures.[14] David Fox, about 1690, owned "3 pictures in the parlour and 25 Pictures of Scenes [probably prints] in the hall."[15] By 1680 it was not uncommon for portraits to be hanging on the walls of Virginia plantation houses, and in the final decade of the century the importation of portraits greatly increased.

Not many seventeenth-century portraits of Virginians have survived, and so those connected with William Fitzhugh are of special significance. In them, the transition begins that leads from the middle-class origins of the family to a landed Virginia aristocracy, and they prepare the way for the likenesses of the Carters, Byrds, Lees, Manns, and so on that populated the magnificent houses of the great plantations in the first half of the eighteenth century.

William Fitzhugh (1651–1701), the son of a woolen draper of Bedford, England, arrived in Virginia about 1673 (Fig. 86).[16] He was a staunch member of the Church of England, but, as we shall see, the Virginia aristocracy wore their religion, like most other things, with ease and grace rather than with a frown and a mea culpa. Fitzhugh obtained a tract of land in Stafford County on the Potomac, where he established his estate, Bedford, named after the beloved homeland area he never forgot. In time, the squire of Bedford owned over 54,000 acres, much of which had been put into tobacco fields that were worked by his fifty-one slaves. His estate, where he created a life-style patterned after the English country gentry, offered most of the amenities found at an English provincial manor. From England, Fitzhugh ordered prodigious amounts of silver plate, which was proudly engraved with his family crest. This silver was set out on those frequent occasions when he entertained his neighbors, or some traveler visiting the country, or the governor himself. Conviviality ruled as imported wine was drunk into the small hours of the morning and entertainment – "three fiddlers, a jester, a tight-rope dancer, an acrobat who tumbled around" – was provided, probably by slaves or indentured servants.[17]

William Fitzhugh was no instant aristocrat, however, and in many ways he was as conservative as a New England merchant. He chose not to overeat, not to drink excessively, nor to be "one of Venus' votaries."[18] Like his fellow planters, he gambled a little at cards or horse racing, but never with reckless abandon. He was attentive to all matters that concerned his business, whether in the colony or with his London agents, and he possessed much of the mercantile mentality associated with New Englanders. But for all this he sought, as much as he could, the way of life of the English gentry rather than that of the London merchant.

Being a gentleman meant being educated, and William Fitzhugh gave serious attention to the matter, for knowledge was one thing separating the upper

from the lower classes. Useful knowledge was necessary to the success of the plantation; but equally important, no gentleman wanted to be an ignorant bore in the society of his peers, which was against the code of the Virginia gentleman planter even at that early date. So Fitzhugh formed a private library at Bedford.[19] Recognizing the practical and social values of education, he obtained for his son a French tutor, probably one of the emigrant indentured Huguenot refugees that had settled on his land. This son, William, Jr., was later sent to England to complete his education and attain some of the social refinement that life on the edge of the wilderness could not provide. To a man like William Fitzhugh, education meant not only pragmatic, academic pedanticism but also a mastery of social graces and entertaining conversation. He no doubt instructed his sons from his own copy of Richard Brathwaite's *The English Gentleman* (1630), a somewhat bourgeois courtesy book about polite social behavior that guided many early Virginians in their search for refinement.

To a man like Fitzhugh, paintings, especially portraits, were not only sentimental mementos but an important part of the paraphernalia of the desired life-style. Family portraits on the walls were as significant as the family crest on the silver; both were symbols of wealth and station. How William Fitzhugh came into possession of his collection of portraits is not known, but in his will of 1701 he left to his son William "my own & Wife's pictures & the other 6 Pictures of my Relations," and to William and another son he left his "Study of Books" and the remainder "of the Pictures & Mapps."[20] One family portrait was perhaps that of his brother, Captain Henry Fitzhugh, who had remained in England. To Henry, William wrote in 1687 pleading for his portrait: "As in my last I intimated & desired your Picture & our Coat of Arms . . . so again I must repeat my former desires & wishes either to see you in person, or to see you truly personated by your lovely picture."[21]

Somewhere along the way, William Fitzhugh acquired the portrait of his father, Henry Fitzhugh (1614–1664), which, like his own portrait, is preserved only in a copy made by John Hesselius in 1751, the originals now being lost (Figs. 85 and 86). Stylistically the two portraits are so unlike Hesselius's own style that we may assume that he was careful in duplicating the character of the originals.[22]

The image of Henry Fitzhugh, the original of which was painted in 1634, is interesting as an example of middle-class portraiture in the age of Charles I and of the period of the Great Migration of Englishmen to the New World. The subject, a dealer in woolen goods, is represented in an enveloping black cloak and a white collar; his hair is neat, curled, and only shoulder-length, and he has a carefully trimmed little mustache. There is nothing about the portrait to suggest pretentiousness, nothing of the lavishness of the portraits being painted of members of King Charles's court in the 1630s; its reserved character is well suited to the merchant class of the early seventeenth century, and Cavalier dash and flourish are totally absent. Stylistically, it has – unlike, say, the Saltonstall portrait of about the same time (Fig. 6) – shed nearly all vestiges of the *retardataire* Elizabethan–Jacobean style; instead, Continental influences dominate the *Henry Fitzhugh*, for the unidentified painter was following the Dutch style in using a somber palette and a dark-toned neutral

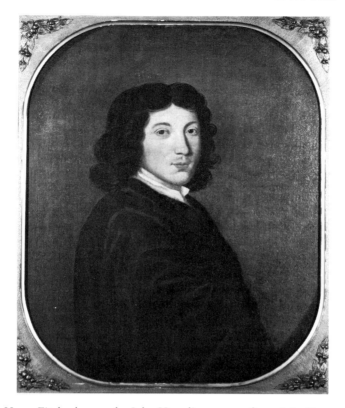

Figure 85. *Henry Fitzhugh*, copy by John Hesselius, 1751, after original by an unknown artist, 1634. Oil on canvas, 30¼ × 25 inches. Virginia Historical Society, Richmond. Bequest of Alice-Lee (Thomas) Stevenson.

background. As the subject died several years before his son immigrated to Virginia, William Fitzhugh may very well have brought this portrait with him when he came over in the early 1670s. The painting may therefore have encouraged the practice of having family portraits about the house, but its bourgeois character would not set the pattern for subsequent portraits of Virginians, who would increasingly incline toward a more aristocratic image of themselves.

The changing image is observable already in the portrait of William Fitzhugh (Fig. 86), which is a modest precursor of the sophisticated Kit-Kat portrait developed by Kneller in the early decades of the eighteenth century. A sense of his own importance is presented in this image of a man shown in the current fashion of gentry attire. In the social framework of the day, a position of something more than a cloth merchant is suggested by the pose, demeanor, and dress of the sitter; it is not a thoroughly aristocratic image, but relative to the *Henry Fitzhugh* it is less bourgeois. William Fitzhugh is shown in a dark brown wig of a length greater than the hair in his father's portrait; as we have seen, the wearing of a wig itself is a custom the rising middle class adopted from higher social circles. He wears a white cravat and a brown robe whose ampleness is in itself a symbol of prosperity and affluence. But the plainness

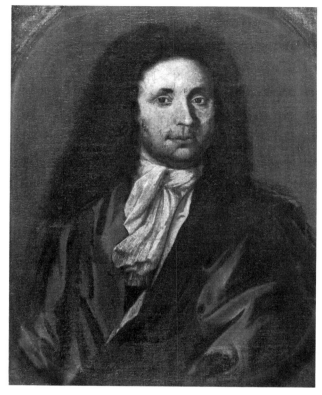

Figure 86. *William Fitzhugh*, copy by John Hesselius, 1751, after original by unknown artist, 1690–95. Oil on canvas, 30 × 25 inches. Virginia Historical Society, Richmond. Bequest of Alice-Lee (Thomas) Stevenson.

of the face and the somberness of the colors reveal Fitzhugh's reluctance to have himself portrayed in a truly aristocratic guise, which would have been pretentious and would have exceeded his station in life.

The inscription on the Hesselius copy of William Fitzhugh's portrait, "aetatis 46, born 1651," would seem to indicate that the original was painted in 1697. That would mean the portrait was painted in Virginia, which would be of singular importance. However, a will of 1700 commences with the words "I William Fitzhugh, of Stafford County, gentleman, now bound for England. . . ." Thus it is possible that the original was painted in England on that trip, and the subject's apparent age could as easily be forty-nine as forty-six. However, in July 1698, Fitzhugh wrote to one of his London agents, saying he then had an indentured servant who was an engraver, and soon thereafter wrote to another agent instructing him to send him some lacquered picture frames, some "colours for painting [and] pencils [brushes], Walnut Oyl & Lynseed Oyl . . . together with half a doz. 3 quarter clothes [stretched canvases] to set up a painter."[23] Among his indentured servants Fitzhugh evidently had one with a special talent for pictorial work, who may have painted the original portrait of his master. The portrait, at least as we know it through John Hesselius's copy, reveals a fluidity of brushwork, a richness of painterly effects,

and subtle nuances of tone, color, and texture; in those respects, it does not look to be the work of one who has been only an engraver. In any case, Fitzhugh's request of his English factor for oil, colors, brushes, and canvases is tantalizing, for it raises the possibility that his unidentified engraver may well have painted portraits on those half-dozen canvases, if they were in fact sent over. There exists, then, the possibility that around 1697–1700 there was in Virginia a painter who could execute portraits in the current fashion and in a competent manner as concerns brushwork, textures, light and shade, likeness, and life essence.

The portrait of William Randolph (1651–1711) may be one of the earliest-surviving examples of painting in Virginia (Fig. 87). The subject, who was born in Warwickshire, England, the son of a country gentleman, immigrated to Virginia about 1670 and settled in Henrico County, where an uncle, Henry Randolph – formerly a merchant in England – had already taken up residence.[24] Around 1678, William married Mary Isham, and thus began one of the most prodigious and distinguished family lines of Virginia. Rising steadily to a position of leadership in the colony, Randolph served as magistrate, justice of the peace, member of the House of Burgesses, speaker of that House, and attorney general of the colony. About the time his portrait was painted, he was active in the founding of the College of William and Mary, of which he became one of the first trustees. As proprietor of several large tracts of land – among them Turkey Island on the James River – he enjoyed gentry status, and each of his seven sons inherited fine plantations. Land being plentiful in the colony, there was no need to follow the law of primogeniture, which had long been observed in England because of the finite amount of land there. Thus, a man like Randolph need not send later sons into the trades but could accumulate enough real property to set each up with his own plantation, even if the number ran to seven.[25]

In his portrait William Randolph appears to be about forty-five years old, which would place its date in the mid-1690s. The style of the great wig he wears and his costume are appropriate for that period. His Steinkirk cravat (named after the battle of 1692) was then fashionable, as was the fitted coat with its narrow lapels and small buttons.[26] In style the portrait is in the general manner of the school of Sir Godfrey Kneller; the brushwork is fluid, the forms are well rounded and textured, and the pose and gesture are characteristic of English baroque aristocratic portraiture of the turn of the century. It is not at present possible to say whether the portrait was executed in Virginia or when Randolph was on a visit to his native land; it is tempting to attribute it to the same hand that painted the original *William Fitzhugh* – the unidentified indentured servant discussed in a preceding paragraph. In any case, the inclination toward an aristocratic image is evident.

There is also, from the 1690s, a portrait of Robert Bolling (1646–1709), who came to Virginia at the age of fourteen (Fig. 88). The subject's parents were London merchants, and how Robert came to emigrate at such a tender age is unknown. As a young man in the Old Dominion, he began acquiring land, engaged in trading, and became a prominent figure in the colony. In 1675 he married Jane, daughter of Thomas Rolfe and granddaughter of Pocahontas; after she died following the birth of a son, John, Bolling married

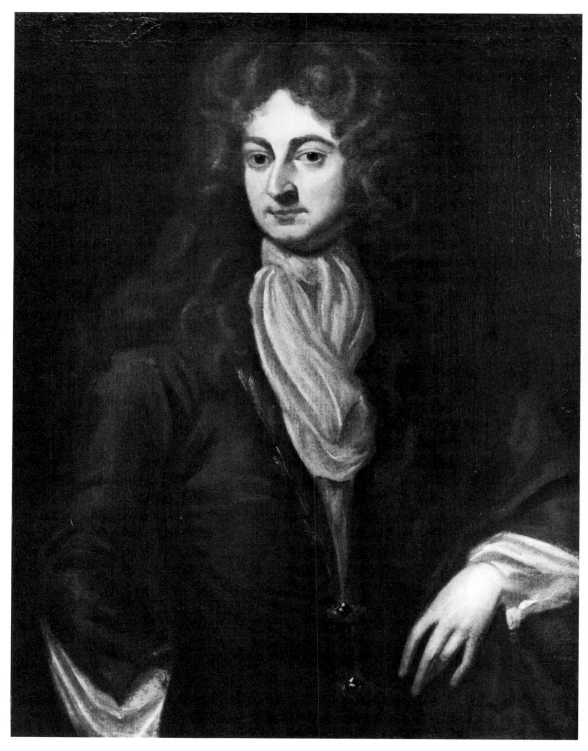

Figure 87. *William Randolph*, artist unknown, c. 1695. Oil on canvas, 35 × 27 inches. Virginia Historical Society, Richmond. Bequest of Kate Brander (Harris) Mayo Skipwith Williams.

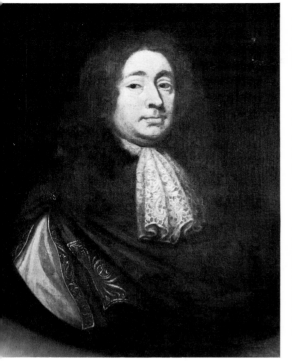

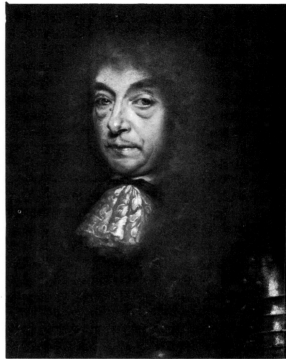

gure 88. *Robert Bolling*, artist unknown, c. 1695. Oil
n canvas, 30 × 25 inches. College of William and Mary
Virginia.

Figure 89. *Portrait of a Gentleman*, by Edmund Ashfield,
c. 1675. Pastel on paper, 11 × 9 inches. British Museum,
London.

Anne, daughter of John Stith, with whom he had several children. In Prince
Georges County he developed his estate, Kippax, named after Kippax Park
in West Riding, Yorkshire, where several generations earlier his ancestors had
been members of the minor aristocracy.

The bust-length portrait of Robert Bolling shows a rather proud man ex-
uding the self-confidence of one who knows his place in the upper levels of
his society. It is not, however, a thoroughly aristocratic portrait; the subject
was still too close to his middle-class mercantile origins to indulge himself to
that extent, but his son John, and his grandson John, Jr., felt no such reser-
vations, as a look at the portraits of these later generations of Bollings will
show (Figs. 116 and 117). Robert's hair is his own, he wears a handsome lace
cravat, and his mantle is trimmed with brocade, suggestive of finery in mod-
eration rather than lavishness. We do not know if the portrait was painted in
Virginia or if Bolling made a trip to England around 1690 and might have
had his likeness taken there. Two contemporary examples of English por-
traiture place the *Bolling* within their tradition in the late seventeenth century.
The *Portrait of a Gentleman* by Edmund Ashfield dates from 1675–90 (Fig. 89),
while John Riley's *Duke of Lauderdale* was probably painted within a year or
two of the *Bolling*.[27] However, comparison of Bolling's portrait with the

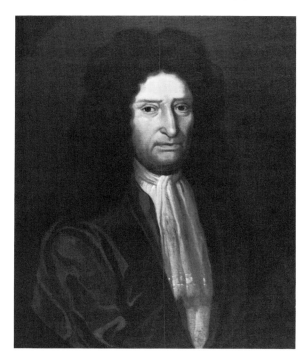

Figure 90. *Richard Lee II*, artist unknown, c. 1695. Oil on canvas, 30 × 25 inches. Private collection.

Lauderdale demonstrates that, although they are both of the same general style, the Virginian's image is less aristocratic than that of the Englishman.

One of the finest groups of portraits from early Virginia is that of the Lee family. The American progenitor was Richard Lee the Emigrant (c. 1613–64), who had been apprenticed to his cousin, John Lee, a London merchant, before emigrating about 1640.[28] Through skillful political maneuvering he was appointed to the Governor's Council, a high and prestigious office, and Governor Berkeley named him secretary of the colony. Among his several large tracts of land in Gloucester County was one on which he built his manor house, Paradise, and not far away he operated what was known as "Lee's Store," where imported goods were sold or traded to his neighbors and to the Indians of the area. Mercantile and political business took him several times to England in the last decade of his life.

Richard Lee II (1647–1714), of the second generation of the family in Virginia (Fig. 90), was the primary beneficiary of Richard Lee the Emigrant's estate. He was sent to England to be educated, for his father accepted the credo so articulately expressed by his friend William Fitzhugh, about 1680, that children were "better never born than ill-bred" or poorly educated.[29] When Richard returned home, he was a scholar as well as a young gentleman. He could read Latin, Greek, and Hebrew fluently, and he began acquiring a library eventually totaling about three hundred titles, which was large by the standards of the day. Intellectual pursuits were never neglected, even as he attended to the business of his plantation and to his civil duties after being appointed, in 1676,

to the council in Governor Berkeley's second tenure. Lee was a staunch Episcopalian and was as devoted to the memory of Charles I as he was to the service of Charles II; several of his books were about these British monarchs, as well as about England, its traditions and heraldry, and its established church. By this generation the Lees thought of themselves, as Louis Wright put it, "as part of the hereditary gentility of England – English country gentlemen living on their Virginia estates."[30]

Men like Richard Lee II who wished to be continually improving themselves and their families as they rose to aristocracy often turned to courtesy books as guides. Lee owned several works on proper behavior, among them Richard Brathwaite's *The English Gentleman* (1630) and H. W.'s *The Accomplished Courtier* (1658). He may not have owned one of the old standards, *The Courtier* (1561) by Baldassare Castiglione, but he could have borrowed one of Ralph Wormeley's two copies, for this Renaissance treatise was still being read in the late seventeenth century by Cavalier English society and by those who were climbing socially toward it. Another reference source, listed in many early Virginia libraries, was Henry Peacham's *The Compleat Gentleman* (1622), which, as seen in Chapter 6, included a long section on painting and other arts. Of a more moralizing tone were the ever popular books by the Anglican minister Richard Allestree – *The Whole Duty of Man* (1659), *The Gentleman's Calling* (1660), and *The Ladies Calling* (1668). These courtesy books are interesting because they help the art historian, as well as the cultural historian, interpret social decorum as it is expressed in portraiture.[31] As it was essential that those acknowledged and generally accepted virtues of the gentry class be incorporated into the portrait image, it is essential that we know the doctrine that Allestree advocated.

Much of what a Virginian like Lee read in Allestree's *The Gentleman's Calling* must have seemed written with him in mind as master of great plantations and enormous wealth. The message was that a gentleman of inherited fortune should work at improving these temporal gifts and should not become idle and lascivious. The author declares on the first page that any man who dissipates such fortune as comes his way not only "falls justly under the blunt censure of folly" but, indeed, sins against God, who placed man in the world "not as a Proprietary, but as a Steward; [God] hath put many excellent things into his possession, but these in trust to be not only kept but negotiated with, and by traffick improved to the use of the true owner [God]."[32] Allestree was addressing the higher, wealthier levels of society, admonishing them not to overindulge in luxury and vanity, for he recognized that the rich as well as the poor needed a moral code to live by. Judging by the popularity of his books, especially among the gentry and even the highest aristocracy in England, he found an audience eager for the kind of guidance he provided. Before 1740 very few Virginians dissipated rather than improved the fortunes their fathers had bequeathed to them, for they diligently subscribed to the moral justification for their way of life that Allestree details:

> . . . he that hath not been excluded from the receipts, must not pretend an exemption from the disbursements, the tasks, but is under a strict obligation of improving what he hath thus received, of bringing in

fruit to the granary, as well in order to his own account and joy in the auditing of the harvest, as also to the glory of God, from whom alone he derives (and must impute) both the seed, and the irrigation, and the very increase. And he . . . that decently administers his province. . . . will find himself placed in such an active state of business, that he shall have little cause to suspect himself neglected, or forgotten by God and Nature, or placed in the world without a calling.[33]

Allestree further reminds his reader that gentlemen were separated from the "vulgar" in many ways – primarily by their education and knowledge, their wealth, their time for leisure, their authority, and their esteem and reputation; these, he claimed, were gifts from God and ought not to be wasted.

It would be an error to think that only the New Englanders had a moral and religious code to live by, and that Virginians were a Cavalier society lax in these matters. The codes of the two areas differed, to be sure, but not fundamentally. The southerner's code did allow a higher level of enjoyment of wealth, fashion, and refinement, following, as stated earlier, the model of the English gentry rather than that of the parsimonious London merchant whom New Englanders tended to emulate. But the Virginians who established the great plantations of the seventeenth and early eighteenth centuries were industrious, detested idleness, looked to God for a blessing on their labors, and abhorred the thought of squandering the gifts and opportunities God had placed in their hands. Many of them were, after all, only a generation or two removed from their middle-class, mercantile origins, and much of the moral code of that society lingered on even as they moved toward an aristocratic way of life.

Richard Lee II embodied the beliefs and characteristics just discussed, and his portrait confirms the traits of his class in its transition. The portrait shows a man about fifty years old, which would place its date in the late 1690s; it has been dated around 1707–8, but that seems a little late. The great wig and the costume are those of a man of wealth and position, but there is nothing lavish about them; although of current fashion, they are not emblems of *vanitas*. There is no haughtiness of demeanor but more an expression of quiet self-confidence and dignity; an egalitarianism among peers prevails, rather than a pretentiousness. The features of his face are, in fact, rather plain, and he accepted that they be painted that way, without the idealizing refinements of the true Knelleresque mode. It is a portrait from an early stage of aristocracy, bespeaking the subject's wealth, position, and justifiable (but not excessive) pride in himself and his accomplishments, and implying God's favor through His gifts, which the sober-looking Richard Lee was not wont to squander or misuse.

The portrait of Mrs. Richard Lee II is a visualization of the proper decorum and moral code set out by Allestree in *The Ladies Calling* (Fig. 91). Lettice, or Laetitia, Corbin (1657–1706), daughter of Henry Corbin, a wealthy Virginia planter, is represented as a woman of dignity – pleasant but reserved, plain yet attractive, refined but not vain. Most of these are the very qualities specified in Allestree's treatise, and the ones the subject would expect the portraitist to

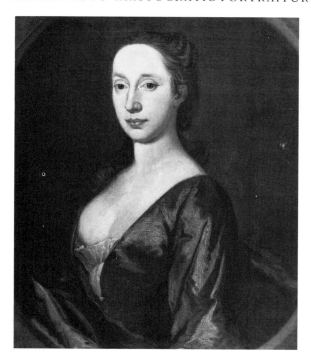

Figure 91. *Mrs. Richard Lee II*, artist unknown, c. 1705. Oil on canvas, 30 × 25 inches. Private collection.

capture. In her face one senses greater individualism than is found in the female stereotype of Kneller's portraits of women. Although the hairstyle and the gown are of the current fashion, neither is excessive or coquettish; their style is of a date somewhat later than that of the attire found in the *Richard Lee II*, perhaps about 1705, in the era of Queen Anne. The brushwork of the fabrics is more skillfully handled than similar passages in her husband's portrait, and the painting of the face has a beautiful simplicity. Because she is not known to have traveled abroad her portrait must have been painted in Virginia, indicating the presence of a very competent artist in the colony.

The portrait of Sir Edmund Andros (1637–1714) belongs to the late-seventeenth-century group we have been discussing (Fig. 92). Before Andros came to Virginia as governor in 1692, he had held that same high office in the colonies of New York and New England. He was very unpopular among New Englanders, and when news of the Glorious Revolution reached Boston in 1689, the Yankee merchants rather roughly packed him onto a ship for England, where he remained until he arrived in Virginia three years later to assume the duties of governor. It was probably during the interim in London, 1689–92, that he had his portrait painted. Mary Beale (1632–1697), best known of the women painters of seventeenth-century England, has been suggested as the artist. She was a student of Robert Walker but copied many works by Sir Peter Lely, thus absorbing something of the latter's style.

In his portrait Andros wears a very long, curled fashionable black wig, a

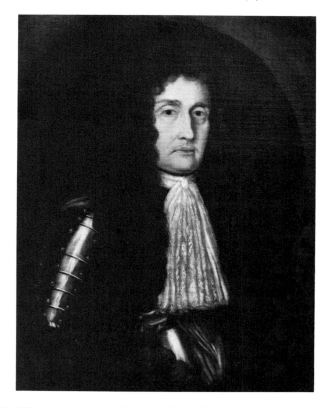

Figure 92. *Sir Edmund Andros*, attributed to Mary Beale, c. 1690. Oil on canvas, 30 × 25 inches. Virginia Historical Society, Richmond.

lace cravat, and a suit of armor draped with a sash. The armor refers not only to military authority as governor but also to his earlier service as a major with the English garrison in the West Indies. His image is sober, steady-eyed, and possessed of those class characteristics outlined in Allestree's *The Gentleman's Calling*. In Jamestown, Andros's portrait, which belongs to the period of William and Mary, was probably flanked by images of their royal highnesses, for that would have been quite normal in the official quarters of their colonial representative, in Virginia as elsewhere throughout the worldwide British Empire. Even before the locus of imperial power in Virginia was transferred from Jamestown to the elegant new Capitol and Governor's Palace in Williamsburg in the years following Andros's tenure, portraits of the chief executive and the reigning monarchs, hanging in gubernatorial chambers, would have suggested to men then aspiring to aristocracy that they should have portraits on the walls of their houses as well.

Taken together, the portraits of William Fitzhugh, William Randolph, Robert Bolling, Richard Lee II, and Edmund Andros form a coherent group, as much in general style as in the cultural qualities they exude. Plain of feature and sober in expression, dignified, avoiding aristocratic pretensions yet emulating aristocratic models, painterly in brushwork but somber of palette, thoroughly baroque in conception and execution – they constitute a period in

the history of Virginia portraiture unto themselves. Although some of the class characteristics found in them reappeared in the images of the generations of Virginians who followed, there would be a noticeable change from the reserved gravity that they possess. Whereas certain middle-class restraints still lingered in their likenesses, the portraits of early-eighteenth-century Virginians would move in the direction of aristocratic Georgian elegance. A new breed would rule the Old Dominion, and a new style would be employed to portray it.

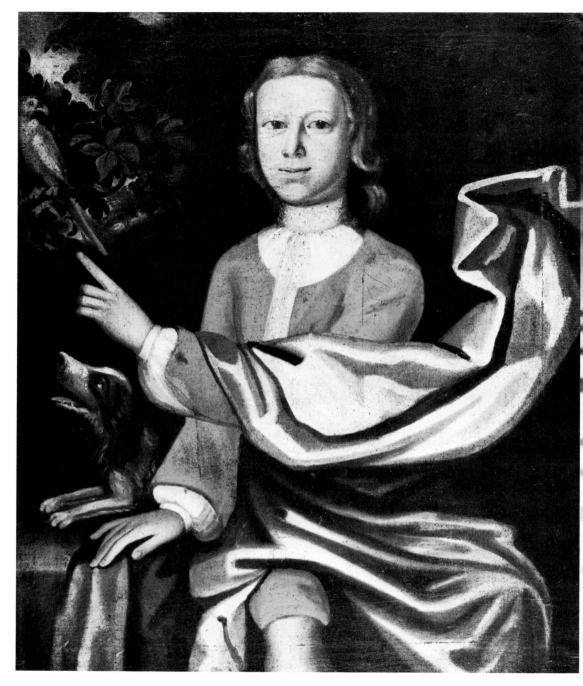

Figure 93. *Edward Jaquelin, Jr.*, attributed to Nehemiah Partridge, c. 1722. Oil on canvas, 31 ½ × 26 inches. Virginia Museum of Fine Arts, Richmond. [See text, p. 199.]

The Aristocratic Fluorescence in Virginia, Part I

Provincial Portraits and London Dandies

Wills, inventories, and public records indicate that the number of portraits in Virginia increased remarkably during the first decades of the eighteenth century. In 1704, for example, Governor Francis Nicholson paid eleven pounds to have Sir Godfrey Kneller's portrait of Queen Anne installed in the new Capitol in Williamsburg.[1] The last testimony of William Churchill of Middlesex County, of 1710, lists ten pictures with gilt frames, while the inventory of the estate of Edmund Berkeley, a member of the Council, taken in 1719, refers to "The portraiture of his sacred Majesty in his solitudes and sufferings [Charles I]..., his own [Berkeley's] and his Ladies pictures. Eleven house pictures. King William & Queen Mary [in] Smal."[2] The inventory of Maximilian Boush of 1728 further suggests the variety of subjects as well as devotion to the ruling family: "Queen Anne & Prince Geo[rge]: pictures... in large gilt frame, 10 Small D° & 2 wth black frames... [and a] prospect of St. Pauls Cath Church."[3] William Dunlop (d. 1739) left in his estate a collection of portraits of English dignitaries, almost certainly mezzotints rather than paintings, because the inventory includes portraits of "Sir William Temple, Lord Shaftsburg [sic], Duke of Buckingham, Lord Godolphin, Lord Oxford, Bolingbroke, Lord King, Milton, Gay, Rowe & Mrs. Howard in frames and glasses with gold edges... and 6 pictures without frames."[4] Also from 1739, the will of Captain William Rogers refers to one "Dutch picture in gilt frame, 7 cartoons [drawings?], 4 glass pictures... and three small pictures, a neat picture of Charles II."[5] And as a final example, the will of 1742 of Henry Hacker, a prominent merchant of Williamsburg, mentions "16 framed pictures, and prints."[6] These records demonstrate that pictures hanging on the walls of plantation houses were fairly common in Virginia in the early eighteenth century; they are, of course, in addition to the known portraits, which have survived in rather large number.

As Virginia planters and their families became increasingly devoted to the gracious life of gentility, their portraits mirrored the constant metamorphosis. A new and elegant architectural setting appeared with refined interiors that called for high-style images. In the seventeenth century, Virginia houses, even among the large landowners, were usually of wood-frame and clapboard construction, modest in design, and of only about four to seven small rooms with whitewashed walls. But the finer homes and public buildings of the first half

of the eighteenth century were of a very different design, size, and character. By then many a son and occasionally a daughter of an early Virginia planter had been to England and had seen or heard about Chatsworth, Chiswick, Blenheim, and, of even greater importance as models for Virginia homes, a host of country houses of the gentry; they had seen the churches and municipal buildings designed by Sir Christopher Wren and James Gibbs. Back home, once they had become masters and mistresses of the family estates, they wanted stately homes in the sophisticated new late baroque or early Georgian styles, and the results established one of the high points in the history of American architecture. The transformation began in Williamsburg shortly before the turn of the century with the so-called Wren Building at the College of William and Mary, which dates from 1695 to 1702. Then came the Capitol (1701–5) and the Governor's Palace (1706–20), followed by Bruton Parish Church (1710–15) and Brafferton Hall (1723) at the college. All were imposing brick edifices with handsome architectural details in the classical manner of that day. In the exquisite homes that arose soon afterward, also made of brick, all vestiges of a surviving medieval heritage were purged as the new style swept from plantation to plantation. This was the era that saw the construction of "King" Carter's Corotoman (1715–20) and Thomas Lee's Stratford Hall (1725–30); about 1726, Benjamin Harrison was building Berkeley on the banks of the James; Rosewell (1726–30) was the home of the Page family, and Nomini Hall (1725–32) was built by Robert Carter; about 1730, Landon Carter was building Sabine Hall, while William Byrd II's magnificent Westover dates from the years 1730–34. These homes, set amid spacious lawns and cultivated gardens and orchards, had rooms that became more spacious, with high ceilings and large windows, and they were more numerous, ranging from eight to sixteen. There were now rooms for specialized activities that reveal the increased sophistication of life – such as dining rooms, social rooms for balls or assemblies, libraries, and accommodations for guests. From England came elegant furniture of the latest style, as well as beautiful fabrics and handsome carpets to adorn the interiors, which glistened with inherited and recently imported silver; musical instruments became standard items among salon furnishings. The fashionable attire of the household further graced the ambience as the wealthy planters and their families began to live in every way the life of the English gentry. The Reverend Hugh Jones, in *The Present State of Virginia* (London, 1724), described life in the colony in Governor Spotswood's time:

> The habits, life, customs, computations &c of the Virginians are much the same as about London, which they esteem their home; the planters generally talk good English without idiom and tone and can discourse handsomely upon most common subjects. . . . They live in the same neat manner, dress after the same modes, and behave themselves exactly as the gentry in London.[7]

So the rough edges and middle-class traits of an earlier generation have been polished to a fine gentility among the heirs of the Byrds, Carters, Lees, Burwells, Pages, Fitzhughs, Bollings, and so on. The transformation is as apparent in the portraits of this younger generation as in the other aspects of their lives just noted.

The portraits are generally of two types: In one, a largely self-taught artist expressed the social aspirations of the new aristocracy in a provincial manner that imitates the appearance of the current English style of painting without fully understanding its nuances and techniques; the other is of the type painted in London while the subject was there, executed by a broad variety of artists ranging from Sir Godfrey Kneller himself to the lesser lights of his students, followers, and successors.

The Jaquelin and Brodnax family portraits are excellent examples of the former type. The group, now at the Virginia Museum of Fine Arts, includes likenesses of Mrs. Edward Jaquelin, Sr., and her children, Edward, Jr. (Fig. 93), Matthew, Elizabeth, Elizabeth Rebecca, and Martha (Fig. 94), and William Brodnax (Fig. 95) and his wife Rebeckah, their two sons, William II and Edward (Fig. 96), and a daughter, Elizabeth (Fig. 97). There is also a portrait of Frances Parke Custis which is now at Washington and Lee University (Fig. 98). They were painted around 1722–23, and are perhaps the work of Nehemiah Partridge, who had been active in the Hudson Valley.[8] Governor Spotswood led a delegation of Virginians to Albany, New York, in the late summer of 1722 to arrange a treaty with the Iroquois Indians; there he or others of his group may have met Partridge and arranged for him to visit Virginia.[9]

The Jaquelins and the Brodnaxes were among the leading families of Jamestown. Edward Jaquelin I (1668–1730) was of French origins and had made his way to England after the revocation of the Edict of Nantes before emigrating to Virginia in 1697. He first married the widow of William Sherwood and thereby became the owner of nearly four hundred acres on Jamestown Island; in 1706 he was married a second time, to Martha Cary, by whom he had several children, portraits of two of whom are illustrated here. Edward Jaquelin evidently approved of the Hudson Valley artist's practice of drawing heavily on mezzotints of English aristocracy for the compositions, poses, and details in the portraits he painted. It gave a decided aristocratic flavor to the likenesses, even though the painter's style lacked the aesthetic subtleties of the prints. The portrait of young Edward Jaquelin, Jr. (1716–34), is clearly modeled after John Smith's mezzotint of the Honorable William Cecil, with only the slight alteration of substituting a bird native to Virginia (Fig. 93).[10] Edward's sister Martha Jaquelin (1711–92) is shown with a delightful still life of fruit, and she wears a light yellow dress with a varicolored silk mantle about her shoulders (Fig. 94). The pose, gesture, and detail of the still life are taken from John Simon's mezzotint of *Lady Carteret* (c. 1690).[11]

The Brodnax family was implanted in Virginia in the middle of the seventeenth century with the arrival of Major John Brodnax, a loyalist officer in Charles I's army who left England at the beginning of the Commonwealth. His son, Robert, was a goldsmith in London, and he seems to have remained in England all his life, but Robert's sons, John and William, immigrated to Virginia, where they prospered. John Brodnax (1668–1719) first settled in Henrico County, then moved to Williamsburg, where he, too, was a goldsmith. John's younger brother, William (1675–1727; Fig. 95), settled on Jamestown Island and married first the widow of Edward Travis and later Rebeckah (1677–1723), who was the mother of William, Edward (Fig. 96), and Elizabeth Rebeckah (Fig. 97).

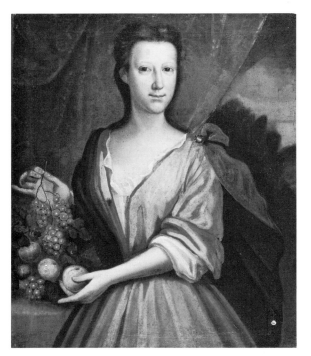

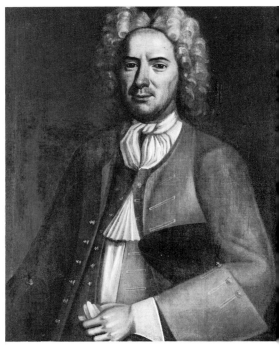

Figure 94. *Martha Jaquelin*, attributed to Nehemiah Partridge, c. 1722. Oil on canvas, 30 × 25 inches. Virginia Museum of Fine Arts, Richmond.

Figure 95. *William Brodnax*, attributed to Nehemia Partridge, c. 1722. Oil on canvas, 30 × 25 inche Virginia Museum of Fine Arts, Richmond.

The Brodnax portraits, like those of the Jaquelin family, belong to a style developed in the Hudson Valley between about 1710 and 1720. That style is a provincial version of the late baroque English portrait transmitted to the colonies by means of mezzotints. The *William Brodnax I* is similar to New York portraits of, say, Colonel Philip Schuyler and Thomas Van Alstyne (both at the New-York Historical Society), of Pieter Waldron (private collection), and of Anthony Van Schaick (Albany Institute of History and Art).[12] The dependency on English mezzotints is seen in the style of painting, particularly in the tonality and the manner of rendering highlights in broad ribbons along the folds of garments; it is further seen in the poses, gestures, and auxilliary details. The *Elizabeth Rebeckah Brodnax*, for example, is based directly on John Simon's mezzotint of Princess Anne (1720), after the portrait painted by Kneller.[13]

The portrait of Frances Parke Custis (1710–44) also belongs to the group painted by the visiting artist from the Hudson Valley (Fig. 98). The subject was the daughter of Frances Parke and John Custis III of Williamsburg and the granddaughter of Col. Daniel Parke; she was related to William Byrd II, her mother's sister, Lucy Parke, being Byrd's first wife. As a Custis, she belonged to one of the most distinguished families of the emerging Virginia aristocracy. An interesting comparison is made between her portrait and the almost contemporary *Evelyn Byrd* (c. 1725; Fig. 103); the latter, painted in England, possesses every characteristic of the London high-style portrait of

re 96. *Edward Brodnax*, attributed to Nehemiah Par-
;e, c. 1722. Oil on canvas, 30 × 25 inches. Virginia
eum of Fine Arts, Richmond.

Figure 97. *Elizabeth Brodnax*, attributed to Nehemiah
Partridge, c. 1722. Oil on canvas, 30 × 25 inches.
Virginia Museum of Fine Arts, Richmond.

its day, whereas the *Frances Parke Custis* is a perfect example of the provincial
version of that style.

The early eighteenth century provincial painter in America frequently relied
heavily on the English mezzotint because he had no other school or master to
learn from. The pictures discussed in the remainder of this chapter, however,
did not have that dependency, for they were painted in England, and English
artists, trained under successful masters, did not feel compelled to copy from
mezzotints, at least not as closely and not as often. Of course, England, too,
had its provincial centers, in places well away from London, and in them one
sometimes finds portraits that form a middle ground between the highest style
of the London studios and the mannered style practiced in the colonies by
such painters as Nehemiah Partridge. A good example of this work is the
portrait of John Baylor (Fig. 99).

John Baylor (1705–72) was the son of John and Lucy Todd Baylor of King
and Queen County. He was sent to England to be educated and attended the
Putney Grammar School before going to Cambridge University. Returning
home a polished young gentleman, he eventually became master of large estates
in Caroline and Orange counties. At Baylor's principal estate, New Market,
his great passions were breeding Thoroughbred horses and lavish living in
general, interests he acquired during his youth in England. His portrait would
do honor to any young man of the English country gentry, and it expresses
well the self-confidence and self-esteem of a scion of Virginia planter aristoc-

Figure 98. *Frances Parke Custis*, attributed to Nehemiah Partridge, c. 1722. Oil on canvas, 30 × 28½ inches. Washington and Lee University, Lexington, Va.

Figure 99. *John Baylor*, artist unknown, c. 1722. Oil on canvas, 48¾ × 40 ¼ inches. Virginia Historical Society, Richmond. Presented by Pelham Blackford, Jr., 1977.

racy. In it, he appears to be about seventeen, and his white wig and the sword at his side suggest he has arrived at an age when he was to be considered a young gentleman rather than a boy. A date of about 1722 seems reasonable, and the style of his blue coat, waistcoat, shirt and black cockade hat would agree with such a date. By that time Baylor was a student at Cambridge, which was, insofar as painting was concerned, a provincial center. The bravura of the brushwork that enlivens the forms and surface of a portrait by Kneller is not a part of the aesthetic of the *John Baylor*. A smooth application of pigment and smooth transitions of tone from shadows to highlights, plus a crisp, linear definition of form characterize the portrait, and the provincial nature of its style becomes apparent if it is compared with the *William Byrd II* (Fig. 105), which came out of the immediate circle of Kneller's London studio. In the *Baylor* the baroque mode is beginning to give way to the Georgian style, which will eventually dominate colonial American portraiture.

William Byrd II (1674–1744) was the quintessence of the Virginia aristocracy of the first half of the eighteenth century. Before turning to his life and his collection of portraits, however, we should note the background from which he emerged. His father, William Byrd I (1652–1704), the emigrant, was the son of a London goldsmith named John Byrd. The latter's wife had a sister

married to Thomas Stegg, who had inherited large tracts of land in Henrico County, Virginia, near the site of present-day Richmond. William was his heir when Stegg's will was proved in May 1671, and sometime soon after that the young man emigrated to Virginia to assume charge of his inheritance. There he married Mary Horsmanden, daughter of a royalist officer who had fled the Cromwell regime in England. In 1674 the first of their five children was born – William Byrd II.

Henrico County was then on the very edge of the wilderness, which facilitated the elder Byrd's trade with the Indians. With neighboring plantations he also traded in slaves, indentured servants, tobacco, imported goods from England, and rum, sugar, and molasses from the West Indies via New England ships. He was, in every essential way, a merchant, with the characteristics of that group. But in Virginia the way to wealth was through land, tobacco, and political office. From his outpost on the perimeter of civilization, William Byrd I became a member of the House of Burgesses in 1677 and three years later was named to the Governor's Council, of which he became president the year before his death. All the while he was acquiring land, until he had amassed holdings of more than 26,000 acres, mostly in Henrico County but some at a site called Westover. In 1691 he moved there to escape the raw frontier and to be nearer the center of political activity in Jamestown and, later, Williamsburg. At Westover he built an unpretentious frame house and began to fill it with imported furniture. But although rising in wealth and political position, Byrd disdained a lavish life-style; his middle-class background prevailed even as he became master of broad estates. When William I died in 1704, he left both of his surviving daughters one hundred pounds each; the rest of his estate went to William Byrd II, who by then had become a London dandy.

As a boy, William II had been sent to England to one of the finest grammar schools, and at age sixteen his father arranged for him to go to Holland to learn business and trade in a mercantile house. By 1690 he was back in London working for a mercantile firm, but within two years he entered Middle Temple to study law and was soon admitted to the bar. He returned to Virginia in 1696, and was elected to the House of Burgesses, but within the year he was again in England.

Restoration gaiety still prevailed in London, and William Byrd II entered into it with full gusto. He was, in those years, a dashing young gallant of keen wit, with a brilliant flair, a taste for high fashion, and a constant succession of merry "jades," as he called his bawdy women companions. Byrd was part of a glittering social whirl in the company of wits at coffeehouses, private clubs, and the theater, and his intimate circle of friends included a distinguished assortment of the English aristocracy. Sir Robert Southwell (Fig. 101), his guardian during his student years and a learned scholar and diplomat, arranged his election to the Royal Society. While traveling on the Continent the handsome young Virginian visited the great palace at Versailles, where in a supreme social coup, he was received by King Louis XIV. In London he met the lustrous group of literary figures that included Alexander Pope, William Congreve, and Jonathan Swift, and he observed the funeral of King William and the assumption of Anne as queen. His portrait of about 1704 reveals the elegant life-style to which he had become devoted (Fig. 105). By 1704, when his father

died, the gracious, sophisticated, and witty character of the thirty-year-old Virginian had been established, and the following year he returned home to assume charge of his sizable inheritance.

In Virginia, soon after his return, he became receiver general for the Crown and in 1709 he was appointed to the council by Governor Francis Nicholson; he would remain a member of that body for the rest of his life. Meanwhile, he began to increase his lands, and by his death in 1744 he would own nearly 180,000 acres, much of which was in the tobacco fields of several plantations that were tilled by slaves and looked after by overseers. In 1706 he had married Lucy Parke, whose father was Colonel Daniel Parke. A daughter, Evelyn (Fig. 103), was born in 1707, and in 1715 the Byrds took Evelyn with them to live in London for five years. During that period, Lucy died. Byrd was home in Virginia again in 1721 but then returned to London as colonial agent for another five years. In 1724 he married Maria Taylor (Fig. 104), the daughter of Thomas Taylor, a gentleman of Kensington. Their first daughter, Anne, was eventually to marry Charles Carter of Cleve, while a second daughter, Maria, would be wed to Landon Carter of Sabine Hall, both thus becoming daughters-in-law of Robert "King" Carter. A third daughter, Jane, married John Page of North End. A son, William Byrd III, who would become his father's heir, married Elizabeth Hill Carter. Thus did the leading families of Virginia become intertwined in a way not unlike the English aristocracy.

William Byrd II returned to Virginia for good in 1726, but the lingering visions of English country houses in the new Georgian fashion and the genteel ways of the English gentry caused him to create at Westover an ambience of grace and refinement unsurpassed in the colonies. He replaced the old frame house his father had built with an elegant brick mansion (Fig. 100). The two-story central block, with hipped roof and dormers and four tall chimneys, rivaled the Governor's Palace in nearby Williamsburg, and such architectural adornments as the handsome stone doorways with their elaborate scroll entablatures resemble designs found in William Salmon's *Palladio Londinensis*, which was published in 1734, the year Westover was completed. Byrd accumulated one of the finest libraries in North America, equaled in number only by that of Cotton Mather in Boston. Among its 3,600 volumes were several books on architecture, including editions of Vitruvius and Palladio, which were no doubt used in designing his magnificent new showplace on the banks of the James River. Byrd's library is interesting in other respects as well. We know it contained a copy of Allestree's *The Whole Duty of Man* because in his diary, under date of September 7, 1712, Byrd mentions reading it. His collection also included a number of books on art, such as Du Fresnoy's *The Art of Painting* (1695); de Piles's *Dissertation sur les Ourages des plus fameux Peintres* (1681), *The Art of Painting* (1706), and *Principles of Painting* (1743); Elsum's *The Art of Painting, After the Italian Manner* (1703); Shaftesbury's *Characteristicks* (1711); Montfaucon's *L'Antiquité expliquée, et représentée en figures* (1719); and a volume listed as *Painting of the Ancients* (? George Turnbull, *A Treatise on Ancient Painting*, 1740). Byrd had a gentleman's interest in art, and while he was in England in 1717–19 he took lessons from a well-known watercolorist named Eleazar Albin (active 1713–59). Byrd's library at Westover indicates some knowledge of the fine arts and an awareness of the current taste

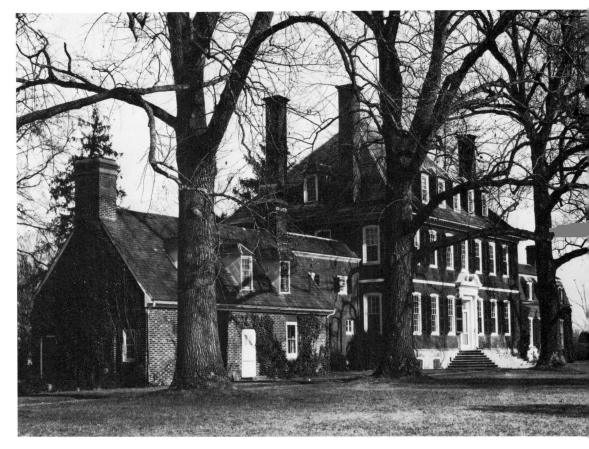

Figure 100. Westover, Charles City County, Virginia. Central section, 1730–34.

in such things. After Westover was completed, he filled it with imported Georgian furniture, silver, cut glass, and such other items as he felt necessary to create an outpost of English elegance in the distant colony.

Not the least of the many things setting Westover apart was the extraordinary collection of portraits that graced its walls.[14] There were more than forty of them; several were of family, but many were Byrd's dear friends in England, with some of whom he continued to correspond. There were portraits of Sir Robert Southwell (Fig. 101) and his wife Lady Elizabeth Southwell; of Lord Oxford and Lord Egmont; of the Duke of Argyll in his steel corselet and scarlet mantle, and of Charles Boyle, the Earl of Orrery; of the Earl of Albemarle and the Marquis of Halifax; of Sir Charles Wager and Sir Wilfred Lawson, third Baronet of Brayton (Fig. 102); of Lady Betty Cromwell and the Duchess of Montague, the daughter of the Duke of Marborough; and of Sir Robert Walpole the Prime Minister – a lordly assemblage indeed.[15] The extent to which Byrd treasured these effigies of his noble friends is revealed in a letter he wrote on July 12, 1736, to John Percival, Lord Egmont, evidently soon after the portrait of the latter had arrived:

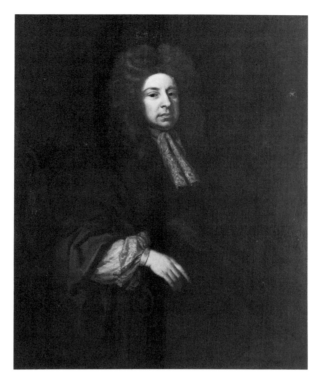

Figure 101. *Sir Robert Southwell*, copy (before 1724) by an unknown English artist after the original of c. 1695 by Godfrey Kneller. Oil on canvas, 50 × 40 inches. Virginia Historical Society, Richmond. Presented by the Ethyl Corporation through Floyd D. Gottwald.

> My Lord. I . . . have the pleasure of conversing a great deal with your picture. It is uncomparably well done & the painter has not only hit your air, but some of the vertues too which usd to soften & enliven your features. . . . I was pleased to find some strangers able to read your Lordships character on the canvas, as plain as if they had been physiognomists by profession.[16]

Visitors to Westover were obviously studying the distinguished gallery, and Nathaniel Walthoe (d. 1772), clerk of the House of Burgesses, was so impressed that he had his own portrait painted and said he would leave William Byrd a diamond ring if he would hang his likeness among the others, to which the lord of Westover good-naturedly agreed.[17] There was reportedly a painting by Titian in the collection, as well as one by Rubens.

In addition, there were the handsome family portraits, of William Byrd, of Lucy his first wife and Maria his second wife, of his oldest daughter, Evelyn, and another daughter, Wilhemina, and of the four children of Maria Taylor Byrd. Evelyn was a beautiful and charming young woman (Fig. 103). She was educated in England and presented to society, and was very popular in London. Her portrait was painted in England, probably around 1724 when she was eighteen and just before Byrd returned to Virginia for good. Sir

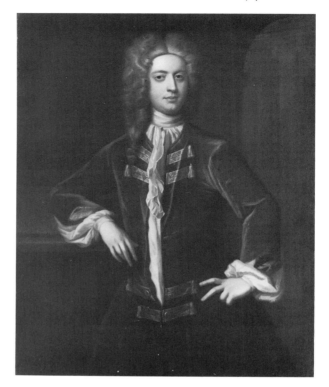

Figure 102. *Sir Wilfred Lawson*, by an unknown English artist, 1720–25. Oil on canvas, 50½ × 39½ inches. Colonial Williamsburg Foundation, Williamsburg, Va.

Godfrey Kneller was dead by then, but Evelyn's portrait is in his style and must be the work of one of Kneller's close followers. She sits in an outdoor setting, wearing a lovely light blue gown and holding a straw hat decorated with flowers and a shepherd's crook in reference to the pastoral theme popular in the eighteenth century. More flowers adorn her hair, a lock of which curls sensuously down over her right shoulder. In what was perhaps a visual pun, a bird is perched on a limb in the upper left. It is an elegant, aristocratic portrait that would have pleased any connoisseur among the English gentry.

The portrait of Maria Taylor Byrd (1698–1771) was also painted in England, about the time of her marriage to William Byrd (Fig. 104). It, too, is a three-quarter length with the subject placed in an outdoor setting. She wears a beautiful pale blue gown of the latest fashion with a low neckline, and the folds of the satin fabric are painted in an exquisite manner betraying the sensuousness and love of finery of that age. This portrait, too, belongs to the tradition of early-eighteenth-century English aristocratic portraiture that followed in the wake of Kneller's brilliant career. At one time it was attributed to Charles Bridges, but it is better than Bridges' work at its best; that attribution was probably made because William Byrd is known to have employed Bridges at Westover in 1735–36. The *Maria Taylor Byrd* represents a new kind of image for the colonies, and it and the *Evelyn Byrd* were among the first, if not the first, of the elegant, three-quarter-length, London high-style portraits in the

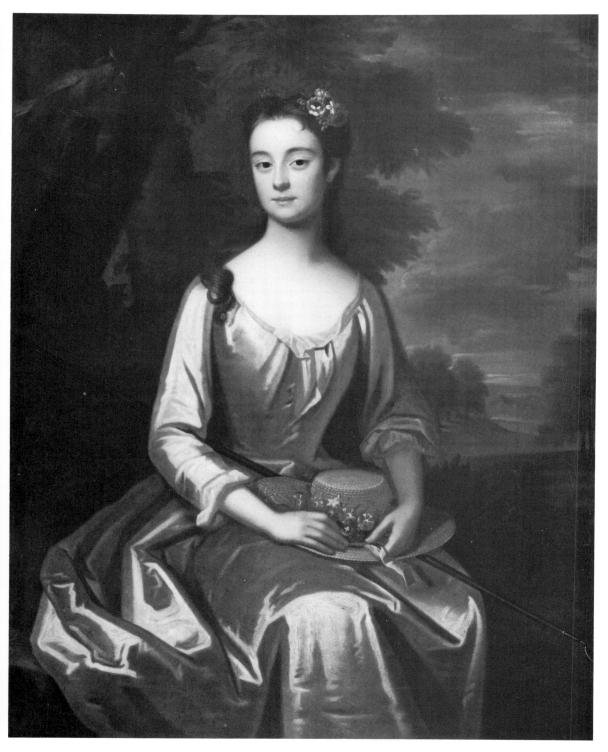

Figure 103. *Evelyn Byrd*, by an unknown English artist, c. 1724. Oil on canvas, 50¼ × 40¼ inches. Colonial Williamsburg Foundation, Williamsburg, Va.

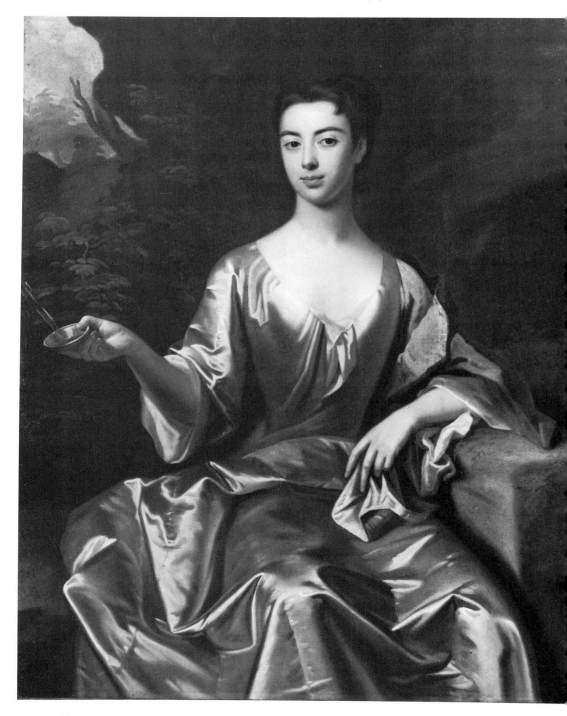

Figure 104. *Maria Taylor Byrd*, by an unknown artist, c. 1724. Oil on canvas, 49½ × 40 inches. Metropolitan Museum of Art, New York, Fletcher Fund, 1925.

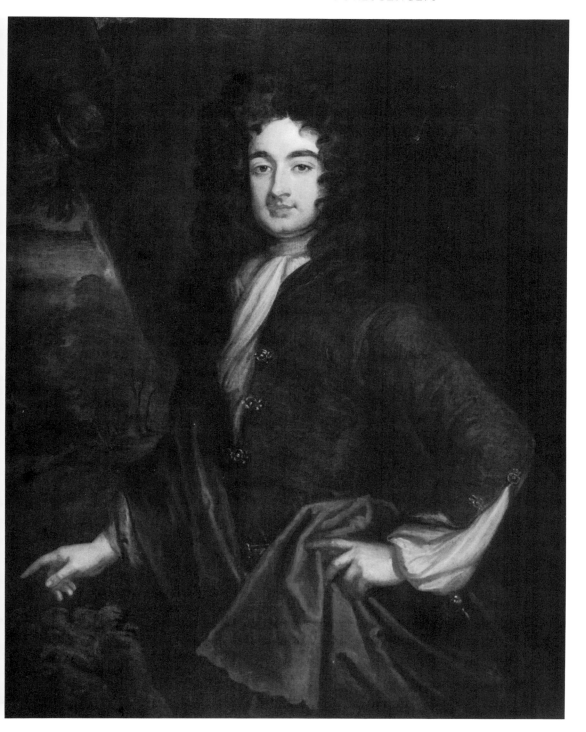

Figure 105. *William Byrd II*, attributed to Sir Godfrey Kneller, c. 1704. Oil on canvas, 49½ × 39¾ inches. Colonial Williamsburg Foundation, Williamsburg, Va.

colonies. Smibert would not bring this type of fashionable late baroque portrait to New England until 1729; in fact, it was this type of portrait that Smibert was trying to achieve in his *Mrs. Francis Brinley and son, Francis* (Fig. 80). One could also compare the portraits of the Byrd women with Smibert's portrait of Mrs. Samuel Browne, Jr. (Fig. 82). But whereas Smibert's portraits of women soon began to show the alteration of his style brought on by the provincial, middle-class, mercantile nature of his patrons, the images of the proud Byrd women are thoroughly English and unabashedly aristocratic.

Finally, there are the portraits of the master of Westover himself. Three portraits of William Byrd are mentioned in his will and there are two now known, although one of these probably was never at Westover because it was painted as a gift to the Earl of Orrery (Figs. 105 and 106). Each of the two known portraits is three-quarter length, showing the subject handsomely attired, and each was painted in England. There seems to be a problem, however, as to which was painted first and which was retained in the family while the other went to Orrery. The portrait at the Virginia Historical Society shows a man of maturity, perhaps in his forties, steady of eye, and less robust and less active than in the other picture. The other image of Byrd, at Colonial Williamsburg, is of a younger man, perhaps in his early twenties, a dandy and a sartorial fashion plate of the day, with an abundance of youthful vigor – a bit of a strutting peacock. And yet the likeness at the Virginia Historical Society is said to have been painted about 1704 (when Byrd was thirty) and reportedly was the one given to the Earl of Orrery, whereas the one at Colonial Williamsburg is thought by some to have been executed about the time of Byrd's second marriage in 1724 (when he was fifty) as a companion to the portrait of Maria Taylor Byrd. On the back of the Virginia Historical Society picture (Fig. 106) is an inscription that reads: "The picture of Wm. Byrd Esqr. of Virginia Given by him to Charles Earl of Orrery. Anno 1725." An account of its provenance, as "traced by the father of the donor," William Byrd of Princeton, New Jersey, is also given:

> The portrait . . . was painted by Sir Godfrey Kneller in 1704 and hung in Colonel Byrd's house in London until 1725. In that year it was given by Colonel Byrd to his friend Charles Boyle, fourth Earl of Orrery. On the original canvas back of the portrait there was a notation to this effect in the handwriting of the Earl of Orrery.[18]

Then follows a sequence of owners for the portrait, which descended in the Otway family in England. All of this would seem to indicate that the Virginia Historical Society portrait was the earlier representation of Byrd.

There are occasions, however, when the art historian or connoisseur simply must rely on his eye, even in spite of documentary evidence that indicates some other explanation. In my opinion, the Colonial Williamsburg portrait was painted when William Byrd was a dashing young gallant, wit, ladies' man and charming man-about-town, in his early years in London, sometime around 1697 to 1704; it may well have been painted by Sir Godfrey Kneller himself. The picture at the Virginia Historical Society is of an older Byrd, painted sometime before his final return to Virginia, or about 1724 to 1726, and left as a memento with his friend the Earl of Orrery. The "Anno 1725" inscribed

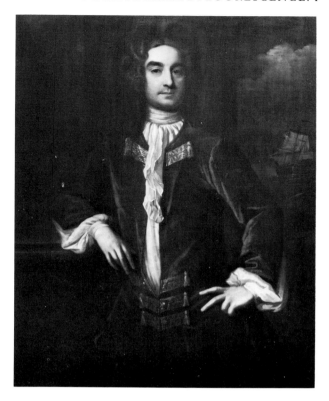

Figure 106. *William Byrd II*, by an unknown English artist, c. 1724. Oil on canvas, 50 × 41 inches. Virginia Historical Society, Richmond. Presented by William Byrd of Princeton, N.J.

on the back probably refers to the date it was given to Orrery rather than to the date it was painted. In the Williamsburg portrait there is a youthful plump-ishness to the face, and the elaborate curled wig that falls over one shoulder and down to the pectoral area of the other side suggests a French influence that may have been a result of the subject's visit to the court of Louis XIV at Versailles. It is an exquisite portrait of the high baroque period, whereas the one at Richmond, although well executed, is more a competent portrait than an exciting painting, aesthetically speaking, and shows a sedate stage of the baroque style, as practiced just before the appearance of the Georgian version of the rococo style. In any case, William Byrd had himself portrayed with all the aristocratic demeanor that the best London portraitists could achieve. Either portrait would have expressed well the sentiments that the lord of Westover had about himself and his position in English and Virginian society. The Williamsburg portrait, hanging at Westover, represented the highest standard of English portraiture then known in the American colonies, and its aristocratic image undoubtedly encouraged other wealthy Virginia planters to have them-selves similarly portrayed.

The Aristocratic Fluorescence in Virginia, Part II

"Pray go very clean, neat, and handsomely dressed to Virginia"

The Carters were among the most prominent of early Virginia families, and a pair of portraits at Shirley Plantation will represent that distinguished line here (Figs. 107 and 108). John Carter I, whose family came from Buckinghamshire, emigrated to Virginia in 1649 as a royalist and a staunch Anglican escaping the Puritan regime. Although something less than a Cavalier, he was evidently a man of some means and culture. He married Sarah Ludlow and established himself on a site he named Corotoman, near the place where the Rappahannock River flows into Chesapeake Bay. During the next two decades he prospered, becoming a member of the Governor's Council; when he died in 1669 he left a considerable estate, the largest part of which went to his eldest son, John II. But John II died early, in 1690, and Corotoman and the bulk of the Carter properties passed to seventeen-year-old Robert (1663–1732). By the time of the latter's death his estate would grow to 300,000 acres, 1,000 slaves, and £10,000 in money; these holdings plus a proud and imperious attitude would earn him the epithet of "King" Carter. Within a year of his brother's death Robert was elected to the House of Burgesses, serving twice as speaker, until 1699 when he became a member of the Governor's Council, of which he was president from 1726 to 1732. As agent for the Fairfax family of England, which held the royal patent to nearly all of the Northern Neck (the area bounded by the Potomac and Rappahannock rivers and Chesapeake Bay), he granted enormous tracts of land to himself and members of his own family, thereby securing much of the region around Corotoman to his own estate.

"King" Carter, devoted to the cause of education for the ruling class, sent his five sons to England to acquire both knowledge and the proper behavior of gentlemen, which were inseparable as far as he was concerned. He was, however, opposed to the vanities of London and once wrote to his son John III not to be so concerned that some of his fellow students were better dressed than he, and to think more about his learning. At home, Carter was an ardent supporter of the newly founded College of William and Mary, of which he was a trustee. His own personal library reflected a combination of practical, religious, and genteel interests; it also contained many books that showed a desire to maintain connections with English traditions, such as biographies of English monarchs and histories of the realm. He informed himself about life at the court of Queen Anne through two volumes on that subject, and he read

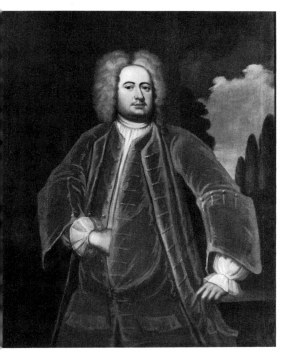

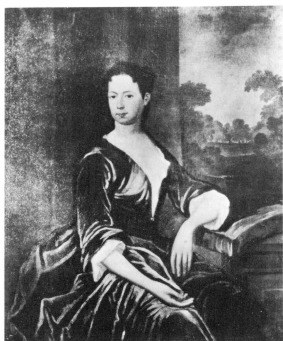

Figure 107. *Robert "King" Carter* or *John Carter III*, artist unknown, c. 1730. Oil on canvas, 49¾ × 40¼ inches. Shirley Plantation, Charles City County, Va. Photo, Colonial Williamsburg.

Figure 108. *Judith Armistead Carter* or *Elizabeth Hill Carter*, artist unknown, c. 1730–35. Oil on canvas, 49½ × 40 inches. Shirley Plantation, Charles City County, Va. Photo, Frick Art Reference Library.

about a gentleman's morality and relationship to God in Richard Allestree's *The Gentleman's Calling*; the latter, as we have seen, stressed the gentleman's social, civil, and religious responsibilities because of his preferred position in education, wealth, authority, and leisure, and it reminded the reader that he possessed these things as gifts from God. Carter once wrote to a William Dawkins in England that "We are but stewards of God's building: the more he lends us, the larger accounts he expects from us."'

In religion "King" Carter was devoted to the Church of England, and his own library contained more than fifty volumes of sermons and treatises on Christian ethics and Christian philosophy. That he saw himself as the overseer of the welfare of the Anglican church in his region is demonstrated by his paying the expenses for building the beautiful Georgian-style Christ's Church in Lancaster County, near Corotoman.

Corotoman, which no longer survives, must have been one of the grandest of the plantation mansions. Reportedly, Carter built it with the intention of rivaling the Governor's Palace at Williamsburg. Commenced about 1715, it was large, elegant in design, and sumptuous in its interior furnishings; it was probably the prototype for the several great houses Carter built on separate plantations for his children, as well as for other Virginia mansions of the first half of the eighteenth century.

Unfortunately, little is known about the portraits that were at Corotoman.

From Carter's diary we learn that in 1727 he "sat to painter" at Corotoman, indicating the presence of an artist in Virginia at that time; but the diary gives no clue as to the painter's identity.[2] There were, in the great mansion, two pairs of portraits of Carter and each of his wives, as well as likenesses of his children, for in his will of 1726 he declared that of "my pictures each child to have his own picture, my son [blank; probably John III, his first son] to have my first picture and his mother's . . . and my son Robert to have my other picture & his mother's picture." Carter was married first to Judith Armistead, the mother of John Carter, and second to Elizabeth Landon, the mother of Robert.

When Robert "King" Carter died in 1732, much of his estate went to his eldest son, John Carter III (c. 1690–1743), who is known to history as "The Secretary," to distinguish him from others of that name. John III was sent to England for his education and studied law at the Inner Temple. In Virginia, he was appointed, in 1722, secretary of the colony, a prestigious post he held for many years; after his father's death he was named a member of the Governor's Council. In 1723 he married Elizabeth, daughter of Col. Edward Hill of Shirley Plantation, an estate his wife inherited when her brother died. John III and Elizabeth resided at Shirley when they were not living at Williamsburg or at Corotoman. The beautiful Georgian house that now stands on the James River site is of a later time, for it was built about 1769, but in an earlier house on the plantation hung the two large portraits of members of the Carter family that are included here.

The two portraits at Shirley have long been believed to represent Robert "King" Carter and his first wife, Judith Armistead Carter (Figs. 107 and 108). It was assumed that these were the two pictures of himself and his wife that "King" Carter bequeathed to his son John, in the will mentioned earlier, which would explain their presence at Shirley. However, on stylistic grounds, the portrait of the woman must date from about 1730–35, and a problem of her identity therefore arises because both of "King" Carter's wives had died well before that, Judith Armistead in 1699 and Elizabeth Landon in 1710. Similarly problematic, the portrait of the man is of about 1730, when Robert "King" Carter would have been sixty-three, and the subject appears to be more like forty or forty-five years old. The portraits at Shirley therefore probably depict a later generation, and Graham Hood has suggested the subjects are actually John Carter III and his wife, Elizabeth Hill Carter.[3] In any case, although the exact members of the family who are represented cannot at present be determined, the images can be accepted as portraying members of the Carter family, because they seem to have been always at Shirley Plantation.[4]

The portrait of the Carter gentleman is an embodiment of Virginia plantation aristocracy, but without the dash and flair of the London-dandy portrait of William Byrd (Fig. 105). It is an image of solid, wealthy gentry. Its style is of the provincial type, and it, like its pendant, may be the work of one of the Hudson Valley patroon painters who visited Virginia around 1730. The broad, highly linear and continuous brushstroke of the highlights in the velvet garments in the portrait of Mrs. Carter, and the generalized landscapes in both portraits are similar to, but less stylized than, say, the *Mrs. Kiliaen Van Rensselaer* (Fig. 64). The Carter paintings belong to the group that includes the

Jaquelin and Brodnax portraits discussed in Chapter 15, for they, too, are the work of artists whose primary school was the late baroque English mezzotint.

The Reverend James Blair (1655–1743) came to Virginia in 1685 after being ordained in the Church of England (Fig. 109). Four years later he was appointed the deputy, or commissary, of the bishop of London, under whose ecclesiastical governance Virginia fell. Also, for several decades Blair was president of the Governor's Council, and he therefore wielded considerable power in matters of both church and state. As early as 1691 he had sent to England a proposal for the establishment of the College of William and Mary, and he served as its first president in a tenure that spanned fifty years. In his religious offices, he was made rector of Jamestown in 1694 and became rector of Bruton Parish Church in Williamsburg in 1710, just as the beautiful new edifice was being erected.

The early Virginians were a devout people, but their faith was something they wore as graciously as they did their learning and their social customs. Anglicanism prevailing, it offered direct ties with England and a link to the monarch and the English government. Such quarrels as Virginians had with the motherland were primarily over economic or governmental matters – as with the Navigation Acts – and they never trembled under the fear of religious interference the way New Englanders had in the seventeenth century. Nor did the Anglican church try to run their lives, other than to attempt to keep them godly while they intently pursued their secular and social ambitions. This relationship explains why the books *The Whole Duty of Man, The Gentleman's Calling*, and *The Ladies Calling* by Richard Allestree, also an Anglican priest, were so popular, for they presented a religious code that accommodated religion to the genteel life-style Virginians were developing. Moreover, the masters of the great plantations did not want their children – or their society generally – to be lacking in the true faith or in Christian ethics. Religion therefore was more a part of the gracious civilized life they sought than a burning zeal or the orienting factor of their existence.

The question is raised: Was there an Anglican type of portrait as opposed to a non-Anglican (say, Congregationalist or Presbyterian) type? The answer is no. In New England, where Anglicans were always in the minority even if they were often in the seats of power, there was little difference between the portraits of persons of one religious persuasion and those of another. In Virginia, too, where Anglicans were in the majority and usually in positions of highest authority, the portraits were little affected, stylistically, as a result of religious beliefs. Such differences as occurred were due mainly to New England Congregationalist merchants' aligning their life-style with that of London merchants, whereas the Virginia planters took the English gentry and aristocracy as their models. If Anglicanism had any impact on portraiture, it was indirectly, by allowing a higher level of toleration before ostentation and vanity were reached – that is, it was more liberal in its attitudes toward the enjoyment of the secular world than were some of the sects founded by dissenters.

In the portrait of Blair a building is seen at the left, and it is significant that the minister chose to have the College of William and Mary rather than Bruton Parish Church included in his picture. The school – to a large extent his creation – became at an early time a repository for a modest collection of portraits,

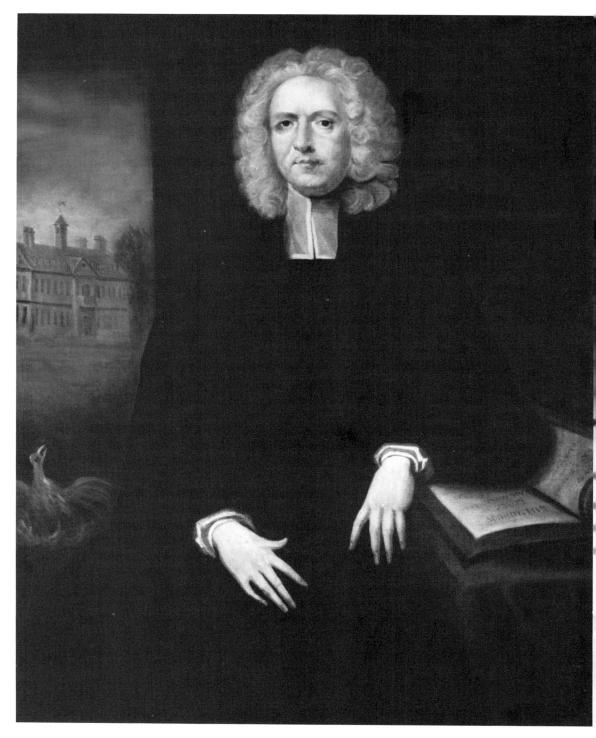

Figure 109. *James Blair*, attributed to Charles Bridges, c. 1740. Oil on canvas, 29 × 23½ inches. College of William and Mary in Virginia.

including two images of Blair and one of his wife, another of the Honorable Robert Boyle (an early benefactor), which was given by the Earl of Burlington, and others of a Professor Dew and a Bishop Johns; these were all saved from a disastrous fire of 1705, and there may have been others that perished in the blaze. The college building was reportedly designed by Sir Christopher Wren, and when it was rebuilt after the fire the new edifice followed the general design of the original. Governor Spotswood and Blair were the primary figures in rebuilding the college, and the bird in the lower left of Blair's portrait is a phoenix, rising from ashes as a symbol of the rebirth of the college under its founder's leadership.

The College of William and Mary had broad support from the planters, who contributed funds and gave their time as trustees. They did so gladly, out of fear that a doltish ignorance should spread through their progeny and their society generally. They were especially anxious to train not scholars of pedantic, narrow, and specialized interests but well-rounded gentlemen of the Renaissance ideal: "Students . . . were expected to wear their learning with grace and ease, as was the manner of gentlemen."[5] That ignorance was considered a curse only slightly less than the pox is evident in a letter written in 1718 by Nathaniel Burwell to a brother about a younger brother who was not attentive to his studies at the college:

> . . . how insensible Lewis is of his own ignorance, for he can neither read as he ought to do, nor give one letter a true shape when he writes, nor spell one line of English, and is altogether ignorant of arithmetic, so that he'll be noways capable of the management of his own affairs and unfit for any gentleman's conversation, and therefore a scandalous person, and a shame to his relations.[6]

The remaining iconographic item in the *Blair* is a reference to the subject's own scholarly and professional work, for it represents a Bible, in Greek, that is open to a section from Saint Matthew on the Sermon on the Mount; this refers to Blair's collected sermons, which were published under the title *Our Saviour's Divine Sermon on the Mount* (London, 1722).[7]

The portrait of Blair is believed to have been painted by Charles Bridges (1670–1747) while he was in Virginia, from 1735 to about 1745.[8] This artist did not have a distinguished career in England, and only one portrait painted by him before 1735 has been identified. Almost nothing is known of his early training, and why he went to Virginia remains a mystery. He was sixty-five years old when he arrived in Williamsburg, bearing letters of introduction to Governor William Gooch and the Reverend James Blair. Gooch informed his brother, Thomas, Bishop of Norwich, that Bridges was being properly received:

> Mr. Bridges I have already loaded with my civilities, 'tho it looks a little odd for a governor to show so much favour to a Painter, as to lend him Coach to fetch his Daughters and Son, and his waggon for two days to bring up his Goods, and to entertain him at Dinner & Supper several times since his arrival, and to promise him as soon as he's settled that he shall begin to show the country his Art, by draw-

ing my Picture, but all this I have done, and upon yr. recommenda-
tion shall continue to do him all the Service in my power.[9]

It is evident from Gooch's letter that Bridges had come, at least in part, to
paint portraits. Although he evidently did so, not a single work can definitely
be documented as being by him, which can be used as the basis for other
attributions made on stylistic grounds. A letter from William Byrd II to Alex-
ander Spotswood, the former governor, dated December 30, 1735, confirms
that he had begun to paint likenesses among the leading families, and was
being recommended, one to another, around the colony. The bearer of the
letter, Byrd wrote,

> is a man of Good Family, but either by the Frowns of Fortune, or his
> own mismanagement, is obliged to seek his Bread . . . in a Strange
> Land. His name is Bridges, & His Profession is Painting, and if you
> have any Employment for him in that way, he will be proud of obey-
> ing your commands. He has drawn my children & several others in
> the neighborhood; & 'tho he have not the Masterly Hand of a Lely or
> a Kneller, yet, had he lived so long ago, as when places were given to
> the most Deserving, he might have pretended to be serjeant Painter of
> Virginia.[10]

The handsome portrait of Alexander Spotswood (1676–1740) at Colonial
Williamsburg may be by Bridges (Fig. 110).[11] Spotswood evidently enjoyed
having pictures around, for his will lists "26 prints" and a painting of "The
Woman taken in Adultery" valued at thirty-six pounds, and sixty-two "prints
with glasses," that is, framed prints under glass.[12] In his portrait, the attire is
of a date around 1735, or about the time Bridges arrived in Virginia. The
subject wears a sword in allusion to his earlier military career under the Duke
of Marlborough at the great victory at Blenheim; the castle in the background
and the battle scene before it may be further references to this moment of
English glory. The scroll in his left hand, now blank as a result of overcleaning
long ago, may have contained the plans of a building, for one of Spotswood's
greatest interests was architectural design. A much later copy of the painting,
now in Richmond, contains such plans on the scroll.

The victory at Blenheim may have been not only the greatest triumph
Spotswood had to celebrate in his portrait but also the last one. After he went
to Virginia as governor in 1710, his policies incurred the wrath of many
members of his own council and the House of Burgesses as well; although
still considering themselves Englishmen, Virginians had already begun to re-
sent governmental interference in their affairs by one whom they considered
an outsider. His opponents managed to have him removed from office in 1722,
after which he retired to his 80,000-acre estate on the western frontier of the
colony, in a region he had long promoted for settlement. There, with the
labor of Germans he had helped to settle the area, he operated iron mines and
smelting mills. His portrait was therefore painted long after he had left the
governor's post, but he obviously recalled with great pride the events at Blen-
heim. As a type of portrait that celebrates a military victory, it is in the same
vein as Smibert's *Sir William Pepperrell* (1746) and Feke's *General Samuel Waldo*

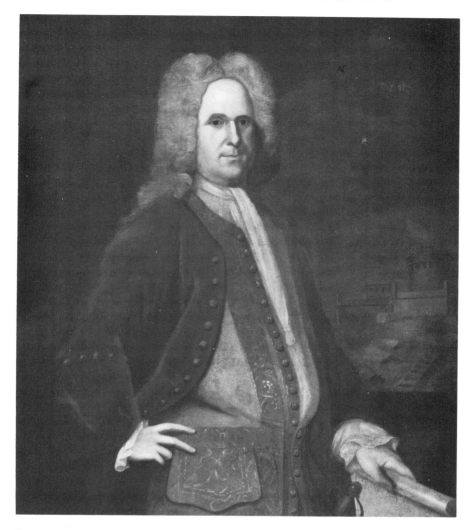

Figure 110. *Alexander Spotswood*, attributed to Charles Bridges, c. 1735. Oil on canvas, 52 × 39½ inches. Colonial Williamsburg Foundation, Williamsburg, Va.

(1748; Fig. 138) which commemorated the English conquest of Louisbourg, Cape Breton Island.

Among the portraits of the leading Virginia families that may have been painted by Charles Bridges are those of Mann Page II and his wife with an infant at her side (Figs. 111 and 112). Mann Page II (1718–78) was the son of Mann and Judith Carter Page, daughter of Robert "King" Carter. The family estate in Gloucester County was near the confluence of Carter's Creek and the York River. There Mann Page I commenced to build, about 1725, one of the greatest of all Virginia plantation houses, Rosewell. This handsome three-story brick mansion had thirty-five rooms, marble trim on the outside, and carved mahogany decoration on the inside. When Mann Page died in 1730, his son Mann Page II inherited it. To Rosewell in 1741 the latter took his

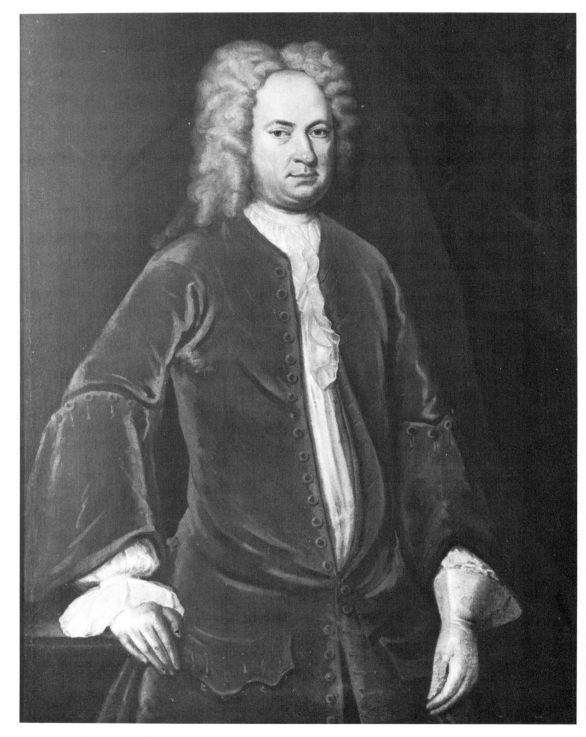

Figure 111. *Mann Page II*, attributed to Charles Bridges, c. 1744. Oil on canvas, 46½ × 36½ inches. College of William and Mary in Virginia.

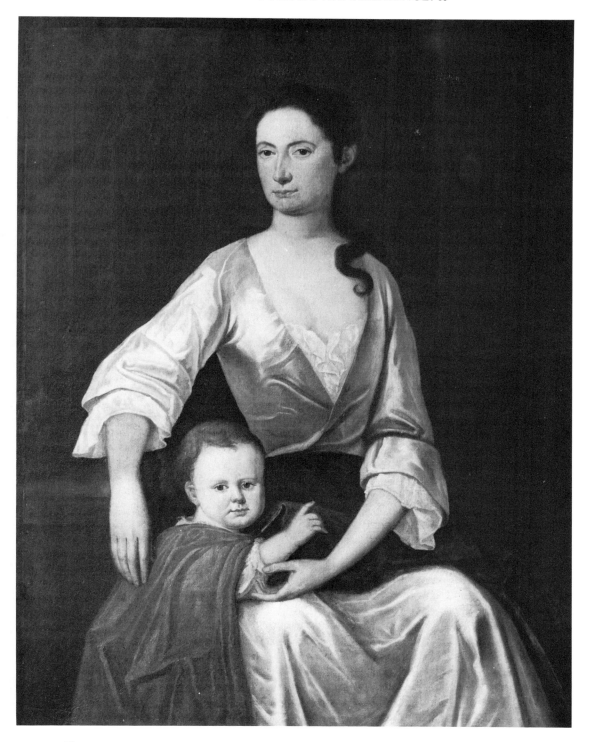

Figure 112. *Mrs. Mann Page II and Child*, attributed to Charles Bridges, c. 1744. Oil on canvas, 46 × 36 inches. College of William and Mary in Virginia.

bride, the former Alice Grymes, and two years later their first child was born; the child's apparent age in the portrait would place its date around late 1744 or early 1745. Presumably, the portrait of Mrs. Page's husband was painted at about the same time, and the costumes in each picture would be appropriate for such a date.

Graham Hood has assembled every available shred of evidence concerning Bridges' work in Virginia, and, convinced that the portraits of two of the children of William Byrd II and the *Mrs. Mann Page II and Child* are by him, uses them as a basis for attributing other portraits to the artist.[13] Like John Smibert, who arrived in New England in 1729, Bridges in 1735 brought the Knellersque baroque style to the colonies, where it was welcomed as the latest fashion, although it was in its final phase and about to be replaced by the rococo-influenced Georgian style. Certainly the *Mann Page II* is a baroque portrait and shows little evidence of the lighter, more delicate Georgian mode. For the *Mrs. Mann Page II and Child*, the artist turned to a baroque mezzotint model for the portrait, thus confirming a commitment to that style; but although John Smith's mezzotint after Kneller's *Mary, Duchess of Ormonde, and Thomas, Earle of Ossory* of 1693 (Fig. 113) was followed in the composition of the poses, the portrait was updated by showing Alice Grymes Page in a gown of current fashion. The design and fabric of the dress are elegant but marked by simplicity rather than lavishness or ostentation. Mann Page wears a white wig over a shaved head, and his coat is of bright red velvet with great cuffs but little adornment; its quality and stylishness are appropriate for a man of means who was a member of the Governor's Council. His face, which is very well painted, suggests a sober, thoughtful, and prudent personality.

Mrs. Page's face appears plain and somewhat dour, and one is reminded of the advice that Col. Daniel Parke wrote to his daughter Lucy, the future Mrs. William Byrd II, outlining those qualities most desired in a woman of breeding, qualities that painters tried to infuse in their portraits: "... do not romp, but behave yourself soberly and like a gentlewoman ... carry yourself so that everybody may respect you. Be calm ... and when you speak, do it mildly."[14] Such advice, so well wrought into the images of colonial American women in what may be called the "decorum of portraiture," comes directly out of the writings of the Anglican minister Richard Allestree, whose works, we have seen, were often found in Virginia plantation houses as favorite guides to behavior. As one looks at the portrait of Mrs. Mann Page II, one sees an embodiment of the advice offered in Allestree's *The Ladies Calling*, in which the author declared one of the foremost of feminine refinements to be modesty, which "appears in the face in calm and meek looks.... Certainly there is nothing gives a greater luster to a feminine beauty."[15] Allestree then attacked the use of artificial accoutrements of beauty in a passage that is reflected in portraits of colonial women like the *Mrs. Page*: "Yet when they have Strein'd their art [cosmetics and fancy attire] to the highest pitch, an innocent modesty and native simplicity of look shall eclipse their glaring splendor, and triumph over their artificial handsomeness."[16] Neither should any movement be contrary to modesty, according to Allestree – do not romp, as Daniel Parke put it – nor should a lady of high social position be loquacious or gossipy, or drink to drunkenness. "Modesty gives an immediate and direct improvement

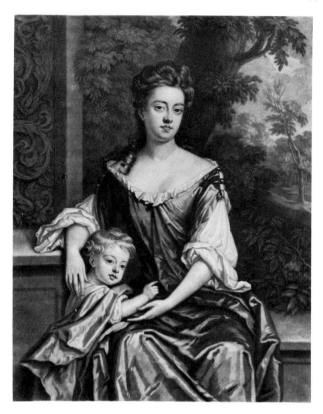

Figure 113. *Her Grace, Mary, Duchess of Ormonde, and Thomas, Earl of Ossory*, by John Smith, 1693, after Sir Godfrey Kneller's portrait of c. 1690. Mezzotint, 12½ × 9¾ inches. British Museum, London.

to Beauty," Allestree concluded, while "Reservedness can make their beauty triumphant."[17] The other feminine attributes, as specified by the celebrated minister were meekness, affection, understanding, and compassion, while affability, courtesy, constancy, piety and devotion he labeled "divine virtues."[18]

Allestree itemized the elements of proper social behavior for women and the qualities they should attempt to develop in themselves and their daughters; the very same characteristics defined in his social manual were writ upon the faces and into the poses and gestures of colonial American women in their portraits. The positive characteristics were worked into the image as much as possible, whereas the negative features were scrupulously avoided. Both individual decorum and class responsibility were at stake, and no woman having her portrait painted would tolerate being represented as violating any of the social ground rules as prescribed by Richard Allestree or other authors of the courtesy books. For well-bred women, *The Ladies Calling* was as essential as a guide as *The Gentleman's Calling* was for their husbands. The portraits of Mann Page II and of his wife with their child are visual proof that colonial American aristocracy tried to live by those rules, or at least wanted to be

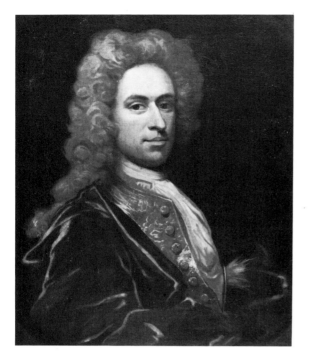

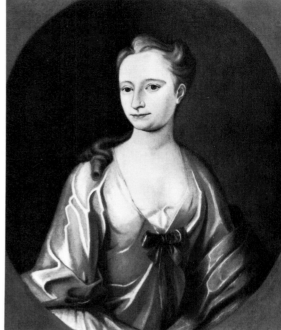

Figure 114. *Thomas Lee*, artist unknown, c. 1725–30. Oil on canvas, 29 × 24 inches. Private collection.

Figure 115. *Mrs. Thomas Lee*, artist unknown, c. 173 Oil on canvas, 30 × 25 inches. Private collection.

portrayed as if they did. Colonial patrons' acceptance of the doctrine that plainness is morally preferable to a fanciful deceit explains in part the plainness of the face in Mrs. Page's image, an image otherwise based on an elaborate aristocratic model – Smith's mezzotint of the Duchess of Ormonde.

Five exceptionally fine bust-length portraits – representing Thomas Lee and his wife, Hannah, John Bolling, Sr., and his son, John, Jr.; and Isham Randolph – as self-images embody the gentry concept that guided the lives of the subjects.

Thomas Lee (1690–1750; Fig. 114), fifth son of Richard II and Laetitia Corbin Lee (Figs. 90 and 91), built Stratford Hall, the beautiful early Georgian brick plantation house of about 1725–30 in Westmoreland County.[19] He was educated at home – that is, he was not sent to England for his schooling – and throughout his life was devoted to learning. In 1722 he married Hannah Ludlow (Fig. 115) and from their eight surviving children came a number of the leaders of the colonial and later periods, including Light Horse Harry Lee and Robert E. Lee. Thomas Lee was the resident agent for the Fairfaxes, the proprietors of the Northern Neck, and held many high-level public offices; after serving in the House of Burgesses he was named to the Governor's Council, of which he eventually became president. He was a "gentleman justice" of his home county, later became a judge of the Supreme Court of Judication for the colony, and was commander-in-chief of the Virginia military

forces. Lee seems to have enjoyed royal favor; when his old house burned in 1729, Queen Caroline sent him a gift of three-hundred pounds to help with the expenses of completing Stratford Hall.

The name "Stratford Hall" was derived from a country estate, Stratford-Langton, that Richard Lee I had purchased outside London. Excepting the Governor's Palace and "King" Carter's Corotoman, Stratford Hall was the finest example of domestic architecture in Virginia when it was completed about 1730. It was beautifully furnished, and on the walls hung the portraits of three generations of Virginia Englishmen, including the likenesses of Richard I and his wife, of Richard II and Laetitia Corbin Lee, and of Thomas and Hannah Lee. There were also portraits of Sir William Berkeley, the governor during Thomas's grandfather's time, and of Lady Berkeley as well as of Thomas and Hannah's first surviving son, Philip Ludwell Lee, and another of Colonial Charles Grymes of Morattico. This collection of portraits, like those in the grand houses of England's gentry and aristocracy, conveyed the idea of family tradition extending through several generations.

The portrait of Thomas Lee, in his fine white wig and his claret-colored cloak over a handsome silver-gray coat, is cast in the mold of the English aristocratic portrait of the early eighteenth century. Lee is shown erect of posture, handsome of features, finely attired, and confident of himself and his position in society. A rich sensuousness in the textures and colors corresponds with the thorough enjoyment of the good life the subject practiced, and rarely indeed does one find a similarly sensuous display in a portrait of a New Englander before 1750. The identity of the artist is unknown, as are the circumstances of the painting of the picture. Because of its high quality one is inclined to think it must have been painted in England; Lee is known to have been in London in 1716–17, when he was about twenty-six years old, but the image in the portrait appears to be of an older man, say, in his mid- to late thirties.

Hannah Ludwell Lee (1701–1749/50), the beloved wife of Thomas Lee, was a granddaughter of Philip Ludwell and Benjamin Harrison (Fig. 115). A pleasant, intelligent woman, she was a capable mistress of the four-thousand-acre estate in Westmoreland County, and a gracious hostess at Stratford Hall and at Williamsburg, where her husband was often engaged in the business of the colony. After her death a long eulogistic poem appeared in London's *Gentleman's Magazine* in May 1750, asking "When will again such charms and virtues meet?/Ah, when a mind and body so complete!" Another line from the poem referred to her as "so loved, so affable, sincere." Her portrait of about 1730 agrees with the attributes of the eulogy. A delicacy is combined with shyness, a refinement is blended with plainness, making the image a lovely incarnation of Allestree's feminine virtues. The style of her portrait is provincial, and because she is not known to have traveled abroad, it was presumably painted in Virginia.

We have already discussed the portrait of the founder of the Bolling family in Virginia – Robert Bolling (Fig. 88)–and the College of William and Mary owns pictures of Bolling men from the next two generations – John, Sr., and John, Jr. (Figs. 116 and 117). A brief description of John, Sr. (1676–1729), was recorded by Robert Bolling (1738–75), a descendant, in a memoir of the family:

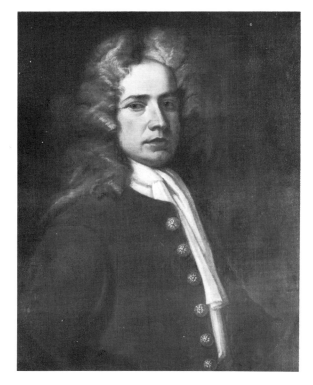

Figure 116. *John Bolling, Sr.*, artist unknown, c. 1720. Oil on canvas, 30 × 25 inches. College of William and Mary in Virginia.

> He had a gay, lively and penetrating spirit. He lived at [his estate called] Cobbs, on Appomattox river, where he received all the profits of an immense trade with his countrymen, and of one still greater with the Indians; and enjoyed at the same time all the pleasures of society, for which never was there a person better formed. It is probable that Mr. Bolling had a very good opinion of himself.[20]

The handsome image of the subject confirms those characteristics just described and again suggests a sensual pleasure that seems to have been beyond most Yankees. There is a bold self-confidence in the face and in the erect posture, while his general bearing reveals a pride in the aristocratic status he had achieved. He was, after all, a man of wealth and position – master of several plantations, a major in the militia, a justice of Henrico County, and a member of the House of Burgesses. In his image, the brushwork is richer and more skillful and the chiaroscuro is bolder than in most portraits by provincial, self-taught painters, and there is a romantic moodiness unexpected in portraits of early-eighteenth-century Americans. Whether painted in England or in Virginia by an English artist, the portrait is one of the finest of its period, around 1720.

The image of John Bolling, Jr. (1700–1757), is believed to have been painted by Charles Bridges during the artist's residence in Virginia between 1735 and about 1745 (Fig. 117).[21] According to the eighteenth-century family biogra-

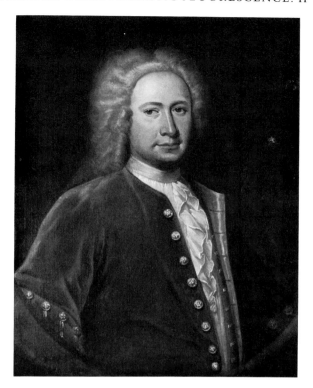

Figure 117. *John Bolling, Jr.*, attributed to Charles Bridges, c. 1740. Oil on canvas, 30⅛ × 25½ inches. College of William and Mary in Virginia.

pher, Bolling "possessed the same gay spirit of his father, without his taste for commerce."[22] This source gives us a picture of the subject that often typified later generations of early Virginia families, who began to concentrate on the enjoyment of the estates formed by their forefathers:

> From infancy to the time of his death, he only studied his pleasure and amusement, which was, perhaps, pardonable in a man who was neither a gambler, drunkard, nor a debauchee. As he had no evil propensity, he thought himself entitled to enjoy innocent pleasures: Horses, Dogs, Hunting, Fishing, good Living, Dancing, his Wife and his Children. . . . Mr. Bolling . . . continued to be fond of good society. His house was open to every one.[23]

John Bolling, Jr., married first Elizabeth Lewis, who died young; in 1728 he wed Elizabeth, the daughter of Dr. Archibald Blair and niece of the Reverend James Blair. Elizabeth Blair Bolling was the mother of his many children, among whom was the poet and author Robert Bolling; her portrait survives and on stylistic grounds may be attributed to the same artist who painted the *Mrs. Thomas Lee* (Fig. 115).[24] John, Jr., inherited the largest share of his father's estate, including the Cobbs plantation near Petersburg. He served in the House of Burgesses for thirty years, held the rank of colonel as commander of his county's militia, and was judge of Chesterfield court. His portrait, which was

painted about 1740–45, suggests a gentle, sensitive man who enjoyed the social position and the material prosperity that preceding generations of Bollings had established for him. The face is especially well painted, capturing an animated spirit as well as a likeness.

Isham Randolph (1685–1742) was the third son of William Randolph I (Fig. 87) and Mary Isham. Early in life he turned to seafaring and trade, and William Byrd II, who took a keen interest in young Isham, arranged for him to obtain command of a merchant ship; between about 1715 and 1736, Isham Randolph crossed the Atlantic regularly, carrying Virginia tobacco to England and English goods to the prospering colony. He maintained a fine house in London that was a gathering place for Virginia society when business brought it to England; in 1717 he married an English woman, Jane Rogers, and their third child, Jane, would later marry Peter Jefferson and become the mother of Thomas Jefferson. While still in his twenties Isham served as the London agent for the colony of Virginia, looking after its business, financial, and legal interests. Among his wide circle of friends in London was the scientist and plantsman Peter Collinson, the correspondent of Carolus Linnaeus, John Bartram, and later, Isham Randolph himself.

After making his last voyage as a merchantman, when he was fifty-one, Randolph settled on his estate in the newly opening western territory of the colony – at a site he called Dungeness – near Charlottesville. He became the burgess from Goochland County and adjutant general of its militia, and built himself a fine house. The English naturalist Collinson, impressed with the civility of life at Dungeness, even though it was in the inland reaches of the Virginia wilderness, advised John Bartram, who was about to leave Philadelphia for a specimen-collecting trip to the south, of the genteel way of life he could expect there:

> I know no person will make thee more welcome than Isham Randolph. He lives thirty or forty miles above the falls of James River, in Goochland – above the other settlements One thing I must desire of thee, and do insist that thee oblige me therein: that thou make up that drugget clothes, to go to Virginia in, and not appear to disgrace thyself or me; for though I should not esteem thee the less, to come to me in what dress thou will, – yet these Virginians are a very gentle, well-dressed people – and look, perhaps, more at a man's outside than his inside. For these and other reasons, pray go very clean, neat, and handsomely dressed, to Virginia.[25]

Randolph did receive Bartram, and the latter wrote to John Custis of Williamsburg about his visit to Dungeness, saying that "Isham was very kind to me, during the time I stayed with him, and sent his man with me to the mountains [to collect specimens] If it lieth in thy way, pray, give my love to him."[26] Writing to Peter Collinson in December 1738, Bartram spoke of his host as "a generous, good-natured gentleman, and well respected by most who are acquainted with him."[27]

The portrait of Isham Randolph was probably painted in England, and the date 1724 is inscribed on the back of the canvas (Fig. 118).[28] The skillful brushstrokes with which the forms, textures, and tones of the portrait were

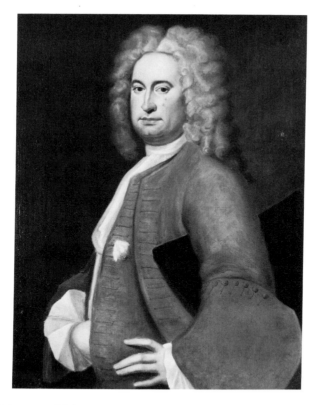

Figure 118. *Isham Randolph*, artist unknown, 1724. Oil on canvas, 34 × 26 inches. Virginia Historical Society, Richmond.

created indicate the work of an artist of considerable training and talent. The subject wears a white wig and a gray coat, and holds a three-cornered hat under his left arm while the right hand is tucked into his waistcoat. His gaze, set directly upon the viewer, is steady and confident, and his expression is sober yet affable. Even the erect posture suggests Randolph's awareness of his station in life. It is a fitting portrait of a man who was a trader, merchant, planter, and sea captain, and who considered himself to be of the gentry in England but of the aristocracy of Virginia.

We have now traced the images of Virginians from the seventeenth century to the middle of the eighteenth century, observing the rise of portraiture in the 1690s in the likenesses that tended to retain characteristics from the middle-class background of the immigrants. But by the second generation the role of gentry had been achieved, and the masters and mistresses of large plantations chose to have themselves portrayed accordingly. Close social ties with England, much closer than between New England and the homeland, caused the aristocratic portrait style of London to be employed with less adulteration than is seen in Massachusetts and Connecticut portraits. The separatist attitude of early Massachusetts and other New England colonies tended to linger on in economics and social customs as well as religion, whereas Virginia was united to England through the Anglican church and the acceptance of English gentry

social codes. The southerners quickly evolved away from the social patterns and values of merchants and tradesmen, whereas New Englanders never really freed themselves from those traits, and all of this was displayed in the portraits of the two groups. In summation, the portrait styles developed, in the first half of the eighteenth century, along two different lines – the one reflecting the mercantile, middle-class character of the northern regions, the other mirroring the gentry life-style cultivated by the Virginia aristocracy.

Maryland and South Carolina before 1740

Seventeenth-century wills and inventories from Maryland and South Carolina have yielded only shadowy references to pictures. Portraits probably existed in the residences of governors or in the plantation houses, but the paucity of evidence indicates that before 1700 far fewer likenesses were to be found in those colonies than survive or can be documented from New England, New York, or Virginia. Nevertheless, the origins and the social, economic, political, religious, and cultural histories of the two colonies must be considered, because any one of these matters could have a bearing on the type of portrait created. For example, Maryland had stronger ties with Catholicism than any of the other colonies, which raises the question of a Catholic influence on art; also, South Carolina began as a proprietary colony in the 1660s with a constitution clearly intended to establish an English type of landed aristocracy, a situation that would affect the portraits of the planter society.

Maryland was known geographically to Captain John Smith, who sailed from Jamestown in 1608 to explore the upper reaches of the Chesapeake, then considered northern Virginia. Little occurred in the way of settlement in the region until after 1632, when King Charles I made a royal grant to Cecil Calvert, the second Lord Baltimore, and Maryland became a separate entity. The colony was named in honor of Henrietta Maria, the Catholic queen consort. Cecil Calvert's father, George Calvert, the first Lord Baltimore, had openly declared his own allegiance to Roman Catholicism.[1] Cecil Calvert followed his father's commitment, and so a Catholic became the proprietor of an English colony in the New World. In 1663, Leonard Calvert, Cecil's brother, sailed from England as governor of Maryland, accompanied by two hundred settlers. Visualizing a land of broad estates in typical aristocratic fashion, Lord Baltimore decreed in his "Conditions of Plantation" that settlers who brought five persons with them when immigrating were entitled to a grant of two thousand acres. To encourage settlement, the proprietor guaranteed that people of all sects would have religious freedom in his colony and so many Puritans and Quakers emigrated to Maryland. With the triumph of the Commonwealth, Lord Baltimore was stripped of his charter, and by 1654, when Protestants outnumbered both Catholics and Anglicans, the Toleration Act was repealed. The ownership of the colony remained in controversy for decades, until the third Lord Baltimore became proprietor in 1675 only to

have his rule overthrown in 1690 following the Glorious Revolution. The next year Maryland became a royal province with a governor now appointed by the Crown rather than the proprietary, and the Anglican church was made the established religion.

In 1694 the capital was moved from St. Mary's to Annapolis, which had been settled in 1649 by Puritans; the move was politically motivated, St. Marys being too closely connected with Catholicism and the proprietary regime as far as royal, Anglican, and Protestant interests were concerned. At Annapolis, construction was immediately begun on a state house, a parish church, and a schoolhouse, but by 1700 the place was still no more than a rough village. The total population of Maryland was then just under 30,000, not counting Indians, and most of the settlers were widely scattered among the tidewater plantations. Between 1700 and 1730, however, Annapolis grew rapidly while the population of the colony tripled, and with prosperity came the beginnings of a refinement of life-style and an interest in the arts.

By the turn of the century, although the Catholic element was stronger in Maryland than in any other English colony in North America, the Protestant sects had the superior numbers while Anglicanism was the official religion.[2] It would therefore be erroneous to think of Maryland as a "Catholic colony," with a predominantly Catholic attitude and influence as far as painting was concerned. Although Maryland again became a proprietary colony in 1715, under Charles Calvert, the fifth Lord Baltimore, Catholicism was still less a factor than either Anglicanism or Protestantism in the development of the province.

In the economics of the region, King Tobacco reigned; accordingly, the planters and the tobacco merchants dominated political and social life, and they established themselves as the ruling gentry of the new land. It was, of course, from members of that class – be they Anglican, Protestant, or Catholic – that the first patronage of portrait painters arose in the colony. Among the great families of early Maryland were the Herrmans, Darnalls, Carrolls, and Bordleys. The founders of these distinguished lines demonstrate the polyglot of social, economic, religious, and nationalistic backgrounds of the colony in the late seventeenth and early eighteenth centuries. The number of portraits from the progenitor generation is not large, but a few are known. Augustine Herrman (1605–86), the son of a successful Protestant merchant of Prague, Bohemia, became associated with the Dutch West India Company and speculated in land and the beaver-skin trade in New Amsterdam before going to Maryland in 1660.[3] He is best remembered for the map he drew of the colony (Fig. 119), which so pleased the third Lord Baltimore that Herrman was granted 13,000 acres in Cecil County. There, as first lord of Bohemia Manor, he built himself a fine house and, by the standards of the day, lived in splendor. His portrait was engraved on the same plate with his map of Maryland; in Herrman's original drawing, from which the plate was engraved, the little portrait may have been drawn by Herrman himself from a portrait of him painted while he was living in Holland, for it has a Dutch quality about it.

Henry Darnall I (1645–1711), the son of a London lawyer, came from an old Catholic family; he was related to the third Lord Baltimore, who may have encouraged his immigration to Maryland in 1672. There Darnall pros-

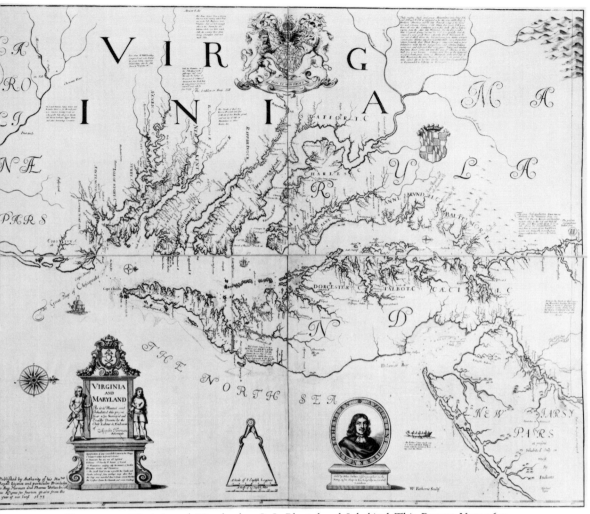

Figure 119. *Virginia and Maryland as It Is Planted and Inhabited This Present Year 1670, Surveyed and Drawne by the Only Labour & Endeavour of Augustin Herrman Bohemiensis,* engraved in London by William Faithorne, 1673. 31 × 36 ½ inches. John Carter Brown Library, Brown University, Providence, R.I.

pered, served as a member of the Governor's Council from 1679 until the Glorious Revolution, and held other high offices while developing his estate, Darnall's Delight, later called Woodyard, in Calvert (renamed Prince Georges) County. His portrait is presently unlocated, but it was published when Pleasants attributed it to Justus Engelhardt Kühn, in his article on that artist.[4] On stylistic grounds it does not appear to be the work of Kühn, although it was probably painted in Maryland about 1700–1710, which would indicate the presence of a painter, probably an itinerate, in the colony even before the arrival of Kühn. A portrait of Mrs. Henry Darnall I, also unlocated, is by the same artist and of the same date.[5] These Darnall portraits were executed in a

235

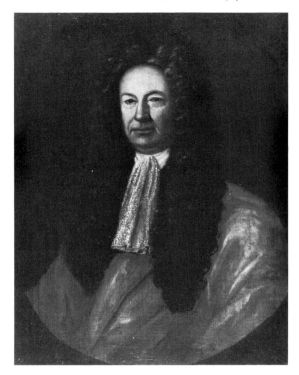

Figure 120. *Charles Carroll the Settler*, artist unknown, c. 1700–1714. Oil on canvas, 31½ × 43½ inches. Maryland Historical Society, Baltimore.

provincial version of the English late-baroque style, and they have some stylistic features in common with certain portraits from the New York area in the early eighteenth century. If they lack aesthetic beauty, they nevertheless possess strong physical likenesses rendered in a straightforward, unidealized manner.

Charles Carroll the Settler (1660–1720), the father of Charles Carroll of Annapolis and grandfather of Charles Carroll of Carrollton, was the son of an affluent Irish "gentleman" of the Catholic faith (Fig. 120). After attending a Jesuit school on the Continent he studied law at London's Inner Temple. His exceptional capabilities gained him the position of secretary to Lord Powis, head of the Catholic party, but he soon entered the service of the Calverts. In 1688, Carroll immigrated to Maryland; when he changed his family motto from "Strong in Faith and War" to "Anywhere so Long as there be Freedom," he revealed his desire to find a place on earth that offered religious toleration. Although he arrived with a commission from the third Lord Baltimore as attorney general, the Glorious Revolution occurred only a few weeks later and his appointment was nullified. Continuing to practice law, with Cecil Calvert as his chief client, he rose quickly to eminence in the colony. In 1693 he married Mary, daughter of Henry Darnall I, and began acquiring land, to the amount of 60,000 acres by the time of his death; much of his fortune came as a result of his acumen as a moneylender. After Benedict Calvert, Cecil's heir, converted to the Church of England, he regained proprietary title to

Maryland and named Charles Carroll his agent and the collector general of the colony. This brought the Settler into conflict with the royally appointed, pro-Anglican governor, and in 1718 the Maryland Assembly passed a law prohibiting Catholics from voting, holding office, practicing law, worshiping publicly, and educating their children according to their faith. Carroll died two years later, leaving to his family an enormous estate and a position well established among the Maryland aristocracy.

The portrait of Charles Carroll the Settler, painted about 1700 to 1714, has been attributed to both Kühn and Gustavus Hesselius, but its style does not resemble the known work of either man; it has also been suggested it may have been painted when the subject was on one of his documented business trips to England. The portrait is a strong characterization of a man of will and substance, which Carroll surely was. Although it belongs to the English tradition – rather than to one from a Continental Catholic country – and generally follows the Kneller style, its unidealized directness, boldness, and simplicity of execution indicate that it is the work of a provincial painter, again possibly one connected with the Hudson Valley. The Settler had several portraits hanging in his Maryland home, for the inventory of his estate lists "3 Pictors being Mr. Carroll and his Spouse & Daughter" in one room and a second portrait of Carroll in another room.[6] And there were others, as we shall see.

The evidence, though meager, suggests that an occasional painter passed through Maryland in the late seventeenth and early eighteenth centuries, but that none found sufficient patronage to take up residence there before Kühn arrived. Although the colony possessed a wealthy aristocracy by that time, the number of potential patrons was low and the concept of a collection of family icons hanging about the manor house had not caught on to the extent it would later. The story of portrait painting comes into sharper focus, however, with the careers of Justus Engelhardt Kühn, who was active in Maryland from about 1708 until his death in 1717, and Gustavus Hesselius, who worked in the colony from 1720 to 1728.

Nothing is known of Kühn's background before December 1708, when he applied for naturalization to the General Assembly sitting in Annapolis, at which time he was referred to as a German; he was probably a part of the religious upheaval that uprooted thousands of German Protestants from their homes in the Rhineland and sent them wandering to far places around the world. In the naturalization proceedings Kühn is described as a painter and a Protestant; soon thereafter he became a member of the established church and made Annapolis his place of residence.

The little town on the Severn River had by then become the economic and social hub as well as the political center of the area. Especially during the Assembly seasons, it attracted the important planters and their families, who reveled in the balls, horseraces, and other forms of merriment. There, too, was the governor with his little court. Although the town was small – permanent residents in 1696 numbered only 374 and by 1729 only 800 – the population swelled during Assembly days. In addition to the livelier forms of sport and recreation, educational and cultural matters received attention. There, as in other provinces, the colonists were concerned that their children not grow up to be ignorant, boorish, unrefined louts; at the newly

established King William's School (which later became St. John's College), the schoolboys learned their letters, numbers, and manners, and, as the schoolmasters were frequently Anglican ministers, they were instructed in the beliefs of the Episcopal church. At the outlying plantations, tutors were often hired to teach the children. Sons of wealthier planters often went abroad for their education (Catholics were usually sent to France whereas Protestants and Anglicans went to England). Soon after the turn of the century a literary tradition began to develop in Maryland, led by Ebenezer Cook, whose poem *The Sot-Weed Factor*, a burlesque on the rustic conditions of life in the colony, was published in London in 1708.[7] The poem, which possesses a humor and skill that captured the attention of the literary wits of contemporary London, indicates the presence of a sophisticated literary talent on the shores of Chesapeake Bay by 1708, the year Justus Engelhardt Kühn arrived in the colony.

J. Hall Pleasants identified ten portraits as the work of Kühn, the most impressive of the group being those of young Henry Darnall III and his sister, Eleanor, the children of Henry Darnall II and the grandchildren of Henry Darnall I, discussed earlier (Figs. 121 and 122). Henry Darnall II, who inherited his father's position in society and his Woodyard Plantation, married Ann Digges, a stepdaughter of Charles Calvert, third Lord Baltimore. It was not unnatural, considering their family lineage and connections as well as their social status among Marylanders, that Henry II and his wife should want aristocratic images of their children.

Henry Darnall III is shown in a grand setting of sumptuous architecture and gardens that reflect far more the influence of mezzotints or some speciality of the artist – such as a penchant for painting landscapes or Old World country seats – than the realities of Woodyard, Henry's boyhood home. No such architecture or formal gardens existed in early-eighteenth-century Maryland, but the elaborate setting no doubt pleased the young boy's parents because it suggests an aristocratic life-style. Mezzotint portraits depicting English aristocracy amid their grand and formal estates were, by the early eighteenth century, readily available in the colonies, particularly where an artist in residence would have them as part of his stock and trade; but even more significant for backgrounds such as that in the Darnall pictures are the engraved "portraits" of country estates that depicted formal gardens of the type seen here. These large engravings were popular in the early eighteenth century, and Johannes Kip and Thomas Badeslade were among the foremost producers of such work.[8] For example, Kip's engravings were available in *Britannia Illustrata, or Views of Several of the Queen's Palaces, as also of the Principal Seats of Noblemen and Gentry of Great Britain, curiously engraved on 80 Copper Plates*, published in London in 1709. By incorporating such sources into the portraits of Marylanders, the artist was able to draw the parallel between the landed aristocracy of the mother country and that of the province. The backgrounds in the portraits of the Darnall children were therefore neither merely scenic nor decorative space-fillers, but reflected Henry Darnall II's perception of the place his family held in society.

In his portrait Henry Darnall III (1702/3–c. 1788) wears a rich brocade coat with silver buttons, a lace cravat, and rose-colored breeches and hose, while a green velvet cloak trails from his left shoulder. He holds a bow and an arrow

and has a quiver hanging at his side. A reference to his aristocratic status is seen in the young boy who attends him, liveried in a rust-colored coat and white vest, and with a metal collar, here apparently made of silver, around his neck as a symbol of slavery; he has retrieved a quail shot by his youthful master. Pleasants has pointed out that this is the earliest example in American portraiture "of a negro slave introduced as an accessory to the portrait of a young aristocrat. The custom of presenting a young slave to a youthful master or mistress to serve as a playmate, and later as a body servant or maid as the case might be, was almost universal among the wealthy planters."[9]

Kühn's portrait of little Eleanor Darnall (1704–96), also of about 1710, was painted as a pendant to that of her brother (Fig. 122). A dependency upon engraved English prototypes is again evident, and Eleanor is represented in the manner of a Maryland "princess." She has light brown hair that is tied with a pink ribbon; her dark red dress has a black velvet train and a white stomacher trimmed with broad bands of lace. A single strand of pearls adorns her neck. Her right hand rests gently on the head of a pet spaniel-type dog. The charming image of Miss Eleanor is nearly overpowered, however, by the enormous, colorful bouquet of assorted flowers in the upper right of the picture; that motif, like those of the great swag of drapery at the left, the balustrade, and the black and white tiled floor, is a pictorial apparatus employed to tell the viewer something of the subject's life-style and social position. The grandiose formal garden with its fountain and statues and the fantastic decorative masks on the balustrade and urn have the same function.

When Henry Darnall II commissioned Kühn to paint the picture of his children, it is possible, even probable that he had seen a grand portrait of young Henry Carroll hanging in the home of his friend Charles Carroll the Settler (Fig. 123). When still a young boy Henry Carroll (1697–1719) was sent to the Jesuit school at St. Omer in French Flanders and then to London, where he studied law at Gray's Inn. He died on a voyage returning to Maryland when his ship was lost at sea. In his portrait he appears to be about ten to twelve years old, which would place its date about 1707–9. He must have been in England when his likeness was taken, for his portrait is in the manner of Kneller's portraits of children of the English aristocracy. For example, the *Henry Carroll* is in the general mode of John Smith's mezzotint of 1701 of Richard, Lord Clifford, with his sister, which was taken from a painting by Kneller (Fig. 124). Several components found in the *Henry Carroll* – such as the balustrade, urn, dog, column, swag of drapery, and a landscape view – are also present in the *Henry Darnall III* and the *Eleanor Darnall*; the fantastic mask on the pillar in Smith's mezzotint may have been the model for the masks in the *Eleanor Darnall*. The portrait of Henry Carroll probably arrived at his father's Maryland home soon after it was painted, or about the time that Kühn arrived in the colony and shortly before he painted the Darnall children. The probability of the *Henry Carroll* influencing both the patron, Henry Darnall II, and the artist, Kühn, is circumstantially great.

A *Portrait of a Young Girl* has been attributed to Kühn, and if it is by him, it reveals yet another source for his images of Marylanders, for it possesses certain features found in seventeenth-century German art (Fig. 125). The domed temple set amid poplar-type trees, the great swag of brocade and the

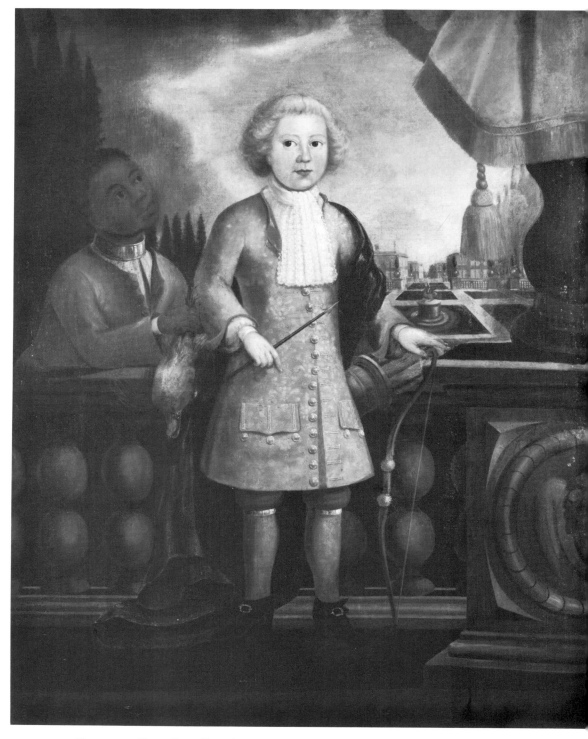

Figure 121. *Henry Darnall III*, by Justus Engelhardt Kühn, c. 1710. Oil on canvas, 53½ × 43 ½ inches. Maryland Historical Society, Baltimore.

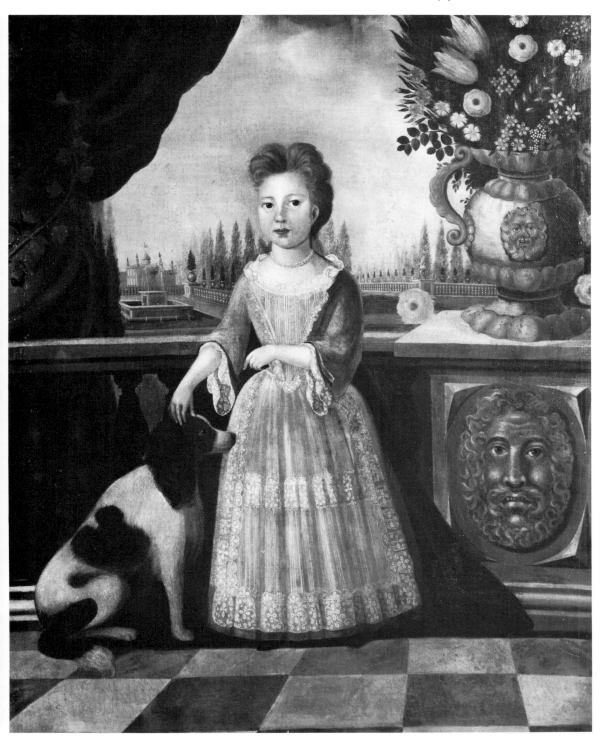

Figure 122. *Eleanor Darnall*, by Justus Engelhardt Kühn, c. 1710. Oil on canvas, 54 × 44½ inches. Maryland Historical Society, Baltimore.

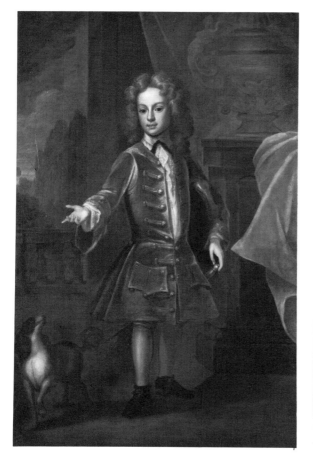

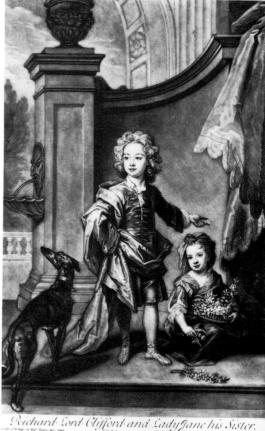

Figure 123. *Henry Carroll*, by an unidentified English artist, c. 1707–09. Oil on canvas, 61¼ × 41¾ inches. Maryland Historical Society, Baltimore.

Figure 124. *Richard, Lord Clifford, and Lady Jane, His Sister*, by John Smith, 1701, after Sir Godfrey Kneller, c. 1700. Mezzotint, 16¾ × 10½ inches. The Henry Francis du Pont Winterthur Museum, Winterthur, Delaware.

column at the upper left all have counterparts, for example, in the self-portrait of 1662 by Joseph Werner (1637–1710), while the flowers at the right and the cherries on the table echo the work of Abraham Mignon (1640–79); Werner and Mignon were well-known painters in their day in Germany, and each worked in a rich baroque style.[10] It would have been natural for Kühn to bring some elements of the art of his native land with him when he immigrated.

The Portrait of a Young Girl is an image of sumptuousness and sensuous splendor that must represent nearly as much fantasy as fact. The red and blue dress with its elaborate lace trim is certainly of a high style, but it is plausible, as are the string of pearls, the fancy pink shoes, the fan, and the stylish coiffeur that reflects the current vogue of Queen Anne's court; also, we may accept the little brown and white dog as an actual pet belonging to the little girl. But nearly everything else in the picture suggests more aspiration than reality. The large rose blossoms, the rich green velvet tablecloth, and the abundance of

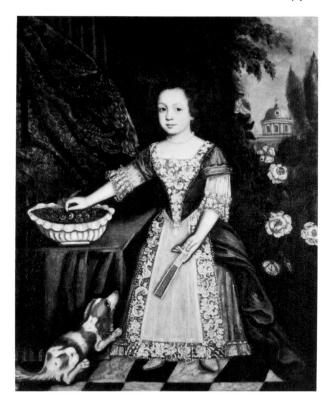

Figure 125. *Portrait of a Young Girl,* attributed to Justus Engelhardt Kühn, c. 1710. Oil on canvas, 51 × 40½ inches. The Nelson–Atkins Museum of Art, Kansas City, Missouri. The Charles T. Thompson Fund.

cherries in the elaborate bowl contribute to the sensuousness of the image. The grandeur of the garden with its little domed temple, the large fluted column at the upper left, and the extraordinarily ornate red-orange swag of brocade drapery all pretend to a setting for life unknown in the colony at that time. Here, as in the portraits of the Darnall children, the provincial aristocracy were allowing the artist to paint their aspirations rather than the objective reality that colonial Americans usually preferred.

Kühn evidently enjoyed painting landscapes as well as portraits, for the inventory of his estate lists "14 pictures & Landskips."[11] This interest would help explain the elaborate settings he worked into some of the portraits. He also painted coats of arms. But the small population of the colony evidently could not fully support an artist, for Kühn died a debtor. Most of the dozen or so pictures now attributed to him appear to date from a single year, 1710, and one must wonder what he did for a living during the remaining seven years of his life.

Gustavus Hesselius (1682–1755) appeared in Maryland about three years after Kühn died.[12] He came to North America from his native Sweden in 1712,

arriving first at Christiana (Wilmington), Delaware, but settling soon afterward in Philadelphia. Hesselius was already a trained painter when he arrived, having studied either in his homeland or perhaps in the Low Countries. He may have been drawn to Maryland by the vacuum created by Kühn's death, but in the end he would be no more successful there than his predecessor was.

Hesselius went to Annapolis about 1720 and remained there until around 1728. The colony was growing in population and continued to accrue cultural advantages. For example, Richard Lewis, a poet, arrived about 1718 from England, after studying for a brief period at Oxford. Lewis joined Ebenezer Cook, the "poet laureate," as a member of a petite literary circle; but unlike Cook, who was himself a "Sot-Weed Factor," or tobacco merchant, Lewis was by profession a scholar and man of letters. In Annapolis, Lewis became a schoolmaster and in his free time wrote some excellent poetry.[13] His best-known work, "A Journey from Patapsco to Annapolis, April 4, 1730," is not only one of the earliest nature poems to sing the glories of the American wilderness but also aspires to the highest level of contemporary English philosophy and demonstrates a thorough familiarity with the thought of Isaac Newton and John Locke. Another sign of cultural growth was the arrival from England of William Parks, who set up a printing press in Annapolis in 1726 and the next year began publishing the *Maryland Gazette*, the earliest of the southern newspapers. Parks invited Marylanders to submit not only articles on practical matters but also literary essays and poetry, and thereby encouraged the development of belles lettres in the colony. In 1728 he brought out Richard Lewis's *The Mousetrap*, "the first belletristic book published in the South."[14] Therefore, although Cook died in 1733 and Lewis the following year, and Parks moved to Williamsburg in 1730 (but continued to publish the *Gazette* until 1737), the decade of the 1720s – the period of Gustavus Hesselius's residence in Annapolis – saw something of a cultural flowering in the province, to which Hesselius himself contributed. (Incidentally, it was only at the close of this period that Baltimore was founded; it was incorporated in 1729 and settled in 1730.)

Only a few portraits that are from the Maryland period can be attributed to Hesselius. One represents Thomas Bordley (c. 1682–1726), the man who brought William Parks the printer over from England (Fig. 126). Born in Yorkshire, England, the son of a prebendary of the Episcopal church, Bordley immigrated to Maryland in 1694 at the age of twelve, accompanying an older brother who was an Anglican priest. He had little or no means when he arrived, but in Annapolis he studied law and distinguished himself in that profession, eventually earning a reputation that extended well beyond his own colony. Entering politics, he became a member of the General Assembly, and in 1712 he was named attorney general of Maryland. When he died in London following an operation to remove "the stone," he left a large estate to his wife (who later married Edmund Jenings) and to his son, John Beale Bordley, who was to become a generous patron of Charles Willson Peale.

A nineteenth-century biographer of the Bordley family described a now unlocated portrait of Thomas Bordley that was full length, showing him in "a long wig and flowing robes, taken by Hesselius, portrait painter at Annapolis."[15] The accuracy of this report and the relationship of such a portrait

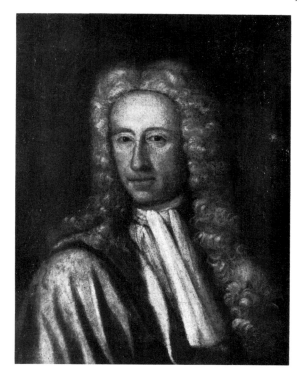

Figure 126. *Thomas Bordley*, by Gustavus Hesselius, c. 1725. Oil on canvas, 27¼ × 22½ inches. Maryland Historical Society, Baltimore.

to the one by Hesselius of c. 1726, illustrated here, is difficult to assess, although the latter does show evidence of having been cut down from a larger picture.[16] Hesselius portrayed Bordley wearing a great white wig of the type that only men of considerable importance wore; what may be a judicial robe is draped over the subject's shoulder, and he wears a Steinkirk at his neck. The face, plain and unidealized, is animated by a lively twinkle in the eyes and a hint of a smile. The portrait, which is not great as a work of art, is a direct, even forceful image.

A portrait of Mrs. Henry Darnall III (Anne Talbot, 1705–?) was at one time thought to be the work of Gustavus Hesselius, but Fleischer has questioned the attribution (Fig. 127).[17] A notation appears in John Digges's account book under date of November 17, 1722: "By payed Gus: Hesselius from drawing Mr. Darnalls and his Ladys Picture."[18] Anne Talbot's mother was a Digges, and it is tempting to associate John Digges's reference with the portrait of Mrs. Henry Darnall III. The portrait descended in the family from the subject down to her great-granddaughter, who gave it to the Maryland Historical Society, so we may be reasonably certain that it is an early Maryland portrait, executed sometime in the 1720s. Whoever the artist was, the portrait has great charm and displays evidence of considerable competence in brushwork, the creation of form, and the play of light and shade.

In the end there is little evidence that Gustavus Hesselius found much patronage in Maryland, and by 1728 he was again living in Philadelphia. In

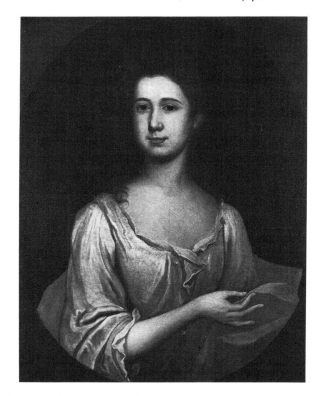

Figure 127. *Mrs. Henry Darnall III*, artist unknown, c. 1720–30. Oil on canvas, 30 × 25 inches. Maryland Historical Society, Baltimore.

that year Hesselius's son, John, was born in Prince Georges County. For the next quarter century, until young John Hesselius returns, there is little evidence of portrait painting in Maryland. So we are left with a few references to portraits in Maryland in the seventeenth century, about a dozen by Kühn around 1710, and a few by Gustavus Hesselius in the 1720s, then little more until after mid-century. Unless additional works or documentation of portraits come to light, we can only conclude that Maryland was not a rich center for the creation of portraits before 1750.

The story is much the same in South Carolina before about 1740. Until 1663, Carolina was not an entity. Spanish explorers from Cuba had visited its shores in 1520, and there was an unsuccessful attempt by some French Protestants to establish a settlement there in the 1560s; finally the English came in the 1580s in the equally unsuccessful adventure of Sir Walter Raleigh's ill-fated colony at Roanoke Island in what is now North Carolina. The better part of a century went by before renewed efforts brought geographic identity and permanent settlement to the area in the years following the Restoration. In 1663, Charles II granted a charter to eight of his favorites, making them the proprietors of the land between the 31st and 36th Parallels, extending to the Pacific Ocean. Their vision of an aristocratic society for the new colony is manifest in a document drawn up by Lord Ashley, one of the proprietors, in

collaboration with his secretary, the philosopher John Locke – the "Fundamental Constitutions" of 1669, which called for a rigid, outmoded feudal system of titled landowners controlling vast estates. The specified intent was "to avoid a too numerous democracy" and to create a "nobility," but a nobility that need not spring from the noble families of England.[19] Land was sold for a penny an acre, and anyone who purchased 12,000 acres was entitled to call himself a baron; if he bought 24,000 acres, he was termed a "cacique," a Hispano-Indian word meaning lord, chief, or prince; if he acquired 48,000 acres, he held the highest rank of landgrave.[20] The system, although too rigid to be practical on the frontier, did establish the principle of a nouveau landed gentry and dangled before commoners the dream of becoming titled aristocracy if they would immigrate to the Carolinas.[21]

By 1700 the wealth of South Carolina was increasing rapidly from trade in lumber, skins, and slaves, and the merchants of Charleston prospered. But it was rice, which had been introduced in 1694, that brought undreamed-of wealth to the planters, and thereafter it – rather than tobacco – was the colony's real "money crop." The climate and marshy terrain were perfect for its cultivation, and slave labor made it highly profitable, providing the wealth and political power base for the establishment of a provincial aristocracy and its concomitant way of life in the plantation manor houses.

The town of Charleston soon developed as the hub of the colony. Founded in 1670 at Albemarle Point, it was relocated ten years later at the confluence of the Ashley and Cooper rivers; its original section was laid out on a grid plan, probably the first such system in the English colonies. As the town prospered, becoming the seaport and political center of the colony, it also became the cultural center.[22] Moreover, every year from May to November the Carolina plantation aristocracy moved into Charleston for "the season," in order to escape the "country fever," or malaria. This concentration of the colony's leading families in one place for six months out of every year gave South Carolina an urban center that Virginia had not developed, even in Williamsburg. The season was a festive time with balls, assemblies, and musical entertainments, and social manners that emulated the refined society of London. At the center of this was the governor and his entourage – for example, Governor Nathaniel Johnson, of whom a portrait survives showing His Excellency in a dark wig and wearing armor. The portrait, one of the earliest from South Carolina, is inscribed "AEtatis:61: April 7:1705"; because there is no evidence of the subject's having been abroad in that year, it is possible the portrait was painted in Charleston.[23] The inscription appears to be authentic, therefore precluding the possibility that it was done by Henrietta Johnston, who did not arrive in South Carolina until 1708.

By 1710, as John Lawson noted, Charleston was "supplied with all things necessary for trade and genteel living."[24] The Church of England, established by law in 1706, "gave a certain impetus to the intellectual life of the community and opened a channel for the transmission of English culture to the province."[25] Anglicans were a minority, but the wealthiest and most culture-conscious families belonged to the established church. By 1704, there were also Presbyterian and Baptist churches as well as Quaker and "French" meetinghouses. The town, as John Lawson noted in 1709,

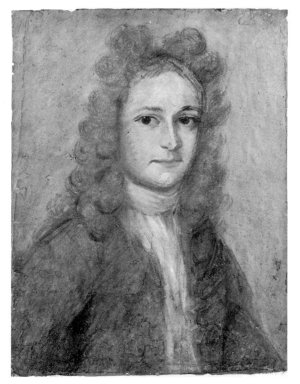

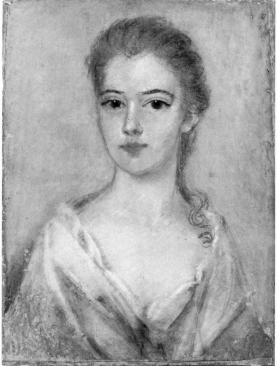

Figure 128. *Colonel Samuel Prioleau*, by Henrietta Johnston, 1715. Pastels on paper, 12 × 9 inches. Museum of Early Southern Decorative Arts, Winston-Salem, N.C.

Figure 129. *Mrs. Samuel Prioleau*, by Henrietta Johnston, 1715. Pastels on paper, 12 × 9 inches. Museum of Early Southern Decorative Arts, Winston-Salem, N.C.

has very regular and fair Streets, in which are good buildings of Brick or Wood, and since my coming thence [eight years ago] has had great additions of beautiful large Brick buildings This place is more plentiful in Money than most or indeed any of the [colonies] on the Continent The merchants are fair, frank traders. The Gentlemen seated in the country are very courteous, live very nobly in their houses, and give very genteel entertainment to Strangers and others that come to visit them.[26]

It was therefore to a Charleston that was prospering and anxious to re-create the cultured ways of English gentry that the first permanent, resident artist came in 1708 – a woman named Henrietta Johnston.[27] She had not immigrated for the purpose of trying her luck as an artist but had merely accompanied her minister husband, the Reverend Gideon Johnston, when he was sent over to be the rector of St. Philip's Episcopal Church and the bishop of London's Commissary for Carolina. Little is known of her early life, but Rutledge believes she was "probably Irish, possibly a pupil of Simon Digby, Bishop of Elphin, and of Edward Lutterel of Dublin."[28] In South Carolina she worked only in pastels. Her little likenesses have great charm mingled with a

simplicity of style and a naiveté, as seen in the portraits of Colonel Samuel Prioleau and his wife, Mary Magdalen (Gendron) Prioleau (Figs. 128 and 129).

The Prioleau family was established in South Carolina when the Reverend Elias Prioleau, a Huguenot, fled France after the revocation of the Edict of Nantes. Some four hundred French Protestants had immigrated to Carolina in the 1690s, and by the end of the decade 195 Huguenot families were living in Charleston. As time passed the French Protestants tended to be assimilated into the established church, more so than into any of the other churches of Charleston, and the Calvinistic zeal of the Huguenots was tempered by the liberalism of the Anglicans. The Reverend Prioleau, who was the minister of the Huguenot Church in Charleston until his death in 1699, had brought his wife and a son with him when he immigrated, and it is his son, Samuel, who is represented in Henrietta Johnston's little pastel portrait. Samuel Prioleau was a successful silversmith who gained high standing among his fellow citizens of the town as a colonel of the Provincial Regiment of Horse, the bulwark of Charleston's defense against its many enemies – including the Spanish and, at times, the Indians. John Lawson observed in 1709 that the townspeople

> have a well disciplined Militia, their Horse are most Gentlemen and well mounted, the best in America Their Officers, both Infantry and Cavalry, generally appear in scarlet Mountings, and as rich as in most Regiments belonging to the Crown, which shows the Richness and Grandeur of this colony.[29]

In his portrait Samuel Prioleau is shown as a civilian and a gentleman, wearing a wig of long curls, a blue-green coat, and a full white stock; the background is yellow-green. His wife, also of one of the French immigrant families, has light brown hair with one curl falling over a shoulder in the current Queen Anne vogue; her unadorned dress with its low neckline is blue and white, and she wears a gold scarf around her shoulders.

Johnston, evidently the first American to make portraits in pastels, was working in a medium that had not yet gained widespread acceptance among artists or patrons. Pastel portraits are first found in England in the 1660s, and the medium was probably introduced from France. The earliest portraitist to make a specialty of pastels was Edmund Ashfield, in the mid-1670s (Fig. 89). But his work is dark and somber, and it attempts to imitate the effects of an oil painting, whereas that of his pupil, Edward Lutterell – an Irishman active in the 1680s and 1690s – is freer, more like a drawing, and of a lighter palette. If Henrietta Johnston was in fact Irish, she may have had contact with Lutterell's work in her native land.

Although frequently debilitated by poor health and often in want of artist's supplies, Johnston seems to have executed the occasional pastel portrait from the time of her arrival until her death in 1728/29. She worked in Charleston, taking the likenesses of residents or of the plantation families during the "season" when they were in the town, but the demand was apparently never great.

The only other artist known to have worked in the colony while Johnston was active was Mark Catesby (c. 1679–1749) who arrived in May 1722. But Catesby was a naturalist and probably never thought of painting a portrait. His apologia in his *Natural History of Carolina, Florida and the Bahama Islands*

(London, 1731–43) supports this, for he informs the reader that "I was not bred a Painter," and he goes on to indicate that his interest is scientific and not artistic.[30] After wandering about South Carolina, Georgia, and Florida, often with an Indian hired to carry his specimen box and such sketching materials as he had, he returned to England in 1726, leaving no record of any work in portraiture.

Insofar as art was concerned, South Carolina did not develop as a major center during the first four decades of the eighteenth century. Whereas wills and inventories of late-seventeenth- and early-eighteenth-century Virginia reveal the existence of many portraits in the houses of the wealthy planters of that colony, there is only meager evidence of family likenesses in Carolina homes of that period – as when several "old pictures," some of which were probably prints, were listed in the inventory of 1724 of Powell and Elizabeth Haywood; or in 1727, when Francis Holmes bequeathed to his son Francis "the Pictures of his Grand Father . . . & myself"; or when Peter Bacot in 1728 left to Marrane Fitch "her Mother's Picture and one other Resembling herself."[31] Otherwise, only a few scant references to mezzotints have come to light. Not until Jeremiah Theus began painting in Charleston about 1740 can we think of the town as a center for portraiture, but that matter belongs to Chapter 28, for by 1740 the third major period of colonial American portraiture is inaugurated.

Part III

THE CULMINATION,
1740–1790

Prologue to the Culmination of the Colonial Portrait Style

The Calvinist Heritage and Franklin's "Way to Wealth"

Life in New England, New York, and Pennsylvania, after 1740 as before, was dominated by two factors: first, the mores, ethics, and virtues of a middle class, a few members of which had risen to the position of provincial aristocracy; and second, religious beliefs based on Protestant or Anglican doctrines, which, while often at odds over theological details, overlapped greatly insofar as their instructions for daily life were concerned. Protestantism held a majority throughout the population and thereby provided a constant infusion of Calvinistic principles, but among the leadership portion of society Anglicanism was always strong. The ruling middle-class aristocracy, whether Protestant or Anglican, increasingly embraced a secular philosophy that forced religion into accommodation as reason challenged faith as the guide for the conduct of life. The period saw a remarkable consummation of the middle-class code founded on personal and societal virtues or characteristics such as industry, moderation, individualism, independence, egalitarianism, materialism, and pragmatism. All the while, of course, certain fundamentals that had been established earlier were retained – for example, devotion to one's calling and the doctrine of prosperity. These are the very things that crystallized into the ultimate form of the colonial American portrait in a unique aesthetic system that was devised by native-born painters.

John Smibert may be seen as the end of the transitional phase of painting in the northern colonies, for after him, Americans were no longer largely dependent upon English or Continental artists when they wanted images of themselves. The greater portion of Smibert's career was over by 1741 when Robert Feke appeared on the scene as the colonies' first native-born, truly gifted artist who would make a profession of painting portraits. Thereafter, the colonies produced their own corps of homegrown painters who impressed upon their images ever more precise characterizations of the colonial American personality. That corps was led by Feke, John Singleton Copley, and Charles Willson Peale, but there were many others. The artistic influence from abroad continued, of course, through such painters as Joseph Blackburn and John Wollaston, but now, instead of foreign artists imposing upon their subjects a style learned abroad and then altered to accommodate their new clientele, we

find native sons making images of people who were of their same cultural (that is, colonial) background, while devising a style for that purpose that was a definite modification of the foreign style that served as their model. The point is an important one, for painters such as Feke, Copley, and Peale – born and raised in the colonies – absorbed the eighteenth-century colonial American character by being themselves products of it from the time of their birth, whereas painters such as Smibert, Kühn, Blackburn, Wollaston, and Theus simply could not delineate the character of their subjects as perceptively. While the native-born artists often learned something of their skills and styles primarily through contacts with the foreign-born painters resident in the colonies, the culmination of the colonial American portrait in its purest form comes at the hands of those native-born artists who worked from about 1740 to 1785 or 1790.

In Part I the virtues defined by John Calvin were identified as the guiding principles of both religious and secular life for Protestants, from the mid-sixteenth century to the late seventeenth century, and they accordingly found their way into the painted portraits. In Part II we saw an exemplary American minister, Cotton Mather, uphold those virtues and objectives but become concerned over an increased worldliness during what we now observe as a transitional period. Now, in Part III, we will observe – especially through the philosophy and writings of Benjamin Franklin – the thorough secularization of the goals and virtues that had been advocated by Calvin and Mather. Franklin, then, is the third link in the socio-religio-cultural continuum, and his relationship with Cotton Mather is an important factor in the continuity that existed between the earlier colonial periods and the final one. What had been primarily religious concerns for Calvin and Mather now became essentially secular and moral concerns for colonists of Franklin's era.

Born in 1706, the son of an immigrant candlemaker, Franklin grew up in Cotton Mather's Boston; as a lad, he was apprenticed to his brother James, publisher of the *New England Courant*. He therefore came from a Protestant, middle-class, craftsman–tradesman background that was tangential to a ba-sically mercantile society but that nevertheless offered some intellectual stim-ulation. The redoubtable Reverend Mather was still alive when Franklin was a young man, and Franklin later recalled visiting the minister at his home; in his *Autobiography* he reported that as a youth he had read Mather's *Essays to Do Good*, freely admitting that they "had an influence on some of the principal future events of my life."[1] In 1784, Franklin wrote to Cotton Mather's son, Samuel, also a Congregationalist minister: "I remember well both your father and grandfather, having heard them both in the pulpit, and seen them in their houses. The last time I saw your father was in . . . 1724, when I visited him He received me in his library."[2] Franklin and Mather were, of course, far apart in many of their religious views, but in spite of his deist beliefs, Franklin throughout his life sought some kind of religious meaning for life, and he seems genuinely to have admired the aged minister. In the area of secular morals and virtues, Franklin "subscribed to a system of ethics that was identical to Cotton Mather's."[3]

Franklin recognized the powerful Calvinist current that still flowed through colonial society; he also knew that for all their worldly preoccupation, colonial

Americans were a devout people. And although there are no overt symbols of Christianity in colonial portraits, references to Christian beliefs are nevertheless present, for in the portraits we see the blessing of God bestowed as a reward (material prosperity) for the diligent, industrious execution of one's calling. The religious element was, in fact, expressed through symbols of secular success and material prosperity, rather than through specific religious symbols.

In the mid-eighteenth century the urge to achieve material prosperity continued to be the great motivating force it had been earlier among the middle class, whether Protestant or Anglican. In a classless society, wealth was the main indication of one's position and was the measure by which others evaluated one's accomplishments. Cotton Mather had written that a man was glorifying God by "the getting of Good for himself," and in that instance "Good" meant material prosperity. Opportunities abounded for making money in colonial America, and industry and diligence at one's personal calling brought divine blessing and material wealth; the wealth was something to be proud of because it indicated one's place in society. Such things are worked subtly – not blatantly – into colonial American portraits, and a respect for wealth is a most important part of their iconography, as may be seen in nearly every colonial portrait. No one explained it better than Benjamin Franklin, who was often echoing the words of Calvin and Cotton Mather.

Franklin often wrote for persons of modest circumstances who were anxious to rise in the world, be they native-born or immigrants to the American colonies. The passages quoted here were directed to the ambitious tradesmen who aspired to wealth and position; but those who had already obtained material prosperity and high status in colonial society had most often gained them by the same means Franklin outlines.

"The Way to Wealth," Franklin wrote in his "Advice to a Young Tradesman" of 1748, "is as plain as the Way to Market."[4] He then declared, "It depends chiefly on two Words, Industry and Frugality," thereby restating one of the main currents of the Calvinist ethic, which praised industry and damned idleness. Franklin, however, further secularized the matter, in the belief that hard-working, prosperous people were essential to the happiness and well-being of a society. Degler has observed that "the advice of Franklin's Poor Richard is but the Puritan ethic shorn of its theology; in Franklin, the Puritan has become the Yankee."[5] Franklin continued his advice to young tradesmen by saying,

> Without Industry and Frugality nothing will do, and with them, everything. He that gets all he can honestly, and saves all he gets (necessary Expenses excepted), will certainly become Rich, if that Being who governs the World, to whom all should look for a Blessing on their honest Endeavors, doth not in his wise Providence otherwise determine.[6]

For the interpretation of the colonial American character as seen in eighteenth-century portraits, and for the comprehension of their iconography, this is a key passage. It eulogizes frugality, industry at one's personal calling, and moderation as a way of life; it proclaims that diligence at one's secular calling

will lead straight and surely to wealth and prosperity – to material riches; it clearly sets forth the doctrine that one can only become prosperous if God ordains it, and thereby makes the religious or pietistic association with worldly success. Such things were understood by Copley's contemporaries as they looked at his portraits of Mrs. Boylston (Fig. 152) or Mr. and Mrs. Winslow (Fig. 165), or by Peale's fellow citizens when they stood before his portrait of the Edward Lloyd family (Fig. 188) of Maryland or that of the John Cadwaladers of Philadelphia (Fig. 189). These ideas come right out of the religious, social, philosophical, and economic foundations of middle-class society as they evolved in the sixteenth and seventeenth centuries; insofar as religious sanction was concerned, it had been advocated by John Calvin and his subsequent interpreters, such as William Perkins, and the concept had been kept alive by latter-day Calvinists such as Cotton Mather, who carried it to the threshold of Franklin's era. There is, moreover, an attitude that men and women were meant to enjoy the fruits of their industry, within moderation and without vanity, and in mid-eighteenth-century colonial portraits we see them doing just that, wearing fine (but not extravagant) attire and surrounded by exquisitely crafted objects such as tables, chairs, and silver inkstands, porcelain and so on – expensive material stuffs that their God-approved prosperity allows them to possess.

The Development of the American Character in a Land of Opportunity

Materialism, Pragmatism, Independence, Self-confidence, Egalitarianism, and the Mercantile Portrait in the North

Every people in every age in every place will have certain collective traits that characterize their society. In the North, where mercantilism was one of the most powerful thrusts that vitalized society, colonial Americans were materialistic and pragmatic, independent and self-confident – and they were egalitarian. These qualities were so strongly imprinted on the character of those who posed for their portraits that they were bound to be expressed in the image, especially as the colonial American portrait reached its mature form in the work of native-born artists.

Colonial America has been referred to as a classless society. That must be qualified, of course, to mean within the European-descended community, for the slave and the Indian were not considered equals among white folk. But within the white community, men and women of humble origins were not more or less permanently relegated to a subservient class by an age-old aristocracy or by laws favoring the latter, as in Europe. The colonies, which developed as a land tailored to the advancement of the middle class, consciously avoided the installation of an actual aristocracy, but that did not prevent the development of the colonies' own brand of it, based mainly on landownership or mercantile entrepreneurship. Therefore, colonial society did become layered, with the wealthy merchant families stationed atop the pyramid in the North, just as the great landowning planters presided in the South.

As Degler has observed, "All through the literature of the period [mid-eighteenth century] one finds references to 'the Better Sort,' 'the Middle Sort,' and 'the Meaner Sort' of people."[1] This informal stratification of society did in fact exist, but there were no real barriers to prevent a person who was reasonably honest, industrious and pious from advancing from origins in "the Meaner Sort" to the highest echelon of the truncated social pyramid and become one of "the Better sort." Wealth, not birthright, established a person's position in society, and according to Franklin the "way to wealth" was open to anyone who would seize the opportunity, be industrious, and have the

acumen to turn a profit. Within a relatively short time in colonial America, one could complete the transition from the "meaner sort" to the "better sort" because of the opportunities that abounded, and there was no stigma attached to having begun in (or having one's immediate ancestors come from) the lower register of society.

Benjamin Franklin made this point in an essay titled "Information for Those Who Would Remove to America" which was written about 1782, translated into several languages, and widely circulated throughout Europe. Its purpose was to attract immigrants by promoting America as a land of opportunity without class restrictions or prejudices, and he pointed out that although there were few who were rich by European standards, there were also very few who were poor. He described America as a working-class society, and inserted a phrase that is most revealing of colonial attitudes toward the fine arts; there were, he wrote "very few rich enough to live idly upon their Rents or Incomes, or to pay the high Prices given in Europe for Paintings, Statues, Architecture, and other Works of Art, that are more curious than useful."[2] He also warned that it was unwise for anyone to go to America

> who has no other Quality to recommend him but his Birth. In Europe it has indeed its Value; but it is a Commodity that cannot be carried to a worse market than that of America, where people do not inquire concerning a Stranger, *What is he*? but, *What can he do*? If he has any useful Art [skill], he is welcome; and if he exercises it, and behaves well, he will be respected.[3]

Franklin then reported that "Multitudes of poor People from England, Ireland, Scotland and Germany, have . . . in a few years become wealthy Farmers, who, in their own Countries, where all the Lands are fully occupied, and the Wages of Labor low, could never have emerged from the poor Conditions wherein they were born."[4] Summarizing the opportunities and absence of prejudices against laborers, craftsmen, shopkeepers, farmers and the like, he went on to say that

> in America . . . there is a continual Demand for more Artisans of all the necessary and useful kinds Tolerably good Workmen in any of those mechanic Arts are sure to find Employ, and to be well paid for their Work If they are poor, they begin first as Servants or Journeymen; and if they are sober, industrious and frugal, they soon become Masters, establish themselves in Business, marry, raise Families, and become respectable Citizens.
>
> Also, Persons of Moderate Fortunes and Capitals, who, having a Number of Children to provide for, are desirous of bringing them up to Industry, and to secure Estates for their Posterity, have Opportunities of doing it in America, which Europe does not afford. There they may be taught and practice profitable mechanic Arts, without incurring Disgrace on that Account, but on the contrary acquiring Respect by such Abilities.[5]

A philosophy like this has direct application to portraiture, as in Copley's image of Paul Revere and Ralph Earl's portrait of Elijah Boardman (Figs. 158 and 130). These pictures represent men who held respected positions in their communities, and who, far from being ashamed that they labored as craftsmen or shopkeeper-merchants, were proud of the fact. There was indeed no stigma implied in an image that showed Americans at their work; on the contrary, there was something honorable about it, and the subjects' industry and success at their callings were badges of accomplishment and prosperity. Elijah Boardman, a merchant in New Milford, Connecticut, stands before his desk at his shop and holds a bill or receipt in his left hand, while his instruments of bookkeeping – the quill pens in a pewter ink stand and a bound ledger book – rest on the top of his desk; nearby, the door opens to reveal his well-stocked shelves of bolts of cloth and other commodities. Middle-class English merchants were less inclined to have themselves portrayed at their shops or offices, but in America no person's social standing was tainted if he was shown working at his personal calling. Indeed, there was high virtue in it, as Franklin noted in his "Information on . . . America" which again sounds like a secularized paraphrase of passages from Calvin's *Institutes*: "Industry and constant Employment are great preservatives of the Morals and Virtue of a Nation."[6]

Paul Revere was a second-generation American and a craftsman – a silversmith by trade – and Copley portrayed him at his work. Revere, evidently proud of the beautiful silver teapot he holds before him, was pleased to have himself portrayed with the results of his labor thrust subtly before the viewer, while his engraver's tools are included nearby. Moreover, Revere's clothes are not those of an idle gentleman or dandy but the work clothes of his daily labor. In all, the subject is represented pursuing diligently the personal secular calling that had been praised as godly work since the days of John Calvin.

Most colonial Americans, however, chose to have themselves portrayed in settings that revealed the fruits of their labors rather than the labors themselves. A merchant may be shown seated at his desk attending to an open ledger (Fig. 151), or a shipowner might be shown with a sailing vessel seen through a window (Fig. 60). Such things make reference to the virtues and rewards of working at some useful business. America offered not only the opportunity to make money but the chance to attain honor, respectability, and prestige in a prosperous, comfortable middle-class society. Throughout the eighteenth century many among Europe's poor crossed the Atlantic to seek opportunities like those that Benjamin Franklin promised in his essay, and when they had their portraits painted, their thorough belief in the system shone forth in their images. Their material acquisitions became emblems of virtue and social standing, and materialism became ever more deeply entrenched in the philosophy that guided their society.

There were several "isms" at play in eighteenth-century America: Materialism, pragmatism, utilitarianism, and egalitarianism, all vital components of the colonial way of life, were bound to assert themselves in the portraiture. These, united with other characteristics such as independence, self-sufficiency, and self-confidence, make up much of the social being who was the colonial artist's subject.

The materialism found in colonial portraiture arose from the desire of the

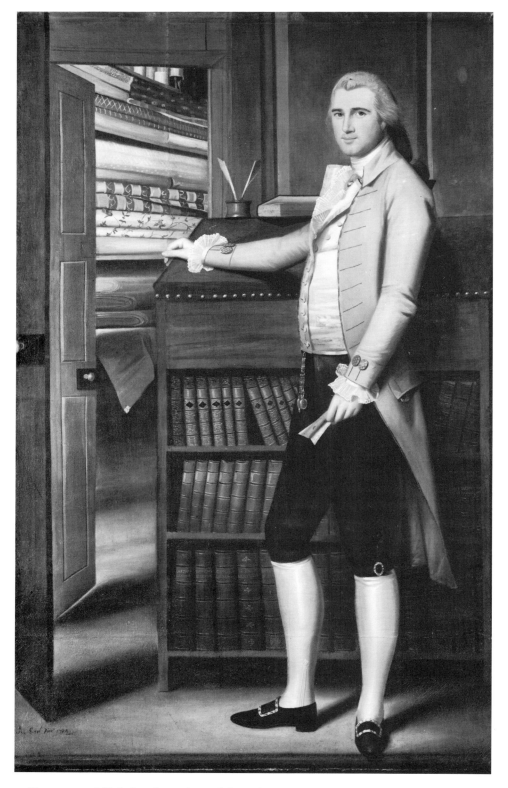

Figure 130. *Elijah Boardman*, by Ralph Earl, 1789. Oil on canvas, 83 × 51 inches. Metropolitan Museum of Art, New York. Bequest of Susan W. Tyler, 1979.

lower middle class, who had few or none of the amenities of life, to acquire them. The result was a nouveau riche eager to gratify its passion for the material pleasures of life previously unavailable to it. This nouveau riche had, nevertheless, limitations imposed on it by the very agency that gave approval to its drive toward prosperity – Calvinist Protestantism. As we have seen, Calvinism permitted prosperity and the enjoyment of daily life in the secular world, as long as moderation was observed and ostentation avoided. This meant it was perfectly acceptable to use one's wealth to surround oneself and one's family with material things providing comfort, convenience, and pleasure. Moreover, material affluence implied God's favor, while among one's fellow citizens the primary measures of merit were people's usefulness to the community and the material wealth they possessed.

It would be difficult to look upon typical examples of mid-eighteenth-century American portraiture without sensing the power of materialism in them – both as cultural symbol and in artistic style. In Robert Feke's *Mrs. Charles Willing* we are confronted with her physical presence and material substance (Fig. 134). The artist modeled and delineated her corporeal form as an actual physical substance, and the pattern, color, fabric and texture of her dress are not so much a representation as a re-creation of it. The gown is both materialistically present and materialistically beautiful. It fills the canvas as a materialistic testimony to the Willings' affluence and their possession of desirable stuffs, and much of the visual joy that the painting offers is due to the artist's virtuosity in re-creating a beautiful physical substance. The colonial painters' subjects found such pleasure in the materialism of their real world that they demanded it in the paintings they commissioned. This effort to re-create the physical world in the portrait is first developed by Robert Feke, not coincidentally the first native-born painter who is a true master of his art. Feke was himself a product of the materialistic colonial society, and hence his way of working meshed with the forces inherent within it. The *Mrs. Willing* represents a totally different manner of image making in contrast to English portraits by William Hogarth, Joseph Highmore, or Thomas Hudson. In the work of the English artists, painterly effect and stylish affectation are far more important than the simple re-creation of the physical world. One style was practiced according to a sophisticated theory of painting that was familiar among artists and connoisseurs; the other catered to the materialism of a pragmatic, self-made people who knew very little about Art.

This distinction becomes even more obvious a few years later if we contrast a colonial portrait by Copley with one by his English contemporary Thomas Gainsborough.[7] A typical work by Gainsborough possesses a lyrical delicacy in its diaphanous brushwork while real form and substance are dissolved into lovely passages of hue and light; but a portrait by Copley – say, the *Mrs. Thomas Boylston* (Fig. 152) – finds strength, force, and vitality in the painter's ability to re-create the physical, material world before his easel, for the stuffs in Copley's *Mrs. Boylston* seem amazingly real and present. The flesh of face and hands, as painted by Copley, take on the physical qualities of flesh, and there is a rich appeal to both our visual and our tactile senses as pigment seems miraculously transformed into the glistening satin of the subject's gown, the lace of her collar, or the crisp cotton ruffles at her sleeves, while the handsome

large chair seems to possess the very substances of rich fabric, shiny-headed brass tacks, and mahogany. The face, the primary part of any portrait, occupies a very small portion of the canvas, while most of the rest of the area is given over to a materialism that forces our recognition of Mrs. Boylston's prosperity; the canvas is compacted with a materialism that both reflects the taste of the subject and is the forte of the painter's style. The means of the artist and the taste of the subject are happily united, and indeed the subjects of colonial portraits seem to have equated Art with the union of a highly individualized likeness and the successful re-creation of material things – specifically, their things and stuffs, the overt symbols of their prosperity, social position, and favor in God's eyes. What gave aesthetic validity to this art was the artist's sensitivity and his control of color, composition, linear rhythms and patterns, light and shadow, and so on, but the essence and force of his art was the sheer materialism of the substances he rendered. Herein lies what is probably the greatest strength of a portrait by Feke, or by one of Copley before he removed to England. We will see in Chapter 20 that the intuitive response to the physical, material world on the part of the native-born painters and their subjects was paralleled by a philosophical and scientific inquiry that was conducted by some of the most brilliant intellects of the age.

The materialism observed in the work of Feke and Copley is found in the art of most native-born colonial painters. Even after two years of study in England, Charles Willson Peale made it a dominant element of his style in the portraits he executed after his return to America. He rejected the painterly mode of Gainsborough, Reynolds, Romney, and West (with whom he studied) and drew upon a deep-rooted characteristic of colonial society – the adulation of material things – to form the foundation of his art. This is seen in *The Edward Lloyd Family* of 1771 with its re-creation of the physical forms of his subjects, of the velvets, satins, laces, and embroidery of their possessions (Fig. 188).

Paralleling materialism in the composition of the colonial character was pragmatism. A dictionary definition states that a pragmatic person is one who is "skilled in business," but also that pragmatism is a philosophical system that "tests the validity of all concepts by their practical results." Another dictionary describes pragmatism as "a nonspeculative system of philosophy, which regards the practical consequences and useful results of ideas as the tests of their truthfulness." We are not concerned here with the formally structured philosophical system of the late nineteenth and early twentieth centuries as devised by William James, John Dewey, and others. Rather, we speak of the attitude that prevailed among the middle class of the seventeenth and eighteenth centuries (and later) that the best test of truth is if it works, that reality consists of what is known from ordinary, primary experience, that the world is what it is and it is pointless to idealize it, that one must face life squarely whatever comes, and that one should neither perpetrate nor accept deception. In brief, it is a hardheaded, practical, no-nonsense, street-sense, see-it-as-it-is outlook on life and the physical world. It is a commonsense philosophy of ordinary people who would have little faith in esoteric, speculative philosophies concerned with ideals and the realm of abstract thought rather the search for

practical solutions to everyday problems as encountered in the home and the marketplace. They had a great faith in the truth they learned from everyday experience, and Benjamin Franklin's truisms as expressed through Poor Richard's almanacs are manifestations of that faith.

There was no formal philosophy called pragmatism among learned men of the seventeenth and eighteenth centuries, but one finds a similar attitude among such intellects as John Locke, Isaac Newton, George Berkeley, and David Hume. These scientists and philosophers tested truth and knowledge through personal, direct, and primary experience. Their philosophy had as its central doctrine that all knowledge is gained from experience (primarily sensory) and that innate ideas and a priori truth simply do not exist. Although the Boston merchant and John Locke or Isaac Newton may have been thousands of nautical miles apart, they in fact held a common guiding outlook – to look at life and the physical world squarely and through their own experience, and to apply the knowledge gained to practical ends. Nor were eighteenth-century colonial Americans ignorant of the works of Locke, Newton, Berkeley, and Hume, as we shall see in Chapter 20.

Because a pragmatic outlook dominated daily existence it is only natural that it should be reflected in the way colonial Americans saw themselves and the way the artists portrayed them. It came down to a choice of whether a portraitist should flatter his subjects, by idealizing the physical facts of their less than ideal features, or present the truth as both painter and subject perceived it to be. For the most part they opted for the latter simply because idealization of life had never been acceptable among American businessmen, craftsmen, and farmers.

Except for a brief flirtation or two with an idealized-portrait formula, brought to the colonies in the mid-eighteenth century by foreign artists such as Wollaston or Blackburn, Americans preferred a matter-of-fact portrayal of their features – a straightforward look at themselves just as they and others would see them, a paint-me-as-I-am aesthetic that arose from a pragmatic respect for truth as perceived through direct personal experience. This is particularly true in the work of native-born artists such as Feke, Copley, and Peale who were sensitive to this trait; and even foreign-born, foreign-trained painters who brought a preconceived ideal with them were often forced to make concessions to the pragmatic expectation of truth without sham in their portraits of colonial Americans. We have seen this happen, for example, in the work of John Smibert, which lost much of its artificial, aristocratic quality within a short time of its arrival in the colonies. Joseph Blackburn soon found his elegant Georgian idealized style facing formidable competition from young Copley's factual representations; and John Wollaston's peculiar voguish mannerisms – most notably the almond-shaped eyes – though all the rage for a decade in the 1750s, never became permanent features in the colonial American portrait style. One need only compare the faces of Isaac Winslow in the paintings by Blackburn (Fig. 140) and Copley (Fig. 165) to see the difference; similarly, in a comparison of Smibert's generalized, idealized image of Mrs. Berkeley in *The Bermuda Group* (Fig. 78) with Copley's Mrs. Winslow (Fig. 165), one recognizes that the real, inherent strength of the native-born artist

was in a pragmatic presentation of the features. There was, in fact, no need to have one's image idealized in a society of self-made, self-confident, independent, and egalitarian folk.

The socio-cultural traits of independence, self-confidence, and egalitarianism were present in the personality of the subjects, of course, before they were woven into the fabric of the portrait, and they were the result of middle-class origins and the patterns of life that developed in colonial America. Living in a place that was thousands of miles removed from the seat of royal and parliamentarian government encouraged independence. This independence did not burst upon the scene in 1776 but evolved steadily throughout the colonial period as Americans became increasingly aware that they were not exactly the same type of social and cultural creatures as the homeland Englishmen. They resented interference in their affairs by king and parliament and had come to respect self-sufficiency insofar as it was obtainable, and their self-sufficiency engendered independence on an individual, personal level. That feeling of individual independence appeared especially in the portraits throughout the mid-eighteenth century, whereas images of national independence appear only with the approach of the Revolutionary War or during it – as in Copley's portrait of the defiant Samuel Adams of about 1772, at the Museum of Fine Arts, Boston, or in Peale's *George Washington at Princeton* of 1779 (Fig. 186).[8]

Colonial independence manifested itself in the colonists' refusal to accept totally the aesthetics of English portraiture and, in collaboration with native-born artists, their will to evolve aesthetic principles of their own – that is, to define their taste as opposed to that of Englishmen in England. They did not accept full out the style of the British school of such portraitists as Gainsborough, Reynolds, or Romney, but instead patronized a style, as devised by native-born artists, that suited the colonial personality. Therefore, the style of a colonial American portrait is not merely the result of native-born painters being unschooled in the techniques of the sophisticated London studios (although this must be taken into account), but rather involves the development of a society that was to a measurable degree distinct from that of England. By their distinct and independent cultural personality colonial Americans, as patrons, helped create a portrait style that was related to but significantly different from the English style.

In many colonial portraits a self-confidence is written into the face and demeanor of the subject; the person portrayed seems to know his or her place in the upper level of society, and to have utter confidence in the socio-economic system of whose validity and success he or she is proof. A quiet, assured, self-possessed quality is exuded from the countenance, which arose among colonial men and women from their ability to do for themselves and to do it well and profitably. There was a feeling of self-satisfaction in the comfort of their lives, as in their fine Georgian homes where their accomplishments were apparent. In their countinghouses, shops, and wharfside warehouses, they saw their prosperity escalate in equal measure to their effort. They were a self-made people whose successes created a confidence in themselves and their way of life.

This self-confidence is seen, for example, in the face of Isaac Winslow as portrayed by Copley (Fig. 165). From the comfort and moderate affluence of

his surroundings, Winslow looks out at us, a man sure of who he is and what he is about. His attitude seems to demand that his features be portrayed truthfully, seems to insist, "Paint me as I am, because what I am is good enough." The artist had no need to engage in deceit by making his subject more elegant, more aristocratic, or, indeed, anything more than just what he was, because this man was satisfied with that which he had become. Native-born artists such as Copley seized on these characteristics to vitalize their portraits, whereas painters who were trained abroad in foreign styles – Blackburn and Wollaston, for example – tended to rely more on a class type of portrait with fashionable mannerisms. If we compare Copley's portrait of the Winslows with Joseph Blackburn's portrayal of the same subjects, we observe that Blackburn's mannered style, one learned abroad, causes the Winslows to appear self-conscious instead of self-confident (Figs. 140 and 165). Copley's likenesses, however, seem more truthful, more forceful, and more expressive of the true colonial character and personality. Whereas Blackburn's figures assume artificial poses, Copley's have settled with natural ease and composure into the snug comfort of their Boston parlor. Copley perceived the real character traits of his fellow citizens, and high among those was self-confidence. Countenances of self-confidence abound in Copley's work, and one need only look at his portraits of Epes Sargent and Eleazer Tyng (both at the National Gallery of Art, Washington, D.C.), Mr. and Mrs. Ezekiel Goldthwait (Figs. 156 and 157), Mr. and Mrs. Thomas Mifflin (Historical Society of Pennsylvania), Nicholas Boylston (Museum of Fine Arts, Boston), Mrs. Isaac Smith (Fig. 154), or Paul Revere (Fig. 158), to cite but a few well known examples.[9] The strength of such portraits is in the direct, straightforward, and truthful portrayal of basic societal traits such as individuality, independence, self-confidence, and egalitarianism, plus the subjects' sense of security and position within their society, all of which came to them as a result of their industry, prosperity, and divine favor. They would seem to be the fulfillment of the Franklinian promises discussed in Chapter 18.

Egalitarianism was deeply rooted in colonial society, and its spirit manifested itself in its portraits. In the North, aside from general stratification into the "better sort," the "middle sort," or the "meaner sort," colonial American society did not have rigid barriers separating the large white middle-class population into distinct classes. To be sure, a "colonial aristocracy" developed, but this was a status open to any person who prospered and generally behaved himself or herself. It had to be that way because most of the leading members of society were only a generation or two removed from humble beginnings, if indeed they themselves had not just risen from them. For example, Thomas Hancock (Fig. 160), one of Boston's richest merchants, was the grandson of a village cobbler, and Benjamin Franklin's father was a candlemaker. There had not yet been time for families to acquire such vast wealth that younger generations could live idly as "gentlepersons" and disdain the thought of laboring for a living. Even among the most affluent families, a man who could not do something useful in his community – like running a good business or providing some service – was somehow flawed. Members of the mercantile aristocracy could not disdain those occupations that had brought them their own wealth, and they could hardly object to the rise of a barrel maker or a

grain merchant when they had themselves risen by similar means. The point was well made by Benjamin Franklin, who declared in his "Information on ... America" that the colonial American

> would think himself more oblig'd to a Genealogist, who could prove for him that his Ancestors and Relations for ten Generations had been Ploughmen, Smiths, Carpenters, Turners, Weavers, Tanners, or even Shoemakers, and consequently that they were useful Members of Society; than if he [the Genealogist] could only prove that they were Gentlemen, doing nothing of Value, but living idly on the Labour of others, mere *fruges consumere nati* [those born merely to eat up the corn], and otherwise *good for nothing.*[10]

At the very heart of the colonial American way of life was an acceptance of the notion that everyone had to be useful, and if he were, he would prosper and so would the community. For a boy, the process of becoming useful usually began with an apprenticeship, as Franklin explained in his "Information on ... America":

> In America ... Artisans willingly receive Apprentices. ... Hence it is easy for poor Families to get their Children instructed; for the Artisans are so desirous of Apprentices, that many of them will even give Money to the Parents, to have Boys from Ten to Fifteen Years of Age bound Apprentices to them till the Age of Twenty-one; ... These contracts for Apprentices are made before a Magistrate ... and, having in view the Formation of a future useful Citizen, obliges the Master ... [that the boy] shall be taught to read, write, and cast Accompts; and that he shall be well instructed in the Art or Profession of his Master.[11]

This was the path that Franklin saw leading to a useful, fully employed, and happy citizenry in general; indeed, many who followed its course prospered greatly and in time rose from indentured servant or apprentice to equality among the most respected members of colonial society. And Franklin often made the point that although restrictions on one's prosperity and upward social mobility were frequently imposed in Europe, such was not the case in America.

Moreover, there lingered that attitude within the Calvinist heritage that, far from disgrace being associated with working at one's secular calling, it was a civic, moral, and religious virtue to do so. So aside from social attitudes that held no prejudice against persons who had made their way up the ladder by diligent industry of any honorable sort, there was, on religious grounds, the Calvinist sanction of secular labor, as observed in Chapter 1, which was still a potent belief among Congregationalists, Presbyterians, and Quakers.

All of this meant that there existed a conviction that men and women were created equal, a sentiment eventually expressed in the Declaration of Independence: "We hold these truths to be self-evident, that all men are created equal." Egalitarianism (in eighteenth-century terms, of course, for women, Indians, and blacks did not share fully in that equality) was not only approved socially and sanctioned by religion but forthrightly declared in the first step taken in establishing colonial independence from England. It would be strange,

then, if something so imbedded in the colonial way of life not appear in colonial American portraits, especially those painted by native-born artists. It is present in the work of Robert Feke, but it was Copley and Peale who made it a key element in their art. We need only look at Copley's portraits of Paul Revere (Fig. 158), Isaac Winslow (Fig. 165), or Mr. and Mrs. Ezekiel Goldthwait (Figs. 156 and 157) to find ourselves invited into the presence of the sitters, where we are greeted as equals. There is direct eye-contact between us, and a good-natured expression – enlivened by the promise of a smile – confirms our welcome. Oftentimes a gesture invites us to join in on a conversation in progress; Mr. Winslow's left hand, for instance, bids us to do so. We meet these people in Copley's portraits as equals, as the prevailing egalitarianism would demand.

A major cause of Charles Willson Peale's discontentment during the two years he spent in England in 1767–69 was, in fact, his egalitarianism; for example, he vowed it was against his principles to remove his hat when the king's carriage passed by in the streets of London. Franklin expressed similar sentiments when he wrote in his "Way to Wealth" that "a freeborn Englishman ought not to be ashamed or afraid to see or speak to any Man living."[12] When the Revolution erupted, Peale answered the call to military service in large measure because he believed the unegalitarian yoke of the British system should be cast off. He thoroughly disliked the Old World aristocratic system but instead, as Sellers observed, "saw, within the great brotherhood of man, what was for him the true aristocracy, an aristocracy of Art and Science only."[13]

What Peale felt so deeply he infused into his portraits, as we may see in his *Benjamin Rush*, where we are cordially invited into the presence, in his home setting, of this eminent and distinguished Philadelphia physician (Fig. 190). We are greeted as equals. Even when Peale painted his many portraits of George Washington as commander of the armies, he painted him as an intimate friend and not as an august dignitary of remote social rank. It would be for Gilbert Stuart to create the idealized image of the great, noble, and aloof Washington. But Peale, who had served as a comrade-in-arms in the Continental army with Washington and to a limited extent knew him socially, refused to see him or portray him in anything but an egalitarian way. Peale felt no need to idealize the man when a truthful representation of his features was so much more desirable. In fact, Peale's likeness is no doubt much more accurate than Stuart's, but Peale's image suffered from being too ordinary, whereas Stuart's gave the nation the hero it could idolize. A similar situation is found in Peale's portrait of Benjamin Franklin (Fig. 192), who was America's first personality of truly international reputation and fame as a philosopher, statesman, inventor, scientist, and literateur. European artists sometimes portrayed him in an idealized or heroic image, but Peale refused to do so.[14] Peale's portrait is far from flattering and it does not indulge in an apotheosis of the subject, for Peale saw Franklin as an equal, without the need to idealize him.

So whether the subject was a great statesman or a merchant or a grande dame of Boston, an equalizing force was at work within colonial society that greatly affected the portrait image. When rarely, under pressure from a client, the native-born artist tried to portray colonial subjects in an aristocratic mode – as in Copley's portraits of Jeremiah Lee and his wife (Figs. 163 and 164) –

the result was as unsuccessful as it was unnatural, or perhaps unsuccessful because it was unnatural. Whenever artists who were European-born and trained tried to impose a mannered or fashionable ideal on the image, they soon learned they must change their style to accommodate colonial American taste and social values, or return to Europe. The artist in materialistic, pragmatic, egalitarian America had to be able to paint his subject with an objective portrayal of the physical reality that was there before him, without engaging in artificial social conceits or ideals. Colonial merchants and their fellow citizens demanded this because the portrait was expected to reflect their materialistic interests, their pragmatic outlook, their egalitarian spirit, and their quiet self-confidence, which came from the good life and the prosperity they had gained through their own labor. Such were the components defining the social being known as the colonial American, in the North, at least, and it would be unthinkable that they should not appear as salient characteristics in the portraits of the upper-middle-class mercantile aristocracy.

Philosophers and Scientists

Nihil est in intellectu quod non prius fuerit in sensu

Because of the way the empirical approach of the foremost philosophers and scientists of seventeenth- and eighteenth-century England – Locke, Newton, Berkeley, and Hume – parallels the commonsense pragmatism of the rising, prospering middle class, one wishes it were possible to measure the influence of their work on the broadening masses of merchants, farmers, craftsmen, and so on. But it would be equally interesting to know the degree to which middle-class pragmatism influenced the thought and methodology of the men of science and philosophy. The rise of the middle class and of an empirical methodology among learned men evolved so closely in both time and space that some correlation seems apparent. In any case, we have seen how the pragmatic attitude of the middle class influenced the style of eighteenth-century colonial American portraiture, and we will now find that the thought of Locke, Newton, Berkeley, and Hume confirms that approach at the highest level of intellectual inquiry. In brief, these men – the empiricists – held that all knowledge came as a result of sensory experience and direct observation, a refutation of the central concept of the rationalists, led by Descartes, which was that metaphysical speculation could lead to the discovery of innate ideas and hence of truth. We shall now explore the matter of how the empiricists paralleled the middle class in their outlook and thereby gave an intellectual foundation to the art of Feke, Copley, Peale, and other colonial American artists.

Inquiry into the wonders of the physical world became possible under Protestantism and Anglicanism to a degree that the Catholic church had never tolerated. To many, that inquiry offered the possibilities of answers to religious questions – questions that faith and revelation could no longer answer to their satisfaction. Under Protestantism, and Anglicanism as well, no objection was raised against the study of the real, physical earth and the celestial region that surrounded it, and so interest in geography, astronomy, physics, optics, and other areas of science escalated. The Catholic church branded many such pursuits heretical because they sometimes created a conflict with Scripture and essential Catholic doctrine. But the non-Catholic middle class and the era of scientific inquiry grew and matured together in complete compatibility.

Robert K. Melton has observed that perhaps the "most directly effective element of the Protestant ethic for the sanction of natural science was that which held that the study of nature enables a fuller appreciation of His [God's]

works and thus leads us to admire the Power, Wisdom and Goodness of God manifested in His creation."' Max Weber noted a "decided propensity of Protestant aesceticism for empiricism," and further observed:

> For the attitude of Protestant aesceticism the decisive point was . . . [that] the knowledge of God and His designs can only be attained through a knowledge of His works. The favorite science . . . was thus physics, and next to it all those other natural sciences which used a similar method, especially mathematics. It was hoped from the empirical knowledge of the divine laws of nature to ascend to a grasp of the essence of the world, which on account of the fragmentary nature of the divine revelation, a Calvinistic idea, could never be attained by the method of metaphysical speculation. The empiricism of the seventeenth century was the means for aesceticism to seek God in nature. It seemed to lead to God, philosophical speculation away from him.[2]

There are virtually no religious symbols or icons in Protestant–Anglican colonial art; this is not only because of anti-icon (anti-Catholic) feelings, but also because it was believed that God was to be found more in his works and his ordering of nature and the universe than in pictures of him or Christ or the saints. Newton established that God had created the universe and set all things in motion; thereafter, God had little to do with the continuing process of nature, his laws of nature being self-fulfilling. Therefore, by understanding the universe and the physical world, one came closer to God than through metaphysical speculation or the elaborate ceremony that the Catholic church had developed. This not only led to the scientific study of nature – a secularization of the search for God – but to the individual seeing himself as a part of the natural order of things as set in motion by God himself. Therefore, if a merchant, tradesman, professor, or farmer followed his calling and did it properly, he was obeying the laws of God and ergo living righteously.[3]

In the early seventeenth century the leading figure among the rationalists was René Descartes (1596–1650), a devout Catholic who was educated at the celebrated Jesuit school at La Flêche. At the latter he studied math, physics, astronomy, and philosophy, but in time he found Catholic restrictions on inquiry too limiting and so fled to Protestant Holland, where he had greater freedom to explore his ideas. To Descartes, the relationship of God, man, and the physical world depended on the assumption that our knowledge of such things came from "innate ideas and intuitive insight" and was "acquired quite independently of sensuous experience."[4] Descartes even sought to prove his own existence by a thinking process rather than through physical evidence, as demonstrated by his motto *Cogito, ergo sum* – I think, therefore I am.

In contrast to Descartes's motto, that of the empiricists was *Nihil est in intellectu quod non prius fuerit in sensu* – nothing is known to us that has not first appeared to our senses.[5] The forerunner of empiricism was the brilliant English philosopher Francis Bacon (1561–1626) whose inductive methodology established the pattern for modern experimental science. But of greater importance for our purposes was John Locke (1632–1704), who was instrumental in establishing a foundation for science through observation and experimentation for an age that was eager to learn about the physical world (Fig. 131).[6] Whereas

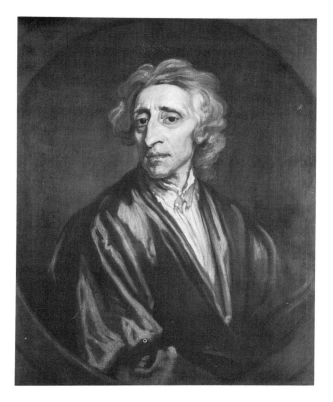

Figure 131. *John Locke*, by Godfrey Kneller, c. 1704. Oil on canvas, 30 × 25 inches. Virginia Museum, Richmond.

Descartes and the rationalists held that reason could arrive at certain indisputable truths independent of sensory observation or experimentation, Locke and his followers denied the existence of innate ideas. The mind, declared Locke, has no knowledge except that which it has received through the raw material of sensory experience. He said the mind at birth was a total blank and such intelligence as it accrued resulted only from experience. In his *Essay Concerning Human Understanding* (1690) he wrote:

> Let us then suppose the mind to be . . . white paper, void of all characters, without any ideas; how come it to be furnished? Whence comes it by that vast store which the busy and boundless fancy of man has painted on it, with an almost endless variety? Whence has it all the materials of reason and knowledge? To this I answer, in one word, from experience. . . . Our observation employed either about external simple objects, or about the internal operations of our minds, perceived and reflected on by ourselves, is that which supplies our understandings with all the materials of thinking.[7]

Locke believed there could be no knowledge of natural objects except as perceived through the senses and relayed to the mind. Robert Feke or John Singleton Copley might well describe their chief aesthetic principle in similar

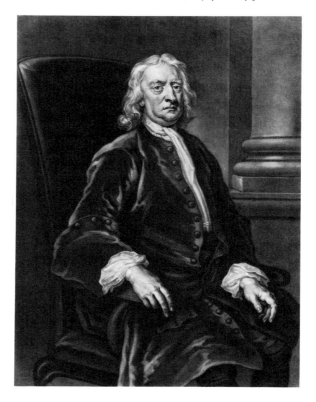

Figure 132. *Isaac Newton*, by John Faber, 1726, after John Vanderbank, 1725. Mezzotint, 13½ × 9¾ inches. British Museum, London.

terms, and one can imagine either of them saying, "I paint the physical world as I know it to be from seeing it with my eyes there before me." Similarly, the common man or woman who sat to Feke or Copley for their portraits would have had more faith in knowledge acquired through their own personal, direct experience of the world than in theoretical speculation about it.

The physical substance that fills the canvases of Feke, Copley, Peale, and other colonial American artists parallels the interest in the study of the physical world, and the most important figure in that study was Issac Newton (1642–1727; Fig. 132).[8] His *Philosophiae naturalis principia mathematica* of 1687, translated into English and published in 1729 as *Mathematical Principles of Natural Philosophy* (known as Newton's *Principles*), was one of the greatest and most enduring contributions to modern scientific methodology.

"In the older Christian tradition [Catholicism]," Bakan wrote, "the physical world was essentially to be despised. Newton facilitated the transfer of reverence previously reserved to the spiritual realm to the physical world by showing it to be an expression of God, and perhaps the way in which God had critically revealed himself to mankind."[9] Newton, of course, was not alone in pursuing a religious quest through science. For example, John Ray, a Fellow of Trinity College at Cambridge University and a member of the Royal Society, published in London in 1691 *The Wisdom of God Manifested in the Works of the Creation*, a treatise that attempted to unite religion and scientific

knowledge – it was a work of one devoted to Christianity yet deeply concerned with the new discoveries of science about the heavens, the physical earth, man, and animals.[10] Also, Samuel Lee, an Oxford scholar and a scientist who came to Massachusetts in 1686, wrote *The Joy of Life* (Boston, 1687), in which he "magnified God's glory through the works of nature"; his book "was influential in popularizing the conception of the philosophical religion."[11] Cotton Mather knew Lee's work and referred to him as a thoroughly learned person. Protestants tended to have little fear of reason and investigation of the physical world because they seldom found any conflict between those things and faith. As Degler put the matter:

> In his ceaseless striving for signs of salvation and knowledge of God's intentions for man, the [seventeenth-century] Puritan placed great reliance upon the human intellect, even though for him, as for all Christians, faith was the bedrock of his belief. "Faith doth not relinquish or cast out reason," wrote the American Puritan Samuel Willard, "for there is nothing in Religion contrary to it. . . ." Richard Baxter, the English Puritan, insisted that "the most Religious, are the most truly, and nobly rational." Religion and reason were complementary to the Puritan.[12]

These attitudes toward reason and knowledge were held by Protestants generally and also by Anglicans, and were not just those of Puritans. In such a climate Newton was free to develop his theories of gravitation, light, motion, astronomy, and mathematics – that is, to search for the natural laws of the physical world. This involved, of course, an intellectual analysis of the highest order, as well as direct observation, but for our purposes Newton epitomizes the spirit of his and subsequent times in his fascination with the physical, material world. Many colonial Americans shared this interest, not only for the profits that could be gained but out of genuine curiosity about nature. Their interest in the physical qualities of nature paralleled Newton's and no doubt caused them to respect an artistic style that reflected nature, as observed directly and as known optically and tactily – that is, through the senses.

Newton's work was well known throughout the colonies in the eighteenth century[13] and was the basis for man's understanding of his own real world, something that surely concerns anyone attempting to understand the material, physical reality suggested in many colonial portraits – most notably Feke's and Copley's. Newtonian thought was, of course, understood by the learned professors and clergymen in America, but, more importantly, through them it was interpreted to a much wider base of the lay society. Moreover, members of that lay society frequently participated directly in the scientific inquiry of the day. Governor John Winthrop, Jr., of Connecticut, was elected to the Royal Society in London in 1663 and corresponded with Robert Boyle and Robert Hooke as well as Newton himself. Winthrop also corresponded with the German astronomer Johannes Hevelius (1611–87), and he was the first to import a telescope to the colonies. A wealthy Boston merchant, Thomas Brattle, was a gifted astronomer who made such careful observations of Halley's comet that they were cited in Newton's *Principles*, while other of his notations were published in the *Philosophical Transactions* of the Royal Society.

The Reverend Joseph Green noted in his diary on May 29, 1711, that he had visited Thomas Brattle's house, where he "saw strange things in a microscope."[14]

Copies of Newton's work were available in private as well as institutional libraries. James Logan had the *Principles* in his personal collection in Philadelphia in the early eighteenth century, and he made it available, as he did with all of his library, to anyone interested in learning things.[15] Harvard and Yale early became centers for the study and dissemination of Newtonian thought.[16] By 1714, Yale College possessed the complete works of Boyle, Locke, and Newton.[17] Samuel Adams studied Locke at Harvard, John Adams had books by both Locke and Newton in his personal library, and by 1750, Benjamin Franklin was urging that the youth of Philadelphia be taught Locke and Newton. Ezra Stiles, president of Yale, was a Newtonian Scholar.[18] At Harvard, when Thomas Hollis of London endowed a chair in mathematics and natural philosophy (which meant natural history, or science) in 1727, the first appointee was Isaac Greenwood, the son of a Boston merchant, who had studied in England with disciples of Newton. Greenwood, whose portrait of about 1735 is at the New-York Historical Society,[19] indoctrinated his Harvard students into Newtonian thought in the 1730s. His successor as Hollis Professor was John Winthrop IV, whose tenure ran from 1738 to 1779, spanning the years of both Feke's and Copley's periods of painting in the Boston area. Winthrop's "course in natural philosophy," Wright has noted, "provided the most advanced scientific instruction in North America in its time. . . . One of his first steps after his appointment was to procure a copy of Newton's *Principia*, which became his guide."[20]

Ministers, too, joined in the experience of learning about the physical, temporal world, and even John Cotton had urged the study of God's natural world.[21] Few men of his time did so more avidly than the Reverend Cotton Mather, who was thoroughly familiar with the works of Newton, Boyle, Kepler, Halley, Huygens, Hevelius, and so on, and praised them.[22] In Mather's *Manductio ad Ministerim* he writes, "What we call natural philosophy [science] is what I most urge you to spend much more time in the study of," while in his *The Christian Philosopher* he further declares, "The essays now before us demonstrate that [natural] philosophy is no enemy, but a mighty and wonderous incentive to religion."[23] Mather perceived two worlds – one physical and natural, the other scriptural and spiritual. He was a transitional figure in the advance of science, for early in life he had tended to explain the unexplained as being supernatural or the will of God; but as his study of science increasingly provided answers to those things that were previously unexplained, the supernatural retreated. This increasing propensity to see and understand the world in a physical sense was paralleled in colonial portraiture by the increasing development of an image that suggested a physical re-creation of nature, for artists such as Feke and Copley were as captivated by the physical world as any scientist or philosopher.

In many ministers' bookcases one would find not only Newton's *Principia*, *Optics*, and *Astronomy* but also Bacon's *Natural History* and *De Augmentatione*, Boyle's *Philosophical Essays* and *Natural Philosophy*, Halley's *Synopsis of Comets*, Huygens's *Discovery of Coelestial Worlds*, Kepler's *On the Loadstone*, Charles

Morton's *Compendium Physicae*, and many more volumes testifying to their fascination with physics, astronomy, and other forms of natural science. Nor were such things kept solely within the ministerial brotherhood, for scientific information was often disseminated from the pulpit. Dr. Alexander Hamilton noted such an occasion in his diary in July 1744, after he had attended church at King's Chapel in Boston; the preacher, he wrote,

> gave us rather a philosophical lecture than a sermon. . . . We had a load of impertinence from him about the specific gravity of air and water, the exhalation of vapours, the expansion and condensation of clouds, the operation of distillation, and the chemistry of nature. In fine it was but a very puerile physical lecture and no sermon at all.[24]

The influence of ministerial awareness of current scientific knowledge is nowhere better demonstrated than in the inoculation controversy in Boston when many were dying of smallpox in the epidemic of 1721. Against great opposition, even the threat of violence, Cotton Mather endorsed Dr. Zabdiel Boylston's attempts to gain approval and acceptance for the new practice, and their determined efforts were soon successful.

So merchants and ministers, professors and physicians alike were participating in the spread of the new knowledge of the physical sciences. Such knowledge offered a double advantage: It allowed the pious, faithful layman to seek in natural laws a fuller understanding of his God, and it permitted an investigation of the physical world about which he was so curious and in which he dwelt and sought material riches. The high-level scientific inquiry into the physical world paralleled the pragmatic interests of merchants, planters, and tradesmen; on each level the concern was with the real, physical world and not with abstract speculation or ideals of the Platonic or Cartesian sort. When we look at the portraits by Feke or Copley we find worked into them a respect for the physical substances of the sitters and their immediate surroundings, and their style depends on direct sensory observation of the physical matter before them. These painters sought no ideal or abstract conception of their subjects, who wanted their portraits to be, as much as possible, optical re-creations of the actual physical fact. And Charles Willson Peale himself eventually, about 1785, gave up portrait painting to devote his time and boundless energy to study the natural sciences and create his natural history museum in Philadelphia. Peale was a follower of Linnaeus, the author of *Systema Naturae* (1758) and the founder of the modern system for plant and animal classification. Peale was also a friend of the Philadelphia naturalist William Bartram, and in Peale the art of painting and the study of the physical sciences are united.

The question may arise that if the thought and writings of Locke and Newton contributed to the development of the style of a colonial American painter, why did a similar influence not occur in eighteenth-century English painting – in, say, the work of Sir Joshua Reynolds or Thomas Gainsborough? This matter needs investigation, but one suspects it is because the art of the English painters was based on a long-standing artistic tradition reaching back to Renaissance and baroque theory. Colonial artists, at least those who were native-born like Feke and Copley, were separated from that theory by the wide Atlantic, and in their art they were responding to the materialism and prag-

matism of their subjects – a materialism and pragmatism supported at the highest intellectual level by the contemporary work in natural philosophy of such men as Locke, Newton, Berkeley, Hume, and their followers.

The Reverend George Berkeley, who became an Episcopal bishop after his return from America, was also an empiricist, as seen in the discussion of Smibert's painting *The Bermuda Group* in Chapter 12 (Fig. 78).[25] In his study of vision he claimed that sensory experience was the only true source of knowledge. Berkeley's theories were presented in two publications, *An Essay Towards a New Theory of Vision* (1709) and *A Treatise Concerning the Principles of Human Knowledge* (1710). In the former especially he was concerned with perception as the mechanism for knowing, or the first step in obtaining knowledge. The senses present "pictures or representations" to the mind, where ideas are formed. We have noted earlier that Smibert's style changed after his arrival in America, and we postulated that the change was due to the taste of his new clientele or to the influence of Berkeley's theory of vision – to which the painter was exposed during the lengthy Atlantic crossing – or to both. Current research is producing evidence that other painters were affected by Berkeley's theories, especially Feke and Copley.[26] Novak has observed that in Copley's mature work, "conceptual bias is modified by his pungent empiricism. . . . Idea is amplified to become form. . . . Abstract knowledge is fortified by the *stuff* of empiricism, distinctive and tactile properties of objects."[27] Berkeley's theories have a compatibility with, and perhaps a direct influence on, both the method employed by native-born colonial American artists and the pragmatic inclinations of the colonial patron.

Next in line in the empiricist chain came David Hume (1711–76), a Scottish-born diplomat, historian, and philosopher who in 1739 published *A Treatise of Human Nature* and the next year brought out, anonymously, the *Abstract of a Treatise of Human Nature*, which attracted more attention than his original publication.[28] In these works he stressed the sensory source of our perceptions, which he called "impressions," and the author promised the reader "to draw no conclusions but where he is authorized by experience."[29] Writing as if he were reviewing his own *Treatise* of 1739, he says in the *Abstract* that the author

> divides our perceptions into two kinds, viz, impressions and ideas. When we feel a passion or emotion of any kind, or have the images of external objects conveyed to our senses; the perception of the mind is what we call an impression, which is a word that he employs in a new sense. When we reflect on a passion or an object which is not present, this perception is an idea. Impressions, therefore, are our lively and strong perceptions; ideas are the fainter and weaker.[30]

For Hume, "impressions always take the precedency" over ideas, and "wherever any idea is ambiguous, [the author] has always recourse to the impression, which must render it clear and precise."[31] All of this stresses the superiority of sensory awareness of reality, as one would expect of an empiricist.

Hume's *Abstract* was published just about the time that Robert Feke comes into historical focus, and in looking at Feke's portraits – say, the *James Bowdoin II* (Fig. 136) – one finds a style that results mainly from intense observation of the object standing before the painter; when Hume says the sensory ex-

perience will render the perception "clear and precise," Feke's clarity of form, richness of tactile substances, and crispness or precision of outline seem to be a visualization of what the philosopher had in mind. These same qualities exist in the style of Copley's colonial portraits, and Charles Willson Peale, too, created his images by first drawing on the canvas, with all the precision he could muster, what was there before him, relying more on the optical sensation of physical reality than on some abstracted ideal. The latter, in terms of artistic style, could be equated with a way of painting arising from aesthetic theory rather than reliance on direct experience of nature. One feature distinguishing the work of foreign-trained artists, such as Blackburn or Wollaston, from Feke or Copley is the stylized mannerisms of the former group – as in the almond-shaped eyes of Wollaston – whereas the native-born painters tend to rely on visual objectivity. Benjamin West subscribed totally to the superiority of artistic theory over nature after he left the colonies, and Copley's art, after he went to England, changed dramatically in that direction. Sir Joshua Reynolds in his *Discourses*, although he frequently advised the painter to study nature, constantly emphasized the superiority of the ideal – that is, continuing the esoteric artistic theory that arose in the baroque period, he stressed the ideal over the specific, which was antithetical to empirical procedure.

It is difficult to determine whether Feke, Copley, Peale, or any other colonial artist ever read and digested the philosophical or scientific treatises of Locke, Newton, Berkeley, and Hume. It would be nice to know if they did, but it is not essential. What is important to recognize is the close parallel between the words of the scientists and philosophers and the art of the native-born colonial painters. The ideas of the scientists and philosophers were not, after all, kept sealed in a vacuum where they could not escape to the outside world. We have seen above the extent to which their thought was disseminated at popular levels of colonial society. Not only was knowledge of current philosophy and the new science the mark of a learned gentleman, it was, because of its practical applications to commerce and agriculture, a necessity. Richard Lewis's "A Journey from Patapsco to Annapolis, April 4, 1730" demonstrates that intelligent colonists could deal with philosophical and scientific ideas as expressed through the arts. The poem "explores the fundamental questions of an intelligent man's theology in view of the new science and philosophy of the day."[32] In lines thirty to thirty-nine the poet gives, as Lemay points out, "the theme of his poem, a statement of his belief in scientific deism (i.e., that the beauty and order of the universe, which operates according to the laws of Newton and the new science, proclaim the existence of God)."[33] Lewis's poem was published in several colonial newspapers – that is, in a popular medium – where it was evidently read, enjoyed, and comprehended.

If one art form, poetry, could be used as a vehicle to express current scientific and philosophical knowledge, so could another art form – painting, and in particular, portraiture. In each, science and art are inseparably united to express some of the foremost issues of eighteenth-century thought. Those ideas expressed by the greatest scientific/philosophical minds of the period or by the poet or painter could be understood by the intelligent layman; if he could apply them in his daily life and enjoy them in the poetry he read, we may assume he could recognize them in his portraits.

277

An Ambience of Elegance

The portrait was not the only manifestation of a religio-secular philosophy and of middle-class prosperity. The home, in fact, became the primary symbol of it all, and the portrait had to take on a certain form in order to achieve an integrality and compatibility with an enriched interior decor. During the first quarter of the eighteenth century, the earlier, medieval survival design of middle-class architecture gave way to the new, classical and Palladian style that was being imported to the colonies, in large part through English design books.[1] Under the patronage of Lord Burlington, Giacomo Leoni published a complete edition of Palladio in 1715 and William Kent produced an edition of Inigo Jones's architectural designs in 1727, while Isaac Ware brought out another edition of Palladio in 1738.[2] Other design books – by James Gibbs, Abraham Swan, and Batty Langley – swiftly crossed the Atlantic, bringing with them the motifs of the new Georgian elegance. Colonial carpenters were thus forced to learn a whole new architectural vocabulary that included pediments, pilasters and quoins, balustrades, cornices, and urns. Small, diamond-leaded windows were replaced by large Palladian windows, and simple, unadorned plank doors were replaced by elegant, paneled doors flanked by pilasters and capped by pediments. Roof lines were lowered and partially hidden by balustrades, while a classical symmetry added a dignity to the whole edifice, which was set off by the formal landscaping of the surrounding grounds. No longer were successful New England merchants devoted, because of their cultural background, to a style of living distinct from that of aristocratic society, as had been the case in the seventeenth century, and one way they showed they now sought to imitate that more refined life-style was in the design of their houses. This found sanction from their clergymen, as demonstrated by the Reverend Cotton Mather's handsome three-story house on Hancock Street, which had classical pilasters, a balustrade across the roof, and an elegant central doorway with an ornate arched transom above it. The good minister could therefore hardly chastise John Mico, Peter Faneuil, or any of the other prospering Boston merchants because of the fine new houses they were building. Public buildings, such as the Old State House in Boston of 1728, were also designed in the new mode. In church architecture, the Anglicans led the way with high-style edifices such as Christ Church, Boston (1723); Christ Church, Philadelphia (1727); Bruton Parish Church, Williams-

burg (1711–15); and St. Philip's Church, Charleston (1727). By the end of the 1730s the seaboard towns had clearly begun to take on a new elegance with these beautiful early Georgian exteriors.

A survey of the great houses of colonial America reveals the elegance with which the northern merchants and the southern planters now surrounded themselves and their families. In the South, the Governor's Palace (1706–20) at Williamsburg set a new standard for innumerable plantation houses. In New England, the form of the wealthy merchant's house was set by such edifices as the McPhedris–Warner House (1718–23) in Portsmouth, New Hampshire; and in the 1730s the Royall House (1733–37) in Medford and the Thomas Hancock House (1737–40) in Boston rose as emblems of mercantile refinement and elegance. The 1750s and 1760s saw the colonial Georgian style reach its fulfillment in such homes as Lindens (1754) in Danvers, Massachusetts (re-erected in Washington, D.C.), the Vassal–Longfellow House (1759) in Cambridge, the Richard Derby House (1762) in Salem, and the posh Lee Mansion in Marblehead; in New York the Morris–Jumel Mansion was built in 1765, while in Philadelphia, Mount Pleasant was finished in 1761 and the elegant design of the town house was established in the Powel House of 1768. The litany of lovely Georgian homes in the South continues with Virginia houses such as Kenmore (1752), Wilton (1753), Carter's Grove (1755), Gunston Hall (1758), and Shirley (1769), and, in Charleston, South Carolina, the Miles Brewton House (1765–69). The period concludes with exquisite examples of Georgian design such as the Corbit–Sharp House (1772–74) in Odessa, Delaware, and the Hammond–Harwood House (1773–74) in Annapolis.

To anyone familiar with even a few of these houses, a vision of refined, stately, elegant, high-style domestic architecture presents itself – a vision connoting the prosperity and social position of the colonial mercantile and planter aristocracy at its zenith. In the North the wealthy merchants were building fine houses in the manner then being employed by their mercantile counterparts in London's Bloomsbury area, while in the South the planters were adopting the style of the homes of England's country gentry. In the colonies the materials used may have been wood or brick as opposed to the stone used in English houses, and the scale may have been more modest, but the style was the same as that employed by the great merchants or the country aristocracy of England.

The interiors of the homes of mercantile and planter society changed along with the exteriors. One now characteristically entered into a fine entrance hall and from there found separate rooms for the parlor, dining room, and library. Each room had its own fireplace, no longer a smoke-blackened cavern but now handsomely enframed by pilasters and cornicelike mantel. The clutter and mess of food preparation that had earlier dominated the main hearth was now often removed from the main house entirely and carried on in a small adjacent building. Upstairs was a master bedroom with separate rooms for children and guests. The new interior design called for classical cornices around the ceiling and doorways of the main rooms, paneled wainscoting on walls, and, occasionally, decorative plastered ceilings. After 1730 decorative wallpapers began to appear as a standard part of Georgian interiors, while crimson damask curtains hung at the windows. The heavy oak and pine furniture of seventeenth-century interiors was replaced by elegantly designed tables, chairs,

highboys, chests, and bookcases wrought from imported mahogany or domestic walnut and fruitwoods, often richly carved.[3] Eventually, after about 1755, the exquisite designs of Thomas Chippendale would dominate the furniture style, while at appropriate places in the house finely crafted pieces of silver and imported porcelain would testify to the wealth of the owners. In other words, the whole ensemble – landscaping, exterior, interior, and furnishings – were now more elegant and more formal, made so not only for the owners' pleasure but also to display the new wealth, prosperity, and social position of people who had often begun life as humble shopkeepers, merchants, tradesmen, craftsmen, seamen, or farmers. Thomas Hancock, whose grandfather was the village cobbler in Cambridge, built on Beacon Hill one of the finest homes in Boston, while Richard Derby, whose ancestor was a soap boiler, built one of Salem's most elegant eighteenth-century houses.

In summary, the setting for life among successful and prosperous folk had changed from one of medieval survival form and utility to one of formal elegance and affluence. The church, public building, and home were all now to be in the same high-style design employed by English aristocracy, and all was calculated to demonstrate prosperity, the fruits of one's diligence at one's secular calling. The interiors in which the portraits were meant to hang demanded that the images reflect the same qualities, even virtues, of success, prosperity, social position, material wealth, and middle-class refinement and elegance.[4] It was, after all, amid such surroundings that colonial portraits were intended to take their place, and not on cold and austere gallery walls of twentieth-century art museums.

Robert Feke and the Formulation of the Colonial American Portrait Style

Although Robert Feke (c. 1707–52) emerges as a historical figure in colonial American painting in the 1730s, it was not until the years 1745 to 1750 that he established himself as the first native-born genius in art, defining in his portraits those traits of character discussed above as they culminated in the final phase of the colonial era.[1] Feke was born about 1707 in Oyster Bay, Long Island, but little is known of his early life or of any artistic training he may have had.[2] His earliest-known portrait, of Phainy Cocks, has been dated about 1732, and seems to have been painted in New York City.[3] But his activity was centered mainly in Newport, Rhode Island, until Smibert's retirement around 1745, when Feke moved to Boston. He made two excursions to Philadelphia, in 1746 and 1748, and then disappeared about 1750. New evidence suggests he died in 1752, possibly in Barbados. Feke's first major commission was for the *Isaac Royall and His Family* of 1741 (Fig. 133).

Isaac Royall, Sr., father of the young man in the portrait by Feke, had moved from Maine to Antigua sometime in the first quarter of the eighteenth century. There he accumulated a large fortune in the sugar, rum, and slave trade, and there his children Penelope and Isaac, Jr. (1719–81), were born. In 1732 he returned to Massachusetts, purchasing Ten Hills Farm, a 600-acre estate in Medford, just outside of Boston. The old seventeenth-century farmhouse was completely remodeled, enlarged, and transformed into an elegant, stylish early Georgian masterpiece of colonial American architecture.[4] The Royall family moved into the house in 1737, just two years before Isaac, Sr., died, and the richness of the interior furnishings is revealed in the inventory that was taken as part of the estate settlement.[5] Most of the estate went to Issac, Jr., and its total value of more than £29,000 made him one of the wealthiest men in the colony. Isaac Royall, Jr., and his family lived in the house until the Revolution, when they fled to Halifax and then to England. Although he never returned, Royall maintained an enduring love for the colony and the home he had lost; educated at Harvard and trained as a lawyer, he endowed the Isaac Royall Professorship in Law at the college, which explains why the portrait of him with his family was given by his descendants to the Harvard Law School.

Feke's portrait of young Isaac Royall, Jr., and his family was painted only

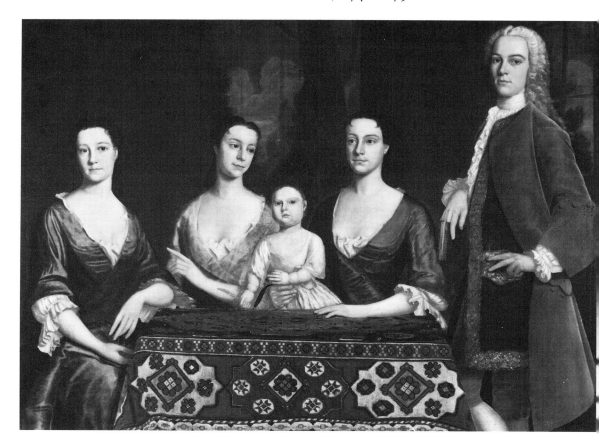

Figure 133. *Isaac Royall and His Family*, by Robert Feke, 1741. Oil on canvas, 56 × 77¾ inches. Harvard University Portrait Collection, Cambridge, Mass. Gift of Dr. George Stevens Jones.

two years after the death of Isaac Royall, Sr., and the inventory of the latter's estate is interesting because it gives us an idea of the material goods and advantages with which his son began his mature life. In addition to the land and the house there were the stable for the four coach-horses and the coach, several other outbuildings, and thirteen slaves. The interior of the main house was richly furnished with ornate sconces, looking glasses, fine paneling, colorful drapes, mahogany tables, numerous chairs, decorative tiles around the fireplaces which had brass andirons, crimson silk damask bed hangings, a japanned tea table, and Turkish carpets, to mention only some of the luxuries. There were more than six hundred ounces of silver plate, valued at £914, and a very interesting library of about one hundred volumes, including a three-volume set of Locke's works, Allestree's *The Whole Duty of Man*, Lord Shaftesbury's works in three volumes, and several scientific treatises. The house itself was an architectural showplace of the new Georgian design with its Palladian details, its symmetrically aligned windows and ornamented central doors, its quoining at the corners and its rustication on the west facade.[6] With such wealth of goods and servants, it is small wonder that Isaac Royall, Jr., appears

as a proud young man in the portrait Robert Feke painted to hang in his handsome house in Medford. The canvas, in fact, is filled with references to the prosperity of this second generation of mercantile aristocracy, and we are reminded that, in addition to preserving likenesses, the purpose of such a portrait was to declare the subjects' affluence, social position, and commitment to a philosophy of refined materialism.

The *Royall Family*, a large, ambitious work, represents Isaac Royall, Jr., standing at the right, beside his wife who holds their daughter, Elizabeth; next to Mrs. Royall is her sister, Mary Palmer, and at the left is Isaac's sister, Penelope, who later became Mrs. Henry Vassall of Cambridge. Royall's wealth would have allowed him to command the best artistic talent available for this portrait, which would normally have been John Smibert; but Smibert was seriously ill at that time and not painting, and so the commission went to Feke.

As in Smibert's *Bermuda Group* (Fig. 78), the several figures in the *Royall Family* are arranged around a table covered with a Turkish carpet, which is parallel to the picture plane; again, the main figure stands at the right holding a book, while the women are seated at the table. The figure of Mary Palmer (second from left in Feke's portrait) is almost identical to that of Miss Hancock, the woman on the left in Smibert's *Bermuda Group*. In the background, through windows with large, rectangular panes, one sees a generalized landscape. At this stage in his career and in this painting particularly, Feke was unquestionably under the influence of Smibert, and we observe the transmission of the formula of the London high-style baroque portrait, through a British artist who had immigrated to the colonies, to a native-born painter who had never studied in England. Although Smibert was the major influence, there was also that of the mezzotint, which played an important role in defining for the colonists just what art was and acquainting them with the recent painting styles of England. Here, the figure of Penelope Royall (far left), who fondles a string of beads, is reminiscent of the mezzotint of Princess Anne by Beckett after the painting by William Wissing (Fig. 146). Both Smibert and the mezzotints transmitted a style that was mainly baroque, and the *Royall Family* is essentially a baroque portrait as a result.

The figures in the *Royall Family* have a greater rigidity than in Smibert's picture, and the composition is additive (individual figures added one by one to form a group), whereas in *The Bermuda Group* there is a rhythmic, interlocking baroque pattern of movement and form throughout the arrangement. This simplistic, additive arrangement is perhaps to be expected in an early effort by a young and relatively inexperienced artist who was imitating a style without thoroughly understanding its subtle nuances. Moreover, a basic stylistic difference exists between the two group portraits, for Feke's manner lacks the fluid, painterly technique that Smibert had learned in England and Italy; Smibert's forms were created by the brushstroke, while those in Feke's picture have a linear crispness that was the result of defining the form by line before painting was begun. Also, Smibert painted his images according to European artistic theory, whereas Feke, unschooled in that theory, relied mainly on direct observation of that which was immediately before his eyes.

In the stiffness of the figures and in the poses they self-consciously assume

there is an artificiality that will eventually disappear from the colonial portrait. The poses, part of a preconceived ideal, were transmitted here through European artists who came to the colonies and through mezzotints, but they suggested pretensions and formality, and they seemed unnatural. That they were purged from the colonial style may be seen by comparing the *Royall Family* with Copley's *Mr. and Mrs. Isaac Winslow* (Fig. 165). During the decade of the 1740s the rigidity and posing eased somewhat in Feke's work, but it never became completely free of it.

In summary, the *Royall Family* is interesting as an expression of the economic and cultural matters that have been the primary focus of this study. In it the native-born artist attempted to put into visual form those things that mattered most to his colonial American patrons. The people portrayed obviously enjoyed their affluence, as indicated by the fashionable clothing and the luxuriant fabrics – velvets, silks, satins, and brocades. The low-cut necklines of the ladies' gowns are revealing and sensual, and indicate a greater devotion to current London fashions than to the strictures of religious zealots. The coiffeur of the women is stylish, and Isaac Royall – who was then only twenty-two years old – wears a white wig as an emblem of high social rank. References to the Royalls' wealth are seen in the Turkish carpet that covers the table and in the suggestion of fine architecture at the right. But the display of one's prosperity had its limits, and even a person as proud as young Isaac Royall recognized the line that was drawn between an acceptable display of prosperity and ostentation. Still, the upward limit of what was tolerated before ostentation was reached had clearly been raised beyond what it had been when colonial American painting began around 1660–70.

In Robert Feke's *Royall Family*, far more than in Smibert's *Bermuda Group*, the course was established for the culmination of the colonial American portrait. After he painted the *Royall Family*, Feke's career languished, however, and there are only eight known portraits between 1741 and 1746. Only after Smibert's retirement in 1745 did Feke come forward as a full-time painter. In 1746 he journeyed to Philadelphia to take the likenesses of the Quaker City's mercantile aristocracy, and in the paintings that resulted from that trip he refined and further defined the colonial American portrait style. Thereafter, Feke tended to avoid the generalized, idealized image we noted in his portraits of the Royall women, and he inclined toward greater specificity of personal features, relying on direct observation of his subject as the primary force underlying his style, even when he used an English mezzotint as a model.

A superb example of Feke's work from the first Philadelphia trip is the *Mrs. Charles Willing* (Fig. 134). Although he drew inspiration from a print by John Faber after Joseph Highmore's portrait of Queen Caroline,[7] both the face and the body of Ann Shippen Willing are surely accurate records of individual, personal, and specific characteristics. In this regard the portrait looks ahead to the portraits by Copley. In spite of Feke's use of the mezzotint of Queen Caroline, the portrait of Mrs. Willing draws its strength and aesthetic integrity from the artist's powerful re-creation of the physical, material world that was there before him; that is, his artistic style is not that of the English school but of one that developed in the colonies, where directly observed reality was the guiding principle. Lacking the formal academic systems for training and study

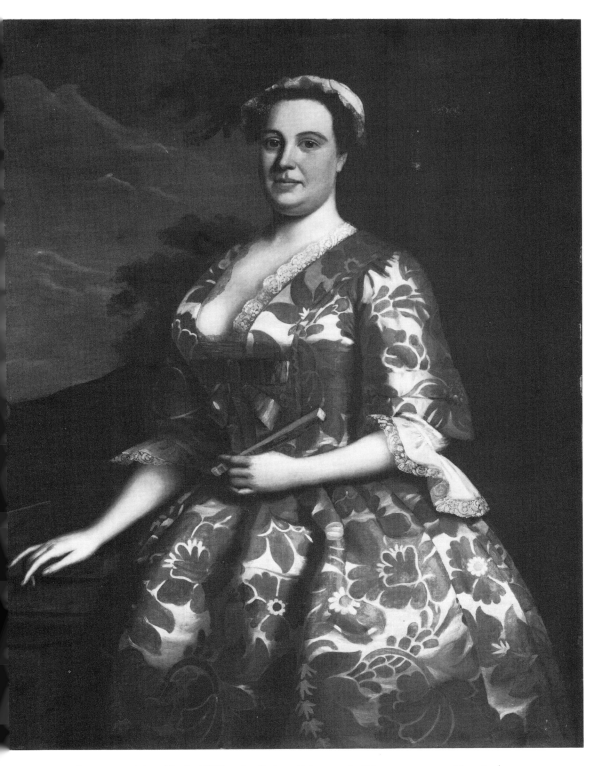

Figure 134. *Mrs. Charles Willing*, by Robert Feke, 1746. Oil on canvas, 50 × 40 inches. The Henry Francis du Pont Winterthur Museum, Winterthur, Del.

in the European beaux-arts manner, a young colonial artist such as Feke (or Copley) had to rely primarily on direct observation of the physical world. Even if Mrs. Willing was a bit plump, it was preferable to portray her that way than to create a visual falsehood about her by transforming the individual characteristic into a generalized, fashionable ideal. The portrait is a reflection of the intense materialistic concerns of successful middle-class folk and of their desire to have their prosperity shown in their images. Mrs. Willing's dress accomplishes this admirably, for it is made of a patterned silk damask, an imported fabric that was expensive in the colonies and therefore available only to those who had attained the highest level of mercantile society.

If there seems to be, to our eyes, a dichotomy between the fashionable elegance of Mrs. Willing's gown and the plainness of her face, that situation caused no problem for the artist or his patron; the painter's subjects, in their prosperity, could afford the finery they were shown in, and in their faces and the form of their bodies they wanted to be represented as the individuals they were. The result was a portrait of folk of humble, middle-class origins who enjoy a comfortable, elegant life-style but stop short of aristocratic pretentions and fanciful idealizations. What they were and what they had made of themselves were honorable and commendable, and in their self-confidence and individuality they saw no need to have falsehoods imposed on their likenesses by the artist's brush. Feke's *Mrs. Willing* is an excellent example of this attitude in portraiture.

Mrs. Willing, like a number of women in colonial American paintings, holds a fan, and its frequent appearance requires an inquiry into its iconographic significance. The fan was something more than a device to cool a person during the heat of summer.[8] As a decorative object, it became a part of a lady's fashionable ensemble, first in Italy and then in France in the seventeenth century. It was in France that the styling of fans reached its highest form; even such celebrated artists as Poussin and Boucher are known to have painted them with classical themes, pastoral scenes, hunts, and religious and political motifs. A couplet by John Gay, written in the early eighteenth century, comes to mind: "Gay France shall make the fan her artist's care,/And with costly trinket arm the fair."[9] In England, fans were often conversation pieces, but more than that they were subtle indicators of fashion, wealth, and sophistication. Among polite society they were used to communicate through a language of their own, as the early eighteenth-century poem by Soame Jenyn, "The Art of Dancing," suggests:

> What daring Bard shall e'er to tell attempt
> The powers that in this little engine dwell?
> What verse can e'er explain its various parts,
> Its numerous uses, motions, charms and arts?
> Its shake triumphant, its virtuous clap,
> Its angry flutter, and its wanton tap.[10]

These quotations reveal the role of the fan in high fashion and in fashionable behavior. Mrs. Willing was therefore represented holding one not because she was warm, but because it was a stylish instrument that suggested gentility.

In Philadelphia in 1746, Robert Feke quickly established himself as a mature

and gifted artist with portraits such as the *Mrs. Willing* or the *Tench Francis* (Metropolitan Museum of Art). But by May 1747 he had returned to Newport, Rhode Island, and soon thereafter he settled in Boston. During the next couple of years he was New England's premier painter, and he created a number of exquisite portraits, such as the *Judge Richard Saltonstall* (Peabody Museum, Salem), the *Isaac Winslow* (Museum of Fine Arts, Boston), the *William Bowdoin* and the *Mrs. William Bowdoin* (Bowdoin College, Brunswick, N.H.), and the *Charles Apthorp* (Cleveland Museum of Art). These are all large, three-quarter-length canvases, and they represent the highest echelon of New England mercantile society.

Among the finest of Feke's portraits of this period are those of Elizabeth Erving Bowdoin and James Bowdoin II (Figs. 135 and 136). Bowdoin was, for our purposes, truly a man of his times – the very model of the successful colonial American of inherited wealth and social position, and the embodiment of those socio-cultural characteristics that have concerned us here. His grandfather, Pierre Baudouin, was a French Huguenot refugee who immigrated to Maine in 1686 but settled in Boston three years later. James's father, James Bowdoin I, one of Boston's wealthiest merchants and land speculators, rose to high position as justice of the peace and as a member of the Governor's Council. When he died in 1747 he left what was then perhaps the largest fortune in New England, for his estate was settled at more than £82,000. While William, the oldest son, inherited the largest share, his half brother, James II, was provided for nicely.

In the year of the elder James Bowdoin's death his portrait was painted by Joseph Badger; other portraits, representing sons William and James II as boys, had long hung in the Bowdoin home, so family portraiture was already a tradition by 1748 when Robert Feke painted the likenesses of William and his wife and of James II and his bride.[11] Because James II and Elizabeth Erving were married that year, it is probable that their pictures were done as wedding portraits.

James Bowdoin II (1726–90) had every opportunity that wealth could provide. We see him as a well-dressed, well-groomed nine-year-old boy playing with a bow and arrow in the portrait John Smibert painted of him in 1735.[12] In his youth he "was distinguished . . . for his steadiness, ingenuity and good behavior . . . , a stranger to the sallies of youth. . . . A close application to study, added to a lively and penetrating genius, distinguished him as a young man of merit . . . while modesty, politeness and philanthropy excited expectations the most flattering as to his future eminence."[13] He was graduated from Harvard College in 1745, and by the time his portrait was painted he had entered the mercantile world, in partnership with his brother-in-law, James Pitts, in trading with the West Indies. James married the daughter of John Erving, one of the most prosperous merchants of Boston, further entrenching him in the New England mercantile establishment. In the years that followed the painting of his portrait he amassed a considerable fortune in his own right.

Bowdoin was an interesting person and a man of his times in many ways aside from being a prosperous merchant. As a member of the mercantile aristocracy, he took seriously his responsibilities of leadership, for he eventually became active in politics, was a member of the Governor's Council, an out-

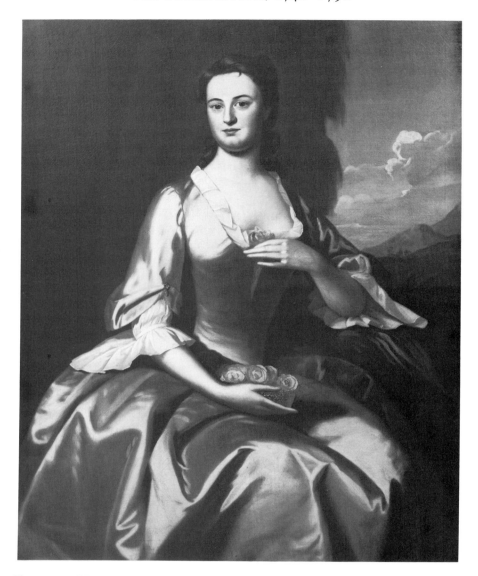

Figure 135. *Mrs. James Bowdoin II*, by Robert Feke, 1748. Oil on canvas, 50⅛ × 40⅛ inches. Bowdoin College Museum of Art, Brunswick, Me. Bequest of Mrs. Sarah Bowdoin Dearborn.

spoken critic of royal policies concerning the colonies, an ardent patriot during the Revolution, and John Hancock's successor as governor of the Common-wealth of Massachusetts. His fine house at the corner of Beacon and Bowdoin streets contained a library of more than twelve hundred volumes in 1774, the titles of which reveal his broad interests. In his "Great Upper Chamber" there were many scientific instruments, including six telescopes and "an Electrical Machine and Apparatus."[4] He was a friend and a frequent correspondent of Benjamin Franklin's, their letters indicating mutual interests in politics and science. Bowdoin published papers on scientific subjects, such as "An Im-

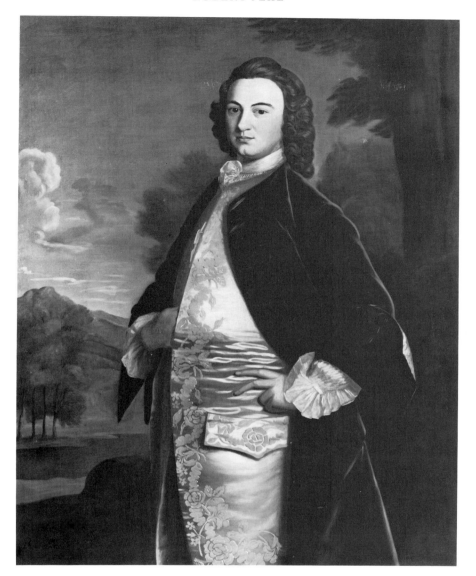

Figure 136. *James Bowdoin II*, by Robert Feke, 1748. Oil on canvas, 50 × 40 inches. Bowdoin College Museum of Art, Brunswick, Me. Bequest of Mrs. Sarah Bowdoin Dearborn.

provement Proposed for Telescopes" (*London Magazine*, November 1761) and "Observations upon a Hypothesis for Solving the Phenomena of Life" (*American Magazine*, March 1788). A founder of the American Academy of Arts and Sciences, Bowdoin was also a member of the American Philosophical Society and of the Royal Societies of London and Dublin. The esteem in which he was held by his peers is indicated by his election, on June 17, 1774, to head the Massachusetts delegation to the First Continental Congress in Philadelphia, but ill health forced him to decline the honor; John Hancock went in his place.

Although most of James Bowdoin's career as merchant, scientist, and civic

leader was yet ahead of him when Feke painted his portrait at the age of twenty-two, the later events of his life help establish for us the type of person Bowdoin was, even as a young man. First and foremost he was a merchant, and the artist represented him as a proud young scion of the merchant world, in an image of remarkable physical, materialistic substance and of affluence. Bowdoin's individual facial features were attentively described and the form of his figure was crisply delineated. In an adulatory hymn to material stuffs, the tactile quality of Bowdoin's velvet coat and satin waistcoat were captured, as were their fine tailoring and beautiful floral adornment. Highlights emphasized the special qualities of each rich fabric, and the color scheme – always a strength of Feke's portraits – was a sophisticated range of brown, ivory, and gold. Brushwork was not a part of the aesthetic of Feke's art, for painterly technique and displays of artistic virtuosity with a brush had to be subjugated to the portrayal of the physical, materialistic object immediately before the painter. Bowdoin's head and figure are roundly three-dimensional with a masterful handling of shadows to produce that effect. But space seems only deep enough to accommodate the man, and then terminates in a flattened backdrop of a generalized landscape lacking the illusion of real depth. There are therefore dichotomies in Feke's style, between the real, physical, and specific form of the figure and the generalization of the background, and also between the real space of the foreground and the flattened plane that stops the recession of space. These features persist throughout Feke's work, one advantage of the method being that it emphasizes the bold mass of the forms of the figures, upon which the painter intended us to concentrate.

Elizabeth Erving Bowdoin (1731–1803), the daughter, sister, and wife of successful merchants, shared in the commitment to industry, prosperity, and piety that was sacred to her class. She was seventeen in the year she married James Bowdoin II and had her portrait painted by Robert Feke. Her features may have been somewhat plain, as her portrait suggests, but her husband saw in her a beauty that gave inspiration to a poem he wrote about her, probably about the time they were wed:

> See down her neck the charming locks descend;
> And, black as jet, in waving ringlets end:
> The jetty locks, as down her neck they flow,
> The lovely white to great advantage show:
> Her comely neck, with symmetry and grace,
> Rises majestic on its noble base,
> And, like a column of superior art,
> Does to the eye a fine effect impart:
> Her piercing eyes their harmless lightning play;
> And dart around a joy-diffusing ray:
> Her cheeks, adorn'd with lovely white and red
> May vie with roses in their flow'ry bed:
> Her coral lips, whene'er she speaks disclose
> The finest iv'ry in concentric rows:
> Her tempting breasts in whiteness far outgo
> The op'ning lilly, and the new faln snow:

> Her tempting breasts the eyes of all command,
> And gently rising court the am'rous hand.[15]

In her portrait, Elizabeth Bowdoin is the very picture of mercantile-aristocracy fashionableness without ostentation. Her coiffeur is of the current style and her lovely blue gown, richly shadowed and highlighted by the artist to convey its elegant satin fabric, is suggestive of wealth and is of a moderately daring exposure. It is every bit as fine in material and style as the gowns worn by Elizabeth's English peers in that day. The pale pink rose blossoms hint at a perfuming of the balmy air in the sensuous manner found in many French rococo portraits of women, but the pose and composition were probably based on a mezzotint by Beckett after a portrait of Princess Anne by William Wissing – a print we have earlier seen Feke draw upon for the image of one of the women in the *Royall Family* (Fig. 146).[16] The pose is therefore refined and genteel, according to the aristocratic model of the mezzotint. That the Bowdoins would have been familiar with the aristocratic images carried by the mezzotints is indicated by the fact that the inventory of James II's estate taken in 1774 lists 125 "pictures"; since their total value was appraised at £7.3, the "pictures" must have been prints, and most of them were probably mezzotint portraits.

In coloration, the *Elizabeth Bowdoin* is dominated by the pastel hues of the rococo style – the light blue, pale pink, and whitish flesh tone – instead of the deeper, richer colors of Smibert's baroque palette. This may have resulted from Feke's exposure to English Georgian portraits, which had adopted the pastel tints of the contemporary French style; there were a few portraits by Joseph Highmore, for example, in the Boston area before 1748 that could have transmitted the new color scheme to the colony. Or the rococo hues could be explained by the presence of a pale blue fabric in the dress itself, in which case fashion rather than art was the agent that carried the new palette across the Atlantic. Although the dark blues, greens, rusts, and oranges of the baroque are not completely purged from the artist's palette, they do frequently give way in colonial painting, in the late 1740s and early 1750s, to the lighter color scheme of the Georgian rococo style; Feke is a pivotal figure in that transition.

Note should also be taken of the manner in which Feke handled shadows. In the *Elizabeth Bowdoin*, as elsewhere in his work, his bold shading was effective in giving volume to the form of his figures. But the shadows are dark and lack light, air, and color. Contemporary English portraitists, more sophisticated in painterly effects that incorporate light and atmosphere even in the shadowed area, could suggest the roundness of form without resorting to dark, airless shadows. Feke seems not to have known of those means, however, and his bold shading, used consistently throughout the figure, became a virtue of his style and one of its real strengths. Young John Singleton Copley, a few years later, would employ the same means, which he probably learned from observing Feke's portraits. Feke evolved his technique for shading from the study of the rich tonal qualities of mezzotints, which, of course, had no color and little light in the dark shadows.

Feke's highly objective, materialistic and physical, yet elegant and dignified imagery is similarly found in his portrait of John Bannister (1707–67), who

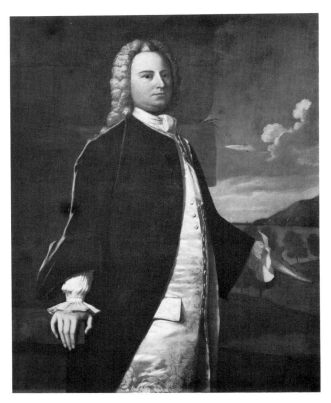

Figure 137. *John Bannister*, by Robert Feke, 1748. Oil on canvas, 50½ × 40½ inches. Toledo Museum of Art, Toledo, Ohio.

was also a member of the mercantile establishment of New England (Fig. 137).[17] Leaving Boston to settle in prosperous and fashionable Newport in 1735, Bannister amassed a fortune through his interests in land speculation, shipping and shipbuilding, and the slave trade. Represented in a standardized pose that is nearly identical to Feke's *Isaac Winslow* of the same year, 1748, Bannister is shown wearing a white wig, a handsome velvet coat, and a satin waistcoat with its tour de force of painterly virtuosity in the brocaded floral pattern. The patron's delight in the finery of stuffs is obvious, as it is in most of Feke's portraits, and such things should be seen here, again, as references to the rewards of industry, to social status, and to the blessing of God – Calvinistic principles that New Englanders inherited from their forefathers and still respected.

Robert Feke was called upon to paint a "state" portrait in 1748, as part of the series depicting the heroes of the battle of Louisbourg; the series had been commenced by John Smibert in 1746. This commission was for the *General Samuel Waldo* (Fig. 138), which Sadik has described as "the greatest portrait to have been painted in America during the first half of the eighteenth century."[18] Waldo (1696–1759) was a Boston merchant who became wealthy by trading in fabrics, wines, and slaves, and who owned an enormous tract of half a million acres in Maine, between the Penobscot and Muscongus rivers.

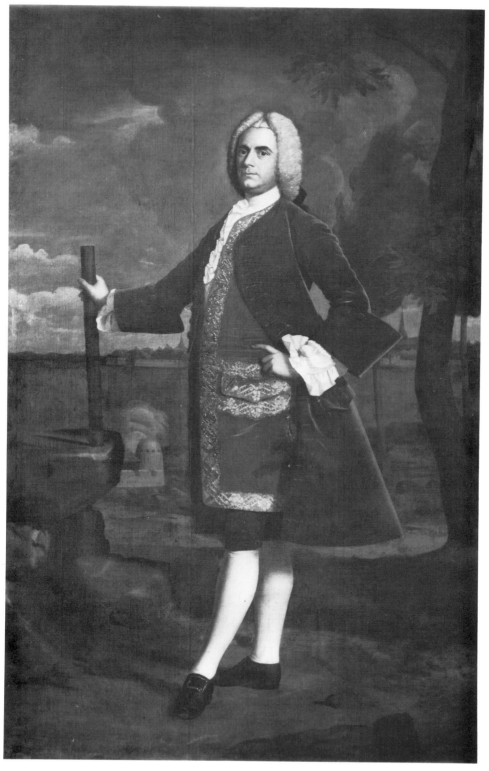

Figure 138. *General Samuel Waldo*, by Robert Feke, c. 1748. Oil on canvas, 50½ × 40½ inches. Bowdoin College Museum of Art, Brunswick, Me. Bequest of Mrs. Lucy Flucker Knox Thatcher.

He encouraged settlement of his vast landholdings and claimed from their forests great quantities of timber for the colonial and British shipbuilding industry. In the war with the French, Samuel Waldo as a brigadier general was second in command to General William Pepperrell when the New England force besieged and captured France's "Gibraltar of America," Louisbourg, Nova Scotia, in 1745. The importance of the expedition was noted in a letter written by John Smibert in Boston on March 5, only two months before the celebrated battle:

> At present there is little talked or thought of but war . . . , four Vessels of force are sailed to lie off Lewisbourg harbour to prevent any succors or provisions going in. This expedition is a great undertaking for this Country. If it succeeds, will be of great importance & be a terrible blow to France, as it will effectually destroy their fishery & make the navigation to Canada very dangerous. But if it does not succeed we shall be almost undone here, for our best men, the flower of the country are going & the expense will be a prodigious sum of money, which if we are not assisted in the charges of it from home must ruin this Province.[19]

The Americans were victorious and Smibert painted large, full-length portraits of two of the heroes; his *Sir William Pepperrell* is at the Essex Institute, Salem, and the *Sir Peter Warren* is owned by the Portsmouth Athenaeum, Portsmouth, New Hampshire.

Feke's large portrait shows Waldo standing, full-length, in civilian dress – a white wig, brown velvet coat, red–orange waistcoat with gold brocade trim, and white stockings. He holds a telescope in his right hand, with which to view the action at the fortification in the middleground; the town on the horizon, across the bay, is Louisbourg. Feke was more specific in background details here than in any other portrait he painted, but the circumstances of the commission no doubt required this.

Feke may have put special effort into the *Waldo* because he knew it would be compared with Smibert's portraits of Pepperrell and Warren. The face is beautifully delineated and the artist has informed the rest of the figure with all of those characteristics that make up the personality of the successful and prosperous colonial American merchant. In fact, there is very little about the image of Waldo itself that has any reference to military rank or accomplishments, and only secondary motifs of the background allude to the battle and the site. Otherwise, the figure of Waldo is represented in a manner almost identical to Feke's merchant portraits such as the *James Bowdoin II, John Bannister, Isaac Winslow,* or *Tench Francis.* Waldo was far more a gentleman of the mercantile establishment than he was a military commander, and he was portrayed accordingly.

Late in 1748, Feke returned to Newport, but the next year he made a second visit to Philadelphia to paint portraits.[20] The last known record of the artist places him in Newport when he attended his brother-in-law's wedding on August 26, 1751. After that he disappeared, although it is now believed that he went to Barbados, possibly for his health but also because there was a

branch of the Feke family there; it is further believed that he died there in 1752.[21]

As a native-born artist, Robert Feke was more sensitive to the real social and cultural characteristics of colonial Americans than any painter who emigrated from England or elsewhere to take their likenesses. He had a rare natural talent, which seems to have developed without formal training, and he was the first native-born painter to define the true colonial style (as opposed to an imported style that was modified to suit colonial tastes). His was the style employed by Copley, Peale, Earl, John Hesselius, and many other American artists, even if they fell briefly under the influence of some foreign style. The style developed by Feke was natural for native-born colonial American artists who probably would have evolved their own manner quite similarly, even if they had not been exposed to his work. For each of them physical form was intensely observed, and they relied more on direct sensory observation than on artistic theory; each was sensitive to the individual and specific features of his subjects, and avoided the generalized and the idealized. Form was first defined by line, with color filled in between the lines, giving a crisp linear quality to the image. Shading was used boldly to provide a sense of real mass and substance, and textures were rendered with a skill that delighted the tactile sense. Careful attention was devoted to facial expressions, postures, and gestures, which conformed to the code of middle-class dignity and the social position of the sitters. References to the subjects' material prosperity were included, which carried the implication that they were pious and in God's good graces. With all of this achieved, we have attained the essential characteristics of a true colonial American style in portraiture.

Blackburn and Wollaston

As the formulation of a portrait style that was a true expression of the colonial American personality began to evolve, it was continually bombarded with artistic influences coming directly from England. That was natural, considering the strong social, cultural, economic, and religious ties with the mother country. The increasing wealth of the colonies and the inclinations of the colonists to have their likenesses taken, as well as a general refinement that included a greater awareness of the arts, were all contributing factors in attracting professional painters who came mainly from England. We now speak not of an occasional individual such as Pelham or Smibert, but of a group who immigrated in the middle decades of the eighteenth century. They came seeking their fortune in a land where competition would not be as keen as in, say, London, where there were numerous successful portrait studios with established masters. Most of them were not of the top rank and some were probably studio assistants or specialists (in painting draperies, backgrounds, etc.) in the employment of master painters. Just as the colonies were a land of opportunity for merchants, tradesmen, farmers, and the like, so it now appeared to be for painters as well. Sometimes they found success, but often it was short-termed and they were required either to relocate within the colonies or to return to England or go to another of the British colonies somewhere around the world. But while they were in America they painted hundreds of charming portraits, which began to populate parlors and libraries in the seaboard towns in increasing numbers. Moreover, they contributed to the taste of colonial patrons and to the instruction of young native-born painters like Copley and Peale. Although in 1725 it would have been unusual to chance upon a professional painter anywhere in the colonies, by 1760 many towns along the seaboard had at least one in residence. The style they brought with them was the elegant, flowery, often effeminate Georgian rococo as practiced by the leading English portraitists of the 1740s, such as Joseph Highmore, George Knapton, Francis Hayman, Allan Ramsay, Thomas Hudson, and Bartholomew Dandridge.

Such was the background of immigrant painters like Joseph Blackburn and John Wollaston, who have been chosen as representative of the group of foreign-born artists who were active in the colonies in the 1750s. They brought with them predetermined styles – that is, styles that had been formed in another part of the world, under a very different aesthetic climate, and in response to

the character and tastes of very different patrons. Although their talents were welcomed as contributions to the increasing refinement of life, the matter was not as simple as merely imposing a foreign style upon a colonial clientele. Although these painters brought, in their art, certain stylistic features that would be warmly accepted, other mannerisms would in the end be rejected as alien to the colonial character and colonial values.

Joseph Blackburn (active c. 1750–c. 1780) is believed to have been English and probably served as an assistant in the studio of a master portrait painter in London or in some provincial center in the 1740s, during which time his personal style was developed.[1] Blackburn's style follows that of Allan Ramsay (1713–84), in whose full-length portrait, *Catherine Paggen as Diana* (Fig. 139), of about 1739 we observe many of the mannerisms later employed by Blackburn in the rendering of fabrics and the human figure. But few artists have left so little in the way of documentation of their activities and whereabouts as Blackburn. No record survives of his birth or early training, and he comes into historical focus only in 1752, when he appeared in Bermuda, presumably already trained as a painter. By 1753 he had arrived in New England, and for the next seven years he worked mainly in Boston, while from 1760 to 1763 he seems to have been painting in Portsmouth, New Hampshire. By the time Blackburn arrived, Pelham and Smibert had died, Feke had departed, John Greenwood was about to leave, and Joseph Badger was about the only active portraitist on the scene; Copley, then fifteen, had only commenced his juvenilia. For the five or six years following his arrival Blackburn enjoyed the position of the premier portrait painter of New England.

At first, Blackburn received his patronage from the cream of New England society – the Bowdoins, Winslows, Ervings, Pitts, Apthorps, Atkinsons, and so on. Moreover, judging by the number of portraits – Park, Hill, and Foote catalogued 126, and in the meantime several more have come to light – his talents must have been in fairly constant demand. However, as Copley's style matured around 1760, colonial patrons exhibited a decided preference for his work, presumably because he captured more of what they felt themselves to be than did Blackburn. So although Blackburn had much to offer and his capabilities were welcomed by many, he was destined to be only a contributor to the consummate colonial portrait, and not the creator of it.

In 1755, Blackburn received one of his most important commissions – for the *Isaac Winslow and His Family* (Fig. 140). By his family lineage, his wealth, and his own accomplishments, Isaac Winslow (1709–77) fulfilled every requirement of membership in the mercantile aristocracy of New England. His great-great-grandfather was Edward Winslow (Fig. 17), who had come over on the *Mayflower* and served as governor of Plymouth Colony; Josiah Winslow, Edward's son, had also been governor of the colony; Isaac's grandfather, Edward II, whose portrait by Smibert is at the Yale University Art Gallery, had married Elizabeth, daughter of Anne Hutchinson.[2] Isaac's father, Edward III, was a silversmith in Boston but also served the community in several civic capacities – as overseer of the poor, selectman, high sheriff of Suffolk County, captain in the Ancient and Honorable Artillery Company, and judge of the Court of Common Pleas. Isaac Winslow therefore had the prestige of family wealth and social position behind him. He was graduated in 1727 from Harvard

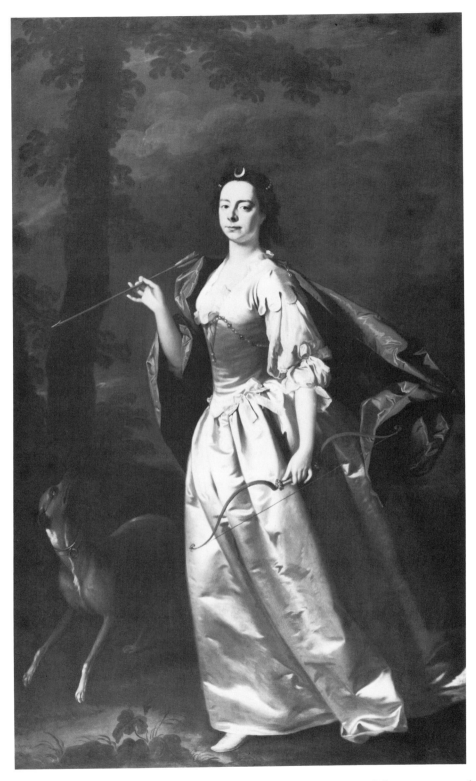

Figure 139. *Catherine Paggen as Diana*, by Allan Ramsay, c. 1739. Oil on canvas, 94½ × 58¾ inches. Virginia Museum, Richmond.

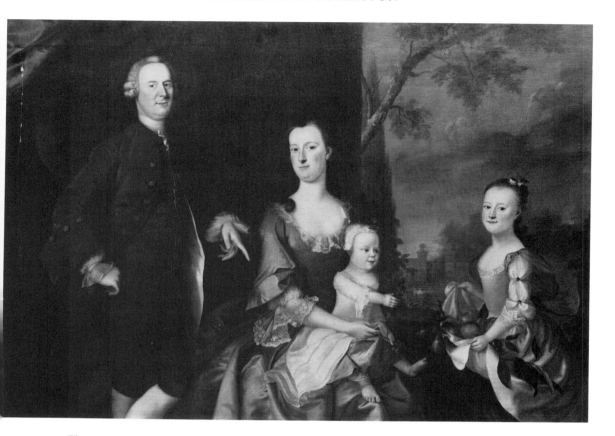

Figure 140. *Isaac Winslow and His Family*, by Joseph Blackburn, 1755. Oil on canvas, 42 × 78 inches. Museum of Fine Arts, Boston. Abraham Shuman Fund.

College, where he was educated in both classical learning and the new sciences and philosophies. In 1747, he married his first wife, Lucy Waldo, daughter of Samuel Waldo; the next year Robert Feke painted his excellent portraits of both Isaac Winslow (Museum of Fine Arts, Boston) and General Samuel Waldo (Fig. 138). Winslow's business acumen brought him wealth to go with his family connections; he and his brother Joshua, whose portrait had been painted by Smibert in 1729,[3] were partners in lucrative shipping activities. Isaac's land speculations, in which he followed the lead of his father-in-law by acquiring enormous, undeveloped tracts in Maine, also proved profitable, and he, James Bowdoin II, and other Boston merchants were members of the Kennebunk proprietorship. By the time Blackburn painted the Isaac Winslow family, Bowdoin and Winslow were probably the two most prosperous merchants in New England, and each was aware of the tradition spanning several generations in family portraiture, which included patronage of Smibert, Feke, Badger, several unidentified artists, and now Blackburn.

The Winslow portrait represents Isaac standing, his wife Lucy Waldo seated, holding their infant daughter, Hannah, and six-year-old Lucy Waldo Winslow at the right. In New England portraiture only three paintings of comparable

size and complexity preceded Blackburn's *Winslow Family* – Smibert's *Bermuda Group* (1729; Fig. 78), Feke's *Royall Family* (1741; Fig. 133), and John Greenwood's *Greenwood – Lee Family* (1747, Museum of Fine Arts, Boston). Whereas Smibert, Feke, and Greenwood had arranged their group portraits around a table, Blackburn devised his composition in the new manner of the conversation piece. Pictures of this genre were often set out of doors in garden surroundings, usually with several figures in casual relaxation. The conversation piece became popular in England in the 1740s, and its leading practitioner in the middle of the eighteenth century was Arthur Devis.[4] The closest English parallel to Blackburn's Winslow portrait, however, is Thomas Hudson's *The Thistlethwayte Family*, which has almost exactly the same components; if Hudson's picture had not been painted two years after Blackburn's, one would suspect it had been the prototype for the Winslow family portrait.[5] The garden setting, with swans floating on a pond before an elaborate stone gateway, was derived from similar scenes in British conversation pieces and not from fact, for no such garden is known to have existed in New England in 1755, even as part of the home of a merchant as wealthy as Isaac Winslow. Here was an instance in which something that might be true enough for an English patron became a falsehood when imposed upon the portraits of an American family. Copley, for example, would later eschew the use of such pretentious emblems of prosperity and refinement in his colonial portraits, and would concentrate on factual symbols instead.

The Winslows, as Blackburn shows us, enjoyed the good things of the secular world, for the portrait is filled with symbols of middle-class virtues, values, and rewards – symbols of prosperity, industry, and divine blessing on it all, as in the handsome suit of clothes Isaac Winslow wears, or the stylish dress of expensive fabric and lace worn by his wife. The Winslows' daughter at the far right also wears a lovely dress that is fashionable and made of exquisite materials. No doubt the Winslows possessed and wore clothes such as we see here, but there the reality of the portrait ends, and exaggeration and mannerism take over.

In Blackburn's portrait all the Winslows except the infant seem to be very self-conscious of having their likenesses taken and have struck a pose for the occasion. This was quite normal according to the English artistic tradition out of which Blackburn emerged, but it suggests pretentiousness – the doing of something or acting in a way that is not completely natural to the subjects. What the subjects are in fact doing is assuming the poses of the people in the mezzotints, or perhaps posing the way Blackburn told them to, according to the London studio fashion of the day. It was a pantomime calculated to invest these people with the refinement they admired in the body language of aristocratic portraiture. The assumed postures of the Winslows in Blackburn's picture become quite evident if we compare them with the natural ease and unaffected poise of Isaac Winslow and his second wife in Copley's double portrait (Fig. 165). In the Copley, where the Winslows have a self-confidence and a natural dignity that required no pretention, the underlying philosophy was "Paint me as I am, because what I am is perfectly good enough." But Blackburn, a foreign artist, was not attuned to this matter and bestowed a feigned elegance on his subjects through artificial poses. Colonial Americans

of middle-class origins had an aversion to pretended refinement and would ultimately prefer the natural refinement that Copley and Peale would capture in their portraits. A further comparison to make this point is found if the image of young Lucy Winslow at the right of the Blackburn portrait is compared with Copley's *Mary and Elizabeth Royall*, painted only three years later (Fig. 148).

Moreover, in the Winslows' faces as painted by Blackburn there is an expression of self-consciousness and shyness that does not fit with an image that otherwise sought to portray success and firmly established social position. The faces here are vapid, inscrutable masks that conceal the true personalities of the subjects, rather than facial studies that perceptively reveal individual character. They are masks of elegance, devised in a foreign studio and imposed on the colonial American. The coy smile, the turning of the head so the eyes look at us with sidelong glances, the unnaturally high foreheads – all are artificial mannerisms that Blackburn learned abroad, and they may also be seen in Ramsay's *Catherine Paggen as Diana* (Fig. 139); they will not be retained as the consummate colonial American portrait is achieved. Instead of employing artistic mannerisms that tend to make every subject look vaguely like every other subject, the colonial patron and native-born artist will search for an image that captures individuality and true character.

Many of the same characteristics of Blackburn's *Isaac Winslow and His Family* are present in his portrait of *Mary Faneuil*, which was also painted in 1755 (Fig. 141). Mary Faneuil (1708–76) was the wife of Benjamin Faneuil, Jr., the brother of Peter Faneuil; her husband's portrait had been painted by John Smibert in 1744, and the same artist produced at least two portraits of her famous brother-in-law.[6] She was therefore a part of New England's mercantile establishment and must have been well aware of the Faneuil tradition of family portraiture.

Blackburn represented Mary Faneuil sitting out of doors, her right arm resting on an architectural segment that seems as out of place for New England as the formal garden at the right; but such things were a part of contemporary English portraits and so they were included here, no matter that they had no real relationship to the subject. The face, as in most of Blackburn's portraits, is weak; although it is a pleasant countenance with a suggestion of a smile, it falls short of being a character study. The usual mannerisms of Blackburn's style – the high forehead and the sheepish smile – are again present. If the portrait lacks strength of characterization in the head, it uses the elaborate satin and lace gown to establish the woman's wealth and social position; that is, exquisitely rendered objects and stuffs are used to tell the viewer about the subject, rather than perceptive character portrayal.[7] Park, referring to both Smibert and Blackburn, noted the problem of imposing a foreign style on colonial Americans: "Both painters treated their work in apparent disregard of the fundamental differences in the character of their subjects, a fact which leads one to believe that they were hampered by the dictates of the [English] school in which they were trained."[8]

Whatever faults critics may find in Blackburn's limited abilities, his portraits always possess charm, refinement, and a reflection of the general life for which his American subjects were searching. Portraits such as the *Mary Faneuil* set

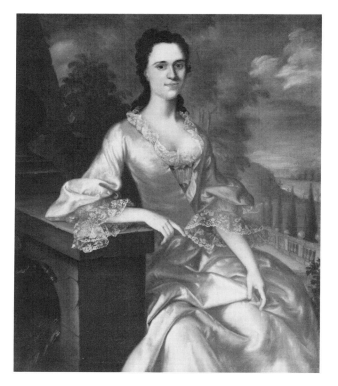

Figure 141. *Mary Faneuil*, by Joseph Blackburn, 1755. Oil on canvas, 50 × 40¼ inches. Museum of Fine Arts, Springfield, Mass. Gift of Mrs. Lewis Tifft.

the standard for their day, and to realize the impact of Blackburn's art, one need only compare his image of Mrs. Faneuil with Copley's portrait of Ann Tyng (Fig. 147), for at that moment, in 1755–56, the young native-born artist was very much under the influence of the English painter.

The final portrait by Blackburn to be discussed here represents the children of James Bowdoin II and Elizabeth Erving Bowdoin, whose names are Elizabeth and James III (Fig. 142). The picture dates from about 1760 and is especially interesting because its subjects complete a social cycle that was increasingly found among the great colonial mercantile families. Old Pierre Baudouin, the French Huguenot refugee, had come to New England in the 1680s to escape religious persecution and to seek his fortune; his son, James Bowdoin I, had prospered greatly, passing on to his sons one of the largest fortunes ever accumulated in the colonies. James II was truly a merchant prince, and by his time the Bowdoin family was among those who constituted the provincial mercantile aristocracy. Now, in this fourth generation, James III and his sister Elizabeth, the subjects of Blackburn's portrait, will become citizens of a world that reaches well beyond the confines of the North American colonies, forsaking provincialism to play out at least part of their lives in England, France, and Italy, as true aristocracy, and involved in international events.

In 1767, Elizabeth Bowdoin (1750–1809) married John Temple, who, al-

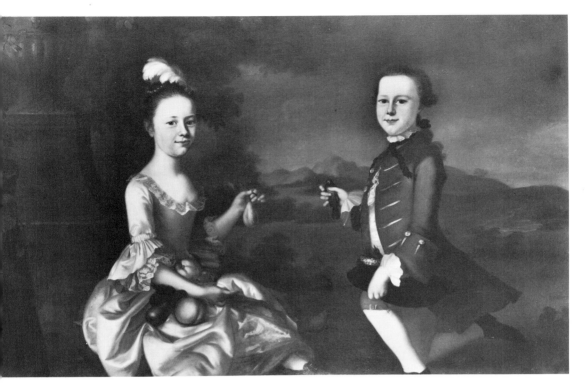

Figure 142. *James Bowdoin III and His Sister, Elizabeth Bowdoin*, by Joseph Blackburn, 1760. Oil on canvas, 37 × 58 inches. Bowdoin College Museum of Art, Brunswich, Me. Bequest of Mrs. Sarah Bowdoin Dearborn.

though born in Massachusetts, spent his early life in England; he returned to the colony in 1762 as the Crown's surveyor general for customs.[9] In 1773, John and Elizabeth Temple went to London to live when John was made surveyor general of England. Thirteen years later John Temple became the eighth Baronet of Stowe, and Elizabeth, the daughter of a Boston merchant, became Lady Temple. During the Revolution, Temple attempted to negotiate a reconciliation between England and America; after the peace treaty was concluded he was appointed British consul general to the United States, and he and his wife returned to take up residence in New York. After John's death in 1798, Elizabeth moved to Boston, where she lived for the rest of her life.[10]

James Bowdoin III (1752–1811) in later life was, like his father, a wealthy land speculator and engaged in politics. But his life was shaped differently from that of James II. He attended Harvard College, graduating with the class of 1771. Sent to England in the hope that the ocean voyage would improve his poor health, he was commended to the care of Benjamin Franklin in London. After a few months at Christ's Church College at Oxford, he left, apparently to concentrate on the refinements of life, writing to his father in November 1771: "I have just begun to learn French, likewise Dancing and Fencing, all which I expect to be perfect masters of before my return";[11] he then asked his father to send more money. By January 1774 he was in Rome,

where he was fascinated by the art and the antiquities, and then traveled to Florence and Bologna. His tour then took him through France, and finally to London, before he returned home. Although he then settled down to his predestined place among the mercantile aristocracy of New England, he had seen something of the world and could hardly be considered provincial. When President Jefferson appointed him to ministerial posts in Europe, he became America's first true collector of fine art, for he often acquired paintings and drawings by the Old Masters while he was abroad.[12]

In Blackburn's portrait, of course, Elizabeth and James Bowdoin III are represented as children of about ten and eight respectively. The little girl wears a lovely light blue dress trimmed in lace, with a yellow petticoat; her bright blue shoes are of the latest fashion, and a string of pearls and a fancy feather adorn her brown hair. Like her counterpart in Blackburn's *Isaac Winslow and His Family* (Fig. 140), she holds an array of fruit, a typical Georgian-rococo motif intended as yet another delight to the senses. James is dressed as a young gentleman in a blue coat, white shirt, red trousers, white hose, and black shoes with silver buckles, and his coat cuffs have silver buttons. His hair is drawn back and tied at the nape of the neck in a stylish manner. He holds a pet bird in one hand and his black three-cornered hat in the other. The faces are sweet and charming, and they display Blackburn's usual mannerisms of the high, receding forehead and the shy smile. The artist placed the Bowdoin children in an outdoor setting that is symbolically elevated by the inclusion of a large urn at the left, à la English gardens but doubtful for an American garden. An expansive landscape extends across the right side of the picture. These are children of genteel society – well groomed, handsomely attired, affable, and obviously born to wealth and prosperity – and the artist utilized every means at his disposal to convey that message through the portrait. Their world seems an elegant idyl that is part English, part colonial Massachusetts.

By 1760, when the *Elizabeth and James Bowdoin III* was painted, Blackburn was beginning to feel the competition of the young genius John Singleton Copley, whose art had matured rapidly in the late 1750s. Seeking an area away from such formidable competition, Blackburn moved to the prosperous seaport of Portsmouth, New Hampshire, where he spent the next three years taking many likenesses that rank among the best of his career. But in 1763 he left the colonies to return to his homeland, where he pursued his profession in rural areas in southwestern England.[13] It would seem, with the emergence of Copley, that Joseph Blackburn realized a love affair was about to commence between two beautifully matched parties – the native-born artists and his provincial, mercantile patron – and that in the making of images of the latter, he was soon to be the odd-man-out. Among the whole bag of artistic mannerisms that foreign artists such as Blackburn brought to the colonies, some were accepted by the patrons and the native-born painters, but others were rejected because they were unnatural to the real colonial American character.

John Wollaston, the son of a minor English painter, had his own studio in London before immigrating to America in 1749.[14] After three years in New York, he went to Philadelphia in 1752; the next year he was in Annapolis, then in Virginia from 1755 to 1757 and in Philadelphia again in 1758, leaving a trail of about three hundred almond-eyed images in his wake. He departed

the North American colonies around 1759 and was working in the West Indies in the 1760s before appearing in Charleston, South Carolina, in 1765. Two years later he returned to England and was still living in 1775.

The town of New York to which Wollaston came in 1749 was then just beginning to awaken to cultural interests. Its appearance was pleasing enough, according to Peter Kalm, the Swedish botanist who visited there in 1750; after noting that New York was not as large in population as Boston or Philadelphia, he observed that "with regard to fine buildings, opulence, and extensive commerce, it vies with them for supremacy."[15] The town's inhabitants, however, often seemed boorish to visitors, lacking in refinement and interested only in making money. The consuming devotion to mercantilism reached up the Hudson River to Albany, where the touring Dr. Alexander Hamilton confided to his diary in 1744 that the thing which counted most among the townspeople "seems to be riches, which they spare no pains or trouble to acquire . . . , their whole thoughts being turned to profit and gain."[16] Benjamin West evidently felt the same way, for his biographer declared that "in New York [in 1759] Mr. West found the society wholly devoted to mercantile pursuits. A disposition to estimate things, not by their . . . beauty, but by the price which they would bring in the market, almost universally prevailed."[17] There was a large and prosperous merchant class, many of whom preferred to patronize taverns and gaming tables instead of the arts and cultural affairs.

Utilitarian matters always seemed to take precedence over cultural improvement, an idea expressed by William Livingston in his newspaper, *The Independent Reflector*, in 1752. After declaring that it was his editorial policy to carry useful items on science, politics, and religion, he announced that "in subjects merely literary, I shall rarely indulge myself"; even as late as 1768 he reported, "We want hands . . . more than heads. The most intimate acquaintance with the classics will not remove our oaks; nor a taste for [Vergil's] *Georgics* cultivate our lands."[18] To Livingston, education was solely utilitarian, as he explained in his newspaper: "The true Use of Education is to qualify Men for the different Employments of Life . . . , in a word, to make them more extensively serviceable to the Commonwealth."[19] The predominance of such attitudes probably explains why John Wollaston did not take up permanent residence in New York, the way Smibert had in Boston or Theus had in Charleston. Life in New York simply was not oriented toward the arts – not yet, anyway.

But there were signs that New York was changing. Although it fell far short of Boston in the number and activity of booksellers, a library was organized by the New York Library Society in 1754. King's College, the forerunner of Columbia University, was established that same year. Entertainments covered a wide range, including puppet shows, a waxworks representing the royal family, and a theater permanently established there in 1750. A few scientific displays attracted attention because of their utilitarian potential. The leading resident scientist was Cadwallader Colden, whose portrait by Wollaston is at the Metropolitan Museum of Art,[20] and in 1748 a few men joined Colden to form the Society for the Promotion of Useful Knowledge – again, emphasis was on the utilitarian. As New Yorkers' wealth was often kept and displayed in the form of silver objects, the town did support a first-

rate silversmith in Myer Myers; the handsome silver pieces that adorned New York homes (a collection of which is preserved at the New-York Historical Society) are excellent examples of the alliance that the merchants could envision between art, wealth, utility, and social status. The art of painting would be accepted only on similar grounds.

New York had a population of about 14,000 when Wollaston arrived, most of whom belonged either to the Presbyterian or the Dutch Reformed church, although the Episcopal was the official church. Anglicization – that is, the shift from Dutch to English culture – had already occurred, and so any nascent Dutch interest in painting had been consumed by an English preoccupation with portraiture. There was, in fact, a paucity of artistic endeavor in New York before Wollaston's arrival; before 1749, the history of portraiture in English New York can claim only an occasional visit by one of the Hudson Valley patroon painters or some other itinerate artist, such as the one who took the likeness of Caleb Heathcote (Fig. 56). Still, the size of the town and the wealth of its merchants must have made it seem, to a London portrait painter, that he might find patronage there.[21]

Wollaston, who was nearly forty when he arrived, brought with him a style that had already been established in the art world of London. The style had certain features in the painting of faces and drapery that had originated in the studio of Thomas Hudson – most notably, the almond shape given to the eyes.[22] These mannerisms Wollaston imposed on his New York subjects, as if they were the same people, socially and culturally, as his London patrons. New Yorkers were evidently happy to have themselves portrayed in Wollaston's fashionable manner, for a large number of portraits exist from the three years he spent in their town.

The *Mrs. Nathaniel Marston* and the *Nathaniel Marston* are fine examples of Wollaston's work in New York (Figs. 143 and 144). Nathaniel Marston (1704–78), one of New York's wealthiest merchants and most influential citizens, owned numerous properties in the city. His own fine house on William and Wall streets was attended by several Negro slaves, and he and his family went about town in a beautiful coach drawn by his handsome "chariot horses." An Anglican, Marston was a major supporter of Trinity Church; he was buried in its cemetery and his will left £500 to the charity school operated by the church. Among his other benefactions, he presented Dr. Samuel Johnson in 1755 with £1,200 pounds to be used for the recently chartered King's College. His wife was Mary Crooks (1700–1768), and their children married into the Van Cortlandt, Lispenard, and Philipse families.

Wollaston's portraits of the Marstons, painted around 1750, establish the social position of the sitters through the finery of things and stuffs – mainly, fashionable attire and handsome furniture – and Nathaniel Marston is specifically shown as a successful merchant carefully attending to his account books. A typical New Yorker, he took great pride in his mercantile accomplishments, saw them as the source of his prosperity, and believed that God was his silent partner in the pursuit of his secular calling. Industry and diligence, as we have seen, were religious and moral virtues, and reference to them in the Marstons' portraits was mandatory. We are, in fact, told more about the Marstons

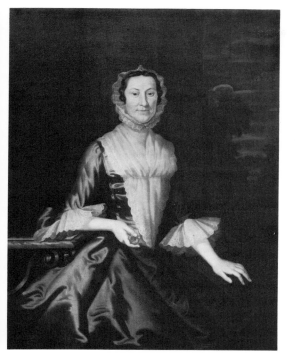

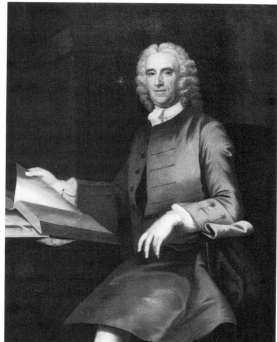

Figure 143. *Mrs. Nathaniel Marston*, by John Wollaston, c. 1750. Oil on canvas, 40½ × 50 inches. Museum of the City of New York. Gift of Mrs. Frederic Grosvenor Goodridge.

Figure 144. *Nathaniel Marston*, by John Wollaston, c. 1750. Oil on canvas, 40½ × 50 inches. Museum of the City of New York. Gift of Mrs. Frederic Grosvenor Goodridge.

through their finery and other objects than through character studies in the faces, which invite little speculation about the subjects' personalities. In painting class portraits rather than images devoted to individual character, Wollaston, like Blackburn, was working from a preconceived notion of what a fashionable likeness was, and what art was, rather than strictly from his observation of the physical model there before him, as native-born artists such as Feke, Copley, or Peale would do. Wollaston would have us believe that Mrs. Marston's eyes were of the same almond shape as those of every other woman he painted in the colonies; it was of little importance to him to search her eyes for indications of individual character.

New Yorkers' meager experience with the fine art of painting at least partially explains their acceptance of a portrait style that certainly had its limitations. But Wollaston's work has a charm, in the pleasant, good-natured faces and in the lovely passages of lace and satin, as well as in the beautiful color harmonies of soft blues, tans, and teal greens. Surfaces of bright satins shimmer in a way that delights the eye, and informs the viewer of the subject's affluence. And so, as with Blackburn in New England, Wollaston found patronage among the wealthy merchant class of New York, which was happy enough to have a painter from London settle in its town and cater to its search for refinement as well as its materialistic tastes. John Wollaston left, in 1752,

probably because after painting the most notable families, patronage was beginning to diminish; but perhaps another reason for his departure was the low aesthetic threshold and lack of interest in art, generally, that existed in New York. The latter part of his colonial career will be discussed in Chapter 28, on portraiture in the South after 1740.

Painters like Blackburn and Wollaston provided a valuable impetus to painting in colonial America, at just the moment when it was greatly needed. First, because society had risen to a level of sophistication that caused it to want what the portrait painter could do for it, and, second, because there were young native-born painters – such as Copley, West, and John Hesselius–who needed some example to follow, even if they did so only briefly. It was mainly through the several hundred portraits by Blackburn, Wollaston, and others like them that the new Georgian rococo style became known throughout the colonies in the 1750s and early 1760s, from New Hampshire to South Carolina. Moreover, the general awareness of portraiture had been greatly enhanced, and the rising generation of native-born artists would reap the fruits of that development. In the decades that followed Wollaston's tenure as portrait painter to New York, the town would host a number of artists, among them Lawrence Kilburn, Thomas McIlworth, John Mare, Abraham Delanoy, and John Durand. In New England, Blackburn would be followed by John Singleton Copley.

Copley's Boston

By the time John Singleton Copley (1738–1815) made his earliest juvenilia around 1753, the New England seaboard was a settled, prospering area with several fine towns, such as Portsmouth, Newport, and New Haven. But the foremost by far was Boston, where Copley's father had operated a tobacco shop on the long wharf and where his stepfather, Peter Pelham, had taught dancing, held musical assemblies, and occasionally produced a mezzotint of a local minister. Although among the total population of New England, farmers outnumbered city folk by a great majority, it was the merchant class and its associates that gave vitality and direction to the great flowering of New England in the third quarter of the century. An eighteenth-century Anglican minister, Arthur Browne, of Newport, Boston, and Portsmouth, revealed contemporary recognition of this when he wrote:

> The inhabitants of the town by more information, better polish and greater intercourse with strangers, insensibly acquired an ascendancy over the farmer of the country; the richer merchants of these towns, together with the clergy, lawyers, physicians and officers of the English navy who had occasionally settled there, were considered as gentry; even being a member of the church of England gave a kind of distinctive fashion.[1]

The merchants who activated the economic pulse of Boston and other New England towns were the determinant force in other aspects of society as well: Their collective, forceful will influenced political events; their preferences altered the course of religion; and, as they were the primary patrons of the culture that arose, their taste laid heavily on its development. Boston was already the "capital" of New England, and the heart of the town lay in the section that reached from the Old Town (State) House down to the waterfront where large numbers of tall-masted merchant ships rode proudly at private and public wharves (Figs. 67 and 68). In between were the warehouses and stores of the great merchants, interspersed with the small shops of lesser vendors and the establishments of the tradesmen. In 1740 the wealthy merchant Peter Faneuil offered to pay for a civic market hall; this was opposed by farmers and small dealers, who saw it as a plot by the greater merchants to regulate prices and commodities. At a packed town meeting of more than seven

hundred people, the merchants carried the vote by a margin of seven, thereby demonstrating their dominance in this as in most matters that concerned the community. Designed by the painter John Smibert, Faneuil Hall, a Georgian-style brick edifice with superimposed rows of arches, pilasters, and cornices, was opened in 1742, and, even more than the Old Town (State) House, the governor's mansion, or any of the several churches, it became the real center of activity within the colony.[2] Not only were business transactions carried on daily on the ground level, but the second floor had a large hall in which many civic affairs were attended to, and as the day of Revolution approached, this basically mercantile structure became the "cradle of liberty" where the burning issues of the day – which were as much economic as they were political or philosophical – were debated.

The French and Indian Wars of 1744–48 and 1754–60, aside from ridding the English territories of a foreign threat and reducing the Indian problem, left the colonists of New England with a very wealthy and powerful class of merchants who were now permitted to concentrate on economic matters. Shopkeepers, shipowners, wholesalers, retailers, commodity speculators, factors, agents, and lawyers prospered in the 1750s and 1760s as they never had before in the colonies, and the primary motivating force in this society was the very real potential for becoming rich. By the end of the 1760s the mercantile establishment had seized control of New England's destiny. The rhythm of life was devoted above all else to the purpose of making money, and excess money could be spent on the refinements of life.

Wealth, in this society, was the source of power, influence, and social standing; the things money could buy – such as fine clothes, handsome houses, beautiful furniture, silver, porcelain, and art – were the material manifestations of success and prosperity. In a land that did not have titled nobility, wealth was the determinant in economics, politics, and social matters – and even in religion.[3] The location of one's pew in church, for example, was often a status symbol that was determined by one's wealth and social standing; the order of listing the names of students at Harvard College followed the same criteria.

Materialism was a concomitant to mercantilism; together they produced a philosophy of life that was superbly expressed in the portraits painted by John Singleton Copley. The virtues as defined by innumerable generations of the middle class since the sixteenth century were now producing a remarkable harvest of materialistic pleasures, and all was blessed by the Calvinistic code still deeply imbedded in Congregationalism. Industry and a disdain of idleness, which began as religious virtues, had become secularized and welded into the pattern of life and the style of portraits.

Although society in Copley's time was, in fact, a middle-class affair from one end of the scale to the other, and was certainly seen as such by European aristocracy, it was nevertheless stratified. Samuel Mather, the brother of Cotton Mather, made the point unequivocally in one of his sermons delivered in Boston, indicating it was so by divine will:

> It appears very evident, that the supreme Governor of the World has been pleas'd to constitute a Difference in Families: For, while most of the Sons of Men are Brethren of low Degree or of common Deriva-

tion; Some are sons and Daughters of the Mighty; They are more
honorably descended, and have greater Relations with others. These
therefore may well wear the Character of the Mighty. . . . Some are
Mighty by means of the Wealth, which the Providence of a bountiful
God has given them.[4]

The population was divided into commonly recognized levels of the "inferior
sort," the "middling sort," and the "better sort." The latter group was the
mercantile aristocracy and although the titles they bore were not "lord" or
"duke" or "baron," they did append "gentleman" or "esquire" to their names.
The merchant-aristocrats differentiated themselves from the "inferior sort"
and even the "middling sort" not only by the power they wielded but also
by the way they dressed, the houses they built and the furnishings they put
in them, the manners they practiced, and the refinements they effected. This,
of course, was exactly the segment of Boston society that had its portraits
painted, and in Copley it found a master who was supreme at delineating its
character and its ambitions. Yet, we must add, this was an aristocracy that
never forgot its middle-class origins and never relinquished its middle-class
virtues. The merchants seem to have remembered respectfully that if they
themselves had not been cobblers or coopers, blacksmiths or booksellers, they
had only to go back a generation or two before the laboring, trade, or even
servant class was reached. They knew full well, and even found pride and
honor in the fact, that they were a self-made aristocracy, and Copley was
astute enough to realize there was no need to be pretentious in the type of
image he created of them.

Fundamental to this self-made Boston aristocracy was individualism, be-
cause it was recognized that men and women had reached or continued to
exist at that level only through individual effort. Individualism, in the case of
portraiture, was translated into specificity of physical features, and that was
precisely what Copley gave his patrons, purging the artificial idealizations that
Joseph Blackburn had offered. Copley's likenesses possess that self-confident
individualism of the self-made, and there is no fathoming of his portraits
without recognizing these traits of the colonial mercantile personality.

Other class characteristics – pragmatism, rationalism, and egalitarianism-
must be recognized because they, too, are essential features in Copley's ar-
chetypal colonial portrait. A pragmatic person is one who acts more according
to what is efficacious than according to what is ideal; *Webster's New World
Dictionary* has defined pragmatism as: "A system of or tendency in philosophy
which tests the validity of all concepts by their practical results," and Boston
merchants charted their secular endeavors by just such a philosophy. The
antithesis of pragmatism is idealism, and merchants in pursuit of prosperity
were little inclined to idealistic fantasy; the ideal seldom paid off in that which
measured success – material wealth. The merchant had the greatest respect for
and confidence in that which really worked or was obviously true, and his
faith in what was pragmatically true led him to desire in his portrait a self-
apparent truthfulness rather than an idealization – a characteristic that Copley
recognized.

Rationalism and egalitarianism were also components of the New England

mercantile personality. As a theoretical system, it paralleled the marketplace pragmatism of the merchants, demanding that the physical world be understood and interpreted in the light of reason, and the process of rational analysis and presentation of the physical world, described without idealization or sentimentality, is reflected in the portraits by Copley, which found approval among his patrons. Egalitarianism was a spirit that had evolved with the middle class, although, to be sure, among equals, some were more equal than others. There was a recognized and accepted stratification of society among colonists, but they remembered their origins and rejected any system of rigid separation of society into official ranks and titles. This spirit of egalitarianism had its impact on Copley's portraits, for in them his subjects look back at us as equals; we are cordially invited into their company through direct eye contact and a good-natured expression. The aloofness and social distance of the aristocratic English portraits by Van Dyck, Kneller, or Reynolds are not present in Copley's portraits of middle-class mercantile society in British North America.

In the matter of religion a very interesting evolution occurred. The mercantile class in Boston certainly had its religious convictions, and by their own standards many were even pious. But the clergy no longer controlled society; instead, the wealth and power of the merchant class was sufficient to force the church to accommodate to its will. The Congregationalist, Presbyterian, Quaker, and other denominations actually did so, up to a point, but when they could go no farther in this accommodation, the prospering merchants and their associates often simply switched their allegiance to a church or to a philosophy that would – primarily to Anglicanism or to deism. We have seen in Chapter 8 how even Cotton Mather became a transitional figure, retaining some of the theocratic ideas of his father and grandfather and their fanatic brethren, yet permitting – under pressure – a greater freedom among the flock to enjoy the pleasures of the material world. In Benjamin Franklin we observe a further transformation to a secularization of the old religious precepts, and Franklin, of course, was a professed deist even from the days when he knew Cotton Mather in Boston.

But it was the Episcopal church that effected the greatest change in the religious pattern of eighteenth-century Boston before the Revolution. As the Church of England, it had been closely aligned with the Crown since the days of Henry VIII, and because of this alliance it was usually tolerant of the social life of the court, the nobility, or the gentry. That is, the Anglican church always had a higher threshold of toleration of worldly pleasures than did the sects of separatist origin, such as the Congregationalists, the Presbyterians, the Quakers, and, lately, the Methodists. When these churches could not elevate the upper limits of what they could tolerate as fast as the swift-moving middle class led by the merchants, the merchants, with relative ease and a swift demonstration of their pragmatism, simply switched their allegiance to one that would – the Episcopal church.

To a people whose life-style itself was constantly becoming more refined amid rich, decorative surroundings, musical evenings, secular ceremonies (such as Masonic installations), and the like, the splendid ceremony of the Anglican church held great appeal, as Schlesinger has noted:

For those on top, the Anglican Church held a compelling attraction. Just as it was the allegiance of the upper class at home, so it was that of the Crown officials sent to America. The dignified ritual of the Book of Common Prayer, with its setting of fine music, exerted an undoubted appeal, but the social prestige of membership probably formed the greater magnet. At any rate, hundreds of Congregationalists, Presbyterians, Quakers, Lutherans, and others, as they moved upward in the world, forsook the faith of their fathers for the more stylish communion.[5]

Moreover, when King's Chapel was completed, it was the handsomest building in Boston and the edifices of the other denominations simply did not approach it in stylishness. Although Anglicans were a minority, making about a third of the population, they were nevertheless a very influential element in society because of their wealth and leadership positions.

Prown has tabulated that of all those who posed for Copley's portraits, 67 percent were Congregationalists and 31 percent were Anglicans.[6] But if some of the merchant aristocracy that Copley painted donned Episcopalianism because it now meshed better with their life-styles than did the Protestant sects of their forefathers, they could not change religion quite as easily as they changed their satin waistcoats or their silk gowns. Most merchants were descendants of Congregationalists, and the morals and values of life imbedded within the religious teachings of that sect held on tenaciously, even after conversion to Anglicanism. The personal as well as the religious virtues of middle-class Congregationalism remained at the core of the New England personality, while the splendor of Anglicanism was often a social veneer by comparison. That Calvinistic influences still persisted in the mid-eighteenth century is seen in Jonathan Edwards's *Sinners in the Hands of an Angry God* (1741) and *A Careful and Strict Enquiry into . . . That Freedom of Will* (1754), the latter "a monument of logical defense of Calvinism."[7] In everyday life the Calvinistic virtues were still considered honorable and practical by the mercantile aristocracy: industry, frugality, religious devotion to one's calling, moderation (always a relative thing), and a disdain of idleness – in brief, the very attributes that had all but guaranteed success and prosperity to the rising Protestant middle class since the mid-sixteenth century. Furthermore, as we have seen, those virtues had religious sanction, for anyone who lived by them received divine blessing on his secular endeavors. All of this was too valuable to discard, even if one now attended services at King's Chapel instead of the Old South Church. In the end, it would be the middle-class Protestant virtues that showed up in Copley's portraits, be the subject Anglican or Congregationalist.

Boston was changing physically, too, in the beauty of its edifices. The old clapboard, medieval-survival-style structures were still in use, associated mainly with the laboring and trade classes, but the rich merchants were committed to the elegant Georgian style for the fine new houses they built. We have already mentioned the Old Town (State) House and King's Chapel, and there were also Christ Church (1723) in the North End and Trinity Church

(1733) in the South End. Faneuil Hall had been built as the proud center of mercantile activity. In nearby Cambridge, Harvard College was adding buildings in the new style, which was also used for the Vassall (Longfellow) House of 1759. Prospering merchants began to erect handsome town houses and even seats in the country. In 1766, John Adams was nearly overwhelmed by the splendor of the Nicholas Boylston House, as he noted in his diary on January 16, 1766:

> Dined at Mr. Nick Boylston's with the two Mr. Boylstons, Mr. Wm. Smith, Mr. Hollowell and their ladies – an elegant dinner indeed! Went over the house to view the furniture, which alone cost a thousand pounds sterling. A seat it is for a nobleman, a prince. The Turkey carpets, the painted hangings, the marble tables, the rich beds with their crimson damask curtains and counterpanes, the beautiful chimney clock, the spacious garden, are the most magnificent of anything I have ever seen.[8]

The wealth that came into the merchant's counting room from his store, his ships, his warehouse, his speculations in land and commodities, was chiefly devoted to further investments for the purpose of making even more money. But in the prosperity of the years between 1750 and 1775 there was sufficient left over to fill his fine new house with beautiful furnishings – the items that unobtrusively appear tucked into the corners of Copley's portraits, subtle references to the material affluence of which his subjects were so proud. And increasingly amid that splendor hung the handsome physical images of the merchants, their families, and their material goods as painted by John Singleton Copley, who, by 1760, had achieved a mature form of artistic expression that captured all the things the mercantile gentry held dear.

John Singleton Copley: The Early Years

Copley, born in Boston in 1738 to Richard and Mary Singleton Copley, probably never knew his father, who died about the time of his birth.[1] On May 22, 1747, his widowed mother married Peter Pelham, a schoolmaster, an Anglican, Boston's leading entrepreneur in arranging musical programs and dance assemblies, and occasionally an engraver of mezzotints. But Pelham died when Copley was only thirteen, and by 1751, Boston was experiencing a temporary nadir in artistic talent. Smibert died in that year as did Pelham, and Feke had left the year before. John Greenwood was there, but he, too, would leave, in 1753. There was also Joseph Badger, a house painter who turned portraitist when the community had no other. As Copley entered his teens, therefore, little in the way of artistic talent was around to offer him instruction or advice.

We may observe Copley's development year by year, and the influences on it are immediately recognizable, until he reached his mature style by 1758 in an incredibly brief five-year period. His mezzotint of the Reverend William Welsteed is a reworking of a plate first made by Peter Pelham in 1743, which represented the Reverend William Cooper; the *Welsteed* (1753) demonstrates the lingering influence of his deceased stepfather's studio, tools, and materials.[2] Searching for instruction in any form available, Copley learned anatomy by copying the musculature of a flayed figure diagrammed in an encyclopedia.[3] Two early paintings of 1754 represent classical subjects taken from European engravings – *Return of Neptune* (Metropolitan Museum of Art) and *Galatea* (Museum of Fine Arts, Boston) – while one of his earliest portraits, the *Brothers and Sisters of Christopher Gore* (c. 1755), now at the Winterthur Museum, shows that he was learning what Joseph Badger had to offer.[4] Copley was inventive in seeking out diverse sources that would advance his art, and among those proving most useful were the English mezzotints that existed in great number in his stepfather's studio, in the studio of John Smibert, which was still extant, and in many private collections.

The *Mrs. Joseph Mann* (Bethia Torrey) of 1753 exhibits several of these early influences (Fig. 145). The simplified anatomical form probably is the result of Copley's seeing portraits by Badger, but the bolder treatment of light and shade suggests he had studied Feke's work as well as mezzotints. The pose, the motif of the hands toying with a strand of pearls, and certain details of

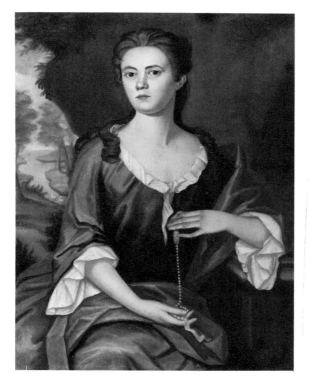

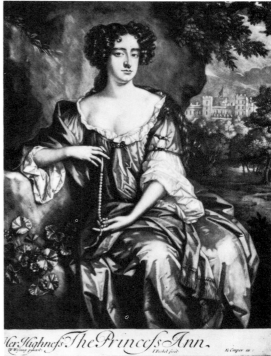

Figure 145. *Mrs. Joseph Mann*, by John Singleton Copley, 1753. Oil on canvas, 36 × 27¼ inches. Museum of Fine Arts, Boston. Gift of Frederick H. and Holbrook E. Metcalf.

Figure 146. *Princess Anne*, by Isaac Beckett after the portrait by William Wissing, 1710–30. Mezzotint, 13¹/₁₆ × 9⅞ inches. The Henry Francis du Pont Winterthur Museum, Winterthur, Del. Gift of Mrs. Waldron Phoenix Belknap.

the landscape are, in fact, taken from a mezzotint of Princess Anne by Isaac Beckett after a painting by William Wissing (Fig. 146). The comparison demonstrates the use of the mezzotint as an instructional device by a young colonial artist who had neither art school nor established master to learn from, and it also reveals that the English mezzotint was still a force in determining the taste of colonial patrons; lacking great collections, such as Europe enjoyed, with which to familiarize themselves on the art of painting, the colonists' judgment and taste in such matters depends heavily on mezzotints. But the form of Copley's *Mrs. Joseph Mann* is more complex than an adaptation of a single mezzotint, for it owes an obvious debt to John Smibert's *Mrs. Samuel Browne, Jr.*, of 1734 (Fig. 82), which was in turn based on Isaac Beckett's mezzotint of Princess Anne after the portrait by Kneller. Although Katherine Winthrop Browne does not have the string of pearls in her hands, suggesting that Copley had used the Beckett mezzotint after Wissing's portrait, there is evidence to suggest that Copley had recourse to the portrait by Smibert. The Beckett engraving was in black and white and its composition is reversed in Copley's *Mrs. Mann*; but Smibert's and Copley's compositions are almost identical (the pearls excepted), and Copley represented Bethia Mann wearing red and blue garments, exactly as in Smibert's *Mrs. Samuel Browne*. The folds of the gown

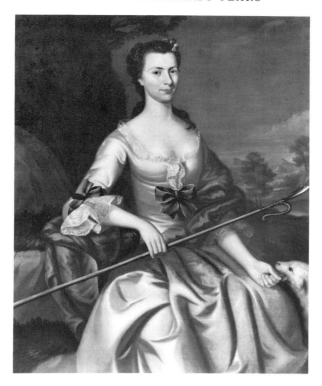

Figure 147. *Ann Tyng*, by John Singleton Copley, 1756. Oil on canvas, 50 × 40¼ inches. Museum of Fine Arts, Boston. Julia Cheney Edwards Collection, bequest of Grace M. Edwards in memory of her mother.

in Copley's *Mrs. Mann* are generalized and often awkwardly composed, and the fabric itself lacks that veristic tactile quality that would in time become one of the real glories of Copley's art. Copley emulated the limitations of his models as well as their strengths, for Smibert's draperies tended to lack tactile specificity. In that matter, Copley would learn more from the study of Feke's work than from Smibert's.

The next major influence on Copley was Joseph Blackburn, who arrived in Boston in 1753. The impact of Blackburn's style is clearly seen in Copley's *Ann Tyng* of 1756 (Fig. 147), which in the motifs of the shepherd's crook and the lamb at the knees is a direct borrowing from Blackburn's *Mary Sylvester Dering* of about 1754, which is at the Metropolitan Museum of Art.[5] In depicting a young woman as a shepherdess, both Blackburn and Copley were following a long tradition that included Sir Peter Lely's *Duchess of Rutland* and Sir Godfrey Kneller's *Duchess of Queensberry*.[6] Blackburn's direct influence on Copley's *Ann Tyng* may be seen by comparing the pose of the figure, the rendering of the satin gown, and especially the treatment of the lace at the cuffs and bodice with Blackburn's *Mary Faneuil* of 1755 (Fig. 141). Even the naive self-consciousness of Mary Faneuil is emulated in Copley's portrait, as are the long neck, the smallness of the head, and the lack of articulation at the wrists. The chief pleasantry of Blackburn's work is the drapery, which, although it may not always fall in well-composed folds and may not always

reflect the anatomical form it covers, is almost always elegant and exquisitely colored, and Copley imitated these features in his image of Miss Tyng. However, he again learned the bad as well as the good in his search for instruction, for the folds of his subject's skirt are ill-formed and confusing; he had not yet mastered the construction of fabric or its relationship to the anatomy underneath. The *Ann Tyng* represents a step beyond the baroque proportions and color scheme of the *Mrs. Joseph Mann* (the baroque elements of which were due to the mezzotint and Smibert influences), and in it Copley arrived at a Georgian rococo elegance, by way of the model offered by Blackburn's art.

One can sense the eighteen-year-old Copley groping for solutions and experimenting with whatever usable sources came his way. To his credit, however, he was perceptive enough to recognize that which was aesthetically faulty in his sources and in his own work. He undoubtedly saw that Ann Tyng was unnaturally rigid in her posture, self-conscious and ill at ease in having her likeness made, and rather vacuous in her facial expression. With determination he set about remedying those inadequacies, and very soon surpassed what Joseph Blackburn's art had to offer him. The verve, strength, sureness, physical presence, and character analysis of Copley's best work are near at hand.

Only two years separate Copley's *Ann Tyng* from his exquisite portrait of Mary and Elizabeth Royall, and the young artist's progress can only be described as amazing (Fig. 148). Mary and Elizabeth were the daughters of Isaac Royall, the wealthy merchant, Anglican, and Tory whose family portrait had been painted by Feke in 1741 (Fig. 133) and whose portrait Copley would paint in 1769.[7] In later years both girls would marry into the mercantile establishment. Elizabeth became the wife of William Pepperrell, who, many years afterward in England would commission Copley to paint his family-group portrait, now in the North Carolina Museum of Art, Raleigh; Elizabeth Royall Pepperrell is the mother shown in the portrait, although she had died by the time it was painted. Mary Royall became Mrs. George Erving.

The year Copley painted the double portrait of the Royall sisters, 1758, marked the turning of his career from groping novice to mature master, in spite of his being only twenty years of age. As we can see in Figure 148, the earlier self-consciousness of his subjects is gone, replaced by an ease and naturalness of posture; the faces have an *animus*, and their eyes return the gaze of the spectator with complete self-possession and composure; the girls nestle comfortably into the sofa – an integral part of their rich environment – and their gestures are natural rather than contrived or dependent on the artificial models of the mezzotints. All substances – whether the flesh or hair, the fabrics, or the fur of the dog or the feathers of the hummingbird – have a reality and believability that are remarkable. The blue and white satin of the dresses becomes a symphony of exquisitely constructed, superbly orchestrated folds with all the tactile reality of real satin. The richness of the physical world, the sumptuousness of the subjects' life-style, and the artist's extraordinary sense of the beautiful are now united into a vivid representation. Here are the "real" people, the material substance and the elegance in combination that the mercantile aristocracy of Boston embraced as a proper expression of themselves and those things and values they held dearest.

Any individual passage delights the eye of the spectator, whether it be the

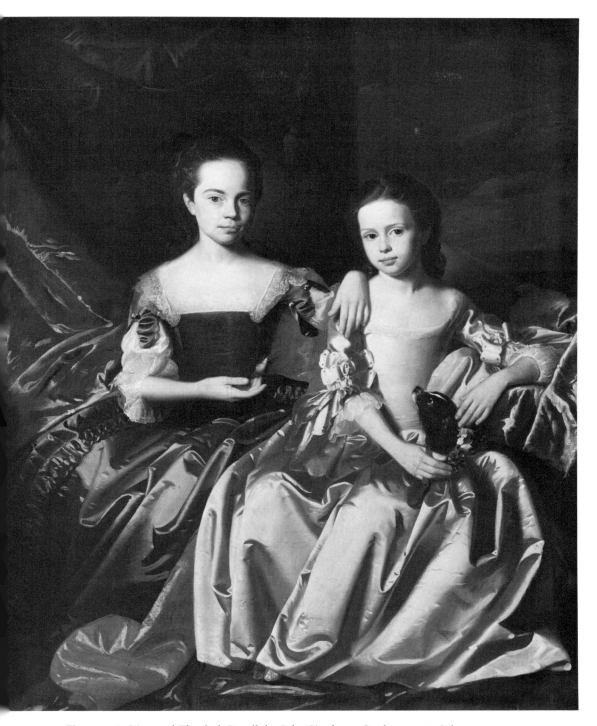

Figure 148. *Mary and Elizabeth Royall*, by John Singleton Copley, 1758. Oil on canvas, 57½ × 48 inches. Museum of Fine Arts, Boston. Julia Knight Fox Fund.

faces of the young girls or the flowers around the puppy's neck; the delicate hummingbird on the tips of the fingers that gives meaning to the position of the arm and hand, which in earlier colonial portraits was so often an empty gesture; a touch of lace, a ribbon, a crisp fold of satin; the intimacy of a hand resting casually on a sister's shoulder – all give a pleasure to the eye seldom attained in colonial American painting.

By 1758, Copley had realized it was his eye on which he could depend most in searching for his own means of expression – rather than the mannerisms of mezzotints or of paintings by Smibert, Badger, or Blackburn – and he probably understood that Robert Feke had approached the same resolution. With his eye Copley studied the physical world there before him in his studio, and his eye became his teacher. This was, of course, by no means out of step with the times, for scientists were then experimenting with optics and philosophers were concerned with sensory, particularly visual, experience, as seen in Chapter 20. Copley's middle-class, mercantile clientele trusted far more what the eye told them of the real world than any esoteric aesthetic theory that had produced a fanciful idealization of that world. For Boston merchants and their entourage, the powerful visual reality of a Copley portrait meshed perfectly with their pragmatism and materialism; the remarkable visual likenesses coincided with their individualism. A perfect union of artistic mode and cultural character had been achieved for the colonial American portrait. Thereafter, for Copley, it was a matter of refining that mode, at least until he moved to Europe, where he would begin anew a search for a very different means of artistic expression. Copley's portrait of Mrs. John Barrett is a splendid example of all this coalescing, and it, too, was painted about 1758 (Fig. 149). The subject was the wife of a merchant of good but not great income, and the Barretts were moderate Tories and Congregationalists. She was plain of feature, and her individualism was more important than idealization. A real living being looks back at the viewer with a confidence arising from a firm belief in the values and virtues of her class, while her social position is declared by the beautiful brown dress trimmed with abundant white lace, and the strong materialistic element testifies to the joy she finds in the fruits of industry and diligence.

In the years that followed, Copley continued to develop his art within the stylistic perimeters established in the late 1750s. As his work found increasing popularity among the mercantile aristocracy, the demand for his talent became constant and brought him an excellent income. But a variety of circumstances caused him to be discontent – perhaps in part because he had attained success so early in life. An artist of rare innate ability, he naturally wanted to push his art to its highest fulfillment, but by the age of twenty he had already arrived at a style and competence of execution that was completely satisfactory to his patrons. He was haunted by the idea that there was an art superior to his that could only be learned abroad, beyond the colonial world with its limited standards of taste and provincial knowledge of art. Moreover, he had heard of the successes and acclaim that Benjamin West was enjoying in London, and it made him wonder if he, too, might not do as well. They were the same age, West and Copley, but the former had early gone to Italy and then startled the London art world with his paintings of classical themes, whereas Copley

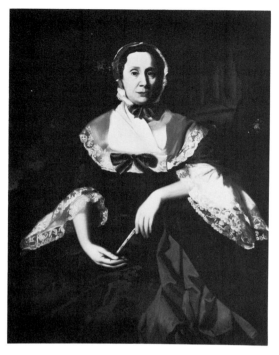

Figure 149. *Sarah Gerrish Barrett*, by John Singleton Copley, 1758. Oil on canvas, 50 × 40 inches. The Nelson–Atkins Museum of Art, Kansas City, Mo. Acquired through the Enid and Crosby Kemper Foundation.

had remained at home, in a remote provincial colony, far from the excitement of the center of the English art world.

Copley's *Boy with a Squirrel* was a product of his discontentment but also a demonstration of the best efforts he could muster (Fig. 150). The artist worked from his strength in that it is a portrait (of his stepbrother, Henry Pelham), yet it is also a genre piece. His intention from the start was to create a work to send to London, to test his abilities against the art produced there, and something beyond simple portraiture seemed appropriate; so he represented his subject lost in his own thoughts, absentmindedly toying with the chain that tethers his pet. The painting is a tour de force within Copley's style, and individual passages amaze the eye of the beholder by their physical reality and their beauty. The sensitivity with which the boy's face is rendered is extraordinary, as are many other exquisitely painted passages – his right hand, so delicately holding the gold chain and so wonderfully wrought in light and shadow; the chain itself, in which every link of the glistening metal is re-created by the artist as if he were an alchemist with a brush; the brilliant display of brushwork and chiaroscuro in the ruffles at the wrists; the miraculous transformation of paint into transparent glass, water, and highlights; the beautiful rendering of the moist-eyed little squirrel in which the soft texture of the fur is a sensuous joy; and the smooth warmth of the mahogany table surface with its high polish and reflections. All of these things were studiously perceived by the artist's eye, and then his hand and brush re-created the sensual

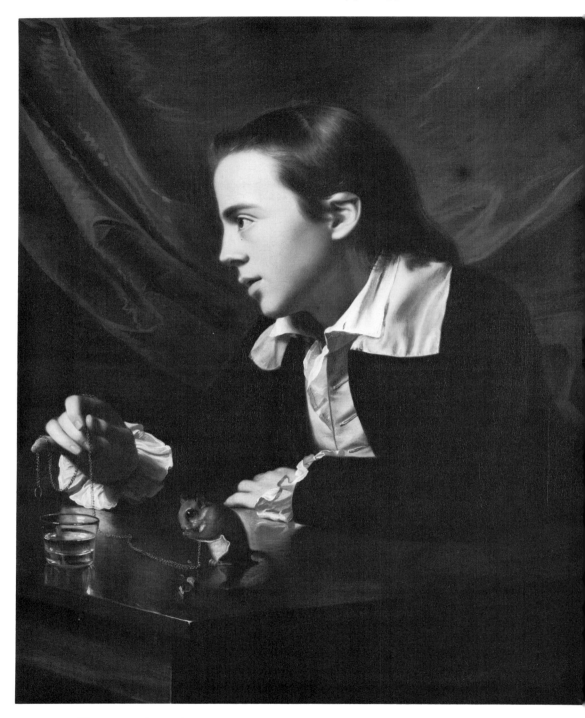

Figure 150. *Boy with a Squirrel (Henry Pelham)*, by John Singleton Copley, 1765. Oil on canvas, 30¼ × 25 inches. Museum of Fine Arts, Boston. Anonymous gift.

experience of the physical world. In brief, Copley pushed to the utmost limits the art form he had developed in service to his mercantile clientele.

When *Boy with a Squirrel* was finished, he sent it to London and anxiously awaited news of its reception. Several months later word came that it had been praised by Benjamin West, Sir Joshua Reynolds, and others of the community of artists. His joy was great, but his quandary was intensified. Should he follow West's example and his recommendation to leave at once for Europe, to study and thereby elevate his art and realize his greater potential; or should he remain at home, where he was eminently successful among his mercantile clientele? The quandary he faced and his feelings about the level of his patrons' taste – with its concomitant stultification of his art – are all too apparent in a letter he wrote to a Captain R. G. Bruce, through whom he had received word of the favorable reception his *Boy with a Squirrel* had received in London; if he did go abroad to study for a year or two, he pondered,

> What should I do at the end of that time (for prudence bids us to consider the future as well as the present)? Why, I must either return to America and bury all my improvements among people entirely destitute of all just ideas of the arts, and without any addition of reputation to what I have already gained... or I should set down in London in a way perhaps less advantageous than what I am in at present, and I can not think of purchasing fame at so dear a rate.[8]

In that passage Copley not only revealed what he thought of his patrons' taste, but also showed himself to be as money-minded as any of the merchants who sat to him. These trains of thought continue in the same letter:

> I would gladly exchange my situation for the serene climate of Italy, or even England, but what would be the advantage of seeking improvement at such a outlay of time and money? I am now in as good business as the poverty of this place will admit. I make as much money as if I were a Raphael or a Correggio, and three hundred guineas a year, my present income, is equal to nine hundred a year in London. With regard to reputation, you are sensible that fame cannot be durable where pictures are confined to sitting rooms, and regarded only for the resemblance they bear to their originals. Were I sure of doing as well in Europe as here, I would not hesitate a moment in my choice, but I might in the experiment waste a thousand pounds and two years of my time, and have to return baffled to America.[9]

Copley was himself a product of the pragmatic, mercantile society that he painted so perceptively. At this time a correspondence began between Copley and West, which is interesting for the discussions on art it contains.[10] But Copley was never as forthright with West as he was with Captain Bruce, for he was reluctant to admit to West that monetary gain weighed equally with artistic advancement in his considerations. His words to Bruce were like those of a true merchant, and we see again how Copley the artist and the mercantile aristocracy of Boston meshed so perfectly in their fundamental beliefs.

Copley: At the Crest of His Colonial Career

Copley decided not to take a chance on European study, not in 1765, at least. He settled down to painting the likenesses of those people whose taste he disdained, and they made him rich. In 1769 he married Susanna Clarke, daughter of Richard Clarke, a wealthy merchant and the Boston agent for the East India Company; her mother was Elizabeth Winslow Clarke, so Copley's "Sukey" was the granddaughter of Isaac Winslow. The marriage brought Copley into the inner circle of Boston's prime society; henceforth he not only painted that society, he was part of it, a position this son of a tobacco shopkeeper enjoyed greatly. The Clarkes were members of the Brattle Street Congregational Church, the most liberal and fashionable of all Congregationalist churches in Boston, but after her wedding, Sukey Clarke Copley transferred her membership to the Anglican Trinity Church, to which her husband belonged.

Beginning in 1769, Copley acquired tracts of land that would eventually total twenty acres on Beacon Hill, almost adjoining the John Hancock property. The tract, just west of the site of the present State House and encompassing the area of Louisburg Square, had three houses on it facing the Common, and one of these Copley remodeled handsomely as his residence, which he furnished in the manner of the finest merchants' houses. Never before had a New England portrait painter prospered so well from diligence at his calling.

Copley painted the portrait of John Hancock in 1765 (Fig. 151), the year after the subject had inherited the enormous fortune of his uncle Thomas. For all his vast new wealth, John Hancock is portrayed modestly, wearing a conservative bob wig with solitaire and a handsomely tailored dark blue suit with gold trim. He was plagued by ill health and appears rather slight of person in his portrait – certainly not the hearty, robust man his uncle was (Fig. 160), any more than he was the businessman that Thomas Hancock was. Copley's portrait is an interesting character study, for the subject does not dominate the canvas with a zesty, bold, self-confident vigor the way, say, Nicholas Boylston does in his portrait;[1] the element of mercantile dynamics is missing. Instead, there is a dreaminess similar to that found in Copley's *Boy with a Squirrel*, painted in the same year. But Hancock was proud of his mercantile heritage and had himself portrayed working at an enormous ledger, in an image that is a latter-day embodiment of the Calvinistic virtues, and the Great

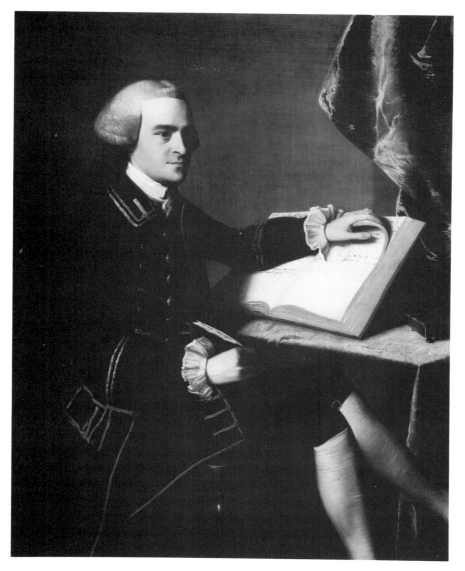

Figure 151. *John Hancock*, by John Singleton Copley, 1765. Oil on canvas, 49½ × 40⅛ inches. Museum of Fine Arts, Boston. Deposited by the City of Boston.

Reformer often spoke in a language that merchants would understand, as when he wrote:

> Earthly blessings . . . have all been given us by the kindness of God, and appointed for our use under the condition of being regarded as trusts, of which we must one day give account. . . . Let us remember by whom the account is to be taken – viz. by him who . . . so highly commends abstinence, sobriety, frugality, and moderation.[2]

John Hancock was heir not only to his uncle's fortune but also to a secular and religious code of virtues that had brought success, prosperity, and divine blessing on his class.

The type of portrait Copley painted in the years following his decision not to go abroad is exemplified by the *Mrs. Thomas Boylston* of 1766 (Fig. 152). This, many might agree, was the consummate Copley portrait and perhaps the zenith of colonial American portraiture. Further, it is the embodiment of those qualities that made up the character of the mercantile aristocracy in New England. The subject sits comfortably and naturally, poised and self-confident, in a handsome gold damask–upholstered armchair of Chippendale design. She seems snugly sequestered in a corner of a fine Boston parlor, the very picture of contentment and satisfaction in the prosperity that has come her way. The column and swag of drapery are examples of artistic license, traditional conventions in portraits since the time of Anthony Van Dyck, here adding notes of affluence and grandeur. The chair, too, is a subtle reference to the material prosperity the Boylstons have earned at their secular calling, which they enjoy in moderation, without ostentation.

The face of Mrs. Boylston deserves special attention in an analysis of Copley's style and the taste of merchants. There is a gentle, reflective expression, with a pleasantness about it, and a feeling of total composure. But on close examination we observe that the face is excruciatingly plain. Copley's subjects, being pragmatic and individualistic, insisted on truthful images of themselves, and, considering their success in the world, saw no need to idealize their appearance. This attitude was the result of a bold self-assuredness, and it led to an attitude of "paint me as I am, for what I am is good enough." If a woman were plain of feature, as Mrs. Boylston surely appears, then a truthful plainness was preferable to a false idealization. But here the genius of Copley rose to the occasion, for he made a virtue of Mrs. Boylston's plainness, giving it a dignity, even a beauty, of its own. Here was a triumph over the limitation imposed by middle-class insistence on truthfulness, for in Mrs. Boylston's face Copley recognized the innate dignity, poise, and grace that in the ways of their society were equated with beauty. At this, Copley was a master, and he far surpassed any foreign-born, foreign-trained artist who, in the colonies, tried to accommodate his patrons' desire for truthfulness; a comparison of Copley's *Mrs. Boylston* with John Smibert's *Mrs. John Pitts* (Fig. 84) makes the point.

Mrs. Boylston's face is strong enough to dominate the large canvas in this three-quarter-length portrait, but nevertheless it occupies only a very small portion of the total canvas area. More than half of the picture is devoted to the rich yellow damask of the large chair and the satin, lace, and ruffles of the subject's dress. The dress is a lively cocoa tan, the ruffles are white, and the lace is black, set over a broad, white muslin collar. The color scheme is one of reserve and dignity, matching therein the character of the woman's face. The fabrics themselves are among the chief glories of colonial painting, for the textures, delicate hues, and highlights and shadows are exquisitely rendered. Copley has filled a large portion of the canvas with material stuffs that mesmerize the eye of the beholder. This powerful materialistic element is an important feature in his portraits generally, and executed so beautifully, they

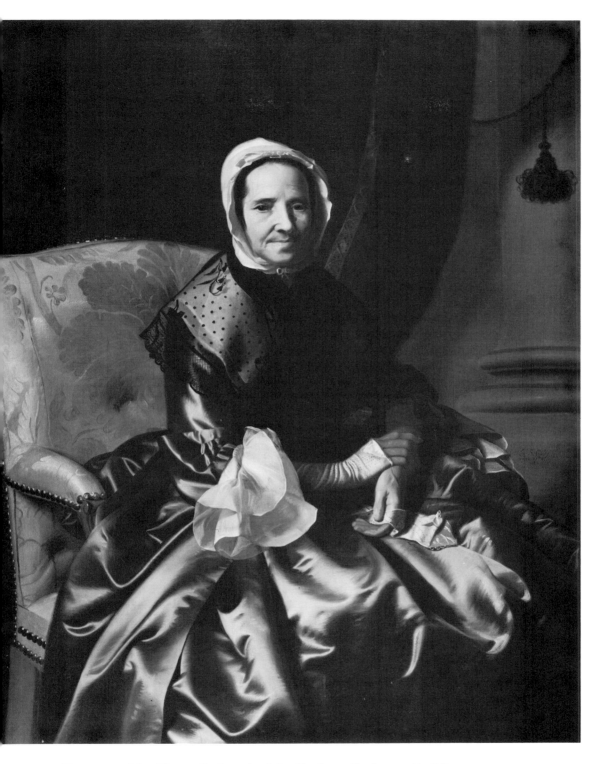

Figure 152. *Mrs. Thomas Boylston*, by John Singleton Copley, 1766. Oil on canvas, 50½ × 40½ inches. Fogg Art Museum, Harvard University Portrait Collection, Cambridge, Mass.

account for much of the aesthetic appeal of his work. But more than that, his near saturation of the canvas surface with material substances appealed directly to the strain of materialism that ran deep in the character of his patrons, for the rich stuffs – the damask, satin, lace, fine mahogany wood, and so on – became iconographic symbols of the material prosperity that people like the Boylstons had achieved. When all of the elements we have been discussing here are taken together – the individualism, the pragmatism, the materialism, the pride without pretension, the natural dignity of the upper middle class, who have succeeded by their own industriousness at their secular calling – we find wrought into this image a grand hymn to those virtues and ambitions that guided the colonial New England mercantile society at its finest hour. Sarah Morecock Boylston was, after all, at the very center of Boston's mercantile establishment, for her two sons, Thomas II and Nicholas Boylston (both of whom sat to Copley in 1767), were among New England's wealthiest merchants. Her life up to the time Copley painted her had been a success story that led straight up the social ladder, for her late husband, Thomas, had started out as a saddlemaker, then became a shopkeeper and finally a rich merchant. This grande dame of Boston's mercantile society thus rose to provincial aristocracy from strictly middle-class, tradesman origins, demonstrating again where the roots of that aristocracy were to be found.

The pair of portraits representing Isaac and Elizabeth Smith, of 1769, again show Copley at the height of his powers, and they celebrate all the social characteristics that have been developing in the colonial New Englander (Figs. 153 and 154). Isaac Smith (1719–87) was a self-made merchant who had prospered during the wars with the French and established his fortune before the depression of the 1760s. His mother, Sarah Boylston Smith, was the daughter of Mrs. Thomas Boylston (Fig. 152) and the sister of Thomas II and Nicholas Boylston; Isaac's brother, William, was the father of Abigail Smith, who later became Mrs. John Adams. Smith's wife, Elizabeth (1726–86), was the daughter of a prominent merchant, Ebenezer Storer. The Smiths were members of the Brattle Street Congregational Church, to which many of the most successful merchant families had gravitated.

The Smith portraits are coloristically brilliant and rich in sensuous and materialistic qualities. Isaac, sitting in a Chippendale chair, wears a handsomely tailored plum-colored suit trimmed with gold buttons and knee buckles; his stock, cuffs, and stockings are white, as is his beautifully coiffed wig. He sits beside a table covered with a blue fabric, and a deep blue damask drape hangs in the upper right of the portrait. The silver inkstand on the table is another subtle symbol of his wealth, while the papers on which he has been writing indicate his mercantile affairs. His space is enclosed, the dark background forcing our eye to concentrate on his head and on shiny gold and silver objects. Mrs. Smith sits in a large, gold-colored upholstered armchair with mahogany wood and numerous glittering brass tacks, each meticulously rendered. She wears a bright blue dress that is nearly enveloped in a sumptuous mauve robe trimmed with green taffeta lapels. Several strands of matched pearls adorn her neck, and more pearls decorate her brown hair. Again, a dark background focuses attention on her head, but she seems to be sitting beside a window that allows a view of a landscape in the distance. She holds a succulent bunch

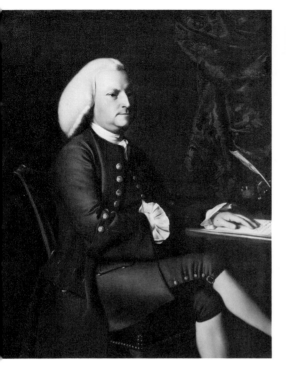

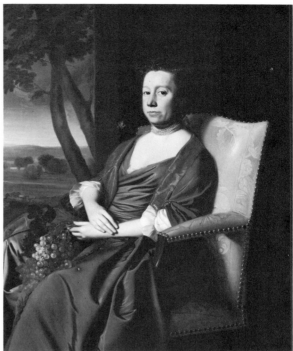

Figure 153. *Isaac Smith*, by John Singleton Copley, 1769. Oil on canvas, 50⅛ × 40⅛ inches. Yale University Art Gallery, New Haven, Conn. Gift of Maitland Fuller Griggs, B.A. 1896.

Figure 154. *Mrs. Isaac Smith*, by John Singleton Copley, 1769. Oil on canvas, 50⅛ × 40⅛ inches. Yale University Art Gallery, New Haven, Conn. Gift of Maitland Fuller Griggs, B.A. 1896.

of freshly picked, light green grapes as a sensuous symbol of fruitfulness and abundance. Copley frequently included showy arrangements of fruit or flowers in his portraits of women, adding a sensory enrichment through those symbols of domesticity and/or fecundity. But the chief delight of Mrs. Smith's portrait is in the extraordinary character study of the face. Once more, as in the Mrs. Boylston, Copley imbued very plain features with a dignity. The subject looks at us steadfastly, with total composure and with absolute security of her place in her society. Moreover, an animus or vital spirit inhabits her face, carrying Copley's art well beyond the representation of physical matter; that is, the image contains the spark of life itself. Mrs. Smith may not be aristocratic by European standards – her hairstyle, for example, would seem modest indeed if seen next to the elaborate coiffeurs of contemporary French, Italian, or even English women at the pinnacle of their societies; the contrast is obvious if her hairstyle is compared with the elaborate coiffeur of the woman sitting at the right in *The Painting Room*, an English print of a few years later (Fig. 155). But as an image of individualism, of pragmatic truthfulness endowed with dignity, of an egalitarianism that permits her to look anyone straight in the eye, and of physical reality, she is unsurpassed. All the other objects in this portrait create a rich world of materialistic delights, but it is the face that makes the portrait come alive.

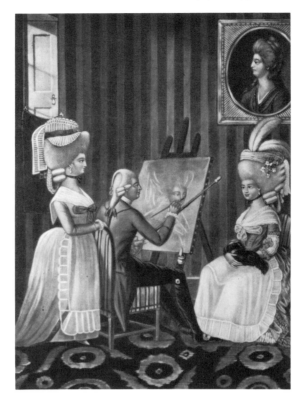

Figure 155. *The Painting Room*, by an unknown English artist, 1782. Mezzotint, 13⅝ × 9⅝ inches. The Henry Francis du Pont Winterthur Museum, Winterthur, Del.

Prown, the Copley scholar, has perceptively analyzed the Smith portraits as follows:

> Since, by the values still dominant in Copley's New England, the achievement of worldly success reflected heavenly favor, there was nothing to be ashamed of in the successful stockpiling of goods. Whether or not Isaac Smith was in fact the superbly calm and confident, as well as wealthy, man of business, and whether or not Mrs. Isaac Smith was the comfortable, warm *mater familias*, this was the way in which they wished to see themselves. Although they did not want to be flattered – if they were homely that is how they wanted to be portrayed – they wanted to be represented, handsome or ugly, in the roles they had cast for themselves. Copley satisfied this demand through portraits that were not only realistic representations of external appearances, but also representations of these people in a particular social role.[3]

Prown touched on many of the major points with which this book has been concerned, not the least of which is the concept of divine blessing on secular endeavors – or prosperity at one's calling as a sign of grace. Long before, the conviction had been implanted in the minds of their middle-class Protestant

forebears that it was God's will that one should be industrious and diligent at a secular calling, that idleness and slothfulness were sins, and that the prosperity and material gain accruing from industry were acceptable in the eyes of God. From the days of Calvin to the time of Isaac Smith, this was a major tenet that was both religious and secular in nature; it was one of the driving forces that led to the success and prosperity of the New England colonies. If those blessings came to New Englanders as a result of their own efforts, they came also as gifts from their God. It was difficult for even the clergy to quarrel with logic such as that, and so the ministers increasingly had to condone the pursuit of material prosperity.

Many of the same features found in the *Mrs. Boylston* and the pictures of the Smiths are present in the superb pair of portraits representing Elizabeth and Ezekiel Goldthwait (Figs. 156 and 157). Ezekiel (1710–82), who had been born into a prosperous merchant family, held high offices as a public servant, first as town clerk of Boston and later as registrar of deeds. In the Goldthwait portraits we are struck by the way we are greeted by these people: Mr. Goldthwait has been writing when our appearance causes him to swing around in his chair to acknowledge us cordially; Mrs. Goldthwait looks up as our arrival interrupts her action of reaching for a piece of fruit. Their eyes make contact with ours, and we are welcomed into their presence, even into the intimacy of their home. Copley has put them at ease, avoiding the self-conscious posing that Blackburn used in *Isaac Winslow and His Family* (Fig. 140); Mrs. Goldthwait is comfortable in her large upholstered chair, and her husband casually rests one arm upon the chair back while he crosses one leg over the other in a very relaxed and informal gesture. The animation of the subjects contributes greatly to the lifelike quality of the portraits and complements the liveliness expressed in the faces. Ezekiel Goldthwait is handsomely attired in a dark red suit and wears a fine white wig – emblems of his success and position in society; the quill pen and papers makes reference to his profession, in which he took pride. Elizabeth Lewis Goldthwait (1715–94) wears a mauve satin dress with black lace (an exceptional display of the painter's virtuosity) at the collar and lively white lace at the sleeves and around her cap. Her chair is again an especially handsome specimen with its teal-green damask fabric and shiny brass tacks, and the rich burgundy of the highly polished tabletop glistens with beautifully rendered reflections. The bowl of fruit serves multiple purposes; it is a typical rococo motif that plays to the senses of taste and smell, and it is a double reference to the subject's fertility (she had thirteen children) and to her gardens, which were famous throughout the colony. Again, much of the canvas is devoted to re-creating the physical world in the form of exquisite substances – the damask, the satin and lace, the mahogany, the fruit. Such imagery could not but appeal to the materialism of the artist's patrons.

The dignity that pervades the Goldthwait portraits was achieved in part through the decorum of the subjects themselves – befitting Ezekiel as a public servant and Elizabeth as a *mater familias* – and in part by the reserved color scheme the artist employed. The latter is particularly noticeable in the *Ezekiel Goldthwait,* which depends more on subtle tonal harmonies than on brilliant hues; the dark tonality focuses attention on the face of the sitter, whose granitelike head is one of Copley's finest character studies. Concomitant with the

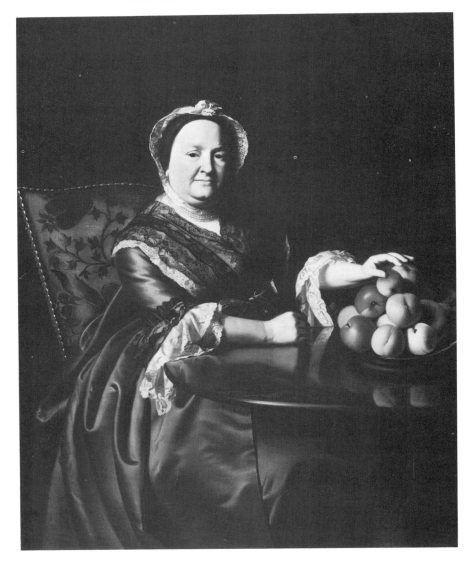

Figure 156. *Mrs. Ezekiel Goldthwait*, by John Singleton Copley, 1770–71. Oil on canvas, 50 × 40 inches. Museum of Fine Arts, Boston. Bequest of John T. Bowen in memory of Eliza M. Bowen.

tonal harmonies that dominate the two portraits is the bold handling of shadows, especially in the faces. Although the shaded areas may lack the light, airiness, and color found in a portrait by Gainsborough, they are extremely effective for the representation of real mass and form. Copley was seldom more skillful in his treatment of light and shade than in these Goldthwait portraits, and the result contributes greatly to their strength.

Finally, the faces of the Goldthwaits possess a conspicuous individualism; in them is a pragmatic devotion to reality rather than to an idealization of the fea-

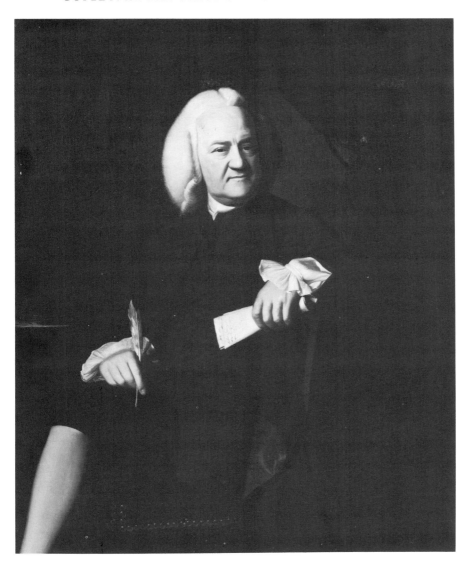

Figure 157. *Ezekiel Goldthwait*, by John Singleton Copley, 1770–71. Oil on canvas, 50 × 40 inches. Museum of Fine Arts, Boston. Bequest of John T. Bowen in memory of Eliza M. Bowen.

tures. Few would call Ezekiel a handsome man, or his wife a beautiful woman. Yet there is dignity and character in those faces, and therein their own handsomeness. Moreover, there is a self-confidence of the self-made who sit easily near the top of the social pyramid of their world. If placed among English portraits of members of the court or high aristocratic circles of contemporary London, such faces would probably have been considered, by Englishmen, coarse and unrefined of feature. But by 1771, the mercantile aristocracy of Boston had defined its own upper level of society and had formulated aesthetic criteria based on its own terms. By effecting its own valid aesthetic criteria and pro-

ducing an artist of Copley's caliber, colonial American portraiture attained its maturity, as the images of the Goldthwaits surely demonstrate.

Copley's portrait of Paul Revere (1735–1818) presents a visualization of the colonial American success story (Fig. 158).[4] Revere's father, Apollos Rivoire, had come to Massachusetts from France in 1716 and was apprenticed to John Coney, a leading silversmith of Boston. Paul learned that craft from his father, and after his father's death in 1754 he assisted his mother in running the family shop. While still in his twenties Revere had his own silversmith shop, to which John Singleton Copley came often in the 1760s; Revere's ledgers contain several entries after Copley's name such as "To a silver picture frame" or "a gold case for picture."[5] It was probably to pay off his accumulated debt that Copley painted Revere's portrait.

Copley and Revere had much in common: Born in Boston within three years of each other, both were sons of immigrants who entered colonial society at the "middling" level as a tradesman or craftsman; the fathers of both died while they were young and both entered the business of the family shop – for Copley, first the family tobacco shop and then his stepfather's studio; both catered to the growing desire for refinement among the affluent mercantile community; and both became successful, prominent figures through their artistry, eventually rising to the upper echelon of their society. The path up the social pyramid lay open even to persons of the trades and crafts if they lived according to the middle-class, Protestant code of virtues and if they prospered sufficiently at their calling to acquire that other requisite of social position, wealth and property.

Benjamin Franklin wrote on many occasions of the virtues of tradesmen and craftsmen such as Paul Revere, and also of the opportunities open to them in colonial America. To Europeans, he declared that "Labouring and Handicraft Men are the chief Strength and Support of a People," and added, "An idle man there is a character of disgrace."[6] Industry and frugality were, of course, the key virtues by which common tradesmen and craftsmen could become wealthy and gain an honorable place in their community. But if a person did succeed, it could only be with the blessing of God; therefore, a portrait of a man at work implied God's approval of honest, secular labor. This philosophy and religious doctrine had its origins, of course, in Calvinism and the rise of the middle class, but Franklin expressed similar sentiments, which again pertained directly to the hardworking, ambitious craftsman, and which reflected ideas inherent in Copley's portrait of Paul Revere. In his "Information for Those Who Would Remove to America," of 1782, Franklin wrote that:

> there is a continual Demand for more Artisans of all the necessary and useful kinds. . . . Tolerably good Workmen in any of those mechanic Arts are sure to find Employ[ment], and to be well paid for their Work, there being no Restraints preventing Strangers from exercising any Art they understand, nor any Permission necessary. If they are poor, they begin first as Servants or Journeymen; and if they are sober, industrious, and frugal, they soon become Masters, establish themselves in Business, marry, raise Families, and become respectable

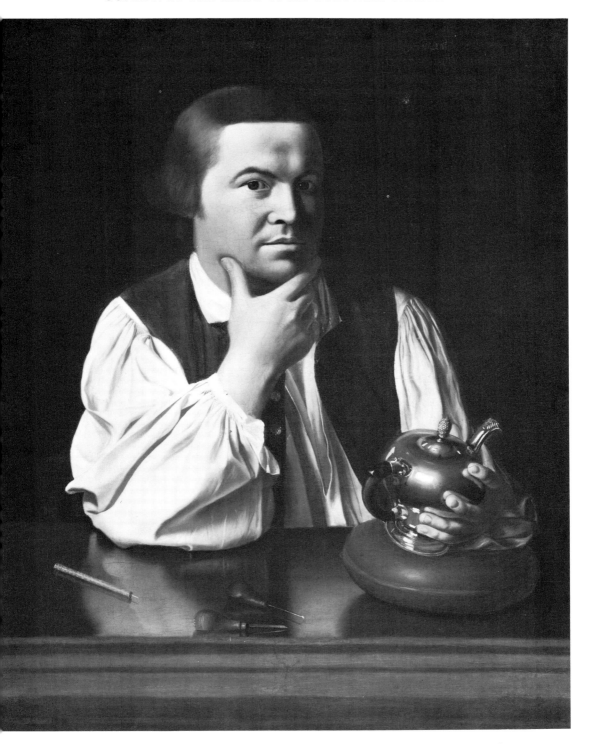

Figure 158. *Paul Revere*, by John Singleton Copley, 1768–70. Oil on canvas, 35 × 28½ inches. Museum of Fine Arts, Boston. Gift of Joseph W., William B., and Edward H. R. Revere.

Citizens. Also, Persons of moderate Fortunes and Capitals, who, having a number of Children to provide for, are desirous of bringing them up to Industry, and to secure Estates for their Posterity, have Opportunities of doing in America, which Europe does not afford. There they may be taught and practise profitable mechanic Arts, without incurring Disgrace on that Account, but on the contrary, acquiring Respect by such Abilities.[7]

The social philosophy expressed in the quotation by Franklin made it possible for Paul Revere to have his portrait painted at work at his craft and dressed in his work clothes, his own hair tied back, and wearing no wig. His profession was honorable, his product was useful to his community, and he was prospering through his industry and frugality; such a man had the respect of contemporary Bostonians, even of those who had attained the level of mercantile aristocracy, because many of their fathers, or they themselves, had commenced the rise to fortune as tradesmen, craftsmen, or shopkeepers. Nor was Boston the only colonial town where that element in society had its influence. In 1776 a Philadelphia newspaper asked, "Is not one half of the property in the city . . . owned by men who wear *Leather Aprons?* Does not the other half belong to men whose fathers or grandfathers wore *Leather Aprons?*"[8] The "Leather Apron" was the symbol of the tradesman or craftsman and was worn with no disgrace. In Revere's portrait, his work clothes, the graver's tools before him, and the beautifully crafted silver teapot in his left hand are all symbols of the respected work ethic; the tools and teapot, so proudly and prominently displayed, were the means by which the subject was making his way in society.

In Revere's face there is that spark of life which so animates portraits by Copley. In the alert eyes we again find that egalitarian feature, for eye contact is immediately established between the viewer and him who is portrayed. We are again welcomed into the presence of one of Copley's people, and admitted as an equal. But there is more than just eye contact between us, for Revere's gesture of thoughtfully rubbing his chin as he pauses at his work suggests that he is contemplating a reply to something we have said to him. There is clearly a feeling that discourse as well as eye contact is occurring, and by such means did Copley give life to painted images.

Finally, one cannot leave this portrait without recognizing one of the most brilliant passages of painterly virtuosity in all of colonial American portraiture – the section showing the left hand holding the teapot, a materialization of physical form in paint and canvas that is truly remarkable.[9] The materialistic instincts of Copley's patrons must have been well satisfied with an image like this, which combined the beautiful with objective reality. That, to mercantile tastes, was the core of such aesthetics as they comprehended.

Portraits such as those of Mrs. Boylston, the Smiths, the Goldthwaits, and Paul Revere embody the fundamental values and virtues of colonial New England society, which were based in two centuries of industry, prosperity, and moderation. Occasionally, however, some members of that middle-class mercantile aristocracy sought a grandiose image of themselves that exceeded moderation. When that happened, Copley faced a problem that he never solved successfully – at least, not as long has he was in Massachusetts.

Copley: Problems with Grandeur and Triumphs in Moderation

Moderation was normally one of the most powerful guiding forces among the people Copley painted. Their religion and their moral code had a relatively high threshold of toleration before ostentation was reached, and most were content to live within the boundary their society had established. Although the upper limit had remained flexible since Calvin's time, the prospering middle class had almost always set restrictions on itself to prevent it from falling victim to the signs of opulence, vanity, and wastefulness that plagued many of the European aristocracy. But occasionally the uppermost level of moderation was breached, and when this was recorded in one of Copley's portraits it usually resulted in a work that was less successful than when the code of the tribe had been honored. Too great a grandeur among a middle-class gentry became pretentious, somehow errant to the true societal values and mores, and, in portraiture, presumptuous – as if bourgeois aristocracy were trying to assume social equality with the aristocracy of the noble family lines of Europe. When Copley and his patrons committed this *faux pas*, the image did not ring as true as it did in such portraits as those of the Goldthwaits, the Smiths, Mrs. Boylston, or Paul Revere. Portraits by Copley that transgress beyond moderation in their imagery prove the strength of portraits in which the limits of moderation were respected. It is significant that Copley did not often attempt colonial portraits in "the grand manner," suggesting that even those who could afford them preferred his usual three-quarter length on a fifty-by-forty-inch canvas, and there are only six of the very large, full-length portraits with grand settings: *Nathaniel Sparhawk* (1764), *Thomas Hollis* (1766), *Thomas Hancock* (1764–66), *Jeremiah Lee* and *Mrs. Jeremiah Lee* (1769) and *Nicholas Boylston* (1773).[1] With the exception of the Englishman Hollis, all of these people ranked among the very wealthiest merchants of New England and, interestingly enough, all were Congregationalists.

Nathaniel Sparhawk (1715–76) was a merchant in Kittery, Maine (Fig. 159). In Copley's portrait the subject's plain, bourgeois facial features are encapsulated by an enormous, luxurious powdered wig of the peerage type, and he wears a bright red-orange velvet suit of exquisite tailoring. But the image seems at odds with the scale and the type of architectural setting. Sparhawk casually rests his left arm on the base of two colossal columns, while a grand

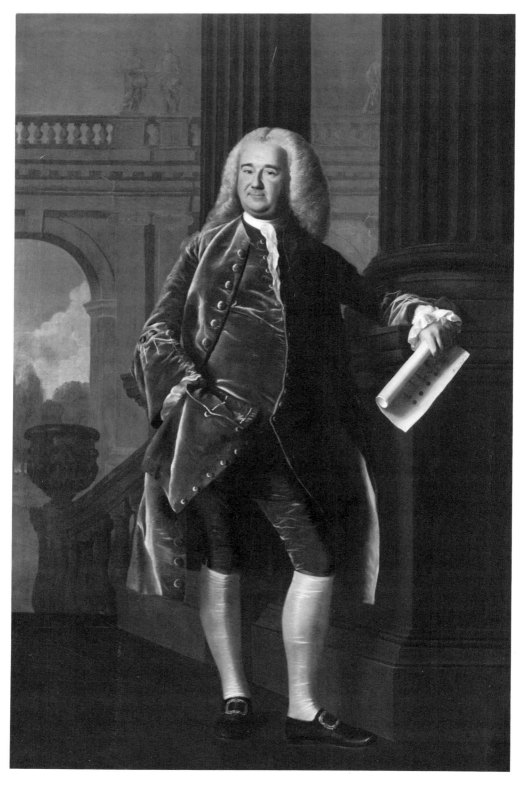

Figure 159. *Nathaniel Sparhawk*, by John Singleton Copley, 1764. Oil on canvas, 90 × 57½ inches. Museum of Fine Arts, Boston. Deposited by the Estate of Frederick H. Rindge.

staircase, complete with large decorative urn, trails off behind him; a large pilastered and balustrated archway, crowned with statues, stretches across the middle ground, and the setting seems more appropriate for a portrait of Lord Burlington than a Kittery merchant. This grand architectural setting is of a magnitude and sophistication such as had never been known in colonial New England, with the result that the subject does not appear to be properly at home amid his real surroundings, the way, say, Ezekiel Goldthwait or Isaac Smith do.

The *Sparhawk* was, as far as can be determined, like most of Copley's portraits, a private commission, yet it has some of the characteristics of an official "state" portrait. Here is the heroic vision of a man of noble deeds applied to a merchant, and it therefore seems presumptuous. Colonial New England – colonial America, for that matter – had had very little experience in creating a "state" type of image because there had been, before the Revolution, very few military heroes or men of high political stature; the race of merchants in the North seemed better represented in an intimate, family type of portrait, at which Copley was at his best. Before Copley's time, New England could claim only a few "state" portraits – Smibert's *Sir William Pepperrell* and *Sir Peter Warren*, and Feke's *Samuel Waldo*, all depicting heroes of the victory at Louisbourg. (Nathaniel Sparhawk, incidentally, was Pepperrell's brother-in-law and may have so admired the idea of a noble full-length portrait that he wanted one of himself.) But other than those three "hero" portraits, there was practically nothing of a tradition in "state" portraiture to guide Copley. So he in part employed his usual style but made the figure full length, and aggrandized the image by means of a noble and monumental architectural setting, borrowed from sources that were quite foreign to the real culture of the people he painted. The result strikes the viewer as a portrait of two separate parts. It was not for Copley to create a successful "state" portrait type for America, nor could Charles Willson Peale do much better, even in his full-length images of Washington; only after Gilbert Stuart returned to the United States in the 1790s would America at last have a successful "state" portrait idiom.

Thomas Hancock (1703–64), a merchant of enormous wealth, had endowed a professorship in Hebrew and Oriental languages at Harvard, and his nephew and benefactor, John Hancock, thought it only fitting that the deed be commemorated appropriately (Fig. 160). John's uncle Thomas had known Nathaniel Sparhawk when they both served on the Governor's Council, and both Hancocks probably knew of the large portrait that Copley painted of Sparhawk in the very year of Thomas Hancock's death. Furthermore, the *Thomas Hancock* is related to a grand-style portrait of another Harvard benefactor, Thomas Hollis, painted many years earlier by the English artist Joseph Highmore; in 1766, Copley painted a replacement for Highmore's *Hollis*, which had been consumed in the fire at the college two years earlier.[2] In the *Hollis*, Copley followed the magnificent architectural setting of the original and included an enormous urn with a bas-relief as well as a great swag of drapery. But in Copley's hands this mode sought grandeur through props and setting rather than through a truly noble image of the man himself, and that was the method Copley would employ until he reached England in 1775. The *Sparhawk, Hollis,*

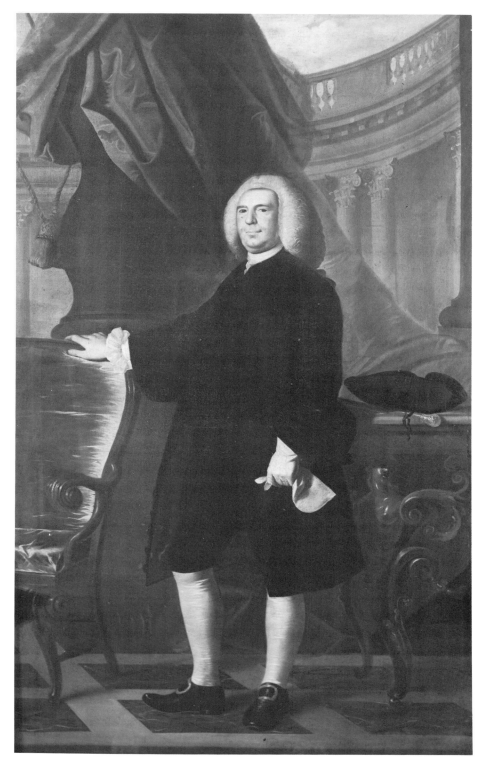

Figure 160. *Thomas Hancock*, by John Singleton Copley, 1764–66. Oil on canvas, 95⅝ × 59½ inches. Harvard University Portrait Collection, Cambridge, Mass.

and *Hancock*, then, all of 1764–66, must be seen as a group in which the artist was attempting to evolve a nobler type of portrait than he usually painted of a merchant.

Who was this man Thomas Hancock, of whom such an impressive portrait was painted not long after his death? He was a merchant above all else, and his story – including the building of his fine house on Beacon Hill – elucidates the type of person who most often sat for Copley's character studies.[3] The family line was established in the New World in 1634 when Nathaniel Hancock came over from the west of England and settled in Cambridge. His son, also called Nathaniel, had a son named John who, after graduating from Harvard in 1689, became a minister at Lexington. The Reverend John Hancock had two sons: John, who became the father of the patriot John Hancock, and Thomas, the merchant. Thomas Hancock was born at Lexington in 1703 and at the age of thirteen was apprenticed to a Boston bookseller. About 1726 he opened his own bookshop and five years later entered into a partnership with the prosperous stationer, book dealer, and publisher Daniel Henchman. He and Henchman, along with Benjamin Faneuil, began manufacturing paper, and the profits from this enterprise, along with a handsome dowry received when he married Henchman's daughter Lydia in 1730, made Hancock a wealthy man while still in his twenties.

Branching out from Bibles and books on religious and learned subjects, Hancock offered a variety of wares; most were imported from England but some came from Holland, Surinam, and elsewhere. Colorful calico, chintz, and damask fabrics; ribbons, laces, buckles, and fans; hourglasses, brass compasses, and swords; tea, rum, and Madeira; and anything else that would turn a profit, even if a little smuggling had to be engaged in to circumvent the Navigation Laws. His rapidly growing fortune was considerably augmented during the French and Indian Wars, when he was a major supplier for the military. Long before that, however, Thomas Hancock had begun to create a life-style for himself and his family that befitted a prosperous merchant. The main symbol of that life-style was, of course, the splendid house he built.

From the beginning the Hancock House was intended to be one of the domestic showplaces of New England.[4] In 1735, Hancock acquired a tract of land on the southern slope of Beacon Hill, well beyond the rim of the town; here was an early example of the wealthy escaping the congestion of the inner city, to build their estates in the suburbs. The house was erected in 1736–37, in the elegant Georgian style. The design of the two-story stone structure was probably taken from an architectural pattern book such as the one by James Gibbs, *A Book of Architecture* (1728), which was being imported into the colonies soon after its publication. The facade was symmetrical, with two windows on either side of a very elaborate doorway (preserved at the Bostonian Society) and one large window over it. There were double chimneys at each end, and the double-pitched gambrel roof had three pedimented dormers and a balustrade across the top. The corners and the windows had quoins of stone from a Connecticut quarry, and all of the glass came from England. Hancock spared no expense, importing carved stone capitals from England and much blue and white Delft tile, for the fireplaces, from Holland. From England also

he ordered wallpapers, some flocked, some decorated with a landscape that was evidently alive with "Different Sorts of Birds, Peacocks, Macoys, Squirrells, Monkeys, Fruit & Flowers."[5] The rooms were beautifully outfitted with rich draperies and carpets, furniture, mirrors, sconces, and silver. There were two large parlors, in one of which were hung the family portraits including the handsome likeness of a bright-eyed, energetic Thomas Hancock as a young man painted by Smibert in 1730.[6] In 1734, Smibert also painted portraits of Thomas's parents, the Reverend John and Mrs. Hancock, which also hung in his parlor, and these were joined in 1739 by Smibert's portrait of Thomas's friend, Christopher Kilby.[7] In 1736, Smibert also painted portraits of Hancock's father-in-law, Daniel Henchman, and his wife, but it is not known if these went into the Hancock or the Henchman house.[8] In time the family pictures were joined by a pair of pastel portraits by Copley of Thomas and Lydia Hancock, and a pair of miniatures of the same subjects,[9] and after Thomas's nephew inherited the house, Copley's portrait of John Hancock (Fig. 151) was placed over the fireplace.

The large, full-length memorial portrait of Thomas Hancock should be considered in relation to the background of the man and his activities just discussed: By profession he was a member of that leading force in colonial New England society, the mercantile establishment; he was enormously wealthy and as a member of the Governor's Council he was a civic leader; he was a public benefactor; and he was obviously aware of the importance of portraiture as a remembrance of family and friends. All of this, plus the size of the fortune that he inherited from his uncle, no doubt made John Hancock feel that the man deserved nothing less than a truly grand memorial portrait.

As the *Hancock* was commissioned posthumously, Copley used the bust-length pastel of about 1758 as his model for the face. But instead of the small wig of the pastel, the head in the large portrait is enveloped in one of great size and impressiveness, of a type that is identified in William Hogarth's satirical, nearly contemporary print, *The Five Orders of Perriwigs* (1761), as the "Old Peerian or Aldermanic" form, as seen in the second row of wigs (Fig. 161). The portly Hancock is given dignity by the black suit, and, as in the portrait of Sparhawk, the setting has been aggrandized beyond anything then known in New England. The marble floor is of a geometric pattern, virtually identical to that of the *Thomas Hollis*, and the furniture is of a lavishness that seems out of character for Boston in the 1760s. The great swag of drapery is a motif descended from high-style portraiture of the baroque era, and the monumental architecture of the background suggests more the great halls of England or the Continent than anything found in local edifices.

In the *Thomas Hancock*, the dichotomy between the figure, rendered in Copley's usual style, and the setting raises the question of what could have served as the artist's model. Nothing, other than the *Sparhawk*, in colonial portraiture up to that date was as grand, and Copley must have looked to portraits of the English peerage or to noble images from the Continent for inspiration. He may have known John Faber's mezzotint after John Vanderbank's *Sir William Lee* (1738), which employed a similar pose in full length, a great wig, an elaborate table very like the one in the *Hancock*, and an architectural setting; or he may have known of some other portrait, such as the

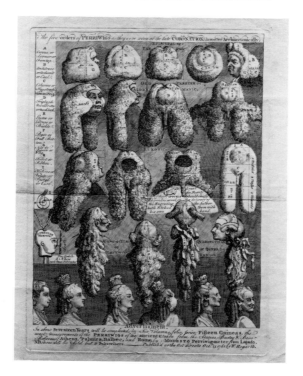

Figure 161. *The Five Orders of Perriwigs*, by William Hogarth, 1761. Engraving, 13½ × 14½ inches. The Henry Francis du Pont Winterthur Museum, Winterthur, Del.

William Shenstone by Edward Alcock, of 1760, which has the geometric marble floor, the huge swag, and an architectural background.[10] Both of these examples are by English artists, but an Italian source may ultimately lie behind them all; for example, Jacopo Amigoni, an Italian who worked in England in the 1730s, painted a stately portrait of Frederick, Prince of Wales, about 1735; the pose of Hancock is similar to that of the prince, as are many features of the setting.[11] Perhaps the most famous Italian portraitist of the era was Pompeo Batoni, who had specialized in painting the images of English nobility visiting Rome and who was a friend of several British artists; his *Portrait of a Young Nobleman* of the 1760s possesses many of the components that Copley used for his Hancock portrait and suggests that for grand, high-style portraiture both the British school and Copley were indebted to Italian masters such as Batoni (Fig. 162).

It is known that Copley had thoughts of travel and study in Italy in the mid–1760s, and that he was discontent with the usual kind of portraiture that he executed so well. The *Sparhawk* and the *Hancock* offered him an opportunity to experiment with what he considered a higher form of art; although such portraits were not history painting – the highest form of all – they were nevertheless a loftier genre of portraiture, and Copley was keenly aware that portraiture was the only type of art his patrons would support. The experiment was not entirely successful in the two full-length portraits, in large measure because of the dichotomy between Copley's standard style for the figure as

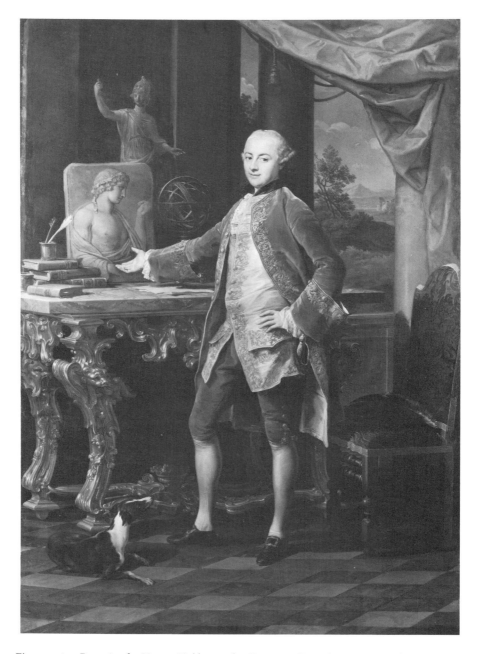

Figure 162. *Portrait of a Young Nobleman*, by Pompeo Batoni, c. 1760. Oil on canvas, 97⅛ × 69¼ inches. Metropolitan Museum of Art, New York. Rogers Fund, 1903.

opposed to the noble, grandiose, monumental, even heroic, character of the setting. That stylistic disunity was still more noticeable in the next full-length portraits he painted in the grand manner.

If the *Sparhawk* and the *Hancock* exceed the bounds of moderation and truthfulness, the portraits of Jeremiah Lee and his wife appear blatantly pre-

tentious (Figs. 163 and 164). Lee was a very prosperous merchant of Marblehead, Massachusetts, where in 1768–69 he built a splendid Georgian mansion that befitted his wealth an social position.[12] As the house, which cost £10,000 and was sumptuous in every respect, was nearing completion, Lee commissioned Copley to paint his and his wife's portraits, which were to hang either in the banquet room or at the landing of the grand stairway.[13]

If Copley's *Thomas Hancock* was a commemorative effigy, the Lee portraits celebrated mercantile wealth and high social position in a manner that can only be described as ostentatious. That is, they exceed that fine line drawn by colonial society between allowable prosperity and a conspicuous display of affluence that many would have equated with vanity, which was a sin. Cast in the mode of "state" or aristocratic portraits, the *Lees* commemorate nothing except unbridled middle-class love of wealth and material stuffs. Jeremiah Lee, richly attired in a suit decorated with gold buttons and gold brocade trim, and wearing a great white wig of the peerage form, has more the energy of a merchant than the poise of nobility, yet his portrait is clearly patterned after a noble prototype of the sort discussed in connection with the *Thomas Hancock*. The letter he holds is a reference to his business affairs, as are the papers and the silver inkstand nearby. Lee stands on a lavish Turkish carpet while a great swag of damask nearly conceals a segment of monumental architecture. The ornate marble-top table, with the gilded figure of a nude female torso worked into each leg, suggests more the furnishings of a French palace or at least a great English house.

Mrs. Lee wears a gold satin gown and a cape trimmed with ermine. In her skirt she carries an assortment of fruit such as Copley often included in portraits of women, but here the subject seems to be represented as a classical goddess – perhaps Pomona or Flora – similar to the manner that Allan Ramsay used to portray Catherine Paggen as Diana (Fig. 139). Several strands of pearls at her neck and more pearls in her hair complete her luxurious ensemble. She is shown in the act of ascending large stone steps while columns behind her again indicate architecture of a grand scale. The inclusion of small bits of monumental architecture in many of Copley's three-quarter-length portraits is unobtrusive and bearable; but here, it rises in importance and exudes pretentiousness. The dichotomy noted in the *Sparhawk* and the *Hancock* is amplified in the Lee portraits, for Copley again employed his usual style in the figures but then resorted to settings that were elaborate and out of character for New England mercantile society. The conflict is most obvious if the plain facial features of Mrs. Lee are contrasted with the grandeur of her setting, and the same may be noted in the image of Jeremiah Lee. In the faces, Copley remained true to elements of his art that had forged a vital, potent portrait style; but in the setting of grandeur he departed from his strength – from reality and from normal cultural restraints that dominated the lives of his mercantile clientele – and the result was less successful than in his portraits of, say, Mrs. Thomas Boylston, the Goldthwaits, or the Isaac Smiths. The Lee portraits are fascinating because both patron and artist reached for something that was actually beyond them. The old law of "Paint me as I am because what I am is good enough" had been breached, and Copley failed to achieve a viable monumental style in these images.

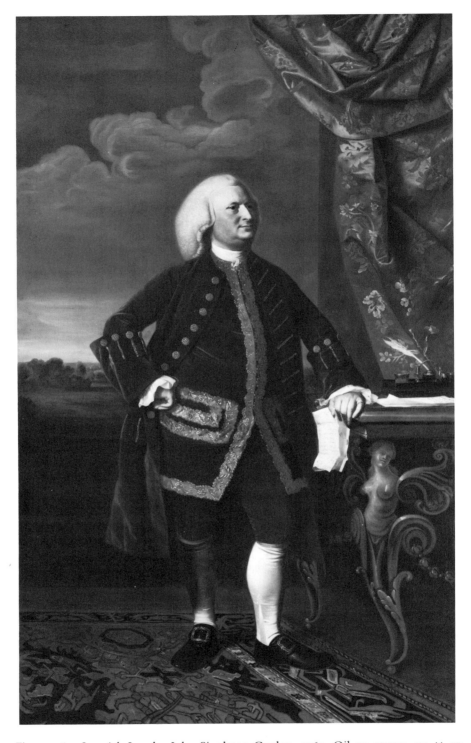

Figure 163. *Jeremiah Lee,* by John Singleton Copley, 1769. Oil on canvas, 95 × 59 inches. Wadsworth Atheneum, Hartford, Conn.

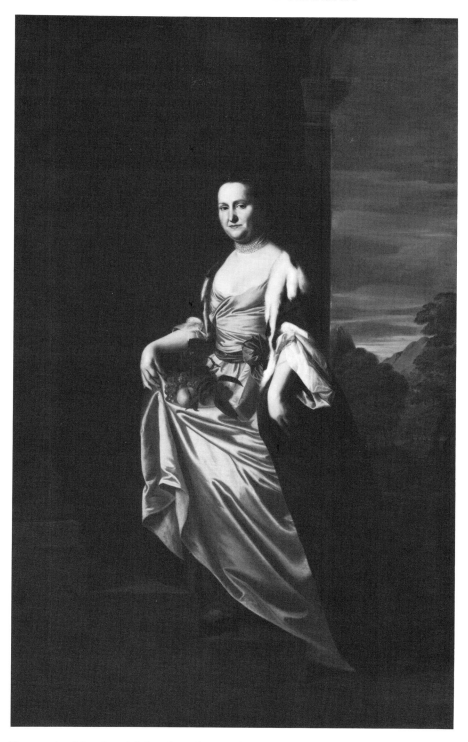

Figure 164. *Mrs. Jeremiah Lee*, by John Singleton Copley, 1769. Oil on canvas, 95 × 59 inches. Wadsworth Atheneum, Hartford, Conn.

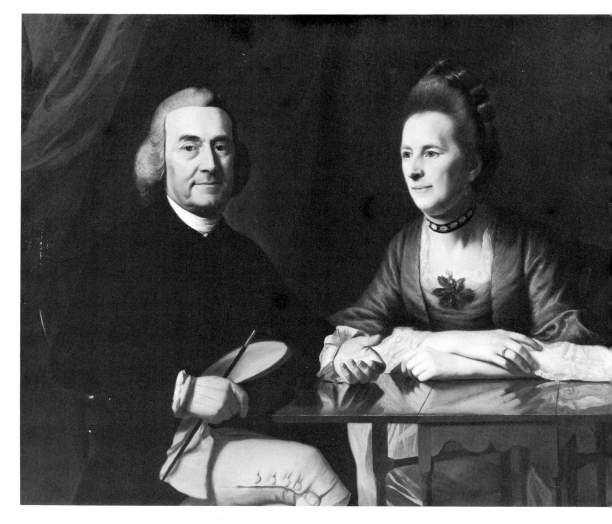

Figure 165. *Mr. and Mrs. Isaac Winslow*, by John Singleton Copley, 1774. Oil on canvas, 40¼ × 48¾ inches. Museum of Fine Arts, Boston. M. and M. Karolik Collection.

It is with aesthetic relief and pleasure that we return to a picture that, as social image, portrays the true character that was the foundation of the mercantile aristocracy of Boston – the *Mr. and Mrs. Isaac Winslow* (1774), the artist's masterpiece of his final year in Boston before departing for Europe (Fig. 165). Isaac Winslow, as noted in Chapter 23, was a descendant of one of New England's oldest families and was one of Boston's most successful merchants. His first wife, the one shown in Blackburn's portrait of 1755 (Fig. 140), was Lucy, daughter of Samuel Waldo; she died in 1768 and two years later he married Jemima (1732–90), daughter of Thomas Debuke of Boston, and it is Jemima who appears with him in Copley's splendid double portrait. Isaac's sister Elizabeth had married Richard Clarke, father of Copley's wife, so Isaac Winslow was Susanna Copley's uncle. The Winslows, like Copley's

father-in-law, were ardent Loyalists, and soon after the Revolution erupted they moved to Halifax, Nova Scotia.

In the Winslow portrait the faces are beautifully painted, in a way that captures incisively both the spark of life and the character of real people; the subjects, confident of their place in society and the sound principles on which that society was founded, felt no need to have the artist idealize their features or their surroundings. Copley has again made a virtue of plainness, given it a dignity, and integrated it with the snug and comfortable but not pretentious or ostentatious setting that seems appropriate and personal to the Winslows. The vibrant lifelike quality of the faces depends on the sheer physical reality that the artist achieved there as successfully as he did in representing the fabric of their clothes or the wood of the table; in all of this he relied on his eye, studiously observing the physical world immediately before him, and then concentrating on executing the essential character and qualities of those objects. Again, the resulting materialism of his imagery suited the taste of his patrons and reflected the materialistic strain that pervaded their society. Through eye contact with Isaac Winslow our presence is recognized and we are invited into his world; moreover, the casual gesture of his left hand is, in fact, a rhetorical gesture suggesting we are engaged in conversation, while his wife reflects upon what is being said.

Mrs. Winslow wears a lovely blue-gray gown with white lace at the sleeves and neckline; a strand of gemstones ornaments her neck, while a beautiful little nosegay of flowers decorates the front of her dress. Yet one would not call her attire sumptuous, luxurious, or ostentatious. Mr. Winslow is handsomely dressed in a black coat and cream-colored breeches, the beige being repeated in his gloves and lining of his hat. His attire, in its color scheme, is of a reserved simplicity, yet it bespeaks his prosperity.

One must also note in this portrait a characteristic that is constant in Copley's portraits of mercantile society, and that is one of decorum – poise, ease, confidence in one's self and of one's place, and a congenial reception extended to one's quest, the viewer. There is no attempt at social intimidation here, nor does any breach of the social code detract from the innate dignity of this mercantile aristocracy.

We cannot leave this portrait without noting some of its exquisite passages of painting. The heads of the sitters, although somewhat too large for the size of the bodies, dominate the picture and must surely be numbered among the best examples of colonial portraiture. One should not overlook the virtuosity with which Isaac Winslow's left hand is painted; the glistening surface of the warm mahogany wood, with the splendidly rendered reflections of hands and lace, is, like that found in *The Boy with a Squirrel*, a tour de force of painting. And the little nosegay at Jemima Winslow's breast is a beautiful thing for the eye to behold.

Reality, essential character, and beauty; materialism, individualism, and egalitarianism; pride, prosperity, and poise; decorum, congeniality, and self-confidence; full approbation of the moral and social code by which the subjects live – these are the elements wrought into Copley's portraits at their best. In the 1760s and early 1770s, Copley developed a style of painting that perfectly

expressed the fundamental characteristics of the society he painted. That happy union accounts in large measure for the strength of his art.

Nevertheless, John Singleton Copley, as we have seen earlier, was not entirely content painting pictures such as that of the Winslows. In provincial Boston amid his clientele's restricted knowledge of art, he felt his art was stultified and his talent not fully challenged. Thus, he finally decided to make his move, setting off in 1774 for a year in Italy before settling permanently in England. His work after his departure is beyond the scope of the present study, but consideration of two portraits from his early years in Europe will further clarify the essential character of his New England style. It is unnecessary to argue that his American portraits are better than the ones painted in Europe, or vice versa; they are only different from one another, and they must all be judged by the aesthetic and cultural criteria that governed them. But different they surely are, and to see this, one need only compare the *Winslow* with the *Mr. and Mrs. Ralph Izard*, which was painted in Italy in 1774 (Fig. 166). Having resolved to rid himself of his provincial style – that, after all, was the purpose of his trip – Copley consciously set about seeking some other means of artistic expression once he was in Italy. But the style of the *Izard* is not basically different from Copley's colonial style, for in the means of painting – the brushstroke, the precise objectivity, the use of color, the rendering of light and shade, and so on – the style has changed very little. It is only in the grandeur of the setting and in the nature of the props that the change occurs. If one compares the ornate table in the *Izard* with the simple table of the *Winslow*, or the ornate swag of the upper right of the Italian picture with the simple drape behind the Boston merchant, the change becomes obvious. The Izards, whom Copley met in Italy, were from South Carolina and were making a grand tour. They and Copley visited Naples and Paestum together to see the Greek temples; they inspected the antiquities of Rome in each other's company, and all in all discovered a rich cosmopolitan life that reached well beyond the provincial limitations of their homeland. To commemorate all this, Copley filled the canvas around the Izards with objects that reflected this increased cultivation – the ancient Greek vase in the upper left, a fifth-century B.C. work by the Niobid Painter; the Roman Colosseum on the distant horizon; and the Hellenistic stature of *Orestes and Electra*, which was then in the Villa Ludovisi in Rome (now at the National Museum, Rome). Copley's Izard portrait, therefore, differs from his colonial portraits by the increased sumptuousness of the objects and cultural milieu, but stylistically, especially in the way he painted the two figures themselves, little has changed. In point of style, the figure of Ralph Izard is not unlike that of John Hancock (Fig. 151).

Although the *Izard* does not represent the new mode he left home to find, Copley did discover and master the new style very soon after reaching England in 1775. His wife, children, and father-in-law left Boston to join him there, and he began work at once on a large group portrait, *The Copley Family* (Fig. 167). This was to be a demonstration piece, to show the extent of his talents to the London art world of painters and patrons. Considering its size, complexity, and number of figures, it was completed in an incredibly short time, especially in view of the slow pace of working for which he was well known

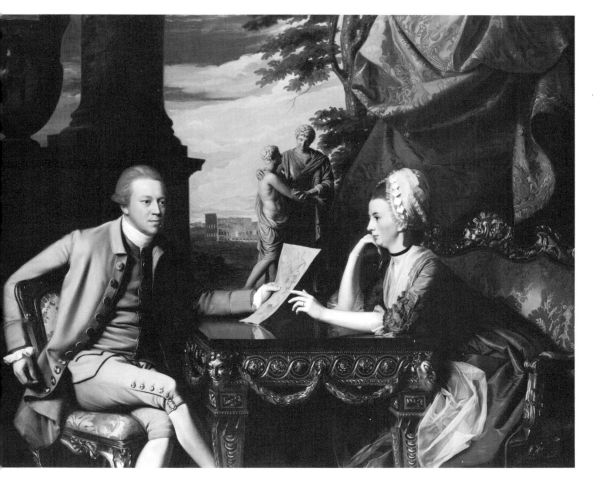

Figure 166. *Mr. and Mrs. Ralph Izard*, by John Singleton Copley, 1775. Oil on canvas, 69 × 88½ inches. Museum of Fine Arts, Boston. Edward Ingersoll Browne Fund.

both before and after. Represented, from the left, are Copley himself standing behind his father-in-law, who holds little Susanna on his lap; Elizabeth Clarke Copley stands in the center while her brother, John Singleton Copley, Jr., the future Lord Lyndhurst and lord chancellor of England, puts his arm around his mother's neck; Mary Copley is the child at the far right. *The Copley Family* was shown at the annual exhibition of the Royal Academy in 1777, where it established the artist's reputation and placed him among the leading portrait painters at the center of the British Empire.

In this family portrait, Copley shed the tight, linear, objective definition of the physical, material world that had been the strength of his colonial portraits, and rendered form, textures, light, color, and atmosphere in a fluid, sophisticated, richly painterly way. The brushstroke, barely discernible in New England portraits, becomes a part of the aesthetics of this new style, and the dark shadows – which gave such solidity to the form of his earlier work, as

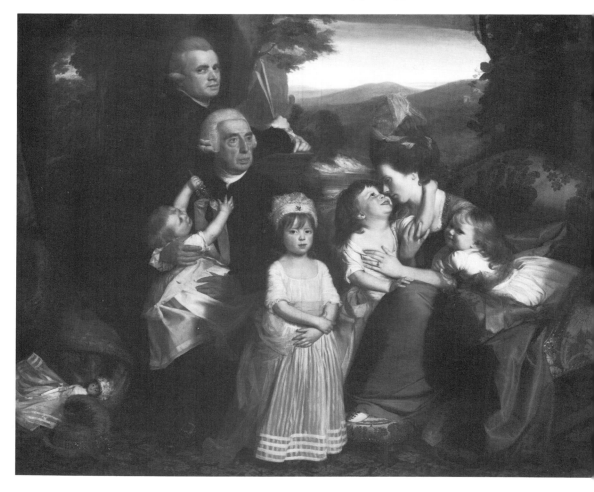

Figure 167. *The Copley Family*, by John Singleton Copley, 1776–77. Oil on canvas, 72½ × 90⅜ inches. National Gallery of Art, Washington, D.C. Andrew W. Mellon Fund, 1961.

in figures 156 and 157 – are purged in favor of light, color, and air. Here was a style that satisfied the sophisticated palates of Londoners who had become accustomed to the splendid painterly effects of Sir Joshua Reynolds, Thomas Gainsborough, George Romney, and the whole brilliant school of English portraitists. In the *Family Portrait*, Copley demonstrated that he had immediately mastered the painterly manner of the London school and, equally important, had correctly interpreted the taste and cultural ambience of his new clientele. Whereas in his earlier career he had tuned his style to the mercantile aristocracy of Boston, he now played to the tastes of the true aristocracy of England. In each of the two halves of his career he proved himself a master at capturing those social and cultural elements at the heart and core of his patrons' existence.

Painting in the South
after 1740

In the South the three areas where artists found a demand for their talents were South Carolina, Virginia, and Maryland. In Carolina, patronage was sufficient to allow a painter, Jeremiah Theus, to establish himself permanently; Virginia, however, relied on the visits of itinerate artists such as John Wollaston or John Hesselius. South Carolina possessed an urban center in Charleston and Annapolis became the hub of life in the upper Chesapeake region; but Virginia never developed a comparable town, for Williamsburg was mainly a governmental center, being neither a commercial center nor a seaport. The three areas had a common economic order in the plantation system, which established a social order that bred a colonial aristocracy closer to the true aristocracy and gentry of England than was the mercantile aristocracy of the northern colonies, which tended to take the London merchants as role models. It was during this period – from the 1730s to the Revolution – that plantation society reached its full flower both in affluence and in the realization of its own special culture.[1]

Although the great planter families represented only a small portion of the total population, it was their wealth and their desire to achieve a refined way of life that most affected the evolution of portraiture south of Philadelphia. Perhaps because of their exceptionally close connections with England, southerners were more inclined toward the class-type of portrait than toward the highly individualistic character studies that Copley painted.

The early history of South Carolina has been recounted in Chapter 17. By 1729 the transition had been completed from proprietary rule to royal colony, but the concept of a landed aristocracy had survived. South Carolina existed in two parts that were frequently joined: on the individual plantations along the lower reaches of the Ashley and Cooper rivers or their tributaries, and in Charleston. Increasingly, Charleston became the most glittering, brilliant, fun-loving, pleasure-indulging, sophisticated, and cosmopolitan town in the South, and the wealthy planters spent long months of each year there, from May to October or November, to escape the malaria-carrying mosquitos that infested the marshes of their rice plantations.[2] It was a bustling seaport from which rice and, after 1747, indigo – the colony's money crops – were exported, and through which innumerable imported goods passed on their way to the great plantations. The center of mercantile life for the colony, the seat of government

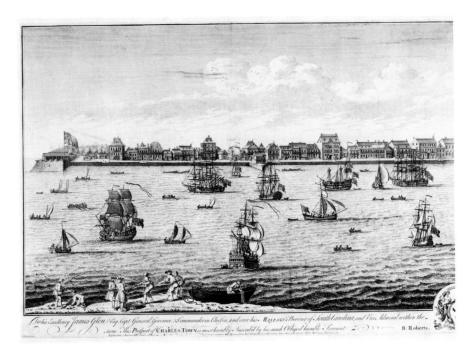

Figure 168. *View of Charleston, South Carolina*, drawn by Bishop Roberts, engraved by W. H. Toms, 1739. Engraving, 19½ × 55 inches. The Henry Francis du Pont Winterthur Museum, Winterthur, Del. [See text, p. 357.]

where the governor resided and his council and the Assembly met, Charleston was also the primary slave market, the center for the trades and crafts, and the rich bazaar that catered to the needs and whims of an expanding population. In 1743 there were about 6,800 residents; only about one-third of them were whites, most of whom were tradesmen or other members of the "middling" and "lower sorts"; but for about six months of each year the population swelled greatly as the planters, their families, and their retinues moved into their fine town houses for the season.

In Charleston the planters joined the congenial gatherings of gentlemen who met at the several taverns as members of the various social clubs – the closest thing to London club life that any colonial town had produced – or they attended horse races and cockfights, which were spiced by rampant wagering, and they gambled at cards or other games of chance to a degree that would have made a visiting New Englander pray for their souls.[3] By day, planter society visited the shops of the peruke maker, the goldsmith, the tailor or seamstress, and by night attended the musical concerts or the frequent balls where, dressed in their fashionable finery, they danced the minuet by candlelight. Charleston was an emporium, as the following advertisement from the *South Carolina Gazette* of November 17, 1740, reveals, and many of the items mentioned appear in the portraits:

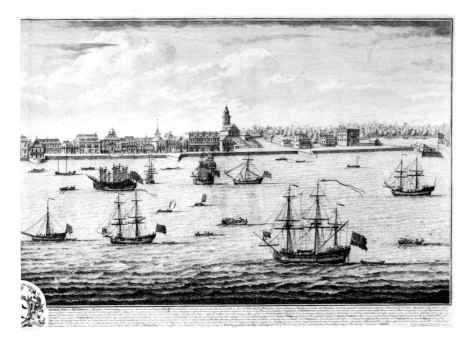

[Just arrived] in the Minerva from London and to be sold by William Stone... a great variety of European and India Goods, viz, rich Brocade, English and India damasks, Ducapes, padusoys and tabbies, Callimantoes, worsted damasks and Camblets, shoes, hose, Gloves and Hatts of all sorts, hoopes, stays, scarlet Cloaks and Manteelets, Genoa's and other Velvet quilted baskets, black snale and Lace, variety of English, Brussels and Flanders Lace, Gold and Silver Watches, and Plate, Glass, China and Earthen Ware, white and colored callicoes and fine chintz, ... fine green and Bohea Tea, Spices and Sago, all sorts of Linnen, Drapery, Cutlary, haberdashery, pewter and ... sundry other goods, which will be sold cheap.

In the 1740s a man named John Paul Grimke operated a Tiffany-type establishment for the pleasure of Carolina's wealthy class, selling diamonds, emeralds, garnets, sapphires, amethysts, topazes and amber; rings, earrings, watches and jeweled shoe buckles; silver coffee and tea services and silver spoons; snuffboxes, and a great variety of other such wares, all imported. Even Governor James Glen expressed concern in 1749 over the hedonism of Carolinians, reporting to the Board of Trade in London that "Plenty is the parent of luxury, and it will perhaps surprize your Lordships to be informed

there is annually imported considerable quantity of fine laces of Flanders, the finest Dutch linnens, and French cambricks, chintz, Hyson teas, and other East India goods, silks, gold and silver laces, etc."[4]

But if planters and merchants pursued their pleasures avidly, they also had their commitments to more serious matters. The colony was a mixture of religious sects – Presbyterians, Baptists, Huguenots, Methodists, Congregationalists, and a few Catholics and Jews – but the ruling class was predominantly Anglican. The governor was, of course, Church of England, and Episcopalians controlled the Governor's Council as well as the Assembly. When the latter established a public school in Charleston, it specified that the schoolmaster had to be Anglican, and the children who attended were thereby indoctrinated into Episcopal beliefs. Moreover, the Anglican church and planter society were well suited to each other.[5] Southern Anglicans were devout and took their religion seriously, but they saw no contradiction between a gentleman's piety and the enjoyment of worldly pleasures and goods. Their religion sanctioned the aristocratic life that upper-class Carolinians were determined to lead, as close to the manner of English gentry as they could make it. Plantation libraries contained books on religion, but these were read more in the hope of mastering a gentleman's moral code than in the expectation of discovering the mystical inner light of revelation or spiritual salvation. Religion, far from condemning worldly success, emphasized that it was a person's duty to act on the gifts of God and to be responsible insofar as family, colony, business, and the less fortunate were concerned – matters discussed in Richard Allestree's *The Whole Duty of Man*, which was still widely read as a guide to being a Christian gentleman. The publisher of the *South Carolina Gazette* in the 1730s and 1740s regularly advertised two books for sale: Allestree's *The Whole Duty of Man* and Benjamin Franklin's *Poor Richard's Almanack*. Next to the Bible, these were probably two of the most read books in the colony.

According to the *South Carolina Gazette* of August 15, 1745, a gentleman had to be familiar with the Greek and Latin authors and have "an extensive Knowledge of Men and Things; Judgment; Wit; Vivacity, good Nature [and] a strong Desire to please." His acquaintance with the classics was not to be that of the scholar, but was rather to inform him of moral truths and civic virtues. A code of good manners was adhered to reverently, although with ease and grace, for "Lack of manners, taste and cultivation put one definitely outside the pale of Charleston society."[6] Artists recognized that "wit, vivacity, good nature [and] a strong desire to please" were respected virtues among their patrons, and accordingly imbued the portraits with those qualities.

Cultivation of good taste included a knowledge and patronage of the arts. Charleston's first dramatic season began in 1735 with a performance of Otway's *The Orphan*, followed the next year by Lillo's *The London Merchant* and Addison's *Cato*. The first known performance of an opera in America occurred in Charleston in 1735 – *Flora, or Hob in the Well*. South Carolinians enjoyed reading Pope, Addison, Swift, and Gay, and copies of *The Spectator*, and *The Tatler*, and *The Guardian* were readily available in the numerous bookshops. Robert Wells, a bookseller, advertised in the *South Carolina Gazette* that he had "sundry books on Architecture" for sale, including Leoni's edition of Alberti's *Ten Books on Architecture* and "Langley's designs of architecture."

The architectural books with their voluminous handsome plates had been invaluable as the planters and merchants began to erect houses and other buildings that bespoke the rising level of refinement of their society. The Anglican churches of St. Philip's of the 1720s and St. Michael's of the 1750s were Georgian high style in design. An exquisite example of the beautiful Georgian plantation house is found in Drayton Hall (1738–42), while in Charleston the Miles Brewton House (1765–69) demonstrates the elegance of mercantile society at its finest hour.[7] These and other such houses were filled with elegant furniture, silver, fabrics, and other splendid objects, much of which was imported from England and elsewhere. By the 1730s and 1740s conditions were ripe for the blossoming of the art of painting, which meant, of course, mainly portraiture, of a type that reflected the genteel life-style of Carolina's provincial aristocracy.

Henrietta Johnston, whose little pastel portraits of the early eighteenth century have already been discussed, died in 1729, but by May 17, 1735, Bishop Roberts was already advertising in the *South Carolina Gazette* that he did "Portrait-painting and Engraving, Heraldry and House Painting." Little is known of Roberts as a portraitist or whether he worked in oils or pastels, and he is best remembered for his watercolor *View of Charlestown, South Carolina,* which was engraved by W. H. Toms in 1739 (Fig. 168). On July 16, 1737, Carolinians were informed that "Gentlemen may be supplied with Land Scapes for Chimney Pieces of all sizes; likewise Draughts of their Houses in Colours or India Ink, by B. Roberts."[8] Although Roberts died in 1739, his wife advertised in the *Gazette,* "Face painting well performed by the said Mrs. Roberts, who has several pictures and a Printing Press to dispose of."[9] Another woman, Madame Peter Precour, gave notice in 1733 that she painted fans and gave drawing lessons.[10]

However, the name most associated with painting in colonial South Carolina is that of Jeremiah Theus, portraitist to the planter and merchant aristocracy for more than thirty-four years. Theus arrived in Carolina in 1736 at about the age of seventeen, accompanying his Swiss émigré family who settled upriver in Orangeburgh.[11] Nothing is known of his early training, if he had any, but by 1740 he had established himself in Charleston, as an ad in the *Gazette* informs us:

> Notice is hereby given that Jeremiah Theus, Limner, is remov'd into the Market Square . . . where all Gentlemen and Ladies may have their Pictures drawn, likewise Landscapes of all sizes, Crests and Coats of Arms for Coaches or Chaises. Likewise for the conveniency of those who live in the Country, he is willing to wait on them at their respective Plantations.[12]

Theus's portraits are not penetrating studies of individual character but belong instead to the class type of portrait in which the individual is sacrificed to an ideal. But they have a wonderful charm, are highly animated, possess a lovely coloration, and express that peculiar combination of materialism, sensuous pleasures, and dedication to aristocratic refinement that appealed to his patrons.

The curious union of the real and the ideal is seen in Theus's *Elizabeth Wragg Manigault* of 1757 (Fig. 169). Elizabeth's father, Joseph Wragg, had come to

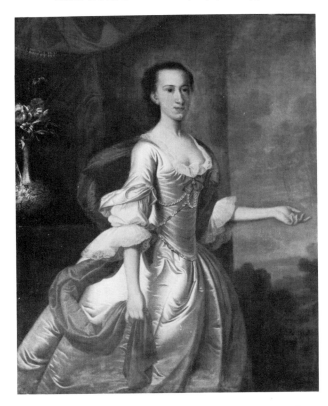

Figure 169. *Elizabeth Wragg Manigault*, by Jeremiah Theus, 1757. Oil on canvas, 50 × 40 inches. Charleston Museum, Charleston, S.C. Gift of Victor A. Morawetz.

Carolina from England in 1710 and established himself as a merchant in Charleston, where he prospered greatly, maintaining business connections with his English uncle, William Wragg. He became a leading citizen, served on the Governor's Council, and married into one of the foremost Huguenot families of the town. Remembering the ways of the gentry in England, he sought to emulate them through a refined life-style. His library contained more than two hundred volumes in the areas of law, history, gardening, architecture, and travel; he owned the writings of John Locke and works by Shakespeare, Dryden, Pope, Addison, and Fielding. In 1755 his daughter Elizabeth (b. 1736) married one of the richest merchants of Charleston, and his library, too, is an indication of a quest for culture, for it contained "the most celebrated authors on Law, Physic, Divinity, Philosophy, History, the Arts and Sciences [and] a pretty good Collection of the Classics."[13] Peter Manigault was of a distinguished Huguenot family, the son of Gabriel and Ann Ashby Manigault, whose portraits by Theus, also of 1757, are in the Metropolitan Museum of Art.[14] Gabriel, one of the wealthiest merchants and plantation owners of Charleston, sent his only son and heir, Peter, to England to be educated and study law at the Inns of Court. In addition to his mercantile activities Peter Manigault took an active interest in civic affairs, serving as speaker of the South Carolina Commons House of Assembly.

While he was in England, Peter Manigault had his portrait painted by Allan Ramsay, then the foremost portraitist of England. In 1751 he wrote from London to tell his parents about his portrait, which he had sent home:

> Tis done by one of the best Hands in England & is accounted by all Judges here, not only an Exceedingly good likeness, but a very good Piece of Painting. . . . I desire Mr. Theus may see it. . . . I'll be extremely obliged to you, if you'll let me know his Judgment; You'll also tell me if you think any Part of it too gay.[15]

He then described the flowers in the lace of his hat, the ruffles, and other details, indicating he knew that it was a fancy piece.

The portrait of Peter Manigault's wife was painted as a pendant to his own, and in it Theus attempted to capture all of the vivacity and enjoyment of refinement and material pleasures that were discussed in the earlier part of this chapter. The relationship to English portraiture is seen if Theus's work is compared to Allan Ramsay's *Catherine Paggen as Diana* of 1739 (Fig. 139); Theus has even tried to add liveliness to an otherwise rigid figure by having Elizabeth Manigault's blue shawl billow behind her, just as in the Ramsay picture. The ice-blue satin gown with its laces and strands of pearls is quite fashionable, indeed as fashionable as any worn by the subject's peers in London, Bristol, or Bath, and it is on the beauty of the fabric, the stylish gown with its rich trim, and the lovely still life at the left that the portrait relies most for its aesthetic values. Social position is expressed by the lavish stuffs that surround or adorn the subject, but a penetrating character analysis in the face is lacking. Theus, like Blackburn and Wollaston, usually created faces that are vacuous, failing to achieve an image of a real, living and thinking being. He was also incapable of obtaining a unity between the face and the rest of the picture, for while everything else in the portrait suggests elegance and a refined beauty, the facial features are almost painfully plain. His patrons evidently insisted on an honest, straightforward likeness but accepted the pleasant vacuousness found in almost every Theus portrait; their love of finery, their lifestyle, and, most importantly, their aristocratic social position was to be expressed through stuffs and objects – no matter that an artistic dichotomy existed between the richness of the objects and the plainness of the face.

The pose of Elizabeth Wragg Manigault is contrived, probably in imitation of a mezzotint, and rigid; the rigidity may well have been caused by the current fashion of inserting a piece of metal in the stomacher, which forced an erect stiffness of the torso. Horace Walpole scoffed at this concession to vanity of wearing "a steel busk down their middle, and a rail of the same metal across their breasts."[16]

Theus's portraits of Colonel Barnard Elliott, Jr. (Fig. 171), and his wife (Fig. 170) are also images of Carolina planter aristocracy. When his father died in 1758, Barnard, Jr. (1740–78), inherited his large and prosperous plantation called Horse Savannah; young Elliott also became master of Bellevue plantation, where he built in the woods a sylvan temple with eight white columns to use as a hunting lodge. A couple of years before Theus painted his portrait, Elliott was in London and while there took an interest in art, especially in hunting scenes. He scoured print shops for engravings to send his brother-in-

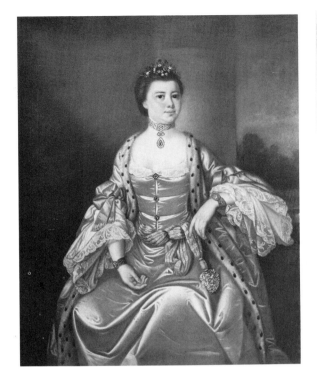 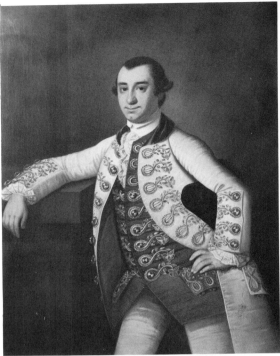

Figure 170. *Mrs. Barnard Elliott*, by Jeremiah Theus, c. 1766. Oil on canvas, 50 × 40¼ inches. Carolina Art Association, Gibbes Art Gallery, Charleston, S.C. Gift of Mrs. Alexina J. C. Holmes.

Figure 171. *Colonel Barnard Elliott*, by Jeremiah Theus, c. 1766. Oil on canvas, 50¾ × 40¼ inches. Carolina Art Association, Gibbes Art Gallery, Charleston, S.C. Gift of Mrs. Alexina J. C. Holmes.

law, Richard Bohun Baker, to whom he wrote in 1764 saying he yearned to see how well the landscape prints

> adorn your Hunting Hall at Bearfield. . . . Had I but fifty guineas to spend I would bring over such a collection of Hunting Pieces etc. as would charm you beyond everything, but they are painted in oil, and are too dear for me. . . . Some fine historical pieces [are] valued at five hundred guineas, . . . for they are beyond description fine.[17]

Back in Carolina, his education in art being greatly improved, Elliott took his place among the highest echelon of provincial society. He was a close friend of the royal governor, Lord Charles Grenville Montagu, and in 1766 he married Elizabeth Bellinger Elliott (d. 1774), his cousin, who, as the granddaughter of the second Landgrave Edmund Bellinger, belonged to one of the wealthiest plantation families of the colony.[18]

The portraits of the Elliotts were probably painted about the time of their wedding. They impress the viewer, first by the splendor of the garments, and second by the plainness of the faces, which again reveal no insight into the subjects' real personalities and which are in marked contrast to the elegance of the attire. It would be difficult to imagine a colonial coat and waistcoat

more elaborate than those worn by Elliott, or a colonial portrait in which the lavish decoration is emphasized to the degree it is here. Mrs. Elliott, with her numerous jewels, cascading effusion of lace, satin, and ribbons, and the ermine trim on her matching shawl, is represented in a manner reminiscent of Queen Caroline or Queen Charlotte herself, as Allan Ramsay or Benjamin West portrayed them. The portraits of the Elliotts clearly reveal that Carolinians tolerated a higher level of worldly pleasures before ostentation was reached than did contemporary New Englanders. This very point is discussed by Bowes, who quotes comments made by Josiah Quincy when he visited Charleston in 1773; Bowes writes:

> Visitors to the city invariably commented on the luxury, taste for finery and expensive pleasures of its best people. Josiah Quincy was shocked by the "state, magnificence and ostentation" of Charlestonians. "Cards, dice, the bottle and horses engross prodigious portions of time and attention: the gentlemen (planters and merchants) are mostly men of turf and gamesters." Wealth to them was a means of procuring comforts and pleasures, an attitude a New Englander like Quincy might deplore but one which an English aristocrat assumed as a matter of course.[19]

Theus's patrons were evidently pleased with the way the artist portrayed them and with what he said of their life-style through his images. A catalogue of his subjects is a "Who's Who" of Carolina society that includes members of nearly every prominent family of the era. Theus lived well from the painting of portraits and amassed a considerable estate by the time of his death in 1774.

During Theus's tenure as portrait painter to Carolina aristocracy, awareness of the art of portraiture blossomed and several artists were lured to Charleston by the promising market. John Wollaston was there by 1765, mingling with society and taking many likenesses – again without much characterization but charming in their idealizing mannerisms and lavish costumes.[20] Wollaston left in 1767 to return to England, and that same year Lewis Turtaz from Lausanne, Switzerland, gave notice in the *South Carolina Gazette* (March 23, 1767) that he would paint "Ladies and Gentlemen's Pictures in Miniature, at the moderate rate of twenty pounds for a head and bust," waiting upon his patrons at their plantations if they lived in the country. The next year Abraham Delanoy arrived from New York, but he did not stay long. Cosmo Alexander's visit in 1772 was equally brief, but in that same year Henry Benbridge established his studio in Charleston after several years of study in England and Italy, and took over the position of leading portraitist from the aging Theus, who died two years later.[21]

Added to the likenesses that were taken locally were a number of portraits painted while South Carolinians traveled abroad – especially to Italy and England – for many of them were seeking the cosmopolitan and sophisticated life of London or Rome. We have already noted Copley's portrait of Mr. and Mrs. Ralph Izard (Fig. 166). A descendant of one of the earliest immigrants to South Carolina, Ralph Izard (1742–1804) was born at the family plantation, The Elms, on Goose Creek, where rice and indigo made his father one of the wealthiest men in the colony. Young Ralph was sent to England for his

education. He returned home in 1764, an English gentleman, ready to be the master of the large estate he inherited. Three years later he married Alice De Lancey, niece of James De Lancey, former chief justice of New York. But Izard had developed a taste for the cosmopolitan life, and in 1771 he and his wife sailed for London, where they maintained a fine house and indulged their interests in literature, music, and art. Ralph's likeness was twice taken, once by Benjamin West and again by John Zoffany, while Alice's portrait was painted by Thomas Gainsborough. During their grand tour of the Continent in 1774 they met Copley in Italy and had their portrait painted amid a splendid assemblage of celebrated works of art reflecting more cosmopolitan than provincial tastes. With the outbreak of the Revolution the Izards removed from London to Paris, but they eventually returned to live in their house in Charleston, where their presence and their portrait collection stimulated an interest in the art of painting.

Arthur Middleton (1742–87) possessed a similar passion for art and for the cultivated life of London, which he helped transplant to Carolina. Born at the family plantation, Middleton Place, he was sent to England to attend Westminster School; he then enrolled at St. John's College, Cambridge, before studying law at the Inner Temple in London. He returned home in 1763 to marry Mary Izard, daughter of Walter Izard of Cedar Grove. By 1768 the Middletons had established their residence in London, although they, too, traveled about on the Continent. In London, Benjamin West painted their portrait, which included their infant son, Henry (Fig. 172). The picture, painted in 1770, is rich in objects that suggest the life-style of the subjects, and the image reflects a familiarity with Italian Renaissance masterpieces depicting the Holy Family. The Middletons returned to Middleton Place in 1771 and the portrait established a new standard for portraiture among the planter aristocracy.

Middleton and Benjamin Rush were both members of the Continental Congress in Philadelphia when Rush penned the following impression of the South Carolinian: "He read Horace and other classicks during his recess from Congress. . . . He disliked business, and when put upon the Committee of Accounts he refused to serve and gave as a reason for it that 'he hated accounts, that he did not even keep his own accounts, and that he knew nothing about them.' "[22] It would be difficult to imagine a New England merchant making such a comment about keeping his accounts, but then Arthur Middleton was more interested in genteel culture than in pragmatic business affairs. Benjamin West also painted, about 1770, a handsome image of Arthur's brother, Thomas Middleton, who after finishing his education in England returned to South Carolina to marry Anne, daughter of Peter and Elizabeth Manigault; that portrait is owned by the Carolina Art Association in Charleston. Miles Brewton was in England in 1775 and sat for his portrait to Sir Joshua Reynolds, president of the Royal Academy. These and other portraits painted abroad provide evidence of the cosmopolitanism of Carolina aristocracy as well as its fascination with art.

In Virginia, the Byrds, Carters, Randolphs, Lees, Harrisons, Custises, Fitzhughs, and other first families continued their forefathers' tradition of commissioning family icons, but as the population was so sparsely scattered because

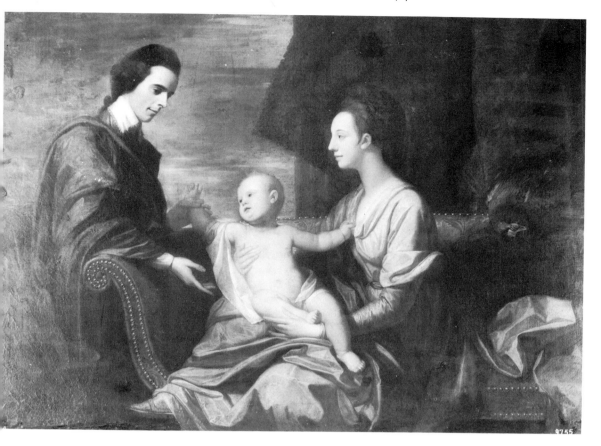

Figure 172. *Arthur Middleton and His Family*, by Benjamin West, 1770. Oil on canvas, 44¾ × 66 inches. Henry M. Drinker, M.D., Philadelphia, Pa.

of the plantation system, the area never attracted a permanent portrait painter. Instead, several artists made excursions to Virginia, leaving a record of charming likenesses of the leading citizenry. Old Charles Bridges lived in Virginia for about ten years before returning to England in 1744 or 1745, as noted in Chapter 16. John Hesselius of Annapolis made several visits to Virginia between 1750 and 1773, while the peregrinating John Wollaston arrived in 1754 for a stay of four years. But there were long lapses of time when Virginia appears to have been virtually without a portrait painter, as between Wollaston's departure in 1758 and Hesselius's brief visit in 1767, a span of nine years. Finally, John Durand worked in the colony between 1769 and 1771. There may have been a few others who passed through the area or of whose identity little is known. The situation, however, was quite unlike that of Massachusetts or South Carolina, where the urban centers of Boston and Charleston permanently supported Copley and Theus.

By the 1740s a plantation aristocracy was firmly established in Virginia, for many of the patrons were now third- or fourth-generation members of the great families. Theirs was inherited wealth, with estates of vast acreage, fine

mansion houses, cleared lands, and legions of slaves to work the tobacco fields. These descendants were not the ones to acquire the new raw tracts of land, clear the forests, and fight off Spaniards, pirates, and Indians. Rather, they needed only to be gentlemen planters who husbanded the great estates properly, or ladies who attended to the rearing of the children in genteel fashion and to social affairs, which were assuming increasing importance among the gentry. The social system itself fostered an aristocratic class, with the planters at the peak of the pyramid, well above the tradesman and small farmer, who in turn were above the servant class, while at the bottom were the slaves and Indians. It was, of course, the men and women of the upper level of society who commissioned portraits, and they expected the artist to imbue their likenesses with symbols of their exalted social position, whether such symbols be in the form of rich material stuffs, garments of the most current fashion, delicate and refined gestures, or whatever. The planters and their families now saw themselves as the peers of English gentry, firmly established on their own vast lands with fine family lines of long standing, enjoying wealth, social position, and control of their segment of the world. With more time and wealth to devote to the genteel pastimes that gave their lives refinement, they attracted the likes of William Dering, a cultural entrepreneur in the mode of Peter Pelham of Boston, who was his almost exact contemporary.

Nothing is known of Dering's early life, but his name suggests he was English or of English descent.[23] He first appears in Philadelphia, where he ran an advertisement in the *Pennsylvania Gazette* for April 10, 1735, announcing he had opened a school to teach dancing. Ten months later he notified Philadelphians that he would also provide instruction in reading, writing, sewing, and French. By November 25, 1737, however, he was in Virginia where he offered to teach "Gentlemens sons . . . Dancing, according to the newest French Manner," as he described it in his advertisement in the *Virginia Gazette*. About 1740 he settled in Williamsburg, presiding over gala balls and assemblies. He became a friend of many of the gentlemen planters of the area, frequently visiting William Byrd II at Westover, for whom on one occasion he played the French horn and with whom another time he looked at a collection of prints.[24]

Only one portrait signed by Dering is known to exist – the *Mrs. Drury Stith* (c. 1745; Colonial Williamsburg) – and one document referring to him as a portraitist – John Mercer's Ledger, Bucks County Historical Society, Doylestown, Pennsylvania, mentions an account settled with the artist for "drawing my Picture."[25] Dering's best known and most ambitious work, however, is his portrait of young George Booth who is shown full length, wearing a white wig, a handsome brown coat, and a fashionable red-orange waistcoat trimmed with gold brocade (Fig. 173). He holds a bow and arrow in his left hand while his little dog has in its teeth a game bird his master has just shot with an arrow. Booth is represented amid much finery, and for purposes of aggrandizement the artist placed him between two white pedestals mounted with nude female sculptured busts. It has been assumed that the motif of the flanking busts, like that of the formal garden beyond, was taken from a mezzotint rather than from objects actually adorning the Booth home, and that is probably correct; however, only about five years after the *George Booth* was painted,

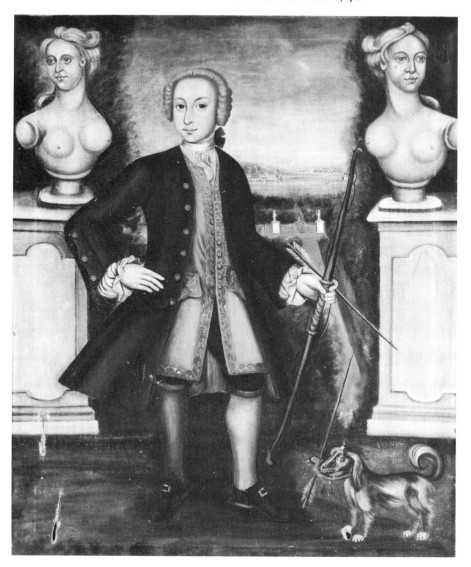

Figure 173. *George Booth*, by William Dering, c. 1745. Oil on canvas, 50¼ × 39½ inches. Colonial Williamsburg Foundation, Williamsburg, Va.

another southerner, Peter Manigault of Charleston, wrote to his parents in 1750 that he was sending home from England "two Busts," and if one southern gentleman could have such objets d'art, so could another.[26] Whether the setting is real or fictitious, the intent was the same: to establish for a young sporting gentleman an ambience that suggested grandeur, for he was meant to be seen as a scion of high estate. The subject's father was Mordecai Booth of Belleville Plantation in Gloucester County, Virginia, on a beautiful site on the North River. A portrait of Mrs. Mordecai Booth exists (private collection), which is also attributed to Dering on stylistic grounds.[27]

Graham Hood in his book on Bridges and Dering has assigned several other

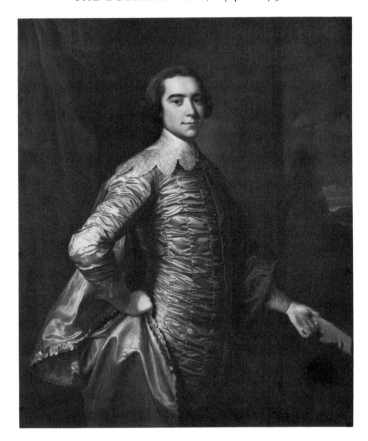

Figure 174. *Robert Carter the Councillor*, by Thomas Hudson, c. 1750. Oil canvas, 30 × 25 inches. Virginia Historical Society, Richmond.

portraits to Dering, but the total number Dering painted was probably small, and he must have engaged in portraiture as a secondary profession. In any case, by 1749 he had left Virginia for Charleston, where his main activities again were centered around assemblies, balls, musical programs, and the teaching of refined skills such as dancing "in the true French (and most approved) Method."[28] Dering is not known to have practiced portraiture in South Carolina, and his death apparently occurred there in 1751.

Virginia planters, like those of South Carolina, often sent their sons to England to be educated and made into polished gentlemen – to burnish away provincial mannerisms and perspectives. Robert Carter (1728–1804), designated as the Councillor, is a case in point; this son of Robert Carter of Nomini Hall and grandson of Robert "King" Carter arrived in England in 1749 and during the next two years indulged in the amusements as well as the cultural opportunities that London offered. About 1750 he had his portrait painted by one of the leading artists of that day, Thomas Hudson (Fig. 174). It was not uncommon in the middle of the eighteenth century to represent a man in the attire of roughly a hundred years earlier, for the era of Charles I was then seen as a golden age of English civilization and was greatly admired. In the 1630s,

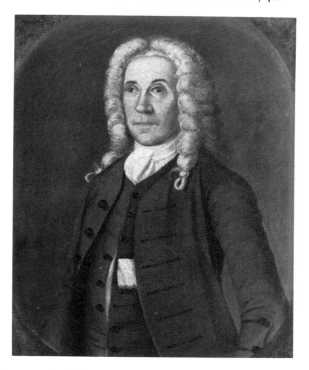

Figure 175. *Henry Fitzhugh*, by John Hesselius, 1752. Oil on canvas, 30 × 25 inches. Virginia Historical Society, Richmond. Bequest of Alice-Lee (Thomas) Stevenson.

Anthony Van Dyck had created the quintessential image of English aristocracy, and by casting young Robert Carter in the guise of a Van Dyckian dandy, Hudson imbued his image with the refinement of an English gentleman. Perhaps to make the use of the Van Dyck costume plausible, Carter is shown holding a mask, as if he were dressed for a masquerade. This motif carried the additional connotation of the subject's participating in the elegant swirl of masquerades, balls, parties, the gay life of sophisticated society. When such pictures were brought back to Virginia, they were bound to affect native-born painters and the planters' concept of the mode of elegant portraiture.

In the Fitzhugh family we may observe the transformations that occurred among the leading families of Virginia with the passing of generations. Henry Fitzhugh (1614–64) was a woolen draper of Bedford, England, and the father of William (1651–1701), who immigrated to Virginia at the age of nineteen to establish a collection of plantations that ultimately totaled 54,000 acres (Figs. 85 and 86). As land was the source of wealth and social as well as civic position in Virginia, William's heirs, grandchildren of a cloth merchant, became landed gentry living on great estates in fine country houses. Such was the case for William's son, Henry Fitzhugh, who inherited 17,598 acres his immigrant father had claimed and developed (Fig. 175). Henry's role was therefore that of gentleman planter, master of inherited estates that he would husband carefully and pass on to the next generation; and each time one generation succeeded another, it followed increasingly the aristocratic ways of its English peers, moving continuously away from its middle-class origins.

Captain Henry Fitzhugh (1687–1758) of Bedford Plantation was called captain because he held that rank in the militia of Stafford County. He was educated in England. As a member of the ruling class, he willingly accepted public offices, serving as high sheriff of his county and as a member of the House of Burgesses from 1714 to 1736. But Henry was a second son, and the portraits of the older members of the Fitzhugh family were bequeathed, by William the immigrant, to his first son, William, Jr.[29] Nevertheless, Henry was well aware of the tradition of having portraits taken as family icons (see Chapter 14 for the earlier Fitzhugh portraits), and so when young John Hesselius appeared in Virginia in 1751–52, he was put to work, making not only Henry's portrait but also copies of the portraits of his father and grandfather that were owned by William, Jr.[30] On this first visit to Virginia when he was just commencing his career, Hesselius also painted portraits of Henry's son, Colonel Henry Fitzhugh of Bedford and his wife Sarah Battaile, and of another son, John Fitzhugh of Bellair, and his wife Alice Thornton. The son of Gustavus Hesselius, the Swedish painter who had settled in Philadelphia, John Hesselius had learned his profession from his father and by observing the works Robert Feke executed in the Quaker City in the late 1740s. The vacuum created by Bridges' return to England in 1745 and Dering's departure in 1749 may have lured the young artist to Virginia in 1751.

Hesselius's *Henry Fitzhugh* shows his subject wearing a fine white wig and a handsome blue-green coat. Fitzhugh, like his father, had himself represented in a bust-length portrait; by age sixty-five he was nearly blind, which accounts for the apparent sightlessness of his eyes in his portrait. But the image of Henry Fitzhugh seems more subdued and more conservative than those of his sons, probably because of his age and his transitional position between middle-class forebears and his Virginia-gentry descendants. Later generations would have a greater display made of their affluence, their refined life-style, and their social position.

The point is made in a portrait of Sarah Fitzhugh, which John Hesselius painted on one of his later visits to Virginia, in 1767 (Fig. 176). Sarah was Captain Henry Fitzhugh's granddaughter and daughter of Colonel Henry Fitzhugh of Bedford. Her grand, three-quarter-length likeness, painted in her twenty-first year, shows her in a dignified pose against a landscape and a segment of monumental architecture, wearing an exquisite saffron gown trimmed with pearls and much lace, while more pearls adorn her neck and her soft brown hair. As in many colonial American portraits, there is a dichotomy between the elegance of the things and stuffs in the picture and the plainness of the facial features; in this regard the *Sarah Fitzhugh* is similar to Theus's *Elizabeth Wragg Manigault* (Fig. 169) or Blackburn's *Mary Faneuil* (Fig. 141).

John Hesselius had made two excursions to Virginia before painting the *Sarah Fitzhugh* – in 1751–52 and 1756 – and two more followed in 1770 and 1773. The latter were undertaken from his home in Annapolis, where he had settled in 1760.[31] Three years later he married a wealthy widow of Primrose Hill who owned large tracts of land, and Hesselius himself became master of a plantation not far from Annapolis. In the records he is sometimes referred to as "gentleman," and he possessed many of the requisite attainments of that

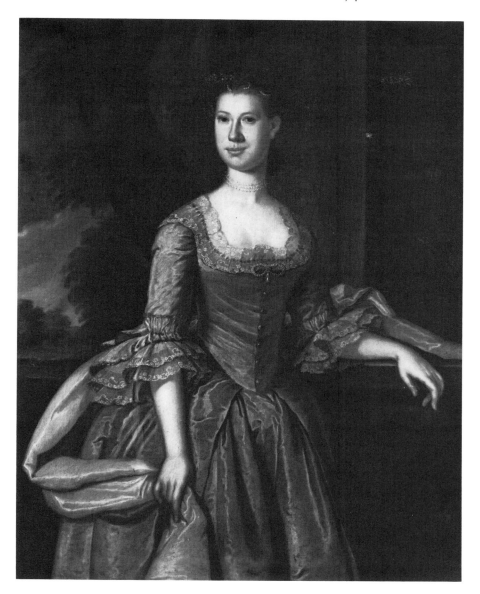

Figure 176. *Sarah Fitzhugh*, by John Hesselius, 1767. Oil on canvas, 50 × 40 inches. Maryland Historical Society, Baltimore.

honored title. In 1749 he had taken lessons at the Philadelphia Dancing Assembly, and music was one of his favorite interests. The inventory of his estate listed a harpsichord, a chamber organ, a guitar, and three violins; the inventory also indicates there were a great many prints and paintings hanging in his house, and among the latter were landscapes, religious pictures, and flower pieces.[32] Hesselius was also interested in science, and his inventory mentions a microscope, a magnifying glass, and a camera obscura. His house was finely furnished, and the plantation was attended by a number of slaves. Just as

369

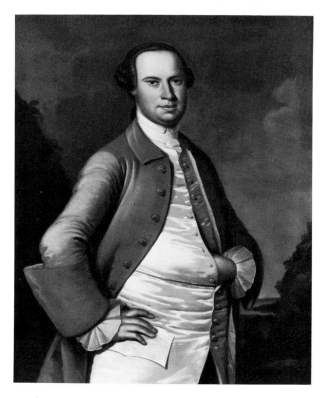

Figure 177. *Samuel Lloyd Chew*, by John Hesselius, 1762. Oil on canvas, 38½ × 30 inches. Museum of Early Southern Decorative Arts, Winston-Salem, N.C.

Copley could perceive the essential character of the New England merchants because he was himself a product of their society, so John Hesselius could portray Virginia and Maryland planters with conviction because he was one of them.

Marylanders, like their peers in Virginia and South Carolina, often had their portraits painted while they were visiting England; Charles Carroll of Carrollton, for example, did so in 1762 or 1763 when he sat to Joshua Reynolds for a portrait that is now in the collection of Mr. and Mrs. Paul Mellon.[33] But most of the Maryland planter aristocracy never made the Atlantic crossing, and by 1760, John Hesselius was well established in Anne Arundel County, where he received commissions from the highest levels of Maryland society. Benedict Calvert of Mount Airy Plantation commissioned portraits of his three children, the twins Elizabeth and Eleanor, and their brother Charles with his young slave, all of which are now in the Baltimore Museum of Art. Hesselius also painted several members of the prominent Chew family in 1762, and his *Samuel Lloyd Chew* represents one of the scions of planter society (Fig. 177). The subject (1737–90), the son of Samuel Chew III of Anne Arundel County, was referred to as Samuel Lloyd Chew of Wells. In later years he was active in political affairs, serving as a delegate from Maryland to the Continental Congresses held in Philadelphia in 1774 and 1775. A Quaker, he prospered in his estate, finding perfect compatibility in his prosperity and his religion. His

portrait reflects his worldly success and his social position, mainly through the handsome fabrics and the fashionable little wig; but it also reveals that John Hesselius had been influenced by the wandering English painter John Wollaston, for the "almond eyes" are clearly present. Comparison of the *Chew* with Wollaston's *Daniel Parke Custis* (Fig. 178) demonstrates the effect Wollaston's style had on Hesselius.

Wollaston, whose early career has been discussed in Chapter 23, worked in Maryland in 1753 and 1754, and the pleasure his patrons there took in his portraits was expressed in a poem published in the *Maryland Gazette* for March 15, 1753:

> EXTEMPORE: *On seeing Mr. WOLLASTON's Pictures*
> *In Annapolis*
> By Dr. T. T.

Behold the won'drous Power of Art!
That mocks devouring Time and Death,
Can Nature's ev'ry Charm impart;
And make the lifeless Canvas Breathe.
The Lilly blended with the Rose,
Blooms gaily on each Fertile Cheek.
Their Eyes on sparkling Gems disclose,
And balmy Lips, too, seem to speak.
Nature and We, must bless the Hand,
That can such heav'nly Charms portray
And save the Beauties of this Land
From envious Obscurity.
Whilst on each Piece we gaze,
In various Wonder, we are lost;
And know not justly which to praise,
Or Nature, or the Painter, most.

But after two successful years in Maryland, Wollaston went next to Virginia, where he remained from 1754 or 1755 to 1758. His reputation preceded his arrival in the Old Dominion through the interconnections of the prominent families in the two colonies.[34] Wollaston, who moved comfortably among plantation society, painted stylish portraits of Virginians in the mode of English aristocracy and gentry. His patrons tended to look to England as the source of the best that life had to offer in such things as their clothing styles and their household furniture, and so they welcomed this artist who could create their images in the fashionable English manner. At the great plantation houses he would sometimes make portraits of an entire family.

Martha Dandridge (1732–1802), the daughter of John and Frances James Dandridge of New Kent County, was a rather plumpish homebody without serious interests in intellectual pursuits, but she was a person of charm and of solid common sense. In 1749 she married Daniel Parke Custis, grandson of the rakish Daniel Parke and of the steady, conservative, and very wealthy planter John Custis. The enormous fortune that Daniel Parke Custis inherited from his father, Colonel John Custis, included a very fine house – the "House

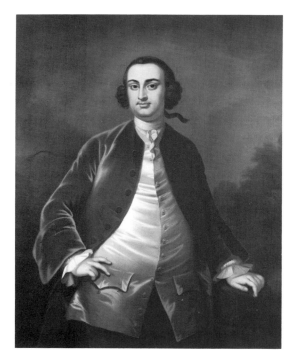 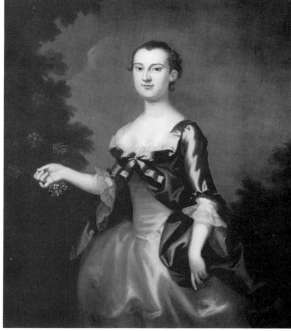

Figure 178. *Daniel Parke Custis*, by John Wollaston, 1757. Oil on canvas, 50 × 42 inches. Washington and Lee University, Lexington, Va.

Figure 179. *Mrs. Daniel Parke Custis* (later, Martha Washington), by John Wollaston, 1757. Oil on canvas 50 × 42 inches. Washington and Lee University, Lexington, Va.

of Six Chimneys" – in Williamsburg, and it was probably while he and his wife were living there that Wollaston painted their portraits (Figs. 178 and 179). Custis died in 1757, leaving Martha Dandridge Custis a very wealthy young widow of twenty-six. The next year a man named George Washington proposed to her, and in 1759 she married him and moved to his 8,000-acre estate, Mount Vernon.

Daniel Parke Custis and his wife lived the life of true Virginia aristocracy – enjoying both inherited wealth and the social position that prominent family lineage afforded. Daniel was born in 1711 at the Custis family estate in Arlington, Virginia. He was a nephew of William Byrd II (Figs. 105 and 106), and Custis's father hoped he would marry his cousin, Evelyn Byrd (Fig. 103), but the young man had eyes only for the daughter of Colonel John Dandridge. After his marriage he built a mansion house – called "The White House" – at his plantation on the Pamunkey River, a branch of the York in New Kent County. There, as his wife played at the spinet, he spent much time improving himself in his library, which contained more than 450 volumes. His collection included the works of numerous classical authors, a set of Shakespeare's works, and the more contemporary literature of Dryden, Pope, and Swift as well as several volumes of *The Spectator*.[35] There were books on science, philosophy, religion, and law, but a number also dealt with the proper conduct of a gentleman or a lady. There were four books by Richard Allestree: *The Whole*

Duty of Man, *The Gentleman's Calling*, *The Ladies Calling*, and *The Art of Contentment*; the library also included William Darrell's *A Gentleman Instructed in the Conduct of a Virtuous and Happy Life. Written for the Instruction of a Young Nobleman* (London, 1704; twelve editions by 1755) and Francis Osborne's *Advice to a Son; or Directions for your better Conduct through the Various and more important Encounters of this Life* (Oxford, 1656). These courtesy and conduct manuals continued to guide a young man, especially one who had not gone to England for his education and polish in proper behavior, just as they had earlier generations of Virginians; when we read their words today we better understand the deportment of the people in colonial American portraits.

In each Custis portrait, graciousness, charm, and high social position were the requisites of the image, and even though a likeness was expected, personal character was not as important as representation of the social code to which the subjects were dedicated. The *Martha Custis* is typical of the vacuousness of Wollaston's facial studies, but her elegant, fashionable satin gown with its ribbons and laces, and the pearls in her hair, tell her story, as does her refined gesture of plucking a blossom from a flowering shrub.

Other portrait painters succeeded Wollaston in Virginia – John Durand, for example, who worked there from 1769 to 1771, painted a number of charming portraits such as those of Mr. and Mrs. Thomas Newton now at Colonial Williamsburg.[36] But the value of Virginia portraits after 1740 lies, for the sake of history and genealogy, in the general likeness of the subject and in his or her grace, refinement, and charm. We never seem to find a crusty individual of the type that stares back at us from a portrait by Copley, nor are we permitted entrée to the real personality that shines forth in a likeness by Copley. The portrayal of class virtues was more important than the powerful individualism of the New England merchants and their families.

Philadelphia – before Charles Willson Peale

Pennsylvania, in comparison to the colonies of the New England group, New York, and Virginia, was founded and settled relatively late. A few tenuous Swedish settlements were along the Delaware River before the middle of the seventeenth century, but then the Dutch claimed the region in 1655. Netherlandish traditions were hardly implanted, however, before the English took the territory in 1664. For nearly two decades little happened in the area, until 1681 when King Charles II made a grant to William Penn of an enormous tract of land between New York and Maryland and westward from the Delaware River. As proprietor, Penn, a Quaker, decreed that his lands should be a haven to the Society of Friends, which had endured so much persecution, in England, New England, and elsewhere. Having witnessed the sufferings of the Quakers, he further insisted that his colony be a place of religious toleration. So virtually from the founding of Pennsylvania, although the Quaker influence was strong, the doors were open to people of many diverse backgrounds, nationalities, and religions. Swedes, Dutch, and English were there, of course, but then also came German, Swiss, Welsh, Irish, and Scottish immigrants – refugees from religious persecution or wretched economic circumstances. This influx made impossible the survival of the tenets of Quakerism in their original form, even if the Quakers themselves had desired it, which was not always the case.

The Society of Friends had been founded in England in the seventeenth century by George Fox (1624–91), who rebelled against the established church and its elaborate formal ceremonies.[1] Fox claimed that only the Bible and, in a mystical sense, the "inner light" emanating from God by way of Christ were needed for the Christian to guide his soul through this life and into the next. Fox began preaching in 1647 and in the years that followed attracted a large following, in spite of suffering persecution and imprisonment. By 1668 he had drawn up a plan for the organization of his Society of Friends – members of which came to be called Quakers because they reportedly trembled with emotion during their religious meetings – and in 1671 the first Yearly Meeting was held in London. The Quakers came to grief, of course, because they rejected the Church of England, and so they suffered in their own country; but they fared little better when they tried to emigrate to Massachusetts, where the Congregationalists passed a law that if a Quaker were found within the

colony, he or she would be deported at once; if the Quaker returned, execution was prescribed.

Early Quakers were known for their gentleness – they refused to bear arms – and for their plain and simple life-style. They wore plain clothing and spurned all class titles (lord, duke, earl, etc.), and they preferred the simple forms of address of "thee" or "thou." Their appearance and speech made them conspicuous. Although the Quaker was not welcome in Puritan Massachusetts, the two sects shared certain features in their codes of life that, though secular, had the sanction of their religions. Like the Puritans, the Quakers held industry, frugality, and moderation in the highest esteem and despised idleness and slothfulness as sins. William Penn had admonished his fellow Quakers that diligence "is the Way to Wealth: the diligent Hand makes Rich. . . . Frugality is a Virtue, too . . . , the better Way to be Rich."[2] Also, dedication to one's secular calling was a virtue and a religious obligation. For Quakers as well as Puritans these qualities almost guaranteed success at their secular callings, bringing them a material prosperity that eventually created a conflict with their devotion to a plain and simple way of life. The result was that many Quakers accommodated their beliefs to their prosperity, which they learned to enjoy as much as any Anglican. James Logan, a Friend who had come over in 1699 as William Penn's secretary and adviser, for example, built himself a fine Georgian house, called Stenton (1728), which still stands in Germantown, outside Philadelphia. But as Wright has observed, "A love of finery in household furnishings and even in dress disturbed some of the stricter Quakers, who at intervals in the monthly meetings made objections that had no visible effect."[3]

The role of Quakerism, however, should not be overstressed in the life of Philadelphia after about 1735, when it entered on a decline while Presbyterianism and Anglicanism were emerging ever stronger. By 1750 the Society of Friends represented only about a quarter of the city's population, and in the last decade before the Revolution, Quakers numbered only one out of every seven persons; this fact led the Bridenbaughs to conclude that "After 1735 it is a real anachronism to speak of Philadelphia as the Quaker City."[4] It was not Quakerism that provided the beat to which the life of Philadelphia marched, but rather trade, craft, commerce, and speculation; mercantilism, sanctioned by the secular virtues held commonly by a variety of religious sects, was the vitalizing and dominating force in the city on the Delaware, rather than the spiritualism of the Society of Friends.

As in almost every other section of colonial America, there was a clearly recognized classification of society into the "better sort," and "middle sort," and the "poorer sort." At the apex of Philadelphia's social pyramid stood the prosperous merchants – some of them Quakers, some Presbyterians, some of any one of a number of religious persuasions; but, as the Bridenbaughs point out, Anglicanism was the stronghold of the mercantile aristocracy, "the congregation of wealth, fashion and position."[5]

Philadelphians, be they merchants of craftsmen, bookkeepers or shipowners, tradesmen or lawyers, prospered at their callings, and those who prospered most refined their life-style in imitation of the mercantile gentry of England. Abhorring ignorance, they gave serious attention to the education of their

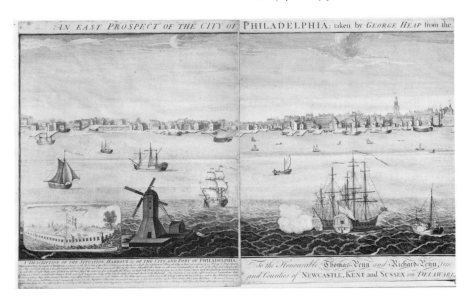

Figure 180. *An East Prospect of the City of Philadelphia*, drawn by George Heap and engraved by G. Vandergucht, London, 1754. Engraving, 24⅞ × 83 inches. The Henry Francis du Pont Winterthur Museum, Winterthur, Del. [See text page 378.]

children. By 1689, only eight years after Charles II's grant to the proprietor, Friends Public School (later called William Penn Charter School) had been founded to teach Quaker children to read and write. By 1750 there were several schools, Quaker and otherwise, in Philadelphia where youths could learn not only such practical disciplines as mathematics, bookkeeping, navigation, surveying, the natural sciences, and foreign languages but also such refinements and amusements as music, dancing, and drawing. There were diversified private libraries, the best known of which, that of James Logan, contained more than two thousand books on math, physics, the natural sciences, and many other topics.[6] Logan's bookshelves included the literary works of Shakespeare, Milton, Gay, Addison, Swift, and Pope, as well as those of the major classical authors; there were religious texts by Calvin, Luther, William Perkins, William Ames, and Richard Hooker, and scientific and philosophical studies by Copernicus, Bacon, Descartes, Kepler, Halley, Harvey, Locke, Newton, and Franklin; there was also a copy of *The Art of Painting* by Roger de Piles. The Library Company was chartered in 1742, the result of the efforts of Logan, Franklin, and some civic-minded tradesmen and "gentlemen." Franklin and other printers published Philadelphia editions of works by Locke, Pope, Goldsmith, Priestly, Samuel Richardson, Blackstone, and other English authors in response to the escalating demand of a literate public. Literature, science, politics, and the improvement of society were among the topics discussed at the gentlemen's clubs, in the manner of London club life; by day men congregated for conviviality at the London Coffee House at Front and Market Streets, they dined together at Peg Mullen's Beefsteak House, and in the evening they met at Daniel Smith's well-known City Tavern. Urban club life

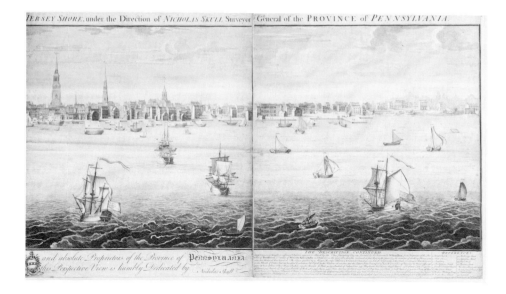

was but one more manifestation of a desire to establish the sophistication of London's upper class along the banks of the Delaware.

Even some of the urbane Quakers joined Anglicans, Presbyterians, Baptists, Lutherans, deists, and other sectarians in associations that sponsored balls, assemblies, and musical evenings. By the 1740s the theater had already been established in Philadelphia. John Beale, in 1748, advertised to teach "Young Ladies, or others . . . the Violin, Hautboy, German Flute, Common Flute, and Dulcimer, by note."[7] Benjamin Franklin in 1739 was already selling the sheet music for Corelli's sonatas in his shop, and he later saw to it that his daughter, Sally, took lessons on the harpsichord.

There was a cosmopolitan quality to life among Philadelphia's wealthy ruling class that transcended religious affiliations. This was due in part to the several nationalities represented in the city, but also to the close contacts that were maintained with Europe, in both business transactions and cultural affairs. Many of the town's affluent citizens either went abroad themselves or sent their sons to become polished gentlemen. Quaker Francis Rawle embarked on a grand tour in 1748; John Morgan, whose Quaker forebears had shifted their allegiance to the Anglican church, went to Edinburgh to study medicine in 1760 and then set off on a tour of the Continent, often in the company of fellow Philadelphian Edward Shippen. Another Quaker, Samuel Powel, spent a year touring about Europe, as did John Allen, son of the chief justice, and so did Quaker Thomas Mifflin and Anglican William Bingham. Benjamin Rush and Francis Hopkinson enjoyed absorbing the knowledge and culture of the Continent, and of course in 1760 young Benjamin West, a Quaker, left Philadelphia to begin a three-year period of study in Italy. All but West returned

to Philadelphia, where they, along with many others who had similar sojourns, contributed to the cosmopolitan spirit of the city.

Immigrants of the working class entered Pennsylvania through the port William Penn had commissioned Thomas Holme to lay out in 1682, on a grid of nine broad avenues and twenty-one intersecting streets, with five large public squares near the corners and at the center. From the beginning, Philadelphia was to be a well-planned city, and a city beautiful. Penn, remembering the Great Fire of 1666 that had raged through the congested houses and shops of London, wanted broad thoroughfares that would act as firebreaks. He also decreed that houses be built in the middle of the lots, rather than abutting one another, in part for the same purpose but also for social and aesthetic reasons. He desired a "sylvan city," a "greene country towne," and prescribed that trees be planted and gardens developed to improve the city's quality of life and visual appearance. In this we find a taste combining the practical or utilitarian with the aesthetic, or, to put it another way, an aesthetic that was influenced by pragmatism – an attitude that resurfaces in the portraiture of the area.

Penn himself expressed a sentiment that laid the foundation for such an aesthetic; it would be good, he wrote, "if we studied nature more in natural things, and acted according to nature, whose rules are few, plain and most reasonable."[8] This statement prefigures the art and interest in natural history of Charles Willson Peale. Philadelphia became a center for inquiry into natural history, a scientific inquiry that encompassed the botanical interests of John and William Bartram and pragmatic investigation of nature's laws to help mankind better understand and cope with his world. The development of a high level of knowledge in the natural sciences found a parallel in the naturalism of portraiture. The combination of a rationalistic approach to the solution of problems with an interest in natural science forged a zeitgeist that would in time become the cultural foundation for the portraits by Peale. It was the age, after all, for the study of natural laws and the natural man, and nowhere in the North American colonies were these pursuits of greater interest than in Philadelphia; Benjamin Franklin was the philosopher in residence and Peale became the painter in residence.

Philadelphia was an eighteenth-century city (Fig. 180). It was not founded until late in the preceding century, and its great growth came after 1700. It therefore did not experience a period in which, in architecture, the medieval survival style dominated (as it had in New England), just as no portraiture deriving from the Elizabethan–Jacobean style had been brought to Pennsylvania (as it had to New England); nor was there anything comparable to the seventeenth-century Dutch tradition that had been implanted in New Amsterdam and the Hudson Valley. When Philadelphians began to build substantial houses, the middle-class gentry had already accepted the late English baroque and early Georgian styles, or at least modest versions of them.

The style was set by such edifices as the Anglicans' new Christ Church (1727) and the State House (1731), later to become Independence Hall. In domestic architecture, James Logan's Germantown residence, Stenton, set a fine standard with its symmetrical red-brick facade with white trim and twenty-four-pane windows. The finest hour for architecture in Philadelphia

came, however, after midcentury as the mercantile establishment – Lutherans and Presbyterians, Anglicans, and Quakers alike – adopted an elegant and graceful life-style that their extraordinary prosperity now permitted. About 1750, Dr. William Shippen, a member of one of the great merchant families of the city, built his fine new brick Georgian house at Fourth and Locust streets. The decade of the 1760s saw the apogee of colonial Philadelphia architecture in such splendid examples as Mount Pleasant (1761–62), Cliveden (1763–64), and the Samuel Powel House (1769).[9] The refinements of the exteriors were matched by the elegance within, and Philadelphia produced a movement in the decorative arts that was never excelled by the craftsmen of other colonial American cities. Prosperity had made it all possible, and, of course, into these interiors came the painted portraits as standard components of the decor and as familial icons.

But portraiture in Philadelphia developed later and more slowly than in places such as Boston, New York, Charleston, or Virginia. There is practically nothing in portraiture from seventeenth-century Pennsylvania, and eighteenth-century portrait painting before the arrival of Peale was sporadic. Gustavus Hesselius had arrived from Sweden in 1712, already a trained painter. He lived in Philadelphia until 1720, when he moved to Maryland, but he returned to Philadelphia about 1730 and remained there until his death in 1755. So few portraits attributable to his hand are known that we suspect he must have been employed at some other profession. His total known oeuvre from his Philadelphia years may be outlined quite briefly: two small bacchanalian pieces of around 1720, if they are in fact by him (Detroit Institute of Arts and Pennsylvania Academy of the Fine Arts); then nothing until about 1735, when he portrayed two Indians, Tishcohan and Lapowinsa (Historical Society of Pennsylvania); next, around 1740, his self-portrait and that of his wife (Figs. 181 and 182); then portraits of Mary Hesselius (his oldest daughter, who became Mrs. Ericus Unander) and of Faithful Richardson of about 1750.[10] Not an imposing production for a total of more than thirty years spent in Philadelphia. Gustavus's son, John Hesselius, was far more successful than his father as a portrait painter, but he worked in Philadelphia only briefly, his main area of operation being around Annapolis, as seen in Chapter 28.

John Smibert left Boston in 1740 on a portrait-painting excursion that carried him to New York City, Burlington, New Jersey, and Philadelphia. In the latter, according to his notebook, he painted fourteen portraits in only two months.[11] A typical example of Smibert's work in Philadelphia is the portrait of the merchant and ship's captain Joseph Turner, who ranked among the city's affluent and socially prominent citizens.[12] But patronage from the city's wealthy merchants could not entice Smibert to remain there, and after his departure it was six years before his successor, Robert Feke, arrived to paint another round of portraits. In 1746, Feke painted the portrait of Benjamin Franklin now at Harvard University, as well as the *Tench Francis* now at the Metropolitan Museum of Art.[13] The *Mrs. Charles Willing* (Ann Shippen) is an excellent reflection of that respect for physical reality, love of finery and elegance, attainment of prosperity, and devotion to individualism that, as we have seen, characterized the taste of a mercantile clientele and gave definition to the style of art that developed in response to those traits (Fig. 134). Feke

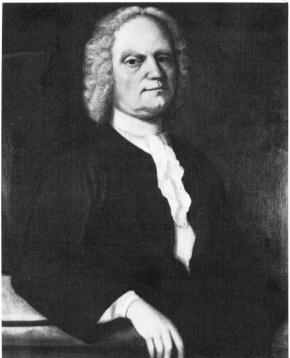

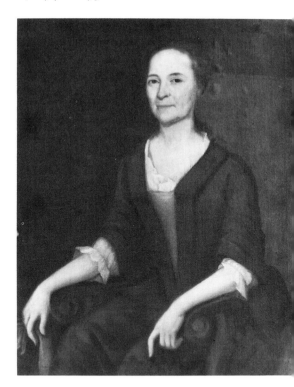

Figure 181. *Gustavus Hesselius*, self-portrait, c. 1740. Oil on canvas, 36 × 28 inches. Historical Society of Pennsylvania, Philadelphia.

Figure 182. *Lydia Hesselius*, by Gustavus Hesselius, 1740. Oil on canvas, 36 × 28 inches. Historical Society of Pennsylvania, Philadelphia.

made a second trip to Philadelphia in 1749 and was again greeted with commissions from several of the leading families. From that visit came the *Margaret McCall*, another likeness of Mrs. Charles Willing, and several more portraits of the Tench Francis family. But in spite of what must have been encouraging patronage, Feke, like Smibert, left Philadelphia to return to New England.

William Williams (1727–91) arrived in Philadelphia in 1747, probably with very little, if any formal training in art.[14] Born in Bristol, he went to sea as a youth, was shipwrecked off the coast of Nicaragua, and eventually made his way to Philadelphia, where he began painting portraits at about the age of twenty. Although little more than a dozen works by him are presently known, he reportedly painted 187 pictures while he was in America, not all of them portraits.[15] His *William Hall* (Fig. 183) is a provincial version of the type seen in Pompeo Batoni's *Portrait of a Young Nobleman* (Fig. 162), although it lacks the latter's sensuousness and painterly sophistication, as well as its aristocratic conception. The young man in Williams's portrait was proud of his learning (judging by the books we see) and of his social position and the prosperity of his family (suggested by his attire and the ornate table). Self-confidence, egalitarianism, and individualism are expressed in the face and figure, while the ships in the distance make reference to his family's mercantile pursuits or to

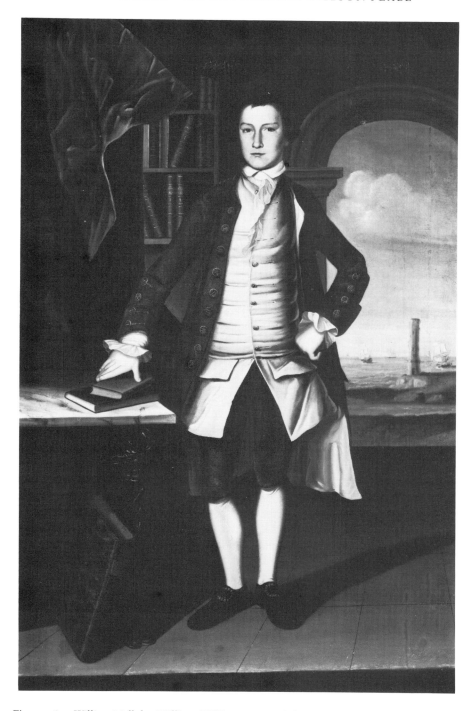

Figure 183. *William Hall*, by William Williams, 1766. Oil on canvas, 5 feet, 11 inches × 3 feet, 10 inches. The Henry Francis du Pont Winterthur Museum, Winterthur, Del.

travel abroad for culture's sake – all conspiring to tell the story of a young Philadelphian, his way of life, and the things he believed in most. Stylistically, there is a tendency to elongate proportions, a linear definition of form, and a simplistic use of local color.

But William Williams's interests were diversified among such things as scenery painting for the theater, writing a Defoesque novel, decorative painting, and teaching drawing and music – he was in many ways Philadelphia's counterpart to Boston's Peter Pelham or Williamsburg's William Dering. Williams has gained a place in the history books as one of the first teachers of Benjamin West. But an average of six pictures a year is not a prodigious output, and he must have devoted much of his time to other activities. Williams left Pennsylvania in 1776 to return to England, and he died in an almshouse in Bristol in 1791.

John Wollaston visited Philadelphia briefly in 1758 and painted a number of the prominent citizens. While there, he left the imprint of his very personal style on Benjamin West, albeit temporarily. Young West had come to Philadelphia from Lancaster shortly before and was painting portraits before he departed for Europe in 1760; Wollaston's influence is evident in West's miniature of Thomas Mifflin (Historical Society of Pennsylvania) and his *Elizabeth Peel* (Pennsylvania Academy of the Fine Arts), both of about 1758. But West and Wollaston were soon gone, and the next painter to appear was James Claypoole (c. 1743–c. 1800), the son of a Philadelphia house painter and glazier.[16] Although resident throughout the 1760s and 1770s, Claypoole left no great mark on the history of painting there. He was the uncle and teacher of Matthew Pratt (1734–1805), who, after his apprenticeship with Uncle James, opened his own studio about 1758.[17] Six years later he went to England to study with Benjamin West; it was then that he painted that most sensitive portrait of West which is now at the New-York Historical Society. In 1768 he returned to Philadelphia, from which he made frequent painting excursions to other colonies, but by the 1780s, Pratt's talent was being squandered as a sign painter. Finally, a wandering Scottish painter, Cosmo Alexander (c. 1724–72), worked in Philadelphia from 1766 to 1768, executing several portraits of the Ross family before moving on to Newport, Rhode Island, where he became the mentor of young Gilbert Stuart.[18]

So, as surprising as it seems, there was no strong tradition of portraiture created by a Philadelphia school of painters before the arrival of Charles Willson Peale. Several painters of note visited the city, only to leave after a short time. Those who were in residence there for longer periods were either of inferior talent or distracted by other activities. When good portrait painters such as Smibert, Feke, or Wollaston came their way, the merchants of Philadelphia offered generous patronage. The wealth was there, the desire to add painted images of themselves to the elegant interiors of their fine homes was present; the time was propitious for the arrival of Charles Willson Peale, who made his first painting foray up from Maryland in 1770.

Charles Willson Peale

Peale, along with Copley, was the quintessential colonial American portraitist. He seized on the precise character of his subjects and depicted them in a style that was itself a revelation of their society and their taste. He, like Benjamin Franklin, personified the intellectual aspiration, wit, and accomplishment of the eighteenth-century American. Peale embodied many of those characteristics that Franklin defined as truly American: He was an ardent egalitarian, an individualist if ever colonial America produced one, a champion of free enterprise and political freedom, a student of the physical, natural world, which led to the naturalism of his art; he was industrious and could neither understand nor abide idleness; and he was a self-made man who from humble beginnings as a craftsman rose to the upper echelon of his society. Furthermore, Peale, like Franklin, represents the secularization of a code originally founded in Calvinistic religious beliefs, and he placed his faith in deism and the Enlightenment rather than in any sectarian dogma. These qualities, so deeply rooted in his own personality, emerged in many of the portraits he painted of his fellow citizens.

Charles Willson Peale (1741–1827) was born in Queen Annes County, Maryland, the son of a schoolmaster of a little academy in Chestertown.[1] The curriculum there included "writing, arithmetic, merchants' accounts, surveying, navigation, the use of globes, several branches of mathematics, Latin, Greek, fencing, and dancing."[2] Young Charles was probably exposed to many of these disciplines, although his early life reveals little interest in scholarly pursuits, in spite of a quick and eager mind. At age thirteen he was apprenticed to a saddlemaker and woodcarver in Annapolis, where in 1762 he set up his own saddlery. He also took up clockmaking and silversmithing, and made a brief foray into politics that was even less successful than his efforts at the several crafts. Then he tried sign painting, and at about the same time first attempted a portrait, of himself, and his career as an artist was launched when he learned that people would pay money for their likenesses.

Peale was not blessed with a remarkable innate talent for art, and he approached painting as if it were a craft to be learned rather than a gift of genius to the divinely inspired. He bought himself a "how to" book – Robert Dossi's *Handmaid to the Arts*, perhaps the London edition of 1758 – and he traded John Hesselius, then the resident portraitist in Annapolis, a saddle for a few lessons

in painting. In 1765, Peale journeyed to Boston, where he visited Smibert's studio, still largely intact fourteen years after the artist's death, and met Copley, who gave him some brief but valuable hints about painting.[3] When Peale visited Copley's studio it was the year the Bostonian painted his *Boy with a Squirrel* (Fig. 150), and by then Benjamin West in London had already attracted the attention of King George III with his classical baroque history paintings.

Returning to Maryland, Peale came to the attention of Charles Carroll the Barrister and John Beale Bordley who, along with several other gentlemen, put up the funds for the fledgling artist to go to England to study. Bordley gave him a letter of introduction to his stepfather, Edmond Jenings, and William Allen of Philadelphia provided a letter to Benjamin West; Carroll wrote to his London agent arranging for Peale to draw on his account up to twenty-five pounds, and closed by expressing the colonial mercantile creed: "I hope he will behave with Diligence and Frugality."[4] The artist sailed for London in 1767. Much of the next two years was spent in Benjamin West's studio, where Peale studiously avoided learning that kind of art for which West was already so famous. Instead, Peale devoted his efforts mainly to painting miniatures, for he knew that portraiture would be the only kind of art to afford him a living back home. Benjamin Franklin was also in London at the time, acting as agent for several colonies. He and Peale became acquainted, and Franklin was both cordial and helpful to the artist.

Peale's only ambitious effort in London was a large portrait of William Pitt, Earl of Chatham, dressed in Roman attire and standing before an altar of peace, with the Banqueting Hall of Whitehall Palace in the background as a symbol of monarchial tyranny (Fig. 184). Pitt, a leading force in the British government, had championed the causes of the common man and of the American colonies. Peale, a dedicated admirer of Pitt, acquired a plaster replica of Joseph Wilton's bust of Chatham to serve as his model. The painting had been commissioned by Peale's friend and patron, Edmond Jenings, a Virginia businessman then resident in London, who believed the work would properly launch his protégé; this was, after all, about the same time that the colonies of New York and South Carolina had ordered marble statues of Pitt by Wilton, out of gratitude for his role in the repeal of the hated Stamp Act.[5] It must have been obvious to all, however, that grand allegory was not to be Peale's forte, for his portrait of Pitt was an awkward allegorical contrivance and, for all the popularity of the subject, even the prints from the plate that Peale himself engraved of it did not find many purchasers back home. The work stands more as an interesting document of the times than as a work of art, and it also testifies to the painter's burning democratic zeal.[6]

Peale was not happy in London, even though he was learning the craft of his profession if not the aesthetics of the brilliant British school of painting. Politically he was continually distressed over the proprietary attitude that Parliament and the government took toward the American colonies, and his egalitarian fervor is demonstrated in his disgust with himself on one occasion for removing his hat, as all did, when King George rode by in his coach; he vowed he would never do it again. And he desperately missed his beloved wife, Rachael, who had remained in Maryland. So he was a happy man when he boarded a ship in 1769 for the voyage that would carry him home.

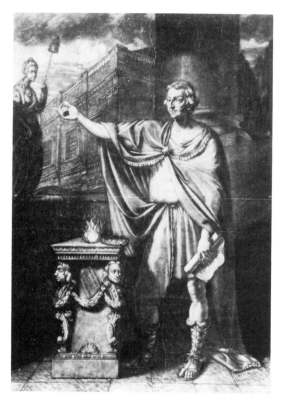

Figure 184. *William Pitt, Lord Chatham*, by Charles Willson Peale, 1768. Mezzotint, 23 × 14¾ inches. Pennsylvania Academy of the Fine Arts, Philadelphia.

The *Peale Family* was largely completed in 1772–73 but was slightly re-worked in 1808–9 (Fig. 185).[7] It represents, at the left, brother St. George Peale with Charles bending over brother James, behind whom stands sister Margaret Jane; in the center, Rachel holds one of the Peale infants; at the far right, mother Margaret Triggs Peale holds a grandchild while Charles's sister Elizabeth sits next to her, and behind the latter stands Peggy Durgan, the Peales' old family servant and nurse. Argus the dog (d. 1803) was an addition in the 1808–9 touch-up. The group is gathered around a table, upon which is a beautifully executed still life; on a shelf in the upper right are three busts of Benjamin West, Peale himself, and Edmond Jenings that Peale had modeled when he was in England.[8] The occasion in this conversation piece is a drawing lesson, as James watches St. George sketch Mother Peale while Charles offers criticism. Charles holds a palette and brushes in his right hand, for he has been working on the canvas that stands behind him with its image of *Concordia Animae*, perhaps the real theme of the picture. The painting is a hymn to family affection, the warmth of which radiates in several faces or is expressed by the tender touch of a hand or by a glance. Even dour John Adams could not miss this unifying element of the picture when he saw it in 1776, noting, "There was a pleasant, happy cheerfulness in their countenances, and a familiarity in their air towards each other."[9] The radiance of familial devotion owed much

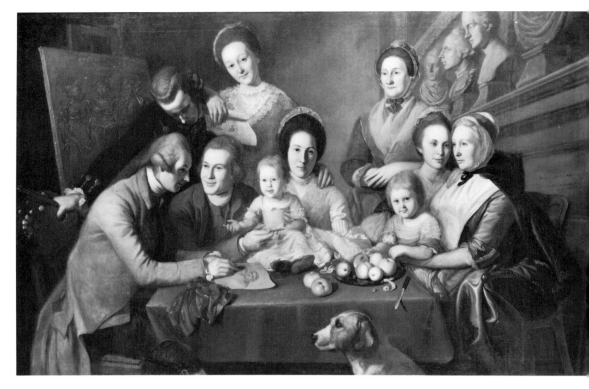

Figure 185. *The Peale Family*, by Charles Willson Peale, 1773 and 1808. Oil on canvas, 56½ × 89½ inches. The New-York Historical Society, New York City.

to Charles Willson Peale's own personality, and later portraits, even when the subjects were not members of his family, often revealed the camaraderie and good-fellowship that developed between the artist and the person being painted.

Stylistically, the *Peale Family* demonstrates the artist's rejection of the influences to which he had been exposed in England. To be sure, Peale returned a better painter than he was before he left, but his style after 1769 is of the colonial type, virtually devoid of the mannerisms of contemporary English portraitists. Whereas Copley immediately mastered the London style, as seen in his family portrait (Fig. 167), Peale rejected it, in part because it was beyond his capacities but also because he knew the elegant style so suited to London high society could not be used to capture the character of provincial Maryland gentry. So he learned the craft of painting while in London, but not the style. The fluid brushstrokes, the glowing atmospheric light and color, and the impressionistic rendering of form – all were manifestations of a sophisticated taste and complicated aesthetics that would not be found among his patrons back home, who would prefer a simple, direct re-creation of their own material world with a forthright expression of their likeness and character. Instead of utilizing the rich, painterly effects of Gainsborough, Reynolds, or Romney, Peale held to the colonial manner, initially established by Robert Feke, of first defining form by linear contours, then filling in between the lines with a single

386

color that would vary in tone but not in hue; St. George's coat in the family portrait, for example, is a single hue of lavender throughout that may change from light to dark lavender, but never does it have an intermingling of reds, blues, or any other absorbed color. Light and shade were used to give objective substance to the image rather than as aesthetic components of themselves.

The form of the figures in Peale's family portrait, as in his later work, looks as if it were derived more from plates in a drawing primer rather than from intensive study of the Apollo Belvedere or the Venus de' Medici. This is especially noticeable in the shape of the heads where the artist, following the advice of the manuals, commenced by drawing an oval; that oval – so obvious here in the heads of Rachael, Margaret Jane, James, and Elizabeth – persists in the final form, while the features were worked within it. The proportions of Peale's figures have an attenuation especially noticeable in St. George's right arm. This tendency to attenuate forms is found in the work of other American painters of the 1770s and 1780s, such as that of Ralph Earl (Fig. 130). It is especially evident in Peale's *George Washington Before Princeton* of 1779, in which the figure is more than eight heads high (Fig. 186); the arms, legs, and torso appear elongated, and the resulting smallness of the head detracts from the grandeur of what was meant to be a heroic "state" portrait.

In the *Washington* we again find the ovoid shape of the head; also, the plainness of features proves Peale's dedication to the facts of nature and once more introduces the matters of individualism and egalitarianism, for the celebrated and internationally famous general is no more idealized than brother St. George in the *Peale Family*. Peale would leave the idealization of Washington's appearance – the creation of a noble, heroic image – to Gilbert Stuart in 1795–96. Even in the pose of the commander-in-chief, and for a formal "state" portrait at that, Peale portrayed the man in a casual, informal posture, taking a brief rest before the battle of Princeton, rather than at some grand, triumphant moment. This pose, with one leg swung easily across the other and one hand nonchalantly resting on a hip, the other on a cannon barrel, was derived from Peale's own observation of his subject, to whom it was probably entirely natural; significantly, it is not derived from classical prescriptions for the expression of greatness, courage, bravery, wisdom, or any such attribute. Peale painted the real individual he knew, not some heroic abstraction that later generations made of the man. Although he would acknowledge Washington's greatness, he saw him – and portrayed him – as an equal and an individual.

Peale revealed his thoughts about his art in a letter of 1772, as he was working on the *Peale Family*, written to his intimate friend and patron John Beale Bordley; in it, we see him explaining the idiosyncracies of his style as being in part by choice, in part due to his own limitations:

> My reputation is greatly increased by a Number of New Yorkers having been here, who have given me the character of being the best painter of America – that I paint more certain and handsomer Likenesses than Copley. What more could I wish? I am glad I can please. But, Sir, how far short of that excellence of some painters, infinitely below that perfection that even portrait Painting may be carried to. My enthusiastic mind forms some Idea of it, but I have not the Exe-

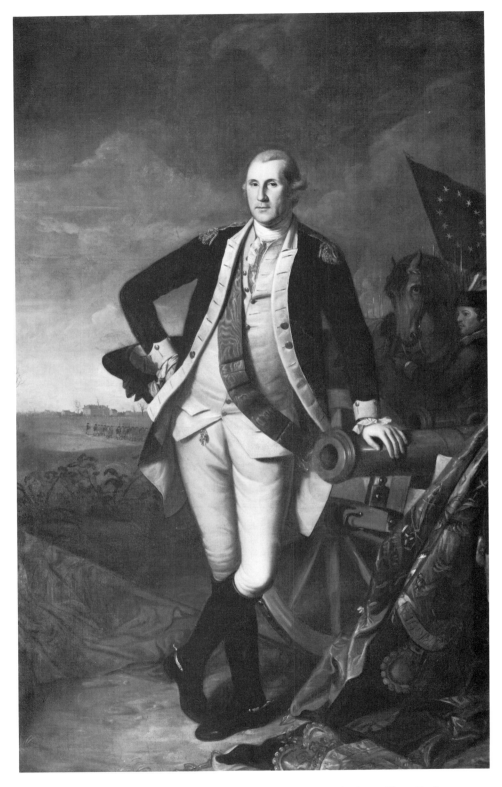

Figure 186. *General George Washington Before Princeton*, by Charles Willson Peale, 1779. Oil on canvas, 94 × 59 inches. Pennsylvania Academy of the Fine Arts, Philadelphia.

cution, have not the abilitys, nor am I a Master of Drawing. What little I do is by mere imitation of what is before me. Perhaps I have a good eye, that is all, and not half the application that I now think is necessary. A good painter of either portrait or History, must be well acquainted with the Grecian and Roman Statues, to be able to draw them at pleasure by memory, and account for every beauty, must know the original cause of beauty in all he sees. These are some of the requisites of a good painter. These are more than I shall ever have time or opportunity to know, but as I have a variety of Characters to paint I must, as Rembrandt did, make these my Antiques, and improve myself as well as I can while I am providing for my support.[10]

That Peale's patrons of the colonial merchant and gentry sets approved of the way he portrayed them is shown in a passage from a letter of 1771 from the painter to Benjamin Franklin:

Since my return to America the encouragement and patronage I have met with exceed my most sanguine expectation, not only in Maryland, which is my native place, but also in Philadelphia I have had considerable business, for which I was very generously rewarded, and my vanity much flattered by the general approbation which my performance hath hitherto met with.[11]

In addition to its financial rewards, his art provided an entrée into the society of the leading families, for as he painted his subjects friendships and associations were formed that endured long after the portraits were finished. The artist found this pleasing, and his lower origins were no more an obstacle to him, although he remained conscious of them, than they were to a wealthy merchant or landowner who had begun as a tradesman or laborer and worked his way to prosperity and social position.

About 1770, Peale's London friend Edmond Jenings again intervened in his life and career, this time to greater advantage than with the Pitt commission. Jenings requested Peale to paint portraits of some of the leading citizens of Maryland and Philadelphia, knowing full well that these would lead to further commissions among the wealthy families of the middle colonies. The commission called for likenesses of John Dickinson, John Beale Bordley, and the Charles Carrolls of Carrollton.[12]

John Dickinson (1732–1808) was then a resident of Philadelphia and a member of the Pennsylvania legislature. This lawyer and political theorist had gained international recognition from his *Letters from a Farmer in Pennsylvania* (1767–68), in which he attacked the Townshend Acts that had imposed duties on many items imported into the colonies. Dickinson favored conciliation with the Crown rather than revolution and refused to sign the Declaration of Independence, but when the rebellion broke out he proved himself a patriot nevertheless. Benjamin Rush knew him well and left an assessment of his character: "He was alike eloquent at the bar, in a popular assembly, and in conversation. Count Wengierski, a Polish nobleman . . . , said he was the most learned man he had met with in America. He possessed the air of a camp and the ease of the court in his manners."[13] Such assessments of Dickinson's per-

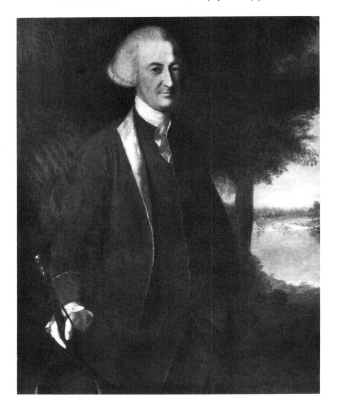

Figure 187. *John Dickinson*, by Charles Willson Peale, 1770. Oil on canvas, 49 × 39 inches. Historical Society of Pennsylvania, Philadelphia.

sonality and character help us comprehend the portrait that Peale painted of him (Fig. 187). William T. Read recalled that the was

> tall and spare, . . . his garb uniting with the severe simplicity of his sect a neatness and elegance peculiarly in keeping with it; and his manners, beautiful emanations of the great Christian principles of love, with the gentleness and affectionateness which . . . the Friends . . . exhibit more than others, combining the politeness of a man of the world, familiar with society in its most polished forms.[14]

Dickinson, whose mother was a Cadwalader, had studied law at the Middle Temple in London; in 1757 he returned to Philadelphia, where he became a very successful lawyer. Entering politics, he was at the eye of many a storm in the two decades preceding the Revolution. He was reelected to the Pennsylvania Assembly in 1770, the year Peale painted his portrait.

Shortly before this, Dickinson married the daughter of Isaac Norris, Jr., who brought to the marriage not only a great wealth but also the beautiful estate of Fairhill, outside Philadelphia and fronting on the Delaware River. It had broad lawns, parterres, orchards, avenues of willow trees, a greenhouse, a fishpond, and a grotto. The house contained an impressive library of about 1,500 volumes, bequeathed to Dickinson College in Carlisle, Pennsylvania,

which was named in his honor. The estate was a splendid example of Quaker elegance and enjoyment of materialistic pleasures.

Sellers has called Peale's portrait of Dickinson "an unusually graceful and poetic composition."[15] He might have added that it was one of the artist's most subtle efforts as well. The subject wears a soft gray powdered wig and a brown suit that blends beautifully with the earth hues and somber tones of the outdoor setting behind him; in his right hand Dickinson holds a gold-headed cane and a three-cornered hat. When writing to the artist about the commission for the portraits of his friends, Jenings had specified that he would like to have wrought into the backgrounds views of American scenery with native plants and trees to remind him of his distant homeland; in the *Dickinson*, Peale obliged by placing the falls of Philadelphia's Schuylkill River at the right. Specificity of the American landscape was as desirable as individuality in the subject's features and character. Dickinson's face is sensitively, even poetically, portrayed, the particular details being worked into the general oval of the head, according to Peale's manner, as discussed earlier in this chapter. Dickinson's gentle resolve is written in the features of his face; it is an unpretentious, forthright image with a look of steady self-confidence about it. In brief, it captures those characteristics we have come to associate with the colonial American portrait: individualism, egalitarianism, prosperity, self-assuredness, and a quiet pride in his accomplishments, without the airs of vanity or pretension.

The *Dickinson* was Peale's first success in Philadelphia, but when it was completed the artist hurried back to Annapolis to rejoin his family, although John Cadwalader tried to persuade him to remain in the Pennsylvania capital. But Peale had commissions to fulfill in his native Maryland, too, such as the large portrait of plantation gentry, the *Edward Lloyd Family* (Fig. 188).

Edward Lloyd (1744–96) was the brother-in-law of John Cadwalader and the master of Wye House in Talbot County, Maryland. In 1767 he had married Elizabeth Tayloe, daughter of Colonel John Tayloe of Mount Airy, Virginia. The Lloyds, connected to distinguished and prominent families in Virginia, Maryland, and Philadelphia, lived in a grand style on their rural estate, amid such luxury as colonial wealth could obtain and colonial character would allow. Ever anxious to follow the latest English fashions, Edward Lloyd made great use of his London agent in furnishing Wye House with beautiful and expensive objects.[16] The house contained one of the finest private libraries in Maryland, an inventory of 1796 listing 732 titles.[17] In their devotion to the current English vogue the Lloyds were probably following the example set by the royal governor, Robert Eden, who arrived in Maryland the same year that Charles Willson Peale returned from study in London.[18]

In Peale's portrait, Edward Lloyd, the fourth of that name and scion of a family that had settled in Maryland in the mid-seventeenth century, stands, his left elbow resting on the sofa and his arm placed tenderly around his infant daughter, Anne, who holds his hand as she snuggles beside her mother. Edward, whose vigor is suggested in his animated pose, wears a handsome maroon velvet suit trimmed in gold and richly embroidered; it was imported from England. His face indicates character, confidence, good humor, and a pensive sensitivity. Outside of his family two of the things he loved most

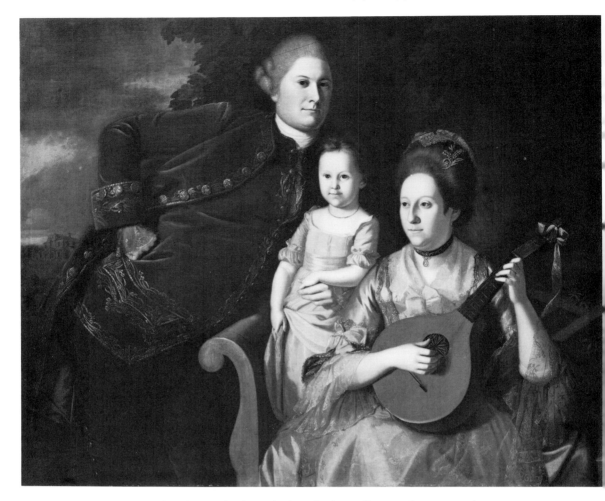

Figure 188. *The Edward Lloyd Family*, by Charles Willson Peale, 1771. Oil on canvas, 48 × 57½ inches. The Henry Francis du Pont Winterthur Museum, Winterthur, Del.

were a robust chase in his own deer park and his large library of splendid bound books. Little Anne, with blue eyes and red-brown hair, wears a yellow dress with pink sash and petticoat to match. Elizabeth Lloyd, beautifully coiffed with a lace scarf and an ornament in her light brown hair, is dressed in a pale green satin gown with a great profusion of exquisite lace, embroidery, and bows; she wears a lovely choker necklace. Mrs. Lloyd strums on a finely crafted cittern, a testimony to her musical skills. She is plain of face, but Peale, like Copley, had a way of making a virtue of honest plainness and endowing it with dignity. As in many a Copley, a bit of fine furniture is revealed as an indication of the subjects' prosperity and refinement of life-style, in this case a light olive-green couch with gracefully curving mahogany arm. In the distance at the far left is a view of Wye House.

The whole painting is a grand symphony on the theme of planter prosperity and the enjoyment of material and cultural pleasures. Peale's *Edward Lloyd*

Family is the American counterpart to Copley's very English *Copley Family* (Fig. 167) of only five years later or of Benjamin West's aesthetically sophisticated *Arthur Middleton and His Family* of 1770–71 (Fig. 172). The naturalism, material objectivity, and quiet pride in material possessions mark Peale's work as expressive of the American character. Again, colonial planter aristocracy are shown enjoying the fruits of the labors of earlier generations, and Peale had just the style to suit their taste.

In 1772, Peale was once more in Philadelphia, this time to paint the Cadwalader family (Fig. 189). Through John Dickinson the artist had met John Cadwalader, Dickinson's cousin, in 1770, and had been commissioned to paint the portraits of five members of the family including the excellent picture of John's father, Dr. Thomas Cadwalader, the respected Quaker physician, which invites comparison with Copley's *Ezekiel Goldthwait* (Fig. 157) of about the same date.[19] Peale also had entrée to the Cadwalader family through Elizabeth, John's wife and the sister of Edward Lloyd of Wye, whose family portrait he had just completed.

Although John Cadwalader (1742–86) was only thirty years old when Peale painted his portrait, he was already one of Philadelphia's wealthiest merchants. In his youth he had made the grand tour of Europe, accompanied by his younger brother, Lambert, with whom, on their return, he had entered into a partnership in a successful firm that imported dry goods. Thoroughly devoted to the good life and to the pleasures of refined society, he participated in the city's convivial club life at coffee houses and taverns, attended the theater regularly, and loved dancing at the assemblies and balls; he drank the best wines, relished rich food, wore the finest clothes of elegant fashion, and had a personal valet. A leading figure in the Jockey Club (founded in 1766), he was a constant spectator at the horse races, where he delighted in wagering; his was one of the best stables in the colony, and he had several carriages, one of which, imported from England, was light green, painted with flowers and crests, and with gilt trim. Cadwalader was a member of the Gloucester Fox Hunting Company of the American Philosophical Society. All in all, his way of life dispels the stereotype of Quaker devotion to the plain and simple.

In 1768, John Cadwalader married Elizabeth, daughter of Colonel Edward Lloyd of Maryland's Eastern Shore. Her father's death a couple of years later brought her an enormous inheritance of about £10,000 including more than 3,500 acres, nearly eighty slaves, and more than one hundred horses. She was known for her beauty and her many accomplishments. In 1769, the Cadwaladers bought a parcel of land with a large house on it near the corner of Second and Spruce streets; nearby lived the cream of Philadelphia society – Chief Justice William Allen, John Dickinson, Samuel Powel, and the rich merchant Thomas Willing. John and Elizabeth Cadwalader undertook at once to renovate the existing house and within a year made it into one of the most exquisite of colonial homes. Its three parlors were handsomely paneled and had elaborate carvings, and for the fireplace of one, Hercules Courtenay carved a relief representing the Judgment of Hercules. On the ceilings were intricate designs in plaster, and some of the architectural carving was gilded. The furnishings were of the very best, the chairs, sofas, tables, and case pieces being wrought from mahogany or walnut, often richly carved, as in the famous

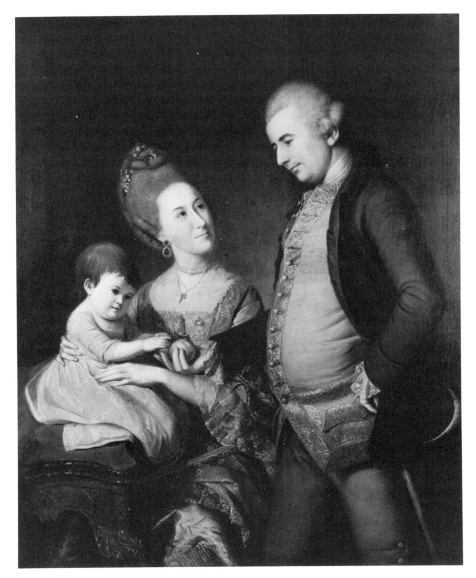

Figure 189. *General John Cadwalader, His First Wife, Elizabeth Lloyd, and Their Daughter, Anne,* by Charles Willson Peale, 1772. Oil on canvas, 51½ × 41¼ inches. Philadelphia Museum of Art: The Cadwalader Collection. Purchased with funds contributed by the Pew Memorial Trust and Gift of the Cadwalader Family.

card table made by Benjamin Randolph that appears in the Cadwalader family portrait.[20] The current vogue of the Chippendale style prevailed throughout. Fine Wilton carpets, imported from England, covered the floors, while beautiful china, porcelain, and silver were in abundance, and silk damask drapes hung at the windows. In the main parlor hung the several family portraits, in ornately carved frames by James Reynolds and Hercules Courtenay, and the focal point of the room was Charles Willson Peale's picture of John and Eliz-

abeth Cadwalader with their little daughter, Anne. It was, in fact, in one of the parlors of the Cadwalader house that the artist painted the portrait.

The Cadwaladers are shown amid accoutrements of success and prosperity. John Cadwalader strides vigorously into the scene, bringing a peach from his orchard to his daughter, whom his wife steadies on the edge of the card table while looking up tenderly at her husband. John is handsomely attired in a brown suit with an ocher waistcoat trimmed with gold brocade. Elizabeth is absolutely resplendent in her fine coiffeur, her jewelry, and especially in her magnificent gown; she wears a gold necklace and amethyst earrings set with seed pearls, and her dress is a blue-gray satin with white lace over a lavender brocade skirt. Those elements of materialism and refinement, so dear to the hearts of upper-middle-class mercantile society in colonial America, are beautifully expressed here, as is the warmth of familial affection which echoes that observed in the *Peale Family*. The richness of stuffs is further stressed by the portion of the elaborately carved table that is not so subtly worked into the picture; it "stands in" for all the other finery of the Cadwaladers' home as an emblem of success, prosperity, and a love of the finer things of life, in a material sense. But these riches had come to John Cadwalader as a result of his earnest and honest labors at his secular calling – the doing of God's bidding on earth – and such prosperity would not have been possible had God not been pleased with Cadwalader's efforts. Both worldly prosperity and God's grace are to be understood from imagery in this mode.

In 1776, Thomas Paine's *Common Sense* was published in Philadelphia and later in the year his *American Crisis* appeared, with its words "These are the times that try men's souls." That same year Peale had moved his family to Philadelphia, where he joined his friend Paine as a radical force in opposition to king and Parliament. The years 1775 and 1776 saw the unfolding of momentous events in the American colonies, and much of the activity centered in Philadelphia. In May 1775, not long after the battles of Lexington and Concord, the Second Continental Congress met there and appointed George Washington commander-in-chief of the Continental army. Peale enlisted, serving as a lieutenant under the command of General John Cadwalader. John Dickinson drafted a petition of conciliation addressed to King George, which was passed by Congress but was refused by the king in September. The next year Dickinson was appointed chairman of a committee to draft a plan for confederation of the thirteen colonies, and Thomas Jefferson was named chairman of a committee to draw up a Declaration of Independence, which was adopted by Congress on July 4. The die had been cast, and the American Revolution was launched.

It was against this background that Charles Willson Peale received a commission to paint the portrait of Julia Stockton Rush, which seven years later would be joined by his portrait of Benjamin Rush, executed in the year that independence was achieved (Figs. 191 and 190). The portraits demonstrate the steadiness of the American character, for although they were created amid political crisis, military events, and final victory of the American cause, they betray no suggestion of such things; instead, a calm decorum of refinement and intellectual or cultural pursuits prevails in each.

Julia Stockton Rush first sat for Peale on June 28, 1776, with additional

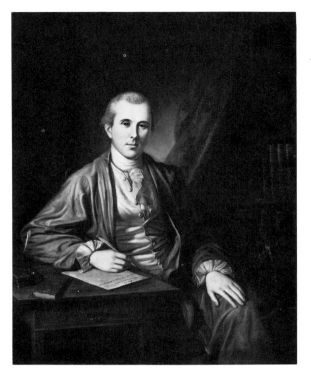

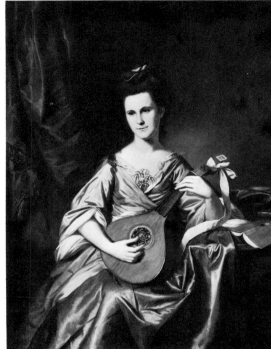

Figure 190. *Benjamin Rush*, by Charles Willson Peale, 1783. Oil on canvas, 50¼ × 40 inches. The Henry Francis du Pont Winterthur Museum, Winterthur, Del. Gift of Mrs. T. Charlton Henry.

Figure 191. *Mrs. Benjamin Rush*, by Charles Willson Peale, 1776. Oil on canvas, 49½ × 39¼ inches. The Henry Francis du Pont Winterthur Museum, Winterthur, Del. Gift of Mrs. T. Charlton Henry.

sittings on July 3 and 5; "presumably everyone was busy elsewhere on July 4th."[21] She was intimately acquainted with the events occurring around her, for both her husband and her father, Richard Stockton of Morven, Princeton, New Jersey, were members of the Second Continental Congress and both were signers of the Declaration of Independence. Earlier that year, on January 11, she had become the wife of Dr. Benjamin Rush, who had known her as a little girl when he was a student at Princeton. Rush met her again when she was about seventeen, and recalled that she was "engaging in her manners and correct in her conversation. I had seen a letter of her writing to Mrs. [Elizabeth Graeme] Ferguson which gave me a favorable idea of her taste and understanding.... From this moment I determined to offer her my hand."[22] The Mrs. Ferguson referred to was the center of a literary circle in Philadelphia, and Julia Stockton's interest in literary matters is thus indicated – and we thereby understand the presence of the books on the table beside her in Peale's portrait. In addition, as Julia was also accomplished in music, Peale portrayed her playing a cittern. The wistful expression on her face conveys the sensitivity of her soul – or, as her husband called it, her "taste."

In Peale's portrait Mrs. Rush is shown as an attractive if not beautiful young woman. Pearls adorn her light brown hair and she wears a lovely light blue gown trimmed with lace and more pearls. Something of the Rushes' aspirations are suggested by the great swag of drapery behind her and the handsome mahogany table beside her. The features of her face are wrought within Peale's schematic oval of the head, but her likeness is not an idealization or a victim of fashionable mannerism; it is a true image, for Peale could paint a portrait in no other way. Although part of her story is told through the props that surround her, much of Julia Stockton Rush is revealed in the perceptive study Peale made of her face; one can seldom say as much for a portrait by Blackburn of Wollaston, and again, as with Copley, we find a native-born artist more attuned to the true character of the colonial American.

The portrait of Benjamin Rush had probably been commissioned at the same time as that of Mrs. Rush, but then the war interfered. Peale did paint some portraits during the years of conflict, and he occasionally visited his family, whom he has settled in Germantown after the British occupied Philadelphia. But as the war wound to its conclusion Peale returned to his profession as an artist, and to the leftover business of painting the companion portrait for the *Julia Stockton Rush*.

In the last half of the eighteenth century Philadelphia had become a remarkable center for scientific inquiry, and in the study of medicine it was ahead of all the American colonies. Indeed, its reputation in these fields was international.[23] No one better represents the scientific, intellectual, and humanitarian excellence of the coterie of learned men of Philadelphia than Benjamin Rush.[24] Rush's and Peale's interests often brought them together, for it was only two years after he painted the doctor's portrait that the artist established his celebrated Museum of Natural History, and some years later Rush assisted Peale in organizing his lectures on natural history.

Benjamin Rush (1745–1813) was descended from John Rush, an Oxfordshireman who, after serving in Cromwell's army, brought his large family to Pennsylvania following the Restoration. They were Quakers then, and Penn's colony offered them a haven. Rush's father was a gunsmith and farmer, and when he died young his widow opened a grocery store so she could afford a proper education for her children. Benjamin was sent to Nottingham School in Cecil County, Maryland, and then to the College of New Jersey (later to become Princeton), where he studied the classics and natural philosophy (science). After receiving his degree in 1760 he apprenticed himself to Dr. John Redman, a well-known Philadelphia physician. To complete his medical education, Rush sailed for Edinburgh in 1766 and studied there under the most renowned medical faculty of that era. He also learned French and taught himself to read Italian, Spanish, and German; he made the acquaintance of the brilliant philosopher David Hume, whose company he enjoyed.

After receiving his degree in 1768, Rush went to London, where he met Benjamin Franklin, the Reverend George Whitefield, and Benjamin West, in whose studio Charles Willson Peale then worked. Through West he met Sir Joshua Reynolds, Samuel Johnson, Oliver Goldsmith, and John Wilkes, dining with this group frequently and discussing politics, art, and literature. Rush

saw Garrick on the stage and noted in his autobiography, "I visited no place with half so much pleasure as the British museum.... Every thing rare and curious in nature and art."[25]

On February 1, 1769, Rush arrived in Paris, with thirty guineas Franklin had loaned him and a number of letters of introduction. He met several prominent physicians and chemists, as well as the king's botanist and Diderot. "I visited all the galleries and churches that were known for containing celebrated pictures," he wrote, and admired "all of the elegant pieces of statuary... in Paris."[26] In March he returned to London and sailed for home the following summer. But his experiences were typical of an increasing number of colonial Americans who were shedding provincialism to acquire an acquaintance with a more cosmopolitan way of life and thinking. This seems to have been especially true among men of science and medicine.

Benjamin Rush set up his practice in Philadelphia, where at first his clientele came from among "the poorer sort." He was appointed to the faculty of the College of Philadelphia as professor of chemistry, and he began writing articles on medical subjects and in opposition to slavery. He had always taken a keen interest in political affairs, and in the exciting days of 1775 he was often in the company of his friends John and Samuel Adams from Massachusetts, Patrick Henry and Thomas Jefferson from Virginia, and Benjamin Franklin and Thomas Paine. As a member of the Second Continental Congress, he put his name to the Declaration of Independence on August 2, 1776, and joined Washington's army, serving as surgeon general under Cadwalader. After the war he remained active in politics until about 1789, opposing Hamilton and the Federalists. When Dr. John Morgan died in 1789, Rush succeeded him as the professor of theory and practice of medicine at the College of Philadelphia, which five years later merged with the University of Pennsylvania.

All this serves as background to the portrait of Benjamin Rush that Peale painted in 1783. In spite of his very successful career as a physician, Rush wished to be portrayed as a sage – as a philosopher-scientist. He is shown in the privacy of his library, wearing a lounging robe reminiscent of the type of garment worn by philosophers of old. Eye contact with the viewer is avoided, for the subject is lost in his own thoughts, reflecting on the topic of a lecture, the first line of which he has written on the paper before him: "We come now, gentlemen, to investigate the cause of earthquakes." At the right are shown some of the books from his library that further indicate his pacific interests. There is Thomas Sydenham's *Opera*, a seventeenth-century work on clinical medicine and epidemiology; Aulus Cornelius Celsus, a Roman of the first century A.D., is represented by *De re medica libri octo*; Thomas Reid, a Scottish philosopher and leader of the commonsense school, who declared that the physical world is known only through the senses, is represented by his *On the Mind*, probably referring to Reid's *An Inquiry into the Human Mind* (Dublin, 1764); there is also Joseph Butler's *Analogy of Religion, Natural and Revealed, to the Constitution and Course of Nature* (London, 1736), written by the English theologian to combat deism; the *Pensées de Pascal* (Paris, 1670) is a collection of the works by Blaise Pascal, the seventeenth-century French philosopher and scientist; and *The Works of Sir William Temple* (London, 1720) in two volumes may be identified in the bookcase. There are other titles: Sir

John Pringle's *Diseases of the Army* (London, 1761); Andreas Sigismund Marggraf's *Opuscules Chymiques* (Paris, 1762); Sir William Lewis's *Commercium philosophico-technicum, or, The Philosophical Commerce of Arts, Designed as an Attempt to Improve Arts, Trades and Manufactures* (London, 1763); James Beattie's *An Essay on the Nature and Immutability of Truth* . . . (Edinburgh, 1770); Benjamin Franklin's *Philosophical Works*; Algernon Sidney's *Discourses Concerning Government*, first published in English in 1698; and the Bible. Whatever is put into a portrait, is put there intentionally, for a purpose, and Benjamin Rush may have specified to the artist which titles he wished to have included to indicate the breadth of his learning.

The style of the *Benjamin Rush* is naturalistic, which is to be expected when both painter and subject were devoted to the study of nature and lived in a society dominated by mercantile materialism. The points made in Chapter 20, "Philosophers and Scientists," are admirably demonstrated here. Peale's respect for truth and his society's regard for individualism are borne out in the portrait; the spirit of egalitarianism is present, for the artist painted his friend as he knew him, as his equal, refusing to impose a heroic quality upon his likeness or to ennoble him beyond what he was. There was no need to falsify the man's image, for what the man was, was good and honorable in itself. The features of Rush's face are as plain as of George Washington in Figure 186; to Peale and his patrons, truth was to be blended with refinement, not with some sentimental, romantic, or idealizing sham.

The Rush portraits represent the zenith of Peale's colonial style and its perpetuation into the era of independence. In them, the colonial American is seen as having arrived at that goal toward which he or she had been aiming all along – the comfort of material prosperity, a sophisticated way of life nurtured by both the arts and the sciences, and membership in an elegant, enlightened society. These portraits rank with Copley's *Mr. and Mrs. Goldthwait* or *Mr. and Mrs. Isaac Winslow* (Figs. 156, 157, and 165) in the matter of the affluence of a mercantile society, but as a pair they go beyond them in showing the interests in science, philosophy, medicine, music, literature, religion, and a host of other areas. Peale enjoyed the company of men such as Benjamin Rush; he found them fascinating and stimulating, and he was welcomed into their society through his own pursuits in art, politics, and natural history.

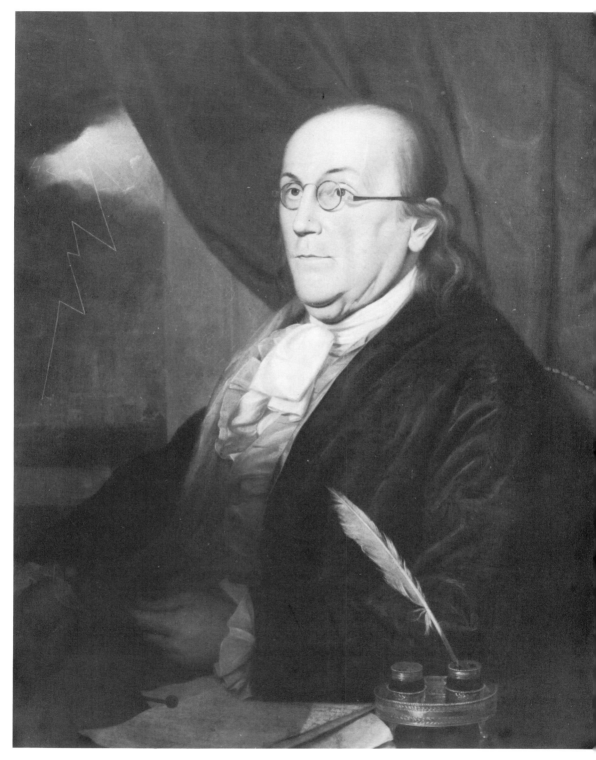

Figure 192. *Benjamin Franklin*, by Charles Willson Peale, 1789. Oil on canvas, 36 × 27 inches. Historical Society of Pennsylvania, Philadelphia.

Epilogue

Peale's Portrait of Benjamin Franklin

It is fitting to conclude this study with Peale's portrait of Benjamin Franklin of 1789 (Fig. 192). Although it dates from several years after the close of the period under consideration, its subject is the supreme example of the colonial American, and its style represents the quintessential means of portraying the colonial American character. Franklin (1706–90) so embodied the many facets of the colonial American personality that he offers a splendid opportunity for a summary of the things discussed throughout this book. Even where he was unlike most of his contemporaries – as in his deism – there is something that is typical of his society. By analyzing his secular and religious beliefs, we may better understand not only Peale's portrait of him, but much about colonial American portraiture in general; that methodology, after all, has been the central thesis of this book. Although many of the pivotal points of Franklin's philosophy have been discussed in Chapters 18 and 19, we will summarize those and others here.

Franklin was the son of devout Presbyterians and tradespeople – candlemakers – of Boston, who brought him up to be pious, industrious, and moral. He was a second-generation American; his father had been a nonconformist in England, so the son came naturally by his inclinations to question religious doctrine. Even from his youth Franklin was more interested in defining the moral man than in subscribing to one of the established sects. In this he was converting religious dogma into a secular code. Despite the fact that for a while in his youth, at about the age of nineteen when he was in London, he claimed to be an atheist, Franklin believed in God.[1] By 1728, in his "Articles of Faith and Acts of Religion," he wrote his own very personal creed: "Let me then not fail to praise God continually, for it is his Due, and it is all I can return for his many Favours and great Goodness to me; and let me resolve to be virtuous, that I may be happy, that I may please Him, who is delighted to see me happy. Amen."[2] True, he did not attend church regularly, Sunday more often being his day devoted to study. Nevertheless, he believed in the existence of God, not in a mystical or spiritualistic sense but in a rationalistic way, convinced there had to be an ultimate power that controlled the universe and all things that happened therein according to their natural patterns.[3] As the archetypal rationalist, Franklin represents the desire of colonial society to maintain a close relationship between secular and spiritual matters.

Many of Franklin's contemporaries found the search for a moral religion more to the point than the dogmatic harangues of the orthodox ministers on Sunday mornings. They therefore turned to secular institutions such as Freemasonry, an organization that Franklin joined in 1731. Here was, as Buxbaum has said:

> a group that taught its members morality rather than theology, and stressed fellowship and toleration. Moreover, it expressed belief in one God, who was discovered through reason, and preached that natural religion was universal. That these doctrines appealed to Franklin is attested to by his very regular attendance at Masonic meetings and his subsequent rise in that organization.[4]

Throughout this study we have observed a pattern that saw a continual erosion of the power of the church before the flood of secularism, and certainly in the portraits of the late colonial period the secular, materialistic strain finds its richest fulfillment. For Franklin and his kind, something like the Junto, which he organized in Philadelphia in 1727, replaced, socially and intellectually, the spiritualism that prayer meetings had offered to earlier generations. Artists like Copley and Peale sensed the power of the secularistic passions in their clientele, and catered to them in their portraits.

Franklin was a deist. As a youth he had read Lord Shaftesbury's *Characteristicks of Men, Manners, Opinions, Times* (1711), which Aldridge calls "the most influential deistical work published in England before Paine's *Age of Reason*,"[5] and he also read the writings on deism by Shaftesbury's follower Anthony Collins. As a deist, Franklin believed in God but offered him no elaborate ceremony and used no iconic symbols. Still, deists as well as nondeists did have religious conviction, which, of course, had to be represented by some means other than the Catholic icon. That is where the element of God's blessing on prosperity entered the image, being demonstrated through fine attire, beautiful household objects, a handsome segment of architecture, or even a distant landscape view of property owned.

Although Franklin accepted much of what Calvin had taught, he parted company with Calvinism on one important point – that the Bible was the final authority in all things – for he believed that reason was the only thing man could ultimately rely on, even in search of God. The deists claimed that one found God by reason, not by Scripture, revelation, or faith alone. Franklin held reason to be God's greatest gift to mankind, and this devotion to reason gave rise to an empirical, pragmatic philosophy. Rationalism and pragmatism led to seeing the world as it actually is, which in turn promoted a realistic, materialistic style such as we find in the portraiture of Charles Willson Peale. A similar perspective formed the basis for the taste of Peale's patrons. Just as Franklin's mercantile society held that theoretical truth did not always produce good results in the countinghouse, so theoretical complexities in art were not as respected as plain, simple, straightforward truth, and Peale's portrait of Franklin is an exposition of this important point.

Franklin himself, as a second-generation American of humble parentage who had worked hard to improve his lot, is the very personification of the prosperous, self-made man. And he saw no reason why material wealth should

not be enjoyed through a comfortable home, fine (but not extravagant) clothes, and the reasonable pleasures of life, just as Calvin had advocated. These things were in no way incompatible with God's will, he believed, and in his "Articles of Belief and Acts of Religion" of 1728 he observes that since God "has created many Things which seem purely designed for the Delight of Man, I believe he is not offended when he sees his Children solace themselves in any manner of pleasant Exercises and innocent Delights.'"[6] This is but another affirmation of the belief in God's approval of the enjoyment of materialistic pleasures, and is a distant echo of words pronounced by Calvin himself, who said that if something secular did no harm, then he saw no reason to condemn it (see Chapter 1).

The doctrine of prosperity was as valid in Franklin's time as it had been in Calvin's day. At its core was the obligation of diligence at one's secular calling, and no one believed in that more ardently than Benjamin Franklin. Early in life he had defined the secular virtues by which he believed he should live, and foremost among these were industry, frugality, and moderation. As the foundation on which to build a successful life, these proved to be as valid and useful for Franklin and his contemporaries as they had been for John Freake (Fig. 10) and his mercantile brethren in the seventeenth century. Industry, frugality, and moderation, joined with piety and prosperity, were the measure against which colonial society judged itself, and the portraits of that society had to include such things. This was, to be sure, a middle-class concept, but if one lived by such a code it had its materialistic and even spiritualistic rewards.

The materialistic drive in Franklin's society was so powerful, it was essential that materialism not be antithetical to piety. Since the days of Calvin the doctrine of God's blessing on diligence at one's secular calling had prevailed, and the result of that diligence was material prosperity. Franklin had been raised in a basically Calvinist home environment, and there was much in Calvinist theory that he agreed with; his personal virtues were industry, frugality, moderation, honesty, temperance, and piety, the very same virtues Calvin had enumerated, and both men abhorred idleness, vanity, and ostentation. It was the doctrinaire, authoritarian Calvinism that the ministers advocated that Franklin found objectionable.[7] But neither John Calvin nor Cotton Mather nor Benjamin Franklin condemned the pursuit of material pleasures if the pursuit were properly moderate.

Franklin and his contemporaries recognized that a difference existed between reasonable pride (satisfaction in earned wealth, security, and social standing) and pride that was a foolish display of ostentation in one's dress, home, or social ambitions. Again, moderation was the guiding principle, which is what one would expect of a middle-class society, traveling its "moderate" road between the extremes of the poor and the aristocracy. For centuries the church had warned against pride, vanity, and ostentation on the grounds that these were sins against God and led to an inordinate concern with the earthly, material world; the philosophy Franklin gave voice to, however, was a condemnation of these vices on secular, rational, and moral grounds. We again see the transformation that is completed in Franklin, from the religious orientation of his forefathers to the secular, pragmatic, rationalistic philosophy of his own time. Spending money foolishly on ostentatious attire, furnishings

for the home, or whatever was unwise and often led to such secular sins as depravity, poverty, and the squandering of one's estate. Franklin's censure of such things was often expressed through Poor Richard's maxims, as when in "The Way to Wealth" (1758) we find Father Abraham quoting the imaginary natural philosopher: "Many a one, for the Sake of Finery on the Back, have gone with a hungary Belly, and half starved their Families. *Silks and Sattins, Scarlet and Velvets*, as Poor Richard says, *put out the Kitchen Fire*."[8] And in the same piece he advised, "Fond Pride of Dress is sure a very Curse; E're Fancy you consult, consult your Purse." But Franklin was not damning fine dress per se – he only did so if one could not afford it or if it became an obsession that distracted one from the secular virtues that he had outlined early in his life. For colonial Americans, moderation was a rule to live by and pride was something that could be justified but had to be held in check; unbridled hedonism, however, is seldom found among them and blatant vanity was branded a sin. All of this was expressed in Franklin's philosophy and was incorporated as part of the character study by colonial portraitists such as Peale and Copley.

Franklin, like most of his colonial contemporaries, held truth as one of the highest of moral virtues. In his *Autobiography*, he called it "the most amiable excellence in a rational being," and he was "convinc'd that *Truth, Sincerity* and *Integrity* in Dealings between Man and Man, were of the utmost Importance to the Felicity of Life."[9] The search for truth was of an empirical and pragmatic nature rather than a pursuit of some abstract, theoretical idea, and the respect for truth in the marketplace or in the study of the physical world was one of the main social underpinnings that demanded a naturalistic style in portraiture. This attitude was expressed by Franklin when he wrote, "If my hypothesis is not truth, it is at least naked. For I have not with some of our learned moderns disguised my nonsense in Greek, clothed it in algebra, or adorned it with fluxions. You have it in *puris naturalibus*."[10] Franklin's interest in natural history and science led him, in 1743, to propose the establishment in Philadelphia of the American Philosophical Society. From the beginning this was meant to be no gathering of ivory-tower theoreticians but a society committed to the promotion of useful knowledge. For example, in the late 1740s, Franklin devoted much time to the study of electricity in his own little laboratory in his Philadelphia home; he eventually concluded that lab-produced electricity and lightning from the skies were of the same properties, and his correspondence with Englishmen on the subject was soon published in *Gentleman's Magazine* (May 1750) and much discussed among members of the Royal Society. His famous experiment with the kite and key in a thunderstorm was first conducted in 1752. He was, of course, ultimately interested in the usefulness of such discoveries and demonstrated the efficacy of lightning rods, which would ground the electrical energy of lightning and render it harmless. It was the invention of the lightning rod, long before his political missions abroad, that made Franklin an internationally celebrated figure.[11] Therefore, in Peale's portrait of Franklin, which was commissioned by the American Philosophical Society, it was only natural that a stroke of lightning and two lightning rods be included, for these reflected the society's interest in useful

scientific discovery. The manuscript on the table is part of the paper published as *Experiments and Observations on Electricity*.[12]

Franklin returned to Philadelphia from his diplomatic mission in France in 1785, after a decade abroad in the service of his country. In that year Peale painted a bust-length portrait of the sage, which eventually served as the model for the one commissioned by the American Philosophical Society in 1789. By then Franklin was old and ailing and could not endure the strain of posing for his friend, even for short periods; he would die the next year, in 1790. Peale, although creating an image of a great man that may have been envisioned as the one by which posterity would remember him, typically refused to idealize or heroize Franklin but portrayed him in all the truthfulness that both men respected as the basis of their endeavors. Franklin looks old, the vigor of earlier years drained, and he had already begun to take opium for the pain of "the stone." He is shown in an informal moment, wearing a blue brocade dressing gown, with a fine silver inkstand at his elbow. Peale thereby represented his subject with symbols of material prosperity of the traditional sort. All in all, the portrait of Franklin embraces most of those economic, religious, cultural, and aesthetic principles that had formed the character of the colonial American and the style used to portray them: materialism, pragmatism, individualism, egalitarianism; prosperity, God's favor for the industrious soul, secularization of the guiding virtues and morals. Painters such as Copley and Peale developed a style that eloquently represented the successful upper middle class in a style that matched their taste and expressed the virtues that were dearest to them. In all of this one sees a continuity under transformation from Calvin to Perkins to the Mathers to Franklin to Charles Willson Peale.

Notes

Preface

1. John Calvin, *Christianae Religionis institutio* (Basel, 1536).
2. See Erik Larsen, *Calvinistic Economy and 17th Century Dutch Art* (Lawrence: University of Kansas Press, 1979).

Chapter 1

1. There were nine editions of Thomas Norton's English translation of Calvin's *Institutes* between 1561 and 1634, and six English abridgments. See Benjamin B. Warfield, *Calvin and Calvinism* (New York: Oxford University Press, 1931), p. 417. Since the early nineteenth century the title of Calvin's treatise has been translated as *Institutes of Christian Religion* and, for convenience, referred to as the *Institutes*.
2. See Louis Wright, *The Cultural Life of the American Colonies, 1607–1763* (New York: Harper & Row, 1962), p. 139.
3. *The Diary of Samuel Sewall, 1674–1729*, ed. M. Halsey Thomas, 2 vols. (New York: Farrar, Straus & Giroux, 1973), 1:67, June 20, 1685.
4. Jonathan Fairbanks et al., *New England Begins: The Seventeenth Century*, 3 vols. (Boston: Museum of Fine Arts, 1982), 2:157 and colorplate 9.
5. *Winthrop Papers, 1498–1649* (Boston: Massachusetts Historical Society, 1931), 2:139.
6. Daniel T. Rogers, "The American Work Ethic," in "Working: Changes and Choices," *Courses by Newspaper*, copyright 1981 by the Regents of the University of California.
7. *Institutes of Christian Religion*, trans. Henry Beveridge (Grand Rapids, Mich.: Eerdmans, 1957), Book 3, chap. 10, sect. 5.
8. Alan Simpson, *Puritanism in Old and New England* (Chicago: University of Chicago Press, 1955), p. 113.
9. *Institutes of Christian Religion*, Book 3, chap. 10, sect. 1, "How to Use the Present Life, and the Comforts of It."
10. Ibid.
11. Ibid., sect. 6.
12. Perkins's treatises and sermons were very popular in England, but they were also translated into several languages and published in influential centers of the re-

formed church such as Basel, Geneva, Leyden, and Amsterdam, giving his work an international authority.

13. The Reverend Richard Mather, for example, owned a set of Perkins's *Workes*; see Suffolk County, Mass., Probate Court Records, 1667, for his will. I am indebted to Ellen Marie Snyder for calling this to my attention.

14. London, 1611, p. 27.

15. London, 1612, 1:750 ff.

16. Perkins, *Workes*, 1:755.

17. Ibid., p. 769.

18. Ibid., p. 770.

19. Ibid., p. 769.

20. See Wright, *Cultural Life of the American Colonies*, p. 140.

21. London, 1651, p. 126.

22. John Cotton, "Christian Calling," in Perry Miller, *The American Puritans, Their Prose and Poetry* (New York: Doubleday, 1956), pp. 181–82.

23. Page 43.

24. John Downame, *The Plea of the Poore* (London, 1616), p. 23.

25. Boston, 1726, p. 709. See also Stephen Foster, *Their Solitary Way: The Puritan Social Ethic in the First Century of Settlement in New England* (New Haven, Conn.: Yale University Press, 1971), especially chap. 4, "Wealth: The Calling, Capitalism, Commerce, and the Problem of Prosperity," pp. 99–126.

26. London, 1639, p. 182.

27. See Bernard Bailyn, ed., "The Apologia of Robert Keayne," *Publications of the Colonial Society of Massachusetts* 42 (December 1964):243–341.

28. See Carl Degler, *Out of Our Past: The Forces That Shaped Modern America* (New York: Harper & Row, 1970), p. 7.

29. Richard Allestree, *The Gentleman's Calling* (London, 1664), pp. 8–10.

30. Ibid., pp. 70–71.

31. Margaret James, *Social Problems and Policy During the Puritan Revolution, 1640–1660* (London: Routledge, 1930), p. 22.

32. *The Diaries of John Hull*, in *American Antiquarian Society Transactions and Collections* 3 (1857):156.

33. Quoted from Thomas Jefferson Wertenbaker, *The Puritan Oligarchy: The Founding of American Civilization* (New York: Grosset & Dunlap, 1947), p. 205.

34. Cotton Mather, *Concio ad Populum* (Boston, 1719), pp. 16–17.

35. Cotton Mather, *A Christian at His Calling, Two Brief Discourses, One Directing a Christian in His General Calling; Another Directing Him in his Personal Calling* (Boston, 1701), pp. 53–54.

36. See Bernard Bailyn, *The New England Merchants in the Seventeenth Century* (Cambridge, Mass.: Harvard University Press, 1979).

37. Simpson, *Puritanism in Old and New England*, p. 34.

38. Alden T. Vaughan, ed., *The Puritan Tradition in America, 1620–1730* (Columbia: University of South Carolina Press, 1972), p. 172. On this matter, see also Richard H. Tawney, "The Rise of the Gentry," *Economic History Review* 10 (no. 1, 1941):1–38; for criticism of Tawney's thesis, see Hugh R. Trevor-Roper, *The Gentry, 1540–1640* (Cambridge University Press, 1953).

39. See Simpson, *Puritanism in Old and New England*, pp. 32–34, and Wertenbaker, *Puritan Oligarchy*, chap. 7, "More of the World, Less of Heaven," pp. 202–7.

40. Cambridge, Mass., 1674, p. 8.

41. See Virginia Bernhard, "Cotton Mather and the Doing of Good: A Puritan Gospel of Wealth," *New England Quarterly* 49 (June 1976):240.

Chapter 2

1. Quoted in Gordon Goodwin, "William Dowsing," *Dictionary of National Biography*, 21 vols. (London: Oxford University Press, 1867–68), 5:1311.

2. Léon Wencelius, *L'Esthétique de Calvin* (Paris: Société d'Edition "Les Belles Lettres," 1937), pp. 166–67 and 184.

3. Cambridge, 1605, p. 829.

4. Roland Mushat Frye, *Milton's Imagery and the Visual Arts* (Princeton, N.J.: Princeton University Press, 1978), p. 25. See especially chap. 3, "Milton's Awareness of the Visual Arts," pp. 20–39.

5. Ibid., p. 32.

6. Ibid., p. 23.

7. See George C. Williamson, *The Portraits, Prints and Writings of John Milton* (New York: B. Franklin, 1968); John R. Martin, *The Portrait of John Milton at Princeton* (Princeton, N.J.: Princeton University Press, 1961); John F. Kerslake, "The Richardsons and the Cult of Milton," *Burlington Magazine* 99 (January 1957):23–24; William B. Hunter et al., *A Milton Encyclopedia* (Lewisburg, Pa.: Bucknell University Press, 1979), 6:202–9, "Portraits."

8. See John Phillips, *The Reformation of Images: Destruction of Art in England, 1535–1665* (Berkeley: University of California Press, 1975).

9. W. F. L. Nuttall, "King Charles I's Pictures and the Commonwealth Sale," *Apollo* 82 (October 1965):302–9.

10. Per Palme, *Triumph of Peace: A Study of the Whitehall Banqueting House* (Stockholm, Almqvist, 1956), p. 83.

11. P. W. Thomas, "Two Cultures? Court and Country Under Charles I," in *The Origins of the English Civil War*, ed. Conrad Russell (New York: Barnes & Noble, 1973), p. 191.

12. Ellis K. Waterhouse, *Painting in Britain, 1530–1790* (Baltimore: Penguin, 1953), p. 57.

13. Oliver Millar, *Sir Peter Lely* (London: National Portrait Gallery, 1978), no. 22, illustrated.

14. John Cotton, *Some Treasures Fetched out of Rubbish* (London, 1660), p. 71.

15. Cotton Mather, *Magnalia Christi Americana*, 2 vols. (Hartford, 1853), 1:255.

16. Boston, 1717, pp. 11–12.

17. Boston, 1725, p. 7.

18. Prynne (1600–69), a militant Puritan pamphleteer, was educated at Oxford; after studying law he was admitted to the bar in Lincoln's Inn in 1628. Thereafter he devoted himself to literary attacks upon court life and episcopacy, and on at least one occasion tried to persuade Parliament to suppress anything contrary to Calvinist doctrine. One of his treatises, *The Unloveliness of Lovelocks* (London, 1628), was an early assault on Cavalier society; its full title included the following: *A Summarie Discourse, Prooving: The Wearing, and Nourishing of a Locke, or Love-Locke, to be altogether unseemely, and unlawfull unto Christians. In which there are likewise some Passages collected . . . against Face-Painting; the wearing of supposititious, poudered, frizled, or extraordinary long Haire; the inordinate affectation of corporall Beautie; and Womens mannish unnaturall, impudent and unchristian cutting of their Haire; the epidemicall Vanities, and Vices of our Age.*

19. Quoted from P. W. Thomas, "Two Cultures?," p. 173.

20. On this matter, see Louis Wright, *Middle-class Culture in Elizabethan England* (Chapel Hill: University of North Carolina Press, 1935).

21. See Roy Strong, *The English Icon: Elizabethan and Jacobean Portraiture* (London:

Routledge & Kegan Paul, 1969); and Roy Strong, *Tudor and Jacobean Portraits* (London: National Portrait Gallery, 1969).

22. See Ursula Hoff, *Charles I, Patron of Artists* (London: Collins, 1942); Oliver Millar, *The Age of Charles I: Painting in England, 1620–1649* (London: Tate Gallery, 1972).

23. See Roy Strong, *Van Dyck: Charles I on Horseback* (London: A. Lane, Penguin, 1972).

24. The portraits of Elizabeth I, James I, and the Earl of Dorset are illustrated in Waterhouse, *Painting in Britain*, plates 18, 21, and 24.

25. Ibid., plate 34.

26. *The Tate Gallery 1974–76, Illustrated Catalogue of Acquisitions* (London: Tate Gallery, 1978), pp. 22–23. For a color illustration, see *The Tate Gallery: An Illustrated Companion to the National Collections of British and Modern Art* (London: Tate Gallery, 1979), p. 11.

27. A portrait of Sir Richard Saltonstall, owned by the Peabody Museum, Salem, Mass., was supposedly painted in Holland about 1644. It is illustrated in *The Saltonstall Papers, 1607–1815*, ed. Robert Moody (Boston: Massachusetts Historical Society Collections) 80 (1972), 1:following p. 268.

28. See Larsen, *Calvinistic Economy*, p. 55.

29. Quoted from George Vertue, *Note Books*, in *The Walpole Society* 18 (1929–30):91.

Chapter 3

1. Calvin, *Institutes of Christian Religion*, Book Three, chap. 19, sect. 9.

2. Ibid., Book Three, chap. 10, sect. 3.

3. Ibid., sect. 2.

4. Thomas Hall, *The Loathsomnesse of Long Haire* (London, 1653), p. 3.

5. Ibid., pp. 7 and 10.

6. Ibid., p. 13.

7. Ibid., p. 14.

8. Ibid., p. 26.

9. Ibid., p. 12.

10. Ibid.

11. Ibid., p. 30.

12. Ibid., p. 75.

13. Ibid., p. 69.

14. Ibid., p. 12.

15. Ibid., p. 15. Similarly, in *The Weekly Comedy*, a play of 1690, one character, Snarl, asks another, Brim, "How many bad women to you think have lain their heads together to complete that mane of yours?" See Richard Corson, *Fashions in Hair: The First Five Thousand Years* (London: Peter Owen, 1971), p. 224.

16. *Loathsomnesse of Long Haire*, p. 15.

17. Ibid., p. 34.

18. Ibid., pp. 56–57.

19. Ibid., pp. 102–3.

20. *Whole Duty of Man*, p. 142.

21. Ibid., pp. 203–5.

22. *Two Centuries of Costume in America, 1620–1820* (New York: Macmillan, 1910), p. 62.

23. *Out of Our Past*, p. 10. Quotations of the law are taken from *General Laws of Massachusetts* (Boston, 1658), p. 3.

Chapter 4

1. The pioneering work on seventeenth-century New England portraits has been done by Louisa Dresser, formerly curator at the Worcester Art Museum and the primary scholar behind that institution's exhibition of 1934 and its catalogue, *XVIIth Century Painting in New England* (Worcester, Mass.: Worcester Art Museum, 1935); since then she has published "Portraits in Boston, 1630–1720," *Journal of the Archives of American Art* 6 (July–October 1966):1–34; and "The Background of Colonial American Portraiture: Some Pages from a European Notebook," *Proceedings of the American Antiquarian Society* 76 (April 1966):19–58. See also Lillian B. Miller, "The Puritan Portrait: Its Function in Old and New England," in *Seventeenth Century New England* (Boston: The Colonial Society of Massachusetts, 1984), vol. 63:153–84.

2. On these portraits, see Dresser, *XVIIth Century Painting in New England*, pp. 81–83, and Fairbanks et al., *New England Begins*, 3:460–62. See also Susan Strickler, "Recent Findings on the Freake Portraits," *Worcester Art Museum Journal* 5 (1981–82):49–55.

3. Suffolk County Probate Records, Court of Probate, Boston, 5:294.

4. For a reconstruction of the original image of the *Mrs. Freake* and an analysis of X-ray studies of the picture, see Dresser, *XVIIth Century Painting in New England*, pp. 165–67, and Fairbanks et al., *New England Begins*, 3:460–61 and fig. 61.

5. See Thomas, "Two Cultures?," p. 189. See also Levin L. Schucking, *The Puritan Family: A Social Study from the Literary Sources* (New York: Schocken, 1970), and Gerald Moran and Maris Vinovskis, "The Puritan Family and Religion: A Critical Reappraisal," *William and Mary Quarterly*, 3rd series, 39 (January 1982):29–63. For a discussion nearly contemporary with the Freake portraits, see A. Marsh, *The Ten Pleasures of Marriage* (London, 1682), reprinted with an introduction by John Harvey (London: Navarre Society, 1972), with illustrations of the twenty original plates; the plate opposite p. 188 shows a seated woman with a child on her lap, very similar in composition to the image of Mrs. Freake and her daughter. See also Degler, *Out of Our Past*, p. 13.

6. For Perkins's quote, see *A Godly and Learned Exposition of Christ's Sermon in the Mount* (Cambridge, England, 1608), p. 170; for Prynne's quote, see *Histrio-Mastrix*, index, n.p., under "Haire."

7. Hull, *Diaries*, 3:211. For the William Woods case, see Robert St. George, " 'Set Thine House in Order': The Domestication of the Yeomanry in Seventeenth-century New England," in Fairbanks et al., *New England Begins*, 2:180.

8. Quoted in Wertenbaker, *Puritan Oligarchy*, p. 174.

9. The portrait of Sir John Clerk is at Penicuik House and is illustrated in Waterhouse, *Painting in Britain*, plate 75.

10. Frances Morris, *Notes on Laces of the American Colonists* (New York: William Helburn, 1926), p. 7.

11. See Marian Powys, *Lace and Lace-Making* (Boston: Charles T. Branford, 1953), plate 25.

12. Bailyn, *New England Merchants*, p. 74.

13. Quoted in Degler, *Out of Our Past*, p. 10.

14. Hudson Moore, *The Lace Book* (New York: Frederick A. Stokes, 1904), p. 23.

15. Esther Oldham, "Sheer Beauty: Early Lace Fans," *Antiques* 82 (August 1962):163.

16. Suffolk County Probate Records, Court of Probate, Boston, 5:294. See also the Turkey-work couch of about 1698 now at the Essex Institute, Salem, illustrated in Jonathan Fairbanks and Elizabeth Bates, *American Furniture, 1620 to the Present*

(New York: R. Marek, 1981), p. 40. For an English example of about the same date, see Fairbanks et al., *New England Begins*, 3:442 and 535, and colorplate 31.

17. See Dresser, "Background of Colonial American Portraiture," and Samuel Green, "English Origins of Seventeenth-Century Painting in New England," in *American Painting to 1776: A Reappraisal, Winterthur Conference Report* (Charlottesville: University Press of Virginia, 1971), pp. 15–70.

18. Dresser, "Background of Colonial American Portraiture," fig. 2.

19. The *Aston* portrait is illustrated in Waterhouse, *Painting in Britain*, plate 36.

20. David Loggan (1635–92) was born in Danzig, the son of a merchant of Scottish descent. After studying in Danzig and Amsterdam he settled in 1656 in London where he specialized in miniature portraits drawn with black lead on vellum. He had the reputation of being one of the foremost miniature draftsmen of his time, and several of his dimunitive portraits are preserved at the British Museum. See Robert Wark, *Early British Drawings in the Huntington Collection, 1600–1750* (San Marino, Calif.: Huntington Library, 1969), p. 36.

21. See *The Winslows: Pilgrims, Patrons, and Portraits; a Joint Exhibition at Bowdoin College Museum of Art and the Museum of Fine Arts, Boston* (Brunswick, Me.: Bowdoin College, 1974), in which these portraits are attributed to Robert Walker, an attribution with which the present author cannot agree, on the grounds of style.

22. For an illustration of the *Mrs. Baker*, see Dresser, "Portraits in Boston," p. 21, and Fairbanks et al., *New England Begins*, 3:colorplate 17. See also Charles K. Bolton, *The Founders: Portraits of Persons Born Abroad Who Came to the Colonies in North America Before the Year 1701*, 3 vols. (Boston: Boston Athenaeum, 1919–26), 3:888–97, in which is published much of the correspondence from Nicholas Roberts to Samuel and Elizabeth Shrimpton that concerns these portraits.

Chapter 5

1. See Karin Calvert, "Children in American Family Portraiture, 1670 to 1810," *William and Mary Quarterly*, 3rd series, 39 (January 1982):87–113.

2. Oakes, *New-England Pleaded With* (Cambridge, Mass.: 1673), p. 12.

3. Feather fans of this type are found in seventeenth-century portraits from both England and the Continent, as in the *Leventhorpe Family* at Melbourne Hall (see Dresser, "Background of Colonial American Painting," fig. 2) and in Johannes Cornelisz Verspronck's *Portrait of a Girl Dressed in Blue*; see Pieter J. van Thiel et al., *All the Paintings of the Rijksmuseum in Amsterdam* (Amsterdam: Rijksmuseum, 1976), illustrated p. 575.

4. For these portraits, see Dresser, *XVIIth Century Painting in New England*, pp. 84–89, and Fairbanks et al., *New England Begins*, 3:458–59 and colorplates 20–22.

5. Calvert, "Children in American Family Portraiture," pp. 94–97.

6. See Dresser, *XVIIth Century Painting in New England*, pp. 98–100, and Fairbanks et al., *New England Begins*, 3:462–63 and colorplate 24.

7. The prerestoration photograph is reproduced in Bolton, *Founders*, 3:991. It is also illustrated in Dresser, *XVIIth Century Painting in New England*, p. 129.

8. See "Genealogical Notices of the Descendants of Secretary Rawson," *New England Historical and Genealogical Register* 3 (October 1849):298.

9. Cotton Mather, *Johannes in Eremo* (Boston, 1695), p. 41.

10. Sidney Gold believed the unidentified artist was Augustine Clement, but his evidence remains circumstantial; see Chapter 6.

11. "Notice of Edward Rawson," *New England Historical and Genealogical Register* 3 (July 1849):201–8.

12. Leverett's gloves are illustrated in Fairbanks et al., *New England Begins*, 2:347; the quotation about them is taken from the same source.

13. For the *Self-Portrait* by Thomas Smith, see Dresser, *XVIIth Century Painting in New England*, pp. 133–38, and Fairbanks et al., *New England Begins*, 3:474 and colorplate 30. See also Roger B. Stein, "Thomas Smith's Self-Portrait: Image/Text as Artifact," *Art Journal* 44 (Winter, 1984):316–27.

14. Illustrated in Waterhouse, *Painting in Britain*, plate 36.

15. Hall, *The Loathsomnesse of Long Haire*, pp. 46 and 74.

16. For the surgical instruments, see Bolton, *Founders*, 2:363–65, and Dresser, "Portraits in Boston," pp. 8–9. Dr. Clark (c. 1598–1664) was reportedly a trained physician when he immigrated to New England in 1637. He settled first in Ipswich, where by 1639 he had been made a magistrate; he twice served as a representative from that town to the General Court of the Colony. Sometime after moving to Boston in 1651 he invented a stove "for warming houses and saving firewood, a device for the control of which the General Court allowed him exclusive rights, in October 1652" (Bolton, *Founders*, 2:363). Clark's son, John, also became a physician; his daughter, Elizabeth, was Cotton Mather's second wife.

17. The *Sir William Petty*, painted by Isaac Fuller about 1650, is illustrated in David Piper, *Catalogue of Seventeenth-century Portraits in the National Portrait Gallery, 1625–1714* (London: National Portrait Gallery, 1963), plate 8g.

18. For an inventory of Increase Mather's library, see the manuscript, written in Mather's own hand, "A Catalogue of Books belonging to Mr. Mather. 8th. 8. 1664. At Boston in New England," in the Boston Public Library; it is published in Julius Herbert Tuttle, "The Libraries of the Mathers," *Proceedings of the American Antiquarian Society* 20 (April 1910):280–92.

19. Increase Mather, *The Great Blessing* (Boston, 1693), p. 10.

20. See Ernest J. Moyne, "The Reverend William Bentley and the Portraits of Governor Winthrop," *Essex Institute Historical Collections* 110 (January 1974):49–56.

21. See Dresser, *XVIIth Century Painting in New England*, pp. 149–50 and 167–68, and Fairbanks et al., *New England Begins*, 3:465–66 and colorplate 26.

22. A portrait believed to represent John Wensley is illustrated and discussed in Fairbanks et al., *New England Begins*, 3:466–67 and colorplate 25.

23. Calvin, *Institutes of Christian Religion*, Book Three, chap. 10, sect. 1.

24. For a discussion of the relationship of the *Hutchinson* to the *Thomas Savage*, the *Captain George Curwin*, and the *Self-Portrait*, all by Thomas Smith, see Fairbanks et al., *New England Begins*, 3:472–73 and colorplate 29.

Chapter 6

1. See Henry and Margaret Ogden, "A Bibliography of Seventeenth-century Writings on the Pictorial Arts in English," *Art Bulletin* 29 (September 1947):196–201; Luigi Salerno, "Seventeenth-century English Literature on Painting," *Journal of the Warburg and Courtauld Institutes* 14 (July-December 1951):234–58; Janice G. Schimmelman, "A Checklist of European Treatises on Art and Essays on Aesthetics Available in America Through 1815," *Proceedings of the American Antiquarian Society* 93 (Part 1, 1983):95–195.

2. See Alan R. Young, *Henry Peacham* (Boston: Twayne, 1979), especially chap. 3, "Advice for Gentlemen."

3. On Bate's book, see Fairbanks et al., *New England Begins*, 3:423; the third section

of *The Mysteries of Nature and Art* is devoted to "Drawing, Limning, Colouring, Painting, and Graving."

4. *The Gentleman's Exercise*, pp. 10–11.

5. For these and other early-seventeenth-century English painters, see Strong, *The English Icon.*

6. *The Gentleman's Exercise*, p. 16.

7. Quoted from Young, *Peacham*, p. 60.

8. *The Compleat Gentleman*, p. 105.

9. Ibid., pp. 105–6.

10. Ibid., p. 106.

11. White's *Art's Treasury* (London, 1690), p. 19.

12. Ibid., p. 21.

13. Ibid., p. 22.

14. Ibid., p. 24.

15. Ibid., pp. 26–30.

16. Ibid., pp. 36–38.

17. Ibid., p. 39.

18. Salmon, *Polygraphice* (London, 1672), p. 3.

19. Ibid., pp. 5–6.

20. Ibid., p. 9. Salmon probably refers to Jacob van der Gracht's *Anatomie der wtterlicke deelen van het menschelick lichaem* (The Hague, 1634), with a later edition in Rotterdam in 1660.

21. *Polygraphice*, p. 73.

22. Ibid., p. 140.

23. Ibid.

24. Ibid., pp. 153–54.

25. Ibid., p. 138.

26. Ibid., p. 254.

27. Ibid., pp. 159–60.

28. Sidney Gold, "A Study in Early Boston Portrait Attributions: Augustine Clement, Painter-Stainer of Reading, Berkshire, and Massachusetts Bay," *Old-Time New England* 53 (January–March 1968):61–77.

29. *Records of the First Church at Dorchester, in New England, 1636–1734* (Boston: G. H. Ellis, 1891), p. 61.

30. For a study of the architectural painter and the various tasks he was called upon to perform, see Abbott Lowell Cummings, "Decorative Painters and House Painting at Massachusetts Bay, 1630–1725," *American Painting to 1776: A Reappraisal, Winterthur Conference Report* (Charlottesville: University Press of Virginia, 1971), pp. 71–125.

31. All three of these portraits are illustrated in Gold, "A Study in Early Boston Portrait Attributions."

32. See Samuel Abbott Green, *John Foster, the Earliest American Engraver and the First Boston Printer* (Boston: Massachusetts Historical Society, 1909).

33. See ibid., p. 52; Gillett Griffin, "John Foster's Woodcut of Richard Mather," *Printing and Graphic Arts* 7 (no. 1, 1959):1–8; Sinclair Hamilton, "Portrait of a Puritan, John Foster's Woodcut of Richard Mather," *Princeton University Library Chronicle* 18 (Winter 1967):43–48; Richard B. Holman, "Seventeenth-Century American Prints," *Prints in and of America to 1850, Winterthur Conference Report* (Charlottesville: University Press of Virginia, 1970), pp. 25–32. The five known surviving impressions are at Harvard University, Princeton University, University of Virginia, the American Antiquarian Society, and the Massachusetts Historical Society.

34. The painted portrait of Richard Mather is illustrated in Gold, "A Study in Early Boston Portrait Attributions," p. 67, fig. 3.
35. Green, *John Foster*, p. 39.
36. Abbott Lowell Cummings, *The Framed Houses of Massachusetts Bay, 1625–1725* (Cambridge, Mass.: Harvard University Press, 1979), pp. 198–201.
37. Sewall, *Diary*, 1:387, February 9, 1968.
38. Ibid., 1:554.

Chapter 7

1. Adriaen Van der Donck, *A Description of New Netherlands*, ed. Thomas F. O'Donnell (Syracuse, N.Y.: Syracuse University Press, 1968), p. 17.
2. For a purely promotional tract, see Daniel Denton, *A Brief Description of New-York, Formerly Called New Netherlands* (London: 1670). For Steendam's poem, see William Loring Andrews, *Jacob Steendam, Noch vaster: A Memoir of the First Poet of New Netherland* (New York: Dodd, Mead, 1908), pp. 43–54.
3. Quoted from Wright, *Cultural Life of the American Colonies*, p. 86.
4. *The Diary of John Evelyn*, ed. William Bray, 4 vols. (London: Bickers, 1906), 1:21–22. See also Johan H. Huizinga, *Dutch Civilization in the Seventeenth Century, and Other Essays* (London: Collins, 1968), pp. 43–46.
5. Esther Singleton, *Dutch New York* (New York: Dodd, Mead, 1909), p. 105.
6. Ibid.
7. Ibid., pp. 106–7, cites a number of these collections from the 1680s and 1690s.
8. Ibid., p. 94.
9. *Catalogue of American Portraits in the New-York Historical Society*, 2 vols. (New Haven, Conn.: Yale University Press, 1974), 2:783.

Chapter 8

1. Eleazer Mather, *A Serious Exhortation to the Present and Succeeding Generation in New-England* (Cambridge, Mass., 1671), p. 21.
2. "God's Controversy with New-England, written in the time of the great drought Anno 1662," *Massachusetts Historical Society Proceedings* 12 (May 1871):86 and 88.
3. *The Letters of Roger Williams, 1632–1682*, ed. J. R. Bartlett, in *Publications of the Narragansett Club* 6 (1874):319.
4. See Samuel Danforth, *A Brief Recognition of New England's Errand into the Wilderness* (Cambridge, Mass., 1671), p. 10.
5. Nathaniel B. Shurtleff, ed., *Records of the Governor and Company of the Massachusetts Bay in New England*, 5 vols. (Boston, 1853), 5:61 and 63.
6. John Norton, *The Heart of New-England Rent at the Blasphemies of the Present Generation* (Cambridge, Mass., 1659), p. 58.
7. *The Cause of God and His People in New-England* (Cambridge, Mass., 1663), p. 11. See also Urian Oakes, *New-England Pleaded With*, p. 27.
8. On this matter, see Wertenbaker, *Puritan Oligarchy*, pp. 76–77, and Robert Middlekauff, *The Mathers: Three Generations of Puritan Intellectuals, 1596–1728* (New York: Oxford University Press, 1971), p. 9. An increased secularization, at the expense of theocratic dominance, was also noted by George Lee Haskins, who wrote that by mid-seventeenth century, "the colony's economy changed to one in which diversity of occupation, abundance, and even luxury had begun to appear. . . . The wealth and the tastes for luxury which . . . trade engendered were such as to become a source of concern to the colony government. The entire basis of the Massachusetts economy had altered, and with that change were born new

ideals which shook, and eventually undermined, the religious foundations of the colonial government"; Haskins, *Law and Authority in Early Massachusetts* (New York: Macmillan, 1960), p. 109.

9. See Thomas J. Holmes, *Cotton Mather, A Bibliography of His Works*, 3 vols. (Cambridge, Mass.: Harvard University Press, 1940); Kenneth Silverman, *The Life and Times of Cotton Mather* (New York: Harper & Row, 1984).

10. Holmes, *Mather, A Bibliography*, 3:934–35.

11. *A Christian at His Calling*, p. 38.

12. Ibid.

13. Ibid., pp. 40–41.

14. Ibid., p. 65.

15. Ibid., p. 70; compare this with a passage from Benjamin Franklin's *Advice to a Young Tradesman* (1748), quoted in Chapter 18, note 6.

16. *A Christian at His Calling*, pp. 42 and 46.

17. Ibid., p. 50.

18. New London, Conn., 1714, p. 1.

19. Ibid., p. 5.

20. Ibid., pp. 7 and 8.

21. Ibid., p. 30.

22. *Bonifacius, An Essay upon the Good* (Boston, 1710), pp. 150 and 107.

23. "Three Puritans on Prosperity," *New England Quarterly* 7 (September 1934):475–93.

24. Sewall, *Diary*, 2:6.

25. See *Edward Randolph; Including his Letters and Official Papers from the New England, Middle, and Southern Colonies in America . . .* , 7 vols. (New York: Burt Franklin, 1967), and Michael G. Hall, *Edward Randolph and the American Colonies, 1676–1703* (Chapel Hill: University of North Carolina Press, 1960).

26. Sewall, *Diary*, 2:6.

27. *A Brief Account . . . of the Church of England*, p. 4.

28. New England then had only Episcopal priests but none of the higher officers of the Church of England. The priests were responsible to the Bishop of London and the writer of the tract *A Brief Account* was trying to forestall the day when the full Episcopal hierarchy would be established in New England.

29. See William E. H. Lecky, *A History of England in the Eighteenth Century*, 8 vols. (London: Longmans, Green, 1878–90), 6:185.

30. See Hugh S. Morrison, *Early Colonial Architecture, from the First Colonial Settlements to the National Period* (New York: Oxford University Press, 1952), pp. 475–79 and figs. 396 and 398.

31. Theophilus Cibber, *Lives of the Poets of Great Britain and Ireland*, 5 vols. (London, 1753), 5:340.

32. Act III, scene iii, lines 37–38; the edition quoted here is George Lillo, *The London Merchant*, ed. William H. McBurney (Lincoln: University of Nebraska Press, 1965).

33. Ibid., Act I, scene i, lines 27–28.

34. Ibid., Act I, scene i, lines 15–22.

35. Ibid., Act III, scene i, lines 1–9.

Chapter 9

1. W. H. Whitmore, ed., *John Dunton's Letters from New England*, 4 vols. (Boston: The Prince Society, 1867), 1:68.

2. Justin Winsor, *The Memorial History of Boston . . . 1630–1880*, 4 vols. (Boston: J. R. Osgood, 1880–81), 2:7–8.

3. Sewall, *Diary*, 1:151, under date of September 3, 1686.

4. Ibid., 1:105.

5. Ibid., 1:424, under date of May 7, 1696.

6. Bailyn, *New England Merchants*, pp. 192–93.

7. Alfred Owen Aldridge, *Benjamin Franklin and Nature's God* (Durham, N.C.: Duke University Press, 1967), p. 121.

8. Richard S. Dunn, *Puritans and Yankees: The Winthrop Dynasty of New England, 1630–1717* (Princeton, N.J.: Princeton University Press, 1962), pp. vi and 191.

9. For references to wigs and items of clothing, see "The Letters of Wait Still Winthrop, 1659–1700," *Collections of the Massachusetts Historical Society*, 5th series (1882), 8:394, 407, 418, 469, 503, and 512.

10. Ibid., 8:500.

11. See Dresser, *XVIIth Century Painting in New England*, pp. 18–19.

12. The *Jaffrey* is illustrated in ibid., p. 90.

13. Winsor, *Memorial History of Boston*, 2:540 and 49.

14. Mabel Swan, *The Athenaeum Gallery, 1827–1873; The Boston Athenaeum as an Early Patron of Art* (Boston: Boston Athenaeum, 1940), p. 132; Robert F. Perkins and William J. Garvin III, *The Boston Athenaeum Art Exhibition Record, 1827–1874* (Boston: Library of the Boston Athenaeum, 1980), pp. 91–92.

15. Noyes's treatise is published in Worthington Ford, "Sewall and Noyes on Wigs," *Publications of the Colonial Society of Massachusetts* 20 (February 1918):109–28.

16. Robert E. Moody, ed., *The Saltonstall Papers, 1607–1815* (Boston: Massachusetts Historical Society Collections), vol. 80 (1972), part 1:102.

17. See William L. Warren, "The Pierpont Limner and Some of His Contemporaries," *Connecticut Historical Society Bulletin* 23 (October 1958):1–10, 50–60, and 97–128; the Collins and Savage portraits are illustrated on pp. 122 and 123. The *Savage* is illustrated in Dresser, "Portraits in Boston, 1630–1720," p. 29.

18. Dresser, *XVIIth Century Painting in New England*, p. 115.

Chapter 10

1. See Dixon R. Fox, *Caleb Heathcote, Gentleman Colonist: The Story of a Career in the Province of New York, 1692–1721* (New York: Scribner, 1926).

2. Quoted from Corson, *Fashions in Hair*, p. 223.

3. See Mary Black, "Contributions Toward a History of Early Eighteenth-century New York Portraiture: Identification of the Aetatis Suae and Wendell Limners," *American Art Journal* 12 (Autumn 1980):4–31, and Mary Black, "Pieter Vanderlyn and Other Limners of the Upper Hudson," in *American Painting to 1776: A Reappraisal, Winterthur Conference Report for 1971* (Charlottesville: University Press of Virginia, 1971), pp. 217–50.

4. Waldron Phoenix Belknap, *Americal Colonial Painting: Materials for a History* (Cambridge, Mass.: Harvard University Press, 1959), plate XIII, figs. 8 and 8A. See also John Marshall Phillips, *The Discoveries of Waldron Phoenix Belknap, Jr., Concerning the Influence of the English Mezzotint on Colonial Painting* (Cambridge, Mass.: Harvard University Press, 1955), pp. 8–9.

5. Belknap, *American Colonial Painting*, plate XI, figs. 4A and 4B, and plate XXV, figs. 22B and 22C.

6. Ibid., plate XXXIV, figs. 36 and 36A.

Chapter 11

1. Daniel Neal, *The History of New England . . . to the Year of Our Lord 1700, to Which Is Added the Present State of New England . . .* , 2 vols. (London, 1720), 2:590.

2. Ibid.

3. For these houses, see Winsor, *Memorial History of Boston*, 2:259 and 521–27; and Morrison, *Early American Architecture*, pp. 475–78.

4. See Richard B. Holman, "William Burgis," in *Publications of the Colonial Society of Massachusetts* 46 (1973):57–81, and John H. Edmonds, "The Burgis-Price View of Boston," ibid. 11 (1910):245–62.

5. See Emma Forbes Waite, "William Price of Boston, Map-Maker, Merchant and Churchman," *Old-Time New England* 46 (Fall 1955):52–56.

6. See Sinclair Hitchings, "Thomas Johnston," in *Publications of the Colonial Society of Massachusetts* 46 (1973):83–131.

7. For Pelham's career in England and a catalogue of the mezzotints he produced there, see John Chaloner Smith, *British Mezzotint Portraits*, 4 vols. (London, 1878–83), 3:964–78.

8. For Pelham's career in America, see Anne Allison, "Peter Pelham, Engraver in Mezzotinto," *Antiques* 52 (December 1947):441–43. Andrew Oliver, "Peter Pelham (c. 1697–1751), Sometime Printmaker of Boston," in *Boston Prints and Printmakers, 1670–1775* (Boston: Publications of the Colonial Society of Massachusetts 46 (1973):133–73), gives a catalogue of Pelham's American work and illustrates all fourteen of his known portraits.

9. Thomas J. Holmes, "Samuel Mather of Whitney, 1674–1773," *Publications of the Colonial Society of Massachusetts* 26 (January 1926): 312–21.

10. Kenneth B. Murdock, *Increase Mather*, 2:270; Robert White made the mezzotint after van der Spriett's painting of 1688.

11. For biographical information on Colman, see William B. Sprague, *Annals of the American Pulpit*, 9 vols. (New York, 1857–69), 1:223–29. Also, "Memoir of Rev. Benjamin Colman, D. D.," *New England Historical and Genealogical Register* 3 (July 1849):220–32. Ebenezer Turell, *The Life and Character of the Reverend Benjamin Colman, D. D.* (Boston, 1749); a facsimile with introduction by Christopher R. Reaske (Delmar, N.Y.: Scholar's Facsimile & Reprints, 1972).

12. *A Dissertation on the Image of God*, p. 3.

13. See a letter from Dummer to Colman, January 15, 1714, published in *Collections of the Massachusetts Historical Society* 5 (1798):198.

14. For the three portraits by Smibert, see *The Notebook of John Smibert*, with essays by Sir David Evans, John Kerslake, and Andrew Oliver (Boston: Massachusetts Historical Society, 1969), pp. 93 and 111, nos. 103–5.

15. Colman, *The Religious Regards We Owe our Country, and the Blessings of Heaven Assured Thereunto* (Boston, 1718), p. 27. I am indebted to Ellen Marie Snyder, a student of Professor Leo Lemay, for information about Colman's will.

16. For the robes, collar, wig, and so on worn by English Episcopal ministers, see the image of George Berkeley in Smibert's *Bermuda Group* (Fig. 78). John Ingamell's *The English Episcopal Portrait, 1559–1835* (New Haven, Conn.: The Paul Mellon Centre for Studies in British Art, 1981) provides numerous examples.

17. *Boston News-Letter*, December 16, 1731. See also Henry Wilder Foote, "Musical Life in Boston in the Eighteenth Century," in *Proceedings of the American Antiquarian Society* 49 (October 1939):293–313.

18. Quoted from John Tasker Howard, *Our American Music: A Comprehensive History from 1620 to the Present* (New York: Crowell, 1965), p. 21.

19. Ibid., p. 18.

20. Ibid., p. 22.
21. Sewall, *Diary*, p. 506.
22. Ibid., p. 285.
23. Howard, *Our American Music*, p. 23. See also Peter Rouse, " 'The Modern Orpheus,' Peter Pelham [Jr.]," *Arts in Virginia* 18 (Winter 1978):21–25. The younger Pelham's activities in Virginia have been summarized by Richard Beale Davis, who described him as a "conductor and instrumentalist in chamber groups and in the theatre, teacher of harpsichord and other instruments, jailer, clerk of two governors.... He gave secular and sacred concerts, he played at theatrical performances, he had his pupils.... [Thomas] Jefferson once paid him 2/6 'for playing the organ,' and he was in constant demand for special occasions, among them the funeral services for Lord Botetourt and for William Rind, publisher of a *Virginia Gazette*. He was also Grand Organist of the Grand Lodge of Virginia Masons in an era when music was a vital part of Masonic rituals and anniversary celebrations." Quoted from Davis's *Intellectual Life in the Colonial South*, 3 vols. (Knoxville: University of Tennessee Press, 1978), 3:1268.

Chapter 12

1. Smibert was not the first trained professional portraitist to come to the colonies; Gustavus Hesselius, for example, had come to Delaware from Sweden in 1711, and John Watson, a Scot, had settled in New Jersey by 1714, while the German Justus Engelhardt Kühn was working in Annapolis between 1708 and 1717. But Hesselius and Watson turned to other professions, and Kühn's total known works number less than a score.
2. On Smibert, see Henry Wilder Foote, *John Smibert, Painter: With a Descriptive Catalogue of Portraits* (Cambridge, Mass.: Harvard University Press, 1950).
3. See Morris R. Brownell, *Alexander Pope and the Arts of Georgian England* (New York: Oxford University Press, 1978), pp. 9–38, "Amateur, Sitter, and Connoisseur." See also Martin C. Battestin, *The Providence of Wit, Aspects of Form in Augustan Literature and the Arts* (New York: Oxford University Press, 1974).
4. For Kneller, see Michael M. Killanin, *Sir Godfrey Kneller and His Times, 1646–1723, Being a Review of English Portraiture of the Period* (New York: Batsford, 1948), and J. Douglas Stewart, *Sir Godfrey Kneller* (London: National Portrait Gallery, 1971).
5. Jonathan Richardson, *An Essay on the Theory of Painting* (London: 1715), pp. 24–25.
6. Ibid., pp. 172–88.
7. See George Vertue, *Note Books*, 6 vols., in *The Walpole Society* (1934), 3:11.
8. *The Notebook of John Smibert*, pp. 78–86.
9. Vertue, *Note Books*, 3:36.
10. Ibid., 3:161.
11. A. A. Luce and T. E. Jessop, eds., *The Works of George Berkeley, Bishop of Cloyne*, 9 vols. (London: Thomas Nelson & Sons, 1957), 8:189.
12. Ibid., 8:190, letter to Sir John Percival, from Newport, R.I., February 7, 1728/29.
13. See Peter Mooz, "Smibert's *Bermuda Group* – A Reevaluation," *Art Quarterly* 33 (Summer 1970):147–57. The small version of the *Bermuda Group* is illustrated in fig. 8.
14. Luce and Jessop, *Works of George Berkeley*, 2:41–42, *Of the Principles of Human Knowledge*, part 1:2. On this subject see also George Berkeley, *An Essay Towards a New Theory of Vision* (Dublin, 1710), and David M. Armstrong, *Berkeley's Theory*

of Vision: A Critical Examination of Bishop Berkeley's "Essay Towards a New Theory of Vision" (Parkville, Australia: Melbourne University Press, 1960).

15. Luce and Jessop, *Works of George Berkeley*, 2:43, part 1:5.
16. Ibid.
17. Ibid., 2:44, part 1:8.
18. Ibid., 2:53, part 1:30.
19. Ibid., 2:25, Introduction:1.
20. See Foote, *John Smibert, Painter*, pp. 65–66.
21. *The Notebook of John Smibert*, pp. 23, 89, and 107–8.
22. *The Works of George Berkeley*, 8:205. See also Alice Brayton, *George Berkeley in Newport* (Newport, R.I.: Anthoensen Press, 1954).
23. *The Works of George Berkeley*, 8:205.
24. Illustrated in R. B. Beckett, *Lely* (London: Routledge & Kegan Paul, 1951), plate 50. Kneller seldom painted group portraits, and when he did, he failed to obtain the unification of the figures that Lely achieved; see, for example, Kneller's *First Duke of Chandos and His Family* of 1713, now in the National Gallery of Canada, Ottawa, and illustrated in John Kerslake, *Early Georgian Portraits*, 2 vols. (London: National Portrait Gallery, 1977), 2:fig. 105.

Chapter 13

1. *The Notebook of John Smibert*, pp. 21–22 and 87–89.
2. For the entire poem, see ibid., pp. 54–55.
3. Advertisement in the *Boston News-Letter*, May 15–22, 1735; see also Foote, *John Smibert, Painter*, p. 77.
4. Henry Wilder Foote, "John Smibert Shows His Pictures, March 1730," *New England Quarterly* 8 (March 1935):14–28.
5. Carl Bridenbaugh, ed., *Gentleman's Progress. The Itinerarium of Dr. Alexander Hamilton, 1744* (Chapel Hill: University of North Carolina Press, 1948), p. 114.
6. *The Notebook of John Smibert*, pp. 87 and 104. See also Stuart Feld, "In the Latest London Manner," *Metropolitan Museum of Art Bulletin* 21 (May 1963):296–308, and Albert T. Gardner and Stuart Feld, *American Paintings: A Catalogue of the Metropolitan Museum of Art* (Greenwich, Conn.: New York Graphic Society, 1965), pp. 3–4.
7. For a wood engraving of Datchet House, see Francis S. Drake, *The Town of Roxbury* (Roxbury, Mass., 1878), p. 327, which is also illustrated in Stuart Feld, "In the Latest London Manner," p. 302.
8. John Bigelow, ed., *The Complete Works of Benjamin Franklin*, 10 vols. (New York: Putnam, 1888), 6:46. See also Paul W. Conner, *Poor Richard's Politicks: Benjamin Franklin and His New American Order* (New York: Oxford University Press, 1965), "Republican Simplicity," pp. 48–66.
9. The *Lady Price* is illustrated in Feld, "In the Latest London Manner," p. 303, fig. 6. Although Lely's *Duchess of Argyle*, in the collection of Ham House, Richmond, also bears this motif, it seems never to have been engraved, and its image would therefore not have been accessible in New England; it is illustrated in Beckett, *Lely*, fig. 128.
10. See also Feld, "In the Latest London Manner," p. 306 and fig. 8, an engraving of the *Madonna and Child with St. John*, by Etienne Picart, after the painting by Annibale Carracci.
11. See Frank Goodyear, *American Paintings in the Rhode Island Historical Society* (Providence: The Rhode Island Historical Society, 1974), pp. 3–6.
12. The subject of this portrait has often been incorrectly identified as Mrs. James

Lindall (1660–1733), as in Foote, *John Smibert, Painter*, pp. 166–67 and 184. In *The Notebook of John Smibert* she is correctly identified in the editor's note, p. 111, no. 107.

Chapter 14

1. See Thomas F. Ryan, *The London Company of Virginia* (New York: n.p., 1908).
2. On this matter, see Philip A. Bruce, *Social Life of Virginia in the Seventeenth Century: An Inquiry into the Origins of the Higher Planter Class* (Lynchburg, Va.: J. P. Bell 1927), p. 83.
3. See Thomas Jefferson Wertenbaker, *Patrician and Plebeian in Virginia; or, The Origin and Development of the Social Classes* (New York: Russell, 1959), pp. 132–33.
4. Dixon Wecter, *The Saga of American Society: A Record of Social Aspirations, 1607–1937* (New York: Scribner, 1937), p. 17.
5. Wertenbaker, *Patricians and Plebeians*, p. 41.
6. Ibid., p. 109.
7. Louis B. Wright, *The First Gentlemen of Virginia: Intellectual Qualities of the Early Colonial Ruling Class* (San Marino, Calif.: The Huntington Library, 1940), p. 93.
8. Wecter, *Saga of American Society*, p. 43.
9. Gilbert Chinard, ed., *A Huguenot Exile in Virginia; or, Voyages of a Frenchman Exiled for His Religion, with a Description of Virginia & Maryland*; from the Hague edition of 1687; with an introduction and notes by Gilbert Chinard (New York: Press of the Pioneers, 1934), pp. 110–11 and 119.
10. Bolton, *Founders*, 1:179–85.
11. *Virginia Magazine of History and Biography* 5 (1898):328–29, and 330.
12. Ibid., p. 333. The Moseley collection remained largely intact into the early twentieth century, descending to Burwell Basset Moseley, but after his death it seems to have been dispersed.
13. *William and Mary Quarterly* 3 (1894–95):181.
14. *William and Mary Quarterly* 1 (1892–93):208.
15. Mary Mann Page Stanard, *Colonial Virginia, Its People and Customs* (Philadelphia: Lippincott, 1917), p. 316.
16. See Richard Beale Davis, *William Fitzhugh and his Chesapeake World, 1676–1701: The Fitzhugh Letters and Other Documents* (Chapel Hill: University of North Carolina Press, 1963).
17. Chinard, ed., *A Huguenot Exile in Virginia*, p. 158.
18. Letter, William Fitzhugh to Henry Hartwell, a merchant in London, dated 1698; quoted from Wright, *First Gentlemen of Virginia*, p. 176.
19. For Fitzhugh's library, see ibid., pp. 179–86.
20. "The Will of William Fitzhugh," *Virginia Magazine of History and Biography* 2 (1895):276–77.
21. *Virginia Magazine of History and Biography* 2 (1895):130, and Davis, *William Fitzhugh and His Chesapeake World*, p. 216.
22. Henry Fitzhugh's portrait bears the inscription, on the back of the canvas, "Henry Fitzhugh Son of Wllm Fitzhugh of Bedford. Aetatis 20, 1634. Copd by John Hesselius 1751." On the back of William Fitzhugh's portrait are the words "Col. William Fitzhugh, 1651–1701, son of Henry Fitzhugh (aetatis 46) born 1614. Copd by John Hesselius 1751." See Richard K. Doud, "The Fitzhugh Portraits by John Hesselius," *Virginia Magazine of History and Biography* 75 (1967):159–73, in which the several generations of Fitzhughs as portrayed or copied by Hesselius are reproduced and discussed.
23. Quoted from Beale, *William Fitzhugh and His Chesapeake World*, p. 367.

24. See Jonathan Daniels, *The Randolphs of Virginia* (New York: Doubleday, 1972).

25. On this matter, see Bernard Bailyn, "Politics and Social Structure in Virginia," in *Seventeenth-Century America*, ed. James Morton Smith (Chapel Hill: University of North Carolina Press, 1959), pp. 108–110.

26. For an illustration of a wig, cravat, and coat of 1695–1700 that are nearly identical to those seen in Randolph's portrait, see Cecil W. Cunnington and Phyllis E. Cunnington, *Handbook of English Costume in the Seventeenth Century* (London: Faber, 1967), p. 146, fig. 70d.

27. For an illustration of Riley's *Duke of Lauderdale*, at Syon House, see Waterhouse, *Painting in Britain*, fig. 86A.

28. Portraits exist that have been said to represent Richard Lee the Emigrant and his wife, Anne. But the costumes, of a period long after the deaths of the subjects, suggest that these are probably of a later generation of Lees. For illustrations, see Ludwell Lee Montague, "Richard Lee, the Emigrant, 1613–1664," *Virginia Magazine of History and Biography* 62 (January 1954):opp. pp. 16 and 17, and Cazenova G. Lee, *Lee Chronicle: Studies of the Early Generations of the Lees of Virginia* (New York: New York University Press, 1957), plate XVIII.

29. Quoted from Wright, *First Gentlemen of Virginia*, p. 165.

30. Ibid., p. 231.

31. On courtesy books, see Esther B. Aresty, *The Best Behavior: The Course of Good Manners – From Antiquity to the Present – as Seen Through Courtesy and Etiquette Books* (New York: Simon & Schuster, 1970).

32. Allestree, *Gentleman's Calling*, p. 1.

33. Ibid., p. 2.

Chapter 15

1. William P. Palmer, ed., *Calendar of Virginia State Papers and Other Manuscripts, 1652–1781*, 11 vols. (Richmond, Va., 1875), 1:94–95; Bruce T. McCully, "Governor Francis Nicholson, Patron *Par Excellence* of Religion and Learning in Colonial America," *William and Mary Quarterly* 39 (April 1982):331. I am indebted to Professor Leo Lemay for calling this reference to my attention.

2. *William and Mary Quarterly* 7 (January 1899):187–88, and ibid., 2 (April 1894):251.

3. Ibid., 4 (October 1895):95.

4. Ibid., 15 (April 1907):279.

5. Ibid., 12 (October 1903):129.

6. Ibid., 2 (July 1893):83.

7. Hugh Jones, *The Present State of Virginia; from Whence Is Inferred a Short View of Maryland and North Carolina* (London, 1724), ed. Richard L. Morton (Chapel Hill: University of North Carolina Press, 1956), p. 43.

8. Waldron Phoenix Belknap first observed the close stylistic relationship between these Virginia portraits and the work of a then anonymous Hudson Valley patroon painter, in his *American Colonial Painting*, p. 309. Mary Black has identified the artist as Nehemiah Partridge in her article "Contributions Toward a History of Early Eighteenth-Century New York Portraiture: Identification of the Aetatis Suae and Wendell Limners"; see also Black's "The Case of the Red and Green Birds," *Arts in Virginia* 3 (Winter 1963):1–3, and "The Case Reviewed: Fresh Evidence . . . ," *Arts in Virginia* 10 (Fall 1969):n.p.

9. A comparison of the Jaquelin–Brodnax group with the Hudson Valley portraits of Evert Wendell and his wife shows the style to be virtually identical. For illustrations of the Wendell portraits, see Black, "Contributions Toward a History of Early Eighteenth-Century New York Portraiture," figs. 4 and 5.

10. For this comparison, see Graham Hood, *Charles Bridges and William Dering: Two Virginia Portrait Painters, 1735–1750* (Charlottesville: University Press of Virginia, 1978), p. 33, fig. 14, where the *Cecil* mezzotint is illustrated.

11. Simon's *Lady Carteret* is illustrated in Belknap, *American Colonial Painting*, plate XXXIII, fig. 34.

12. These four Hudson Valley portraits are illustrated in ibid., plate LIV.

13. Ibid., plate XXXI, fig. 31.

14. See "The Will of Mrs. Mary Willing Byrd, of Westover, 1813, with a List of the Westover Portraits," *Virginia Magazine of History and Biography* 6 (April 1899):346–58. Many of the portraits listed were, of course, painted and placed in Westover after William Byrd's time.

15. The original of the *Sir Robert Southwell* of 1695, by Sir Godfrey Kneller, is in the Royal Society, a gift from the subject; see Norman Robinson, *The Royal Society Catalogue of Portraits* (London: Royal Society, 1980), p. 286. A copy, the one once at Westover, is in the Virginia Historical Society, Richmond.

16. Marion Tinling, ed., *The Correspondence of the Three William Byrds, of Westover, Virginia, 1684–1776*, 2 vols. (Charlottesville: University Press of Virginia, 1977), 2:487. A portrait of Lord Egmont by Kneller is at the National Portrait Gallery, London, and the one at Westover may have been a copy of it; see Kerslake, *Early Georgian Portraits*, 2:fig. 192.

17. A portrait of Walthoe existed at the Virginia plantation house at Lower Brandon in 1915, and it may have been the one from the Byrd collection.

18. Virginius Cornick Hall, Jr., *Portraits in the Collection of the Virginia Historical Society* (Charlottesville: University Press of Virginia, 1981), pp. 41–42.

Chapter 16

1. Letter dated February 23, 1720/21, in the Fairfax Papers, Huntington Library, San Marino, California, quoted in Wright, *First Gentlemen of Virginia*, p. 256.

2. The diary, for the years 1722–27, is in Alderman Library, University of Virginia, Charlottesville. See Hood, *Bridges and Dering*, p. 5, note 8.

3. Ibid., pp. 70–72.

4. The National Portrait Gallery in Washington owns a portrait identified as Robert "King" Carter, but Hood, who attributes it to Bridges, believes it represents a member of the Howell family; see ibid., p. 74.

5. Wright, *First Gentlemen of Virginia*, p. 110.

6. *William and Mary Quarterly* 7 (July 1898):43–44.

7. See Parke Rouse, *James Blair of Virginia* (Chapel Hill: University of North Carolina Press, 1971), pp. 232–40.

8. See Hood, *Bridges and Dering*, as the most recent study of this artist's life and career. An older study is by Henry W. Foote, "Charles Bridges, 'Sargeant-Painter of Virginia,' " *Virginia Magazine of History and Biography* 60 (January 1952):3–53. See also Hood, "A New Look at Charles Bridges, Colonial Virginia Painter, 1735–45," *American Art Journal* 9 (November 1977):57–67.

9. Letter dated May 26, 1735, quoted from Foote, "Charles Bridges," p. 10.

10. *Virginia Magazine of History and Biography* 36 (July 1928): 211–12.

11. On Spotswood, see Walter Havighurst, *Alexander Spotswood, Portrait of a Governor* (New York: Holt, Rinehart & Winston, 1967).

12. *Virginia Magazine of History and Biography* 8 (July 1901):108.

13. The Page portraits have been attributed to Bridges by Hood in *Bridges and Dering*, pp. 16–27.

14. *Virginia Magazine of History and Biography* 20 (October 1912):375.

15. Allestree, *Ladies Calling*, p. 5.
16. Ibid., p. 6.
17. Ibid., p. 19.
18. Ibid., p. 51.
19. Burton J. Hendrick, *The Lees of Virginia: Biography of a Family* (Boston: Little, Brown, 1935).
20. *A Memoir of the Bolling Family in England and Virginia* (Richmond, Va.: W. H. Wade, 1868), p. 4.
21. Hood, *Bridges and Dering*, p. 62.
22. *Memoir of the Bolling Family*, p. 5.
23. Ibid., pp. 5–6.
24. The *Mrs. John Bolling, Jr.* is illustrated in the *Virginia Magazine of History and Biography* 22 (1914):following p. 216; and in Hood, *Bridges and Dering*, p. 67, fig. 38.
25. *William and Mary Quarterly*, 2nd series, 6 (October 1926):304. Collinson's letter was dated London, February 17, 1737.
26. Ibid., p. 306. Bartram's letter is dated November 19, 1738.
27. Ibid., p. 309.
28. In *The Eye of Thomas Jefferson*, ed. William Howard Adams (Washington, D. C.: National Gallery of Art, 1976), pp. 5–6, the *Isham Randolph* is attributed to the British School. Hood, in *Bridges and Dering*, p. 5, n. 8, believes it was painted in Virginia by a presently unidentified artist who was active there in the 1720s.

Chapter 17

1. A full-length, early seventeenth-century portrait of the first Lord Baltimore, in the aristocratic Continental baroque style, is owned by the Enoch Pratt Free Library in Baltimore.
2. See Matthew Page Andrews, *History of Maryland: Province and State* (New York: Doubleday, Doran, 1929), pp. 183–86.
3. On Herrman, see Thomas Allen Glenn, *Some Colonial Mansions and Those Who Lived in Them* (Philadelphia: Henry T. Coates, 1897), pp. 123–38; an account of his life is given in *Dictionary of American Biography*, 4:592–93.
4. On Kühn, see J. Hall Pleasants, "Justus Engelhardt Kühn, an Early Eighteenth-Century Maryland Portrait Painter," *Proceedings of the American Antiquarian Society* 46 (October 1936): 243–80; the *Henry Darnall I* is illustrated opp. p. 271.
5. Ibid., opp. p. 274.
6. Sally D. Mason, "Charles Carroll of Carrollton and His Family, 1688–1832," in *"Anywhere So Long As There Be Freedom," Charles Carroll of Carrollton, His Family & His Maryland* (Baltimore: Baltimore Museum of Art, 1975), pp. 9–33, and catalogue no. 4, pp. 120–21; a second portrait of Carroll the Settler is illustrated on p. 121, which could be the work of Kühn. See Pleasants, "Kühn," pp. 276–77.
7. For the history of literature and belle lettres in early-eighteenth-century Maryland, see J. A. Leo Lemay, *Men of Letters in Colonial Maryland* (Knoxville: University of Tennessee Press, 1972), pp. 71–184.
8. See Sir Mervyn Edmund Macartney, *English Manor Houses and Gardens in the 17th and 18th Centuries. A Series of Birds-eye Views Reproduced from Contemporary Engravings by Kip, Badeslade, Harris and Others* (London: Batsford, 1908).
9. Pleasants, "Kühn," pp. 253–54.
10. For illustrations of the work of Werner and Mignon, see Gotz Adriani, *Deutsche*

Malerei im 17. Jahrhundert (Cologne: DuMont Buchverlag, 1977), fig. 57, p. 70, and fig. 41, p. 53.

11. Pleasants, "Kühn," p. 250.
12. Roland E. Fleischer, "Gustavus Hesselius: A Study of His Style," in *American Painting to 1776: A Reappraisal, Winterthur Conference Report for 1971* (Charlottesville: University Press of Virginia, 1971), pp. 127–58.
13. See Lemay, *Men of Letters in Colonial Maryland*, "Richard Lewis," pp. 126–84.
14. Ibid., "William Parks: Printer," pp. 111–25.
15. Elizabeth B. Gibson, *Biographical Sketches of the Bordley Family* (Philadelphia, 1865), p. 20.
16. See Fleischer, "Hesselius: A Study of His Style," pp. 148–49.
17. Roland Fleischer, "Gustavus Hesselius," Ph.D. dissertation, Johns Hopkins University, 1964, catalogue no. 13.
18. Ann Van Devanter et al., *"Anywhere So Long As There Be Freedom," Charles Carroll of Carrollton, His Family & His Maryland* (Baltimore: Baltimore Museum of Art, 1975), p. 138.
19. *The Works of John Locke*, 9 vols., 9th edition (London, 1794), 9:175–76.
20. Wecter, *Saga of American Society*, p. 30, and Schlesinger, *Birth of the Nation*, p. 129.
21. See Wecter, *Saga of American Society*, p. 31.
22. On this subject, see Frederick P. Bowes, *The Culture of Early Charleston* (Chapel Hill: University of North Carolina Press, 1942; reprinted, Westport, Conn.: Greenwood, 1978).
23. The *Nathaniel Johnson* is illustrated in Richard P. Sherman, *Robert Johnson, Proprietary & Royal Governor of South Carolina* (Columbia: University of South Carolina Press, 1966), opp. p. 31. The portrait is owned by the Carolina Art Association, Charleston.
24. John Lawson, *The History of North Carolina* (London, 1714), p. xiv.
25. Bowes, *The Culture of Early Charleston*, p. 5.
26. Quoted from Mrs. St. Julien (Harriott Horry Rutledge) Ravenel, *Charleston, the Place and the People* (New York: Macmillan, 1907), pp. 84–85.
27. See Margaret Middleton, *Henrietta Johnston of Charles Town, South Carolina* (Columbia: University of South Carolina Press, 1966.
28. Anna Wells Rutledge, *Artists in the Life of Charleston, Through Colony and State, from Restoration to Reconstruction* (Philadelphia: American Philosophical Society *Transactions* 39 [November 1949]), part 2.
29. Quoted from Ravenel, *Charleston, the Place and the People*, p. 85.
30. Mark Catesby, *The Natural History of Carolina, Florida and the Bahama Islands, Containing the Figures of Birds, Beasts, Fishes, Serpents, Insects and Plants* (London, 1731). See George Frick and Raymond Phineas Stearns, *Mark Catesby: The Colonial Audubon* (Urbana: University of Illinois Press, 1961), and George Frick and Joseph Ewan, eds., *The Natural History of Carolina, Florida and the Bahamas . . .* (Savannah, Ga.: Beehive Press, 1974).
31. Rutledge, *Artists in the Life of Charleston*, p. 112.

Chapter 18

1. Benjamin Franklin, *The Autobiography of Benjamin Franklin: A Genetic Text*, ed, J. A. Leo Lemay and Paul M. Zall (Knoxville: University of Tennessee Press, 1981), p. 11.
2. Franklin to Samuel Mather, May 12, 1784; Franklin, *The Writings of Benjamin Franklin*, ed. Albert Henry Smyth, 10 vols. (New York: Macmillan, 1907), 9:208.

Franklin made similar comments in a letter to Samuel Mather dated July 7, 1773; see Franklin, *The Papers of Benjamin Franklin*, ed. Leonard W. Labaree et al., 23 vols. to date (New Haven, Conn.: Yale University Press, 1959–), 20:286–87.

3. A. Whitney Griswold, "Three Puritans on Prosperity," *New England Quarterly* 7 (1934), p. 484. The three Puritans are Cotton Mather, Benjamin Franklin, and Timothy Dwight. See also *The Papers of Benjamin Franklin*, 1:255–56, editors' comment: "In the fall of 1727 Franklin 'form'd most of my ingenious Acquaintances into a Club for mutual Improvement, which we called the Junto.' An important inspiration for it was the deep influence which Cotton Mather's *Essays to Do Good* had had on Franklin. Mather had proposed voluntary associations to promote religion and morality. . . . Franklin took the suggestion, secularized it, gave it a practical and specific purpose."

4. Franklin, *The Papers of Benjamin Franklin*, 3:308 and note 4; see also 7:326–50, where the various forms, editions, and translations of this piece are discussed. It appeared in *Poor Richard's Almanack* of 1758, was later published separately as *Father Abraham's Speech*, and was presented under the title *The Way to Wealth* in 1774.

5. Degler, *Out of Our Past*, p. 8.

6. Franklin, *The Papers of Benjamin Franklin*, 3:308.

Chapter 19

1. Degler, *Out of Our Past*, p. 44.

2. Franklin, *The Writings of Benjamin Franklin*, 8:604.

3. Ibid., 8:605–6.

4. Ibid., 8:608.

5. Ibid., 8:608–9.

6. Ibid., 8:613.

7. A good comparison here would be Copley's *Mrs. John Greene* in the Cleveland Museum of Art with Gainsborough's *Mary, Lady Bate-Dudley*, owned by Lord Burton but on loan to Marlborough House. For illustrations, see Jules D. Prown, *John Singleton Copley*, 2 vols. (Cambridge, Mass.: Harvard University Press, 1966), 1:fig. 261, and John Hayes, *Gainsborough, Paintings and Drawings* (London: Phaidon, 1975), plate 130.

8. For the *Samuel Adams*, see Prown, *Copley* (1966), 1:fig. 302.

9. For illustrations of Copley's portraits not reproduced herein, see ibid., 1:fig. 89 for the *Sargent*; fig. 317 for the *Tyng*; fig. 331 for the *Mifflin*; and fig. 184 for the *Boylston*.

10. Franklin, *The Writings of Benjamin Franklin*, 8:606.

11. Ibid., 8:612–13.

12. Ibid., 7:348.

13. Charles Coleman Sellers, *Portraits and Miniatures by Charles Willson Peale*, in *American Philosophical Society Transactions* 42 (1952), p. 3.

14. See Charles Coleman Sellers, *Benjamin Franklin in Portraiture* (New Haven, Conn.: Yale University Press, 1962), plates 32, 33, and 35.

Chapter 20

1. "Puritanism, Pietism and Science," *Sociological Review* 28 (January 1936), p. 10.

2. Weber, *The Protestant Ethic and the Spirit of Capitalism*. Translated by Talcott Parsons, with a foreword by R. T. Tawney (London: Allen & Unwin, 1930), p.

249. See also David Bakan, *The Duality of Human Experience: Isolation and Communion in Western Man* (Boston: Beacon, 1966), pp. 23–24.

3. Bakan, in *The Duality of Human Experience*, p. 22, wrote: "Since God has predestined the world, everything in the world is orderly. [The Protestant] eschews magic and becomes interested in science. The latter . . . is a way by which he can come to understand God through God's work. The interest in science [provides] him with the means of controlling the world and increasing his wealth."

4. Newton P. Stallknecht and Robert S. Brumbaugh, *The Spirit of Western Philosophy* (New York: Longmans, Green, 1950), p. 309.

5. Ibid., p. 295.

6. On Locke, see Richard I. Aaron, *John Locke* (New York: Oxford University Press, 1971); John W. Yolton, *Locke and the Compass of Human Understanding: A Selective Commentary on the "Essay"* (Cambridge University Press, 1970); and Yolton, *John Locke and the Way of Ideas* (New York: Oxford University Press, 1956).

7. *An Essay Concerning Human Understanding*, ed. Peter H. Nidditch (New York: Oxford University Press, 1975), Book Two, p. 105.

8. On Newton, see I. Bernard Cohen, *Franklin and Newton: An Inquiry into Speculative Newtonian Experimental Science* (Cambridge, Mass.: Harvard University Press, 1974); I. Bernard Cohen, *Introduction to Newton's Principia* (Cambridge, Mass: Harvard University Press, 1971); R. E. Schofield, *Mechanism and Materialism, British Natural Philosophy in an Age of Reason* (Princeton, N.J.: Princeton University Press, 1970); Frank E. Manuel, *A Portrait of Isaac Newton* (Cambridge, Mass.: Harvard University Press, 1968); Richard S. Westfall, *Science and Religion in Seventeenth Century England* (New Haven, Conn.: Yale University Press, 1958); and Westfall, *Never at Rest: A Biography of Isaac Newton* (Cambridge University Press, 1980).

9. *The Duality of Human Experience*, p. 26.

10. Ray's book was well known in America; Cotton Mather, for example, cites it several times in *The Christian Philosopher* of 1721.

11. Wertenbaker, *Puritan Oligarchy*, p. 263.

12. *Out of Our Past*, p. 16.

13. See Frederick E. Brasch, "The Newtonian Epoch in the American Colonies, 1680–1783," *Proceedings of the American Antiquarian Society*, n.s. 69 (1939):314–32.

14. Quoted from Howard, *Our American Music*, p. 18.

15. Frederick B. Tolles, "Philadelphia's First Scientist: James Logan," *Isis* 47 (1956):20–30; Edwin Wolf, 2nd, *The Library of James Logan, 1674–1751* (Philadelphia: Library Company of Philadelphia, 1974).

16. See Theodore Hornberger, *Scientific Thought in the American Colleges, 1638–1800* (Austin: University of Texas Press, 1945).

17. See Wright, *Cultural Life of the American Colonies*, p. 225.

18. See Theodore Hornberger, "Samuel Johnson of Yale and King's College: A Note on the Relation of Science and Religion in Provincial America," *New England Quarterly* 8 (1935):378–97.

19. Illustrated in *Catalogue of American Portraits in The New-York Historical Society*, 1:305, no. 784.

20. *Cultural Life of the American Colonies*, p. 225; see also pp. 269–71 for a bibliography on colonial American science.

21. See Theodore Hornberger, "Puritanism and Science: The Relationship Revealed in the Writings of John Cotton," *New England Quarterly* 10 (1937):503–15.

22. See Theodore Hornberger, "The Date, Source, and Significance of Cotton Mather's Interest in Science," *American Literature* 6 (1935):413–20.

23. Cotton Mather, *The Christian Philosopher* (London, 1721), p. 8; Josephine Piercy, ed., Scholars' Facsimiles & Reprints (Gainsville: University of Florida Press, 1968). For Mather's interest in science, see Silverman, *Life and Times of Cotton Mather*, pp. 40–42, 93–94, 243–54, and 405–10.

24. Bridenbaugh, ed., *Itinerary of Dr. Alexander Hamilton*, p. 110.

25. On Berkeley, see Armstrong, *Berkeley's Theory of Vision*; Luce and Jessop, eds., *Works of George Berkeley*; Edwin Gaustad, *George Berkeley in America* (New Haven, Conn.: Yale University Press, 1979); Gary Thrane, "Berkeley's 'Proper Object of Vision,'" *Journal of the History of Ideas* 38 (April–June 1977):243–60; John W. Yolton, "As in a Looking-Glass: Perceptual Acquaintance in Eighteenth-Century Britain," *Journal of the History of Ideas* 40 (April–June):207–34; George Pitcher, *Berkeley* (London: Routledge & Kegan Paul, 1977); J. F. Bennett, *Locke, Berkeley and Hume* (New York: Oxford University Press, 1971); and Martin Lean, *Sense Perception and Matter* (Atlantic Highlands, N.J.: Humanities, 1953).

26. I am indebted to Ann Gibson Hernstrom, whose seminar paper first alerted me to this matter.

27. Barbara Novak, *American Painting of the Nineteenth Century: Realism, Idealism, and the American Experience* (New York: Harper & Row, 1979), p. 20.

28. On Hume, see Barry Stroud, *Hume* (London: Routledge & Kegan Paul, 1977); Nicholas Capaldi, *David Hume the Newtonian Philosopher* (Boston: Twayne, 1975); and V. C. Chappel, *Hume* (New York: Doubleday, 1966).

29. *An Abstract of a Treatise of Human Nature, 1740, A Pamphlet Hitherto Unknown, by David Hume*, reprinted with an introduction by J. M. Keynes and P. Sraffa (Cambridge University Press, 1938), p. 5.

30. Quoted from Stallknecht and Brumbaugh, *The Spirit of Western Philosophy*, p. 328.

31. Ibid., p. 329.

32. Lemay, *Men of Letters in Colonial Maryland*, p. 147.

33. Ibid., p. 140. Lines thirty-six to thirty-nine read: "Thro' sylvan Scenes my Journey I pursue,/Ten thousand Beauties rising to my View;/Which kindle in my Breast poetic Flame,/And bid me my Creator's Praise proclaim."

Chapter 21

1. See Morrison, *Early American Architecture*, pp. 473–84.

2. See Helen Park, "A List of Architectural Books Available in America Before the Revolution," *Journal of the Society of Architectural Historians* 20 (October 1961):115–30.

3. For a survey of the furnishings of this period, see Fairbanks and Bates, *American Furniture, 1620 to the Present*, pp. 85–194, and the bibliography on pp. 537–52.

4. For illustrations of period rooms, see John A. H. Sweeney, *Winterthur Illustrated* (Winterthur, Del.: The Henry Francis du Pont Winterthur Museum, 1963), and Alan Gowans, *Images of American Living: Four Centuries of Architecture and Furniture as Cultural Expression* (Philadelphia: Lippincott, 1964).

Chapter 22

1. For the early bibliography on Feke, see Waldron Phoenix Belknap, "The Identity of Robert Feke," *Art Bulletin* 29 (September 1947):201–7; Theodore Bolton and Henry Binsse, "Robert Feke, First Painter to Colonial Aristocracy," *Antiquarian* 15 (1930):33–37; Helen Comstock, "Feke and the Nelsons of Virginia," *Antiques* 75 (May 1959):458–59; James T. Flexner, "Aristocratic Visions: The Art of Robert

Feke," *Magazine of Art* 40 (January 1947):2–7; Flexner, "Robert Feke," *Art Bulletin* 28 (September 1946):197–202; Henry Wilder Foote, "John Smibert and Robert Feke in Newport," *Rhode Island History* 9 (April 1950):33–36; Foote, "Robert Feke, Portrait Painter," *Rhode Island History* 6 (April 1947):35–43; and Lloyd Goodrich, *Robert Feke* (New York: Whitney Museum of American Art, 1946).

2. Peter Mooz, "The Art of Robert Feke," Ph.D. dissertation, University of Pennsylvania, 1970; "New Clues to the Art of Robert Feke," *Antiques* 94 (November 1968):702–7; "Robert Feke: The Philadelphia Story," in *American Painting to 1776: A Reappraisal, Winterthur Conference Report* (Charlottesville: University Press of Virginia, 1971):181–216.

3. Peter Mooz, "Colonial Art," p. 51, in John Wilmerding, ed., *The Genius of American Painting* (New York: Morrow, 1973).

4. See Arthur L. Finney, "The Royall House in Medford: A Re-evaluation of the Structural and Documentary Evidence," in *Architecture in Colonial Massachusetts* (Boston: Colonial Society of Massachusetts, 1979), 51:23–41.

5. For the inventory of Isaac Royall, Sr.'s, estate, see ibid., pp. 34–41.

6. Finney, ibid., p. 30, believes the doorway of the west facade was modeled on plate twenty-three of William Salmon's *Palladio Londonensis* (London, 1734).

7. As noted by Mooz in "Robert Feke: The Philadelphia Story," p. 195. The Faber print of Queen Caroline is reproduced in Belknap, *American Colonial Painting*, plate XXIX, fig. 28.

8. See Nancy Armstrong, *A Collector's History of Fans* (London: Studio Vista, 1974); also, *Fans and the Grand Tour* (Brighton: Brighton Art Gallery and Museum, 1982).

9. M. A. Flory, *A Book about Fans* (New York: Macmillan 1895; reprinted, Detroit: Gale Research, 1974), p. 38.

10. Ibid., p. 37.

11. On all of these portraits, see Marvin S. Sadik, *Colonial and Federal Portraits at Bowdoin College* (Brunswick, Me.: Bowdoin College Museum of Art, 1966), pp. 16–56.

12. Ibid., p. 31, illustrated; the portrait is listed in Smibert's *Notebook*, p. 93, no. 117.

13. Written soon after Bowdoin's death and published anonymously in the *Massachusetts Magazine* 3 (1791):6.

14. See Sadik, *Portraits at Bowdoin College*, pp. 40–42. James Bowdoin II is also associated with the famous Pope Orrery in the Harvard University Collection of Historical Scientific Instruments. The Orrery is adorned with gilded brass statuettes of Benjamin Franklin, Isaac Newton, and Bowdoin; the latter was probably included out of recognition of his interests in science and scientific instruments. See Jonathan Fairbanks and Wendy Cooper, *Paul Revere's Boston, 1735–1818* (Boston: Museum of Fine Arts, 1975), p. 73, for an illustration of the Orrery.

15. Quoted from Sadik, *Portraits at Bowdoin College*, pp. 49 and 51.

16. Mooz, "Colonial Art," p. 59.

17. See Susan Strickler, *Toledo Museum of Art, American Paintings* (Toledo, Ohio: Toledo Museum of Art, 1979), pp. 48 and 118.

18. Sadik, *Portraits at Bowdoin College*, p. 61. Sadik discusses the problem of the *Waldo* at one time being attributed to Smibert, and the reasons for that attribution, on pp. 57–61.

19. Quoted from Foote, *John Smibert, Painter*, pp. 91–92; see also Sadik, *Portraits at Bowdoin College*, p. 61.

20. See Mooz, "Robert Feke: The Philadelphia Story," pp. 203–10.

21. Mooz, "Colonial Art," p. 60.

Chapter 23

1. The two main references for Blackburn are Lawrence Park, "Joseph Blackburn
 – Portrait Painter," *American Antiquarian Society Proceedings* 32 (October 1922):270–
 329, and John Hill Morgan and Henry Wilder Foote, "An Extension of Lawrence
 Park's Descriptive List of the Work of Joseph Blackburn," ibid., 46 (April
 1936):15–81. See also C. E. Collins Baker, "Notes on Joseph Blackburn and
 Nathaniel Dance," *Huntington Library Quarterly* 9 (November 1945):33–47; and
 Frank W. Bayley, *Five Colonial Artists of New England* (Boston: privately printed,
 1929), pp. 51–135.

2. For the portraits of several generations of the Winslow family, see *The Winslows:
 Pilgrims, Patrons and Patriots*.

3. See Smibert, *Notebook*, p. 88, no. 19, and p. 105. Smibert also painted a portrait
 of Joshua's wife, Elizabeth Savage Winslow, which is number 18 in the Smibert
 notebook, under the year 1729. Foote listed the Joshua and Elizabeth Winslow
 portraits in his "Questionable Attributions" section in *John Smibert, Painter*, pp.
 226–28; but the artist's notebook reveals that he did take the likenesses of the
 Winslows. The *Joshua Winslow* is on loan to the Boston Athenaeum; see *The
 Winslows: Pilgrims, Patrons and Patriots*, p. 15.

4. See Sydney H. Pavière, *The Devis Family of Painters* (Leigh-on-Sea, England: F.
 Lewis, 1950). See also Mario Praz, *Conversation Pieces: A Survey of the Informal
 Group Portrait in Europe and America* (University Park: Pennsylvania State Uni-
 versity Press, 1971); G. C. Williamson, *English Conservation Pictures of the Eigh-
 teenth and Early Nineteenth Centuries* (New York: Hacker Art Books, 1975); and
 Ellen D'Oench, *The Conversation Piece: Arthur Devis & His Contemporaries* (New
 Haven, Conn.: Yale Center for British Art, 1980).

5. See Ellen G. Miles, *Thomas Hudson, 1701–1779: Portrait Painter and Collector* (Lon-
 don: Greater London Council, 1979), cover illustration, and Joyce Boundy, "An
 Unpublished Conversation Piece by Thomas Hudson: The Thistlethwayte Fam-
 ily," *Apollo* 108 (October 1978):248–50. Hudson's picture, dated c. 1757–58, is
 in the collection of Mrs. D. L. Rowlands.

6. See Smibert, *Notebook*, p. 98, no. 229; the editor of the *Notebook* believed this
 entry referred to Benjamin Faneuil, Sr., father of Benjamin, Jr., and Peter. The
 Notebook also records as number 168 a "Marey A. Funnell" (Smibert's phonetic
 way of spelling Faneuil), but this is thought to be a Mary Aneuil (1715–90) who
 married John Jones about 1743. See also Foote, *John Smibert, Painter*, p. 165; Mary
 Ann was the sister of Benjamin, Jr., and Peter Faneuil.

7. Park, "Joseph Blackburn – Portrait Painter," p. 277.

8. Ibid., p. 278.

9. Copley drew pastel portraits of the Temples in the mid–1760s; see Prown, *Copley*
 (1966), 1:figs. 207 and 208.

10. See Sadik, *Portraits at Bowdoin College*, pp. 70–73.

11. Ibid., p. 137.

12. On James Bowdoin's collection, see ibid., Appendix B, pp. 208–22.

13. For Blackburn's career after he returned to England, see Dresser, "The Back-
 ground of Colonial American Portraiture," pp. 41–53.

14. See Wayne Craven, "John Wollaston in England and New York," *American Art
 Journal* 8 (November 1975):19–31. Carolyn J. Weekley, "John Wollaston, Portrait
 Painter: His Career in Virginia, 1754–1758," master's thesis, University of Del-
 aware, Newark, Del., 1976.

15. Quoted from Michael Kammen, *Colonial New York: A History* (New York: Scrib-
 ner, 1975), p. 290.

16. Bridenbaugh, *Gentleman's Progress, The Itinerarium of Dr. Alexander Hamilton*, p. 73.
17. John Galt, *The Life and Studies of Benjamin West, Esq.* (London, 1816), p. 81.
18. Quoted from Kammen, *Colonial New York*, p. 243.
19. Ibid., p. 251.
20. Illustrated in Craven, "John Wollaston in England and New York," p. 28, fig. 15.
21. See Wayne Craven, "Painting in New York City, 1750–1775," in *American Painting to 1776: A Reappraisal, Winterthur Conference Report for 1971* (Charlottesville: University Press of Virginia, 1971), pp. 251–98.
22. For a comparison of Wollaston's *Mrs. John Waddell*, a New York portrait, with Hudson's *Elizabeth Griffin, Countess of Portsmouth*, see Craven, "John Wollaston in England and New York," p. 26, figs. 11 and 12.

Chapter 24

1. Quoted from Carl Bridenbaugh, *Cities in Revolt: Urban Life in America, 1743–1776* (New York: Capricorn, 1964), p. 137.
2. For an engraving of 1780 illustrating the appearance of Faneuil Hall before it was enlarged to its present size, see Morrison, *Early American Architecture*, p. 440, fig. 367.
3. On this point, see Bridenbaugh, *Cities in Revolt*, pp. 136–39.
4. Quoted from ibid., p. 137.
5. Arthur M. Schlesinger, *The Birth of the Nation: A Portrait of the American People on the Eve of Independence* (New York: Knopf, 1968), p. 137.
6. Prown, *Copley* (1966), 1:130.
7. Wright, *Cultural Life of the American Colonies*, p. 174.
8. *The Diary and Autobiography of John Adams*, ed. L. H. Butterfield, 4 vols. (Cambridge, Mass.: Harvard University Press, 1961), 1:294–95.

Chapter 25

1. The definitive source for Copley is Jules Prown's two-volume study, *John Singleton Copley* (Cambridge, Mass.: Harvard University Press, 1966), with an extensive bibliography, pp. 463–72. See also Augustus Thorndike Perkins, *A Sketch of the Life and a List of Some of the Works of John Singleton Copley* (Boston, 1873); Martha Babcock Amory, *The Domestic and Artistic Life of John Singleton Copley* (Boston, 1882); Guernsey Jones, ed., *Letters and Papers of John Singleton Copley and Henry Pelham* (Boston: Massachusetts Historical Society Collections, vol. 71, 1914); Frank W. Bayley, *The Life and Works of John Singleton Copley* (Boston: Taylor Press, 1915); Barbara N. Parker and Anne B. Wheeler, *John Singleton Copley: American Portraits* (Boston: Museum of Fine Arts, 1938); James T. Flexner, *John Singleton Copley* (Boston: Houghton Mifflin, 1948); and Jules D. Prown, *John Singleton Copley, 1738–1815* (Washington: National Gallery of Art, 1965).
2. For illustrations of the Cooper and Welsteed mezzotints, see Prown, *Copley* (1966), 1:figs. 4 and 5.
3. See Jules D. Prown, "An 'Anatomy Book' by John Singleton Copley," *Art Quarterly* 26 (Spring 1963):31–46.
4. Illustrated in Prown, *Copley* (1966), 1:figs. 7, 9 and 29.
5. Blackburn's *Mary Sylvester Dering* is illustrated in Gardner and Feld, *American Paintings*, p. 13.

6. For Lely's *Rutland*, see Beckett, *Lely*, fig. 114; for Kneller's *Queensberry*, see Kerslake, *Early Georgian Portraits*, 2:653, fig. 655.
7. Copley's *Isaac Royall* is illustrated in Prown, *Copley* (1966), 1:fig. 254.
8. Copley to R. G. Bruce, 1767; quoted from Allan Cunningham, *The Lives of the Most Eminent Painters and Sculptors*, 4 vols. (New York, 1834), 4:140.
9. Ibid.
10. See Guernsey Jones, *Copley–Pelham Letters*, pp. 43, 50, 56, and 194.

Chapter 26

1. Copley's *Nicholas Boylston* is illustrated in Prown, *Copley* (1966), 1:fig. 182.
2. Calvin, *Institutes*, Book 3, chap. 10, sect. 5.
3. Prown, *Copley* (1966), 1:70.
4. For a very interesting study of Revere, his work, and his times, see Fairbanks and Cooper, *Paul Revere's Boston*.
5. See Esther Forbes, *Paul Revere and the World He Lived In* (Boston: Houghton Mifflin, 1969), p. 112.
6. Conner, *Poor Richard's Politicks*, p. 40.
7. Benjamin Franklin, *Autobiography, and Other Writings*, ed. Russell B. Nye (Boston: Houghton Mifflin, 1958), pp. 191–92.
8. Quoted from Degler, *Out of Our Past*, p. 44. Degler also makes the point that "the narrow distance – by European standards – between the base and the summit of society [meant] that colonial craftsmen were to be found on every level of society, from slave to gentry."
9. A silver teapot by Revere that is very similar to the one in the portrait is owned by the Museum of Fine Arts, Boston; it is illustrated in Fairbanks and Cooper, *Paul Revere's Boston*, p. 23, fig. 7.

Chapter 27

1. Prown points out that by 1767 Copley had painted a full-length portrait of Governor Francis Bernard, which was also given to Harvard College, but it is presently unlocated; see Prown, *Copley* (1966), 1:43.
2. Copley's *Hollis* is illustrated in ibid., 1:fig. 158.
3. See W. T. Baxter, *The House of Hancock: Business in Boston, 1724–1775* (New York: Russell & Russell, 1965).
4. On the Hancock House and for illustrations of it, see Arthur Gilman, "The Hancock House and Its Founder," *Atlantic Monthly* 11 (June 1863):692–707; Walter Watkins, "The Hancock House and Its Builder," *Old-Time New England* 17 (July 1926):3–19; Margaret Henderson Floyd, "Measured Drawings of the Hancock House by John Hubbard Sturgis: A Legacy to the Colonial Revival," *Architecture in Colonial Massachusetts* (Boston: Colonial Society of Massachusetts, 1979), 51:87–94; Marshall Davidson, "Lost Landmarks," *The American Heritage History of Colonial Antiques* (New York: American Heritage, 1967), pp. 152–53.
5. Letter from Hancock to James Rowe of London, January 23, 1737, quoted from Gilman, "The Hancock House," p. 702.
6. The half-length portrait of Thomas Hancock is listed in the Smibert *Notebook*, no. 40, pp. 89 and 106; it is illustrated in Fairbanks and Cooper, *Paul Revere's Boston*, p. 40, no. 37.
7. The portraits of the Reverend John and Mrs. Hancock are listed in Smibert's *Notebook*, nos. 88 and 95, p. 92; and the *Kilby* is no. 172, on p. 96.
8. See Smibert, *Notebook*, p. 93, nos. 120 and 121.

9. Illustrated in Prown, *Copley* (1966), figs. 75, 76, and 155.

10. These portraits are illustrated in Kerslake, *Early Georgian Portraits*, 2:nos. 458 and 727.

11. Ibid., no. 219.

12. The Lee Mansion is illustrated in Morrison, *Early American Architecture*, figs. 419-22.

13. On the location of the Lee portraits in the Lee Mansion, see Prown, *Copley* (1966), 1:71.

Chapter 28

1. On the history of art in the South, see Jesse Poesch, *The Art of the Old South: Painting, Sculpture, Architecture and the Products of Craftsmen, 1560-1860* (New York: Knopf, 1983), and Carolyn J. Weekley et al., *Painting in the South: 1564-1980* (Richmond: Virginia Museum, 1983).

2. See Bowes, *Culture of Early Charleston*, for an interesting analysis of the social, cultural, religious, and governmental life of Charleston before the Revolution.

3. On this topic, see the chapter on "Club Life and Societies" in Hennig Cohen, *The South Carolina Gazette, 1732-1775* (Columbia: University of South Carolina Press, 1953), pp. 17-24.

4. Quoted from P. C. Weston, ed., *Documents Connected with the History of South Carolina* (London, 1856), pp. 84-85.

5. Bowes, *Culture of Early Charleston*, p. 21.

6. Ibid., pp. 10-11.

7. For an engraving of St. Philip's Church that was published in London's *Gentleman's Magazine* (June 1753), see Bowes, *Culture of Early Charleston*, frontispiece; for St. Michael's, Drayton Hall, and the Miles Brewton House, see Morrison, *Early American Architecture*, figs. 335, 343, and 350.

8. *South Carolina Gazette*, July 16, 1737.

9. Ibid., February 2 and 9, 1740.

10. The references to Madame Precour and other artists are cited in Cohen, *The South Carolina Gazette*, p. 54; see also Anna Wells Rutledge, *Artists in the Life of Charleston*, still the standard scholarly survey of the topic.

11. On Theus, see Margaret S. Middleton, *Jeremiah Theus, Colonial Artist of Charles Town* (Columbia: University of South Carolina Press, 1953).

12. *South Carolina Gazette*, August 30, 1740.

13. Ibid., April 25, 1774.

14. Illustrated in Gardner and Feld, *American Paintings*, p. 18.

15. Quoted from Rutledge, *Artists in the Life of Charleston*, p. 116; Ramsay's portrait of Manigault, currently unlocated, is illustrated in fig. 5.

16. Quoted from Gardner and Feld, *American Paintings*, p. 18.

17. Quoted from Rutledge, *Artists in the Life of Charleston*, p. 116.

18. See Middleton, *Jeremiah Theus*, pp. 128-29.

19. Bowes, *Culture of Early Charleston*, pp. 118-19. Quincy's quotations are from *Memoir of the Life of Josiah Quincy Jun. of Massachusetts* (Boston, 1825).

20. See Weekley, "Wollaston," pp. 21-22.

21. For Benbridge's career in Charleston, see Robert G. Stewart, *Henry Benbridge, 1743-1812* (Washington, D.C.: National Portrait Gallery, 1971), pp. 19-21.

22. George W. Corner, ed., *The Autobiography of Benjamin Rush: His "Travels Through Life" Together with his Commonplace Book for 1789-1813* (Westport, Conn.: Greenwood Press, 1970), p. 153.

23. On Dering, see J. Hall Pleasants, "William Dering: A Mid-Eighteenth Century

Williamsburg Portrait Painter," *Virginia Magazine of History and Biography* 60 (January 1952):56–63; Hood, *Bridges and Dering*, pp. 99–122; Carolyn J. Weekley, "Further Notes on William Dering, Colonial Virginia Portrait Painter," *Journal of Early Southern Decorative Arts* 1 (May 1975):21–28.

24. Maude H. Woodfin, ed., *Another Secret Diary of William Byrd of Westover, 1739–1741* (Richmond, Va.: Dietz Press, 1942), pp. 139 and 178.

25. The *Mrs. Stith* is illustrated in Hood, *Bridges and Dering*, p. 102, fig. 62, and the Mercer reference is quoted from p. 103. See Beatrix Rumford and Carolyn J. Weekley, *American Folk Portraits: Paintings and Drawings from the Abby Aldrich Rockefeller Folk Art Center* (Boston: New York Graphic Society, 1981), pp. 87–91.

26. Manigault's letter is quoted in Rutledge, *Artists in the Life of Charleston*, p. 116.

27. Dering's *Mrs. Mordecai Booth* is illustrated in Hood, *Bridges and Dering*, p. 104, fig. 63.

28. *South Carolina Gazette*, December 11, 1749; see also the *Gazette* for November 12, 1750.

29. See "The Will of William Fitzhugh," *Virginia Magazine of History and Biography* 2 (1895):277: "Give to my son William my own and my wife's pictures [and] the other six pictures of my relations." The will was dated 1700.

30. Doud, "The Fitzhugh Portraits by John Hesselius." See also Hall, *Portraits in the Collection of the Virginia Historical Society*, pp. 83–85.

31. The main study on Hesselius to date is Richard Doud, "John Hesselius: His Life and Work," master's thesis, University of Delaware, Newark, 1963. See also Doud, "John Hesselius, Maryland Limner," *Winterthur Portfolio* 5 (1969): 129–53.

32. The inventory of Hesselius's estate is given in Doud, "John Hesselius: His Life and Work," pp. 109–14.

33. Illustrated in Van Devanter, *"Anywhere So Long As There Be Freedom,"* Charles Carroll of Carrollton, p. 143, no. 16.

34. See Weekley, "John Wollaston," pp. 31–35.

35. See "Catalogue of the Library of Daniel Parke Custis," *Virginia Magazine of History and Biography* 17 (October 1909):404–12. Many of Custis's books had been owned by his father and grandfather, and after his death most of them were divided between his son, John Parke Custis, and George Washington.

36. See Franklin Kelly, "The Portraits of John Durand," *Antiques* 122 (November 1982):1080–87, figs. 9 and 10.

Chapter 29

1. On Fox and the early history of the Quakers, see John L. Nickalls, ed., *The Journal [of George Fox]* (Cambridge University Press, 1952); *The Works of George Fox*, 8 vols. (Philadelphia and New York, 1831); Vernon Noble, *The Man in Leather Breeches: The Life and Times of George Fox* (New York: Philosophical Library, 1953); Harry E. Wildes, *The Voice of the Lord* (Philadelphia: University of Pennsylvania Press, 1965).

2. Quoted from Degler, *Out of Our Past*, p. 8.

3. *Cultural Life of the American Colonies*, p. 43.

4. Bridenbaugh, Carl, and Bridenbaugh, Jessica, *Rebels and Gentlemen: Philadelphia in the Age of Franklin* (New York: Oxford University Press, 1965), p. 17.

5. Ibid., pp. 17–18.

6. See Edwin Wolf, 2nd, *The Library of James Logan, 1674–1751* (Philadelphia: Library Company of Philadelphia, 1974). See also Frederick B. Tolles, *James Logan and the Culture of Provincial America* (Boston: Little, Brown, 1957).

7. Bridenbaugh and Bridenbaugh, *Rebels and Gentlemen*, p. 150.

8. William Penn, "Reflections and Maxims," reprinted in James P. Wickersham, *A History of Education in Pennsylvania* (Lancaster, Pa., 1886), pp. 35–36.

9. For illustrations, see Morrison, *Early American Architecture*: Christ Church, fig. 445; Independence Hall, fig. 453; Stenton, fig. 444; Mount Pleasant, fig. 445; Cliveden, fig. 449. For the Powel House, see George Bishop Tatum, *Philadelphia Georgian: The City House of Samuel Powel* (Middletown, Conn.: Wesleyan University Press, 1976).

10. For illustrations of all of these paintings, see Roland E. Fleisher, "Gustavus Hesselius," pp. 127–57.

11. See Smibert, *Notebook*, pp. 96–97.

12. Smibert's *Joseph Turner* is illustrated in Mooz, "Robert Feke: The Philadelphia Story," p. 190, fig. 4; also in Peter Mooz et al., *Philadelphia Painting and Printing to 1776* (Philadelphia: Pennsylvania Academy of the Fine Arts, 1971), p. 36, no. 29.

13. Feke's *Franklin* and *Francis* are illustrated in Mooz et al., *Philadelphia Painting and Printing to 1776*, p. 13, no. 6., and p. 17, no. 10. See also Mooz, "Robert Feke: The Philadelphia Story" and "New Clues to the Art of Robert Feke."

14. See David H. Dickason, *William Williams: Novelist and Painter of Colonial America* (Bloomington: Indiana University Press, 1970), and William Gerdts, "William Williams: New American Discoveries," *Winterthur Portfolio* 4 (1968):159–67.

15. See David H. Dickason, "Benjamin West on William Williams: A Previously Unpublished Letter," *Winterthur Portfolio* 6 (1979):127–33.

16. See Edgar P. Richardson, "James Claypoole, Junior, Rediscovered," *Art Quarterly* 33 (1970):159–75.

17. See William Sawitzky, *Matthew Pratt* (New York: New-York Historical Society, 1942).

18. See G.L.M. Goodfellow, "Cosmo Alexander in America," *Art Quarterly* 26 (1963):308–22.

Chapter 30

1. The bibliography on Charles Willson Peale is enormous; the Index (1954) to vols. 1–75 of the *Pennsylvania Magazine of History and Biography* alone lists over one hundred references to articles about him. We will list here only a few of the more useful sources, which will offer among them extensive bibliographical material. See Charles Coleman Sellers, *Charles Willson Peale*, 2 vols. (Philadelphia: American Philosophical Society, 1947); Sellers, *Portraits and Miniatures by Charles Willson Peale*; Sellers, *Charles Willson Peale, A Biography* (New York: Scribner, 1969); Theodore Bolton, "Charles Willson Peale, An Account of his Life and Work," *Art Quarterly* 2 (Autumn 1939):354–85, and "Charles Willson Peale, The First Catalogue of his Portraits in Oils and in Miniature," ibid., supplement, pp. 417–45; Charles Elam, *The Peale Family: Three Generations of American Artists* (Detroit: Detroit Institute of Arts and Wayne State University Press, 1967); Robert Plate, *Charles Willson Peale* (New York: McKay, 1967); Edgar P. Richardson, Brooke Hindle, and Lillian Miller, *Charles Willson Peale and His World* (New York: Abrams, 1983). *The Selected Papers of Charles Willson Peale and his Family*, ed. Lillian B. Miller and Sidney Hart (New Haven: Yale University Press, 1983–).

2. Wright, *Cultural Life of the American Colonies*, p. 110.

3. Sellers, *Charles Willson Peale* (1947), 1:63.

4. Ibid., 1:68.

5. For a discussion of Wilton's statue of Pitt, see Wayne Craven, *Sculpture in America*,

from the Colonial Period to the Present (Newark: University of Delaware Press, 1984), pp. 47–49 and fig. 2.1. The Maryland Assembly, acting in Annapolis in 1766, had also voted to erect a statue of Pitt in the capital, but nothing came of the project.

6. On the *Pitt*, see Sellers, *Portraits and Miniatures by Charles Willson Peale*, pp. 172–73, where the iconography is explained. See also the contemporary notice about the *Pitt* in *Virginia Gazette*, April 20, 1769, reprinted in *Virginia Magazine of History and Biography* 38 (1930):372–73.

7. For the *Peale Family*, see Sellers, *Portraits and Miniatures by Charles Willson Peale*, pp. 157–58.

8. On Peale's work as a sculptor, see Wayne Craven, "The Origins of Sculpture in America: Philadelphia, 1785–1830," *American Art Journal* 9 (November 1977):8–10.

9. *Familiar Letters of John Adams and His Wife, Abigail Adams* (New York, 1876), p. 215.

10. Quoted from Sellers, *Charles Willson Peale* (1947) 1:113.

11. Ibid., 1:99.

12. For the Bordley and Carroll portraits, see Sellers, *Portraits and Miniatures by Charles Willson Peale*, p. 37, no. 61, and p. 49, no. 120.

13. Corner, ed., *Autobiography of Benjamin Rush*, pp. 154–55.

14. William T. Read, *Life and Correspondence of George Read* (Philadelphia, 1870), p. 570.

15. Sellers, *Portraits and Miniatures by Charles Willson Peale*, p. 68.

16. See Howard McHenry, "Wye House, Talbot County, Maryland," *Maryland Historical Magazine* 18 (1923):293–99, and J. Donald Tilghman, "Wye House," ibid., 48 (1953):89–108.

17. See Edwin Wolf, 2nd, "The Library of Edward Lloyd IV of Wye House," *Winterthur Portfolio* 5 (1969):87–122.

18. Karol A. Schmiegel, "Encouragement Exceeding Expectation: The Lloyd–Cadwalader Patronage of Charles Willson Peale," *Winterthur Portfolio* 12 (1977):87–102.

19. See Nicholas Wainwright, *Colonial Grandeur in Philadelphia: The House and Furniture of General John Cadwalader* (Philadelphia: Historical Society of Pennsylvania, 1964), pp. 108–15, for illustrations of Peale's portraits of Dr. Thomas Cadwalader and his wife, and of their son Lambert. See also Schmiegel, "Encouragement Exceeding Expectation," pp. 90–91, for John Cadwalader's patronage of Peale.

20. The card table is illustrated and discussed in Wainwright, *Colonial Grandeur in Philadelphia*, pp. 118–19; it is now owned by the Philadelphia Museum of Art. See *Antiques* 110 (July 1976):131, fig. 6.

21. Quoted from "Major Peale Portraits Join Winterthur Collection," *Winterthur Newsletter* 24 (January 1980):1.

22. Corner, ed., *Autobiography of Benjamin Rush*, p. 116. See also Whitfield Bell and L. H. Butterfield, eds., *My Dearest Julia: The Love Letters of Dr. Benjamin Rush to Julia Stockton* (New York: Neale Watson Academic Publications, 1979).

23. For a survey of these matters, see Bridenbaugh and Bridenbaugh, *Rebels and Gentlemen*, chap. 8, "The Medical Profession," and chap. 9, "The Love of Science."

24. On Rush, see Corner, ed., *Autobiography of Benjamin Rush*; Frederic Fox, *Dr. and Mrs. Benjamin Rush* (Princeton, N.J.: Princeton University Press, 1974); David Hawke, *Benjamin Rush* (Indianapolis, Ind.: Bobbs-Merrill, 1971); and Robert E. Jones, "Portraits of Benjamin Rush, M.D., by his Contemporaries," *Antiques* 108 (July 1975):94–113.

25. Corner, ed., *Autobiography of Benjamin Rush*, p. 66.
26. Ibid., p. 69.

Chapter 31

1. Aldrich, *Benjamin Franklin and Nature's God*, p. 17.
2. Franklin, *The Papers of Benjamin Franklin*, 1:103–4.
3. Aldridge, *Benjamin Franklin and Nature's God*, p. 23.
4. See M. H. Buxbaum, *Benjamin Franklin and the Zealous Presbyterians* (State College, Pa.: Pennsylvania State University Press, 1975), pp. 80–90. See also Melvin M. Johnson, *The Beginnings of Freemasonry in America* (New York: George H. Doran, 1924).
5. *Benjamin Franklin and Nature's God*, p. 13.
6. Franklin, *The Papers of Benjamin Franklin*, 1:103.
7. Buxbaum, *Franklin and the Zealous Presbyterians*, p. 105.
8. Franklin, *The Papers of Benjamin Franklin*, 7:346.
9. Benjamin Franklin, *The Autobiography*, ed. Leonard W. Labaree (New Haven, Conn.: Yale University Press, 1964), p. 114.
10. Quoted from Carl Van Doren, *Benjamin Franklin* (New York: Viking Press, 1938), p. 175.
11. See Peter Collinson, ed., *Experiments and Observations on Electricity, Made at Philadelphia, by Mr. Benjamin Franklin* (London, 1751). Also, Bernard Cohen, *Benjamin Franklin's Experiments* (Cambridge, Mass.: Harvard University Press, 1941).
12. See Sellers, *Portraits and Miniatures by Charles Willson Peale*, pp. 82–83.

Selected Bibliography

The Selected Bibliography contains sources that were especially useful. Many additional references are cited in the Notes.

Adams, John. *The Diary and Autobiography of John Adams*, ed. L.H. Butterfield. 4 vols. Cambridge, Mass.: Harvard University Press, 1961.

Agrippa, Henry Cornelius. *The Vanity of Arts and Sciences*. London, 1676.

Aldridge, Alfred Owen. *Benjamin Franklin and Nature's God*. Durham, N.C.: Duke University Press, 1967.

Allestree, Richard. *The Gentleman's Calling*. London, 1664.

Allestree, Richard. *The Ladies Calling in Two Parts*. 2nd edition. Oxford, 1673.

Allestree, Richard. *The Whole Duty of Man, laid down in a plain and familiar way for the use of all*. London, 1660.

Allison, Anne. "Peter Pelham, Engraver in Mezzotinto." *Antiques* 52 (December 1947):441–43.

Ambler, Louise Todd. *Benjamin Franklin, A Perspective*. Cambridge, Mass.: Fogg Art Museum, 1975.

Andrews, Matthew Page. *History of Maryland: Province and State*. New York: Doubleday, Doran, 1929.

Andrews, William Loring. *Jacob Steendam . . . A Memoir of the First Poet of New Netherland*. New York: Dodd, Mead, 1908.

Andrews, William Loring. *A Prospect of the Colledges in Cambridge in New England . . . Engraved by Wm. Burgis in 1726*. New York: Dodd, Mead, 1907.

Aresty, Esther B. *The Best Behavior: The Course of Good Manners – from Antiquity to the Present – as Seen Through Courtesy and Etiquette Books*. New York: Simon & Schuster, 1970.

Armstrong, David M. *Berkeley's Theory of Vision: A Critical Examination of Bishop Berkeley's "Essay Towards a New Theory of Vision."* Parkville, Australia: Melbourne University Press, 1960.

Arts of the Anglo-American Community in the Seventeenth Century. Winterthur Conference Report, 1974. Charlottesville: University Press of Virginia, 1975.

Bailyn, Bernard, ed. "The Apologia of Robert Keayne." *Publications of the Colonial Society of Massachusetts* 42 (December 1964): 243–341.

Bailyn, Bernard. *The New England Merchants in the Seventeenth Century*. Cambridge, Mass.: Harvard University Press, 1979.

Bailyn, Bernard. "Politics and Social Structure in Virginia." In *Seventeenth-Century America*, ed. James Morton Smith. Chapel Hill: University of North Carolina Press, 1959.

Bakan, David. *The Duality of Human Experience: Isolation and Communion in Western Man.* Boston: Beacon, 1966.

Baker, Charles Henry Collins. *Lely and the Stuart Portrait Painters.* 2 vols. Boston: Small, Maynard, 1913.

Baltzell, E. Digby. *Puritan Boston and Quaker Philadelphia: Two Protestant Ethics and the Spirit of Class Authority and Leadership.* New York: Free Press, 1980.

Bate, John. *The Mysteries of Nature and Art.* London, 1634.

Battestin, Martin C. *The Providence of Wit: Aspects of Form in Augustan Literature and the Arts.* New York: Oxford University Press, 1974.

Baumgarten, Linda. "The Textile Trade in Boston, 1650–1670." In *Winterthur Conference Report, 1974.* Charlottesville: University Press of Virginia, 1975, pp. 219–274.

Baxter, William T. *The House of Hancock: Business in Boston, 1724–1775.* New York: Russell & Russell, 1965.

Bayley, Frank W. *Five Colonial Artists of New England.* Boston: privately printed, 1929.

Belknap, Waldron Phoenix. *American Colonial Painting: Materials for a History.* Cambridge, Mass.: Harvard University Press, 1959; completed after Belknap's death by Charles Coleman Sellers and Damie Stillman.

Belknap, Waldron Phoenix. "The Identity of Robert Feke." *Art Bulletin* 29 (September 1947):201–7.

Benson, Adolph B., ed. *The America of 1750. Peter Kalm's Travels in North America.* 2 vols. New York: Wilson-Erickson, 1937.

Bercovitch, Sacvan. *The American Jeremiad.* Madison: University of Wisconsin Press, 1978.

Bercovitch, Sacvan. *The Puritan Origins of the American Self.* New Haven, Conn.: Yale University Press, 1975.

Bercovitch, Sacvan, ed. *The American Puritan Imagination: Essays in Revaluation.* Cambridge University Press, 1974.

Berkeley, George. *An Essay Towards a New Theory of Vision.* Dublin, 1710.

Berkeley, George. *A Treatise Concerning the Principles of Human Knowledge.* London, 1710.

Bernhard, Virginia. "Cotton Mather and the Doing of Good: A Puritan Gospel of Wealth." *New England Quarterly* 49 (June 1976):225–41.

Bigelow, John, ed. *The Complete Works of Benjamin Franklin.* 10 vols. New York: Putnam, 1888.

Bilodeau, Francis W. *Art in South Carolina, 1670–1970.* Columbia: University of South Carolina Press, 1970.

Black, Mary. "Contributions Toward a History of Early Eighteenth-century New York Portraiture: Identification of the Aetatis Suae and Wendell Limners." *American Art Journal* 12 (Autumn 1980):4–31.

Black, Mary. "Pieter Vanderlyn and Other Limners of the Upper Hudson." In *American Painting to 1776: A Reappraisal, Winterthur Conference Report for 1971.* Charlottesville: University Press of Virginia, 1971, pp. 217–50.

Bolingbroke, Judith. *William and Mary Fabrics.* Leigh-on-Sea, England: F. Lewis, 1969.

Bolton, Charles K. *The Founders: Portraits of Persons Born Abroad Who Came to the Colonies in North America Before the Year 1701.* 3 vols. Boston: Boston Athenaeum, 1919–26.

Bolton, Theodore, and Binsse, Henry. "Robert Feke, First Painter to Colonial Aristocracy." *Antiquarian* 15 (1930):33–37.

Bowes, Frederick P. *The Culture of Early Charleston.* Chapel Hill: University of North Carolina Press, 1942; reprint, Greenwood, Westport, Conn., 1978.

Brasch, Frederick E. "The Newtonian Epoch in the American Colonies, 1680–1783." *Proceedings of the American Antiquarian Society,* n.s. 69 (1939):314–32.

Brathwaite, Richard. *The English Gentleman, containing sundry excellent Rules or exquisite Observations, tending to Direction of Every Gentleman, of selecter ranke and qualitie.* London, 1630; reprint, New York: Walter J. Johnson, 1975.

Brayton, Alice. *George Berkeley in Newport.* Newport, R.I.: Anthoensen Press, 1954.

Bridenbaugh, Carl. *Cities in the Wilderness: The First Century of Urban Life in America, 1625–1742.* New York: Roland Press, 1938.

Bridenbaugh, Carl. *Cities in Revolt: Urban Life in America, 1743–1776.* New York: Capricorn, 1964.

Bridenbaugh, Carl. *Mitre and Scepter: Transatlantic Faiths, Ideas, Personalities, and Politics, 1689–1775.* New York: Oxford University Press, 1962.

Bridenbaugh, Carl, ed. *Gentleman's Progress. The Itinerarium of Dr. Alexander Hamilton, 1744.* Chapel Hill: University of North Carolina Press, 1948.

Bridenbaugh, Carl, and Bridenbaugh, Jessica. *Rebels and Gentlemen: Philadelphia in the Age of Franklin.* New York: Oxford University Press, 1965.

A Brief Account of the Revenues, Pomp and State of the Bishops, and Other Clergy of the Church of England. Boston, 1725.

Brown, Robert E. *Middle-class Democracy and the Revolution in Massachusetts, 1691–1780.* Ithaca, N.Y.: Cornell University Press, 1955.

Browne, Alexander. *Arts Pictoria; or, An Academy treating of Drawing, Painting, Limning, and Etching. To which are added Thirty Copper Plates expressing the Choicest, Nearest, and most Exact Grounds and Rules of Symetry . . .* London, 1669. (A second edition was published in London in 1675.)

Browne, Alexander. *The Whole Art of Drawing, Painting, Limning, and Etching. . . .* London, 1660.

Brownell, Morris R. *Alexander Pope and the Arts of Georgian England.* New York: Oxford University Press, 1978.

Bruce, Philip A. *Social Life of Virginia in the Seventeenth Century: An Inquiry into the Origin of the Higher Planter Class.* Lynchburg, Va.: J. P. Bell, 1927.

Burroughs, Alan. *John Greenwood in America.* Andover, Mass.: Addison Gallery of American Art, 1943.

Buxbaum, M. H. *Benjamin Franklin and the Zealous Presbyterians.* State College: Pennsylvania State University Press, 1975.

Cady, Edwin Harrison. *The Gentleman in America: A Literary Study in American Culture.* Syracuse, N.Y.: Syracuse University Press, 1949.

Calvert, Karin. "Children in American Family Portraiture, 1670 to 1810." *William and Mary Quarterly* 3rd series, 39 (January 1982):87–113.

Calvin, John. *Institutes of Christian Religion,* trans. Henry Beveridge. 2 vols. Grand Rapids, Mich.: Eerdmans, 1957.

Carroll, Peter. *Puritanism and the Wilderness: The Intellectual Significance of the New England Frontier, 1629–1700.* New York: Columbia University Press, 1969.

Catalogue of American Portraits in the New-York Historical Society. 2 vols. New Haven, Conn.: Yale University Press, 1974.

Catesby, Mark. *The Natural History of Carolina, Florida and the Bahama Islands, Containing the Figures of Birds, Beasts, Fishes, Serpents, Insects, and Plants.* London, 1731.

Chase, Gilbert. *America's Music, from the Pilgrims to the Present.* New York: McGraw-Hill, 1966.

Chinard, Gilbert, ed. *A Huguenot Exile in Virginia; or, Voyages of a Frenchman Exiled for His Religion, with a Description of Virginia & Maryland; from the Hague edition of 1687; with an introduction and notes by Gilbert Chinard.* New York: Press of the Pioneers, 1934.

Christensen, Carl C. *Art and Reformation in Germany.* Detroit, Mich.: Wayne State University Press, 1979.

Clarke, Hermann F., and Foote, Henry Wilder. *Jeremiah Dummer, Colonial Craftsman and Merchant, 1645–1718.* New York: Da Capo, 1970; first published in 1935.

Clebsch, William. *From Sacred to the Profane: The Role of Religion in American History.* New York: Harper & Row, 1968.

Coburn, Frederick W. "Jeremiah Dummer: Gold- and Silversmith and Limner." *Art in America* 20 (February 1932):77–82.

Coburn, Frederick W. "Jeremiah Dummer's Portraits of John Coney, Silversmith, and Mary Atwater Coney, His Wife." *Art in America* 18 (August 1930):244–51.

Cohen, Bernard, ed. *Cotton Mather and American Science and Medicine.* 2 vols. New York: Arno Press, 1980.

Cohen, Hennig. *The South Carolina Gazette, 1732–1775.* Columbia: University of South Carolina Press, 1953.

Cohen, I. Bernard. *Franklin and Newton: An Inquiry into Speculative Newtonian Experimental Science.* Cambridge, Mass.: Harvard University Press, 1974.

Colman, Benjamin. *A Dissertation on the Image of God Wherein Man Was Created.* Boston, 1736.

Colman, Benjamin. *Industry and Diligence in the Work of Religion.* Boston, 1717.

Comstock, Helen. "Feke and the Nelsons of Virginia." *Antiques* 75 (May 1959):458–59.

Conner, Paul W. *Poor Richard's Politicks: Benjamin Franklin and His New American Order.* New York: Oxford University Press, 1965.

Corner, George W., ed. *The Autobiography of Benjamin Rush: His "Travels Through Life" Together with his Commonplace Book for 1789–1813.* Westport, Conn.: Greenwood, 1970.

Corson, Richard. *Fashions in Hair: The First Five Thousand Years.* London: Peter Owen, 1971.

Cotton, John. *Christ the Fountaine of Life.* London, 1651.

Craven, Wayne. "John Wollaston in England and New York." *American Art Journal* 8 (November 1975):19–31.

Craven, Wayne. "Painting in New York City, 1750–1775." In *American Painting to 1776: A Reappraisal, Winterthur Conference Report for 1971.* Charlottesville: University Press of Virginia, 1971, pp. 251–98.

Craven, Wayne. *Sculpture in America, from the Colonial Period to the Present.* Revised edition. Newark: University of Delaware Press, 1984.

Croft-Murray, Edward, and Hulton, Paul. *Catalogue of British Drawings, XVI & XVII Centuries.* 2 vols. London: British Museum, 1960.

Cross, Arthur L. *The Anglican Episcopate and the American Colonies.* New York: Longmans, Green, 1902.

Crouch, Joseph. *Puritanism and Art: An Inquiry into a Popular Fallacy.* New York: Cassell, 1910.

Cummings, Abbott Lowell. "Decorative Painters and House Painting at Massachusetts Bay, 1630–1725." In *American Painting to 1776: A Reappraisal, Winterthur Conference Report for 1971.* Charlottesville: University Press of Virginia, 1971.

Cummings, Abbott Lowell. *The Framed Houses of Massachusetts Bay, 1625–1725.* Cambridge, Mass.: Harvard University Press, 1979.

Cunnington, Cecil W., and Cunnington, Phyllis E. *Handbook of English Costume in the Seventeenth Century.* London: Faber, 1967.

Daniels, Jonathan. *The Randolphs of Virginia.* New York: Doubleday, 1972.

Davis, Richard Beale. *Intellectual Life in the Colonial South.* 3 vols. Knoxville: University of Tennessee Press, 1978.

Davis, Richard Beale. *William Fitzhugh and His Chesapeake World, 1676–1701: The*

Fitzhugh Letters and Other Documents. Chapel Hill: University of North Carolina Press, 1963.

Davison, Archibald T. *Protestant Church Music in America.* Boston: E. C. Scribner Music, 1933.

Day, Clive. "Capitalistic and Socialistic Tendencies in the Puritan Colonies." In *American Historical Association, Annual Report . . . for 1920.* Washington, D.C.: Smithsonian Institution, 1925, pp. 223–35.

Degler, Carl. *Out of Our Past: The Forces That Shaped Modern America.* New York: Harper & Row, 1970.

Denton, Daniel. *A Brief Description of New-York, Formerly Called New Netherlands.* London, 1670.

Dilliard, Maud Esther. *An Album of New Netherland.* New York: Twayne, 1963.

Doud, Richard K. "The Fitzhugh Portraits by John Hesselius." *Virginia Magazine of History and Biography* 75 (1967):159–73.

Doud, Richard K. "John Hesselius: His Life and Work." Master's thesis, University of Delaware, 1963.

Doud, Richard K. "John Hesselius, Maryland Limner." *Winterthur Portfolio* 5 (1969):129–53.

Dow, George Francis. *The Arts and Crafts in New England, 1704–1775.* Topsfield, Mass.: Wayside Press, 1927.

Dow, George Francis. *Every Day Life in the Massachusetts Bay Colony.* Topsfield, Mass.: Wayside Press, 1935.

Dowdey, Clifford. *The Golden Age: A Climate for Greatness in Virginia, 1732–1755.* Boston: Little, Brown, 1970.

Dresser, Louisa. "The Background of Colonial American Portraiture: Some Pages from a European Notebook." *Proceedings of the American Antiquarian Society* 76 (April 1966):19–58.

Dresser, Louisa. "Portraits in Boston, 1630–1720." *Journal of the Archives of American Art* 6 (July–October 1966):1–34.

Dresser, Louisa. *XVIIth Century Painting in New England.* Worcester, Mass.: Worcester Art Museum, 1935.

Dunn, Richard S. *Puritans and Yankees: The Winthrop Dynasty of New England, 1630–1717.* Princeton, N.J.: Princeton University Press, 1962.

Earle, Alice Morse. *Two Centuries of Costume in America.* New York: Macmillan, 1910.

Eckenrode, Hamilton James. *The Randolphs: The Story of a Virginia Family.* Indianapolis, Ind.: Bobbs-Merrill, 1946.

Erikson, Kai T. *Wayward Puritans: A Study in the Sociology of Deviance.* New York: Wiley, 1966.

Evelyn, John. *The Diary of John Evelyn,* ed. William Bray. 4 vols. London: Bickers, 1906.

Fairbanks, Jonathan, and Bates, Elizabeth Bidwell. *American Furniture, 1620 to the Present.* New York: R. Marek, 1981.

Fairbanks, Jonathan, et al. *New England Begins: The Seventeenth Century.* 3 vols. Boston: Museum of Fine Arts, 1982.

Fairbanks, Jonathan, and Cooper, Wendy, et al. *Paul Revere's Boston, 1735–1818.* Boston: Museum of Fine Arts, 1975.

Finney, Arthur L. "The Royall House in Medford: A Re-Evaluation of the Structural and Documentary Evidence." In *Architecture in Colonial Massachusetts.* Boston: Colonial Society of Massachusetts, 1979, 51:23–41.

Fleischer, Roland E. "Gustavus Hesselius: A Study of His Style." In *American Painting to 1776: A Reappraisal, Winterthur Conference Report for 1971.* Charlottesville: University Press of Virginia, 1971, pp. 127–58.

Flexner, James T. "Aristocratic Visions: The Art of Feke, with a Chronological List of His Works." *Magazine of Art* 40 (January 1947):2–7.

Flexner, James T. "Robert Feke." *Art Bulletin* 28 (September 1946):197–202.

Foote, Henry Wilder. *Annals of King's Chapel from the Puritan Age of New England to the Present Day.* 3 vols. Boston: Little, Brown, 1882–1940.

Foote, Henry Wilder. "Charles Bridges, 'Sargeant-Painter of Virginia.' " *Virginia Magazine of History and Biography* 60 (January 1952):3–53.

Foote, Henry Wilder. *John Smibert, Painter; with a Descriptive Catalogue of Portraits.* Cambridge, Mass.: Harvard University Press, 1950.

Foote, Henry Wilder. "John Smibert and Robert Feke in Newport." *Rhode Island History* 9 (April 1950):33–36.

Foote, Henry Wilder. "John Smibert Shows His Pictures, March 1730," *New England Quarterly* 8 (March 1935):14–28.

Foote, Henry Wilder. "Musical Life in Boston in the Eighteenth Century." *Proceedings of the American Antiquarian Society* 49 (October 1939):293–313.

Foote, Henry Wilder. *Robert Feke: Colonial Portrait Painter.* Cambridge, Mass.: Harvard University Press, 1930.

Foote, Henry Wilder. "Robert Feke, Portrait Painter." *Rhode Island History* 6 (April 1947):35–43.

Forbes, Esther. *Paul Revere and the World He Lived In.* Boston: Houghton Mifflin, 1969.

Foster, Stephen. *Their Solitary Way: The Puritan Social Ethic in the First Century of Settlement in New England.* New Haven, Conn.: Yale University Press, 1971.

Fox, Dixon R. *Caleb Heathcote, Gentleman Colonist: The Story of a Career in the Province of New York, 1692–1721.* New York: Scribner, 1926.

Franklin, Benjamin. *Autobiography, and Other Writings,* ed. Russell B. Nye. Boston: Houghton Mifflin, 1958.

Franklin, Benjamin. *The Autobiography of Benjamin Franklin,* ed. Leonard W. Labaree. New Haven, Conn.: Yale University Press, 1964.

Franklin, Benjamin. *The Autobiography of Benjamin Franklin: A Genetic Text,* ed. J. A. Leo Lemay and Paul M. Zall. Knoxville: University of Tennessee Press, 1981.

Franklin, Benjamin. *Benjamin Franklin's Autobiography, An Authoritative Text, Backgrounds, Criticism,* ed. J. A. Leo Lemay and Paul M. Zall. New York: Norton, 1986.

Franklin, Benjamin. *The Papers of Benjamin Franklin,* ed. Leonard W. Labaree, William B. Willcox, et al. 23 vols. to date. New Haven, Conn.: Yale University Press, 1959–

Franklin, Benjamin. *The Writings of Benjamin Franklin,* ed. Albert Henry Smyth. 10 vols. New York: Macmillan, 1907.

Franklin, Phyllis. *Show Thyself a Man: A Comparison of Benjamin Franklin and Cotton Mather.* The Hague: Mouton, 1969.

Frick, George, and Stearns, Raymond Phineas. *Mark Catesby: The Colonial Audubon.* Urbana: University of Illinois Press, 1961.

Frick, George, and Ewan, Joseph, eds. *The Natural History of Carolina, Florida and the Bahama Islands; Containing Two Hundred and Twenty Figures of Birds, Beasts, Fishes, Serpents, Insects and Plants.* 2 vols. Savannah, Ga.: Beehive Press, 1974.

Frye, Roland Mushat. *Milton's Imagery and the Visual Arts.* Princeton, N.J.: Princeton University Press, 1978.

Gardner, Albert T., and Feld, Stuart. *American Paintings: A Catalogue of the Metropolitan Museum of Art.* Greenwich, Conn.: New York Graphic Society, 1965.

Gaustad, Edwin. *George Berkeley in America.* New Haven, Conn.: Yale University Press, 1979.

Gilman, Arthur. "The Hancock House and Its Founder." *Atlantic Monthly* 11 (June 1863):692–707.

Glenn, Thomas Allen. *Some Colonial Mansions and Those Who Lived in Them.* Philadelphia: Henry T. Coates, 1898.

Gold, Sidney. "A Study in Early Boston Portrait Attributions: Augustine Clement, Painter-Stainer of Reading, Berkshire, and Massachusetts Bay." *Old-Time New England* 53 (January–March 1968):61–77.

Goodrich, Lloyd. *Robert Feke.* New York: Whitney Museum of American Art, 1946.

Green, Samuel. "English Origins of Seventeenth-Century Painting in New England." In *American Painting to 1776: A Reappraisal, Winterthur Conference Report for 1971.* Charlottesville: University Press of Virginia, 1971, pp. 15–70.

Green, Samuel Abbott. *John Foster, the Earliest American Engraver and the First Boston Printer.* Boston: Massachusetts Historical Society, 1909.

Griswold, A. Whitney. "Three Puritans on Prosperity." *New England Quarterly* 7 (1934):475–93.

Hall, David D. *The Faithful Shepherd: A History of the New England Ministry in the Seventeenth Century.* Chapel Hill: University of North Carolina Press, 1972.

Hall, Thomas. *The Loathsomnesse of Long Haire.* London, 1653.

Hall, Virginius Cornick, Jr. *Portraits in the Collection of the Virginia Historical Society: A Catalogue.* Charlottesville: University Press of Virginia, 1981.

Haller, William. *The Rise of Puritanism; or, The Way to the New Jerusalem as set forth in Pulpit and Press from Thomas Cartwright to John Lilburne and John Milton, 1570–1643.* New York: Columbia University Press, 1938.

Harrington, Virginia. *The New York Merchant on the Eve of the Revolution.* New York: Columbia University Press, 1935.

Hendrick, Burton J. *The Lees of Virginia: Biography of a Family.* Boston: Little, Brown, 1935.

Henretta, James A. "Economic Development and Social Structure in Colonial Boston." *William and Mary Quarterly.* 3rd series, 22 (January 1965):75–92.

Hoff, Ursula. *Charles I, Patron of Artists.* London: Collins, 1942.

Holmes, Thomas, ed. *Cotton Mather, A Bibliography of His Works.* 3 vols. Cambridge, Mass.: Harvard University Press, 1940.

Hood, George. *A History of Music in New England.* Boston, 1846.

Hood, Graham. "A New Look at Charles Bridges, Colonial Virginia Painter, 1735–45." *American Art Journal* 9 (November 1977):57–67.

Hood, Graham. *Charles Bridges and William Dering: Two Virginia Portrait Painters, 1735–1750.* Charlottesville: University Press of Virginia, 1978.

Hornberger, Theodore. "The Date, Source, and Significance of Cotton Mather's Interest in Science." *American Literature* 6 (1935):413–20.

Hornberger, Theodore. "Puritanism and Science: The Relationship Revealed in the Writings of John Cotton." *New England Quarterly* 10 (1937):503–15.

Howard, John Tasker. *Our American Music: A Comprehensive History from 1620 to the Present.* New York: Crowell, 1965.

Huizinga, Johan H. *Dutch Civilization in the Seventeenth Century, and Other Essays.* London: Collins, 1968.

Hull, John. *The Diaries of John Hull,* in *American Antiquarian Society Transactions and Collections* 3. Worcester, Mass., 1857, 109–316.

Hume, David. *Abstract of a Treatise of Human Nature.* London, 1740. Reprinted with introduction by J. M. Keynes and P. Sraffa, Cambridge University Press, 1938.

Ingamells, John. *The English Episcopal Portrait, 1559–1835: A Catalogue.* New Haven, Conn.: The Paul Mellon Centre for Studies in British Art, 1981.

James, Margaret. *Social Problems and Policy During the Puritan Revolution, 1640–1660.* London: Routledge, 1930.

Johnson, Edgar A. J. *American Economic Thought in the Seventeenth Century.* London: P. S. King, 1932.

Johnson, Melvin M. *The Beginnings of Freemasonry in America.* New York: George H. Doran, 1924.

Jones, Hugh. *The Present State of Virginia; from Whence is Inferred a Short View of Maryland and North Carolina.* London, 1724, ed. Richard L. Morton. Chapel Hill: University of North Carolina Press, 1956.

Kammen, Michael. *Colonial New York: A History.* New York: Scribner, 1974.

Kammen, Michael. *People of Paradox: An Inquiry Concerning the Origins of American Civilization.* New York: Knopf, 1972.

Kelly, Franklin. "The Portraits of John Durand." *Antiques* 122 (November 1982):1080–87.

Kerslake, John. *Early Georgian Portraits.* 2 vols. London: National Portrait Gallery, 1977.

Killanin, Michael M. *Sir Godfrey Kneller and His Times, 1646–1723, Being a Review of English Portraiture of the Period.* New York: Batsford, 1948.

The Kit-Cat Club, Done from the Original Paintings of Sir Godfrey Kneller by Mr. Faber. London, 1735.

Kittredge, George Lyman. "Cotton Mather's Scientific Communications to the Royal Society." *Proceedings of the American Antiquarian Society* n.s. 26 (1916):18–57.

Larsen, Erik. *Calvinistic Economy and 17th Century Dutch Art.* Lawrence: University of Kansas Press, 1979.

Lecky, William E. H. *A History of England in the Eighteenth Century.* 8 vols. London: Longmans, Green, 1878–90.

Lee, Cazenova G. *Lee Chronicle: Studies of the Early Generations of the Lees of Virginia.* New York: New York University Press, 1957.

Lemay, J. A. Leo. *Men of Letters in Colonial Maryland.* Knoxville: University of Tennessee Press, 1972.

Lewalski, Barbara K. *Protestant Poetics and the Seventeenth-Century Religious Lyric.* Princeton, N.J.: Princeton University Press, 1979.

Lillo, George. *The London Merchant,* ed. William H. McBurney. Lincoln: University of Nebraska Press, 1965. First edition, London, 1731.

Locke, John. *An Essay Concerning Human Understanding,* ed. Peter H. Nidditch. New York: Oxford University Press, 1975; first published London, 1690.

Locke, John. *The Works of John Locke.* 9 vols. 9th edition. London, 1794.

Luce, A. A., and Jessop, T. E., eds. *The Works of George Berkeley, Bishop of Cloyne.* 9 vols. London: Thomas Nelson, 1948–57.

McCully, Bruce T. "Governor Francis Nicholson, Patron *Par Excellence* of Religion and Learning in Colonial America." *William and Mary Quarterly* 39 (April 1982):310–33.

McNeill, John T. *The History and Character of Calvinism.* New York: Oxford University Press, 1954.

Mandle, Earl Roger. *Dutch Masterpieces from the Eighteenth Century: Paintings and Drawings, 1700–1800.* Minneapolis: Minneapolis Institute of Arts, 1971.

Marshall, Rosalind K. *Childhood in Seventeenth Century Scotland.* Edinburgh: National Galleries of Scotland, 1976.

Mather, Cotton. *Bonifacius, An Essay upon the Good.* Boston, 1710.

Mather, Cotton. *A Christian at His Calling, Two Brief Discourses, One Directing a Christian in His General Calling; Another Directing Him in His Personal Calling.* Boston, 1701.

Mather, Cotton. *The Christian Philosopher*. London, 1721. Scholars' Facsimilies & Reprints edition, ed. Josephine Piercy. Gainsville: University of Florida Press, 1968.

Mather, Cotton. *Icono-clastes: An Essay Upon the Idolatry Too Often Committed Under the Profession of the Most Reformed Christianity*. Boston, 1717.

Mather, Increase. *The Necessity of Reformation*. Boston, 1679.

Mather, Samuel. *A Testimony from the Scripture Against Idolatry & Superstition, in Two Sermons . . . , Preached the One on September 27, the Other on September 30, 1660*. Boston, 1725.

Melton, Robert K. "Puritanism, Pietism and Science." *Sociological Review* 28 (January 1936):1–30.

Michaelson, Robert S. "Changes in the Puritan Concept of Calling or Vocation." *New England Quarterly* 26 (1953):315–36.

Middlekauff, Robert. *The Mathers: Three Generations of Puritan Intellectuals, 1596–1728*. New York: Oxford University Press, 1971.

Middleton, Margaret S. *Henrietta Johnston of Charles Town, South Carolina*. Columbia: University of South Carolina Press, 1966.

Middleton, Margaret S. *Jeremiah Theus, Colonial Artist of Charles Town*. Columbia: University of South Carolina Press, 1953.

Miller, John. *New York Considered and Improved*, ed. Victor H. Paltsits. Cleveland: Burroughs Brothers, 1903; first published 1695.

Miller, Lillian B. "The Puritan Portrait: Its Function in Old and New England." In *Seventeenth-Century New England*. Boston: The Colonial Society of Massachusetts, 1984, vol. 63:153–84.

Miller, Perry. *The American Puritans, Their Prose and Poetry*. New York: Doubleday, 1956.

Miller, Perry. *The New England Mind: From Colony to Province*. Cambridge, Mass.: Harvard University Press, 1953.

Miller, Perry. *The New England Mind: The Seventeenth Century*. New York: Macmillan, 1939.

Miller, Perry. *Orthodoxy in Massachusetts, 1630–1650*. Cambridge, Mass.: Harvard University Press, 1933.

Molesworth, Sir William. *The English Works of Thomas Hobbes*. 11 vols. London, 1839–45.

Mooz, Peter. "The Art of Robert Feke." Ph.D. dissertation, University of Pennsylvania, 1970.

Mooz, Peter. "Colonial Art." In John Wilmerding, ed., *The Genius of American Painting*. New York: Morrow, 1973, pp. 25–80.

Mooz, Peter. "New Clues to the Art of Robert Feke." *Antiques* 94 (November 1968): 702–7.

Mooz, Peter, et al. *Philadelphia Painting and Printing to 1776*. Philadelphia: Pennsylvania Academy of the Fine Arts, 1971.

Mooz, Peter. "Robert Feke: The Philadelphia Story." In *American Painting to 1776: A Reappraisal, Winterthur Conference Report for 1971*. Charlottesville: University Press of Virginia, 1971, pp. 181–216.

Mooz, Peter. "Smibert's *Bermuda Group* – A Reevaluation." *Art Quarterly* 33 (Summer 1970):147–57.

Morgan, John Hill, and Foote, Henry Wilder. "An Extension of Lawrence Park's Descriptive List of the Work of Joseph Blackburn." *Proceedings of the American Antiquarian Society* 46 (April 1936):15–81.

Morison, Samuel Eliot. *Builders of the Bay Colony*. New York: Houghton, 1930.

Morris, Frances. *Notes on Laces and the American Colonists*. New York: William Helburn, 1926.

Morrison, Hugh. *Early American Architecture, from the first Colonial Settlements to the National Period.* New York: Oxford University Press, 1952.

Morton, W. S. "The Portraits of Lower Brandon and Upper Brandon, Virginia." *William and Mary Quarterly*, 2nd series, 10 (1910):338–40.

National Portrait Gallery, Complete Illustrated Catalogue, 1856–1979, ed. Kai Kin Yung. London: National Portrait Gallery, 1981.

Nickalls, John L., ed. *The Journal [of George Fox].* Cambridge University Press, 1952.

Oakes, Urian. *New-England Pleaded With.* Cambridge, Mass., 1673.

O'Donoghue, Freeman. *Catalogue of Engraved British Portraits Preserved in the Department of Prints and Drawings in the British Museum.* 6 vols. London: British Museum, 1908–25.

Ogden, Henry, and Ogden, Margaret. "A Bibliography of Seventeenth-century Writings on the Pictorial Arts in English." *Art Bulletin* 29 (September 1947):196–201.

Oliver, Andrew. "Peter Pelham (c. 1697–1751), Sometime Printmaker of Boston." In *Boston Prints and Printmakers, 1670–1775.* Boston: Colonial Society of Massachusetts 46 (1973):133–74.

Park, Lawrence. "Joseph Blackburn – Portrait Painter." *American Antiquarian Society Proceedings* 32 (October 1922):270–329.

Peacham, Henry. *The Art of Drawing with the Pen, and Limning in Water Colours.* London, 1606.

Peacham, Henry. *The Compleat Gentleman.* London, 1622.

Peacham, Henry. *The Gentleman's Exercise, or, An Exquisite Practise, as well for Drawing all manner of Beasts in their true Portraitures, as also the making of all kinds of colours to be used in Lymning, Painting. . . .* London, 1612.

Perkins, William. *An Exposition of Christ's Sermon on the Mount.* Cambridge, England, 1608.

Perkins, William. *How to Live, and That Well, in All Estates and Times: Especially When Helpes and Comforts Faile.* London, 1611.

Perkins, William. *A Warning Against the Idolatry of the Last Times.* Cambridge, England, 1605.

Perkins, William. *The Workes of That Famous Minister of Christ in the University of Cambridge, Mr. William Perkins.* 3 vols. London, 1612–13.

Philadelphia Painting and Printing to 1776: An Exhibition in Conjunction with the Seventeenth Annual Winterthur Conference and with the Cooperation of the Historical Society of Pennsylvania. Philadelphia: Pennsylvania Academy of the Fine Arts, 1971.

Phillips, John. *The Reformation of Images: Destruction of Art in England, 1535–1665.* Berkeley: University of California Press, 1975.

Pleasants, J. Hall. "Justus Engelhardt Kühn: An Early Eighteenth Century Maryland Portrait Painter." *Proceedings of the American Antiquarian Society*, 46 (October 1936):243–80.

Pleasants, J. Hall. *Two Hundred and Fifty Years of Painting in Maryland.* Baltimore: Baltimore Museum of Art, 1945.

Poesch, Jessie. *The Art of the Old South: Painting, Sculpture, Architecture and the Products of the Craftsman, 1560–1860.* New York: Knopf, 1983.

Pratt, Waldo Selden. *The Music of the Pilgrims: A Description of the Psalm-book Brought to Plymouth in 1620.* Boston: Oliver Ditson, 1921.

Prown, Jules D. *John Singleton Copley.* 2 vols. Cambridge, Mass.: Harvard University Press, 1966.

Prown, Jules D. "Mind in Matter: An Introduction to Material Culture Theory and Method." *Winterthur Portfolio* 17 (Spring 1982):1–18.

Prown, Jules D. "Style as Evidence." *Winterthur Portfolio* 15 (Autumn 1980):197–210.

Prynne, William. *Histrio-Mastix. The Players Scourge, or, Actors Tragedie . . .* London, 1633.

Quick, Michael. *American Portraits in the Grand Manner.* Los Angeles: Los Angeles County Museum of Art, 1981.

Raesly, Ellis L. *Portrait of New Netherland.* New York: Columbia University Press, 1945.

Reps, John W. "Boston by Bostonians: The Printed Plans and Views of the Colonial City by Its Artists, Cartographers, Engravers, and Publishers." In *Boston Prints and Printmakers, 1670–1775.* Boston: Colonial Society of Massachusetts 46 (1973): 3–56.

Richardson, Edgar; Hindle, Brooke; and Miller, Lillian. *Charles Willson Peale and His World.* New York: Abrams, 1983.

Richardson, Jonathan. *An Essay on the Theory of Painting.* London, 1715.

Riley, Stephen T. "John Smibert and the Business of Portrait Painting." In *American Painting to 1776: A Reappraisal, Winterthur Conference Report for 1971.* Charlottesville: University Press of Virginia, 1971, pp. 159–80.

Rouse, Parke. *James Blair of Virginia.* Chapel Hill: University of North Carolina Press, 1971.

Rutledge, Anna Wells. *Artists in the Life of Charleston, Through Colony and State, from Restoration to Reconstruction.* Philadelphia: American Philosophical Society *Transactions* 39 (November 1949):part 2.

Rutman, Darrett B. *American Puritanism, Faith and Practice.* Philadelphia: Lippincott, 1970.

Rutman, Darrett B. *Winthrop's Boston: A Portrait of a Puritan Town, 1630–1649.* Chapel Hill: University of North Carolina Press, 1965.

Sadik, Marvin S. *Colonial and Federal Portraits at Bowdoin College.* Brunswick, Me.: Bowdoin College Museum of Art, 1966.

Salerno, Luigi. "Seventeenth-Century English Literature on Painting." *Journal of the Warburg and Courtauld Institutes* 14 (July-December 1951):234–58.

Salmon, William. *Polygraphice.* London, 1672.

Saunders, Richard H., III. "John Smibert (1688–1751): Anglo-American Painter." Ph.D. dissertation, Yale University, 1979.

Sawitzky, William. *Matthew Pratt.* New York: The New-York Historical Society, 1942.

Scheurleer, T. H. Lunsingh. "The Dutch and Their Homes in the Seventeenth Century." In *Winterthur Conference Report, 1974.* Charlottesville: University Press of Virginia, 1975, pp. 13–42.

Schimmelman, Janice G. "A Checklist of European Treatises on Art and Essays on Aesthetics Available in America Through 1815." *Proceedings of the American Antiquarian Society* 93 (part 1, 1983):95–195.

Schlesinger, Arthur M. *The Birth of the Nation: A Portrait of the American People on the Eve of Independence.* New York: Knopf, 1968.

Schmiegel, Karol A. "Encouragement Exceeding Expectation: The Lloyd–Cadwalader Patronage of Charles Willson Peale." *Winterthur Portfolio* 12 (1977):87–102.

Schmiegel, Karol A. "Patronage of Artists by the Lloyd Family of Maryland's Eastern Shore." Master's thesis, University of Delaware, 1975.

Schneider, Herbert W. *The Puritan Mind.* New York: Holt, 1930.

Sellers, Charles Coleman. *Benjamin Franklin in Portraiture.* New Haven, Conn.: Yale University Press, 1962.

Sellers, Charles Coleman. *Mr. Peale's Museum: Charles Willson Peale and the First Popular Museum of Natural Sciences in America.* New York: Norton: 1980.

Sellers, Charles Coleman. *Portraits and Miniatures by Charles Willson Peale.* In *Transactions of the American Philosophical Society* 42 (1952):part 1, pp. 3–369.

Sensabaugh, George F. *Milton in Early America*. Princeton, N.J.: Princeton University Press, 1964.

Sewall, Samuel. *The Diary of Samuel Sewall, 1674–1729*, ed. M. Halsey Thomas. 2 vols. New York: Farrar, Straus & Giroux, 1973.

Shurtleff, Nathaniel, ed. *Records of the Governor and Company of the Massachusetts Bay in New England*. 5 vols. Boston, 1853.

Silverman, Kenneth. *The Life and Times of Cotton Mather*. New York: Harper & Row, 1984.

Simpkins, Francis B., ed. *Art and Music in the South*. Farmville, Va.: n.p., 1961; Jon D. Longaker, "Painting," pp. 109–32.

Simpson, Alan. *Puritanism in Old and New England*. Chicago: University of Chicago Press, 1955.

Singleton, Esther. *Dutch New York*. New York: Dodd, Mead, 1909.

Smibert, John. *The Notebook of John Smibert*. With essays by Sir David Evans, John Kerslake, and Andrew Oliver. Boston: Massachusetts Historical Society, 1969.

Smith, Adam. *An Inquiry into the Nature and Causes of the Wealth of Nations*. London, 1776.

Smith, James Morton, ed. *Seventeenth-Century America*. Chapel Hill: University of North Carolina Press, 1959.

Smith, John Chaloner. *British Mezzotinto Portraits*. 4 vols. London: H. Sotheran, 1878–83.

Stack, George J. *Berkeley's Analysis of Perception*. The Hague: Mouton, 1970.

Stanard, Mary Mann Page. *Colonial Virginia, Its People and Customs*. Philadelphia: Lippincott, 1917.

Steegman, John. *A Survey of Portraits in Welsh Houses*. 2 vols. Cardiff: National Museum of Wales, 1957–62.

Stein, Roger B. "Thomas Smith's Self-Portrait: Image/Text as Artifact." *Art Journal* 44 (Winter, 1984):316–27.

Stewart, J. Douglas. *Sir Godfrey Kneller*. London: National Portrait Gallery, 1971.

Stoddard, Whitney. "Three Puritans on Prosperity." *New England Quarterly* 7 (September 1934):475–93.

Strickler, Susan. "Recent Findings on the Freake Portraits." *Worcester Art Museum Journal* 5 (1981–82):49–55.

Strickler, Susan. *Toledo Museum of Art, American Paintings*. Toledo, Ohio: Toledo Museum of Art, 1979.

Strong, Roy. *The English Icon: Elizabethan and Jacobean Portraiture*. London: Routledge & Kegan Paul, 1969.

Strong, Roy. *Tudor and Jacobean Portraits*. London: National Portrait Gallery, 1969.

Tatum, George Bishop. *Philadelphia Georgian: The City House of Samuel Powel*. Middletown, Conn.: Wesleyan University Press, 1976.

Tawney, Richard H. *Religion and the Rise of Capitalism*. New York: New American Library, 1948; first published 1926.

Thomas, P. W. "Two Cultures? Court and Country Under Charles I." In *The Origins of the English Civil War*, ed. Conrad Russell. New York: Barnes & Noble, 1973, pp. 168–93.

Tipton, I. C. *Berkeley: The Philosophy of Immaterialism*. London: Methuen, 1974.

Troyen, Carol. *The Boston Tradition; American Paintings from the Museum of Fine Arts, Boston*. New York: American Federation of Arts, 1980.

Van Devanter, Ann C. *"Anywhere So Long As There Be Freedom": Charles Carroll of Carrollton, His Family & His Maryland*. Baltimore: Baltimore Museum of Art, 1975.

Van Doren, Carl. *Benjamin Franklin*. New York: Viking, 1938.

Vaughan, Alden T., ed. *The Puritan Tradition in America, 1620–1730*. Columbia: University of South Carolina Press, 1972.

Viner, Jacob. *Religious Thought and Economic Society*. Durham, N.C.: Duke University Press, 1978.

Walpole, Horace. *Anecdotes of Painting in England . . . Collected by the Late George Vertue*. 3 vols. London, 1862.

Ward, Edward. *A Trip to New-England, With a Character of the Country and People, both English and Indians*. London, 1699.

Warfield, Benjamin B. *Calvin and Calvinism*. New York: Oxford University Press, 1931.

Warren, William L. "The Pierpont Limner and Some of His Contemporaries." *Connecticut Historical Society Bulletin* 23 (October 1958):1–10, 50–60, and 97–128.

Warwick, Edward, and Pitz, Henry C. *Early American Costume*. New York: The Century, 1929.

Waterhouse, Ellis K. *Painting in Britain, 1530–1790*. Baltimore: Penguin, 1953.

Weber, Max. *The Protestant Ethic and the Spirit of Capitalism*. Translated by Talcott Parsons, with a foreword by R. T. Tawney. London: Allen & Unwin, 1930. First published in German in Leipzig, 1920.

Wecter, Dixon. *The Saga of American Society: A Record of Social Aspiration, 1607–1937*. New York: Scribner, 1937.

Weddell, Alexander W. *A Memorial Volume of Virginia Historical Portraiture, 1585–1830*. Richmond, Va.: William Byrd Press, 1930.

Weeden, William B. *Economic and Social History of New England, 1620–1789*. Boston, 1890.

Weekley, Carolyn J. "John Wollaston, Portrait Painter: His Career in Virginia, 1754–1758." Master's thesis, University of Delaware, 1976.

Weekley, Carolyn J., et al. *Painting in the South: 1564–1980*. Richmond: Virginia Museum, 1983.

Weekley, Carolyn J. "Portrait Painting in Eighteenth-Century Annapolis." *Antiques* 111 (February 1977):345–53.

Wencelius, Léon. *L'Esthétique de Calvin*. Paris: Société d'Edition "Les Belles Lettres," 1937.

Wertenbaker, Thomas Jefferson. *Patrician and Plebeian in Virginia; or, The Origin and Development of the Social Classes*. New York: Russell, 1959.

Wertenbaker, Thomas Jefferson. *The Puritan Oligarchy: The Founding of American Civilization*. New York: Grosset & Dunlap, 1947.

Westfall, Richard S. *Never at Rest: A Biography of Isaac Newton*. Cambridge University Press, 1980.

Westfall, Richard S. *Science and Religion in Seventeenth Century England*. New Haven, Conn.: Yale University Press, 1958.

White, John. *Arts Treasury, Containing Extraordinary Rarities and Curious Inventions*. London, 1671.

Whitley, William T. *Artists and their Friends in England, 1700–1799*. 2 vols. Boston: The Medici Society, 1928.

Whitman, Samuel. *Practical Godliness, The Way to Prosperity*. New London, Conn., 1714.

Williams, Hermann W. *American Painters of the South*. Washington, D.C.: Corcoran Gallery, 1960.

Williamson, George C. *The Portraits, Prints and Writings of John Milton*. New York: Burt Franklin, 1968.

Wilson, Robert. "Art and Artists in Provincial South Carolina." *Yearbook*. Charleston: City of Charleston, 1899.

The Winslows: Pilgrims, Patrons, and Portraits; a Joint Exhibition at Bowdoin College Museum of Art and the Museum of Fine Arts, Boston. Brunswick, Me.: Bowdoin College, 1974.

Winsor, Justin. *The Memorial History of Boston . . . 1630–1880.* 4 vols. Boston: J. R. Osgood, 1880–81.

Winthrop Papers, 1498–1649. 5 vols. Boston: Massachusetts Historical Society, 1929–47.

Wolf, Edwin, 2nd. "The Library of Edward Lloyd IV of Wye House." *Winterthur Portfolio* 5 (1969):87–122.

Wolf, Edwin, 2nd. *The Library of James Logan, 1674–1751.* Philadelphia: Library Company of Philadelphia, 1974.

Wolff, Cynthia. *Samuel Richardson and the Eighteenth-Century Puritan Character.* Hamden, Conn.: Anchor Books, 1972.

Woodfin, Maude H., ed. *Another Secret Diary of William Byrd of Westover, 1739–1741.* Richmond, Va.: Dietz Press, 1942.

Wright, Louis B. *The Cultural Life of the American Colonies, 1607–1763.* New York: Harper & Row, 1962.

Wright, Louis B. *The First Gentlemen of Virginia: Intellectual Qualities of the Early Colonial Ruling Class.* San Marino, Calif.: The Huntington Library, 1940.

Wright, Louis B. *Letters of Robert Carter, 1720–1727: The Commercial Interests of a Virginia Gentleman.* San Marino, Calif.: The Huntington Library, 1940.

Wright, Louis B. *Middle-class Culture in Elizabethan England.* Chapel Hill: University of North Carolina Press, 1935.

Wright, Louis, and Tinling, Marion, eds. *The Secret Diary of William Byrd of Westover, 1709–1712.* Richmond, Va.: Dietz Press, 1941.

Young, Alan R. *Henry Peacham.* Boston: Twayne, 1979.

Ziff, Larzer. *Puritanism in America.* New York: Viking, 1973.

Index

References to illustrations are given in parentheses immediately following the entry, with page numbers indicated in bold type. Titles such as Mrs., Rev., Col., and Gov. do not affect alphabetization; portraits are alphabetized by last names. The works of an artist or author are listed at the end of the entry, after all other subentries.